SIENA, FLORENCE AND PADUA:
ART, SOCIETY AND RELIGION 1280–1400

SIENA, FLORENCE AND PADUA:
ART, SOCIETY AND RELIGION 1280–1400

Volume I: Interpretative Essays

Edited by Diana Norman

Yale University Press, New Haven & London
in association with The Open University

Library of Congress Cataloging-in-Publication Data
Siena, Florence, and Padua: art, society, and religion 1280–1400 /
edited by Diana Norman.
p. cm.
Includes bibliographical references and index.
Contents: v. 1. Interpretative essays.
ISBN 0-300-06124-2 (v. 1: hb). -- ISBN 0-300-06125-0 (v. 1: pb)
1. Art, Italian. 2. Art, Gothic -- Italy. 3. Art, Early Renaissance -- Italy. 4. Art and society -- Italy.
5. Art patronage -- Italy. 6. Art and religion -- Italy. I. Norman, Diana, 1948-N6913.S53 1995
701'.03'094509023--dc20 94-25653
 CIP

Edited, designed and typeset by The Open University

A354vol1i1.1

Printed in Singapore by C.S. Graphics PTE Ltd

1.1

Contents

List of plates

Preface

This book is the first of two volumes on the relationships between art, religion and society in Siena, Florence and Padua from 1280 to 1400. It is published by Yale University Press in association with the Open University. The essays in both volumes were written with the needs of Open University undergraduate students primarily in mind. However, the authors hope that they will also be of value to other readers with an interest in this subject.

The illustrations within each volume are accompanied by captions which supply essential information concerning the identity of the artists (where known); the dates at which the works of art are thought to have been executed; the medium and scale of the works; and both their present and (where known) original locations. The measurements of many sculptures and frescoes have proved impossible to obtain. In these cases the authors have endeavoured to indicate the broad scale of the works concerned within the text of the essays.

The authors wish to acknowledge the essential contribution made to the production of both volumes by a number of other members of the Open University staff: Roberta Wood (course administrator), Julie Bennett, Abigail Croydon, Jonathan Hunt and Nancy Marten (editors), Tony Coulson (librarian), Sarah Hofton and Richard Hoyle (designers), John Taylor (graphic artist) and Sophie White (course team secretary).

The authors also wish to thank Professor Martin Kemp for his careful and constructive comments on the first drafts of all the essays within these two volumes. Additionally they wish to thank Louise Bourdua, Paul Davies, Christa Gardner von Teuffel, Dillian Gordon, Laura Jacobus, Andrew Martindale and Gervase Rosser for critical comments on the first drafts of particular essays. Each of the authors has benefited from the criticisms and observations made by these readers. Any inaccuracies or questionable judgements that remain are the responsibility of the authors alone.

The authors of the essays in the two volumes are:

Diana Norman (Lecturer in Art History, The Open University)

Tim Benton (Professor in Art History, The Open University)

Colin Cunningham (Staff Tutor in Art History, The Open University)

Charles Harrison (Staff Tutor and Professor in the History and Theory of Art, The Open University)

Catherine King (Senior Lecturer in Art History, The Open University).

Siena, Florence and Padua

On 3 September 1402 Gian Galeazzo Visconti – one of a line of Visconti rulers of Milan – died. His death had a significant impact upon each of the three cities studied in this volume.

Florence was then a politically independent city state and a thriving centre of textile manufacture. It had extensive territorial holdings throughout Tuscany and functioned as a 'Commune' with broadly republican and democratic ideals.[1] For over a decade Milanese forces led by the Visconti had been threatening its territories and, in so doing, challenging its independent political identity. For Florence, Gian Galeazzo's death meant the removal of a powerful political and military threat.

Siena, like Florence a city of bankers and merchants with widespread international contacts, was already under the direct political domination of Gian Galeazzo. In 1399 a weak and politically divided regime had petitioned him to become *signore*, or sole governor, of Siena. His death enabled the city to revert to its former political status as an independent Commune.[2]

Padua was already well accustomed to seigneurial rule by 1402. At the beginning of the previous century it too had been a Commune. In the 1330s a powerful local family, the Carrara, rose to dominate the city's political and cultural life; by the 1370s their ascendancy had effectively secured a princely regime influential throughout north-eastern Italy. Two powerful neighbours – Venice to the east and Milan to the west – were thus antagonized, while the family's autocratic style had made it increasingly unpopular within Padua itself. The Visconti rulers of Milan were thus able to exploit the situation and expel the Carrara from the city. In 1388 Gian Galeazzo was established as *signore*. Padua was retaken in 1390 by the last of the Carrara *signori*, Francesco il Novello, but the Visconti threat continued to curb his political autonomy. Gian Galeazzo's death in 1402 removed this constraint. Three years later, however, Francesco il Novello was himself executed by the Venetian government and Padua became subject to Venetian rule.[3]

This passage of Italian history provides an appropriate starting point for the present collection of essays. It serves to highlight the fact that the three cities shared certain experiences in common. All three possessed traditions of communal government, and all three sought to extend their political domination to the surrounding countryside and neighbouring towns. In addition, however, all three were subject, to a greater or lesser degree, to the domination of an individual *signore* and his family. Thus, both Florence and Siena experienced brief periods during the fourteenth century when judicial and military authority was entrusted to a powerful outsider. Nevertheless, the two Tuscan cities retained an essentially communal style of government throughout the period studied in the volume, whereas Padua was subject to seigneurial rule from the fourth decade of the fourteenth century onwards.

A comparative study of the three cities thus presents considerable potential for the historian of fourteenth-century Italy. But what of the art of the period? Does a comparison of the three cities offer a similar potential for the investigation and interpretation of fourteenth-century painting, sculpture and architecture? It has long been recognized that fourteenth-century Florence was a city in which the arts of painting, sculpture and architecture were actively pursued and highly valued. It may fairly be said that both popularly and in scholarly circles Florence has conventionally been given a particular prominence in the history of western art. As early as the fourteenth century, Florentine writers praised their city for the quality of its artistic practitioners and their skill. The reputation established by these writings was further enhanced by the enormously influential *Lives of the Artists*, written in the sixteenth century by the writer and artist Giorgio Vasari, a native of Arezzo, then part of Florence's subject territory. The reputation of Florence was also linked to the work of the innovative fourteenth-century artist Giotto, a Florentine whose status within western art is comparable to that of Michelangelo or Rembrandt.[4] The significance of Giotto in particular and of Florentine art in general is, therefore, well established within the study of fourteenth-century Italian art. But despite the priority given to Florence, the significance of Sienese art of the same period is also widely recognized. Thus, it is generally acknowledged that the work of Sienese artists – and in particular that of Duccio – was also highly influential in the development of fourteenth-century Italian art. Indeed, there is a long historiographical tradition of comparing the art of fourteenth-century Florence with that of Siena, and of assessing their respective contributions to the history of art.[5] Conventionally, such comparisons emphasize the qualities of space, volume, structure and three-dimensionality said to characterize the art of Giotto and Florentine artists in general, and contrast these with the qualities of line, colour, pattern and lyricism which, it is said, distinguish the art of Duccio and his Sienese successors.

Despite his close association with Florence, however, much of our understanding of Giotto's abilities and skills as a painter rests upon the unsigned and undocumented frescoes which line the walls of a small and architecturally undistinguished chapel in Padua. Nothing concrete is known about why Giotto travelled to Padua to fulfil a commission for a powerful local merchant, Enrico Scrovegni.[6] It is generally acknowledged, however, that Giotto's presence in the city in the early fourteenth century and the legacy he left in the form of this impressively coherent cycle of frescoes in the Arena Chapel provided an important stimulus for later painters there. These included Paduan painters such as Guariento, who worked for the Carrara family and its close associates in the middle decades of the century, and other artists such as the Veronese painter Altichiero, who executed a number of impressive cycles of painting in the 1380s on

behalf of the Carrara and other prominent Paduan families.[7]

There are good reasons, therefore, to study the art of each of these three cities. But what of their relationship one with the other? To what extent were there cultural, social and political contacts between them? We have already noted the example of Giotto, a Florentine painter whose best-known work was executed in Padua and who thereby exerted a significant influence upon Paduan art. But other examples may also be cited to illustrate the complexity and variety of contacts between the three cities. The potentially rich interaction between Siena and Florence is nowhere better demonstrated than in the small Tuscan hill-top town of San Gimignano which, with its series of tall towers, still retains the characteristic contours of a fourteenth-century Italian city. An independent Commune during the first half of the fourteenth century, San Gimignano nevertheless had close political and cultural contacts with its southern neighbour, Siena. The San Gimignanese government frequently appointed its chief military and judicial officer, the Podestà, from leading Sienese families and employed a series of Sienese painters and sculptors to produce works of art to embellish the interior of the town hall and principal church.[8] A further example of the potentially close relationship between the two towns occurred in 1334 when a wealthy San Gimignanese woman, Simona, founded an Augustinian convent in her home town. The first abbess of the new convent was a nun from the Augustinian convent of Santa Marta in Siena.[9] In 1353, however, San Gimignano was incorporated into Florentine territory and became a subject town of Florence. The Florentines demolished the town's Dominican priory and built an impressive fortress in its place. Florentine officials were now sent to govern the town and Florentine artists – such as the painter Lorenzo di Niccolò – received commissions to work there. Nevertheless, despite this new Florentine political domination, painters from Siena, including both Bartolo di Fredi and Taddeo di Bartolo, continued to find employment in San Gimignano.[10]

A similarly complex amalgam of cultural and social relationships existed between Padua and both Florence and Siena. Giotto, as we have said, was working in Padua in the early decades of the fourteenth century. Prominent members of the Carrara circle also had contacts with the two Tuscan cities. For example, Bonifacio Lupi, originally from Soragna near Parma, took up residence in Padua in the 1360s and served the Carrara as both a diplomat and military commander. He was also responsible for at least two major artistic commissions awarded to the Veronese painter Altichiero. These survive today in and near the Franciscan basilica of Sant'Antonio in Padua. Between 1362 and 1363, however, Bonifacio was sent by Francesco il Vecchio to Florence, where he served as commander of the Florentine militia. His political contacts with Florence facilitated his founding of a hospital within the city. In surviving documentation of Bonifacio Lupi's affairs, there are also references to his acting in 1379 and 1387 on behalf of a Sienese, Nicolò di Silva, who wished to erect a chapel within one of Padua's churches. Such contacts may well, in turn, have been assisted by the fact that Bonifacio's wife, Caterina dei Francesi, came from Staggia, a small town situated just a few kilometres north of Siena but already by this date part of the Florentine state:[11] an example of how territory close to one city might become part of another city's political domain, overlapping spheres of influence thereby being established.

The repercussions of Gian Galeazzo Visconti's death, and numerous other examples of contacts between the three cities, establish clearly that Siena, Florence and Padua were not simply self-contained entities. Despite the highly developed sense of civic identity characteristic of each, all were inevitably drawn into wider political and cultural arenas. Each was engaged in a continuing process of territorial rivalry, either with each other (in the case of Florence and Siena) or with larger and more powerful neighbours (like Milan). Similarly, the presence within the three cities of newly founded religious orders – such as the Franciscans, the Dominicans and the Augustinian Hermits – broadened the cultural and intellectual horizons of the cities themselves and provided vital avenues of opportunity for Florentine, Sienese and Paduan artists to work elsewhere in Italy.

The small Umbrian hill town of Assisi was one such venue. Assisi never played a prominent role within fourteenth-century politics, except at a purely local level, but it was celebrated as the birthplace of Saint Francis. Shortly after the saint's death, an impressive double-storied basilica was erected on the outskirts of the town. This became the focal point for extensive campaigns of artistic embellishment, particularly in the form of cycles of mural painting. Such painted schemes, commissioned by popes, cardinals, high-ranking members of the Franciscan Order and even the royal family of Naples, drew painters from many parts of Italy. Given the proximity of Assisi to both Florence and Siena, this monumental venture inevitably attracted painters from the two cities. Thus, the Florentine painter Cimabue worked in both the Upper Church and the Lower Church. Giotto and other members of his workshop are also frequently associated with several other schemes in the basilica.[12] From Siena, meanwhile, came both Simone Martini and Pietro Lorenzetti. Assisi thus became a place of artistic experimentation and innovation (especially for mural painters and artists interested in depicting a narrative) – a development addressed in both the second and fourth essays in this volume.

It was not only the new religious orders, however, which provided fruitful opportunities for Sienese and Florentine artists to work outside their own cities. The political, diplomatic and economic links between Florence, Siena and the southern Italian city of Naples presented further opportunities for artistic activity. As the second essay describes, little now survives of the works which Giotto is documented as painting for the royal court of fourteenth-century Naples. What does survive, however, in relatively intact and impressive form is a series of tomb monuments for various members of the royal family. Significantly for our present purposes, the majority of these are documented as the work of Sienese or Florentine sculptors and thus provide examples of an important and influential genre of fourteenth-century sculpture – a topic explored in some detail in the fifth essay.

The three cities of Siena, Florence and Padua – considered both in themselves and in terms of their place within a broader Italian context – thus provide a compelling and suggestive focus for the study of Trecento art. Moreover, as

the title of this volume suggests, the authors of the various essays recognize the significance of the political and social contexts within which fourteenth-century art was first produced and subsequently received. Emphasis is thus given, particularly in the first essay, to the differing political regimes and histories of the three cities and to the ways in which these affected their artistic life. Similarly, it is recognized that aspects of contemporary religious practice and belief, and of contemporary learning and scholarship – along with social, political and economic factors – were highly formative influences upon the art of the three cities. Accordingly, the ninth and tenth essays focus upon precisely these themes.

A further major theme is the issue of patronage. Partly as a legacy of Italy's classical past and partly as a result of the impact of medieval feudalism, patronage was an integral part of fourteenth-century Italian society.[13] From the moment of birth, the life of any fourteenth-century Sienese, Florentine or Paduan would have been subject to a complex network of personal and familial relationships, obligations and reciprocal arrangements. Such relationships were fundamental to the political life of both communal Siena and Florence and seigneurial Padua. They were also central to matters of religion. Indeed, it has plausibly been argued that the cult of the saints – particularly the cult of the 'patron' saints of towns, guilds, religious orders, confraternities and individuals, and the belief in their active and daily intervention on behalf of their devotees – was but another manifestation of the widespread practice of patronage within fourteenth-century Italian culture and society.[14]

The potential for acting as a patron within fourteenth-century Italian society was, however, substantially conditioned by considerations of both class and gender. While members of wealthy and politically powerful families would have been in a position to exercise considerable patronage – political, religious, commercial and cultural – members of artisan families (from whom the majority of painters, sculptors and builders were drawn) would have had far fewer opportunities for such activities. Indeed, it is probable that artists would generally have been clients or petitioners, working to secure commissions for work from wealthy patrons. Yet within the narrower, more localized world of the workshop, neighbourhood and parish, a successful artist might also be in a position to dispense favours to fellow artists, neighbours and relatives. Women of all classes, meanwhile, enjoyed much less scope as patrons – a reflection of the severe restrictions placed upon their financial and social independence.[15]

It has long been recognized that patronage was a highly influential factor in the production and reception of Italian Renaissance art. Art cost money and therefore was initiated by those individuals who could command enough financial resources to support such ventures. They inevitably tended to be drawn from the ranks of the social élite. They also expected to play a more dominant part in defining the content of the works commissioned than the conditions of the art market allow today. For example, although Bonifacio Lupi left the day-to-day negotiations for the embellishment of his funerary chapel in Sant'Antonio to others – such as his wife and the eminent Paduan lawyer Lombardo della Seta – it is also clear that he had a number of clearly defined aspirations for the art

that he had gone to the expense and trouble of commissioning.[16] It is, however, frequently a matter of debate as to just how far patrons actively determined the final resolution of the art which they commissioned. Documentary evidence is tantalizingly sparse and often disappointingly uninformative. Contracts specify the materials to be used, the manner of payment and time-scale to be observed, but are customarily reticent about the subject-matter chosen and its significance. There is also the closely related question of how much fourteenth-century patrons were willing, as a rule, to leave to the discretion and acknowledged skill of the artists themselves. Aspects of such inherently complex questions are addressed in the present volume in the essays on Duccio, on civic patronage and on the relationship between art and learning.

As we have already noted, there were two contrasting political regimes within the three cities. In Padua during the second half of the century a powerful *signore* and his family effectively ruled the city. He, his family and members of his circle formed a close-knit élite which sought to emulate, in terms of their way of life and social aspirations, the courts of both northern Europe and southern Italy. In the two Tuscan cities of Siena and Florence, meanwhile, a rather different situation prevailed. Although leading families in both Siena and Florence aspired to noble status, the largest artistic projects in both cities were civic and communal in origin. The contrasting styles and patterns of art patronage arising from these differing political and social contexts are explored in the seventh and eighth essays of this volume.

If investigation of the circumstances that surround the patronage of fourteenth-century Sienese, Florentine and Paduan art are essential for its study, examination of the conditions for its actual practice are no less so. Thus, the present collection of essays also includes analyses of the distinctive practices of fourteenth-century painters, sculptors and builders. The second and third essays address a number of features characteristic of the fourteenth-century painter's training and workshop practice. The fifth essay, meanwhile, is devoted to the practice of sculpture in the three cities, challenging the conventional approach whereby the study of large-scale figural sculpture is given pride of place. Instead, the essay emphasizes the diversity of the work of fourteenth-century sculptors. The sixth essay then provides a succinct analysis of the building trades in each of the three cities, and discusses a range of factors which affected the practice of architecture in fourteenth-century Siena, Florence and Padua.

The final essay reviews conventional approaches to the art of the three cities and suggests a number of alternative avenues of inquiry. For example, it is noted that within the study of fourteenth-century Italian art, there has long been a tendency to focus upon monumental art designed for the public arena of the town hall, cathedral, mendicant church or oratory – to the detriment of such items as illuminated manuscripts, reliquaries, textiles and other kinds of artefact designed for more private or domestic purposes. We know that many fourteenth-century artists were actively involved in the production of such objects. Painters frequently contributed exquisitely crafted, brightly coloured and often highly illusionistic illuminations for manuscripts, which were produced in all three cities.

In introducing this collection of essays, it is also essential to address the crucial and fundamental question of the rate of survival of fourteenth-century Italian art. Our understanding of the art of both fourteenth-century Italy in general and of the three cities at the heart of this study is substantially constrained by this factor. In many ways San Francesco at Assisi, with its extensive cycles of thirteenth- and fourteenth-century mural paintings, is unique. Such a high rate of survival can undoubtedly be attributed to the value that the Catholic Church placed upon religious art – with its power to teach, make memorable and excite emotion – and to the powerful influence of the Franciscan Order and its determination to preserve the church in which its founder was buried.

In the case of Florence and Siena, the story is somewhat different. Churches belonging to powerful orders such as the Franciscans and the Dominicans sought to preserve their art – the frescoed chapels at Santa Croce and the chapter-house murals at Santa Maria Novella in Florence being cases in point. And yet, even Giotto's frescoes in the Bardi and Peruzzi Chapels were once covered in a layer of whitewash, with several crucial passages of painting lost forever. Similarly, we have lost a whole cycle of paintings by Pietro and Ambrogio Lorenzetti for the chapter-house and cloister walls of San Francesco in Siena – all that survive are two impressive mural paintings, a few tantalizing fragments and intriguing descriptions by later writers of the sheer power and vivacity of this cycle.[17] Domestic art suffered similar depredations as owners refashioned their residences to accommodate new requirements by their families and the latest preferences in interior decoration and furnishings. In Padua, meanwhile, after the fall of the Carrara, the Venetians apparently operated a self-conscious policy of erasing monuments and artistic schemes which could be associated with the fallen regime. Thus, little survives today of the Reggia – the heavily fortified residential enclave of the Carrara – which once boasted extensive schemes of painted decoration.[18]

One of the fascinations of studying fourteenth-century Italian art is, therefore, the piecing together of the available historical evidence in order to 'reconstruct' not only the physical form and content of the works of art, but also the historical situations within which they were first made and functioned. For example, adequate study of Duccio's achievement as a painter depends on the most thorough and scrupulous historical reconstruction of his major commission for the *Maestà*, the immense, double-sided, altarpiece for the high altar of Siena's Duomo. Subsequently dismantled and now located in a number of modern gallery collections, reconstruction of this altarpiece requires a wide variety of skills, encompassing the talents of the modern restorer, iconographer, archivist and historian.[19] The essays in the present volume, and those in the accompanying volume of case studies, reflect and depend upon this combination of skills and approaches on the part of the authors themselves and in their use of the work of other scholars. These essays, in turn, represent a further stage in the attempt to reconstruct – and hence appreciate and understand – the artistic legacy of Trecento Siena, Florence and Padua.

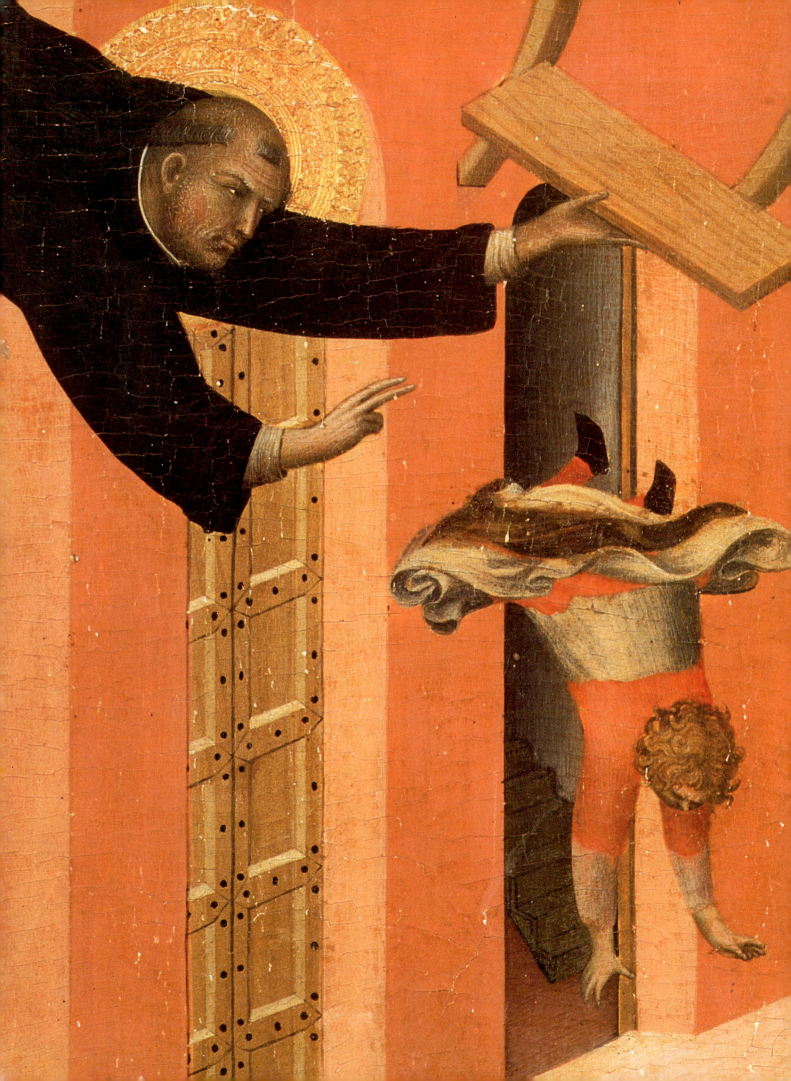

The three cities compared: patrons, politics and art

Prominent among the more impressive paintings in Siena's main art gallery, the Pinacoteca, is a large and resplendent painting by the fourteenth-century Sienese painter Simone Martini (Plate 2). Originally designed to be hung in Siena's principal Augustinian church, above the tomb of a local *beato*,[1] Agostino Novello (d.1309), the painting depicts the holy man himself, in the habit of the Augustinian Hermits, the religious order to which he belonged. On either side of this arresting image are four scenes depicting posthumous miracles attributed to him. He is shown restoring life to the victims of four separate fatal accidents – a compelling visual

endorsement of late medieval belief in the power of the saints to intervene in everyday life (Plate 1). These narrative scenes are testimony to Simone Martini's ability to convey in pictorial terms concrete and lively information about a local *beato*, his association with a particular religious order and his miraculous intervention in people's daily lives. A comparison between *The Blessed Agostino Novello* and an earlier thirteenth-century example of this type of hagiographical representation (Plate 3) reveals that Simone Martini has been able to convey a much greater sense of the physical presence of the saint himself, and, despite his economical use of detail, has

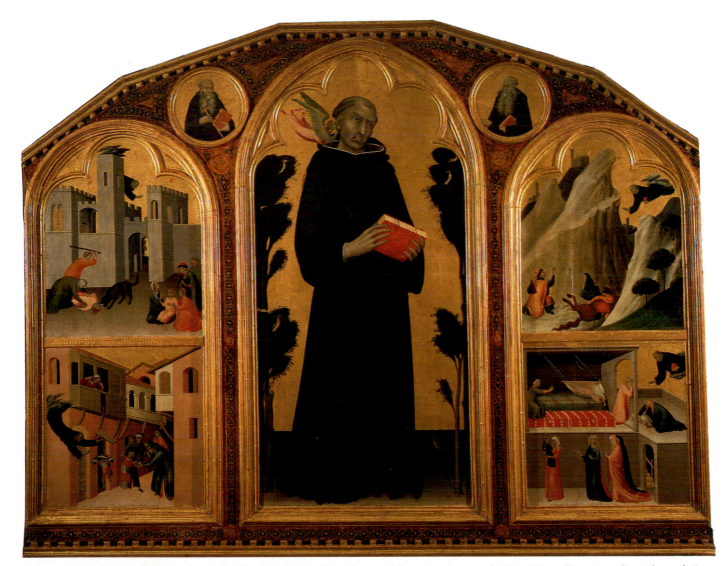

Plate 2 Simone Martini, *The Blessed Agostino Novello and Four of his Miracles*, 1320s, tempera on panel, 200 x 256 cm, Pinacoteca, Siena, formerly in Sant'Agostino, Siena. Photo: Lensini.

Plate 1 (Facing page) Simone Martini, *The Miracle of the Fallen Child*, detail of *The Blessed Agostino Novello* (Plate 2). Photo: Lensini.

Plate 3 Bonaventura Berlinghieri, *Saint Francis and Scenes from his Life*, 1235, tempera on panel, 153 x 111 cm, San Francesco, Pescia. Photo: Scala.

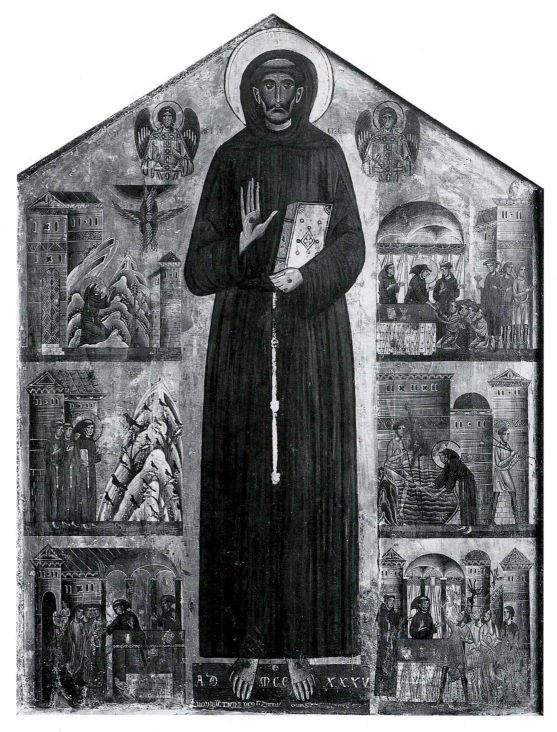

presented a much more complex and naturalistic depiction of the city and its rural surroundings than the schematic pictograms of the earlier painter. In short, the later painting provides evidence of a highly developed ability on the part of its maker to describe and record in pictorial terms dramatic and emotive situations alleged to have taken place in and around a fourteenth-century city environment.

A number of contemporary paintings indicate a similar impulse to portray the urban environment of the city. Several specifically depict – albeit in generic form – the distinctive urban topographies of fourteenth-century Siena, Florence and Padua. Bartolo di Fredi, for example, included in the background of *The Adoration of the Magi* a townscape showing

the recognizable outline and dark green and white marble embellishment of Siena Duomo (Plate 4). The appearance of mid fourteenth-century Florence is similarly recorded in a mural (once located on the inner wall of the loggia of one of the city's confraternity buildings) depicting the Virgin protecting the city beneath her ornate cloak (Plate 5). In this instance strict topographical accuracy has been sacrificed in order to convey a condensed overall view of the city, yet it is still possible to identify a number of the city's key public monuments – notably the octagonal shape and striking dark green and white marble revetment of the baptistery (Plate 13) and the striped bell-tower of the now destroyed church of San Pietro Maggiore. In Padua's principal Franciscan church of

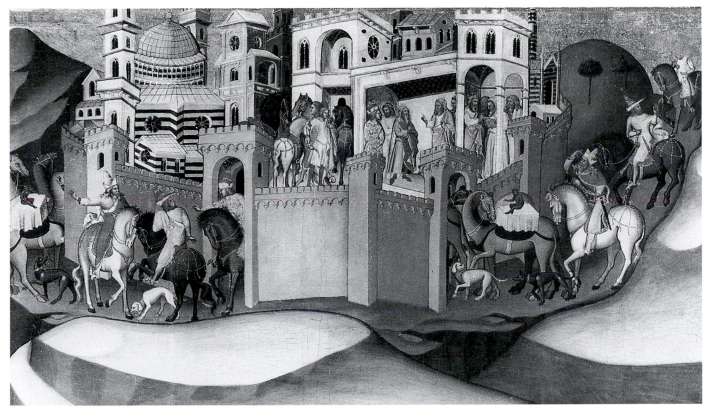

Plate 4 Bartolo di Fredi, *The Three Magi before Herod*, detail of *The Adoration of the Magi*, 1367?, tempera on panel, Pinacoteca, Siena, possibly formerly in the Duomo, Siena. Photo: Lensini.

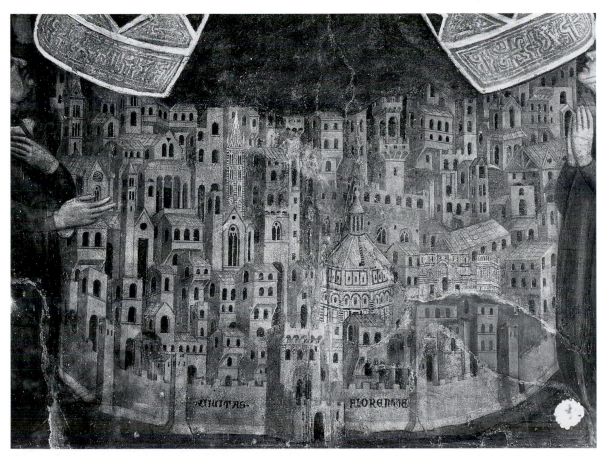

Plate 5 Anonymous, detail of *The Madonna of Mercy*, 1342, fresco, Museo del Bigallo, Florence, formerly in the loggia of the Confraternity of the Misericordia. Photo: Alinari.

Sant'Antonio (known as the Santo), a mural celebrating the miraculous appearance of Saint Anthony of Padua to a local Franciscan *beato*, Luca Belludi, includes a view of fourteenth-century Padua in which the curving roof of the city's town hall, the Palazzo della Ragione, can be discerned amid the closely packed detail of the city (Plates 6 and 7).

Such depictions convey a highly developed sense of these three cities as physical entities, and a pride in their major civic monuments. Similar values are evident in contemporary literary sources originating from the three cities. Dante, in *The Divine Comedy*, places in the mouth of a Sienese noblewoman, Pia dei Tolomei, the simple statement: 'Siena mi fè' (Siena made me)[2] – a powerful indication of the close identity that a fourteenth-century person might feel towards the city of her birth, upbringing and residence. Similarly, a verse of a thirteenth-century poem by the Florentine Brunetto Latini conveys a vivid sense of the perceived value of urban as opposed to rural social mores: 'When going through cities, go, I advise you, in a stately manner [*cortesemente*] … It is not urbane to move without restraint … Guard against moving

like a man from the country, don't squirm like an eel.'[3] Fourteenth-century Padua boasts a comprehensive description of its civic amenities in 'Visio Egidii Regis Patavie', written *c*.1316 by a Paduan judge, Giovanni da Nono. In this work Egidius, the mythical king of ancient Padua, exiled from his city, is consoled by a vision of an angel who prophesies the rebuilding of the city and its future greatness. The literary device enables the author to incorporate a concrete, if somewhat stylized, description of the gates, walls, and principal public buildings of his home town.[4] Throughout the fourteenth century all three cities also produced chronicles, many of them written in the vernacular. These often contained vivacious and detailed records of the city's rules of law, election procedures, expenditure and commercial transactions, as well as detailed reports on the city's political and economic triumphs and misfortunes.[5]

A keen awareness of the value of being born or brought up within a particular city existed, then, within medieval Siena, Florence and Padua, as it did in many other Italian city states. Civic pride was produced out of a sense of the importance of

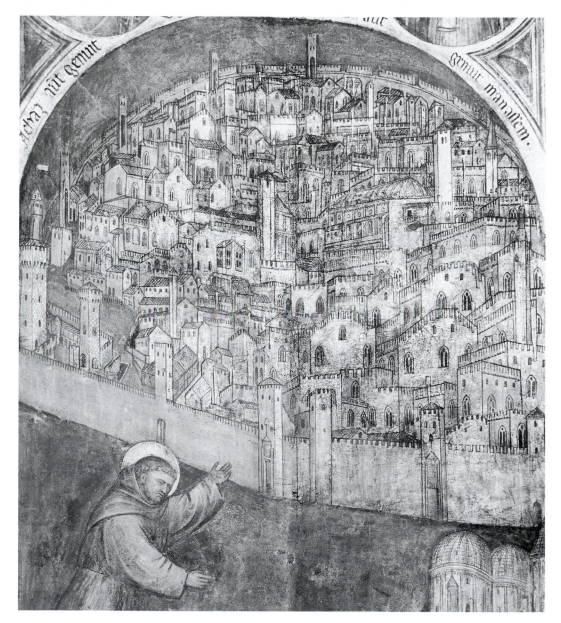

Plate 6 Giusto de'Menabuoi, detail of *Saint Anthony of Padua Appearing to the Blessed Luca Belludi*, before 1383, fresco, Conti Chapel, the Santo, Padua. Photo: Scala.

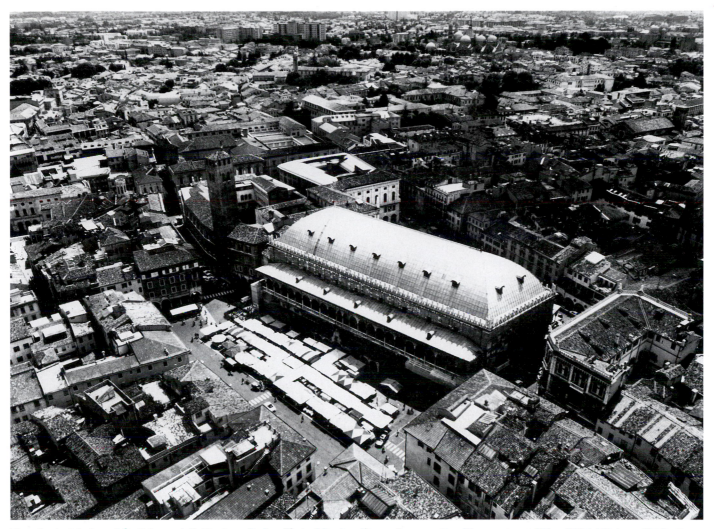

Plate 7 Aerial view of the Palazzo della Ragione, Padua. Photo: Massimo Deganello, reproduced by courtesy of Musei Civici Padova, Gabinetto Fotografico.

the city within human society, and embraced an affectionate concern for the city's physical fabric. As we have seen from the examples cited in the opening paragraphs, art contributed to the articulation of these values, both by producing the monuments which enhanced the city's appearance and by furnishing idealized representations of the city as a place where civil society could flourish and where the daily intervention of the saints sanctified urban life.

This essay seeks to examine the ways in which the production of art and the civic histories of fourteenth-century Siena, Florence and Padua interacted, focusing on the similarities and differences in the nature of that interaction in each of the three cities. It will identify the principal centres of civic life in each city – for example, the town hall, the cathedral and other major churches – and outline salient points in the political and social development of the city during the fourteenth century. With such a comparative historical framework, the reader may be encouraged to evaluate critically the extent to which the ebb and flow of art production – in this period and within each of the three cities – was contingent upon a number of external political and socio-economic factors.

THE URBAN FABRIC

Unlike most of medieval Europe, northern and central Italian society and culture was predominantly urban, and Siena, Florence and Padua all shared in the astonishingly precocious development of a civic-based society. Each owed its foundation and notion of civil society to Roman times, but, like other north and central Italian towns, subsequently passed through a period of impoverishment and depopulation between the sixth and tenth centuries, while retaining vestiges of urban government and administration. Likewise each profited from the medieval economic boom, which began in the tenth century and proceeded with only temporary setbacks until the mid fourteenth century. Each city experienced large-scale immigration from the surrounding countryside, and, in order to absorb the growth in population, each urban society developed new and non-agrarian sources of livelihood.[6] Florence was most successful in this respect, achieving by the late thirteenth century a widespread commercial network of international banking and mercantile interests, supported at home by a highly organized textile industry and a number of related craft industries. Her

economic prosperity and increased population was marked in 1284 by the inauguration of a new and ambitiously extensive circle of communal walls. A fifteenth-century topographical view of the city (Plate 9) gives a graphic indication of how this circle of walls provided a formidable line of defence and also enclosed large new and undeveloped areas north and west of the city. Siena, while equally successful in terms of establishing banking and mercantile interests on an international scale, never developed her home-based industries to a similar degree, and Padua's wealth was based on a strictly local economy. Nevertheless, both Siena and Padua also rebuilt and extended their city walls under pressure of increased population, but while Florence boasted a population of some 75,000 in 1250, Siena and Padua had populations of approximately 20,000 each at this date. At the beginning of the fourteenth century, therefore, Florence already constituted a major urban centre, which, in terms of its economic prosperity and population, could be rivalled by few other Italian or indeed European cities. Siena and Padua by comparison were cities of middle rank with populations about one-third the size of that of Florence.[7]

Siena

Although all three cities shared in Italy's medieval urban development, each was highly individual in terms of its urban topography, formed by the city's precise geographical location and the circumstances of its early history. As graphically portrayed in a late sixteenth-century topographical view of the city (Plate 8), Siena constituted a typical Tuscan hilltop town, lying like a three-pointed star along the ridges of three ranges of hills, each encompassing one of the three administrative districts (*terzi*) of the city: the Terzo di Città (the oldest part of the city), the Terzo di San Martino and the Terzo di Camollia. The main ecclesiastical centre of the cathedral, with its integral baptistery and campanile (Plate 11) was located within the ancient heart of the city – the Terzo di Città. Opposite the cathedral was the great civic hospital of Santa Maria della Scala, an orphanage, pilgrim hospice and home for the sick, aged and indigent, and a focal point for the citizens' charity and benevolence. In the valley between the hills marking the Terzo di Città and the Terzo di San Martino lay the principal political centre of the city, marked by the Palazzo Pubblico, with its tall tower dominating the city's skyline, and the graceful sweep of the semi-circular public area of the Campo.

Other focal points within Siena's urban fabric were the large churches and convents belonging both to the older religious orders such as the Benedictines and the new mendicant orders such as the Dominicans and Franciscans.[8] Like other medieval Italian towns, Siena attracted mendicant friars from the new religious orders, those specially founded to serve the spiritual needs of a rapidly expanding urban society. These orders tended to establish themselves on the towns' outskirts, where there was land readily available to build the large churches and squares needed for the substantial congregations that their specifically urban mission attracted. With urban growth and a need to defend these outlying religious foundations, they were gradually absorbed

into the urban fabric. Nevertheless, with their monumental scale and the open spaces in front of them, they tended to maintain a dominant presence within their area of the city. Thus, in Siena the southern edge of the Terzo di San Martino was marked out by the Servite church and convent of Santa Maria dei Servi and the outer fringes of the Terzo di Città by the Augustinian Hermits' church and priory of Sant'Agostino and the Carmelite church and convent of San Niccolò del Carmine. Meanwhile to the east, the city's skyline was dominated by the bulk of San Francesco and its attached Franciscan convent, and to the west by San Domenico and its Dominican priory.

Interspersed between these ecclesiastical foundations were numerous parish churches, oratories and conventual buildings housing male or female religious orders, together with such pious and philanthropic foundations as confraternity buildings, hospitals and orphanages. Jostling and competing for urban space with these religious and charitable foundations were other buildings designed to accommodate a variety of commercial and domestic functions. The uniformity of such buildings was occasionally relieved by property belonging to an owner who could afford to build on a scale and with a degree of embellishment approaching that of the city's major civic buildings. Similarly, some areas of the city were dominated by the properties of family clans whose collective identity was symbolized by a tall, massive tower. These often consisted of a conglomeration of buildings connected to one another by balconies and forming private courtyards and enclaves within the urban fabric – the surviving Castellare degli Ugurgieri is a case in point.[9]

Florence

By contrast, Florence, Siena's northern neighbour, was situated upon the river plain of the Arno, a river which flowed through the city itself towards Pisa and the sea. Although not navigable to the sea, the Arno provided the city with a number of economic advantages – principally a source of water for the cleaning and dyeing of wool and the powering of water mills.[10] The oldest part of the city (which followed the design and layout of the Roman foundations) lay on the north bank of the Arno (pictured to the left of *The Map of the Chain*, Plate 9). Here lay the commercial centre of the town with the city's principal market-place, the Mercato Vecchio, situated over the ancient forum. A few yards away loomed the impressive three-storied structure of Orsanmichele, a building which began as the city's grain market but was transformed mid century into an oratory, confraternity building and religious centre for the city's guilds. To the north of the commercial centre lay the cathedral, with its free-standing campanile and baptistery, built on what was originally the edge of the twelfth-century city (Plate 13). The political heart of the city, marked by the town hall, the Palazzo dei Priori, was located on what were once the eastern confines of the early medieval city. As in Siena, this civic building was given further distinction by the large square stretching north and west of it, an urban space further distinguished by a number of other public buildings

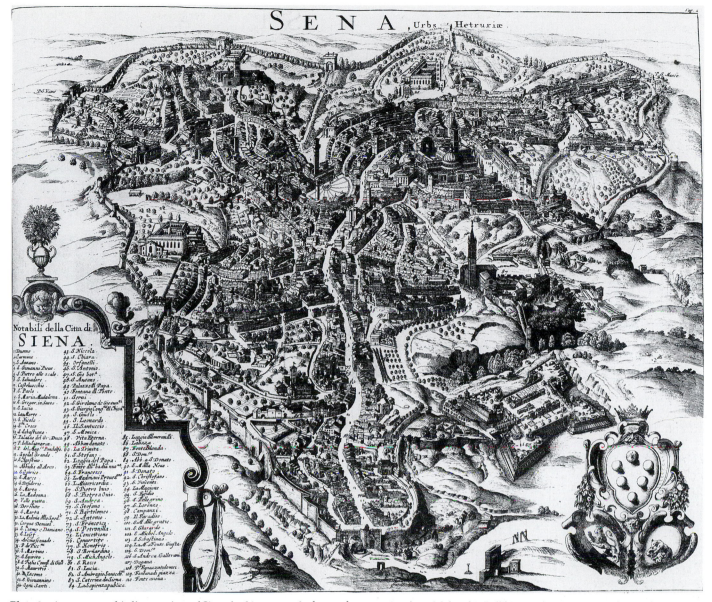

Plate 8 Anonymous, bird's-eye view of Siena looking towards the south, engraving from Malavolti, *Dell'historia di Siena*, Museo Civico, Siena. Photo: Lensini.

built around it. A short distance to the east lay the Palazzo del Podestà, which once functioned as the fortified residence and office of the chief judicial official – the Podestà.[11]

Like Siena, Florence was divided into different districts, each of which exercised its own administrative, economic, military and defensive duties. At the beginning of the fourteenth century the city was divided into six divisions (*sestiere*), five to the north and one south of the Arno. In 1343 these *sestiere* were reorganized into four quarters – each adopting the name of a major church lying within its confines. Thus, the north and central part of the city took its name, San Giovanni, from the baptistery; the eastern part, Santa Croce, from the large Franciscan church and convent on its outskirts; the western part, Santa Maria Novella, from the equally imposing Dominican church and priory on its outer periphery; and the southern part of the city, Santo Spirito, from the church and priory of the Augustinian Hermits.

Apart from these major mendicant churches, Florence also provided sites for churches belonging to other religious orders, most notably the Benedictines at the centrally located abbey of the Badia; the Carmelites south of the river at Santa Maria del Carmine; the male and female order of the Humiliati, north of the river at Ognissanti; and the Servites in a small oratory to the north of the city.

As in Siena, between these large-scale public monuments stood a mass of smaller buildings designed for a variety of religious, charitable and domestic functions. Within the private sector of urban housing, the buildings tended to be plain in style and only towards the end of the fourteenth century became more elaborate, as exemplified by the Palazzo Davizzi.[12] Otherwise, such residential buildings were distinguished by tall towers and occasional street loggia, designed for the ceremonial familial gatherings of Florence's wealthier noble and mercantile family clans.

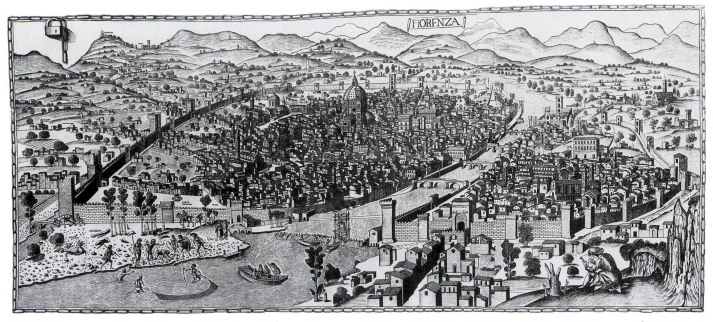

Plate 9 Anonymous, view of Florence looking towards the east, known as *The Map of the Chain*, *c.*1471–82, woodcut, Uffizi, Florence. Photo: Alinari.

Padua

Padua, situated on the north-eastern plains of Italy, possesses an urban aspect distinctively different from those of her Tuscan counterparts, Siena and Florence. Yet like Florence, her urban and economic development was determined in part by her location near the confluence of two rivers. The Brenta left the Alpine foothills at Bassano and flowed south to a few kilometres from Padua, then turned east to flow into the lagoon near Venice; the Bacchiglione encompassed Padua itself within its convoluted course before flowing south to its estuary near Chioggia. As a glance at a seventeenth-century antiquarian view of Padua will reveal, the structure of the city's waterways was extremely complex (Plate 10). The form of these waterways was determined in part by the Bacchiglione's natural course and in part by the construction of canals, which divided the city into discrete districts. The river itself also provided a navigable outlet to the sea and, consequently, valuable opportunities for trade. Its water was also utilized for milling and the cleaning and dyeing of wool.

The urban topography of Padua is also distinct from that of Florence (and to a lesser extent from that of Siena) in that the cathedral and its adjacent baptistery lies in close proximity to the city's main market-places and political centre. The political buildings, the Palazzo della Ragione and the Palazzo degli Anziani (Plate 7), were built in the twelfth and thirteenth centuries while Padua was still an independent Commune. This part of the city was further dominated by the Reggia, the imposing residence of the Carrara family, which ruled the city from 1337 until 1405. The Reggia is now reduced to a few of the domestic buildings, one of which houses the offices and library of a present-day academic institution, and the remnants of a frescoed chapel by the fourteenth-century painter Guariento. It once comprised, however, a magnificent complex of buildings, courtyards and stables linked to the western walls of the old city by a series of 28 arches, the Traghetto.[13]

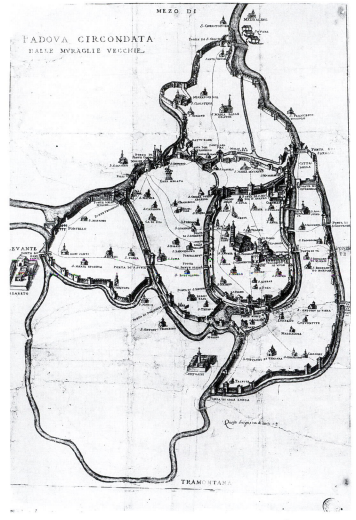

Plate 10 Vincenzo Dotto, reconstruction of mid fourteenth-century Padua, looking towards the south, engraving from Portenari, *Della felicità di Padova*, 51 x 56 cm, Biblioteca Civica, Padua. Reproduced by courtesy of Musei Civici Padova, Gabinetto Fotografico.

Like Florence and Siena, fourteenth-century Padua was divided for purposes of administration. In the case of Padua, the four quarters were named after civic monuments lying within them. The quarter of the cathedral encompassed the ecclesiastical, political and seigneurial centres already described. The quarter of Pontemolino – 'Bridge of the Mill' – took its name from the bridge that lay at the head of Padua's principal street, the Via Maggiore, and the numerous mills in the close vicinity. The bridge itself provided access to the northern suburbs of San Giacomo and Codalunga (the latter being the location for the Carmelite church and convent of Santa Maria del Carmine) and the western Borgo Nuovo which was encompassed by the circuit of new walls, the *murus spaldi*, completed by 1270.

The quarter of Torricelli – named after its numerous towers – took in the southern part of the old city, an area dominated by the Castello, a ninth-century fortification rebuilt by successive rulers of Padua. This quarter also included the south-western area of the city – the Borgo Nuovo – enclosed by the circle of new walls. In this area lay both the Dominican church and priory of Sant'Agostino (now demolished) and, further north, the Benedictine monastery of San Benedetto Novello and the Benedictine convent of San Benedetto Vecchio. The Torricelli quarter also encompassed an area of the city to the south-east known as the Rudena. It was here that Padua's largest and most celebrated ecclesiastical foundation was situated, namely the Franciscan church and convent of Sant'Antonio which, as a shrine to Saint Anthony of Padua (d.1231, cd1232), attracted large numbers of pilgrims from throughout Europe. Between Sant'Antonio and the southernmost line of the city walls, on the site of a Roman theatre, lay the wide open space of the Prato della Valle, a space frequently utilized during the fourteenth century for civic festivals. Nearby lay the ancient and prestigious Benedictine church and monastery of Santa Giustina.

The fourth quarter of Padua, Ponte Altina – also named after a bridge in the area – covered an area to the north and east of the old city. In close proximity to this quarter lay the harbour of Ognissanti from which one could journey to Venice or Chioggia. On the northernmost limits of this quarter lay the remains of Padua's Roman Arena, which in the early fourteenth century had become the site of the residence of one of Padua's leading families, the Scrovegni. This once imposing building is now totally destroyed but for its oratory, now known as the Arena Chapel and famed for its frescoed decoration by Giotto. In close proximity to the Scrovegni residence lay the church and priory of the Augustinian Hermits, dedicated to Saint James the Less and Saint Philip but known popularly as the Eremitani after the hermits themselves. As in Siena and Florence, between these major ecclesiastical and political sites lay tightly packed buildings designed for diverse religious, residential, commercial and philanthropic purposes.[14]

The particular circumstances of their geographical location and urban development formed the significantly different urban topographies of Siena, Florence and Padua. Nevertheless, the cities also shared a number of broad characteristics: the main political, ecclesiastical and commercial centre of each became a focal point in terms of large-scale building, further distinguished by architectural, sculpted and painted embellishment. In addition, all three cities boasted several large-scale church and conventual complexes. Since they tended to be located at some distance from the civic and cathedral centres, these exercised a prominent public role within their particular urban area and thus provided further centres for the commissioning and execution of fourteenth-century Sienese, Florentine and Paduan art.

Within this broad framework of key civic monuments, moreover, all three cities were also endowed with numerous other kinds of religious and secular buildings, designed for public communal functions and for housing paintings and sculpture fashioned to assist in such group activities – the Florentine Confraternity of the Misericordia's *Madonna of Mercy* is a compelling case in point (Plate 5). Finally, they also contained numerous domestic residences which, very occasionally, as in the case of the Reggia in Padua, attained a scale and degree of magnificence that challenged even the city's civic monuments. It remains to be asked how far the three cities also shared a common experience in the commissioning and execution of such civic monuments during the fourteenth century. It is to this question that the essay now turns.

PATRONS AND POLITICS

We may begin by asking who was responsible for the initiation of these civic monuments. Broadly speaking, one might answer that in fourteenth-century Siena and Florence a balance was maintained between communal and familial interests. For example, while the Communes subsidized the construction of the cities' major churches, familial patronage accounted for the commissioning of many of the privately endowed chapels within them. In the early fourteenth century a similar situation pertained in Padua, but from the 1330s onwards the balance shifted significantly in favour of specifically familial patronage. One particular family – the Carrara – together with other families belonging to their inner circle, began to dominate the commissioning and execution of fourteenth-century Paduan art. For an explanation of this contrast in circumstances, the differing political histories of the three cities need to be taken into account.

At the beginning of the fourteenth century the ruling magistracy of Siena was the Council of Nine (1287–90, 1292–1355), an executive committee of nine men elected by cast lot from the most prosperous and well-established of Siena's merchant and banking families.[15] Political office was not, as in Florence, dependent on membership of one of the city's commercial guilds, but members of the Nine would be closely associated with other merchant families through ties of marriage and kinship. They did not claim to be 'noble', that is descended from rural, feudal aristocracy, since in a nominally democratic Commune like Siena, such status entailed certain civil disadvantages.[16] The term of office of a member of the Nine was short – two months in all – but after holding civic office former members would find themselves in receipt of other government posts within the highly organized and sophisticated administrative structure of fourteenth-century Sienese government. The Nine were supported by larger committees – notably the Commune's General Council, the

Consiglio della Campana – which debated and legislated for Siena's affairs, but the Nine tended to take the initiative in the city's political affairs and were thus extremely influential. Although undoubtedly an élite, they represented a corporate point of view which was pledged to the notion of representing the common good. More significantly in the present context, they actively promoted a variety of artistic projects, including the construction and embellishment of major civic sites such as the Palazzo Pubblico, the Campo, the cathedral and the hospital of Santa Maria della Scala, as well as numerous other aspects of urban planning and development.[17]

In the early fourteenth century the political regime in Florence was broadly similar to that of Siena. The main executive power lay with the Priorate, an elective magistracy of first three and subsequently six men, one representative for each of the city's *sestiere*. As in the case of Siena, office in the Priorate was for a short, fixed term and was supported by larger legislative assemblies and numerous administrative offices designed to assist in governing both the city itself and its ever-increasing subject territories. In Florence, however, membership of the Priorate was consequent upon membership of one of 21 of the city's guilds.[18] These guilds were organized in a hierarchical structure: the *arti maggiori* (seven major guilds) and the *arti minori* (five middle guilds and nine minor guilds). The total number is itself a considerable reflection of the rich range of artisan skills on which the city's wealth largely depended. In addition, the number of families whose members were eligible to govern was further reduced by the practice of awarding government office, as a rule, to members of only the major and middle guilds. Such guildsmen tended to belong to those professions which already had the highest social status and the greatest financial resources.

In the last decade of the thirteenth century and the early decades of the fourteenth century the Florentine government initiated one civic project after another. As the Priorate itself came under guild control, so did the financing and administration of such civic projects. For example, in 1333 responsibility for the construction and embellishment of the cathedral was delegated to one of the greater guilds, the Arte della Lana, or woollen cloth manufacturers. Other key ecclesiastical sites such as the baptistery and Santa Croce were similarly assigned to specific guilds.

In both Siena and Florence there was a period of demographic expansion and economic prosperity in the thirteenth century and the early decades of the fourteenth century which facilitated the intensive building programmes undertaken in both cities from the mid thirteenth century onwards. Coincidentally, these decades also encompassed the working careers of a number of highly innovative artists including, in Florence, the architect and sculptor Arnolfo di Cambio and the painter Giotto; and in Siena, the painters Duccio, Simone Martini, Ambrogio and Pietro Lorenzetti, and the sculptors Lorenzo Maitani and Tino di Camaino.

From the 1330s and 1340s, however, the political stability and economic prosperity of the two cities suffered badly from a number of major disasters. In the 1330s the economies of both Florence and Siena were adversely affected by a series of bankruptcies among the cities' major banking houses, caused principally by the bad debts of the English monarchy. In 1346 and 1347 adverse weather conditions caused crops in Tuscany to fail and food shortages and riots ensued in both cities. Finally, the Black Death struck both cities with terrible ferocity in 1348. Thus, in Siena, the chronicler Agnolo di Tura describes parents abandoning their children and records burying five of his children with his own hands.[19] Boccaccio, in the preface to *The Decameron*, similarly describes the horrific nature of the epidemic, where corpses were left piled up outside houses and buried unceremoniously in mass graves, stored layer after layer like merchandise in a ship.[20] Modern demographic studies suggest that in Florence the population dropped from some 100,000 to 30,000, while Siena's population of approximately 50,000 was reduced by at least 50 per cent.[21] The social and economic disruption caused by such an epidemic was, of course, far-reaching. Moreover, the Black Death was followed by further outbreaks of plague, and it has been argued that the later outbreaks of plague had more discernible effects on patterns of social and religious behaviour than the earlier epidemic.[22] In the longer term, despite these disasters, Florence was able to survive as a leading mercantile and industrial centre. Siena's post-plague economic recovery could not compete with that of Florence, although recent historians have questioned the gloomy picture of Siena's slow economic decline painted by an earlier generation.[23]

One demonstrable effect of the Black Death was a significant change in the social composition of the two civic societies as a result of the drastic reduction of the existing city population and the increase in immigration from the surrounding countryside. This demographic change increasingly destabilized the existing political regimes. In Siena in 1355 the Nine were overthrown and there followed a rapidly changing series of political regimes, the social composition of which combined a more varied and more widely representative selection of noble, mercantile and popular elements.[24] In 1368 alone no less than four governments rose and then fell from power. In order to alleviate the effects of political instability, the government resorted in 1399 to placing the city under the jurisdiction of a single individual, Gian Galeazzo Visconti. As ruler of the politically powerful north Italian city of Milan, Gian Galeazzo was thus able to extend his sphere of political domination into southern Tuscany. Only his death in 1402 allowed the city to regain its political independence before its final submission to Florence in the mid sixteenth century.

Florence experienced comparable unrest, with both popular and noble elements agitating for representation within the government. After the short, but autocratic, rule of Walter of Brienne, Duke of Athens, as governor (1342–43), a more broadly based regime was established in the city. Executive power resided in the hands of a nine-man Priorate, chaired by the Gonfaloniere di Giustizia – the Standard Bearer of Justice – and supported by two executive collegiate bodies and two large legislative bodies. The chronicler Giovanni Villani wrote that 'before ... the *popolo grasso* ['the fat people' – members of the greater guilds] ruled ... now we have the government of the artisans and common people'.[25] Despite Villani's strictures, however, it was still only members of 21 of Florence's major, middle and minor guilds who could attain

government positions. This restriction led to civil discontent, culminating in 1378 in the revolt of the disfranchised textile workers, the *ciompi*. With the support of the then Gonfaloniere di Giustizia, Salvestro de'Medici, the *ciompi* were able to secure representation within the government together with the minor guilds. In Siena such groups had been able to maintain their position, but in Florence, by the end of the fourteenth century, an oligarchy of wealthy Florentine families, whose members had close-knit social and economic ties, were once again monopolizing government posts.[26]

FLORENCE AND SIENA AFTER THE BLACK DEATH

The extent to which these political and socio-economic developments in the latter half of the fourteenth century affected the production and reception of art within the two Tuscan cities has long been the subject of debate among cultural historians. The publication in 1951 of Millard Meiss's study, *Painting in Florence and Siena after the Black Death*, was particularly influential. Meiss put forward a strong case for the close interdependence of fourteenth-century art and contemporary socio-economic conditions. He argued that, in the first decades of the fourteenth century, Florence and Siena enjoyed a period of economic growth and prosperity and that these socio-economic conditions were highly conducive to the production of art. In the second half of the century, according

to Meiss, the series of socio-economic misfortunes that assailed the two cities reversed this process decisively and caused sharp disjunctions between the style and tempo of the art produced in the first half of the century and that of the second half of the century. Meiss's thesis has subsequently been subjected to a number of critical assessments and proposed modifications. In each case scholars have questioned the adequacy of Meiss's thesis at the detailed local level.[27] In the present context what is interesting is his proposal that the social and economic dislocation of the Black Death caused a marked decline in the level of Sienese and Florentine artistic activity. In order to test this proposal, we will examine the histories of two comparable communal projects, the Duomo and Baptistery in Siena, and the Duomo and Baptistery in Florence. These were architectural projects with substantial sculptural elements; painting played a secondary role. Nevertheless, by virtue of their scale and civic importance, they provide a striking test case for the general thesis of decline in the latter half of the century.

The Duomo in Siena

While Siena's Duomo was under the religious care of a bishop and a college of canons, the building's construction and artistic embellishment (Plate 11) was controlled and orchestrated by Siena's government, which delegated responsibility to a board of works, the Opera del Duomo. This

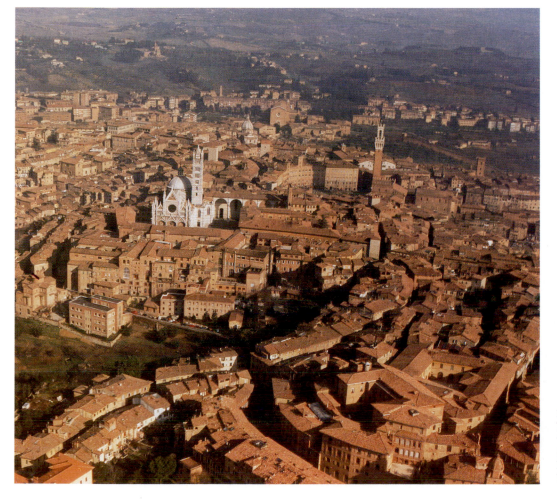

Plate 11 Aerial view of the Duomo, Siena, showing the 'new cathedral' extension (right) and, beyond, the Palazzo Pubblico and the Campo. Photo: Lensini.

committee of citizens controlled the commissioning of sculpture, metal-work, woodwork, painting and manuscript illumination for the cathedral, as well as the construction of the building, following an immensely complex programme which began in the mid thirteenth century and lasted throughout the fourteenth century. (At one stage it involved the reorientation of the building so that the main body of the cathedral became the transept.[28]) In the last decades of the thirteenth century, the Opera was responsible for appointing as *capomaestro* (master craftsman in charge of the work) the Pisan sculptor Giovanni Pisano who supervised and contributed to the execution of a programme of sculptures for the cathedral façade. This was a complex scheme designed to honour the Virgin Mary's role in the Incarnation.[29] In 1308 the Opera commissioned Duccio's huge double-sided high altarpiece, the *Maestà*, and supervised the painter's work on it over a number of years until its festive installation on the high altar in 1311.[30] In the third and fourth decades of the century

the Opera extended the cathedral's programme of painted altarpieces by commissioning from Simone Martini and Lippo Memmi (Plate 12), Ambrogio and Pietro Lorenzetti and Bartolommeo Bulgarini altarpieces for four altars in the cathedral transepts, the narrative subjects of which were designed to celebrate the four major feasts of the Virgin Mary, to whom the cathedral was dedicated. The presence on all five altarpieces of the city's 'patron' saints – those who were deemed to have assisted the city in some particular way – indicates clearly that these works of art, commissioned by the Opera on behalf of Siena's government, were designed to serve a straightforwardly liturgical and devotional function. However, they were also intended to fulfil a political role: celebrating Siena's perceived status as a city under the divine protection of the Virgin Mary and the saints.[31]

Sienese government support of the cathedral remained consistently committed throughout the century, and the cathedral was the object of numerous legacies, making it one

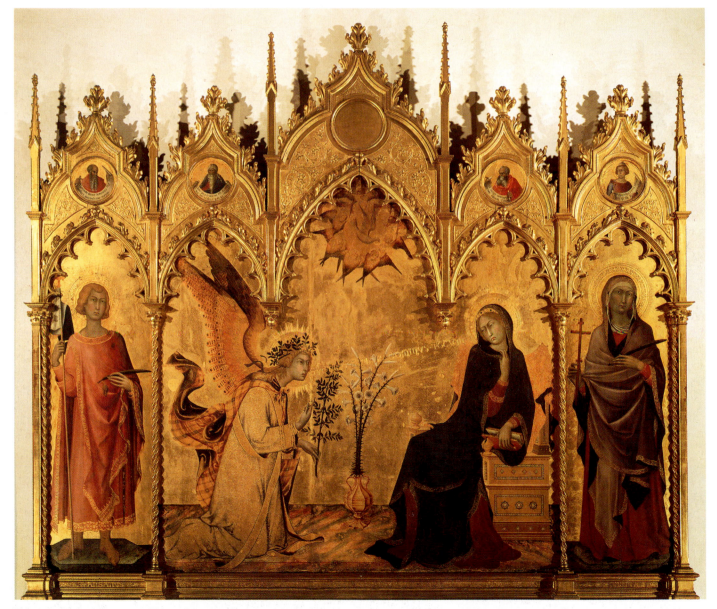

Plate 12 Simone Martini and Lippo Memmi, *The Annunciation and Saints Ansanus and Massima*, 1333, tempera on panel, main panel, 184 x 114 cm, side panel, 105 x 48 cm, Uffizi, Florence, formerly on the altar of Saint Ansanus, Duomo, Siena. Photo: Scala.

of the wealthiest institutions in the city. However, its development too was subject to certain kinds of hiatus and changes of direction caused by the political and economic events that bedevilled the city in the second half of the century. In the aftermath of the Black Death, which drastically reduced the cathedral workforce, emptied the city's coffers and contributed to the downfall of the Nine, it was decided in 1357 to dismantle part of the newly erected extension to the cathedral, a structure which was already beginning to show marked defects. Nevertheless, work resumed in the 1360s and 1370s to complete the baptistery and to graft both it and the newly extended choir above it onto the original building.[32]

Another change of direction within this communal enterprise occurred in the latter half of the century in connection with the patronage of the cathedral's altars. In 1374 the painter Bartolo di Fredi was paid by the guild of stone-workers, the Maestri della Pietra, for an altarpiece depicting the Virgin and Child and the guild's patron saints. Similarly, in 1389 the painters Luca di Tommè, Bartolo di Fredi and Andrea di Bartolo were paid by the guild of shoemakers, the Arte dei Calzolai, to paint an altarpiece of the assumption of the Virgin for their guild chapel in the cathedral.[33] Such a guild presence within Siena's Duomo, a

civic building previously under the more or less exclusive control of the government and its agent, the Opera, might reflect changed conditions for the production of fourteenth-century art in Siena. Undoubtedly these conditions were affected by larger socio-economic changes within Sienese society, in which more popular elements were gaining greater political authority.[34]

The Duomo in Florence

As in Siena, the fabric of the cathedral, together with its adjacent free-standing campanile, constituted a civic not an ecclesiastical responsibility in Florence: the Commune provided most of the money and impetus for the project (Plate 13). As already noted, responsibility for this project was delegated to the Arte della Lana, which appointed an Opera del Duomo from among its members. These guildsmen, appointed like their Sienese counterparts for a term of six months at a time, frequently requested professional specialist advice from artists and very occasionally consulted a broader spectrum of the Florentine public. Under the supervision of the Opera, Florence's new Duomo, built around the ancient church of Santa Reparata and its surrounding buildings,

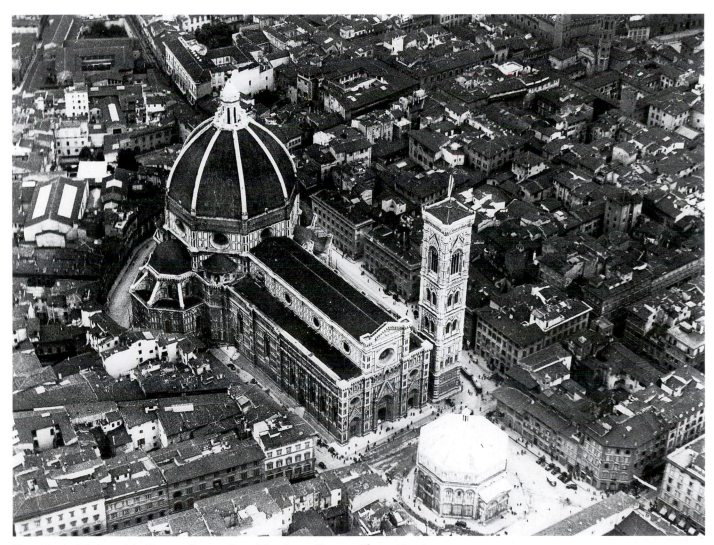

Plate 13 Aerial view of the Duomo, Campanile and Baptistery, Florence. Photo: Alinari.

underwent several phases of construction. Beginning in 1296, on the façade opposite the baptistery, the construction work proceeded slowly eastwards. Work on the project was frequently delayed by the diversion of government resources to other projects, by the establishment of numerous commissions to discuss existing and alternative plans for the project, and by public inertia. The Black Death and the later outbreaks of plague further contributed to the delays. Nevertheless, it is a tribute to the Florentine government's self-declared determination to build 'the most beautiful and honourable church in Tuscany'[35] that work on this ambitious civic project was sustained throughout the century. Most of the façade and the walls of the nave had been completed by 1355, the interior piers and vaulting following over a decade later. In 1366 and 1367 the Opera approved plans for a fourth bay and an octagonally shaped choir. It was not until 1413, however, that these plans were finally brought to fruition when the architect Brunelleschi solved the technical problem of constructing a dome to cover the huge space allocated to the crossing in these fourteenth-century plans.[36]

Like the Duomo in Siena, the Duomo in Florence and its adjacent buildings provided locations for both sculpture and painting. The cathedral was furnished with painted panels, frequently portraying the city's patron saints, but the civic authorities of Florence do not seem to have shared Siena's commitment to furnishing the cathedral with a programme of painted altarpieces.[37] In the case of sculpture, meanwhile, in the last decade of the thirteenth century and the first decade of the fourteenth century, Arnolfo di Cambio was active in carving a sculpted programme for the façade of the cathedral. Reconstruction of this sculpted ensemble suggests that Florence's Duomo façade, like that of Siena, was designed to celebrate both the Virgin Mary (to whom the cathedral was dedicated) and additionally a number of saints who were deemed to have a special affection for the city and its political fortunes.[38] This sculpted embellishment was further extended from 1334 onwards, when, under the supervision of Giotto (as cathedral *capomaestro*), then the Pisan sculptor Andrea Pisano and finally the sculptors of the cathedral workshop, a complex programme of figural reliefs was completed *c.*1368 for the campanile. Similarly, in 1401, the guild of importers, refiners and exporters of cloth – the Arte di Calimala – initiated a competition for the design of a set of bronze doors for the baptistery to act as companion piece to the doors designed and executed between 1318 and 1330 by Andrea Pisano (Plate 14).[39]

In summary, therefore, there are well-substantiated instances of external political and socio-economic factors contributing, particularly in the second half of the century, to compromises, changes in direction or delays in the realization of the construction and decoration of these two major civic monuments in fourteenth-century Siena and Florence. Nevertheless, the continuity of the artistic programmes, conducted over and beyond the confines of the fourteenth century, is also a remarkable testimony to the persistence of two governments' commitment to the long-term embellishment of their ecclesiastical centres. It is thus perhaps unwise to make too strong a claim (at least within the realm of large-scale, prestigious civic enterprise) that the conditions of art production in the first and second halves of the

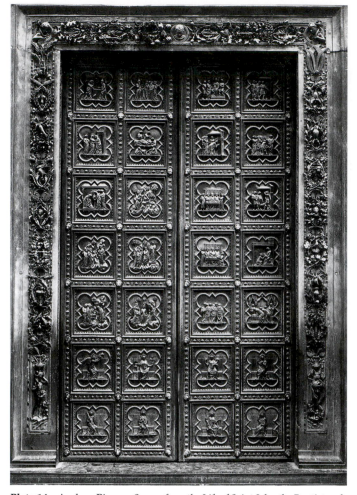

Plate 14 Andrea Pisano, *Scenes from the Life of Saint John the Baptist and the Virtues*, 1318–30, bronze, *c.*500 cm high, south (originally east) door, Baptistery, Florence. Photo: Alinari.

fourteenth century were strongly different. In the cases of the cathedral and baptistery complexes of Siena and Florence, the evidence points to the maintenance of civic ambition and activity, albeit modified and constrained by social and economic circumstances, rather than to fundamental disruption of these endeavours.

THE CASE OF PADUA

What, however, of the comparison between fourteenth-century Padua and its history of art patronage and the histories of Siena and Florence? Did the Black Death and its socio-economic effects have comparable impact on the production and reception of art within Padua? Is Meiss's thesis of post-plague decline any more or less applicable in Padua than in Siena or Florence? As already indicated, Padua differed strikingly from Florence and Siena in terms of its political constitution. In direct contrast to the communal regimes of the two Tuscan cities, Padua was ruled from 1337 to 1405 by a single family, the Carrara. Prior to this period of personal, seigneurial rule, it had been an independent Commune, albeit with brief periods of despotic control. In general, however, prior to the rise of the Carrara, Padua had enjoyed a period of political stability, governed competently

by an élite of lawyers, judges, notaries and guildsmen. As in Siena and Florence, noble magnates only entered the political life of the Commune on the terms set by the communal bureaucracy. The relative political stability and self-confidence of communal Padua was further marked by the production of both a body of political theory (which has been characterized as the prototype of the civic humanism of the fifteenth century), and a number of major civic monuments, including both the Palazzo della Ragione and the Franciscan church of Sant'Antonio.[40]

From as early as 1310, however, conditions became increasingly unstable, with Padua's political autonomy threatened by her powerful neighbour, Verona, then under the rule of the Scaligeri family. In 1318, shaken by military defeats at the hands of both the Veronese and the Venetians, and with its collective political decision-making processes immobilized by civil faction and unrest, the Paduan government elected Jacopo I da Carrara as Capitano del Popolo, a position which offered broad but not limitless political power. The Carrara family's bid to control the city was continued by Jacopo's nephew Marsiglio who, in 1328, opened the city gates to Cangrande della Scala, a Veronese who occupied the city and appointed Marsiglio as *signore*, although the latter remained under Veronese control. In 1337, with the defeat of the Scaligeri by Venetian and Florentine forces, Marsiglio was made Gonfaloniere and Capitano Generale of the Commune. He thereby consolidated his personal control over the Paduan government, but only on the sufferance of Venice, which, as a condition of support, exacted the right of military aid together with economic privileges for Venetians and for certain Venetian religious bodies which held land in Padua and its territories.

Thereafter followed a succession of Carrara rulers: Ubertino (ruled 1338–45); Jacopo II (assassinated in 1350 by Guglielmo da Carrara, an illegitimate son of Jacopo I); Francesco il Vecchio (ruled 1350–88) and Francesco il Novello (ruled 1388, 1390–1405). Francesco il Vecchio began his term of office in partnership with his uncle Giacomino. In 1355 he deposed Giacomino and thus further extended his political and judicial powers. Under Francesco il Vecchio, therefore, Padua experienced the full force of seigneurial rule. In 1362 he reformed the communal statutes and thereafter effectively created a household government of kinsmen and favourites. The focus of judicial and administrative power now lay with the Podestà and his staff of five judges and knights, all of whom were appointed personally by Francesco from friendly Communes such as Florence and Bologna and from the ranks of the north Italian nobility.[41]

Francesco il Vecchio's foreign policy of almost continual warfare with neighbouring north Italian states necessitated continuous employment of members of the Italian and European feudal nobility who had the military and diplomatic skills required to pursue such a policy. Carrara seigneurial rule thus changed the social composition of Padua's governing classes and coincidentally that of the major patrons of fourteenth-century Paduan art. The introduction of 'outsiders' to key judicial posts reduced the importance of those Paduan families whose members had been the judges, notaries and guildsmen of the communal era. In the case of the guilds, Francesco il Vecchio also took care both to curtail

their political and legislative powers and to exploit them in economic terms by forcing them to contribute to the expense of waging war.

However, the situation was not merely one of noble magnates profiting at the expense of the Paduan mercantile and professional classes. As in the case of Siena and Florence, the Carrara also needed to control the power of the nobility who, with their military skills and fortified properties in the countryside, could pose a political threat to the Carrara regime itself. Thus, Francesco il Vecchio perpetuated a number of earlier communal restrictions against the private jurisdiction and armed retainers of the noble magnate class, and made residence within urban property a requisite for Paduan citizenship. Similarly, the Carrara household included members of well-established Paduan families. A notable case, and one with direct implications for art patronage, was that of the Buzzacarini, an old judicial family whose male representatives served Francesco il Vecchio and his son as ambassadors, military leaders and judges of Padua's subject cities. This alliance was further consolidated by Francesco il Vecchio's marriage to Fina Buzzacarina, who, in her own right, became a significant patron of fourteenth-century Paduan art.[42] If certain members of Padua's older ruling élite were thus useful to the Carrara and duly prospered under their regime, the greater proportion of the inhabitants of both the city and its surrounding territories nevertheless remained disfranchised and burdened by forced labour and taxes – restrictions retained from the communal period and rigidly enforced by the Carrara in order to pursue their dynastic policies of warfare and territorial expansion.

From 1370 onwards Francesco il Vecchio involved Padua in a series of wars, which extended Paduan territory but also led to heavy taxation within the city and to hostilities with Venice. In 1388 the city was occupied by Gian Galeazzo Visconti, the ruler of the large and powerful north Italian city of Milan, and Francesco il Vecchio was exiled to Monza, where he died in 1393. With Florentine and Venetian support, however, his son Francesco il Novello was able to return to rule the city in 1390. Nevertheless, he too continued to involve Padua in wars with its north Italian neighbours, following a reckless policy of military and financial commitment which further sapped the economic welfare and political loyalty of his Paduan subjects. In 1405 the city and its territory were annexed by the Venetians and Francesco and his son were taken to Venice and executed while other members of the family and close associates were banished from Padua. Padua then became a subject city of Venice and part of the Venetian empire on the Italian mainland.[43]

In addition to these political upheavals, the Black Death afflicted Padua as drastically as it had Siena and Florence. The first outbreak of bubonic plague was registered in the city in 1347 and was followed by other less virulent outbreaks in 1360–61, 1371, 1400 and 1405. Its devastating effects on Paduan society can be gauged from the records of the university, the best for any fourteenth-century medical school. In 1349 all the chairs in medicine and surgery were vacant. By 1351, in another consequence of the advent of bubonic plague, the university had increased its professorships of medicine from three to twelve.[44] However, in spite of the debates inspired by Meiss over the production of Sienese and

Plate 15 Interior view of the Baptistery, Padua, with frescoes by Giusto de'Menabuoi, *c.*1375–78. Photo: Alinari.

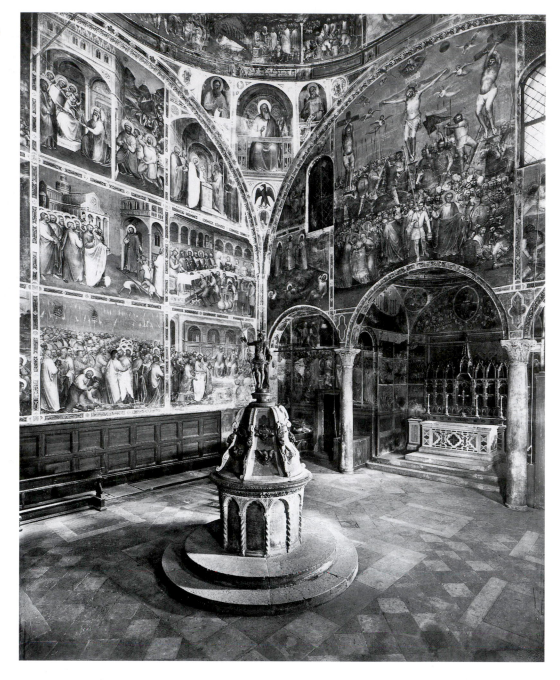

Florentine art, it has rarely been argued that artists working in Padua from 1348 onwards were notably affected by the Black Death and the changed socio-economic conditions it brought. If anything, art production in Padua appears to have accelerated in the second half of the century, a development at least partially caused by the increasing self-confidence and political power of the Carrara regime.

As already noted with respect to fourteenth-century art patronage, the case of Padua is strikingly different from that of Siena and Florence. In the main, Padua's principal public monuments were much more obviously the direct result of private initiative. Consider again, for example, the case of the Duomo and Baptistery in Padua. Little remains of the fourteenth-century embellishment of the cathedral, an ancient foundation reconstructed in the 1120s under the supervision of the Commune, following an earthquake in 1117.[45] The

adjacent baptistery, however, retains much of its fourteenth-century fresco paintings (Plate 15). Designated by Fina in her will[46] as a funerary chapel for herself and her husband, Francesco il Vecchio da Carrara, and endowed by the sale of her silver and her clothing, the baptistery once had as its major focal points the funerary monuments of both. What remains of the painted decoration of Fina's funerary monument signals very clearly who had commissioned the interior decoration of the baptistery and for what purpose: thus, Fina herself is portrayed being presented to the Virgin Mary and Child by the patron saint of the baptistery, John the Baptist. The interior was decorated with an elaborate cycle of frescoes depicting scenes from the Old and New Testaments, executed by Giusto de'Menabuoi in the mid 1370s. Such imagery was entirely traditional for a baptistery (as witnessed by the mosaic cycles of those of Florence and Venice), and the

iconography is appropriate to the Christian message of redemption attached to the rite of baptism, but nevertheless this baptistery and its painted decoration present conclusive evidence of the scale and magnificence of Carrara art patronage within Padua during the last decades of the fourteenth century.[47]

The extent of such patronage – and its vitality during the latter decades of the fourteenth century – is also revealed in the history of the embellishment of Padua's principal Franciscan church, Sant'Antonio. What emerges is a compelling example of the balance that could be achieved between the institutional requirements of the Franciscans themselves and the dynastic requirements of Padua's lay patrons, particularly those associated with the Carrara. Initially a much simpler structure than its present form, the church was enlarged in the mid decades of the thirteenth century in order to provide a suitably dignified resting place for the highly popular Saint Anthony, whose mortal remains were installed in the new basilica in 1263. In its final highly individual domed form, the Santo became the focal point of an international religious cult, attracting pilgrims from all over Europe en route to Rome and Jerusalem.[48]

Much of the Santo's sculpted and painted embellishment, particularly that from the first half of the fourteenth century, has been altered or destroyed. For example, it is possible that Giotto worked in the Santo, although nothing that can confidently be attributed to him survives. In the second or third decade of the century, the friars' chapter-house was decorated with a series of murals, in all probability by a close follower of Giotto. Although now in poor condition, this cycle once included a Crucifixion and scenes from the life of Saint Francis and other Franciscan saints, including the martyrdom of the Franciscans at Tana in Morocco. It is not known whether this decoration was the result of specifically Franciscan or lay sponsorship.[49] In the chapel of the Conti family, however, we have a more securely documented instance of the assertion of Franciscan collective identity and history, but in this case within the confines and context of a privately endowed chapel. Designed to house the tomb of Naimerio and Manfredino Conti, two close members of the Carrara inner circle, the chapel also celebrated the cult of the local Franciscan *beato* Luca Belludi. Naimerio and Manfredino commissioned (probably at the time of the chapel's dedication in 1382) a fresco cycle from Giusto de'Menabuoi – the same artist who had painted the baptistery for Fina Buzzacarina. This Conti cycle of paintings combined scenes devoted to the celebration of the cult of Luca Belludi, and indeed of Saint Anthony himself (Plate 6), the legend of Saints Philip and James the Less (to whom the chapel was dedicated), and the portrayal of both Naimerio and Manfredino Conti and members of their immediate family.[50]

This tradition of patronage initiated by well-placed local families is further exemplified by the chapel (originally dedicated to Saint James the Great) commissioned in 1372 by Bonifacio Lupi from the Venetian sculptor Andriolo de'Santi and later painted (*c.*1373–79) by the Veronese painter Altichiero. As in the case of the baptistery, this privately endowed chapel was specifically founded to house the tomb monuments of the patron, his wife Caterina dei Francesi and four of his male relatives. The painted scheme of the chapel

Plate 16 Altichiero, *Bonifacio Lupi and Caterina dei Francesi Presented to the Virgin Mary and Christ Child by Saints James the Great and Catherine of Alexandria, c.*1373–79, fresco, Lupi Chapel, the Santo, Padua, formerly dedicated to Saint James the Great, now dedicated to Saint Felix. Photo: Osvaldo Böhm.

incorporates subject-matter which alludes to Bonifacio Lupi's and his family's hopes for redemption and life everlasting, and it incorporates portraits of the patron, his wife (Plate 16) and perhaps a number of his close intimates and associates at the Carrara court. At the same time, however, the frescoed scenes portraying the legend of Saint James are highly suitable for a major pilgrim church, and the decoration of the altar wall includes a series of painted roundels in which are depicted the Franciscan Saints Claire, Anthony of Padua, and Francis and Louis of Toulouse.[51] Once again, the Santo offers a further example of a chapel designed to combine the interests of the Franciscan Order and of influential lay patrons.

SIENA AND FLORENCE: TWO FRANCISCAN CHURCHES

How does this history of lay patronage within the major Franciscan church in Padua compare with the histories of the Franciscan churches of Siena and Florence? In the case of Siena's Franciscan church and convent of San Francesco, the Sienese government offered financial support in the form of

subsidies both for the construction of the church and for its further embellishment. Thus, in 1286 the Franciscans made an appeal to the Council for financial aid to complete their church façade since in its present unfinished state it did not 'redound to the honour of the city of Siena'.[52] In 1339 the Council of Nine similarly offered financial aid to assist in the renovation of San Francesco.[53] Nevertheless, the situation here was not as clear-cut as in the case of the cathedral. As the centre of its own parish, the church also became the natural focal point for the religious devotion of citizens living within the vicinity of the church and convent. Even more importantly, like the Santo in Padua, San Francesco became the place where they wished to be buried. Within the church's Latin cross plan, provision was made for a series of privately owned funerary chapels where members of a family (or associations of related families) could be buried and commemorated by tomb monuments and mural paintings. However, by contrast with the Santo, very little survives as evidence of fourteenth-century familial patronage in San Francesco, Siena.

Recent work on the decoration of the chapter-house and cloister of the adjacent Franciscan convent suggests, however, that the painted programme executed there by Ambrogio and Pietro Lorenzetti was the fruit of a collaborative venture between a Sienese family, the Petroni, and the Franciscans themselves, the latter seeking to celebrate their collective identity by commissioning paintings celebrating events in the order's history. Thus, two frescoes originally painted for the chapter-house by Ambrogio Lorenzetti (which survive today, relatively intact, upon the walls of the third chapel to the left of the chancel) depict the martyrdom of Franciscans at Tana (a theme also depicted in the chapter-house of the Santo) and the Franciscan saint, Louis. Louis is shown repeating his Franciscan vows and accepting from Pope Boniface VIII the bishopric of Toulouse, thereby forfeiting his right to the kingdom of Naples, much to the annoyance of his father Charles II of Anjou (Plate 17). The martyrdom scene was probably the culmination of a whole cycle of paintings executed on the cloister walls that celebrated the life of the Blessed Pietro da Siena, a Sienese Franciscan and thus the logical focus for a local cult within Siena's main Franciscan church. At the same time, however, it was appropriate that a local family with the name Petroni should have paid for the commissioning of a cycle of paintings which commemorated the sanctity of a friar whose very name alluded to their own. If the Petroni family did contribute to this scheme of embellishment of the convent, a reminder of their involvement is also preserved by an impressive sculpted portal which opens onto the cloister where Ambrogio Lorenzetti's mural cycle was once located.[54]

The surviving historical evidence for the art patronage of San Francesco precludes any definitive statement as to which had the greater impact – religious or lay initiative. Nor is it possible, given the limited evidence, to argue that in the latter half of the century either kind of patron became the more dominant. It seems, rather, that throughout the century San Francesco was consistently patronized by local families, whose political and economic standing allowed them to acquire endowment rights over certain parts of the church's fabric, and to embellish these to commemorate their familial identity and social status. However, such initiatives had to be negotiated with the Franciscans.

Plate 17 Ambrogio Lorenzetti, *Saint Louis of Toulouse before Pope Boniface VIII*, c.1329, fresco, 403 cm wide, Bandini Piccolomini Chapel, San Francesco, Siena, formerly in the chapter-house of the adjoining Franciscan convent. Photo: Alinari.

As in Padua and Siena, the city's government gave financial support to the construction of its Franciscan church – Santa Croce. Likewise, the construction and embellishment of Santa Croce was the result of an amalgam of differing interests. The Franciscans ensured that paintings and sculptures executed within their church and convent depicted subject-matter that reflected their order's collective identity and particular preoccupations. For example, within their refectory, probably at the behest of the Florentine Manfredi family, the painter Taddeo Gaddi executed a mural which skilfully combined a number of religious subjects.[55] First, it offered a highly illusionistic depiction of the Last Supper, a subject which – given the painting's location – was very appropriate to the communal life of the friars. Secondly, it included as its centrepiece an imposing painting of the tree of life, an image intended to convey the spirit, if not the letter, of an important Franciscan theological text, Saint Bonaventura's *Lignum Vitae*. Thirdly, it showed four narrative scenes, two of which were taken from the legends of two major Franciscan saints – Francis himself and the Angevin Louis of Toulouse (Plate 18).

Santa Croce today still preserves a remarkable number of fourteenth-century family chapels.[56] The funerary function of these chapels is vividly exemplified in the Bardi di Vernio Chapel, where two tomb monuments present an intriguing combination of sculpted and painted imagery. In the case of the larger and more imposing tomb, the painted portrait of a kneeling figure (variously identified as Bettino or Andrea di Bardi) and the depiction of Christ as judge emphasizes the monument's funerary function (Plate 19). Alongside appears the far less ornate tomb of a female member of the Bardi family.[57] These tombs are surrounded by a fresco cycle executed *c*.1340 by Maso di Banco and portraying scenes from the life of the fourth-century pope, Saint Sylvester.

In point of fact the Bardi di Vernio Chapel is one of several frescoed family chapels still surviving in Santa Croce, the names of which – Bardi, Peruzzi, Baroncelli, Rinuccini and Castellani – all commemorate the families who originally commissioned the paintings within them. The earliest, Giotto's cycle of Saint Francis for another Bardi family chapel, probably dates from about 1315. Agnolo Gaddi's cycle of scenes from the legend of the True Cross, executed for the

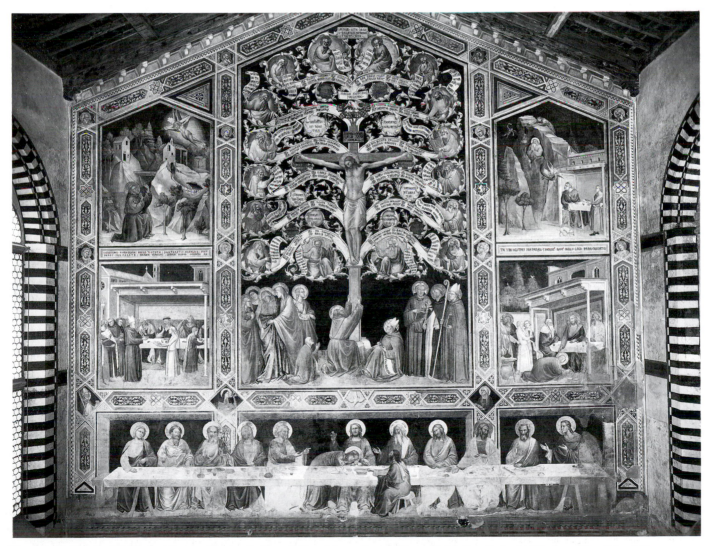

Plate 18 Taddeo Gaddi, *The Last Supper, Christ as the Tree of Life* and *Scenes from the Lives of Saints Francis, Louis of Toulouse, Benedict and Mary Magdalen*, *c*.1360, fresco, *c*.1100 x 1200 cm, Museo dell'Opera di Santa Croce, formerly the refectory of the Franciscan convent of Santa Croce, Florence. Photo: Alinari.

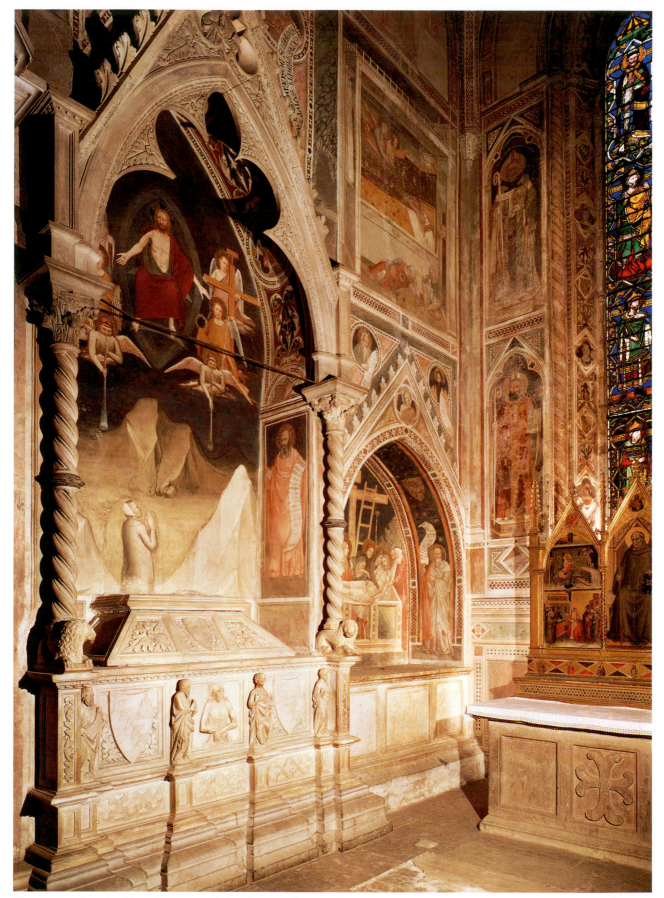

Plate 19 Attributed to Maso di Banco, tomb monument with mural of *The Resurrection of a Male Representative of the Bardi Family*, *c*.1335–41, 416 x 223 cm, Bardi di Vernio Chapel, Santa Croce, Florence. Beyond is the tomb monument with mural of *The Entombment of Christ and a Female Representative of the Bardi Family*. Photo: Scala.

walls of the chancel, then under the patronage of the Acciaiuoli family, dates from the 1380s. The spread of these dates indicates an impressive and continuous history of lay, familial patronage of the church throughout the fourteenth century.

The similarities between the patterns of patronage in these three Franciscan churches are thus considerable. In each case the interests and needs of the Franciscan Order and community (who wished to commemorate and celebrate their saints and holy martyrs) were balanced against those of lay patrons with their own religious and familial concerns. In all three cases the surviving evidence suggests that the churches were the recipients of a tradition of lay patronage which displayed a steady continuity throughout the century. In matters of iconography, however, certain significant differences between the Tuscan and north Italian examples emerge. As Margaret Plant has pointed out, the Paduan paintings show a marked preference for the portrayal of knightly themes, such as a saint intervening in a battle scene, and for portraiture. Thus, a constant theme in fourteenth-century Paduan painting and sculpture is the depiction of the patron kneeling, either in full armour or costume denoting his or her rank, before the Virgin Mary in the company of other saints (Plate 16). Such portraiture frequently occurs within the context of painted narrative cycles.[58] Although the Florentine Bardi di Vernio tombs furnish a Florentine example of such a trend (Plate 19), overall the painted schemes of Santa Croce's privately owned chapels do not display the same degree of preoccupation with celebrating courtly, chivalric themes or the individualized personalities of those responsible for the paintings' origination. It can thus be argued that on the evidence of what survives of lay, familial patronage within the major Franciscan churches of Siena, Florence and Padua, the courtly ambience established by Carrara rule in Padua had a distinctive effect on the production of art in that city. At the same time, however, lay, familial sponsorship of art within the Franciscan churches of both Siena and Florence was also significant, albeit in less overtly dynastic terms.

CONCLUSION

What, then, are the principal similarities and differences identified in this essay between the political and patronal contexts of fourteenth-century Siena, Florence and Padua? Broadly speaking, in a comparison of the three cities and their art, Padua stands out as markedly different from the Tuscan cities of Siena and Florence. Its political history as a city governed from the fourth decade of the fourteenth century by a single family naturally distinguishes it from Siena and Florence with their continued tradition of communal government. This difference in political fortunes demonstrably affected both the style and tempo of art production within each of the cities. Thus, and in direct contrast to the corporate, communal sponsorship of the cathedral and baptistery projects in Siena and Florence, Padua Duomo and Baptistery received its most lavish fourteenth-century embellishment at the behest of a female member of the Carrara family. It is, of course, possible to argue that the patronage of the Carrara – as rulers of Padua – is not in essence any different from that of the Sienese and Florentine governments. Yet, in terms of its intention and function, the artistic enterprise of the Carrara was highly dynastic in its nature and impact. It was intended to celebrate the magnificence and piety of the Carrara family, their friends, political allies and illustrious guests – not that of the corporate citizenry of Padua. By contrast, preambles to documents relating to the cathedral projects of Siena and Florence indicate clearly that (despite the influence well-placed individuals might bring to bear on such corporate enterprises) the intention behind the construction and embellishment of the cathedral complexes was firmly communal and for the benefit of the city as a whole.

Similarly, the fourteenth-century embellishment of each of the three cities' principal Franciscan churches provides further evidence of the distinctiveness of the conditions for the production of art that prevailed within Padua. Even on the basis of a simple comparison of surviving monuments – and it must be acknowledged that survival rates are highly erratic – it is plausible to suggest that the contrasting political cultures of Siena, Florence and Padua were evident in the art commissioned for the family chapels within their Franciscan churches. In Padua there is clear evidence from the surviving monuments that it was permissible for individuals to promote themselves, their families and their close associates in a clear, assertive and unambiguous way (even if due allowance had to be made for the preoccupations of the religious order in whose church such familial monuments were located). In Siena and Florence, however, there is nothing comparably unambiguous in either San Francesco or Santa Croce. What survives of fourteenth-century familial artistic schemes in these two churches is suggestive of a political climate and culture which was highly inimical to the overt promotion of a specific family identity – whether by portraiture or by the introduction of secular themes and imagery.

What all three cities unambiguously held in common was that art was highly valued. It was valued for a number of reasons, one of the principal ones being that it provided the buildings, sculptures and paintings which, in a practical, functional sense, facilitated in different ways certain kinds of civic activity and ritual. The respect and value placed upon art by the governing and social élites of all three cities is reflected in the continuity of art production that occurred throughout the fourteenth century. As we have seen, the century was marked from the fourth decade onwards by a series of socio-economic disasters, which had devastating effects on the populations, social make-up and economies of all three cities. Yet despite such disasters, artistic projects continued to be initiated and sustained. Enterprises such as the cathedral projects of Siena and Florence faltered but then found new directions and means of artistic expression. At the same time, in a changing social, economic and religious climate, other kinds of artistic enterprise sponsored by newly empowered patrons emerged. In Padua, meanwhile, the momentum of art production gained immeasurably in the latter half of the century, precisely at the time when outbreaks of plague were devastating Italian society, and yet also precisely at the time when the Carrara and their adherents had established their dominance within the city. Significantly, the Carrara, no less than the governing élites of fourteenth-century Siena and Florence, knew the value of art as a means of celebrating their political power and their princely magnificence.

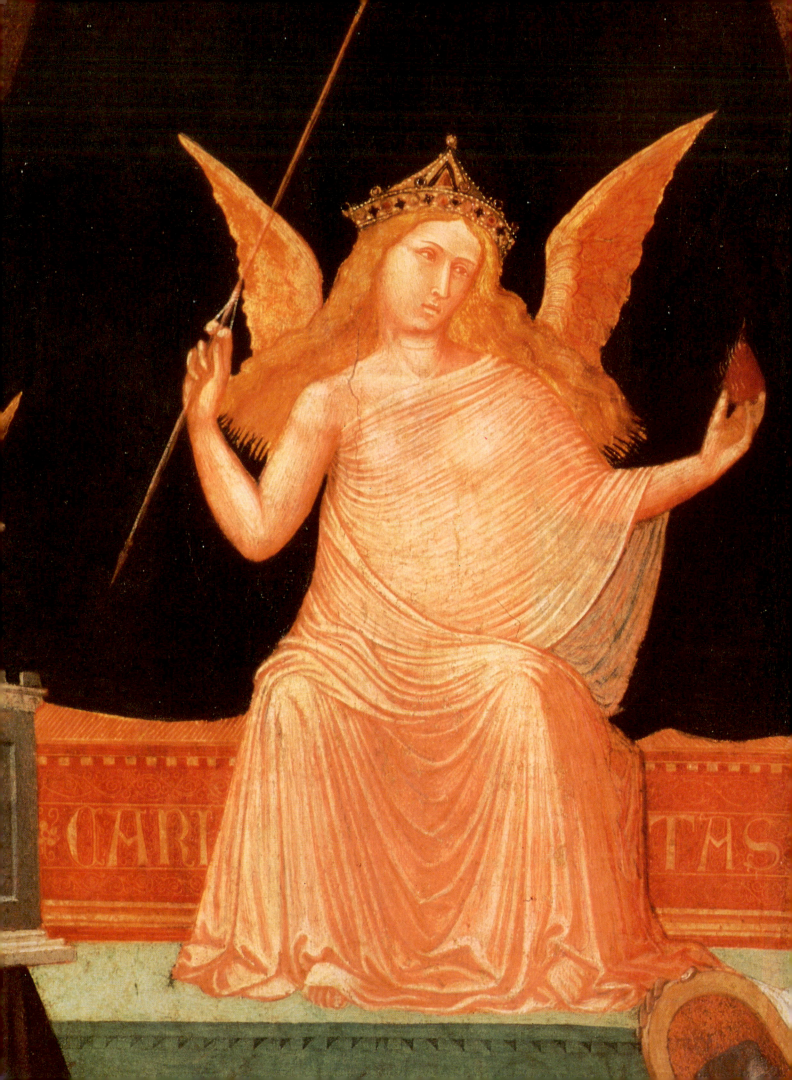

City, contado and beyond: artistic practice

In 1360 Maestro Naddo di Corbo, a carpenter from the village of Monselvoli, declared to the Sienese government that his original reason for moving to Siena had been to provide his sons with an education and that they were now 'satisfactorily trained in the art of manufacturing wool' and consequently were 'unable to work the land'.[1] This simple statement made by a fourteenth-century artisan provides a clear indication of the close *interdependence* between fourteenth-century Italian cities and their surrounding countryside – the *contado* or *territorio*. For the cities, the countryside represented a source of labour and food. Conversely, for the inhabitants of the countryside, the cities exerted a powerful pull, providing opportunities for professional training, employment and monetary gain.

Artists practising their manual trade – *arte* – in fourteenth-century Siena, Florence or Padua had much in common with the carpenter from Monselvoli. Many of them migrated from the countryside to one of these three cities to find training and employment. Thus Giotto, one of Florence's most celebrated artists, originated from the Mugello, a rural area of the city's subject territory, while Arnolfo di Cambio, the architect–sculptor commissioned by the city to design and supervise the embellishment of the cathedral's façade, came from the small and then independent Tuscan town of Colle Val d'Elsa. Apart from such local migration, which constantly added to the cities' existing pools of skilled craftsmen and women, artists born and trained in other parts of Italy were also attracted to work in these venues. This was particularly the case in fourteenth-century Padua, a city which apparently lacked the highly developed and indigenous craft traditions of Siena and Florence, but which housed a powerful court committed to the patronage of art and thus held out to artists good prospects of employment. The aim of this essay is, therefore, first, to examine the working conditions for artists functioning in each of these cities; and secondly, to examine the range and variety of commissions obtained by such artists both within the three cities and further afield.

THE PRACTICE OF ART

Reconstructing the conditions for the practice of art within fourteenth-century Siena, Florence and Padua is by no means a straightforward exercise, since surviving documentation concerning the identities, working conditions and professional practices of artists is limited and uneven. Indeed, it has taken the combined effort of the archival scholarship and art-historical research of several generations of scholars to provide even the currently known body of named fourteenth-century artists working within the three cities on identifiable projects. Moreover, despite such endeavour, no surviving works of art can be assigned to the names of many artists figuring in such documents as guild membership lists. Similarly, many fourteenth-century works, particularly those which have been removed from their original locations or have survived in a very poor condition, remain unattributed or grouped under such fanciful pseudonyms as 'The Master of the Dominican Effigies' or 'Ugolino Lorenzetti'.[2] Such qualifications notwithstanding, however, our knowledge of fourteenth-century art and its practitioners is sufficient to allow a number of broad generalizations and distinctions to be made concerning the working practices of artists within the three cities.

Siena and Florence each offered broadly comparable working conditions for their artists. Thus within both cities there was a flourishing craft tradition, supported by well-established but highly flexible structures for the training and professional conduct of such practitioners. Artists formed a tight-knit and distinctive social grouping within the artisan populations of the two cities, a grouping, moreover, which habitually intermarried and co-operated professionally. A striking example of such co-operation occurs in the first half of the century, with the documented collaboration between Simone Martini and his brother-in-law Lippo Memmi, both of whom signed *The Annunciation* for Siena's Duomo (Chapter 1, Plate 12).[3] Close analysis of the punchwork on a number of panel paintings by the Sienese painters Pietro and Ambrogio Lorenzetti likewise reveals that the two brothers, while operating their own workshops, utilized one another's tools.[4] This tradition of family-based art practice continued in the second half of the century. Thus in Florence four brothers – Andrea (better known as Orcagna), Nardo, Jacopo and Matteo di Cione – secured a livelihood marked by numerous prestigious commissions, the monumental sculpted tabernacle in Orsanmichele and the painted decoration of the Strozzi family chapel in Santa Maria Novella being two such examples. Meanwhile in Siena in the last decades of the century the painter Bartolo di Fredi and his son Andrea established a flourishing workshop which furnished Siena and her neighbouring towns with numerous altarpieces and mural paintings.[5]

In both Florence and Siena the professional practice of artists was controlled and assisted by the guilds. Florentine painters initially had an independent guild, but around 1315 this became incorporated with one of the greater guilds, that of the doctors and apothecaries – the Arte dei Medici e Speziali.[6] Similarly, those who worked with gold and precious metals belonged to the greater guild of the Arte della Seta (also known as the Arte di Por Santa Maria). In Siena, painters belonged to the Arte dei Pittori and workers of gold and other precious metals to the Arte degli Orafi.[7] In both

Plate 20 (Facing page) Ambrogio Lorenzetti, detail of *Maestà* (Plate 37). Photo: Scala.

cities, sculptors who worked in stone belonged to the stoneworkers' guild – the Maestri di Pietra – but they might also enlist in either the woodworkers' or the blacksmiths' guild. In Florence the guild structure and its hierarchy were much more influential in the government and political life of the city than in Siena. Even there, however, the relatively low social status of artists precluded them from any sustained participation in the Consulate of the greater guilds or in the Priorate and other influential government bodies: such roles tended to be confined strictly to members of the guild élite.[8]

As guild members, Florentine and Sienese artists were subject to regulations which required them to honour any contractual obligations they had undertaken and which prohibited them from impeding other members' professional activities. In return, the guild offered its members a degree of legal protection, with its elected officials adjudicating members' disputes over debts, partnership agreements and contracts. It also offered a sense of solidarity and a degree of social care and benevolence. Thus, as a member of a guild, an artist would be afforded a decent burial and his widow and orphaned children would receive some financial support. Indeed, several of the guilds were closely associated with confraternities, whose membership gathered together for regular communal religious devotions and organized fellow members' funerals. In 1349, in the wake of the Black Death, the Florentine painters actually founded a confraternity, the Compagnia di San Luca, to honour the evangelist Saint Luke (who was believed to have been a painter) and to practise mutually beneficial philanthropic and devotional activities.[9]

In terms of their social and economic standing, artists in both cities were not generally deemed wealthy or politically significant individuals. Some, however, achieved a modest degree of wealth and status within the first half of the century. Thus Giotto accumulated property within both Florence itself and the surrounding countryside, hired out looms, and had shares in the consolidated public debt, the *monte delle doti*. This public institution's records also contain the names of the painters Taddeo Gaddi and Bernardo Daddi, an indication of the extent to which some Florentine artists were able to profit from their profession.[10] Duccio likewise owned property in Siena and a smallholding at Castagneto in the Sienese countryside,[11] while Pietro Lorenzetti, as guardian of the orphaned sons of the Sienese sculptor Tino di Camaino, invested in land on their behalf.[12] In 1324 Simone Martini raised 340 florins to pay for his conjugal home and as his financial contribution towards his marriage.[13] In 1407 Bartolo di Fredi left 25 florins to Siena Duomo's building fund in his will – a bequest which bespoke a degree of affluence.[14]

In the first half of the fourteenth century, Florentine and Sienese artists had limited opportunities to participate in the government of their two cities. Such participation tended to arise from their professional expertise. Thus in 1295 Duccio, together with the Pisan sculptor Giovanni Pisano and four others, acted in an advisory capacity to the Sienese government on the placing of one of Siena's principal fountains.[15] Similarly, in 1331, Simone Martini was paid eight lire by the Sienese government to inspect and record three recently conquered castles within the Sienese territory.[16] Artists were also frequently asked to act as specialist advisers for the Opera del Duomo. One notable exception to this

general pattern of artists' involvement in government being limited to matters of technical expertise occurred in the case of Ambrogio Lorenzetti. In 1347 he is recorded as a participating member of Siena's Consiglio della Campana,[17] an incident which clearly points to this artist's singular prestige.

When, in the period following the Black Death, the political scene in Siena became increasingly fluid and political representation was extended to citizens of artisan status, artists were more easily able to obtain government posts. Thus the painters Lippo Vanni (1360 and 1373) and Luca di Tommè (1373 and 1379) each served twice on the city's principal magistracy of the Consistory, whilst the painter Bartolo di Fredi appears to have been a highly active agent for the Sienese government. In the mid 1370s he was sent to the small town of Montalcino, within Siena's subject territory, to settle a dispute about taxes, and in 1376 he held the office of Castellan of the Masse, an area of Sienese territory just outside the city itself. These political activities inevitably supplied him with contacts who were then able to secure him lucrative commissions – a number of altarpieces for the church of San Francesco in Montalcino being a case in point.[18] Florence, although subject to similar periods of democratization in which lesser guild members were able to secure political representation, nevertheless resisted the infiltration of artists into its governing bodies. Florentine artists continued in the main, therefore, to be confined in their dealings with government agencies to acting as expert advisers on various government-sponsored projects.[19]

Despite such differences in respect of political opportunities open to artists, however, both Siena and Florence were cities that had well-established artistic communities. The two cities were thus places in which local artists could find ample opportunities both to acquire the necessary skills for following an artistic trade (be it painting, sculpting or building) and to earn a reasonable livelihood by such a trade. Padua, by contrast, was a city in which art was nurtured in the main by artists who were *stranieri* – foreigners – attracted to the city either by the award of a specific commission or by the incentives provided by the presence of the powerful Carrara court.

Of those better-known artists who are documented as working in Padua during the fourteenth century, the painters Giotto, Giusto de'Menabuoi and Cennino Cennini came from Florence; the painter Jacopo Avanzo[20] from Bologna; the painter Altichiero from Zevio, near Verona; and the sculptor Andriolo de'Santi from Venice. Only the painter Guariento actually came from the city itself. Fourteenth-century documents within the Paduan archives name many other painters and associated craftsmen, such as goldsmiths, stone-carvers and woodworkers, practising their craft within Padua,[21] some of whom, moreover, claimed their place of origin as Padua or its outlying territories. In particular, Padua, with its long established university, had a lively tradition of manuscript illumination, which provided employment for numerous illuminators, some of whom were no doubt indigenous. The fact remains, however, that with the exception of Guariento's paintings, all of the major surviving artistic monuments of fourteenth-century Padua are the work of artists from elsewhere.

Once established in Padua, artists conducted their affairs and professional practice in similar ways to their Tuscan counterparts. They owned property within the city and its outlying rural districts, hired and trained apprentices, belonged to the relevant craft guilds, acted as professional experts in judging fellow artists' work and left their estates to their wives and children. Thus, for example, in 1352 Guariento sold land with a house in Padua's subject town of Piove di Sacco in the Paduan territory.[22] In 1382 Giusto de'Menabuoi acted as witness to the painter Jacopo di Lorenzo.[23] In 1395 Antonia, Giusto de'Menabuoi's widow, apprenticed her fourteen-year old son to an apothecary.[24] The close-knit nature of the Paduan artistic community is further indicated by a document of 1387 recording the acquisition of property by Giusto de'Menabuoi from Pietro, son of Guariento.[25]

Under the Carrara, the guilds of Padua were not politically powerful. Francesco il Vecchio, for example, while taking a number of steps to protect the interests of the wood guild, sought to curb the overall economic and political autonomy of the guilds. Membership of a Paduan guild was thus not a means of gaining political representation within the city's governing bodies or of securing a marked improvement in one's social and professional status. Since political power resided with the Carrara family – which by the second half of the century had established an autocratic princely regime – the professional interests of Paduan-based artists were best served by securing work and political favours from the Carrara. In the case of Giotto, who worked in Padua in the early decades of the fourteenth century when the city was still an independent Commune, we have no secure historical evidence concerning the professional conditions under which he worked. All we know is that he worked on a private commission for Enrico Scrovegni, a member of an extremely wealthy and politically powerful Paduan family, and that he may have been employed by Padua's government to execute paintings for the Salone of the Palazzo della Ragione and by the Franciscans at the Santo.[26] By contrast, we know that Guariento, Andriolo de'Santi, Altichiero, Giusto de'Menabuoi and Cennino Cennini associated themselves closely with the Carrara court, each artist securing at least one and sometimes several commissions from members of the Carrara family or from members of their inner circle.[27] A vivid example of the benefit that an artist might receive from the Carrara occurred in 1375, when Francesco il Vecchio granted the Florentine painter Giusto de'Menabuoi Paduan citizenship.[28]

Despite their contrasting political circumstances, Siena, Florence and Padua each provided attractive conditions for the practice of art. In each city there was sufficient wealth and either civic or dynastic pride to ensure a steady occurrence of major commissions and thus to attract and sustain the practice of leading contemporary artists. It was seldom if ever the case, however, that such artists confined their activities to a single city. On the contrary, most worked on a variety of projects in a variety of locations, and in order to appreciate fully the significance of their work in a particular place – such as Siena, Florence or Padua – it is also necessary to locate such local projects within the wider pattern of a given artist's activity. It is to this theme that we now turn.

CIVIC PROJECTS

The long drawn-out building programmes for the Sienese and Florentine cathedrals and their sculpted and painted embellishment offered artists opportunities for work throughout the fourteenth century. In Siena the cathedral project provided work for local Sienese artists such as the sculptors Tino di Camaino (*capomaestro* from 1319 to 1320) and Giovanni d'Agostino (*capomaestro* in 1336 and from 1340 to 1345). Shortly before acting as *capomaestro,* it appears that Tino di Camaino was able to secure the commission for an imposing tomb monument commemorating the Sienese Cardinal Riccardo Petroni (Plate 21).[29] In the first half of the century several innovative and talented Sienese painters – Duccio, Simone Martini, Pietro Lorenzetti and Ambrogio Lorenzetti – likewise received commissions for the programme of Marian altarpieces in Siena Duomo, a tradition continued in the second half of the century by the commissions awarded to such painters as Bartolo di Fredi for further altarpieces for the cathedral. In Florence, meanwhile, the cathedral project provided work for local artists such as Giotto (*capomaestro* from 1334 to 1337), Taddeo Gaddi, Orcagna, Andrea Bonaiuti (all acting in the 1360s as advisers on the construction of the cathedral)[30] and Bernardo Daddi and Giovanni del Biondo, painters who, in the second half of the century, received commissions for painted panels to ornament the broad faces of Florence Duomo's nave piers. In

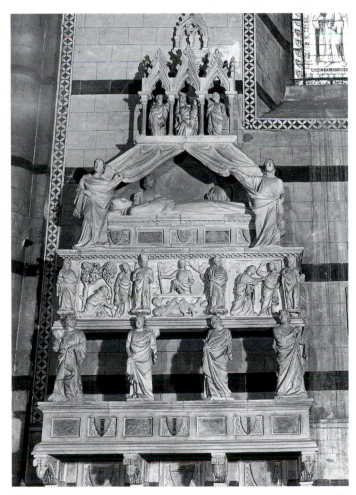

Plate 21 Tino di Camaino, tomb of Cardinal Riccardo Petroni (d.1314), *c.*1318, marble, Duomo, Siena. Photo: Tim Benton.

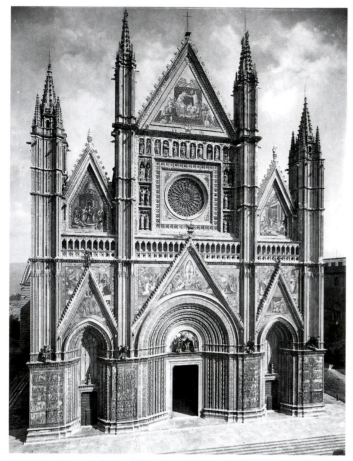

Plate 22 Duomo, Orvieto, founded 1290, façade begun 1310. Photo: Alinari.

addition to providing work for locally based artists, however, both projects attracted artists from other parts of Tuscany and further afield. Thus between 1287 (when he is first mentioned as *capomaestro*) and 1314, the Pisan architect–sculptor Giovanni Pisano took charge of the artistic – and more particularly the sculpted – embellishment of Siena's Duomo. At Florence in the 1320s the Sienese sculptor Tino di Camaino executed a tomb monument for the cathedral which commemorated Antonio degli Orsi, Bishop of Florence, and a sculpture of Christ being baptized for the exterior of the baptistery.[31] During the 1330s and early 1340s, Andrea Pisano (who was born in the small town of Pontedera, situated on the Arno equidistant between Pisa and Florence, but, as his name suggests, associated himself closely with Pisa) worked on such major public Florentine projects as the bronze baptistery doors and the campanile and also acted as *capomaestro* for the cathedral itself.

Just as artists from other towns were attracted to the cathedral projects of Siena and Florence, so other nearby cities provided fourteenth-century Sienese and Florentine artists with comparable opportunities. Pisa, with its cathedral, baptistery and enclosed cemetery – the Campo Santo – provided one such venue. Further south, the new cathedral of the hill-top town of Orvieto provided another (Plate 22). The plans for this vast cathedral were agreed in 1284 and its foundation stone was laid in 1290. As in both Siena and Florence, the ambitious scale of this cathedral project and its architectural design necessitated the services of a large

workforce of builders and stoneworkers, led by the Sienese sculptor–architect Lorenzo Maitani, who served as *capomaestro* for a period of 20 years from 1310 to 1330 (although this period of engagement was interrupted by projects elsewhere in other Tuscan and Umbrian towns). Other masters from Siena and Florence also served in this capacity, including the Florentine painter–sculptor Orcagna (appointed in 1358). Like the Duomos of Siena and Florence, the entrance façade of this monumental building was also graced by an ambitious sculpted programme which incorporated bronze and marble sculpture, sculpted figures in the round and (on the broad flat piers framing its three entrance doors) an extensive programme of carved reliefs – a scheme which provided ample work for both stone-carvers and metalworkers (Plate 24).[32] Once the building construction was sufficiently advanced, goldsmiths, glaziers, wood-carvers, metalworkers and painters worked within the cathedral itself to embellish it in a suitably magnificent way. Among this large workforce of craftsmen drawn from throughout Italy (and very occasionally from further afield), Sienese artists tended to predominate. Thus, for the chapel of the prized relic of the Holy Corporal,[33] the Sienese goldsmith Ugolino di Vieri crafted a magnificent gold and silver shrine, incorporating within it a series of narrative scenes commemorating and celebrating both the life of Christ and the history of the relic itself (Plate 23).[34]

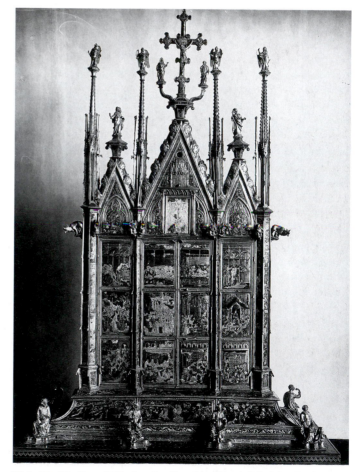

Plate 23 Ugolino di Vieri and colleagues, *Scenes of the Miracle of Bolsena and the Passion of Christ*, reliquary of the Holy Corporal, front face, 1338, enamel and metalwork, 139 x 63 cm, chapel of the Corporal, Duomo, Orvieto. Photo: Alinari.

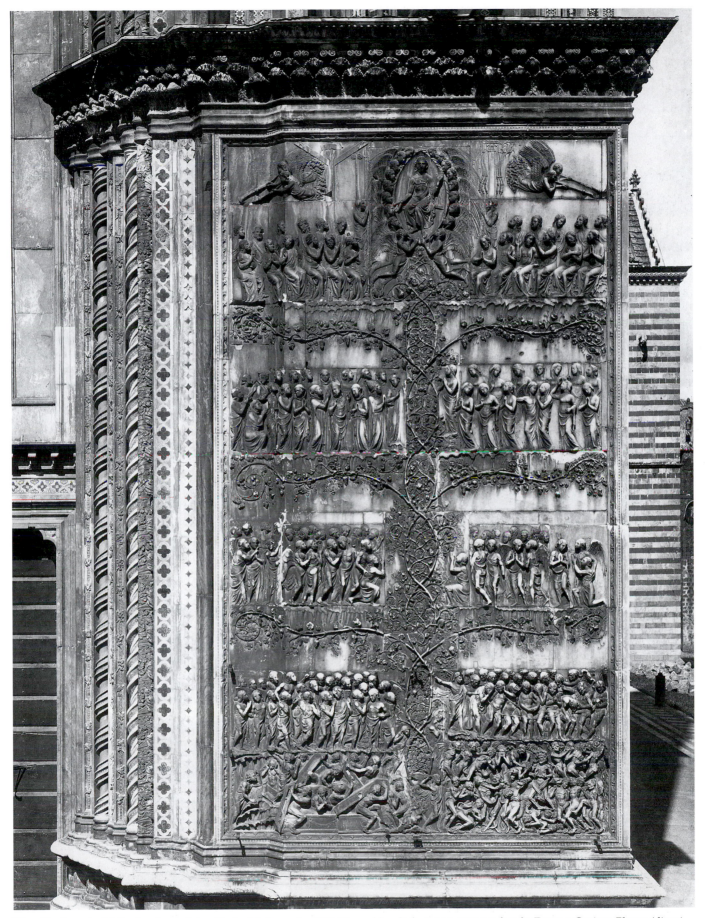

Plate 24 Lorenzo Maitani and associates, *The Last Judgement*, *c.*1310–30, marble relief, pier on entrance façade, Duomo, Orvieto. Photo: Alinari.

In striking contrast to the Duomos of Siena and Florence – and indeed those of Pisa and Orvieto – Padua's Duomo did not apparently provide artists with secure ongoing prospects of work throughout the century. Such work as there was appears to have been largely due to the initiative of private individuals and their families. As noted in Chapter 1, what survives of fourteenth-century art within the Santo offers evidence that artists were regularly employed by Padua's leading families. Careful historical and archaeological reconstruction of the decorative campaigns conducted in the Eremitani, the Paduan church of the Augustinian Hermits, provides another striking picture of sustained familial patronage conducted throughout the century. Thus it appears from surviving fragments that a chapel belonging to a local family, the Sanguinacci, was decorated around the 1320s with a series of fresco paintings, one of which, an enthroned Virgin with saints, provides evidence of a locally commissioned painter having studied Giotto's monumental figure style in the nearby privately owned Arena Chapel. On the wall of another chapel of the Eremitani, a votive image of a Virgin and Child with a diminutive donor figure kneeling at the foot of the Virgin's throne similarly suggests that once again a Paduan painter was absorbing lessons from Giotto's Arena Chapel frescoes and utilizing them on behalf of his patron (Plate 25). It is not known whether the fresco cycle executed in the 1350s by the Paduan painter Guariento upon the walls of the chancel and chancel apse was the result of a commission from a private patron, but on the evidence of comparable commissions for other church chancels it seems likely. Partly destroyed by a bomb during World War II, this elaborate painted cycle once comprised *Christ Enthroned in the Company*

of Saints, scenes from the lives of Saint James the Less and Philip (to whom the church was dedicated) and Saint Augustine (the founder of the Augustinian Hermits). At the base of these narrative paintings is a series of allegorical personifications of the seven planets and seven ages of man (Chapter 10, Plate 225). Around 1370 the Paduan-based Florentine Giusto de'Menabuoi executed another ambitious painted scheme depicting Saint Augustine with the liberal arts and the virtues for the chapel of the Paduan jurist, Tebaldo di Niccolò dei Cortellieri, only a few fragments of which survive. In 1373 Giusto also received a commission from the executors of a German nobleman, Enrico Spisser, a knight in the service of Francesco il Vecchio, to paint a chapel in the church. In 1375 the Venetian sculptor Andriolo de'Santi received a payment for working on Spisser's tomb. Finally, at the end of the century the Veronese painter Altichiero received a commission from the Dotti family to execute paintings for the interior and exterior of their family chapel. Unfortunately, however, nothing survives today of these two artistic schemes.[35]

Investigation of the history of other artistic schemes initiated in other Paduan churches and in the churches of Florence and Siena has revealed a similar pattern of sustained patronage extended to artists by local private patrons and their families throughout the fourteenth century and beyond.[36] Nor, moreover, was the potential for work arising from such commissions in major churches limited to purely local and lay initiatives. The major religious orders under whose care these churches resided provided further significant opportunities for fourteenth-century artists. As local communities belonging to much larger, highly organized corporate bodies extending throughout (and occasionally beyond) Europe, the religious orders, and more particularly the newly founded mendicant orders, were well placed to offer commissions to artists whose work for a particular locality had impressed the local representatives of that order.

Dominican and Franciscan patronage

Among the newly founded orders, the Dominicans and Franciscans were particularly astute in their exploitation of art for the promotion of their collective identities and ideologies. For example, Joanna Cannon has demonstrated that, in the first three decades of the fourteenth century, the commissioning of altarpieces for major Dominican churches within Tuscany and nearby Umbria was closely associated with the meetings of the Provincial Chapters of the Dominican Order.[37] Thus, shortly before the Provincial Chapter held in 1306 at San Domenico in Siena, it appears that Duccio's workshop executed a polyptych of *The Virgin and Child with Saints* for the high altar of that church. This in turn may well have replaced an earlier panel of *The Virgin and Child Enthroned* by the thirteenth-century painter Guido da Siena. Some fourteen years later, the high altar in the Dominican church of Santa Caterina in Pisa was graced by an even more elaborate polyptych designed and painted by Simone Martini, apparently executed in time for the Provincial Chapter held in the priory in 1320 and significantly including within its programme of saints an image of the not

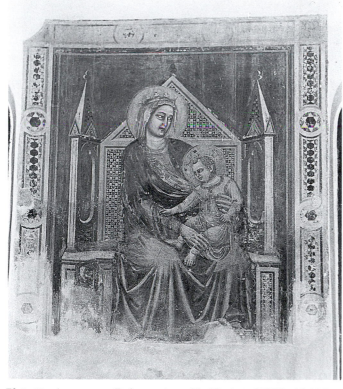

Plate 25 Anonymous Paduan painter, *The Virgin and Child with Male Donor*, c.1310–20, fresco, Eremitani, Padua. Photo: Photo: Alessandro Romanin.

yet canonized Dominican Saint Thomas Aquinas. A year later, when the Chapter met in the Florentine priory of Santa Maria Novella, the high altar had probably just been embellished with a multi-storied polyptych executed by the Sienese painter Ugolino di Nerio. As Cannon astutely observes:

> a splendid new altarpiece would have been a fitting decoration for the host church and one which would have impressed visitors from other houses. They in turn may have decided to embellish their own houses in a similar manner in time for the next meeting of the Chapter, hoping to rival or surpass their brothers with the aptness and novelty of the work they commissioned.[38]

In addition, it appears that, in the first half of the century at least, Dominican patronage furnished artists with commissions that encouraged them to experiment in terms of both format and iconography, and thus gave considerable impetus to innovation within fourteenth-century altarpiece design. Significantly for our present concerns, such institutional patronage also offered painters (and particularly Sienese painters) opportunities to work and make their work known outside their native city.

Such Dominican influence upon fourteenth-century altarpiece production appears to have been paralleled by a similar network of Franciscan commissions. The survival of seven polyptychs, each with a pronounced Franciscan iconography, executed by either Ugolino di Nerio or one of his circle (including the prestigious commission of *c*.1325 for the high altarpiece of Santa Croce, Florence),[39] suggests that during the first half of the fourteenth century the Franciscans also played a role in the encouragement and dissemination of this particular artistic form. It is almost certainly within the field of fourteenth-century mural painting, however, that Franciscan patronage exerted its most decisive impact – the

mural embellishment of the basilica of San Francesco at Assisi being seminal in this respect (Plate 26). This remarkable double-storied basilica was founded at Francis's home tówn of Assisi in 1228, the year of his canonization, and was consecrated in 1253. In the first half of the fourteenth century, the church became a remarkable focal point for Sienese and Florentine painters working on mural schemes within it.[40]

The Lower Church was the first foundation of this vast ecclesiastical complex dedicated to the founder of the Franciscan Order. The walls of the nave (in all likelihood originally orientated towards the east, but later re-orientated to the west) were probably painted by an unknown artist between 1253 and 1266 with a series of frescoes depicting scenes from the life of Christ on one wall and scenes from the life of Saint Francis on the other – an iconographic scheme which underscored the highly controversial Franciscan ideal of Francis as a type of Christ figure.[41] The mural programme for this church was continued in the last decade of the thirteenth century in the main apse and transept chapels of the Upper Church by the Florentine painter Cimabue and his workshop. Here three mural cycles, depicting scenes from the life of the Virgin Mary, Saint Peter and the Book of Revelation respectively, reflected the dedications of the three altars located within this part of the church, and also expressed in visual terms Saint Francis's particular devotion towards the Virgin Mary, Saint Peter and the Archangel Michael. At approximately the same period the upper tier of the nave walls of the Upper Church was furnished with a cycle of murals depicting, on the right wall (as one faces the high altar), scenes from the Old Testament and, on the left, scenes from the New Testament (Plate 27). This detailed pictorial scheme was then further extended to the lower walls by a cycle of 28 scenes depicting the life of Saint Francis, the

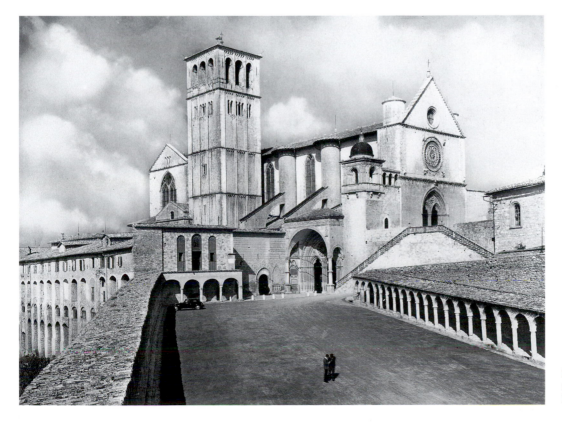

Plate 26 San Francesco, Assisi, founded 1228, consecrated 1253. Photo: Alinari.

Plate 27 View of interior (looking towards the high altar), Upper Church, San Francesco, Assisi. Photo: Archivio Fotografico Sacro Convento, Assisi/G.A. Brescia.

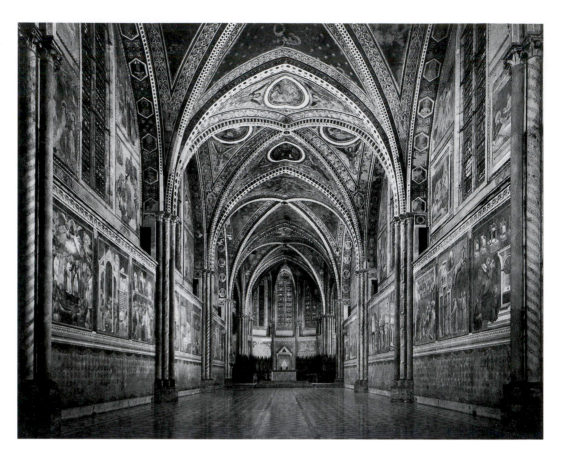

significance of which, it has been observed, lies in the fact that it is 'the first monumental visualization of the life of a near contemporary, in immediately recognizable settings and costumes' (Plate 28).[42] There are no documented references to the identities of the painters of these schemes for the nave of the Upper Church. The majority of the Old and New Testament series are, however, generally attributed to the Roman painter Jacopo Torriti, and the Saint Francis series either to a youthful Giotto or an unknown painter dubbed the Master of the Saint Francis Legend.[43]

In the fourteenth century, with the Upper Church already extensively and lavishly decorated with several monumental fresco cycles, the Lower Church became the focal point for several further campaigns, conducted primarily by Sienese masters but including several other painters working within the ambience of the Florentine master Giotto. At

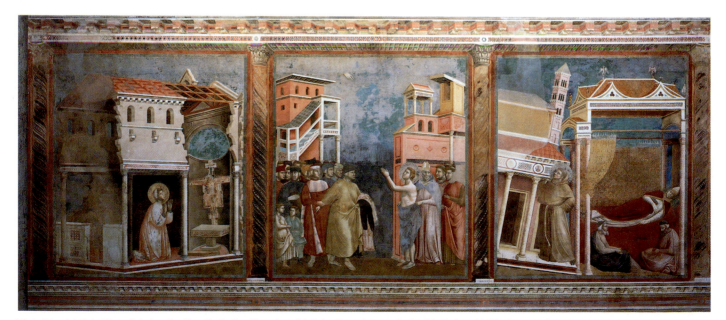

Plate 28　(a) *Saint Francis before the Crucifix in San Damaino*, (b) *Saint Francis Repudiating his Father*, (c) *The Dream of Innocent III*, *c.*1295–97, fresco, Upper Church, San Francesco, Assisi. Photo: Stefan Diller.

undocumented dates, but in all probability in the second and third decades of the century, a number of privately owned chapels were embellished with series of fresco cycles whose subjects reflected both the chapels' dedications, the preoccupations of their founders (or their heirs), and the ideals of the Franciscan Order in whose church they were placed. An outstanding example of this combination occurs in the first chapel on the left as one enters the building, where Simone Martini executed a series of frescoes depicting the life of Saint Martin of Tours, whose hagiography, celebrating as it did an ex-member of the imperial guard and patron saint of France, readily leant itself to the expression of certain chivalric and francophile themes (Plate 29). Such themes had pertinent associations both for the Franciscan Order and for the person commemorated in this chapel. From the Franciscan perspective it echoed the perception of Saint Francis as the prototypical saintly knight.[44] From the standpoint of the patron, meanwhile, the subject of Saint Martin was appropriate since the titular church of Cardinal Gentile di Partino da Montefiore (d.1312) in Rome was dedicated to Saints Martin and Sylvester, and the cardinal had in all probability a special devotion to Saint Martin.[45]

In the third and fourth decades of the fourteenth century the crossing and transepts of the Lower Church were painted with as ambitious a programme as the earlier one in the Upper Church. In the Lower Church the high altar is placed directly over the tomb of Saint Francis in the crypt below. In order to underline the religious significance of such a placement, each of the four webs of the massive groin vault above the high altar shows a pictorial abstraction of an aspect of Franciscan doctrine (Plate 30). Attributed to a painter who

had probably worked in Giotto's workshop and is known as the Maestro delle Vele (Master of the Vaults), these vault frescoes present, respectively, allegorical representations of Chastity, Poverty and Obedience (three monastic virtues which the saint particularly advocated) and *Saint Francis in Glory*. At approximately the same date, the same painter probably executed, on the low walls and broad transverse arch of the north transept, a cycle depicting the early life of Christ. The narrative chronology of this cycle continues in the south transept with a powerfully evoked cycle of the Passion of Christ, executed under the direction of the Sienese painter Pietro Lorenzetti (Plate 31). A measure of the overall programmatic intent of the Franciscan Order for its principal church can be gauged from the presence on each of the transept walls (contiguous with the nave of both the Upper and Lower Churches) of a monumental Crucifixion. One of them shows Saint Francis clutching the base of the cross, thus emphasizing this saint's particular devotion to the image of Christ crucified.

Although the precise datings and attribution of these ambitious pictorial schemes are the subject of ongoing debate among scholars of fourteenth-century art, what is clear is that between roughly 1315 and 1330 the Lower Church at Assisi was the location for intense artistic activity, with several campaigns of fresco decoration proceeding simultaneously and involving a number of master painters and their workshops. Assisi must thus have presented these painters with unequalled opportunities both to co-operate and to compete with another. Summoned to Assisi as master painters, they were expected by their patrons to bring their previous experience to bear upon the nexus of requirements

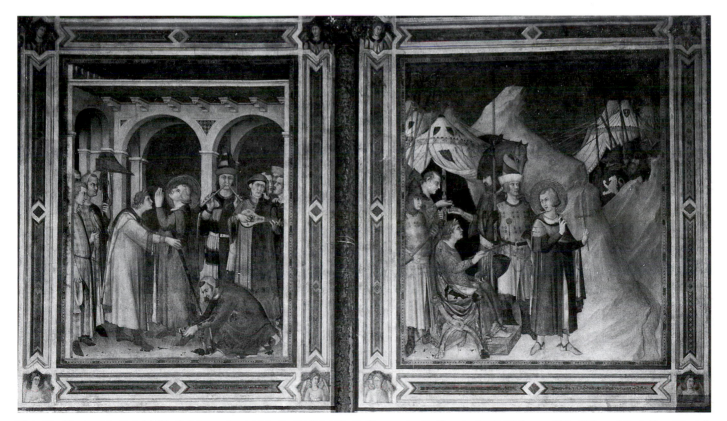

Plate 29 Simone Martini, (a) *The Knighting of Saint Martin*, (b) *Saint Martin Renouncing the Sword*, *c*.1317–19, fresco, 265 x 200 cm, Montefiore Chapel, Lower Church, San Francesco, Assisi. Photo: Archivio Fotografico Sacro Convento, Assisi.

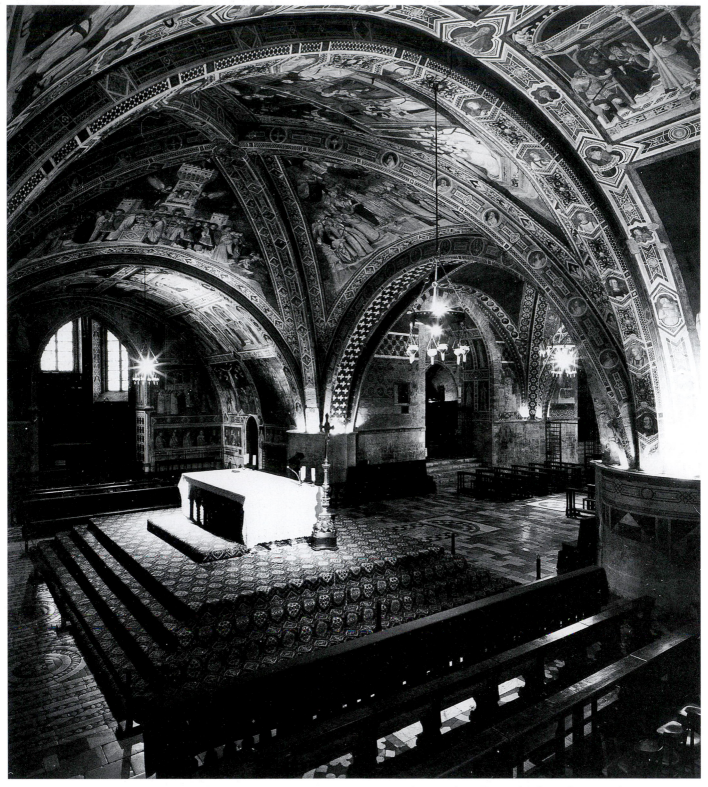

Plate 30 View of crossing and north transept, Lower Church, San Francesco, Assisi. Photo: Archivio Fotografico Sacro Convento, Assisi.

encompassed by each of the painted schemes on which they were employed. In addition, they could benefit from exposure to each other's work, and from a range of options copy, improvize and boldly set out newly forged modes of representation upon the walls of this remarkable church.

In the second half of the fourteenth century, with the completion of the embellishment of their principal church, the main impetus for the further embellishment of other Franciscan churches appears to have come from lay patronage. The iconography and design of such schemes (as in the case of the late fourteenth-century mural cycles in the Santo, Padua) were affected by the taste and aspirations of such sponsors. Yet it is possible to perceive the larger interests of the Franciscan Order continuing to co-exist with localized

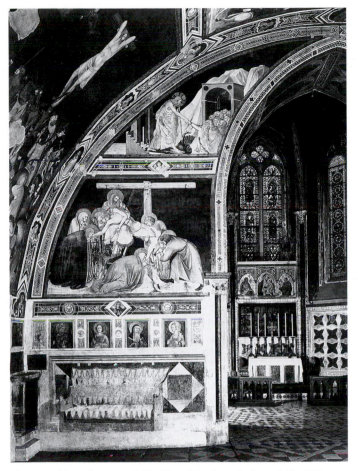

Plate 31 Pietro Lorenzetti, *The Deposition from the Cross*, 369 x 232 cm, and (above) *Descent into Limbo*, c.1315–19, fresco, south transept, Lower Church, San Francesco, Assisi. Photo: Kunsthistorisches Institut, Florenz.

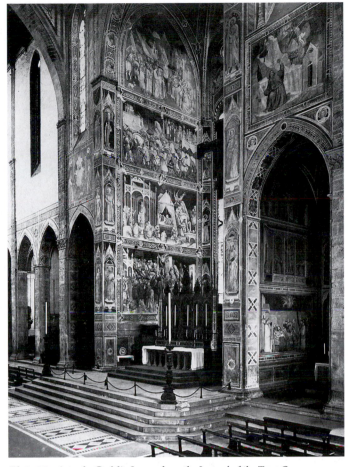

Plate 32 Agnolo Gaddi, *Scenes from the Legend of the True Cross*, 1388–93, fresco, chancel, left wall view, Santa Croce, Florence. Reproduced from Eve Borsook, *The Mural Painters of Tuscany from Cimabue to Andrea del Sarto*, Phaidon Press, 1960.

and personal patronal interests. Thus, between 1388 and 1393 the Florentine painter Agnolo Gaddi was commissioned by the Florentine Alberti family to fresco the walls of the chancel of the Franciscan church of Santa Croce in Florence. This ambitious cycle, depicting the history of the True Cross, is remarkable in that it was the first monumental pictorial representation of this subject (Plate 32). Given the dedication of the church to Santa Croce and the presence of a highly prized relic of a fragment of the Cross within it, the introduction of such an iconographic scheme is entirely appropriate. It is notable, however, that the frescoes also provide a skilful visualization of the particular Franciscan devotion to the cult of the cross – a devotion inspired by Saint Francis himself receiving the stigmata on his feet, hands and side.[46]

PROJECTS FURTHER AFIELD

Apart from the influence of the major religious orders, what other social and political factors affected the practice of art within fourteenth-century Siena, Florence and Padua? Throughout the century, all three cities pursued concerted policies of territorial expansion, thus frequently coming into conflict with their neighbours – Florence and Siena with each other; Florence with Pisa; and Padua with Venice, Verona and latterly Milan. Moreover, in addition to such rivalry between city states, each of the cities was also obliged, as a result of its territorial ambitions, to confront locally powerful nobles and their allies. Such territorial expansion was vital in enabling the Sienese, Florentine and Paduan governments to secure adequate food supplies and trade routes and to recruit a sufficient workforce and militia.

The process of territorial acquisition and the various forms it took were complex. Both the surrounding countryside and rural towns with it were acquired by a variety of means – bequest, sale or outright military conquest.[47] It was often difficult for the city governments to keep hold of newly acquired towns, the frequent rebellions of Siena's subject towns of Massa Marittima and Montalcino being cases in point. In order to maintain control and also to accommodate strongly felt local needs, the city governments had to resort to a variety of ways and means of administering their subject territories and populations in matters of justice, taxation and political participation. One striking exemplification of this process was military fortification and urban resettlement. Thus Padua's territory – the Padovano – was progressively controlled during the periods of both communal and Carrara rule by the construction of an impressive set of fortresses – Francesco il Vecchio's fortifications at Montagnana being a notable example such of a policy (Plate 33). Elsewhere *entirely*

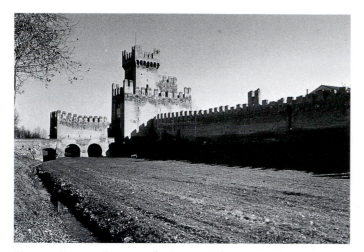

Plate 33 Fortress (known as the Porta Legnano) and walls of Montagnana. Commissioned by Francesco il Vecchio da Carrara and constructed between 1360 and 1362 under direction of Francesco de'Schicchi. Photo: Index/Abbiati/A.G.Stradella, Florence.

argued that, in the case of Siena at least, young painters who could not yet compete with well-established masters of their day were obliged to accept commissions for altarpieces within the churches of the *contado* towns.[49] Not only well-established artists but also younger ones thus benefited from *contado*-based commissions.

The strategically important town of Massa Marittima provides an example of the kinds of opportunity afforded to artists by the extension of Sienese political and cultural hegemony throughout southern Tuscany. During the thirteenth and early fourteenth centuries Massa Marittima was an independent Commune. Located in an area of rich and extensively mined iron deposits, it naturally constituted a desirable acquisition for the Sienese, who conquered it in 1335. Prior to this event and during its period of autonomy, the civic authorities of Massa had employed both Pisan and Sienese artists, the former travelling easily down the coast to Massa Marittima. Between 1287 and 1304 a Pisan architect and sculptor was responsible both for the design and construction of the choir of the city's cathedral and for the elegant additions to the upper part of the façade (Plate 35).[50] The city authorities also commissioned (from a Sienese artist in Duccio's circle) a close version of Duccio's celebrated double-sided high altarpiece for the Duomo of Siena.[51] From another Sienese artist, Goro di Gregorio, they commissioned a tomb for the city's patron saint, Cerbonius, easily remembered by virtue of his unusual attribute of a flock of geese (Plate 36). Once securely under Sienese rule, control of this town was maintained not least by the construction by Sienese stoneworkers in the newer section of the town of an imposing fortress which was built on a hill overlooking and dominating the older civic centre of the cathedral and town hall.

new towns were founded within both Tuscany and northern Italy. Florence was particularly assiduous in this respect, as attested by such towns as San Giovanni Valdarno, Terranuova Bracciolini, Firenzuola and Scarperia, all of which provide vivid testimony of the city's self-conscious policy of active colonization of her newly won territory.[48] Similarly, the foundations of the border town of Torrita di Siena and the port of Talamone (Plate 34) illustrate the Sienese attempt to control their outlying borders and provide an outlet for maritime trade.

Such territorial expansion also had notable effects on the practice of art. For a start, it provided a lucrative source of commissions and patronage. Indeed, it has plausibly been

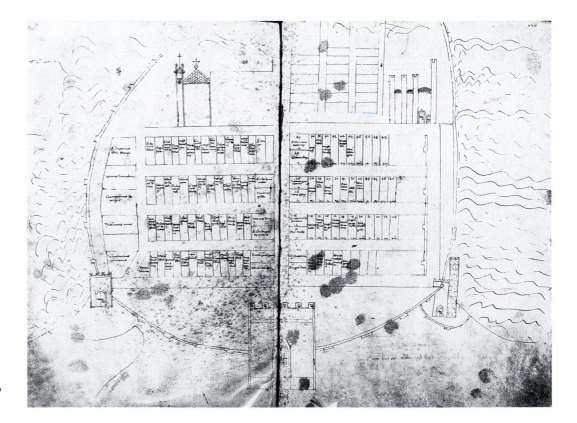

Plate 34 Schematic plan of ground lots in Talamone, 4 April 1306, Archivio di Stato, Siena, 209 *Capitoli* 3, folios 25 verso–26 recto. Reproduced by permission of Archivio di Stato di Siena.

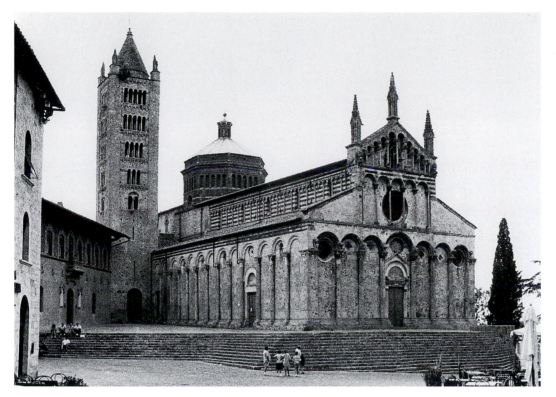

Plate 35 Duomo, Massa Marittima, begun mid twelfth century with choir constructed between 1287 and 1304. Photo: Index.

Sienese painters were also able to acquire work in Massa Marittima and thus to deploy their specifically *Sienese* skills. Ambrogio Lorenzetti, for instance, furnished the city's principal Augustinian church with an altarpiece[52] – a work which, like the copy of Duccio's *Maestà*, provided a further compelling instance of a talented painter innovatively reworking a particularly Sienese iconography (Plate 37). In this case the painting's subject – the Virgin Mary with the Christ Child enthroned in majesty and in the company of a large and courtly gathering of saints – constitutes a comment by Lorenzetti upon both Duccio's high altarpiece for Siena's Duomo and Simone Martini's mural for the principal council hall of Siena's Palazzo Pubblico.[53] At the same time, however, the introduction of this altarpiece into Massa Marittima was also undoubtedly conditioned by the specific local needs of the Augustinian Hermits and the citizens of Massa Marittima.

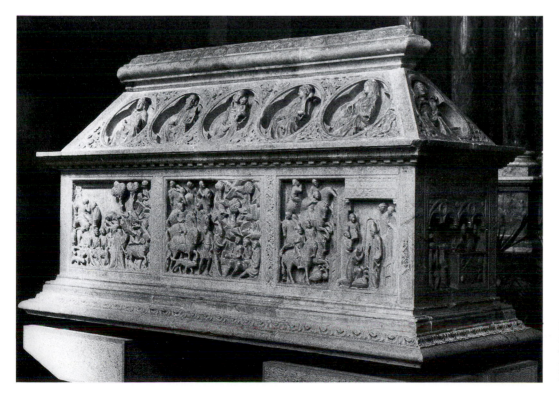

Plate 36 Goro di Gregorio, reliquary tomb (*arca*) of Saint Cerbonius, 1324, marble and polychromy, choir, Duomo, Massa Marittima. Photo: Index.

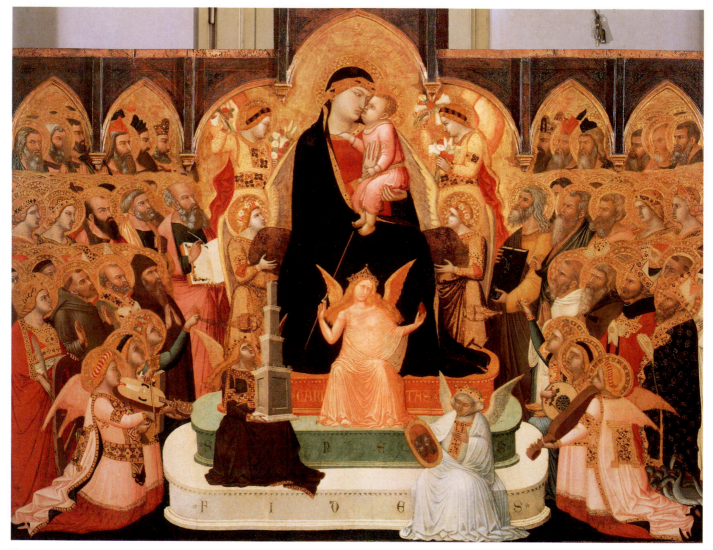

Plate 37 Ambrogio Lorenzetti, *Maestà*, *c*.1335–37, tempera on panel, 161 x 207 cm, Pinacoteca, Massa Marittima. Photo: Scala.

In place of the principal patron saints of Siena, Cerbonius himself appears at the extreme right and beside him the founder of the Augustinian Order – Augustine. The iconography of this altarpiece painting thus encapsulates the complex tension between overtly Sienese themes (in the self-conscious relationship to two works executed for major public sites in Siena itself) and the local circumstances of one of its subject cities.

Although the case of Siena and Massa Marittima represents a particularly outstanding example of the opportunities afforded to artists by the interaction of a city state and its *contado*, the relationship was not unique. That relations between Padua and her subject cities offered opportunities to Paduan-based artists is attested by two commissions awarded to the Paduan painter Guariento. The first, datable to *c*.1332, was awarded by Maria de'Bovolini and resulted in a large-scale painted crucifix for the Franciscan church of Bassano, then one of Padua's subject towns guarding her northern frontier.[54] The second was for a large-scale and intricately decorated polyptych, signed and dated 1344 by the painter, and depicting as its main subject the coronation of the Virgin. The historical evidence for the provenance and commissioning of this altarpiece suggests that the project was

initiated by an archpriest of the Duomo of San Martino in Piove di Sacco, an important town in the southern Padovano. The archpriest, one Alberto, was a friend and ally of the Carrara family and perhaps because of this was able to secure work for Guariento from the Carrara.[55]

Guelphs and Ghibellines

The policy of territorial expansion conducted by all three cities led to inter-city conflicts which were then further exacerbated by internal political rivalries and factions and by political interventions by foreign powers. The histories of the foreign policies conducted by each of the three fourteenth-century city states are highly complex, and are made still more complicated by the adherence of various political factions within the three cities to either the Guelph or the Ghibelline cause. Much ink has been spilt on the origins, the history and indeed the very names of these two political allegiances.[56] By the fourteenth century, moreover, other designations were also being used to characterize such rivalries and conflicts of interest, the Whites and the Blacks of Florence being a case in point. 'Guelph' and 'Ghibelline' were convenient names used by local chroniclers to identify and

dignify the endemic factionalism that dogged city politics in the thirteenth and fourteenth centuries. Nevertheless, when attempting to gauge how such political rivalries and allegiances might have affected the commissioning and practice of fourteenth-century art, it is useful to keep in mind the traditional notion of the Ghibellines as supporters of the Holy Roman Emperor and the Guelphs as supporters of the Papacy.

By the fourteenth century those north European rulers who laid claim to the title of the Holy Roman Emperor had only limited influence over political events in Italy, yet their rare expeditions into Italy to be crowned in Rome and to intervene in the politics of the Italian city states had certain repercussions for the political fortunes of Siena, Florence and Padua. Thus, for example, the arrival in Italy in 1310 of Henry of Luxemburg, King of Germany, to be crowned as Henry VII, Holy Roman Emperor, in Rome in 1312 resulted in a general Ghibelline revival, with the then staunchly Guelph cities of Florence, Siena and Padua all maintaining a stance of hostility towards Henry and his pro-Ghibelline allies of Pisa and Verona.[57]

Such incidents notwithstanding, the relatively limited nature of their intervention in Italian affairs meant that successive Holy Roman Emperors had little noticeable effect on the artistic practice of Florentine, Sienese or Paduan artists, who could only very rarely secure commissions from such a transitory patron. Isolated examples occur in the case of Ghibelline Pisa, where Henry VII and his retinue were temporarily in residence between 6 March and 28 April 1312, and 10 March and 8 August 1313, and were thus able to award commissions of a number of sculptural monuments.[58] The principal surviving evidence for an imperial commission awarded to one of the three cities' artists occurs in the sculpted group of Henry VII enthroned with his counsellors, which constitutes the remains of a once impressive tomb monument executed in 1315 by the Sienese sculptor Tino di Camaino for an original site within Pisa's Duomo. An incident related to this imperial commission provides a convenient illustration of the complexity of Guelph–Ghibelline rivalries and the unexpected effects that these might have upon fourteenth-century artistic practice. It appears that on 26 July 1315 Tino di Camaino failed to collect the final five days' wages owing to him. It has been suggested that the reason for this was that Tino, together with other Guelphs from his native Siena, fought against the victorious Ghibellines at the battle of Montecatini (29 August 1315) and, although evading capture, lost both his job as *capomaestro* of Pisa's Duomo and the remuneration for his work on this most imperial and Ghibelline of monuments.[59]

The Papacy and the Angevins of south Italy

Rather more can be said in respect of the influence on Sienese, Florentine and Paduan artists of the other major protagonists in the Guelph–Ghibelline divide – the Pope and the Angevin rulers of the south Italian kingdom of Naples. Utilizing the resources of the vast papal clerical administration and bureaucracy, successive popes' policies in respect of all three cities were far more decisive and far-reaching than those of the Holy Roman Emperor. Despite the fact that between 1308 and 1377 the papal curia was based in the French town of Avignon, the Pope's intervention in Italian affairs continued to be mediated through papal legates and other representatives. In the last decades of the thirteenth century and the early years of the fourteenth century, the papal court in Rome with its cardinals and curial officials provided work for artists, including the Florentines Arnolfo di Cambio (who executed a large number of funerary and liturgical monuments for popes and cardinals for churches within Rome and other central Italian towns) and Giotto, whose heavily restored mosaic of the *Navicella* (probably executed between 1300 and 1304) for Saint Peter's remains the principal surviving evidence for his sojourn in that city.[60] Once removed to Avignon, the papal court acted as a valuable conduit of cultural cross-fertilization, attracting a number of artists to work there, most notably the Sienese painter Simone Martini, who took up residence between 1340 and 1344, and executed for Cardinal Giacomo Stefaneschi (the patron also responsible for Giotto's *Navicella*) two murals within the porch of Notre Dame des Doms, the papal church at Avignon.[61]

Those cities which allied themselves with the Guelph cause almost invariably found themselves involved politically with the Angevin regime in southern Italy. Chosen by Popes Urban IV (1261–64) and Clement IV (1265–68) to oust the Hohenstaufen (and thus Ghibelline) rulers of Sicily and southern Italy, this royal dynasty was founded by Charles I of Anjou, who ruled the kingdom of the Two Sicilies until 1285, the year of his death. Thereafter until 1435 his descendants ruled the kingdom of Naples, the common designation for the vast territory of southern Italy. This branch of the French royal family presided over a south Italian court where, not surprisingly, French culture was greatly favoured.[62] In the case of both Siena and Florence, the course of each city's political history was affected by its relations with that dynasty. In 1324 Florence placed itself for ten years under the protection of Robert I's son Charles of Calabria, an expense relieved only by Charles's death in December 1328.[63] In 1326 the Sienese government also summoned Charles to keep peace within the city, torn as it was by factional disputes between the Salimbeni and Tolomei families.[64] Another important factor in such alliances between the Angevins and the two Tuscan cities was the financial interests of the Florentine and Sienese banking houses, both of which had secured highly favourable terms within this south Italian kingdom.

Close political and commercial relations of this type also extended to cultural links, attested by the presence of several Sienese and Florentine artists at the Angevin court in Naples. It is almost certain, for example, that Simone Martini went to Naples prior to his departure to Avignon, and was employed at the Angevin court. At all events he was responsible for the most daring and innovative piece of Angevin propaganda in Naples – the Saint Louis altarpiece, in which the Franciscan Saint Louis, Bishop of Toulouse, brother to King Robert of Naples and only recently canonized in 1317, is represented as a compelling icon of regal sanctity (Plate 38).[65] In 1328 Giotto was likewise assigned a monthly salary by King Robert of Naples, and in the capacity of a salaried court painter received payments between 1329 and 1332 for frescoes and

Plate 38 Simone Martini, *Saint Louis of Toulouse*, 1317, tempera, main panel 250 x 188 cm, predella 56 x 205 cm, Museo di Capodimonte, Naples. Photo: Scala.

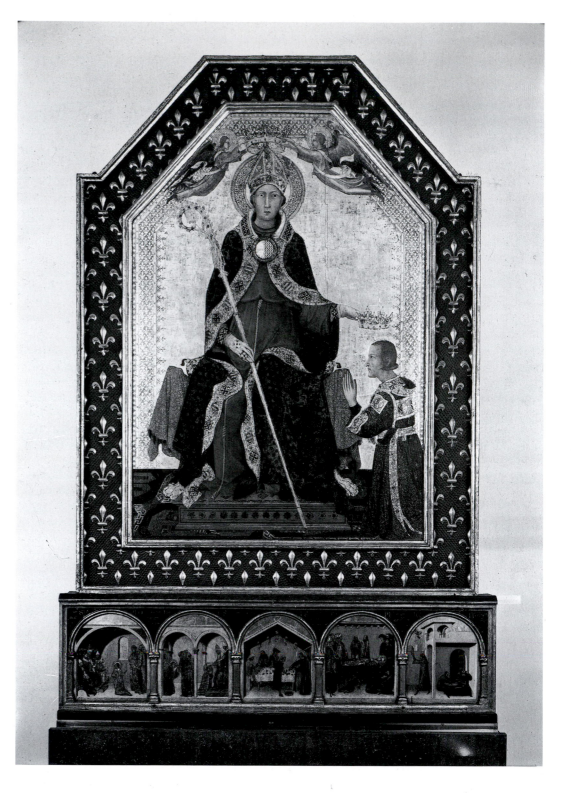

panel paintings, all of which are now lost.[66] Between 1323 and 1337 (the year of his death) Tino di Camaino executed a large number of architectonic and richly figural tomb monuments for members of the Angevin royal family, including the double-sided monument of Catherine of Austria, first wife of Charles of Calabria (Plate 39). King Robert himself was commemorated by a tomb monument executed between 1343 (the year of his death) and 1345 by two Florentine sculptors, Giovanni and Pacio da Firenze,[67] thus continuing this remarkable record of employment for Florentine and Sienese

artists at the Angevin court. A final coda to this sequence occurs with the presence in Naples in 1383 of the Sienese painter Andrea Vanni, who in the more politically flexible circumstances of the post-plague era was employed by the Sienese government on a diplomatic embassy to the current Pope, Urban VI, then resident in Naples. It appears, however, from a complaint voiced by the painter himself that, such were the demands of his diplomatic duties, he had little opportunity to pursue his profession as a painter whilst there.[68]

Plate 39 Tino di Camaino, tomb monument of Catherine of Austria (d.1323), *c.*1323, marble, San Lorenzo Maggiore, Naples. Reproduced by permission of the Conway Library, Courtauld Institute of Art, University of London.

As with Florence and Siena, so with Padua also: an allegiance to the Guelph cause had an effect upon the working conditions of Paduan-based artists. Thus Florence, with its Guelph sympathies and its powerful Guelph Party, frequently supplied the Carrara regime with judges and holders of the office of Podestà. Conversely, a leading member of the Carrara court, Bonifacio Lupi, served a term as Florence's Capitano del Popolo (Chapter 1, Plate 16). Moreover, quite apart from his services to the Florentine Commune, Bonifacio also built and made financial provision for a hospital in Florence, probably commissioning a local Florentine painter, Cennino Cennini, to paint a mural for the hospital loggia and thereby possibly encouraging the painter's subsequent move to Padua to take up service with the Carrara.[69]

The Angevins were also an influential factor in Padua's affairs. As a north-eastern Italian city state, Padua was geographically located within an area of Italy which enjoyed political and diplomatic contacts with Austria and Hungary, and during the fourteenth century Hungary was ruled by a further branch of the Angevin royal family. Francesco il Vecchio da Carrara, in pursuit of his efforts to create a territorial state within north-east Italy, had cause on several occasions to obtain the military and diplomatic support of King Louis the Great of Hungary (d.1382). Once again, Bonifacio Lupi acted as diplomat on Francesco il Vecchio's behalf, visiting the Hungarian court at Buda in 1372. Such was the impact of his visit that it appears he may have instructed Altichiero, the painter of his funerary chapel within the Santo, to include idealized representations of King Louis within a cycle of paintings depicting the legend of Saint James the Great.[70] Thus the case of at least one Paduan-based patron of art once again offers a concrete example of the complex interplay of historical factors that affected the exchange of artistic ideas between Padua and its Italian and north European neighbours.

CONCLUSION

We have seen in this essay that those fourteenth-century Italian artists who chose to pursue their profession primarily in Siena, Florence or Padua did not necessarily confine their professional activities to a single city. Rather, it seems that their working lives constituted complex patterns of geographically dispersed commissions which might on occasion take them as far as Rome, Naples or even beyond the borders of Italy itself. Such patterns of work were affected by a number of political, economic and cultural factors. Furthermore, the close political relations between the various neighbouring Italian city states, even in the teeth of inter-city political and economic rivalries and outright military hostilities, furnished artists with the kinds of social contact necessary to obtain work. Sienese artists thus secured commissions in Florence, as attested by Duccio's *Rucellai Madonna* and Ugolino di Nerio's Santa Croce polyptych (Chapter 3, Plates 55, 66). Pisa likewise provided throughout the fourteenth century a series of commissions awarded to both Sienese and Florentine artists. Other city states such as Arezzo (before its absorption into the Florentine state), Perugia and Orvieto extended similar possibilities, the latter's cathedral providing important opportunities for artists from

Siena and Florence seeking work. In the case of Padua, the city's close (if frequently stormy) relations with her north Italian neighbours Venice, Verona and Milan furnished possibilities for further artistic exchange. The Veronese painter Altichiero worked for both the Scaligeri court at Verona and the Carrara court at Padua, and the Paduan painter Guariento secured the highly prestigious commission for the huge and now sadly ruined mural of *The Coronation of the Virgin* for the Palazzo Ducale in Venice. Further afield, the Angevin kingdoms of Naples and Hungary, the papal courts in Rome and Avignon, and the religious orders were all active patrons of art and also possessed wide-ranging administrative structures and intellectual contacts. They thus cut across more locally based initiatives and provided unparalleled opportunities for artists to acquire work both at home and abroad.

What is the significance of such dispersed patterns of artistic endeavour? How do they affect our understanding of fourteenth-century artistic practice within the three cities? In the first instance they provide a framework within which we may evaluate how artists acquired and utilized the technical and expressive skills required by their profession. For example, an artist might become aware not only of artistic schemes within, say, Florence itself, but also of other artistic

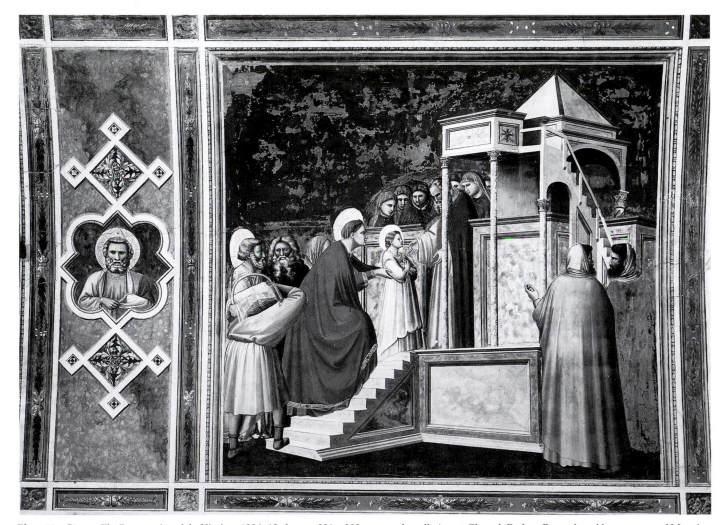

Plate 40 Giotto, *The Presentation of the Virgin*, c.1304–13, fresco, 231 x 202 cm, north wall, Arena Chapel, Padua. Reproduced by courtesy of Musei Civici Padova, Gabinetto Fotografico.

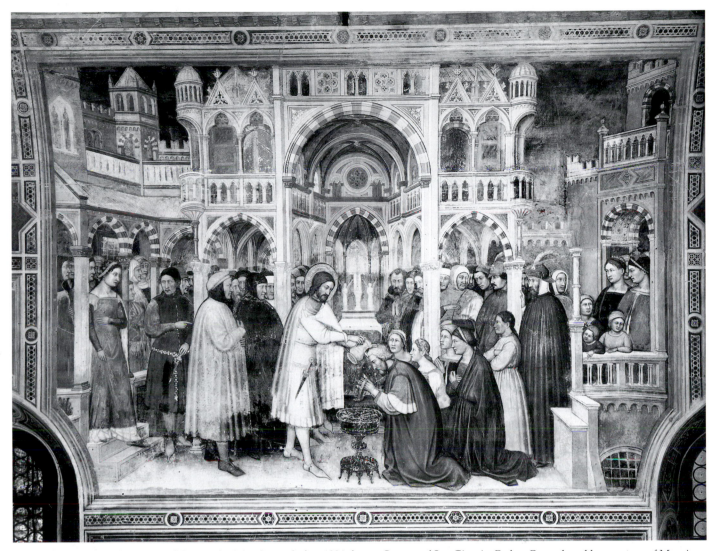

Plate 41 Altichiero, *The Baptism of the King by Saint George*, before 1384, fresco, Oratory of San Giorgio, Padua. Reproduced by courtesy of Musei Civici Padova, Gabinetto Fotografico.

schemes located elsewhere. As a result, that artist might acquire new techniques and means of expression which he would not have had the opportunity to acquire by confining his activities to Florence alone.

A common art-historical designation for this process is 'influence'. For example, it is commonly said of Giotto's work and of his Arena Chapel frescoes in particular that both had a decisive 'influence' over later painters working in Padua. That Giotto's frescoes in the Arena Chapel provided later artists with an inspiring and stimulating resource is surely undeniable. *Simply* to explain the work of later artists in terms of Giotto's 'influence' is surely equally inadequate. The relationship between Giotto and, let us say, Altichiero is more complex than simple appeal to 'influence' will allow. Obviously, being commissioned to work in Padua provided Altichiero with the opportunity to study, at first hand and in some detail, Giotto's fresco cycle painted some 60 years earlier. Certain correspondences between the two painters' monumentally conceived figures and orderly treatment of pictorial space provide visual evidence that the Veronese painter understood and availed himself of certain facets of Giotto's stylistic repertoire (cf. Plates 40, 41). Yet Altichiero

also brought with him other pictorial skills and aptitudes obtained independently in Verona while working within the courtly culture of the Scaligeri regime – a culture marked especially by an interest in secular, chivalric values which in turn affected the painter's treatment of religious art. His repertoire included not only a markedly different colour palette from Giotto's high-keyed colour scheme and a preference for more complex figure compositions, but also a greater use of contemporary costume and more frequent insertion into his religious paintings of scenes from daily life and of portraits of his patrons and their associates. The relationship between the Paduan work of Giotto and Altichiero thus provides a fitting symbol of the complex implications of the fact that fourteenth-century Sienese, Florentine and Paduan painters worked in a variety of locations. Early in the century the Florentine Giotto executed a remarkable fresco cycle in the Arena Chapel in Padua. Some 60 to 70 years later the Veronese painter Altichiero also executed a number of fresco cycles in Paduan chapels. And in doing so he creatively combined both aspects of his native Veronese traditions and elements of the artistic legacy of his now famous Florentine predecessor.

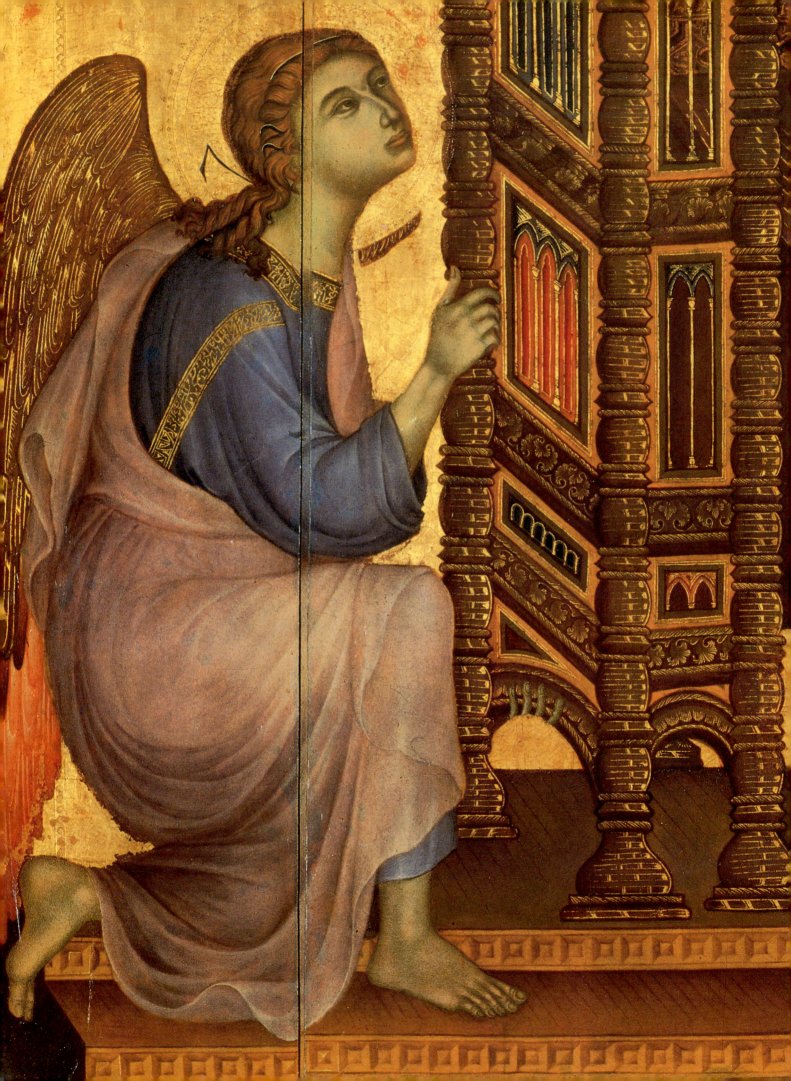

Duccio: the recovery of a reputation

In 1621 the Sienese scholar Giulio Mancini took issue with a well-known claim by Giorgio Vasari that the late thirteenth-century Florentine painter Cimabue 'had brought painting back to life'. As a proud Sienese, Mancini rejected this claim to Florentine pre-eminence, observing robustly that at the time of Cimabue's birth, 'painting was already born and walking through the streets of Siena'.[1] The idea of painting being brought 'back to life' had a long pedigree, beginning in the fourteenth century in the work of the humanist scholar Petrarch. In his writing, Petrarch frequently expressed the view that, following a period of 'darkness', a revival of the wisdom and cultural values of antiquity was imminent. During the fourteenth and fifteenth centuries this concept of cultural rebirth was extended beyond scholarship to the practice of art, and in particular to the work of the Florentine artist Giotto. It received, however, its most powerful statement in the immensely influential mid sixteenth-century publication of the *Lives of the Artists* by Vasari.

Vasari, born in Arezzo which was then part of the Florentine state, was an unashamed eulogist for Florence and its artists. He therefore greatly admired the Florentine painter Giotto and his art. By contrast, Duccio, as a Sienese painter, was not accorded comparable status. Indeed, in his biographical account, Vasari dated Duccio's artistic activity some 30 years after the date of the painter's death and, moreover, his attribution of work to Duccio was confused and inaccurate.[2] Duccio was therefore deprived of the powerful historiographical endorsement that has always attended the memory of his younger contemporary, Giotto. The historiographical precedence given to Giotto did not, however, begin only in the sixteenth century. Siena's fourteenth-century chroniclers left lively accounts of the installation in Siena's Duomo of Duccio's most important surviving work – the double-sided altarpiece known as the *Maestà*, which depicted the Virgin Mary in majesty. Nevertheless, they did not endow the painter with the distinctive identity and reputation that had already been assigned to Giotto by Dante, Boccaccio and Petrarch and which was put into detailed form by the Florentine chronicler Filippo Villani, in his late fourteenth-century account of Florence and its famous citizens.[3] Subsequent Sienese scholars, writing as late as the sixteenth and seventeenth centuries, and often, as in the case of Mancini, *published* only in the twentieth century, attempted to keep Duccio's memory alive. In general, however, their stance was a defensive one. Thus, Mancini, while broadly criticizing Vasari's history of Italian art and its partiality towards Florentine artists, relied on Vasari for his own inaccurate account of Duccio's works. In short, as one modern Duccio scholar has aptly noted, 'Duccio's position in the historiography of art is, in many respects, a near disaster from which his reputation has only recently begun a very partial recovery.'[4]

One of the major problems facing the modern Duccio scholar is that the painter lived during a period for which documentary sources survive only in a very limited and irregular quantity. There are only two surviving paintings by Duccio for which there are commissioning documents – the so-called *Rucellai Madonna* and the *Maestà* – the latter the only surviving signed work (Plate 55). Indeed, such was the power of Florentine art historiography that from the early sixteenth century onwards the *Rucellai Madonna* was attributed to Duccio's slightly older *Florentine* contemporary Cimabue (doc.1272–1302). It is only in the twentieth century that this important early work by Duccio has been correctly attributed to him once more.[5]

Surviving contemporary records document the painter's working practice as occurring between 1278 and 1318–19, but they provide no information concerning Duccio's apprenticeship and training as a painter. In addition, they offer very little evidence about the range of commissions that he received and whether he worked elsewhere than Siena and Florence, either in Italy or further afield. Therefore, in order to reconstruct a plausible outline of Duccio's practice as a painter, modern art historians have had to attribute a number of late thirteenth- and early fourteenth-century paintings to him on grounds of style alone. Even now, despite the best efforts of several generations of modern art historians, there is by no means unanimity regarding either the number of paintings executed by Duccio or their dates.

The group of works generally attributed to Duccio is a relatively small one, amounting to only six to nine panel paintings, some of which are, however, multi-panelled altarpieces.[6] It is, though, acknowledged that a much larger number of early fourteenth-century Sienese paintings can be assigned to anonymous painters who worked within Duccio's sphere of influence. The exact professional relationship of these painters to Duccio is not known. By the time that he had received the prestigious civic commission for the *Maestà* in 1308, Duccio was, in all probability, Siena's leading painter. Moreover, given the scale and complexity of the *Maestà*, it is likely that he was already the head of a flourishing workshop with fully trained or apprentice painters working under him. Suggested members of the workshop include both subsequently famous painters such as Simone Martini and Ambrogio and Pietro Lorenzetti and also less well-known painters such as Ugolino di Nerio and Segna di Bonaventura. Whether or not one or more of these painters was a member of Duccio's workshop remains a matter of debate. What is unambiguously clear from a considerable body of early fourteenth-century Tuscan paintings, however, is that

Plate 42 (Facing page) Duccio, *Angel*, detail of *Rucellai Madonna* (Plate 55). Photo: Scala.

Duccio's favoured pictorial formats and modes of representation provided models for other contemporary painters working in or around Siena.

The attribution of paintings to Duccio by modern art historians is based upon a combination of perceptive visual analysis and judicious weighing of other kinds of historical evidence. Such an approach is, however, beset with difficulties. As John Pope-Hennessy has remarked, 'the trouble is a subjective one, that no two art historians have precisely the same standard of similitude'.[7] Ironically, precisely because of this lack of certainty about what constituted the work of Duccio himself and what constituted the work of those within his ambit, there has been a healthy tendency, particularly in more recent Duccio scholarship, to acknowledge the essentially collaborative nature of fourteenth-century painting practice. Collaboration began in the workshop, where an apprentice painter was taught his craft by following a systematic and essentially co-operative pattern of training in the various stages of preparing, designing, painting and embellishing a panel. In addition, he was encouraged to emulate the work of other painters and respect the pictorial conventions, and indeed the perceived 'sanctity', of certain kinds of religious image. A successful apprentice painter would thus tend to produce work that followed a well-defined and respected 'house style'.

An interpretation and evaluation of Duccio's stature and significance as a painter must therefore combine not only analysis of such documentary evidence as survives[8] and comparison of securely and more tentatively attributed works, but also recognition of the diffusion of his influence through the collaborative endeavours of his workshop. It is to the elucidation of this complex mix of factors that the rest of this essay now turns.

BIOGRAPHY AND BACKGROUND

The first known documentary reference to Duccio is for a payment of 16 November 1278. It was made by the officials of the Sienese treasury – the magistracy of the Biccherna – for the painting of twelve chests in which to keep communal documents. Thereafter, references to Duccio occur in the official government records of Siena at a steady rate until an uncertain date in 1318–19 when his wife Taviana is named as a widow. Although his date of birth is not known, it is thus clear that by 1278 he was already a fully trained painter who attracted work from one of the city's leading magistracies and that, by 1319 at the latest, he was dead. It is likely, therefore, that Duccio was probably somewhat older than his better-known contemporary Giotto (doc.1301–37), and conversely slightly younger than the Florentine painter Cimabue (doc.1272–1302) and the Pisan sculptor Giovanni Pisano (doc.1265–1314).

Fourteenth-century Sienese tax returns indicate that Duccio, at different points in his life, lived in three different city locations: first in the Terzo di Città, then in the Terzo di Camollia, and finally again in the Terzo di Città. It appears from another contemporary source that it was in the last location – in a house in the neighbourhood district or *contrada* of Stalloreggi just beside the city gate of Due Porte – that the

Maestà was painted.[9] As well as owning property in the city, which apparently combined his workshop and the family home for his wife and seven children, Duccio owned and rented two separate parcels of land in the Sienese *contado* – a compelling example of the close ties that Siena's citizens had with the surrounding countryside. Despite his status as both a city and a rural property holder, it seems that Duccio had a propensity for 'living on the edge of legality'.[10] He was the recipient of numerous fines, mostly arising from property disputes and debt, but in one case for the more serious offence of evading militia duty in the south-western area of Siena's territory, known as the Maremma.[11]

As regards his profession as a painter, documents indicate that from time to time Duccio was engaged in what, at first sight, might appear to be a mundane task of painting chests and wooden book covers in which the receipts and expenditure of the Biccherna were recorded. It is likely, however, that in contemporary terms such commissions were quite prestigious. None of Duccio's contributions to this artistic genre survive, but surviving examples by other painters demonstrate that such commissions could, in fact, involve a degree of artistic invention.[12] It appears from other surviving small-scale panel paintings by Duccio that he had a flair for working on a miniature scale and for imparting a degree of liveliness of expression to this kind of artistic work. The fact that Duccio, even as an established painter, was employed to produce artefacts such as book covers is symptomatic of the highly diversified production characteristic of a fourteenth-century painter's workshop. Similar versatility is indicated by another entry in the Biccherna accounts of 1295, where Duccio is named as a member of a six-man committee of experts that advised on the siting of one of the city's new fountains, the Fonte d'Ovile.[13] It is of interest that on this occasion Giovanni Pisano is also named as an expert, thereby demonstrating the close-knit nature of Siena's community of artists. This situation undoubtedly facilitated the easy exchange of ideas and professional expertise between practitioners of the various arts.

A further set of documents records three specific commissions for paintings, all of them destined to be placed over altars and thus important public commissions for the painter. The first document is a contract, dated 1285, awarded to 'Duccio di Buoninsegna, painter, of Siena' by the officials of the Florentine lay confraternity, the Societas Sancte Marie Virginis, more commonly known as the Laudesi of Santa Maria Novella.[14] The wording of this legal document offers little in the way of description regarding the scale, format and subject-matter of this confraternity altarpiece, referring merely to 'a large panel' and 'the image of the blessed Virgin Mary and her omnipotent Son and other figures'. However, it is now generally agreed that the contract refers to the painting depicting the Virgin and Child with angels that is known today as the *Rucellai Madonna*,[15] thus making it the earliest documented painting by Duccio (Plate 55). It remains an intriguing matter of debate why a Sienese painter, rather than a tried and tested Florentine painter such as Cimabue, was commissioned to execute a painting which, in terms of its sheer scale, materials and workmanship, would have represented a considerable financial investment for the

Laudesi of Santa Maria Novella. One conceivable explanation is that other, older Sienese painters such as Guido da Siena (active 1270–80s) were monopolizing all the major public commissions in Duccio's home town of Siena and that Duccio therefore had to search farther afield for this kind of work.[16] Equally, it may have been that the Dominican Order, with priories in both Siena and Florence, was instrumental in securing this commission for the Sienese painter. Whatever the precise explanation, it is clear that some fifteen years later Duccio was able to secure a similar commission within his home town, one that was, moreover, awarded to him by the Sienese government itself.

A second document records that on 4 December 1302 the painter was paid for his work on an altarpiece for the Nine in the recently completed Palazzo Pubblico.[17] The work is now lost, but its subject was a *Maestà* and thus probably broadly similar to the *Rucellai Madonna*. Duccio was, in addition, paid for a predella – a box-like structure that would have formed a stable base for the main part of the altarpiece and would also have been painted with figures or narrative scenes. At this date, such a predella would have been a relatively novel feature, but one that was destined to become a standard

fixture on later fourteenth-century Italian altarpieces.[18]

Duccio's third documented commission was for the monumental, double-sided altarpiece, the *Maestà*, for the high altar of the Duomo in Siena. Due to both its imposing scale and its prestigious civic site, it probably represented by far the most demanding project of Duccio's entire career as a painter. It has taken, however, the combined technical and historical expertise of modern restorers and art historians to recover a realistic sense of the sheer scale and complexity of the original enterprise. The dramatic history of the *Maestà* is briefly as follows. It remained over the high altar of the cathedral from the time of its installation in 1311 until 1506 (despite the relocation of the altar itself). Thereafter, it was placed in the vicinity of one of the cathedral's subsidiary altars. In 1771, however, the altarpiece was drastically cut down and separated into numerous pieces, thereby completely destroying its original physical structure and aesthetic integrity. The pieces were subsequently dispersed to a variety of locations and modern scholars have therefore had to reconstruct its original composite appearance. Of the numerous reconstructions proposed, the most highly regarded is that of John White (Plates 43 and 44). From his

Plate 43 Reconstruction after White of the front face of the *Maestà*. Reproduced from John White, *Duccio: Tuscan Art and the Medieval Workshop*, 1979 by permission of Professor John White and Thames & Hudson, London.

Plate 44 Reconstruction after White of the back face of the *Maestà*. Reproduced from John White, *Duccio: Tuscan Art and the Medieval Workshop*, 1979 by permission of Professor John White and Thames & Hudson, London.

painstaking work it is now possible to appreciate the sheer ambition of the enterprise, both in terms of the complex physical structure of the altarpiece and in respect of its extensive range of subject-matter. This combines the *Maestà* theme (Plate 57) with a large number of narrative scenes from the Infancy, Ministry and Passion of Christ and from the last days of the Virgin.[19]

The documents that survive for this major commission are characteristically reticent about how and why this great altarpiece was painted. They do, however, indicate that the commission was administered by the Opera del Duomo and thus by lay officials appointed by Siena's government, who closely monitored the progress of the enterprise. It was generally thought that a document of 9 October 1308 was the initial contract for the high altarpiece, but it is now suggested that this document, in fact, represents a subsequent agreement between Duccio and a representative of the Opera to clarify the details of how and when the painter should be paid for his work.[20] It is quite possible, therefore, that work began on this ambitious painting before 1308. A nineteenth-century copy of another document, generally dated *c.*1308–9, records another agreement, which concerns the manner of payment for the

painting of the back face of the altarpiece (Plate 44).[21] Both documents name only Duccio as contracted to work on the painting of the *Maestà* which, at first sight, might seem to imply that Duccio would do all the work himself. In point of fact, the stipulation that Duccio should 'work with his own hand' upon the painting was a means by which the commissioners could endeavour to ensure that the work was not sub-contracted out. Other painters were involved in the project but Duccio was deemed to be in charge of the overall enterprise. An entry in the Biccherna accounts of June 1311 for payment of four musicians for 'a meeting with the panel of the Virgin Mary' confirms two later mid fourteenth-century descriptions of the festivities of 9 June 1311, marking the installation of the *Maestà* upon the high altar of Siena Duomo.[22]

The documents offer evidence that Duccio's working practice extended for at least about 33 years. There are, however, a number of areas where they are notably uninformative. They provide no indication of where he might have received his training as a painter. There are also several periods of some four to seven years for which there is no information on his activities. We have no securely

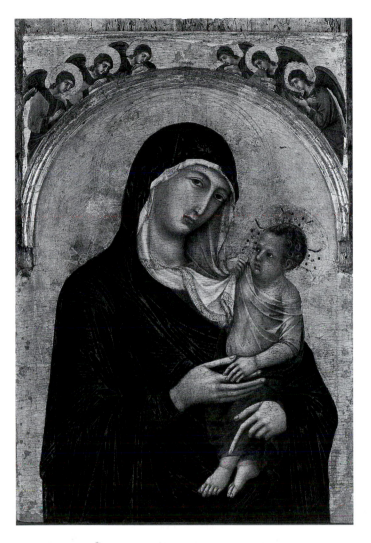

Plate 45 Duccio, *The Virgin and Child*, *c.*1300–5, tempera on panel, 98.5 x 63.5 cm, originally the centrepiece of a polyptych, Galleria Nazionale dell'Umbria, Perugia, formerly in San Domenico, Perugia. Photo: Index.

documented evidence that he travelled and worked anywhere other than Florence and Siena, either in or beyond Italy. Nevertheless, since the provenance of a panel depicting the Virgin and Child (attributed to Duccio and once the centrepiece of a polyptych) is San Domenico in Perugia, there is circumstantial evidence that Duccio worked in that Umbrian city (Plate 45).[23] Given this possibility, it is also likely that he was familiar with the extraordinarily rich mural cycles of San Francesco in the nearby town of Assisi. This hypothesis receives further support from a study of the earlier *Rucellai Madonna*, which arguably demonstrates an awareness of Cimabue's work at Assisi (Plate 55, cf. Plate 46).[24]

It has also been proposed that Duccio worked in Pisa. This proposal is based upon a payment made on 4 May 1302 to one 'Duccio' for work on the mosaic of *Christ Enthroned with the Virgin and Saint John* for the principal apse of the Duomo at Pisa, a project in which Cimabue was also involved.[25] It must be acknowledged that the name Duccio was a fairly common one at that time and that we have no other evidence of Duccio having worked on an enterprise of this kind. On the other hand, however, the proposal that Duccio worked on this particular Pisan project may provide a clue to the origins of his subsequent work on the *Maestà*. The Pisan mosaic provides an example of an early fourteenth-century scheme for a large-scale figural composition specifically designed to embellish the most sacred part of a cathedral. The imposing treatment of the *Maestà* theme on the high altarpiece of the Duomo in Siena might have been inspired by such a mosaic.

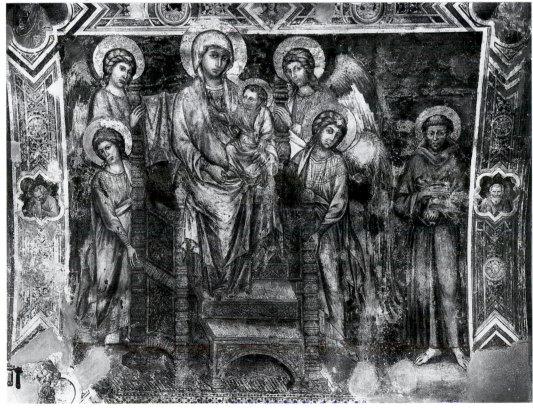

Plate 46 Cimabue, *The Virgin and Child Enthroned with Angels and Saint Francis*, *c.*1280, fresco, Lower Church, San Francesco, Assisi. Photo: Alinari.

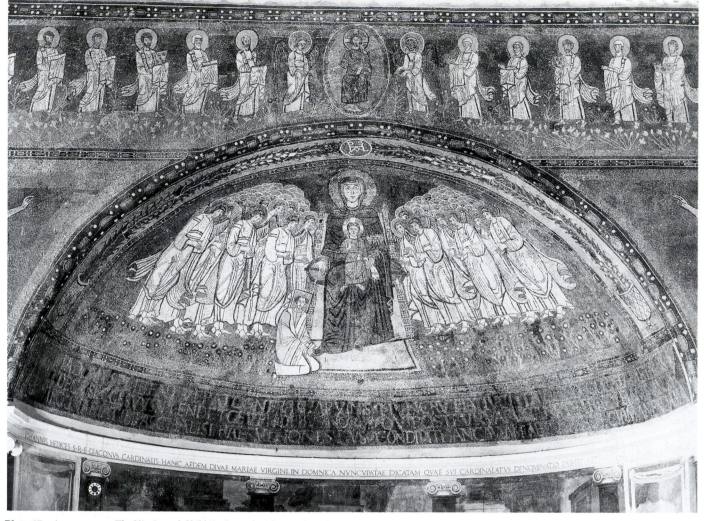

Plate 47 Anonymous, *The Virgin and Child Enthroned with Angels and Donor, c.*818, mosaic, principal apse, Santa Maria in Dominica, Rome. Photo: Alinari-Anderson.

Since, however, in terms of subject-matter, a number of earlier mosaics in Rome provide much closer analogies to the *Maestà*, it may also be the case that Duccio visited Rome (Plate 47, cf. Plate 57).[26] It is significant, moreover, that several Roman churches contained examples of monumental narrative cycles of scenes from the New Testament – works that could have inspired the series on the back face of the *Maestà* (Plate 44).

It is also sometimes assumed that Duccio was aware of Giotto's narrative series in the Scrovegni Chapel – known popularly as the Arena Chapel – in Padua, although there is no firm historical evidence to suggest that Duccio travelled to north-east Italy (Chapter 4, Plate 68). Similarly, it has been suggested that the painter visited France during the late 1270s and also worked there in the 1290s. This proposal is based on two references (one to 'Duch de Siene' and the other to 'Duche le lombart') in Parisian tax records of 1296–97 and also on the apparent indebtedness of Duccio's work to French Gothic art. Another modern scholar has argued that a visit by Duccio to the eastern Byzantine empire cannot entirely be ruled out.[27]

Such geographically dispersed activities are proposed because the body of work generally attributed to Duccio does, indeed, provide evidence of a painter who was apparently aware, not only of the art of central Italy, but also of contemporary art produced in northern Europe and Byzantium. To take but one example, in a tiny panel painting known by its subject-matter as the *Madonna of the Franciscans*, the painter – who in all likelihood was Duccio himself – took as his theme the very traditional religious subject of the Virgin Mary depicted with Christ as a child upon her lap (Plate 48).[28] She is portrayed, moreover, seated upon an ornate ceremonial seat with angels in attendance. This subject, which effectively celebrates the Virgin's honourable role as both mother of Christ and queen of heaven, had a long and august history, as attested by numerous Byzantine icons and by a number of large-scale thirteenth-century panels produced by Tuscan painters for major churches in Siena (Plates 49 and 50).

The *Madonna of the Franciscans* also, however, shows an extraordinarily inventive variation on this well-established, conventional religious subject. In addition to Mary, her Son and the attendant angels, this figural painting includes, within the left-hand corner, three diminutive figures, all of whom are shown in an act of devotion before the Virgin and the Christ Child. The brown habits of these figures identify them specifically as Franciscan friars, thus introducing an element of innovation into an otherwise traditional iconography. In

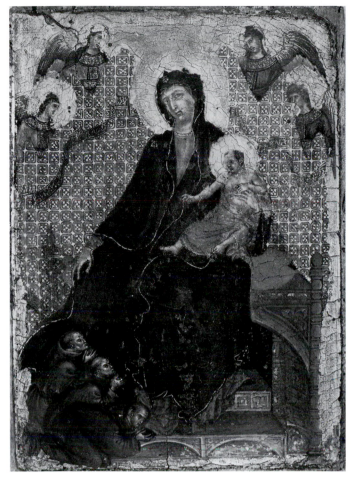

Plate 48 Duccio, *Madonna of the Franciscans*, *c.*1295–1300, tempera on panel, 23.5 x 16 cm, Pinacoteca, Siena. Photo: Index.

Although it was not unknown for earlier representations of the subject of the Virgin enthroned to show a votive figure, the particular intensity of the relationship in the *Madonna of the Franciscans* is remarkable and prompts speculation on what inspired Duccio to treat the subject in such a distinctive way. From its tiny scale and unusual iconography, the painting appears to have been commissioned by a member of the Franciscan Order for purposes of private religious devotion. Given that the Franciscan Order was founded by an individual whose style of religious devotion epitomized a very intense and personal spiritual relationship with the crucified Christ, it may well be that Duccio's patron encouraged him to reformulate a traditional subject in this particular way. Other scholars have quite rightly remarked on the fact that details of the painting are comparable to examples of northern European Gothic art. The iconography of the Virgin as queen of heaven had already received extensive treatment within the elaborate figural programmes of sculpture, painting and stained glass of French Gothic cathedrals (Plate 51). The striking use of the diamond pattern on the cloth of honour behind the Virgin Mary and the presence of the votive figures are also typical of a number of French and English Gothic manuscript illuminations.[29] A

certain ways, however, the introduction of these figures merely makes explicit what was already implicit in this conventional religious subject. The point of such paintings was that religious devotees should have before them a representation of God, not in the form of a remote divinity, but as a child. This was to remind them of the incarnation of God as man, which formed the central tenet of late medieval Christian belief. Moreover, the Virgin was portrayed in such paintings as holding the Christ Child, emphasizing her maternal relationship with him. Such vividly evoked representations of her motherhood served to underline her religious status as the most powerful intermediary that late medieval Catholics could have between themselves and God.

The treatment of the Virgin in such paintings sought to emphasize this kind of intercessionary relationship. In the *Rucellai Madonna* the Virgin is represented according to the conventions of a well-established Byzantine type of image in which the Virgin is shown looking directly at the viewer, while also inclining her head towards the all-important figure of the Christ Child (Plate 55). In the *Madonna of the Franciscans*, however, the slope of the Virgin's right arm and the rippling gold edge of her mantle are used to great effect to indicate her apparent interest in the particular petitioners represented (Plate 48). Furthermore, the device of the Virgin holding part of her mantle protectively over the three friars serves to underline her spiritual role as divine mediatrix.

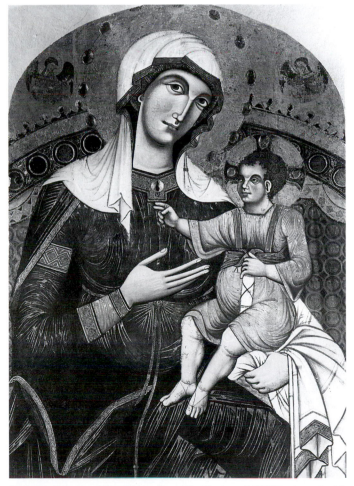

Plate 49 Master of San Bernardino, *The Virgin and Child Enthroned with Angels*, 1262, tempera on panel, 142 x 100 cm (cut down), Pinacoteca, Siena, formerly in the oratory of Santa Maria degli Angeli, Siena. Photo: Alinari.

Plate 50 Coppo di Marcovaldo, *The Virgin and Child Enthroned with Angels*, known as the *Madonna del Bordone*, 1261 (the faces of the Virgin and Child repainted in the early fourteenth century), tempera on panel, 220 x 125 cm, Santa Maria dei Servi, Siena. Photo: Lensini.

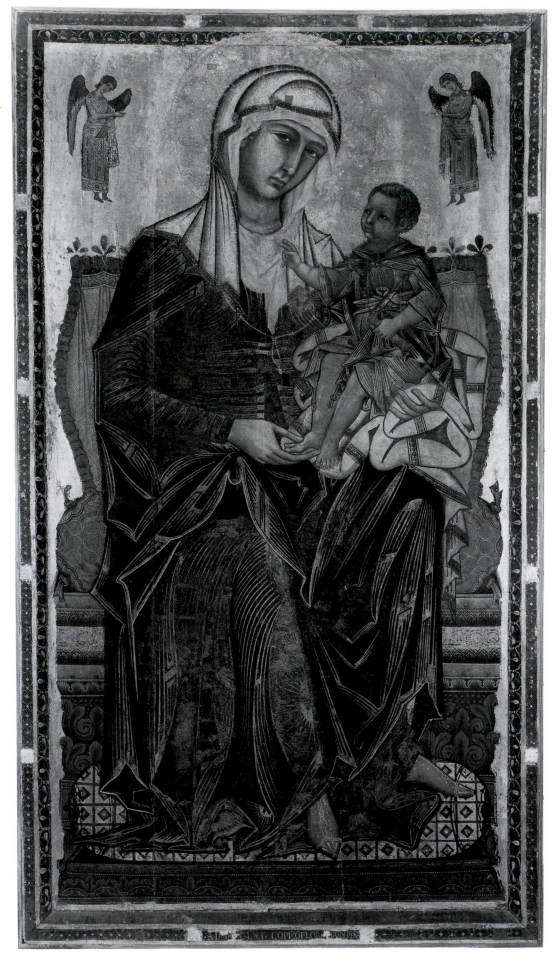

Plate 51 Anonymous, *The Virgin and Christ Child Enthroned with Angels*, twelfth century, stained glass known as *La Belle Verrière*, Cathedral of Notre-Dame, Chartres. Photo: Giraudon.

prototype of the Virgin extending her mantle towards a supplicant has been found in an early fourteenth-century mural in a church in Cyprus.[30] Such a source might, at first sight, suggest that Duccio did, indeed, travel east. Yet Cyprus was at that date under the rule of a French noble family and therefore both Duccio and the anonymous painter of the Cypriot painting might well have had a common French Gothic source.[31] It has also been observed that the soft modelling of the figures in the *Madonna of the Franciscans* is closely comparable to Byzantine manuscript illuminations and paintings produced by artists working in the Palaeologan style – a term coined from the late thirteenth-century ruling dynasty of the eastern Byzantine empire.[32]

Within this one tiny painting, therefore, we are able to discern how Duccio was apparently aware, not only of his Italian thirteenth-century predecessors (who themselves utilized well-established Byzantine pictorial schemes and devices), but also of contemporary Byzantine and northern Gothic art. Yet we do not know when or for whom this painting was executed, or what were the exact sources for Duccio's inventive contribution to this well-established genre. In this respect it is as well to remember that a tremendous amount of late thirteenth- and early fourteenth-century central Italian art simply has not survived. We cannot fully

reconstruct, therefore, what Duccio could have seen in the very places – Siena and Florence – where he is securely documented as working. A number of thirteenth-century paintings do still survive in Siena to give us an indication of the kinds of image that once embellished Siena's churches (Plates 49 and 50). These paintings provide us with the most likely source to which Duccio would have turned when commissioned to execute paintings such as the *Rucellai Madonna* and the *Madonna of the Franciscans*. Other surviving examples also incorporate lively painted narrative scenes, study of which may well have aided Duccio when he later came to organize the painting of the back face of the *Maestà* (Plate 52, cf. Plate 44).

Similarly, the sculptures of Nicola Pisano for the monumental mid-thirteenth century pulpit of the Duomo in Siena and of his son Giovanni for the turn-of-the-century cathedral façade would have constituted another readily accessible and highly stimulating source for a painter commissioned to paint the high altarpiece of the same prestigious building. Thus, Nicola Pisano's portrayal of the first magus in his *Adoration of the Magi* as a kneeling figure with his crown over his arm appears to have been reused by Duccio in his portrayal of the same scene on the front face of the predella of the *Maestà* (Plates 53 and 54). Similarly, the statuesque poses and cascading drapery folds of some of the women portrayed in the *Maestà* show a disposition reminiscent of Giovanni Pisano's statues of the sibyls on the cathedral façade.[33] Indeed, since Giovanni's sculpture itself shows marked correspondences to contemporary French Gothic sculpture, one is presented in this instance with a highly specific local Tuscan source from which Duccio might have absorbed an apparently distinctively northern European stylistic idiom.

The possibility of influence from art that was not local to Tuscany cannot, of course, entirely be excluded. There were, at that period, undoubtedly Byzantine painters working within central Italy with whose work Duccio was probably acquainted. Similarly, Byzantine artefacts were being imported into Italy at that time, although the fact that many of the illuminated manuscripts were in Greek would have limited the extent of their dissemination.[34] Similar patterns occurred in respect of northern Gothic art. Siena and Florence were both centres of international banking and commerce and merchants from both cities had close links with northern Europe. One outcome of this relationship was that easily portable small-scale artefacts such as illuminated manuscripts and metal-work were imported into both cities. Duccio could therefore have encountered such highly valued artefacts within Siena and, precisely because of the worth attached to them, readily grasped the potential in emulating certain of their stylistic features for the benefit of his own patrons and clients.

Ultimately, faced with so little secure historical evidence, it is a question of weighing up the balance of probabilities. If it can be demonstrated that there was a local source readily to hand, it is surely more reasonable to ask first what effect it might have had on Duccio than to seek more distant, but also more implausible, influences. Moreover, it is essential not merely to identify possible prototypes but also to investigate the extent to which Duccio creatively deployed them.

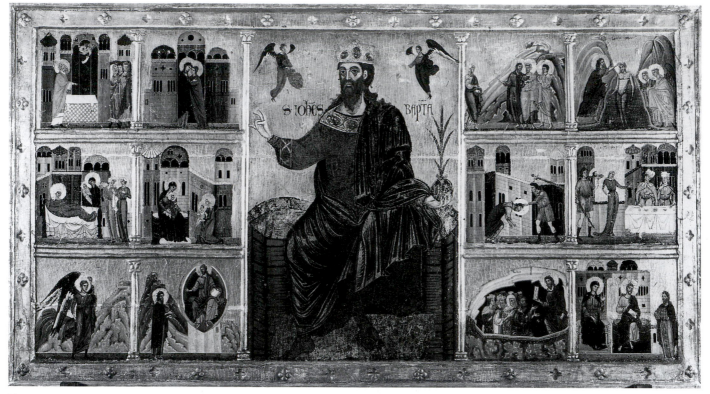

Plate 52 Anonymous, *Saint John the Baptist Enthroned and Scenes from his Life, c.*1265–70, tempera on panel, 92 x 170.5 cm, Pinacoteca, Siena. Photo: Lensini.

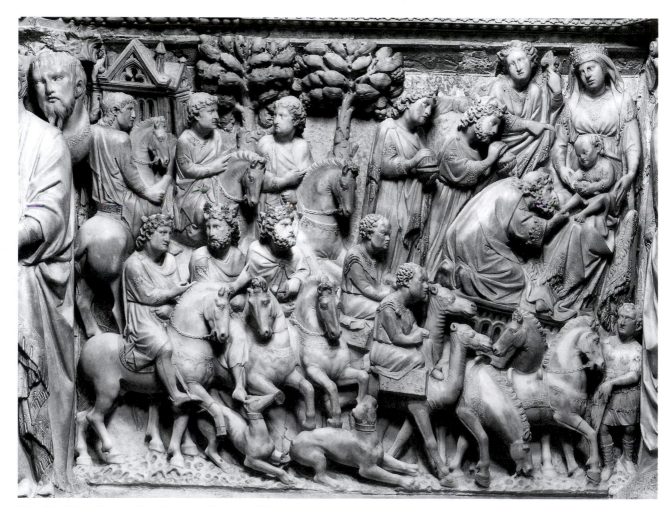

Plate 53 Nicola Pisano, *The Adoration of the Magi*, 1265–68, marble, 85 x 97 cm, sculpted pulpit relief, Duomo, Siena. Photo: Tim Benton.

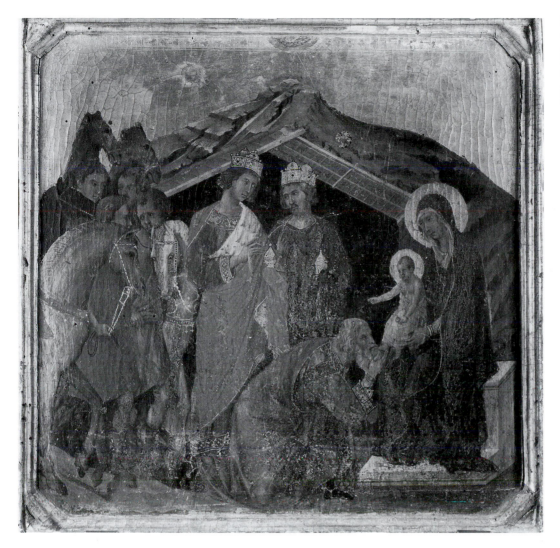

Plate 54 Duccio, *The Adoration of the Magi*, *c.*1308–11, tempera on poplar panel, *c.*48 x 48 cm, Museo dell'Opera del Duomo, Siena, formerly on the front predella panel of the *Maestà*. Photo: Lensini.

What, then, was the nature of Duccio's own achievement? Clearly, judgements vary from person to person, but it appears from the paintings for which Duccio arguably took a major responsibility that this early Sienese painter was particularly adept in three kinds of accomplishment. First, his work offers evidence of a painter who, on the one hand, was able to preserve traditional and revered pictorial formats and styles of representation whilst, on the other hand, being able to invent new pictorial formats and enliven his representational repertoire by highly naturalistic detail. Indeed, it might be argued that it was Duccio's particular achievement to combine the traditional and the innovative in such a mutually enriching manner. Secondly, the paintings associated with Duccio represent the work of a painter who was highly knowledgeable and skilled in the techniques of fourteenth-century Italian panel painting. Thirdly, they demonstrate Duccio's abilities as an artist who could both participate in and organize the essentially collaborative activities of a fourteenth-century painter's workshop. In the rest of this essay we shall examine these three key accomplishments of Duccio by reference to the two major works unquestionably attributed to him – the *Rucellai Madonna* and the *Maestà* – and to a number of other paintings attributed to his workshop.

THE *RUCELLAI MADONNA*

Although the 1285 contract for the *Rucellai Madonna* offers a certain amount of information concerning the subject of the painting and the materials to be used upon it, it offers no indication of its designated location (Plate 55). It is thus still a matter of debate where, exactly, this huge painting was first placed. Given that the *Santa Trinita Madonna* and the *Ognissanti Madonna* – two closely comparable paintings by Cimabue and Giotto respectively – have traditionally been described as high altarpieces for major Florentine churches,[35] it has been suggested that Duccio's *Rucellai Madonna* was originally intended for the high altar of Santa Maria Novella.[36] Other scholars, however, have argued that the painting was originally commissioned for one of the chapels in the right or eastern transept of the church, a chapel that, moreover, may once have been under the patronage of the Laudesi of Santa Maria Novella (Plate 56, A).[37] Indeed, it has even been argued that Duccio's painting was once integrated within a painted mural scheme (of which only two paintings and remnants of painted decoration in the dado zone have survived) and that this painted chapel scheme involved the close collaboration of Duccio and Cimabue.[38] In contradiction of this view, however, a number of scholars have observed that the narrow altar wall of the chapel, with what would

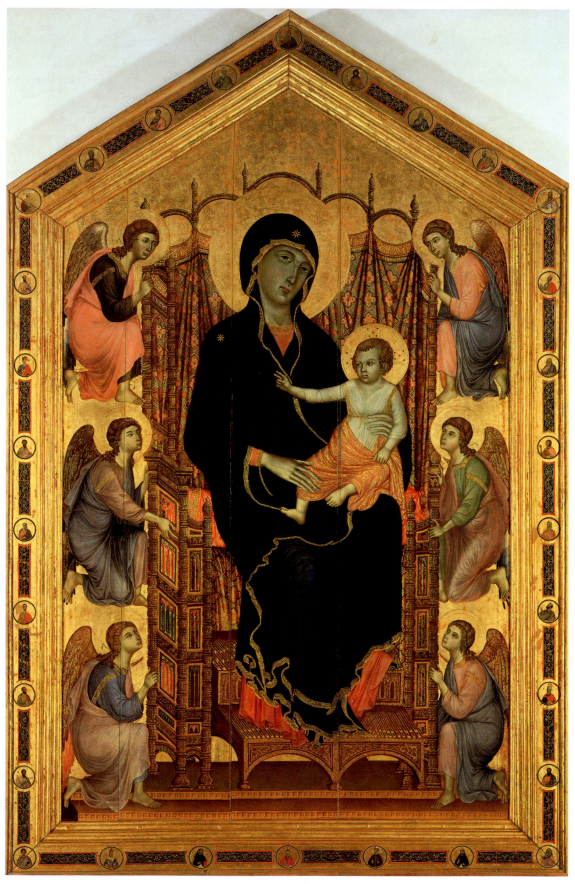

Plate 55 Duccio, *Rucellai Madonna* (after restoration), 1285, tempera on poplar panel, 450 x 293 cm, Uffizi, Florence, formerly in Santa Maria Novella, Florence. Photo: Scala.

have been a tall lancet window, does not present an appropriate setting for a painting of the scale and shape of the *Rucellai Madonna*. Moreover, given that the contract specifies only 'a large panel … in honour of the blessed and glorious Virgin Mary', the painting may not necessarily have been placed over an altar at all but may instead have been hung on a wall. Such a location would account for the nine original rings still visible on the back of the panel. The case for it being hung on a wall is given further support by an early sixteenth-century source, which describes the painting as situated on the end wall of the eastern transept (Plate 56, B).[39] In such a location this huge painting would have exerted a dominant presence within the eastern transept of the church and would have formed a natural focal point for the collective devotions of the confraternity, who would have gathered on a daily basis to sing *laude* in honour of the Virgin.

At all accounts, this painting was undoubtedly designed as an aid to religious devotion, specifically that of the

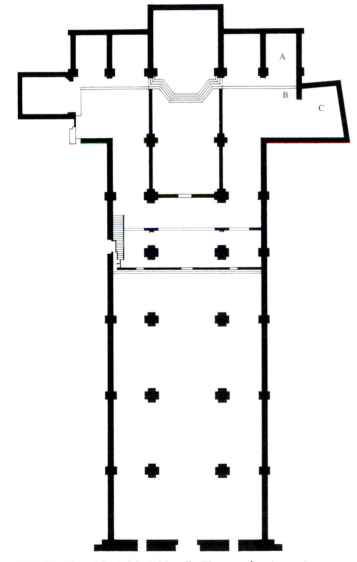

Plate 56 Plan of Santa Maria Novella, Florence showing various possible locations for the *Rucellai Madonna*. Reproduced from Blake Wilson, *Music and Merchants: The Laudesi Companies of Republican Florence*, 1992 Clarendon Press, figure 5 by permission of Oxford University Press.

confraternity who had commissioned the painting. As already noted, the painting embodies an old and much revered iconography. Such an iconographic theme would have been appropriate for any painting designed to embellish a Christian church of that date. However, its subject would have been particularly apt for both the Dominicans of Santa Maria Novella, whose church was dedicated to the Virgin, and a Laudesi confraternity whose collective devotions were primarily directed to praising and honouring her. It also appears that the painting's subject of the Virgin enthroned was further elaborated in order to acknowledge the special preoccupations both of the Dominicans and of the Laudesi. Thus, on the surface of the wide gable frame there appears a series of 30 tiny painted roundels. On the sides and upper gable are depicted the twelve apostles and twelve of the prophets. A figure of Christ appears at the apex of the gable. On the lower frame appear five saints who have traditionally been identified as: Saint Catherine of Alexandria, a saint much admired by the Dominicans for her learning; Saint Dominic, the founder of the Dominican Order; Saint Augustine, whose rule the Dominicans followed; Saint Zenobius, the patron saint of Florence; and Saint Peter Martyr, a thirteenth-century Dominican martyr who probably founded the confraternity of the Laudesi.[40] More recently, however, it has been suggested that the central roundel depicts not Augustine but Jerome, and that the roundel to the immediate right represents Augustine not Zenobius. This revision of the identification of these two bishop saints is highly plausible because of the two figures' close correspondence to the late thirteenth-century murals of Jerome and Augustine in one of the nave vaults of the Upper Church at Assisi (Chapter 4, Plate 78). In addition, whereas Saint Zenobius would have had only a tangential significance for either the Dominicans of Santa Maria Novella or the Laudesi confraternity, Saint Jerome would have been directly relevant to both. On the one hand, Saint Jerome was honoured by the Dominican Order as a scholar and cardinal, and, on the other hand, his writings were highly influential in the promotion of the cult of the Virgin, thus making him an appropriate saint for the central position on the lower frame of a devotional painting for a Marian confraternity.[41]

The *Rucellai Madonna* provides a striking example of how Duccio could both adhere to time-honoured pictorial conventions and yet be highly resourceful and inventive in his treatment of them. Recent technical investigation of the painting, undertaken in 1989 by a team of experts led by Alfio del Serra, has revealed, for example, that in his treatment of the two major cult figures Duccio took care to convey a strong sense of their three-dimensionality. The dense blue of the Virgin's mantle was skilfully modelled in order not only to convey the fall of the fabric but also to indicate the outline of her breast and the protrusion of her knee beneath the drapery. Compared with earlier and contemporary treatments, the Christ Child appears as if firmly seated upon his mother's lap. The face, arms and feet of the figure of the infant are executed in immensely fine gradations of tone in order to impart a sense of the rotundity and softness of the flesh. The very mannered conventions customarily employed by thirteenth-century Italian painters serve to indicate the nature of Duccio's achievement in this respect (Plate 55, cf. Plate 49).

Perhaps the most telling example of Duccio's skill in balancing in his figures a degree of life-likeness and a sense of timeless, other-worldly qualities occurs in his treatment of the six angels. Although these are portrayed as disembodied creatures suspended against a gold background, closer examination reveals that they were apparently based on figures positioned in identical, kneeling poses. Moreover, the precisely differentiated positioning of their hands on the sides and base of the Virgin's throne indicates that they should be perceived as literally in the act of lifting it up and transporting it into heaven. Naturalistic observation was thus deployed in order to make more concrete the visual apprehension of a heavenly vision of the Virgin and her Son.[42] Such inventive reworking of a well-established and revered iconography would have given the Laudesi of Santa Maria Novella a highly effective religious image upon which to focus their spiritual devotions.

Duccio's achievement in this respect is even more clearly revealed when the techniques deployed upon the execution of the *Rucellai Madonna* are taken into account. The technical investigation and recent restoration clarified much about both the techniques of late medieval panel painting and Duccio's consummate abilities in this respect.[43] First, it drew attention to the sheer scale of the enterprise. The *Rucellai Madonna* is over four and a half metres high. In terms of design and execution, therefore, Duccio had to approach his task like a mural painter working on a wall, even to the extent of using scaffolding. We know from the contract of 1285 that the Laudesi supplied Duccio with a ready-made panel. In terms of its carpentry, the *Rucellai Madonna* represented a fairly straightforward physical structure, which comprised a series of five massive, vertical planks of poplar, each eight centimetres thick, held together by a system of vertical and horizontal battens attached to the back of the panel. It is important to appreciate, however, that (as was customary for panel paintings of that date) the broad frame and its mouldings would already have been attached by the carpenter to the panel before it was consigned to Duccio. Given that Duccio utilized the broad surface of the frame to extend the figural content of his painting, there was in all probability some degree of consultation between carpenter and painter.

We can, with little room for doubt, reconstruct the essentials of Duccio's working procedures. On receipt of the panel, he and any assistants he had working with him on this Florentine commission began the skilled and time-consuming activity of preparing the panel for gilding and painting. The first stage was the application of several coats of size (a dilute glue) to the panel and its frame. Pieces of fine linen cloth were laid upon the panel and its frame in order to even out any flaws on their surfaces. Due to deterioration with age, the weave and frayed edges of this material can now be seen in some areas of the *Rucellai Madonna*. The next stage was the application of several layers of gesso (gypsum), comprising first, layers of the coarser *gesso grosso* and second, layers of the smoother, more refined *gesso sottile*. Next, Duccio and his team scraped down the gesso layers to form a smooth surface for the painting and for the gold leaf that forms the background of the *Rucellai Madonna* – and, indeed, of most late thirteenth- and early fourteenth-century panel paintings.

As the master-in-charge of this project, Duccio then executed the initial design in charcoal. This was fixed at a later stage in ink, applied either by a quill pen or a brush. Although the technical investigation of the *Rucellai Madonna* did not reveal evidence of any such underdrawing, it appears from X-radiography examination of predella panels from the *Maestà* and the triptych of *The Virgin and Child with Saints* in the National Gallery, London that Duccio and his team characteristically used both brush and quill pen.[44] The divisions between the areas to be gilded and those to be painted were lightly scored into the gesso with a metal stylus. Physical evidence for this has been found in the *Rucellai Madonna*. Next, a layer of bole – soft, greasy, red-brown clay which provided a smooth surface against which the gold leaf could later be burnished – was laid on, using diluted size or egg white. Only then was gold leaf applied, having first been beaten into paper-thin pieces, some seven or eight centimetres square. The skilful application of gold leaf onto the bole ground may well have been delegated to a member of Duccio's workshop who was particularly expert in handling this delicate, expensive commodity. The gold leaf was then gently rubbed with a hard, polished stone, in order to impart a shining intensity to a religious painting of this type. Once burnished, the entire surface of the gold background and details such as the haloes and the decorative border were embellished with incised patterns using a metal stylus, compasses and dividers. In the *Rucellai Madonna*, certain details such as the haloes of the Christ Child and the angel on the lower right of the painting were given a more elaborate pattern by gently tapping iron punches against the gold leaf to leave a decorative imprint upon it.

Finally, the process of painting began, but only after the paints themselves had been prepared by a labour-intensive process involving grinding pigments on a hard stone slab until they were exactly the right consistency. The pigments were combined with the binding agent of egg yolk at the last possible moment before painting. Due to its setting properties, the resulting egg tempera could neither be thickly applied to achieve a textured surface nor blended and manipulated with a brush while wet. It had to be applied, therefore, with some form of hatching, the modelling and blending of the colours being achieved by the painstaking application of layer upon layer of fine, intermeshed brush strokes. This highly organized and systematic application of paint is seen in such details as the modelling of the heads of the Christ Child and attendant angels of the *Rucellai Madonna* (Plate 42). Finally, details such as the edge of the Virgin's mantle and the stars on her head and shoulder were embellished with mordant gilding. This was a process in which small pieces of gold leaf were laid upon a layer of adhesive – linseed oil was used for this purpose – which had previously been applied to the area to be decorated. The painting may then have been varnished in order to protect its elaborately crafted surface.

The *Rucellai Madonna* provides an example of the very controlled palette characteristic of most early fourteenth-century Tuscan panel painters, who had at their disposal only a limited number of pigments derived from a variety of minerals and vegetable substances.[45] In analysing the colour scheme of the *Rucellai Madonna*, it is striking how, apart from

the gold leaf, it is apparently based upon only four basic colours – blue, red, brown and green (Plate 55). Such variety as there is, is achieved by each of these colours being modulated. This may be done either by the addition of white to provide a lighter shade, such as the green in the central right-hand angel's tunic, or by the mixing together of two colours to form another, as can be seen in the pale mauves of two of the angels' mantles. By controlling his palette so rigorously, Duccio was able to balance one colour against another to great effect. He also skilfully utilized the inherent properties of each colour to draw attention to the various figures and to their respective degrees of religious status. Thus, he painted the mantle of the Virgin in azurite, which is a pigment of great depth and opacity, but is, nevertheless, a fairly dark colour with which to cover a large area of a painting. In order to counteract its effect, Duccio exploited the bright, eye-catching properties of red vermilion on the Virgin's sleeve, bodice, hemline and cushion. The brown of the wooden throne was similarly enlivened by gilding and by the use of red for the insets of a series of Gothic apertures on the throne's arm rests. Meanwhile, the choice of green for the background of the cloth of honour provided Duccio with a colour that mediated in chromatic terms between the subdued brown of the throne and the bright reds and golds of its embellishment. The colours deployed on the angels' garments offer a similarly graphic example of a painter self-consciously utilizing the various tones and combinations of blue, red and green.[46] Finally, by portraying the Christ Child in a combination of strikingly light and luminous pigments and materials – whites, pinks, mauves and golds – Duccio was able to convey to the spectator the pictorial and religious significance of this key cult figure.

How, then, may we sum up the significant points in this analysis of the *Rucellai Madonna*? First, the painting shows the extent to which Duccio worked within a well-established tradition of pictorial representation and yet, within that tradition, explored the potential of a number of pictorial innovations. Indeed, as we have seen, many of these innovations substantially enhanced the effectiveness of the traditional religious functions that such paintings were designed to serve. Secondly, the newly restored painting provides evidence of the very logical, systematic and highly skilled processes by which fourteenth-century panel paintings were characteristically executed. The painting thus demonstrates both Duccio's technical skill as a painter and his distinctive contribution to the treatment of a certain type of devotional painting. For further evidence of this kind of achievement combined with the additional skill of organizing a collaborative workshop, we must, however, look not to the early example of the *Rucellai Madonna* but to the later and more thoroughly researched *Maestà*.

THE *MAESTÀ*

The main painting on the front face of the *Maestà* – even more than the *Rucellai Madonna* – exemplifies Duccio's inventive treatment of the iconographic theme of the Virgin as at once mother of Christ, queen of heaven and divine mediatrix (Plate 57). Comparison with Duccio's two earlier works on this theme reveals his elaboration of the portrayal of this highly traditional subject (Plate 57, cf. Plates 48 and 55). The elaboration was, of course, in part dictated by the different shape of panel on which he was working. Designed as the centrepiece of an architectonic, multi-tiered structure wide enough to be displayed over the high altar of Siena Duomo, the painting's format was wider than it was high (Plates 43 and 57). In addition, the figures accompanying the Virgin and

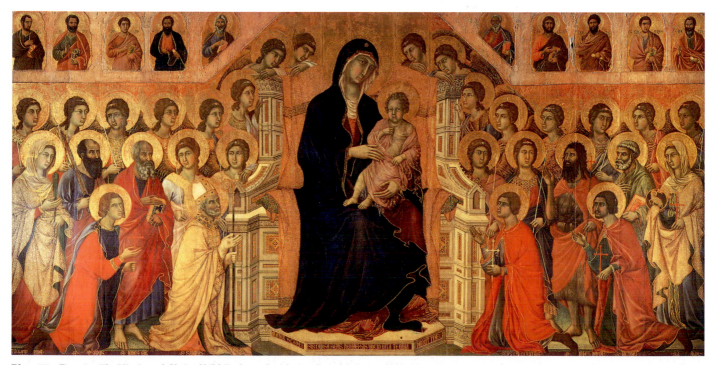

Plate 57 Duccio, *The Virgin and Christ Child Enthroned with Angels and Saints*, c.1308–11, tempera on poplar panel, c.212 x 425 cm, Museo dell'Opera del Duomo, Siena, formerly on the front face of the *Maestà*, high altarpiece of the Duomo, Siena. Photo: Lensini.

Plate 58 Duccio, *Saint Agnes*, detail of *The Virgin and Christ Child Enthroned with Angels and Saints* (Plate 57). Photo: Lensini.

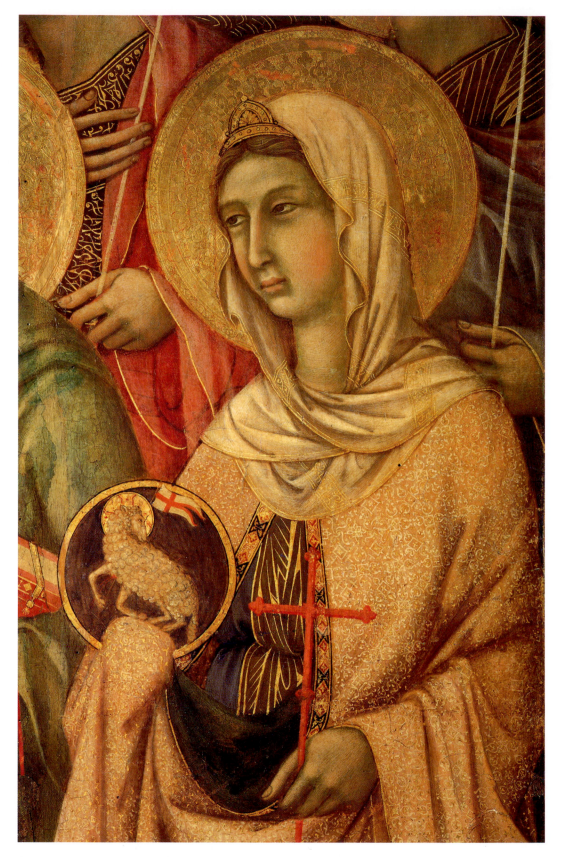

Child were not to be restricted merely to angels, but were to include ten full-length saints. The decision to add to the traditional figural composition in this manner was partly dictated by the painting's function as a monumental, civic icon, designed to play a specific intercessionary role for the citizens of Siena.[47] As already suggested above, Duccio may well have seen precedents for such an ambitious figural composition in earlier, large-scale mosaic and fresco paintings (Plate 47). Notwithstanding such precedents, Duccio's treatment of the figures in the *Maestà* was remarkable in its

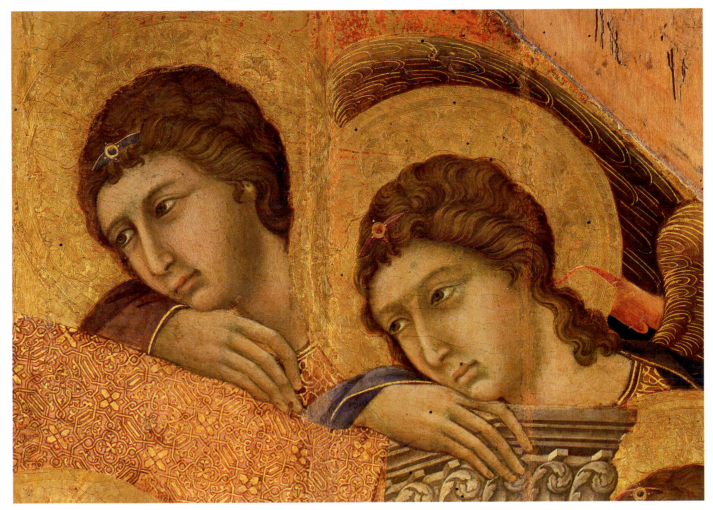

Plate 59 Duccio, *Angels*, detail of *The Virgin and Christ Child Enthroned with Angels and Saints* (Plate 57). Photo: Lensini.

assured representation of their physicality and its varied characterization in terms of age and gender. His approach to the use of pictorial space was also highly competent. Its full effect is now impaired, as a result of the trimming of the painting by a few centimetres on all of its sides. Originally, there would have been an area of gold background between the frame and the outermost figures on either side. This would have given the impression of a company of figures whose positions would cumulatively have suggested a gentle curve into depth on either side of the Virgin's throne.[48]

The painting also gives a compelling demonstration of Duccio's extraordinary technical skill as a painter of tempera on panel. The richness of colour and the brilliance of the gold leaf still prompts a feeling tantamount to awe when viewing the painting in its location within the Museo dell'Opera del Duomo. Close examination of a detail, such as the head of Saint Agnes, reveals the network of fine brush strokes and intricate hatching characteristic of fourteenth-century tempera painting. The tiny strokes of paint appear to the human eye to coalesce and give the illusion of the rotundity of the human form that they describe (Plate 58). Similarly, a mere detail such as the cloth of honour draped over the back of the Virgin's throne indicates the attention paid by the painter to the decorative possibilities of abstract, geometric pattern (Plate 59). It also provides an exemplar of *sgraffito*, another technique used with increasing self-assurance by fourteenth-

century panel painters as the century progressed. The technique entailed the application of a layer of paint over gold leaf which, once dry, was delicately scraped away in parts to reveal the gold beneath, producing a pattern of paint and gold.[49]

Examination of the cloth of honour in the *Maestà* also offers further evidence of Duccio's increasing skill in translating empirical observation of natural phenomena into pictorial form. Instead of resorting to the device of indicating folds of drapery by merely superimposing brown lines of paint on top of an unbroken pattern in the cloth – a technique that he had used in the *Rucellai Madonna* – in the *Maestà* Duccio adjusted the pattern of the cloth of honour in order to simulate the interruption that naturally occurs when patterned drapery falls into folds (Plate 57, cf. Plate 55).

The *Maestà*, with its 52 surviving narrative scenes, is our only evidence of Duccio's skills as a narrative painter (Plates 43 and 44). In the *Rucellai Madonna*, the *Madonna of the Franciscans* and *The Virgin and Christ Child Enthroned* from the front face of the *Maestà*, Duccio's principal task was the depiction of a number of holy figures who, by their stance and gesture, convey to the spectator the religious veneration appropriate to those thus represented (Plates 48, 55 and 57). In the case of the commission for the *Maestà*, Duccio was provided with a much more complex task. In this instance, he was called upon to depict such holy figures in specific

narrative situations described in the New Testament and other religious texts. Perhaps not surprisingly – given the extent and variety of the narrative scenes involved – it appears that it was in this area of the *Maestà* that Duccio most relied on the assistance of other painters. Detailed examination of the various narrative scenes reveals significant stylistic differences in the treatment of the figures and their settings. It is reasonable, therefore, to assume that several painters co-operated upon this ambitious enterprise.

If this was so, how was such collaboration organized? Relying primarily on stylistic analysis, James Stubblebine proposes that discreet parts of the *Maestà* were allocated to different individual painters, each of whom had responsibility for several narrative scenes.[50] Recent technical investigation of one of the narrative paintings from the back face of the predella of the *Maestà* suggests, however, that the collaboration involved was a much more highly integrated affair. It appears that in the painting of *The Healing of the Blind Man* at least three painters were working together (Plate 60). The first, arguably Duccio himself, was responsible for the preliminary design, executing the principal figures in the narrative drama and, indeed, extensively adjusting the pose of the blind man in order to make a dynamic, iconographic point. A second painter was apparently then responsible for the precisely executed drawing and painting of the architectural background, whilst a third and less competent painter drew the subsidiary figures in the scene.[51]

This interpretation, based on modern technical investigation, accords well with what can be reconstructed of the characteristic practice of fourteenth-century painters, which habitually entailed the frequent copying of the work of others and the requirement to work in a very flexible and co-operative manner.[52] With our modern concept of the highly gifted, creative individual artist and the prestige

attached to such a person, it is often difficult either to acknowledge the extent of collaborative work in fourteenth-century painting or to accord to it the critical acclaim that it deserves. However, recognition of the inherently collaborative nature of the overall endeavour does not imply the negation of Duccio's unique and decisive contribution to the project. Thus, notwithstanding the extent of the collaboration on the *Maestà*, there remains clear evidence of a singular personal intervention and contribution to this great work of art. The well-integrated structure of the painting's overall design and the carefully calculated organization of the narrative sequence on the two faces of this double-sided altarpiece clearly represent the work of a single mind. On the evidence of the investigation of *The Healing of the Blind Man*, this direction and leadership apparently extended to every aspect and detail of this complex work. The combination of creative concern for both overarching conception and intimate detail may logically be attributed to Duccio himself.

THE TRIPTYCH IN THE NATIONAL GALLERY, LONDON

Once the skilful orchestration of essentially collaborative enterprises is accepted as a crucial aspect of Duccio's personal achievement as a painter, then much of the tension concerning what is or is not by Duccio himself may be resolved. For example, the small-scale triptych now in the National Gallery, London (Plate 61) has been attributed by some art historians to Duccio, although other scholars disagree with this attribution.[53] However, it has been demonstrated that this triptych shares the same measurements as another triptych now in the Museum of Fine Arts, Boston (Plate 62) and it appears that both triptychs were designed according to the same proportional system as that used in the *Maestà*.[54] Quite apart from the matter of their identical carpentry, the triptychs share the same tooled gold leaf pattern and the same geometric designs on the outside of the shutters. The identity of design even extends to the cunning device of using different forms of diamond shape to differentiate between the shutters. The minor variation of interlocked diamond shapes on the left shutter and free-standing diamond shapes on the right shutter (Plate 63) acted as a visual prompt to the owners of the triptychs as to the order in which the wings should be opened and closed.[55] These similarities of carpentry and design offer compelling evidence of a process whereby, in order to meet a steady demand, similar artefacts were produced within a single painter's workshop according to a standardized pattern.

Further evidence of such a process is given by consideration of both the choice of the figures represented on the triptych in the National Gallery and their distinctive treatment. Throughout the painting there are echoes of Duccio's work. The placing of the mother and child – and indeed the tender motif of the child playing with his mother's veil – is strikingly similar to the Perugia *Virgin and Child* (Plate 61, cf. Plate 45). In terms of their miniature scale and somewhat disembodied form, the four angels are similar to the more emotively rendered angels grouped around the head of the Cross in *The Crucifixion* on the back face of the *Maestà* (Plate 61, cf. Plate 64). The systematic organization of the colour of the angels' mantles and robes is reminiscent of that

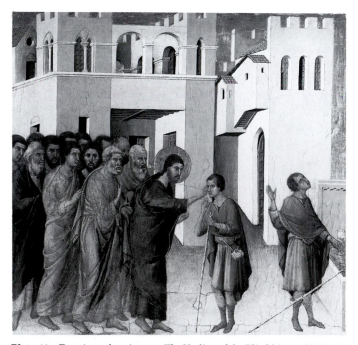

Plate 60 Duccio and assistants, *The Healing of the Blind Man*, *c.*1308–11, tempera on poplar panel, 43.5 x 45 cm, formerly on the back predella panel of the *Maestà*. Reproduced by courtesy of the Trustees, The National Gallery, London.

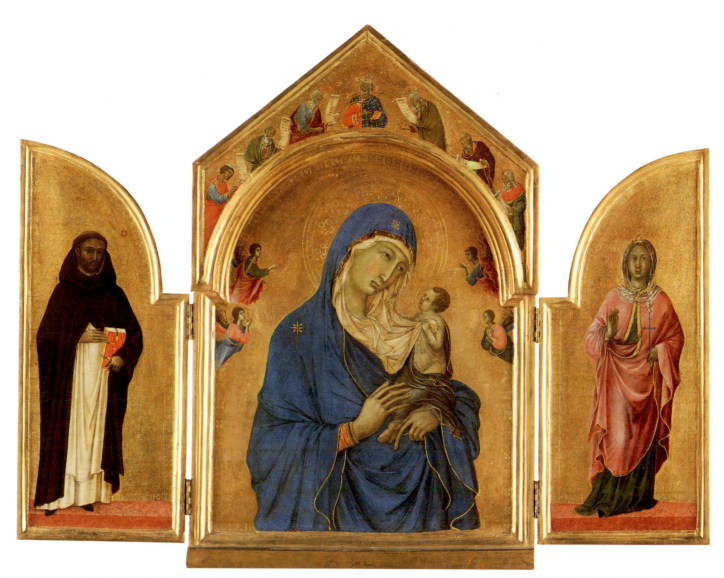

Plate 61 Duccio and assistants, *The Virgin and Child with Saints Dominic and Aurea of Ostia, c.*1300, tempera on panel, central panel including framing 61.5 x 39 cm, left wing 45 x 20.5 cm, right wing 45 x 18 cm. Reproduced by courtesy of the Trustees, The National Gallery, London.

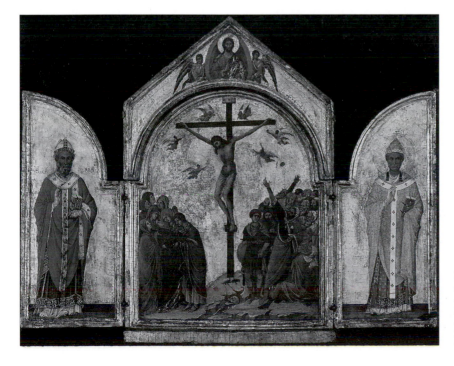

Plate 62 Duccio and assistants, *The Crucifixion with Saints Nicholas and Gregory the Great, c.*1300, tempera on panel, central panel including framing 60.8 x 39.4 cm, wings 45.2 x 19.4 cm. Grant Walker and Charles Potter Kling Funds, courtesy of The Museum of Fine Arts, Boston.

Plate 63 Duccio and assistants, *The Virgin and Child with Saints Dominic and Aurea of Ostia* (Plate 61), shutters closed. Reproduced by courtesy of the Trustees, The National Gallery, London.

Whilst the carpentry and design of the triptych suggest that Duccio's workshop was producing standardized artefacts, it also appears from the painting's iconography that it was made with the particular requirements of a specific private patron in mind. Clearly, its scale and portability made it highly suitable for private religious devotions. Thus, although the subject of the Virgin and Christ Child was commonplace, in this instance the half-length pose of the Virgin encouraged a sense of the intimacy appropriate to an object designed for private contemplation. The choice of saints for the wings, however, was by no means commonplace and it has therefore prompted speculation. The presence of Saint Dominic on the left-hand wing would suggest a Dominican interest. The female saint on the right is more difficult to identify but, on the visual evidence of the fragmentary inscription and on other kinds of historical evidence, it appears that she represents Saint Aurea of Ostia.[57] It has been suggested that the triptych could have been commissioned by Cardinal Niccolò da Prato (d.1321), who was both a high-ranking Dominican and Cardinal Bishop of Ostia, and would therefore have had a special veneration for these saints.[58] It is also significant in this context to recall that Duccio painted the *Rucellai Madonna* (Plate 55) for a confraternity based in Santa Maria Novella, the principal Dominican church in Florence. In addition, he and his workshop may well have executed polyptychs for two other Dominican churches. The first was probably for San Domenico in Perugia (Plate 45). The second, which survives in more complete form, was probably for the high altarpiece of San Domenico in Siena,[59] and is in its own right an important contribution to the development of the fourteenth-century Sienese altarpiece (Plate 65). Significantly, these two 'Dominican' altarpieces may well have been painted within the first decade of the fourteenth century. This was precisely the time when Cardinal Niccolò da Prato, as papal legate of Benedict XI, was active in Tuscany. If Cardinal Niccolò da Prato was, indeed, the patron of the triptych in the National Gallery, then the commission provides a compelling demonstration of the way in which even standardized artefacts from a busy painter's workshop might include highly personalized imagery.

CONCLUSION

What, then, may be said of Duccio's impact upon his contemporaries and upon later fourteenth-century Italian artists? Although little survives of his output, what does survive appears to have been highly influential. Thus, for every one of his paintings, it is possible to find other early fourteenth-century Tuscan and Umbrian paintings that supply evidence of their painters having directly emulated Duccio. There exist, for example, a number of impressive, large-scale paintings executed in the fourteenth century for various Tuscan churches which, in terms of their format, iconography and pictorial treatment, appear to be indebted to the *Rucellai Madonna*.[60] Similarly, the two triptychs discussed above have close counterparts in other small-scale works which, because of their technical quality and pictorial iconography, have prompted intense debate as to whether they too can be attributed to Duccio's hand.[61]

of the *Rucellai Madonna* (Plate 61, cf. Plate 55) and the Old Testament prophets grouped in the gable are broadly similar in costume and figural type to the more monumentally conceived prophets portrayed on the front face of the predella of the *Maestà* (Plate 61, cf. Plate 43). Finally, although the figure thought to be that of Saint Aurea lacks the scale and statuesque qualities of Saint Agnes on the extreme right of *The Virgin and Christ Child Enthroned* on the front face of the *Maestà*, the highly competent treatment of the drapery folds of her mantle and the impression of the transparency of her veil are indicative of a similar skilful control of technical and representational means (Plate 61, cf. Plate 58). The painter of this work, therefore, if not Duccio himself, was certainly thoroughly conversant with Duccio's work. Moreover, examination of the drapery around the Christ Child's legs by means of infra-red reflectography reveals underdrawing executed with a quill pen. The drawing style employed is similar to that discovered on panels from the front and back faces of the predella of the *Maestà*.[56] It is likely, therefore, that Duccio may have been responsible, at the very least, for laying in crucial parts of the design of this triptych.

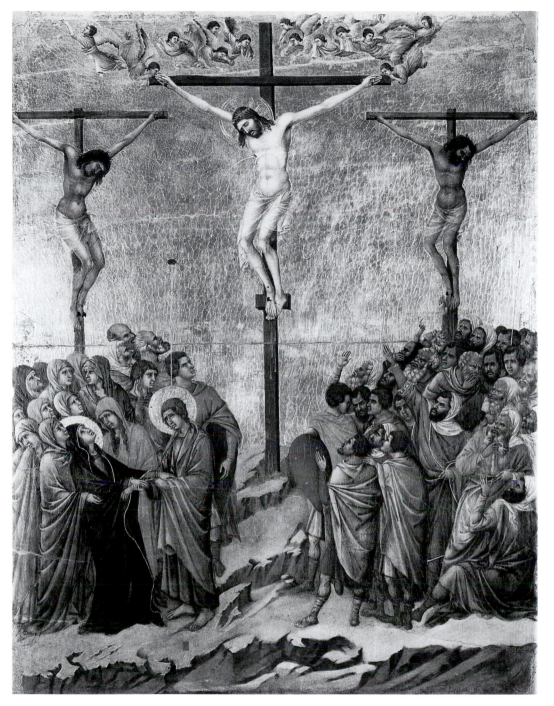

Plate 64 Duccio and assistants, *The Crucifixion*, c.1308–11, tempera on poplar panel, 101.4 x 76 cm, Museo dell'Opera del Duomo, Siena, formerly on the back face of the *Maestà*, high altarpiece of the Duomo, Siena. Photo: Lensini.

The scale and ambition of the *Maestà* were never again attempted in fourteenth-century Italian altarpiece design. Select parts of the *Maestà* were, however, utilized as inspiration for later work. The great central image of the Virgin enthroned, with its powerful Marian iconography, was adopted and adapted by subsequent Sienese painters, particularly those commissioned to celebrate the Virgin as civic patron (Chapter 7, Plate 140). The multi-tiered front face of the *Maestà* was highly influential in the development of the fourteenth-century central Italian polyptych. Over the century this became more and more ambitious and complex in the number and organization of its constituent parts. However, the extraordinary number of narrative scenes on the back face

of the *Maestà* was not repeated on later altarpieces. Although some altarpieces (particularly those produced in Venice and elsewhere in northern Italy) included narrative scenes framing a central iconic image, the most common location for painted narrative on Tuscan altarpieces was the predella and – from the middle of the century onwards – a sequence of pinnacle panels.

Altarpieces produced by Ugolino di Nerio, Simone Martini and Ambrogio and Pietro Lorenzetti all furnish evidence that these prominent Sienese master painters were significantly receptive to Duccio's contribution to this particular genre of religious art. Whether they trained under Duccio and were members of his workshop is more debatable. Probably the

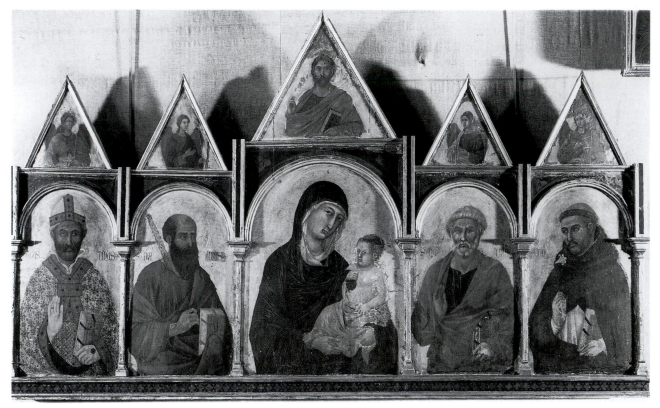

Plate 65 Duccio and assistants, *The Virgin and Child with Saints*, 'Polyptych 28', *c.*1305, tempera on panel, 139 x 241 cm, Pinacoteca, Siena, possibly formerly the high altarpiece of San Domenico, Siena. Photo: Lensini.

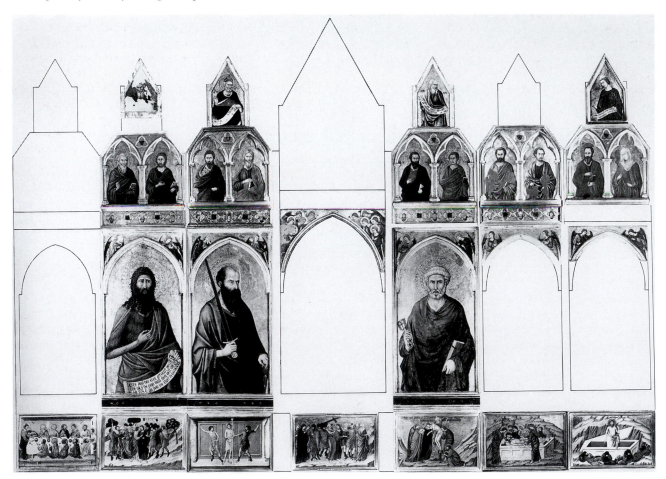

Plate 66 Reconstruction of Ugolino di Nerio, *The Virgin and Child with Saints, Prophets and Scenes from the Passion*, *c.*1324–5, tempera on panel, various collections, formerly the high altarpiece of Santa Croce, Florence. From Bomford *et al.*, *Art in the Making: Italian Painting Before 1400*, 1989 reproduced by courtesy of the Trustees, The National Gallery, London.

most likely to have done so was Ugolino di Nerio (active 1317–27), whose fourteenth-century polyptychs appear to be indebted to those produced within Duccio's workshop. In particular, the multi-tiered design of his high altarpiece for Santa Croce in Florence would seem to have been derived from both the front face of the *Maestà* and another early fourteenth-century Sienese altarpiece – the so-called 'Polyptych 47' – that is generally attributed to Duccio's workshop. In addition, the scenes on the predella bear close resemblance to corresponding scenes on the back of the *Maestà* (cf. Plates 44 and 66).[62]

What of Duccio's relationship to his younger contemporary, Giotto? Comparisons are frequently made between the works of the two painters. The *Rucellai Madonna* and Giotto's *Ognissanti Madonna* hang at present (1994) in the same room in the Uffizi, Florence, and although dated some 25 years apart have much in common in terms of format and iconography (Plate 55, cf. Chapter 4, Plate 72). Similarly, Duccio's highly inventive religious narrative in the *Maestà* is frequently compared to that of Giotto in the Arena Chapel (Plates 43 and 44, cf. Chapter 4, Plate 68). Both monuments are major artistic achievements in terms of the sheer scope and variety of narrative and representational means. However, comparisons between their pictorial schemes, particularly when the comparisons neglect to take account of the historical circumstances in which the two projects were executed, tend inevitably to obscure the precise nature of the achievement of one or other painter.

Because of the physical nature of the materials that they were using and the locations in which they were working, Duccio and Giotto were obliged to use strikingly different methods of pictorial representation and narration. These were also affected by the different techniques that the painters were employing, the contrasting viewing conditions under which the paintings were to be seen and the distinct religious roles for which the narrative paintings were designed. Duccio's painted narrative was part of an altarpiece, whose function was to complement the celebration of Mass, hence the very detailed depiction of the events of Christ's Passion (Plate 44). In contrast, Giotto's narrative paintings were designed for the walls of a privately owned chapel. The paintings were undoubtedly intended to complement the religious worship that took place within the chapel, but also to serve the patron's motives for funding the chapel. Their cumulative message was, therefore, less focused upon the symbolism of the altar. For this reason the timeless, awesome, essentially iconic qualities of the enthroned Virgin on the front face of the *Maestà* are not matched by any single painted image in the Arena Chapel frescoes (Plate 57). Furthermore, the sequence of the narrative of the Passion series in the *Maestà* is more complex than Giotto's essentially unbroken linear progression around the walls of the Arena Chapel. The overall pictorial scheme of the *Maestà* incorporates different-sized formats, varied according to both the demands of the narrative and the greater or lesser religious significance ascribed to individual narrative events. In all the above ways Duccio's achievement in the *Maestà* might reasonably be said to be more versatile than that of Giotto in the Arena Chapel. To say this, however, is not to diminish Giotto's distinctive achievement. Giotto and his team painted the murals of the Arena Chapel in a no less skilled and considered – although different – fashion. By virtue of their scale, the height at which they were situated and the swiftness of their execution (a demand inherent in the fresco technique), these mural paintings were of necessity painted in a bolder and more monumental manner.

As indicated at the beginning of this essay, Giotto and his reputation have been well served by the fact that 'the patent on the history of art was taken out in Florence'.[63] In the sixteenth century Siena was absorbed by Florence and Sienese historians were never able to match the power and influence of Florentine eulogists. Fortunately, however, more recent generations of scholars have begun to recover Duccio's worth as a painter and hence to enhance his reputation. Arguably, the most revealing lesson to be learned from this exercise of rehabilitation is that much of Duccio's achievement lay precisely in his ability, as the head of a flourishing workshop, to organize and facilitate the work of other painters. However, it should be remembered that it was his combination of creative imagination and overall vision that enabled the production of the *Rucellai Madonna* and the *Maestà* – two great paintings which have rightly attained a place within the canon of western European art.

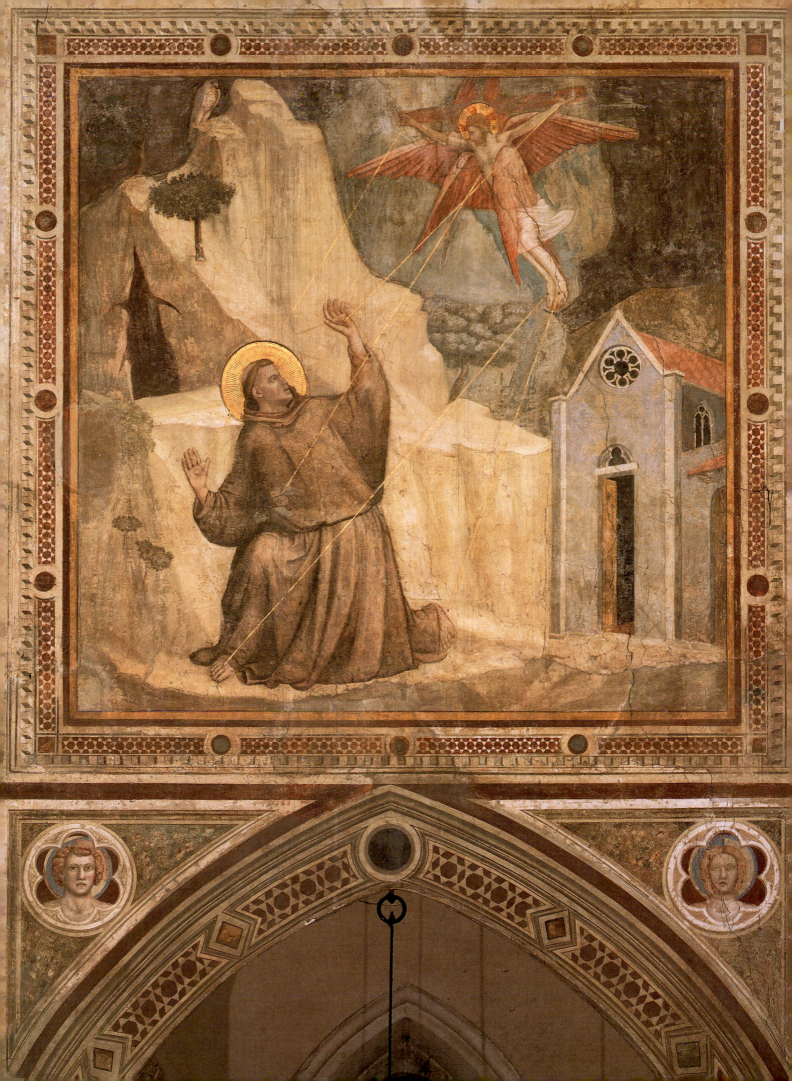

Giotto and the 'rise of painting'

GIOTTO'S MODERNITY

'Giotto is often considered the founder of the modern school of painting.' That sentence appeared in Martin Davies's catalogue of paintings of the Earlier Italian Schools in the National Gallery, London – not a work given to sensational statements.[1] A more circumspect way of expressing the same point would be to say that the work of Giotto occupies a central place in the tradition of western pictorial art, as that tradition has been conceived and understood in the modern period. To put the point in this form is to make clear that what is intended is not simply a claim about the work in question. Something is also being said about the tradition itself and about the ways in which it has been established and thought about in modern times. What is being suggested is that the very idea of a continuous tradition in western pictorial art depends in part upon the perception that the work of Giotto is different in some qualitatively significant sense from the art of his predecessors, and that it is somehow of a piece with the art of those who came after him.

In fact, the association of Giotto with a qualitative change in art is far from being the invention of twentieth-century interests. In Dante's *Purgatorio*, written around 1317, Giotto's ascendancy over Cimabue is cited as evidence of the unpredictability of fortune,[2] whilst an early testimonial to his modernity appeared in Boccaccio's *Decameron*, written in the middle of the fourteenth century. According to Boccaccio, Giotto 'brought back to light that art which had for many ages lain buried beneath the blunders of those who painted rather to delight the eyes of the ignorant than to satisfy the intelligence of the wise'.[3] Some 50 years later Cennino Cennini, author of *Il libro dell'arte* (*The Craftsman's Handbook*), described Giotto as the person who had 'changed the profession of painting from Greek [by which he meant Byzantine style] back into Latin [by which he meant Roman or classical style], and brought it up to date'.[4] Cennini was thereby claiming authority for himself as a guide to practice, since Giotto had been the master of Cennini's master's master. The view of Giotto as the artist who had recovered and rejuvenated lost skills was elaborated by Lorenzo Ghiberti in the second of his *Commentarii*, written in Florence in the mid fifteenth century. A century later Giorgio Vasari credited 'Giotto, the Florentine painter' with reviving the arts of painting and design and with bringing painting 'to such a form that it could be called good'.[5] That the latter four commentators identified Giotto's achievement with the revival of lost or neglected skills and standards confirms rather than contradicts the view that he was seen as somehow modern even in his own time. For these Florentine writers, an idea of a lost golden age, associated with what survived of classical art and classical learning, was inseparable from those concepts of achievement or, more significantly, of historical progress that were central to the self-image of Florentine culture.[6]

It is clear, then, that the identification of Giotto with significant development in art has a long history. However, none of these Florentine writers could have anticipated the terms in which twentieth-century observers have represented the modernity of Giotto's work. Here, for instance, is the German art historian Julius Meier-Graefe, writing in 1905 near the beginning of his long and highly influential book *Modern Art*. He is discussing 'the rise of painting'. As many subsequent writers have done, he follows Dante and Vasari in placing the crucial step towards modernity between Cimabue's work and Giotto's, but in the significance he attributes to that step he voices the concerns of his own day:

> The first step was the transition from mosaic to fresco. It was decisive. The artist himself became the decorator, and undertook the expression of his thought; in his hands thought necessarily underwent a corresponding change.
>
> ... In his mosaics, as in his gigantic Madonna-pictures, Cimabue still shows the decorative grandeur of an art directed to the ornamentation of vast interiors. In Giotto's hands, painting is already pictorial.
>
> The example that will best illustrate our present thesis is perhaps Giotto's beautiful and harmonious fresco-series in the Chapel of the Arena at Padua. [See Plate 68.] This work contains the germ of all that later art has laboriously achieved
>
> ... it is the starting-point of what I may call the gallery-characteristics of all our art. The picture has already become something we must look at alone, divorced from its surroundings and governed by its own laws.[7]

There are three particular values for which Giotto's work is here made the vehicle: individualism of expression, the ascendancy of the pictorial over the decorative or ornamental, and the self-sufficiency or autonomy of the finished work. Viewed as the artist in whose work these three values may first be found conjoined, Giotto is made to stand at the commencement of a development that, in the eyes of Meier-Graefe and his fellow early Modernists, was to lead in the end to the work of Cézanne. In other words, it was to lead to what for the Modernists was the central achievement of modern art. Writing a few years after Meier-Graefe, the English art critic Clive Bell brought the two names explicitly together: 'if the greatest name in European painting is not Cézanne it is Giotto'.[8]

Plate 67 (Facing page) Giotto, *The Stigmatization of Saint Francis*, c.1315–20?, fresco, c.390 x 370 cm, Bardi Chapel, Santa Croce, Florence. Photo: Scala.

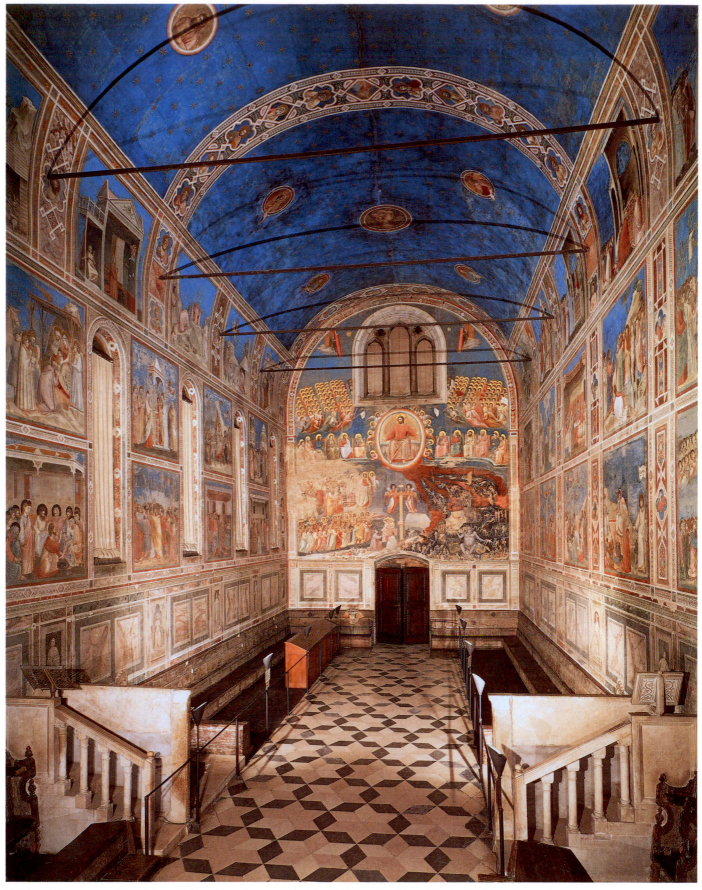

Plate 68 Nave, Arena Chapel (overall dimensions in metres: height 12.80, length 20.82, width 8.42), Padua. Photo: Scala.

Just as there has been controversy throughout the twentieth century as to the basis on which the true meaning and imagery of the modern should be established, so there have been different ways in which the significance of Giotto's work has been represented. Viewing it within the framework of a development that was supposed to lead to Cézanne, critics like Meier-Graefe and Bell stressed the relative independence of Giotto's work from the wider world of social and historical concerns. For the Mexican mural painter Diego Rivera, on the other hand, Giotto was part of the history of revolutionary resistance to oppression, within which Rivera was concerned to locate his own work during the 1930s: 'Giotto was a propagandist of the spirit of Christian charity, the weapon of the Franciscan monks of his time against feudal oppression.'[9]

These differing views are presented here in order to demonstrate the forms of preoccupation and idealization that have tended inescapably but often unconsciously to colour our understanding of Giotto's work, along with the work of other major figures from the past. The quotations from Meier-Graefe and Rivera bear witness to two related modern tendencies: on the one hand, to agonize over the isolation of the experience of art – an isolation often associated with the separation of pictorial art from design and decoration – and on the other, to idealize art's revolutionary potential.

These have, indeed, been crucial issues for modern criticism, and it would be surprising if they had not had some effect upon the ways in which we regard the art of the past. Yet it needs to be recognized that there is no surviving evidence to suggest that any artist of the early fourteenth century experienced a moment's anxiety about the separation of the pictorial from the decorative, whilst there is every likelihood that the idea of art as a weapon of political resistance would have been alien to the entire cast of Giotto's thought. The very pervasiveness of such concerns in modern ideas about art makes it important that we seek consciously to compensate for their effects when we look at the art of earlier periods.

Yet it is undeniably true that Giotto's art has retained a particular fascination for those in whose work these concerns have been paramount, and that the meaning and value of Giotto's art have remained matters of interest and controversy. So long as we avoid confusing the conditions under which artists worked in the fourteenth century with the conditions under which we do our thinking now, it may be that the modern fascination with Giotto still has something to tell us about the historical individuality of his enterprise. Specifically, it may help to highlight those factors that, in the eyes of near contemporaries like Boccaccio, raised his work above the normal standards and expectations of his time.

In this essay, then, I mean to review some historical considerations that may help to compensate both for the partisanship of Florentine sources and for the effects of those modern concerns and idealizations in which the claims of Florentine writers are often unwittingly reproduced. This will not be a study of Giotto as a specifically Florentine artist. Rather, I shall attempt to examine those assumptions about the extent and character of a Giottesque *oeuvre* and style that are themselves partly Florentine in origin. I do so not in order to undermine the status of the artist Giotto but, on the contrary, in order the more securely to identify those

distinctive aspects of his work that have made it seem so pertinent to artists and other observers from different ages and of different persuasions.

The principal concern of this essay is to establish a context for what we might call the 'Paduan Giotto', the artist responsible for the painting of the Arena Chapel. This mural scheme is both a touchstone for Giotto's work as a whole and one of the most highly regarded ensembles in the history of art. The focus on this work that is implicit in this essay[10] has led, on the one hand, to some emphasis being placed on the so-called 'Assisi problem' and, on the other, to relatively brief consideration being given to Giotto's late and less well-preserved fresco schemes in Florence.

THE NAME OF GIOTTO

Before we try to look back at Giotto's work through the concerns of the modern period, there is one strong caution that must be entered. The names of those accorded the status of great artists serve not merely to identify historical individuals. They are also the headings under which more or less disparate bodies of myth come to be gathered into manageable narratives. The greater the attraction of a certain name – earned, for example, by its firm association with a major surviving work – the stronger will be its pull and the more inexorable its function as a means of organizing other material into a single, graspable narrative or *oeuvre*. Dante and Boccaccio were not the only literary figures to mention Giotto's name. Petrarch praised Giotto's frescoes in Naples,[11] and in his will of 1370 commended a painting by Giotto which he bequeathed to Francesco il Vecchio da Carrara.[12] The painter's appointment as *capomaestro* of the Duomo in Florence, coming near the end of his life, ensured that he would be remembered in the city as one of its dignitaries. Paradoxically, the power of Giotto's name to serve as a label for highly regarded art is in part a consequence of his status as a 'great man' – and not simply a great artist – in Florentine literature. Tales of his wit and intelligence were recounted by Ghiberti and elaborated by Vasari.[13] Combined with testimonials such as these, the association of the name of Giotto with the Arena Chapel in Padua gives this name an enormous power of attraction. Thus, there will clearly be a far greater incentive to associate other works with the named and already celebrated artist of the Arena Chapel than there would be to add to the corpus of works attributed to the unnamed painter of a more pedestrian decorative scheme. The visitor to Italy will find a wide range of works unquestioningly attributed to Giotto in local guide books. In some of these works the painter of the Arena Chapel may have had a controlling hand, in others he may have played a minor part, whilst still others would be dismissed by modern scholars as associated with the name of Giotto only through hearsay or opportunism.

The question of attribution raises a series of important methodological issues. On what basis should we decide whether to accept or reject Giotto's authorship of a given work? At one level, this will be a matter of what we are prepared to accept as *evidence* of authorship. Potential forms of evidence are likely to fall into one of two categories: the documentary and the stylistic. The strongest form of evidence

would be one that satisfied the requirements of both categories at once, for example a surviving contract for a still extant work, which not only named the artist but also stipulated that the work in question was to be from his own hand (and not delegated to assistants or contracted out). In the presence of such evidence, the name of Giotto could properly be allowed to stand for a particular historical individual endowed with certain practical skills and possessed of a certain style, which could be seen as demonstrated in the work in question.

In fact, there is not a single extant work by Giotto for which such independent documentary evidence survives. Contemporary documentation of specific relevance to his practice as an artist is summarized by John White along the following lines.[14] The first surviving record of Giotto's name identifies him in 1301 as living in Florence in the parish of Santa Maria Novella. By 1320 he appears to have been a member of the Florentine Arte dei Medici e Speziali (guild of doctors and apothecaries) into which a formerly separate painter's guild had been incorporated some five years previously. Records of payments made between December 1328 and April 1332 testify to a sojourn in Naples and to Giotto's attachment to the household of Robert of Anjou, King of Naples,[15] but of the frescoes and panel paintings mentioned in these Neapolitan records not one is definitely known to survive (although various attributions have been made among surviving fragments of decorative schemes). Giotto's appointment as *capomaestro* of the Duomo in Florence is recorded in April 1334, and his death in January 1337.

In the absence of more substantial documentation, we are reliant upon the less dependable information of literary sources – those of the Florentines Ghiberti and Vasari and of others who left written accounts of works identified with Giotto – and upon such positive indications of an artistic identity, or individual style, as we may be able to assemble on the basis of circumstantial evidence. In making or testing attributions to this identity we will be largely dependent upon the evidence of our own eyes. All other things being equal, that is to say, we will accept that a work is by Giotto if and only if we find it fitting to represent the artist that we take him to be. To the extent that the name of Giotto is associated with supreme artistic achievement, we will be likely to reject any work that seems to fall short in quality. In this case, the name of Giotto stands not so much for a documented historical individual as for a set of mutually reinforcing values and expectations. If an apparently documented work fails to meet these expectations, it may then be the value of the documentation that is questioned.

These points may be clarified by reference to examples. There are three major panel paintings that are inscribed with Giotto's name: *The Stigmatization of Saint Francis*, made for the church of San Francesco in Pisa and now in the Louvre in Paris (Plate 69); a polyptych now in the Pinacoteca, Bologna, showing *The Virgin and Child with Saints Peter and Paul and Archangels Gabriel and Michael* (Plate 70); and a polyptych of *The Coronation of the Virgin* in the Baroncelli Chapel in Santa Croce, Florence (Plate 71). Yet for White the first is 'for the most part no more than a workshop product', whilst the 'abysmal drop in quality in the signed altarpiece in Bologna is redolent of the same state of affairs'. As for *The Coronation of*

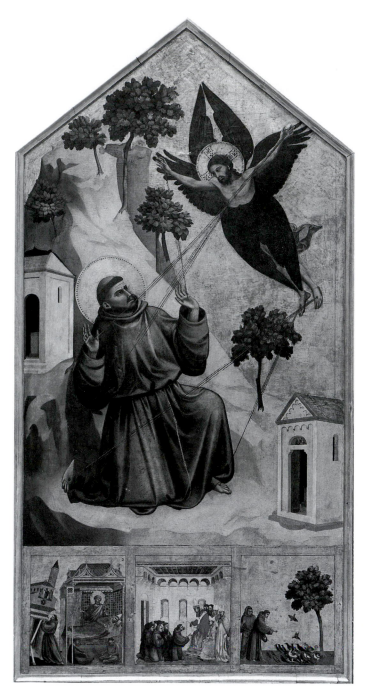

Plate 69 Giotto, *The Stigmatization of Saint Francis, c.*1300?, tempera on panel, 314 x 162 cm, Musée du Louvre, Paris, formerly in the church of San Francesco, Pisa. Photo: Réunion des Musées Nationaux Documentation Photographique.

the Virgin, whilst White judges it 'qualitatively superior' and allows the composition to be Giotto's, he judges that the 'particular qualities of colouristic delicacy and structural softness do not appear to stem from Giotto's own hand'.[16]

It is significant that the principal measure against which White tests the quality of these three paintings is the large panel of the Virgin, painted for the altar of the church of Ognissanti in Florence and now in the Uffizi in the same city (Plate 72). Although universally attributed to Giotto, this painting is unsigned and, indeed, unmentioned in any surviving document earlier than the second decade of the

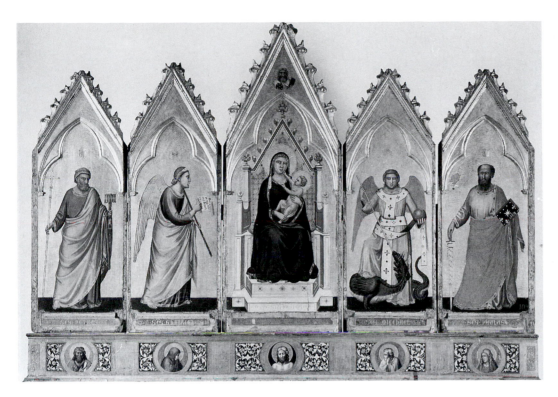

Plate 70 Giotto, *The Virgin and Child with Saints Peter and Paul and Archangels Gabriel and Michael*, tempera on panel, 190 x 340 cm, Pinacoteca, Bologna. Photo: Gabinetto Fotografico Soprintendenza Beni Artistici e Storici Bologna.

fifteenth century. In its present location, this large and ambitious work invites comparison with Cimabue's great *Santa Trinita Madonna* and with Duccio's *Rucellai Madonna*, both of which now hang in the same gallery of the Uffizi. It is easy to see how such a work might have seemed to Cennini and others to re-establish a classical solidity in an art dominated by 'Greek' forms of stylization. Two particular qualities of Giotto's altarpiece stand clearly revealed in comparison with the *Rucellai Madonna* (Chapter 3, Plate 55).

The architectural organization and detail of the composition serve to create the illusion of a coherent and plausible space, which extends into depth beyond the literal plane of the picture. Within this space the figures are gradually and softly modelled so as to appear relatively solid and life-like. Of course, the one achievement is the condition of the other. There can be no convincing illusion of solidity in a painted body unless the apparent volume of the pictorial space is sufficient to contain it. It is this relative coherence of

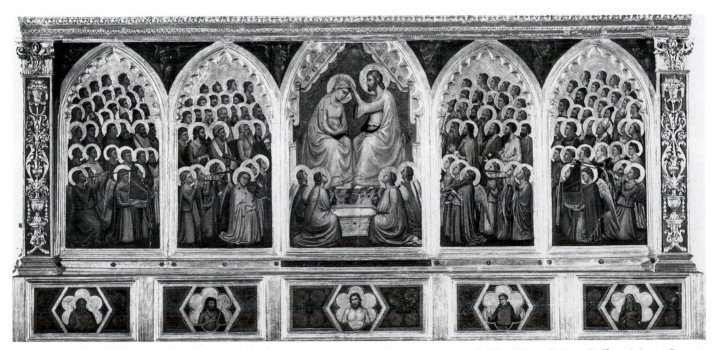

Plate 71 Giotto, *The Coronation of the Virgin*, *c.*1328–34 (frame not contemporary), tempera on panel, 185 x 325 cm, Baroncelli Chapel, Santa Croce, Florence. Photo: Alinari-Brogi.

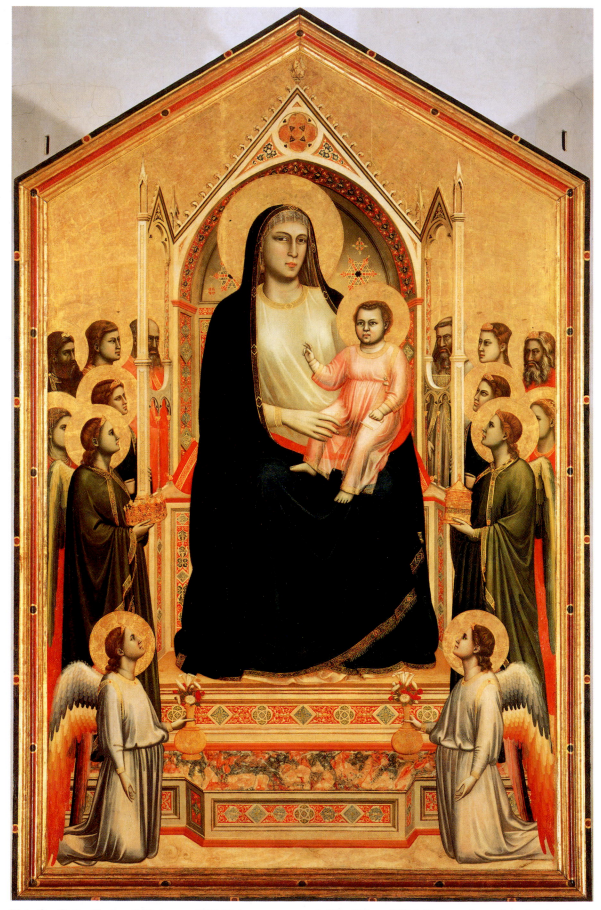

Plate 72 Giotto, *Ognissanti Madonna*, *c.*1306–10, tempera on panel, 325 x 204 cm, Uffizi, Florence, formerly in the church of Ognissanti, Florence. Photo: Scala.

relations between figures and spatial ground that seems to have appeared to Giotto's contemporaries – as I think it still does to us today – both to connect his work to the relatively naturalistic styles of Roman times and to effect a form of modernization of the resources of painting.

It does not follow, of course, that Giotto's work is 'better' than that of Duccio. Naturalism is simply one property that a painting may have. Decorative sophistication and richness is another, and it may not always be reconcilable with a high degree of naturalism. The decorative qualities of Giotto's panel are certainly impressive, as recent cleaning has confirmed, but his craftsmanship in this respect was not in any sense in advance of Duccio's. A more important point is the *use* that Giotto makes of the achieved increase in naturalism. The world of his picture is one that seems reachable and close, both in physical and in psychological terms. To achieve this effect, various devices have been deployed to engage the spectator's responsive imagination. Notable among these are the angels isolated near the front of the picture space, with all the apparent solidity of sculptured figures, and the open-eyed outward gaze and monolithic physical presence of the Madonna, so much more suggestive of an actual proximity to the spectator than the oblique and sinuous arrangement of Duccio's figure, even though the latter is located closer to the front of the illusory space. In its strong and coherent plastic organization, its combination of sculptural with psychological presence, and its unquestionable level of aesthetic attainment, the *Ognissanti Madonna* does, indeed, appear a fitting addition to the *oeuvre* of the painter of the Arena Chapel.

It might seem surprising that the panel painting that is most confidently associated with the level of achievement expected of Giotto is one to which he did not append his name. White's conclusion is:

> Giotto signed those major products of his workshop which he had largely not himself painted. These were the works that were in need of the protection of a signature to prove their provenance. In the panels that he carried out himself his brushwork was its own endorsement.[17]

To talk of brushwork as a form of endorsement is to assume that the artist's own hand will be immediately recognizable and distinguishable from the hands of others. Yet in the sixteenth century Vasari admitted into the list of Giotto's works not only the three signed panels that White disparages, but also a number of works that few modern scholars would accept as bearing any traces of Giotto's controlling hand. Vasari, no mean painter himself, was presumably well equipped to make relevant discriminations between painted surfaces. The point here is not simply that there is likely to be disagreement, over the course of time and between different judges, as to what constitutes the true style or hand of Giotto. More significantly, the *form* of authorship that the name Giotto is taken to stand for will change in response to different interests and different concepts of the practice and nature of art.

With our modern concern to isolate the authentic touch of the master, we share some common ground, in terms of material interest, with those Italian patrons of the mid fifteenth century and later who wished to ensure that they got the best value – that is, the application of the finest available skills – in return for their financial outlay. However, we should not assume that the representative *fourteenth*-century observer had quite the same interest as does the modern museum curator or connoisseur in distinguishing between the work of Giotto's own hand and the productions of his workshop. At that time the transfer of artistic value 'from gold to skill'[18] had not really begun. Some contracts that survive from the early fourteenth century do stipulate that works should be from the master painter's own hand,[19] but it does not follow that such contracts were necessarily fulfilled by the master working alone, or even that the majority of the final painted surface can safely be seen as the work of one person. In practice, the master's 'hand' tended to mean his overall control rather than his personal touch. In fact, it could be said that the concern to secure the master's personal touch, which is revealed in contracts of the 1440s and after,[20] was not so much a condition under which Giotto himself worked in the early fourteenth century as a long-term consequence of the skills demonstrated in such work as his, and of the esteem that came to be accorded to those skills. In Giotto's day, in so far as the artist was *capomaestro*, that is, was responsible for control of his workshop, he and that workshop were generally treated as synonymous. If the concept of stylistic personality is to make any sense under such conditions, we will need to acknowledge that skills in organization, instruction and delegation must have been among the identifying qualities of the individual concerned. In studying the work of Giotto today we need to recognize that, whilst the practised connoisseur or restorer may be able to distinguish a personal touch, albeit rarely without leaving some possibility of disagreement,[21] many of the works that we think of as being by Giotto are the productions of a presumably large and well-organized team. Among these productions we can certainly include the decorations of the Arena Chapel, even though it is from these same decorations that the individual stylistic personality attached to Giotto's name has been very largely deduced.

In view of the encouragement to scepticism extended in this section of the essay, there is one point that should be made quite clear. To suggest, on the one hand, that the name of Giotto is a form of myth and, on the other, that the decorations of the Arena Chapel must be the productions of a workshop is not necessarily to impugn the *aesthetic* properties of those decorations, or of any others with which Giotto's name may have been appropriately or inappropriately associated.

GIOTTO'S DEVELOPMENT AND THE 'ASSISI PROBLEM'

The problems that we have been considering are of particular moment when we attempt to establish the pattern of Giotto's career and to trace his development as an artist. His work on the Arena Chapel in Padua can be dated with some probability between 1304 and 1313, and may well have been completed some time before the later date.[22] There is no surviving work attributed to Giotto that can with absolute security be dated earlier than this on *other* than stylistic grounds. There is a strong likelihood that he was responsible for the design of a large mosaic for the façade of Saint Peter's in Rome, showing Christ walking on the water, and that this

Plate 73 Nicolas Beatrizet, engraving after Giotto's *Navicella*, 1559. Photo: Warburg Institute, University of London.

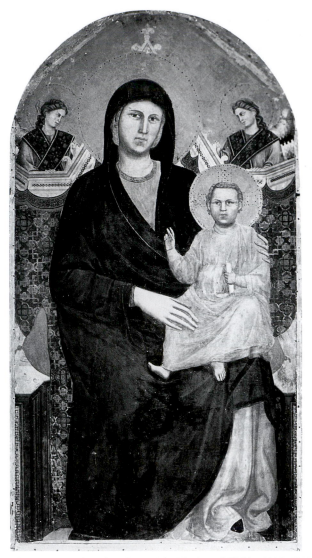

Plate 75 Attributed to Giotto, *The Virgin and Child*, c.1295–1300, tempera on panel, 180 x 90 cm, Uffizi, Florence, formerly in Santa Giorgio alla Costa, Florence. Photo: Scala.

work was done close to the beginning of the century. Known as *The Navicella*, it is recorded in early commentaries and graphic studies (Plate 73). However, the mosaic was removed and remade in reduced form in the early seventeenth century, and no very substantial conclusions about Giotto's pre-Paduan style can be drawn from what now survives.

Under these conditions, the identification of any work as an early work by Giotto requires the making of two connected assumptions: the first is that the decoration of the Arena Chapel is the achievement of a mature artist, and the second is that the work in question can be seen as revealing a relatively immature form of the same artistic hand.

The first assumption is surely a reasonable one, if only because it is unlikely that an unproven artist would have been accorded so substantial a commission or would have been able to assemble the workshop required to discharge it. (A date of c.1265 is normally accepted for Giotto's birth.[23] One persuasive reason for its acceptance is that it would put him

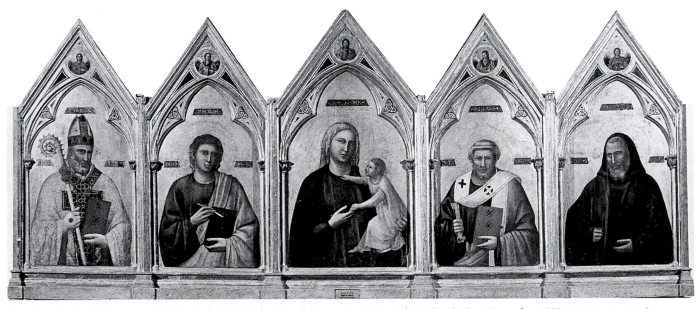

Plate 74 Giotto, *The Virgin and Child with Saints Nicholas, John the Evangelist, Peter and Benedict*, Badia polyptych, c.1305, tempera on panel, Uffizi, Florence, formerly in Santa Croce, Florence. Photo: Scala.

at an appropriate age for the work in Padua.) However, the second assumption must be far less secure, since it requires a form of extrapolation: a kind of guesswork as to how the relative immaturity of the same hand might be expected to reveal itself in other paintings through significant forms both of similarity and of difference. It must be particularly insecure when the extrapolation required is one that takes evidence from a workshop in which Giotto is presumed to have exercised a controlling function – the workshop responsible for the Arena Chapel frescoes – and uses this evidence to identify the painter's individual but earlier hand in projects where he might have been working as one of a team, if not under the direction of an older master. The problems of attribution of works to the early Giotto are considerable enough in the case of relatively modest panel paintings, such as the Badia polyptych (Plate 74) or *The Virgin and Child* formerly in Santa Giorgio alla Costa (Plate 75), both of which have been identified with works ascribed to Giotto by Ghiberti in the middle of the fifteenth century, but these problems must increase exponentially when major decorative schemes are in question.

There is indeed one decorative scheme of major importance with which the name of Giotto has traditionally been associated: the painting of the Upper Church of San Francesco at Assisi (Plates 76 and 77). Saint Francis died in 1226. By then the order of Friars Minor, which he founded in 1209, had become a powerful reforming movement. The church that was to commemorate Saint Francis was founded in 1228, at the time of his canonization, and it was consecrated in 1253. It was built high on the side of a steep hill, with a vaulted lower level and an upper church that was amply lit by tall, gothic windows. A Brief issued by Pope Innocent IV at the time of its consecration urged that the church should be decorated with outstanding works. In the major medieval cathedrals of the Italian cities, quality of decoration was typically secured by lavish expenditure on mosaics and marbles. The initial impression made by the Upper Church of San Francesco at Assisi is indeed one of richness and colour, but this effect is very largely achieved by painted decorations on plaster surfaces. Given what seems a considerable investment in painting on the part of the Franciscans, it is worth bearing in mind that the painting of a wall cost considerably less than mosaic inlay or patterning with polychrome marble.

The project as a whole was nevertheless very prestigious, and it is reasonable to assume that the most highly accredited painters would have been employed. The earliest decorations in the Upper Church were probably executed around 1280. Cimabue played a major part in this stage of the campaign. It seems likely that completion of the decorations in the nave and vault occupied various teams of artists over at least the next 25 years.

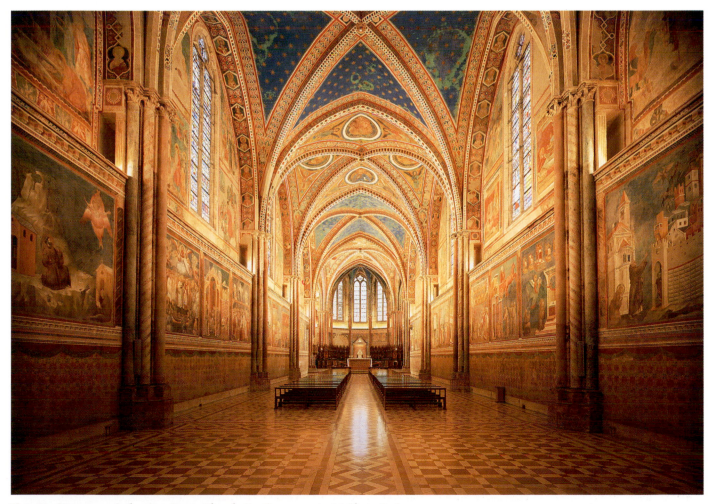

Plate 76 View towards the altar, Upper Church, San Francesco, Assisi. Photo: Scala.

Plate 77 Scheme of decoration of the nave, Upper Church, San Francesco, Assisi. Reproduced from John White, *Art and Architecture in Italy 1250–1400*, 1993 Yale University Press.

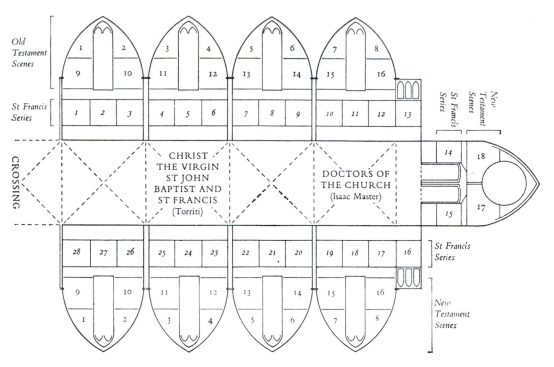

Key:

Old Testament Scenes
1 Creation of the World
2 Creation of Adam
3 Creation of Eve
4 Fall
5 Expulsion
6 Adam and Eve Labour [destroyed]
7 Sacrifices of Cain and Abel [destroyed]
8 Cain killing Abel
9 Building of the Ark
10 The Ark
11 Sacrifice of Abraham
12 Abraham and the three Angels
13 Isaac and Jacob
14 Isaac and Esau
15 Joseph lowered into the Well
16 Joseph and his Brethren

New Testament Scenes
1 Annunciation
2 Visitation [destroyed]
3 Nativity
4 Adoration
5 Presentation
6 Flight into Egypt
7 Teaching in the Temple
8 Baptism of Christ
9 Feast at Cana
10 Resurrection of Lazarus
11 Betrayal
12 Flagellation
13 Way of the Cross
14 Crucifixion
15 Lamentation
16 Resurrection and the Holy Women
17 Ascension
18 Pentecost

St Francis Series
1 St Francis and the Madman of Assisi
2 St Francis giving away his Cloak
3 Dream of the Palace
4 St Francis before the Crucifix in San Damiano
5 St Francis repudiating his Father
6 Dream of Innocent III
7 Confirmation of the Rule
8 Vision of the Fiery Chariot
9 Vision of Fra Leone
10 St Francis and the Demons at Arezzo
11 Trial by Fire
12 St Francis in Ecstasy
13 Institution of the Crib at Greccio
14 Miracle of the Spring
15 Preaching to the Birds
16 Death of the Knight of Celano
17 St Francis preaching before Honorius III

18 Apparition at Arles
19 Stigmatization
20 Death of St Francis
21 Apparitions of St Francis
22 Funeral of St Francis
23 Mourning of the Clares
24 Canonization of St Francis
25 Dream of Gregory IX
26 Healing of the Man of Herda
27 Resuscitation of a Woman
28 Liberation of Peter the Heretic

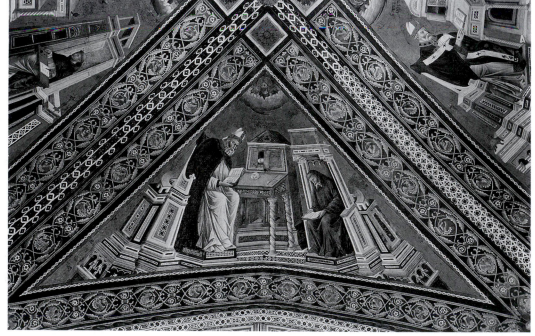

Plate 78 *Saint Jerome*, detail of *The Doctors of the Church*, *c.*1290–1300?, fresco, Upper Church, San Francesco, Assisi. Photo: Archivio Fotografico Sacro Convento, Assisi.

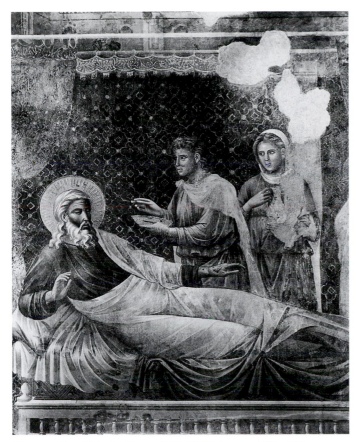

Plate 79 *Isaac Rejecting Esau*, c.1290–1300?, fresco, c.300 x 300 cm, Upper Church, San Francesco, Assisi. Photo: Archivio Fotografico Sacro Convento, Assisi.

Giotto's hand has been traced by various commentators in four separate areas of the Upper Church: in the vault over the nave at the entrance end, which is painted with figures of the Doctors of the Church (Plate 78); in scenes from the Old Testament painted on the upper register of one wall of the nave (Plate 79); in scenes from the New Testament painted on

the facing wall (Plate 80); and in a series of 28 scenes from the Life of Saint Francis, which occupy the lower register of the nave, running in sequence from one side wall to the other, and embracing two intermediate areas on the entrance wall (Plates 68, 81–84, 87–89, 91). The authorship of this last series in particular is a matter over which considerable controversy has raged.[24] The stakes are high. In White's words, 'The painting of the Legend of St Francis … is one of the supremely important events in the history not only of Italian but of European art.'[25]

No author seriously accords Giotto a controlling hand in all these areas of the painted interior. The extremes of opinion may be illustrated respectively by the assessments of Luciano Bellosi and of White. Bellosi stands as representative of the celebratory tradition of art-historical writing, which still reflects the power of Florentine idealizations, White as representative of an academic form of art history in which this power is consciously acknowledged and resisted.

Bellosi, writing in a popular Library of Great Masters series initiated in Florence,[26] ascribes to Giotto a hand in both the Old Testament and New Testament scenes, a controlling role in the execution of *The Doctors of the Church*, and primary responsibility for the conception and execution of the scenes from the Life of Saint Francis. Regarding the latter, Bellosi refers to 'Giotto and his team of painters'. Although he acknowledges that variations in quality of execution reveal the contributions of different hands in the various scenes of the Life of Saint Francis, Bellosi concludes that 'all the scenes … are distinguished by a unity of conception and outlook found only in the work of Giotto'.[27] Some support for this conclusion might seem to be provided by the testimonies of

Plate 80 *The Lamentation*, c.1290–1300?, fresco, c.300 x 300 cm, Upper Church, San Francesco, Assisi. Photo: Alinari.

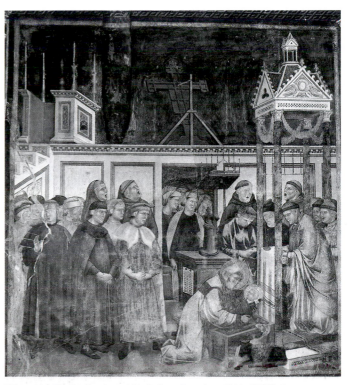

Plate 81 *The Institution of the Crib at Greccio*, c.1290–1305?, fresco, Upper Church, San Francesco, Assisi. Photo: Archivio Fotografico Sacro Convento, Assisi.

Ghiberti and Vasari (in the second edition of his *Lives of the Artists*), both of whom attribute the Saint Francis cycle unquestioningly to Giotto.

White, writing in the Pelican History of Art, attributes the Old Testament and New Testament scenes to more than one workshop of Roman artists, or of Tuscan artists under Roman influence, one probably including Jacopo Torriti and another led by a painter designated the 'Isaac Master', to whom White also accords responsibility for *The Doctors of the Church*. In White's opinion, the Isaac Master is not to be identified with Giotto. As for the 28 frescoes depicting scenes from the Life of Saint Francis, White draws on the work of a range of scholars in order to identify three separate if not always clearly distinct hands. These are the so-called 'Saint Cecilia Master' (identified with the author of an altarpiece from Santa Cecilia in Florence, now in the Uffizi), who is credited with the principal responsibility for the opening and three concluding frescoes in the cycle (Plate 82); the 'Master of the Saint Francis cycle', who is seen as bearing a specific responsibility for frescoes 2 to 19 (Plate 83); and a 'third controlling hand', seen as responsible for frescoes 20 to 25 (Plate 84). The title of Master of the Saint Francis cycle is deliberately chosen in order to leave open the unresolvable identity of the 'genius' who presided over the series as a whole. However, in a closely argued chapter on 'The Assisi problem', White concludes, albeit tentatively, with the 'currently unfashionable view' that the Saint Francis cycle is not by Giotto.[28] In White's account, then, there is no area of the decoration in the Upper Church at Assisi that is positively attributable to Giotto.

In the Lower Church there are further frescoes, which have also been connected with the name of Giotto. These are located in the Magdalen Chapel and in the north transept. Here the connection with the hand of the painter responsible for the Arena Chapel is unquestionable, since some of the scenes are clearly related to pictures of the same subjects at Padua (Plate 85). However, the versions at Assisi are generally of inferior quality to those at Padua. In particular, the contrast of dramatic effects achieved in *The Raising of Lazarus* and in *The Resurrection* in the Arena Chapel is largely missing from the scenes of the same subjects in the Magdalen Chapel at Assisi. On documentary grounds alone, the Magdalen Chapel is most unlikely to have been painted before the Arena Chapel, so that for this reason if for no other it would be implausible to regard paintings in the former as earlier works from the same hand as those in the latter. It is by no means impossible that Giotto himself executed some of the frescoes in the Lower Church at Assisi – White implies without quite stating it that Giotto may have been responsible for a series of single figures of saints – but it seems likely that subordinates who had worked closely with him on the compositions at Padua were responsible for the majority of the later versions at Assisi.

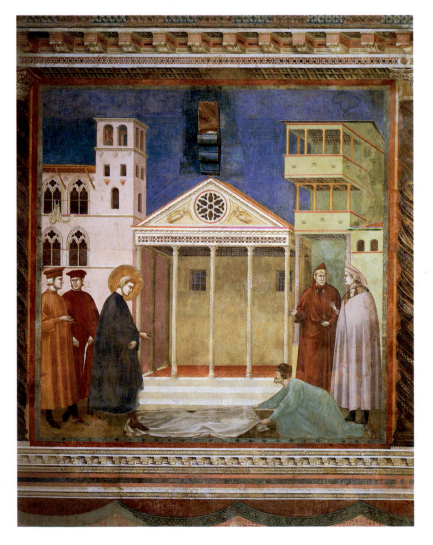

Plate 82 *Saint Francis and the Madman of Assisi* (*Homage of a Simple Man*), *c.*1290–1305?, fresco, 270 x 230 cm, Upper Church, San Francesco, Assisi. Photo: Scala.

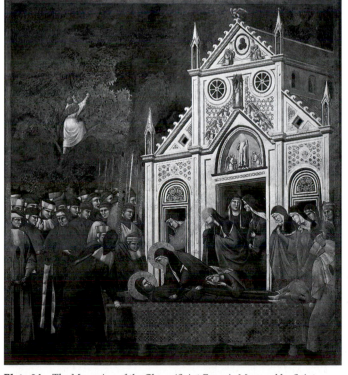

Plate 83 *The Preaching to the Birds, c.*1290–1305?, fresco, 270 x 230 cm, Upper Church, San Francesco, Assisi. Photo: Archivio Fotografico Sacro Convento, Assisi.

Plate 84 *The Mourning of the Clares (Saint Francis Mourned by Saint Clare), c.*1290–1305?, fresco, 270 x 230 cm, Upper Church, San Francesco, Assisi. Photo: Scala.

Although I have meant to draw attention to various problems that cluster around the name of Giotto, it is not my intention that this essay should become enmeshed in specific questions of attribution to individual names. It would be inconsistent with my earlier cautions on the meaning of authorship to allow these questions to dictate the concerns of argument. What can be said is that greater credibility attaches to White's combination of scepticism with open-mindedness about unresolved issues than to Bellosi's determination that the Great Master's authorship should be accepted wherever quality and innovation are discovered. To the extent that White's arguments are persuasive, I consider that further discussion of the Old and New Testament scenes or of *The Doctors of the Church* would tend to unbalance this essay. However, I believe that consideration of the Life of Saint Francis cycle must occupy a significant place in any essay surveying the work associated with Giotto's name, *even if the artist we know as Giotto played no part whatsoever in its execution.* I will attempt to justify this last statement in the course of the following section.

THE CYCLE OF THE LIFE OF SAINT FRANCIS

Even to a modern visitor to the Upper Church at Assisi, the ambition of the Saint Francis cycle is palpable and exciting. The continuous band of 28 scenes runs some three metres deep along each side of the nave, commencing at well over head height. The principal figures are almost life size. Particularly in the least densely populated scenes, the figure–ground relations are established with a clarity, breadth and grandeur for which there is little obvious precedent in previous medieval painting. A similarly powerful plastic effect is achieved in Pietro Cavallini's frescoed *Last Judgement* in Santa Cecilia in Trastevere in Rome, probably executed in the early 1290s (Plate 86). The importation of a powerfully modelled type of painting from late thirteenth-century Rome would certainly help to account for aspects of the appearance of the later decorations in the Upper Church at Assisi. In particular, it would explain an evident move away from the relatively flat and rhythmical style associated with Cimabue. However, so far as one can tell from the present condition of Cavallini's Roman work in fresco, the effect of plasticity is achieved as if by 'carving' the figures out of an indefinite and tenebrous ground by means of pronounced highlights. What is striking about the Saint Francis cycle is not so much the quality of modelling of the figures as the powerfully naturalistic effect that results from the modelling being established gradually and evenly within clearly illuminated fields – within fields, that is to say, that are lit, both broadly and directionally, as if by the light of the sun (Plate 87). It is possible that there were substantial Roman precedents for this last effect, but if so they have not survived.

The difference noted here is a crucial one for the subsequent development of painting, and *a fortiori* for any estimation of Giotto's role in that development. We should, therefore, be more precise about the nature and implications of the changes involved. Among the most remarkable painters of the late thirteenth and early fourteenth centuries, there were some, Cavallini and Giotto among them, who had clearly learned from looking at sculpture – not only at

Plate 85 *The Raising of Lazarus,*
*c.*1314–29, fresco, Lower
Church, San Francesco, Assisi.
Photo: Alinari.

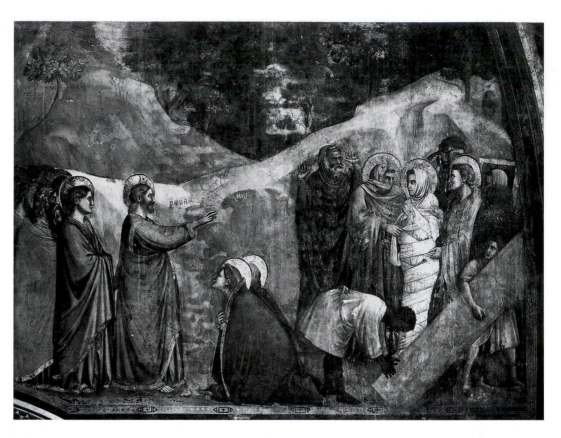

classical sculpture but also at the work of such recent and contemporary artists as Nicola and Giovanni Pisano and Arnolfo di Cambio. What seems to have interested the painters was the sculptors' ability to conceive a figure in the round so as to achieve the illusion of physical presence and animation. Specifically, both Cavallini and Giotto developed pictorial versions of those crucial resources that the sculptors brought together in the representation of the human figure: bodily volume (realized in smoothly modulated surfaces), expressive drapery (deployed to give rhythmic variations of surface and depth) and contained bodily torsion (conveyed in the dynamic variation of weight and mass).[29] For the most part the establishment of this illusion of bodily presence was

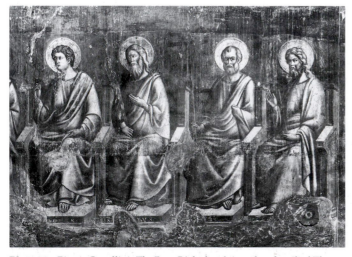

Plate 86 Pietro Cavallini, *The Four Right-hand Apostles*, detail of *The Last Judgement*, early 1290s?, fresco, Santa Cecilia in Trastevere, Rome. Photo: Alinari-Anderson.

achieved in painting by using strong chiaroscuro effects – marked light–dark contrasts – in order to model delineated figures (Plate 86).

However, if strong chiaroscuro serves to enhance sculptural illusion, it tends to do so at the expense of just those forms of spatial illusion that are the distinctive preserve of painting: effects of imagined depth and atmosphere. It was only when painters began to conceive of the pictorial ground not as dark and opaque but as primarily a transparent field of light that the figures occupying this ground could be accorded their full potential as vehicles of expression and feeling. This also required that those figures appear physically and spatially distinct, as they tend not to be within sculptural ensembles. In other words, it was only once the lessons learned from sculpture had been translated into painterly terms – specifically when pictorial intervals were opened up to the play of light and shadow – that the considerable gain in naturalism could be fully registered as a gain in expressive power. It needs to be emphasized that this was not simply a matter of achieving sculptural solidity in the representation of figures. For the full realization of painting's potential, what was required was that the pictorial ground be technically transformed into a believable and coherent *space*. The conditions and implications of this technical change are well explained by Paul Hills:

> If cast shadows link object and ambient in a spatial continuum, they also draw attention to the breathing spaces between one object and another. Like linear perspective, directional light divides as well as links, connecting figures or objects across spaces without visible touching. Released from the necessity of making physical connection, the painter of light uncovers spaces that are eloquent of mental or spiritual communion.[30]

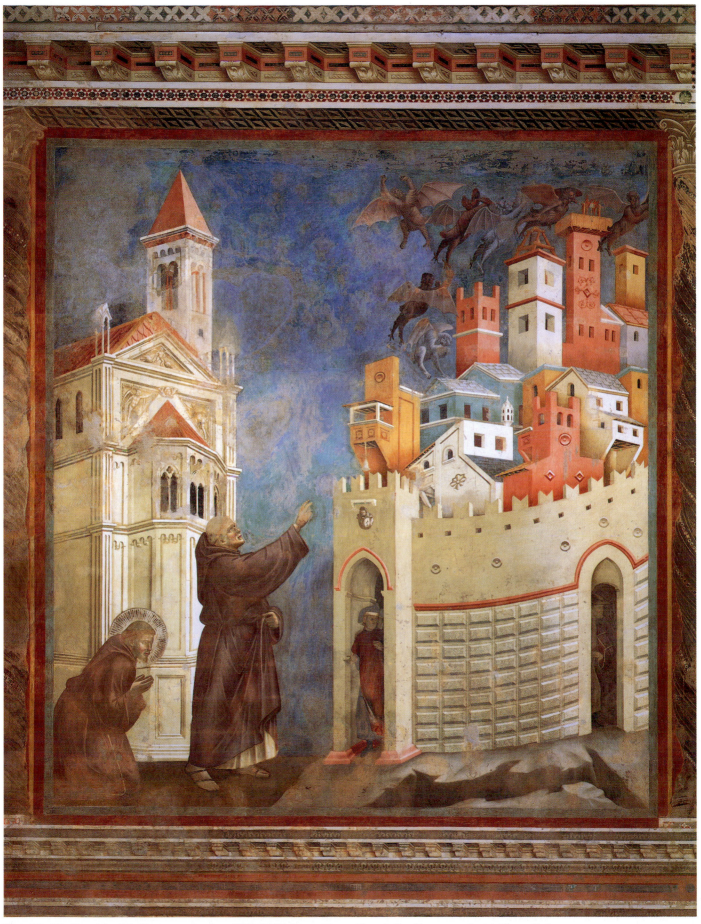

Plate 87 *The Exorcism of the Demons at Arezzo, c.1290–1305?*, fresco, Upper Church, San Francesco, Assisi. Photo: Scala.

In late medieval painting generally, figures tend to serve as vehicles of meaning in so far as they can be identified with specific concepts and narratives. Their pictorial function is to stand as reinforcing symbols for those concepts and as vivid mnemonics for narratives that are already established. However, if painted figures could be imaginatively perceived as occupying spaces – worlds – of their own, then they could be conceived of as individual and expressive vehicles for the very human content and values that those narratives are supposed to convey, that is to say, they could be identified with the *development* of meaning and not simply with its repetition. Around 1300 the potential status of painting was thus considerably advanced in the distribution of powers and priorities between words and images, the literary and the pictorial, which any civilized society must manage according to its own ends.[31]

To register the ambitious aspect of the Saint Francis cycle is to respond to the sense of this potential, and to recapture in imagination the moment of its realization. Even if there were not strong practical reasons for assuming that the frecoes in the lower register of the nave of San Francesco were painted last,[32] it would be hard to deny the sense of exciting stylistic change and expansion experienced as one views the lower level of decoration. In the scenes of the Life of Saint Francis a remarkable form of humanist naturalism found expression in art for what was perhaps the first time.

As Hills suggests, the broader change in question was one that the Franciscan movement had had a large hand in articulating, at least to the extent that the movement perpetuated the radical teachings of its founder:

> The Franciscan movement re-established the value of narrative rich in human incident. It seized upon imagery with which the believer could empathize. Whereas the events of Christ's life may have seemed remote in time and space, for Italians the events of Francis' life took place in familiar places and the memory of them lived on. All the more reason, therefore, for painters of the late thirteenth century to pursue a new degree of authenticity when they depicted those events in panel or fresco. And as Francis' life became mythologized as parallel to that of Christ, so the realism appropriate to the one close in time became expected in the rendering of its great foretype.[33]

It was implied earlier that there was a tendency within the Franciscan movement to favour painting as a practical form of decoration because of the potential it embodied. As Hills suggests, this tendency was consistent with the emphasis that Franciscan preaching placed on empathy and on imaginative visualization. In so far as this emphasis encouraged seeing and experiencing *for oneself*, it entailed a form of relaxation of authority. By the time the church at Assisi was built, the Franciscan Order had already split into the Spirituals, who remained loyal to the spirit of Saint Francis's vow of poverty, and the Conventuals, who found it in themselves to assent to the ownership of property. Unsurprisingly, the latter position had been endorsed by the papacy within four years of Saint Francis's death. But at its origins, the Franciscan movement had what we might now consider a revolutionary character, and revolutions produce changes in knowledge and in thought, notably in thought about the nature of human relations and about the determining conditions of human life.

Where there are channels permitting them to do so, such changes tend to make themselves felt in art. Their effects are not simply to be understood through the picturing of stories like the Life of Saint Francis, however necessary such pictures may be to the spread of those confusing myths that trail in the wake of revolutions and counter-revolutions. The deeper effects are experienced through changes in the techniques of art, and in the means by which the resources of representation are organized and deployed.

To recapitulate the argument in the paragraph above, it is not only a form of technical change that serves strongly to distinguish the frescoes of the lower register from those on the walls above (and notably from those devoted to depicting the Doctors of the Church, which, for all the brightness of colouring consequent on their good condition, appear artificial and archaic in their reliance on patterns and angles to create the sense of variety and depth). Rather, the technical development was a necessary condition and accompaniment of a larger achievement: the engagement of painting at a primary level in the establishment of a new imagery of the human. The cycle of the legend of Saint Francis at Assisi served as a kind of testing ground for painting's capacity publicly to articulate a revised conception of the human, a conception for which the legend – in Saint Bonaventura's telling of it[34] – was to furnish definitive imagery. White's claim concerning the importance of the Life of Saint Francis cycle thus acquires support not only from the subsequent history of painting, in which the cycle's innovations can be seen to be reflected, but also from the evident significance of those innovations as regards the cycle's own historical moment. In a limited sense, the narrative scenes serve to propagandize the self-image of the Franciscan movement at the close of the thirteenth century. At a deeper level, however, the work at Assisi provides a vivid practical context in which the technical developments that determine how figures and figure–ground relations are represented in painting may be connected to the developments in religious and philosophical thought that decide how people see themselves and each other. These connections will not be straightforward. Changes in people's social and psychological attitudes and beliefs are complex and hard to track, and, as already said, they cannot simply be captured in pictures. However, if art is made of forms and colours and figures and spaces, it is also made with ideas and beliefs. When the latter change, so must the character of the former.

This is perhaps the moment at which to recall Rivera's apparently bizarre claim that 'Giotto was a propagandist of the spirit of Christian charity, the weapon of the Franciscan monks of his time against feudal oppression.' We may now be able to reformulate that claim in the following terms. Thirteenth-century Italy saw significant forms of change in thought about the social and religious ordering of human relations. The Franciscans were not the only religious order involved in articulating the changes in question, but these changes were certainly given a distinctive and comprehensible cast in the teachings of Saint Francis and through the movement that he inspired. In view of the great expansion of the Franciscan Order and the number of new churches for which it was responsible, it would be surprising if it had *not* had a considerable effect on the course of art. In

fact, the order appears to have been unusual in the degree of practical opportunity and encouragement it afforded to the development of painting. It also provided painting with an appropriate form of imagery. However, we should not assume that the effects of fundamental social and religious changes will simply be readable out of the illustrative content of pictures, whether by Giotto or by anyone else; we should rather look for these effects in the ways in which such pictures are conceived, organized and produced. Whether or not we can place Giotto at Assisi at the appropriate moment, when we consider the broad change in painting with which his name is reasonably associated, it would seem perverse *not* to take these other changes into consideration.

GIOTTO AS A 'FRANCISCAN' PAINTER

There remains, then, the specific issue of Giotto's involvement in the Saint Francis cycle – an issue that can now be seen as crucial, bearing as it does on the possibility that the painter's early career may be explicitly linked to the expansion of the Franciscan movement as a whole. The problem of the authorship of the Saint Francis cycle is connected to the problem of its dating, which has been variously set between the 1290s and the 1330s.[35] For the purposes of the present essay, it can be asserted that a date later than *c.*1305 would appear to rule out Giotto's involvement, since it seems inconceivable either that he could have been working on both the Saint Francis cycle and the Arena Chapel decorations during the *same* period, or that the eclectic and exploratory frescoes in the Upper Church at Assisi could plausibly be *later* productions by the same artist whose Paduan cycle appears so unitary and so confidently established.

On the other hand, there seems no reason to assume that an earlier date automatically allows us to identify the Master of the Saint Francis cycle with Giotto, not, at least, unless our investment in the myth of Giotto is so substantial that the cycle appears inconceivable without him. Where the power of the myth goes unchecked, there is a strong danger of arguments becoming circular. Various assumptions – concerning, respectively, the date of Giotto's birth, the dating of the Saint Francis cycle, the authorship of the cycle and the nature of the development of Giotto's style – may all appear to support one another, when in fact none of them has been independently established and tested. One clear example of such circular argument is the claim made by Bellosi that the Saint Francis frescoes must be attributed to Giotto on the grounds that they are 'distinguished by a unity of conception and a consistency of outlook found only in the work of Giotto'.[36] In this case the *assumption* that the Saint Francis Master and Giotto are one and the same has *already* served to rule out the other strong – if so far anonymous – candidate for the very distinction that is supposed to be in question: the Saint Francis Master himself. In other words, the cycle must be by Giotto, for Bellosi, because it cannot be allowed that a pictorial revolution of such an order could be achieved by any artist other than the gifted and congenial individual cited by Dante and Boccaccio, let alone by the collective efforts of a largely unrecorded, shifting and still unidentifiable collection of semi-itinerant artisans.

As a counter to these various assumptions – or rather in order to restrain their tendency to become mutually reinforcing – I propose to reverse the priorities accorded to work and author respectively and to suggest the following hypothesis. I propose that, rather than the Saint Francis cycle being inconceivable without the presiding genius of the presumably young Giotto, the form of painterly realism we associate with the mature Giotto stands inadequately explained – it stands without definite technical and psychological grounds – unless we accord the experience of the Saint Francis cycle a strong role in its formation.[37] Although the forms of innovation that we have seen at work in the cycle may not be realized in a style that can be closely identified with that of the Paduan Giotto, the humanist naturalism for which the cycle is a definitive vehicle is certainly continued in the Arena Chapel frescoes, as in little other surviving work of so early a date. (It is not until the next decade at the earliest that a comparable form of naturalism appears in the work of other artists than those of Giotto's immediate circle, and when it does, as in the work of Ambrogio and Pietro Lorenzetti, the dependence on Giotto's example remains clear.) Thus, rather than relying on dubious stylistic evidence and assumptions to establish Giotto's presence in Assisi, I propose that we acknowledge the presence of an 'Assisian effect' – rather than an explicitly Assisian *style* – in Giotto's Paduan frescoes, and then ask how that effect might be explained.

In referring to the 'experience' of the Saint Francis cycle, I mean to allow for the real possibility that the Giotto we see at work in the Arena Chapel is someone who had responded fully and imaginatively to work he had had no hand in making. An early chronicle, Riccobaldo Ferrarese's *Compilatio cronologica* of *c.*1312–18, records the existence of work by Giotto at Assisi, although Riccobaldo Ferrarese does not mention the Life of Saint Francis, which, given the prestige of the project, he might have been expected to specify if that was the work he had in mind. It is thus quite possible that Giotto was in Assisi working on another commission during or after the painting of the Saint Francis cycle and that he saw the cycle at first hand, although not as a contributor. As we have seen, Ghiberti and Vasari do indeed associate Giotto with the work in the Upper Church, San Francesco. However, it is worth reiterating that they were Florentines, and moreover Florentines who were writing during a period of intense cultural rivalry between different city states. Responsibility for the Saint Francis cycle would have been an impressive feather in any cap. The claims of Bellosi's text serve again to remind us that concepts of achievement and influence that are at work in the art history of our own day are still marked by powerful fixations with renewal and progress, which were established by writers in Florence in the fifteenth and sixteenth centuries. Among the consequences of these fixations was a tendency severely to underestimate Roman contributions to the renewal of art. To this day, debates about attribution are effected by the operations of national and local interests. The narrowing of the canon of Giotto's *oeuvre* has been an enterprise to which people writing in the English language have made many of the most emphatic contributions.

It seems that, in any serious attempt to identify the Paduan Giotto as a significant author of the Saint Francis cycle, we must meet two substantial conditions. First, we will need to guarantee our own freedom from the persuasive effects of Florentine propaganda, and, second, we will need to take into consideration the arguments of Richard Offner and subsequent observers, who maintain that the stylistic differences between the cycle in Assisi and works that are definitely attributable to Giotto in Padua and Florence are far more telling than their similarities. Among the disparities noted by Offner (in his influential article 'Giotto, non-Giotto') are a tendency in the Saint Francis cycle for figures to be treated more sculpturally than they are by Giotto, and to be more starkly isolated from their spatial grounds. Giotto, by conceiving of light itself as the medium by which form is modelled, both softens the internal contours of his figures and integrates these figures more successfully with their spatial and architectural surroundings (in this connection, compare Plates 81 and 93). On points of detail, Offner notes consistent differences between Assisi and Padua in the treatment of facial features, hands, drapery and haloes. These remain convincing arguments against the identification of the Paduan or Florentine Giotto as the author of the cycle in Assisi, or even as a significant agent in the establishment of its style.

On the other hand, it is certainly true that the most likely means by which experience of the Saint Francis cycle might have come to invest Giotto's work in Padua is if he had had some hand in it. Offner's perceptive observations on the respective means of relating figures to spatial ground are quite consistent with the suggestion that Giotto responded to the new form of pictorial naturalism explored at Assisi and that he went on to develop the possibilities involved in ways that led to more coherent and expressive forms of composition in Padua. If Giotto had indeed made his mark in Assisi as a relatively young man, that would help to explain what looks on the evidence like a continuing pattern of Franciscan commissions extending over several years and to several different cities. The panel of *The Stigmatization of Saint Francis* now in the Louvre was painted for the principal Franciscan church in Pisa; Giotto decorated two chapels in the Franciscan church of Santa Croce in Florence, one of them, as we shall see, with scenes from the Life of Saint Francis; and Riccobaldo Ferrarese refers to work by Giotto in the churches of the Friars Minor at Rimini and Padua.[38]

My suggestion, then, is that we should accept a relatively early date for the Saint Francis cycle, say in the later 1290s, which would be in keeping with the evidence of a strong Roman presence in the decorations as a whole, and further that we imagine a Giotto no older than his twenties developing as an artist with some practical experience of that project, although not as one of its controlling agents. That we cannot definitely find Giotto's 'hand' at work in Assisi no more rules out this possibility than it would rule out the possibility that Taddeo Gaddi served as an assistant in Padua if we failed definitely to separate out his hand from the unifying impression of Giotto's style in the Arena Chapel. If this proposition entails that the development of Giotto's style and prestige would have had to be rapid between the supposed period of work in Assisi and the main work of the Arena Chapel frescoes, that would seem entirely consistent

with the view implied above, that for anyone with the practical and intellectual skills to appreciate it, the Saint Francis cycle represented an immediate enlargement of the potential of painting and of the field of its effectiveness. It would also be consistent with what we know of Giotto: that he was someone who would have learned fast. Even if we discount the legend of his wit, the Paduan work we *can* securely attribute to him is sure evidence of a remarkable and responsive intelligence.

If Giotto is thus to be associated with what has been described as a quasi-revolutionary movement, there is one caveat that must be entered. It is suggested above that the new ideas generated by the Franciscan movement during the early thirteenth century were necessary (although not sufficient) causes of the important changes that took place in painting at the end of that century and during the first three decades of the next. It does not follow, however, that we would be justified in conceiving of Giotto as a person with sympathies that were revolutionary in the modern sense of the term. The Giotto who makes his mark in contemporary Italian records is not so much a painter as a man of business. White offers a concise summary:

> He made his will in 1312, and in 1313 a claim for the return of household property in Rome implies a longish but not very recent stay in that city. In 1314 six notaries were pursuing debtors in the courts on his behalf. Various dealings in land are recorded of him, and he also hired out looms. The latter was a standard way of putting money to work without infringing the ecclesiastical prohibition of usury [the sin of lending money for interest], and work it certainly did, at a rate of about 120 per cent a year![39]

Changes in art are no doubt connected in powerful and complex ways to changes in social and religious attitudes, but when we think about the nature of these connections, it is important that we try to put our modern prejudices aside.

THE STIGMATIZATION OF SAINT FRANCIS

Three pictures of *The Stigmatization of Saint Francis* are associated with the name of Giotto and attributed to various stages of his hypothesized career with varying degrees of certainty as to the extent of his authorship. Discussion of these three images will help, first, to give practical exercise to some of the issues discussed so far, and, secondly, to extend the account of Giotto's work past the supposed periods of work in Assisi and Padua, to address what are generally considered later commissions in Florence.

Two versions of *The Stigmatization* have been mentioned already. The first (Plate 88), in fresco, forms part of the section of the Life of Saint Francis from which the hand of the Saint Francis Master is deduced by White and others. It occupies a position on the nave wall of the Upper Church at Assisi. The second is the panel painting made for San Francesco in Pisa and now in the Louvre (Plate 69). This is inscribed with Giotto's name but judged by White 'for the most part no more than a workshop product' – a judgement that other scholars have contested.[40] The third version of *The Stigmatization* is another image in fresco. It was painted as part of a commission from the Bardi family, one of the wealthiest

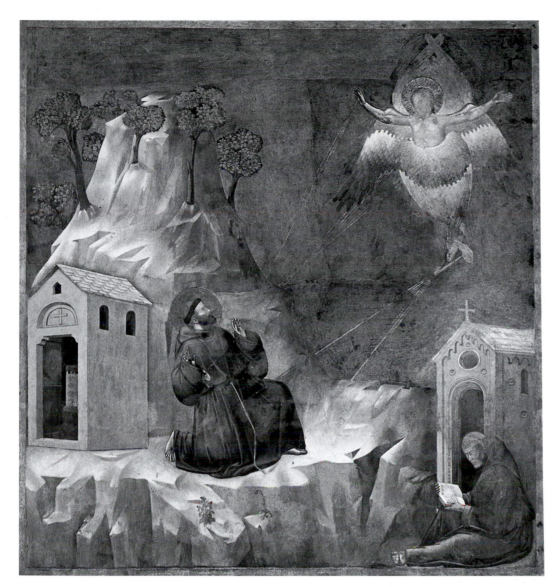

Plate 88 *The Stigmatization of Saint Francis*, c.1290–1305?, fresco, 270 x 230 cm, Upper Church, San Francesco, Assisi. Photo: Scala.

banking families in Florence, and is situated on the entrance wall of the Bardi Chapel in Santa Croce, Florence (Plate 67).

For many writers, Bellosi included, the Louvre panel represents conclusive evidence of Giotto's responsibility for the Saint Francis cycle. Not only is its principal scene clearly based on the fresco of the same subject in Assisi, but the three smaller scenes at the base of the panel echo three other scenes from the central section of the Saint Francis cycle: *The Dream of Innocent III*, *The Confirmation of the Rule* and *The Preaching to the Birds*. For writers of this persuasion, given the closeness of the connection of the scenes on the panel with the Assisi frescoes, the inscription of Giotto's name on the Louvre panel is the glue that conclusively sticks that name to the Saint Francis cycle.

There are various objections that can be raised to this position, however. White's downgrading of the Louvre panel to the status of a workshop product does not really count among them, since it would be a commonplace event for such a product to be based on an earlier design by the presiding master, particularly if that design formed part of a prestigious project. More to the point is the observation that the Saint Francis cycle achieved immediate prominence on its

completion, and that echoes of its themes and treatments occur in many works that are certainly not attributable to Giotto. It would not be surprising if reference to *The Stigmatization* at Assisi were explicitly required in an altarpiece commissioned for a Franciscan church, as the Louvre panel was. In addition, the resemblance between the Louvre panel and the Assisi fresco is not really close enough to establish conclusively that both derive from a single drawing, or even from drawings by the same hand.

Of course, in relating a fresco to a panel painting we are comparing works produced under very different technical conditions and with very different technical resources. We are also comparing works that may have altered in different ways with the passage of time. Much of the dramatic effect that we observe in the panel is due to the silhouetting of the dark figure of the winged Christ against the brightness of the burnished gold ground. This reverses the tonal relations of the fresco at Assisi, in which Christ's pale pink wings stand out from the deep blue of the sky. The gold ground could not have been used in a fresco, nor could the soft but opaque blue of the fresco have been easily achieved with tempera on panel. It is possible, though, that the dark wings of the panel

Plate 89 *The Renunciation of Worldly Goods,*
*c.*1290–1305?, fresco, Upper Church, San Francesco,
Assisi. Photo: Scala.

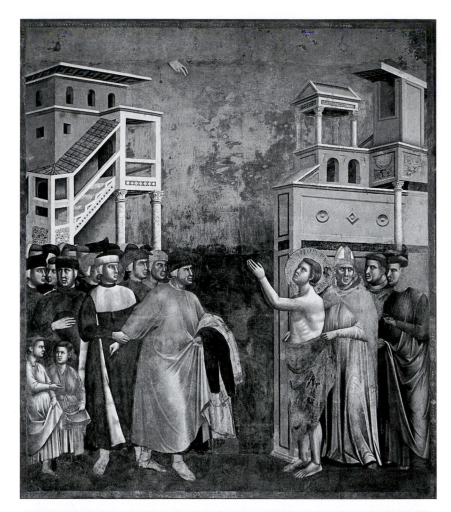

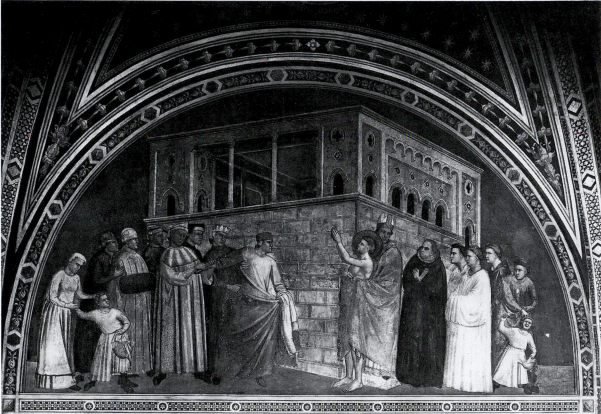

Plate 90 Giotto, *The Renunciation of Worldly Goods*, *c.*1315–20?, fresco, Bardi Chapel, Santa Croce, Florence. Photo: Alinari.

were originally silver. The Louvre painting is very large for a single-panel work, and differences of scale are therefore not as considerable as they tend to be when frescoes and panels are compared. However, in trying to relate the two compositions, we still have to make allowance for considerable differences in format, and also for the different original sitings of the two works, respectively as one of a band of narrative scenes on the walls of a nave and as a single image set over an altar.

A more straightforward comparison can be made between the frescoes in Assisi and Florence, although before drawing conclusions even in this case we will need to bear in mind that the scene in the Bardi Chapel is set over the entrance of a small chapel, and that the walls of this chapel were whitewashed in the eighteenth century, repainted after the whitewash was removed in the mid nineteenth century, and cleaned of repainting in the mid twentieth century. There is, however, general agreement that this is a work that can be attributed to Giotto. There is also general agreement that it was painted later than the Arena Chapel, and probably after 1317.

Apart from the points already made about differences in media and format, I will draw attention to a single related element in the three images: the treatment of the figure of the saint himself. In the Louvre panel, the pose is close enough to that in the fresco in Assisi to suggest, first, that the one image is derived from the other, and, secondly and for our purposes more significantly, that no critically interesting transformation has taken place in the process of derivation. The figure in the panel occupies a greater proportion of the picture surface, as one might expect given the different format, and the finer medium of tempera on panel allows for an increase in detail and characterization, but there is a corresponding loss of the imaginative depth and complexity that enlivens the Assisian fresco.

If we now turn to the Florentine version of *The Stigmatization*, we can see that, whilst there is still great enough similarity to the earlier fresco to suggest some dependency, this dependency is of a very different order. The subject is repeated in the essentials of its organization, but is dramatically reinterpreted in its effects. The most significant change is that the relation of the upper to the lower torso has been transformed by exactly reversing the position of the legs. The result of this change is not only to bring tension and animation to the figure itself, but also to shift its axis relative to the vision of the crucified Christ, so that the vision appears to project from the picture plane and to hang in space, as it were before our eyes. By means of this formal manipulation, the psychological content of the represented scene is brought vividly home to the imaginative experience of the viewer.[41]

Skill in this particular respect and of this order is to be found at work throughout the decorations of the Arena Chapel. If we can talk sensibly of a Giottesque style, this ability to generate psychological complexity by means of formal adjustments is certainly one of its most characteristic and telling achievements. This particular form of skill is certainly not discernible in any fully developed form in the Saint Francis Cycle at Assisi, and it is not noticeable at all in the Louvre panel, whatever other virtues that work may possess. These are not entirely secure grounds on which to dismiss the Saint Francis cycle or even the Louvre panel from the canon of Giotto's works. Rather, they are grounds on which to admit the Florentine fresco, while reserving judgement about the two other versions of *The Stigmatization*.

THE BARDI AND PERUZZI CHAPELS

In 1450 Ghiberti recorded the then accepted fact that Giotto had decorated four chapels in Santa Croce. Two sets of frescoes survive: in the Bardi Chapel, which is painted with scenes from the Life of Saint Francis, and in the Peruzzi Chapel, which is painted with scenes from the Lives of John the Baptist and John the Evangelist. In both cases, Giotto was working for members of wealthy Florentine banking families. Both sets of frescoes were once covered with whitewash. In addition, two of the six principal scenes in the Bardi Chapel were substantially obliterated when tombs were built against the walls. This damage notwithstanding, the Bardi Chapel frescoes permit two observations that can be taken to be supportive of the two principal hypotheses of this essay: first, that Giotto may have worked at Assisi in a subsidiary capacity, and, secondly, that the key to the identification of a Giottesque style lies in the formal organization of his work, and in the distinct forms of psychological complexity that the organization enables.

The first observation, already touched on in discussion of *The Stigmatization of Saint Francis*, concerns the relationship between the remaining narrative scenes in the Bardi Chapel and the Assisian versions of the same subjects. In no case do the frescoes in the Bardi Chapel repeat the compositional forms of the earlier Saint Francis cycle. In each case, it seems that a quite different intelligence has decided the means of spatial organization, the ordering of figure groups and the relation of figures to architectural settings. On the other hand, in each case there is some echo of the frescoes in Assisi, most clearly in the poses and gestures of principal figures. For example, in the two versions of *The Renunciation of Wordly Goods* there is clear similarity in the central and opposed figures of the naked Saint Francis and his father (Plates 89 and 90). Indeed, the later image of the saint gives something of the impression of a formula being repeated. However, this similarity at the centre of the two compositions serves only to underline their marked dissimilarities in overall character. Even when allowance is made for the difference of format and viewpoint, *The Renunciation of Worldly Goods* in the Bardi Chapel appears both more lucid in its organization and far more sophisticated in its evocation of the dramatic moment. On the one hand, the looming building serves to concentrate the focus on the central episode, whilst on the other, the children misbehaving at either side serve both to emphasize the edges of the pictorial space and to direct a form of sympathetic insight towards the rejected father. The suggestion made here is not that a 'mature' Giotto was reusing earlier compositions of his own. On the contrary, the similarities may simply have been dictated by the patron. It would, after all, have been thought quite appropriate to reproduce standard Franciscan iconography in an important Franciscan church. What seems more significant is that the relationship between the two sets of frescoes seems to imply

Plate 91 *The Apparition at Arles*, c.1290–1305?, fresco, Upper Church, San Francesco, Assisi. Photo: Scala.

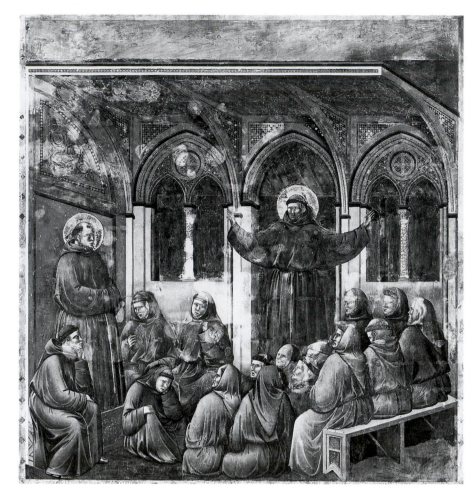

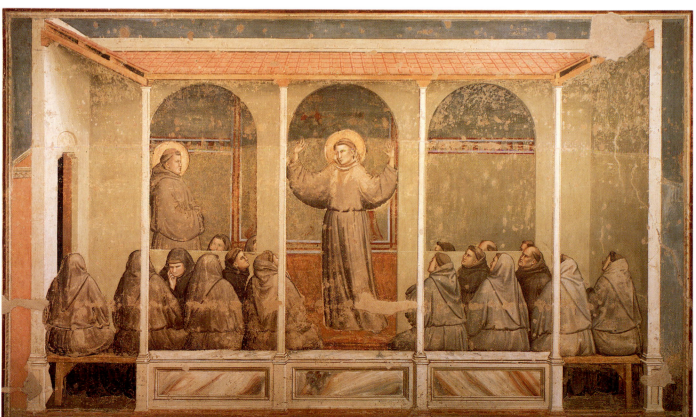

Plate 92 Giotto, *The Apparition at Arles*, c.1315–20?, fresco, c.280 x 450 cm, Bardi Chapel, Santa Croce, Florence. Photo: Alinari.

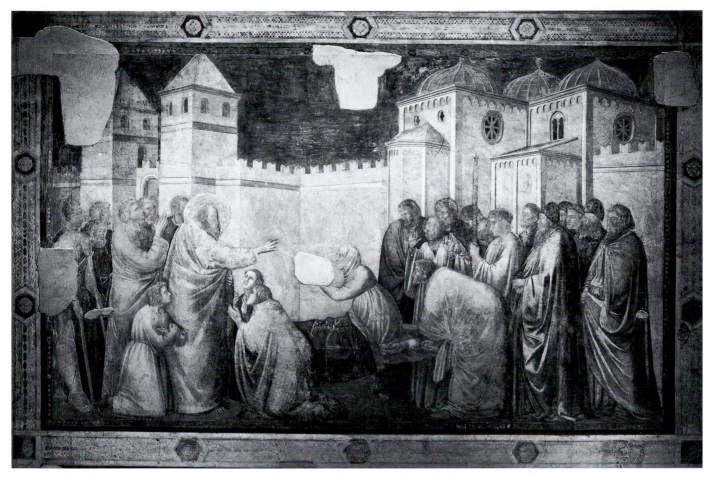

Plate 93 Giotto, *The Raising of Drusiana, c.*1325, fresco, *c.*280 x 450 cm, Peruzzi Chapel, Santa Croce, Florence. Photo: Scala.

both an informed acquaintance with the earlier cycle *and* the maintenance of an intelligent critical distance from it.

The second observation, following on from this, is that in each case Giotto's tendency has been to rationalize and to clarify the pictorial space and content relative to the literal surface of the wall: to 'simplify' the geometry of the compositions, the better to express the significance of their content. This tendency can be seen most clearly at work in the later version of *The Apparition at Arles.* Whilst a 'memory' of the earlier, Assisian version is, as it were, loyally preserved in the version in the Bardi Chapel, it is not easy to believe that the taste at work in the latter could even in an early stage of its development have conceived the dense and busy gathering of the former (Plates 91 and 92).

The majority of the work in the Bardi Chapel was done in fresco. The scenes in the Peruzzi Chapel were painted for the main part *a secco*, most of the paint being applied on dry plaster, which had been laid on over areas each corresponding to half of an entire scene. The paintings are badly abraded and there has been considerable loss of colour and detail. What is still evident, though, is the breadth and clarity of the compositions, which cover individual areas substantially larger than those of the Arena Chapel narratives. In the scene of *The Raising of Drusiana* in particular (Plate 93),

it is possible to see gathered together the various components that it was Giotto's achievement to synthesize into a transmissible style: the gravity and plasticity of figure forms, which was largely developed in late thirteenth-century sculpture and in Roman painting; the luminosity and breadth of pictorial space, which is so notable a feature of the Saint Francis cycle at Assisi; and the rational and architectural organization of pictorial spaces, which can be seen developing in Giotto's own work in Padua.

Giotto here succeeds in what was to remain a significant test of ambitious painting for the next two centuries: the lucid organization of complex figure-groups within a large space defined by logically continuous and varied architectural forms. It has been argued in this essay that the components of Giotto's mature style derive not simply from Florentine precedents but from a number of centres throughout Italy, Rome and Assisi foremost among them. Yet, at least in terms of the achievement represented by *The Raising of Drusiana*, it seems appropriate to recognize Giotto as the founder of a distinctly Florentine tradition. On the evidence of surviving works, the next significant development in the techniques involved was, indeed, to be made in Florence – in Masaccio's work on the Brancacci Chapel. But this was not to be for another 100 years.

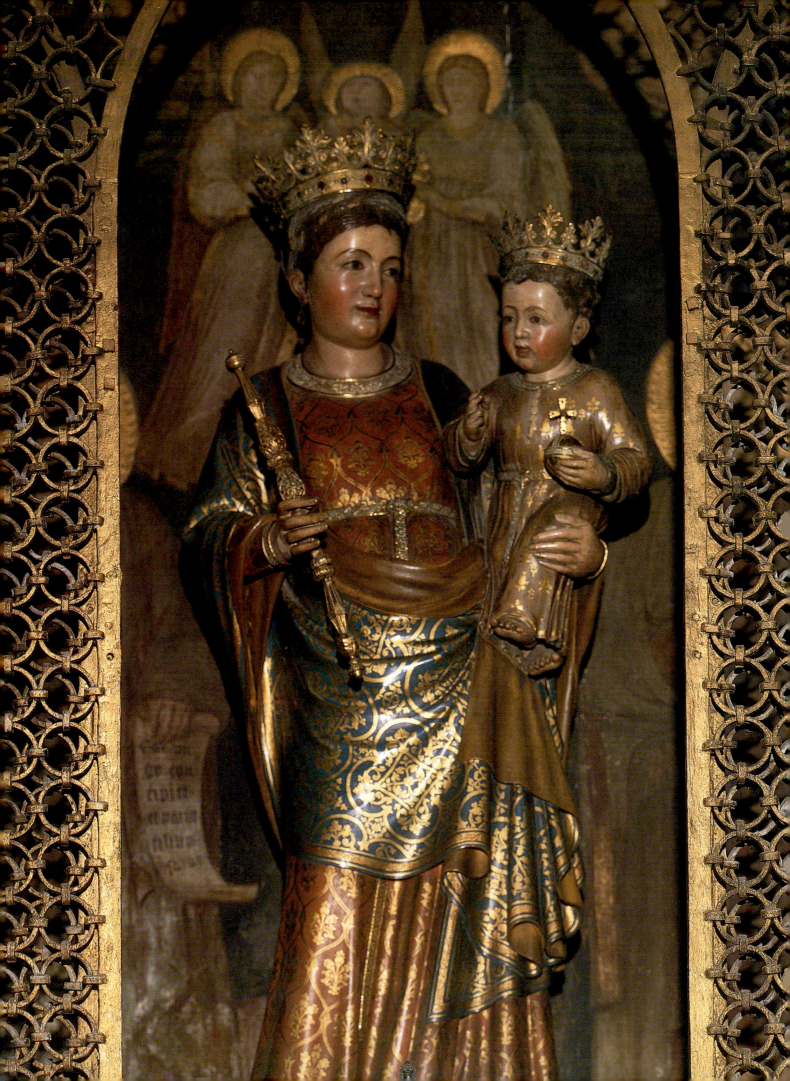

The arts of carving and casting

SCULPTURE THEN AND NOW

Our modern idea of sculpture comes from the late sixteenth-century academic theorists and their successors who divided design into painting, architecture and sculpture – the latter umbrella term including modelling, casting and chasing[1] techniques. Within the traditions of the academies of art which valued fine art so highly, sculpture came to signify statuary in marble and bronze, usually of monumental scale. Such an approach is enshrined in key texts like the magisterial analysis by John Pope-Hennessy, *Italian Gothic Sculpture* (first published 1955), which deals with large-scale pieces in bronze and stone. In this essay, however, I shall be using the term to take in the great range of materials and techniques involved in three-dimensional designing in this period, such as silver, gold, jewels, iron, bronze, stone, clay, wood, bone, enamel, paint, leather, cloth and stucco.

One method of studying sculpture associated with these academic definitions has been to trace the careers of artists whose biographies are retrievable – like Tino di Camaino or Arnolfo di Cambio – considering the development of their artistic ideas and analysing their influence on pupils and devotees. This approach has great strength in offering a chronological sequence, but it is problematic in other ways. Documentary evidence is available only for a handful of sculptors, most of whom were peripatetic. Studying them takes one away from Siena, Florence and Padua and, I would argue, away from the diversity of scale, functions, media and techniques embraced by the frameworks in which sculptures were produced in the fourteenth century.

To bring out this variety of carving and casting, we need to look at fourteenth-century meanings for sculpture, and at the institutions which controlled the teaching and production of works of art. Such an approach involves considering the differing strengths of the three cities in terms of their expertise, and the wide range of functions assigned by different groups of patrons to pieces of sculpture. It also involves examining the interplay of the skills and ambitions of individual artists with the powers of their paymasters, their audiences and their fellow guildsmen. The result, admittedly, is less coherent chronologically, but arguably obtains a less anachronistic picture of sculpture during this time.

If modern academic attitudes have given us selective notions of fourteenth-century sculpture in one way, the accidents of time have skewed them in other ways. The ephemeral creations of sculptors – say, for religious drama – have not survived. Many pieces made from precious materials have been broken and melted down, and much wood-carving has disappeared. Sculpture for church adornment and furnishing, as well as the individual or family tombs attached

to churches, have survived relatively better than the sculpture belonging to civic buildings and palaces or fountains, bridges and city gates. The entire range of portable pieces for domestic use (like carved chests and other ornamented furniture) is missing. Of the very small items, coins, medals and seals are quite well represented because they were preserved by institutions, while things associated with private persons (like jewellery, bookbindings, the ornament of clothes and armour) have been dispersed. We tend to be left with the monumental institutional sculpture in durable but not precious materials. And, consequently, the power of sculpture to dominate a grand public space – its impressiveness and strength – is emphasized.

So the values of the academies of art have joined with the continuity of certain institutions like the Church and the relative durability of stone and bronze to support a restricted definition of sculpture. Something of the very different values pertaining in the fourteenth century is revealed when we consider the extraordinary sums spent on a pair of gold and silver portrait busts of Saints Peter and Paul. Pope Urban V had them made by two Sienese goldsmiths, Giovanni Bartolo and Giovanni di Marco Argentario, in 1368–69 at a cost of 1336 florins.[2] They were burned in the 1799 fire at Saint John Lateran in Rome, and we only know their appearance through engravings (Plate 95). These sculptures cost eight times what the Capitani of the Compagnia della Misericordia in Florence paid Alberto Arnoldi in 1364 for his three greater than life-size marble statues of the Virgin and Child and two angels. These statues survive in superlative condition to this day in their original location on the altar of the Loggia del Bigallo (Plate 96).[3]

How did people in this period term 'sculptors'? Documents named casters and carvers in ways which emphasize the diverse materials and techniques in use, rather than the figurative or formal powers which we probably think of as uniting them. These men were called goldworkers or woodworkers (*orefici, lignaiuoli*) or masters of gold, wood, iron and stone (*magister lapidum, maestro di legname, maestro di ferro, maestro di pietra*). Sometimes techniques are to the fore with a 'master of cutting or sculpting' (*magister pro celatura seu schulptura*), and only rarely are figurative skills in evidence with a 'master of engraving figures' (*magister intagliatori figurarium*). References to a 'sculptor' are very much in the minority.[4]

How did contemporaries consider the arts of sculpture in general? Sculpture tended to blend with building, and figurative categories were seen as being on a continuum to which ornament also belonged. Scholars called sculpture a mechanical art, which was, as the Florentine writer Brunetto Latini described in his *Livre de trésor (The Book of Treasures)*,

Plate 94 (Facing page) Rainaldino di Pietro da Francia, *Virgin and Child*, detail of tabernacle for the Chapel of Mater Domini (Plate 120). Photo: Alessandro Romanin.

Plate 95 Giovanni Bartolo and Giovanni di Marco Argentario, engraving of reliquary busts of Saints Peter and Paul, 1368–69, Saint John Lateran, Rome. Reproduced from Josephus Maria Soresinus, *De Capitibus...Apostolurum Petri et Pauli, in...Lateranensi Ecclesia Asservatis Opusculum*, 1673, Rome, British Library 658.a.7, reproduced by permission of the British Library Board.

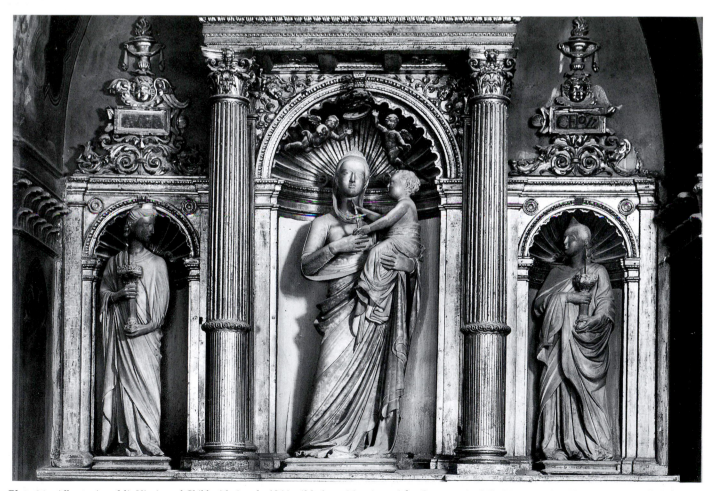

Plate 96 Alberto Arnoldi, *Virgin and Child with Angels*, 1364, gilded marble, altar of the Compagnia della Misericordia, Florence (now called the Loggia del Bigallo). Photo: Alinari.

'the skill in which one always works with the hand and the feet, like the tailor, the draper, the shoe-maker, and the other crafts which are necessary to the life of man'.[5] These mechanical arts were so called because they were taught by practice and did not entail theory – unlike the liberal arts – and hence have sometimes been called the practical arts. Within these arts, the writers of the great medieval encyclopaedias like Hugh Saint Victor and Vincent of Beauvais subsumed crafts that entailed working with paints, stone, wood, clay and stucco under *architectonica* or architecture; they treated casting and engraving metal as a branch of *fabrilis* or smithing.[6] The division of sculptors into different guilds depending on the materials and techniques with which they worked followed this line of reasoning.

Fourteenth-century viewers and artists wrote no art criticism. A scholar like Petrarch could use sculpture as an example of something which gave pleasure, but while the reasons given for pleasure are interesting to note – that sculpture is skilled and life-like – he gives no further details.[7] Contracts and accounts of disputes over quality are unhelpful, as they simply state judgements of relative beauty or record decisions. Theologians had something to say about art, but it was specifically about religious art. It is, for instance, helpful to know of the dictum of Pope Gregory I (590–604), repeated by a fourteenth-century Italian cleric Fra Giovanni Dominici, that art is the book of the illiterate, which should teach, delight and move.[8] (Speaking of an image of Christ, Gregory had stated that it could inflame spectators with love and delight their minds.) These ideas should be held in mind to differentiate the didactic, the entertaining and the touching elements in the largely religious sculpture surviving from the fourteenth century.

Only rarely would the figurative skills of sculptors be highlighted in ways which relate to modern notions of an artist. The most emphatic examples of this happening known to me are Florentine. First, there is the way 'sculpture' and 'painting' were shown side by side as mechanical arts, but with special reference to their figurative powers, in the reliefs on the campanile of the cathedral. The sculptor is carved as working on a small free-standing statue of a naked man which recalls the Satyr of Praxiteles (Plate 97; see also Chapter 10 and Chapter 11, Plate 236). To signify painting, the relief represented a man making an altarpiece.[9] Secondly, there is the way that some Florentines who belonged to the guilds of the saddlers, goldsmiths, painters and stoneworkers formed a Confraternity of Saint Luke in 1339 to venerate the patron saint of artists, who was believed to have painted Christ and Mary.[10] This is the moment in which figurative artists self-consciously step towards forming their own organization separate from their guild colleagues to stress their skills in representation. Today this emphasis on representational skills seems important to us, but in practice many sculptors then would be jacks of all trades. For example, when we trace the activities of Maestro Michele di Ser Memmo in Siena, we find him making a silver seal for the Biccherna (the Sienese finance office) in 1340 and mosaics for the cathedral in 1358, working on the aquaducts and fountains of the city in 1360, putting the bells and clocks in order for the Biccherna in 1369, and making a metal column for the Cappella di Piazza in 1370.[11]

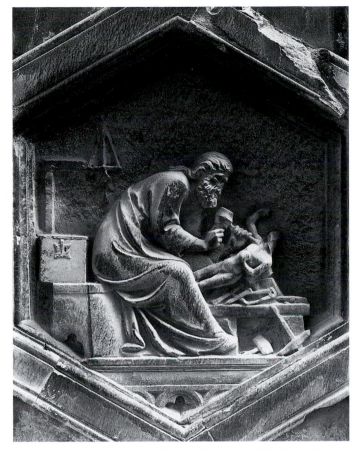

Plate 97 Attributed to Andrea Pisano, *Sculpture*, c.1337–43, marble, Campanile, Duomo, Florence (original sculpture now removed to Museo dell'Opera del Duomo, Florence). Photo: Alinari-Brogi.

WORKING PRACTICES

Sculptors belonged to a variety of guilds in the three cities, and only within their structures were the arts taught and practised. In Padua and Siena they belonged to the guild of the goldsmiths, the guild of the wallers and the guild of the woodworkers. (The guilds varied in size. For instance, in Siena in 1361 there were 21 *capomaestri* in the goldsmiths' guild, but in 1363 there were 62 *capomaestri di pietra* in the stoneworkers' guild.[12]) In Florence they belonged to two organizations: the guild of the wood and stoneworkers and that of the goldsmiths, which was a segment of the Arte della Seta or silk guild. Artists were not restricted to one medium. For example, in Siena Mariano d'Agnolo Romanelli was a carver of figured work in wood and stone, as well as being responsible for the enamelled gold reliquary bust of Saint Mark at San Salvadore.[13] The Sienese Lorenzo Maitani, *capomaestro* for Orvieto Duomo between 1310 and 1330, is documented as having designed one of the giant bronze symbols of the evangelists – the angel of Saint John – in 1300.[14]

Siena's guild of the goldsmiths in 1361 comprised 21 *capomaestri* running *bottege* (workshops), some masters with *bottege* who were called *lavorenti* or labourers, and a number of apprentices called *gignari* or *garzoni*. The guild regulations suggest that the interests of the *capomaestri* or masters with *bottege* were paramount, and to be protected against those of strangers to the city and those whom they paid and trained.

Only *capomaestri* could vote or stand for election to govern the guild. Elaborate rules ensured that neither families nor business associations could control it. Inferior materials were not to be used. *Capomaestri* were not to poach the workers of others, and workers and apprentices were not to make money on the side by selling their skills to others. The forming of business partnerships and the taking of a *bottega* or an apprentice were to be approved by the guild. No goldsmith could work in the city without joining the guild. The guild ruled that the proper feast days should be kept as holy days, and that none should open their shops in Lent until the bells rang 'because of the preaching'. Special devotion was to be paid to the patron saint of goldsmiths, Saint Eligius, on his feast day. In addition, the guild was anxious that all members should receive a dignified funeral.[15] We find a similar pattern in the surviving regulations of the guild of woodworkers in Padua. In this city women, Jews and those of illegitimate birth and dishonourable family were excluded. Presumably because of variations in demand, only the stone-cutters were able to insist that members were citizens of Padua; the other guilds accepted foreigners who had lived in the city for some time.[16]

Artists learned by living in the house of a master and working under him. For example, in Padua in 1378 Stefanino, son of the physician Federico, signed an agreement with the goldsmith Alberto, son of Salvo of Florence, that Stefanino's son Giovannino, aged fourteen, would serve a six-year apprenticeship.[17] Under the eye – and thumb – of their master, boys learned to contribute to work in the style of the workshop leader. Even after apprenticeship when the designer would pass some time as a paid, living-in worker at a *bottega*, a master might expect to control his life. In Padua in 1399 Giovanni, son of the goldsmith 'Lampret [Lamprecht] of Ternelencium' in Germany, bound himself to work for eight months for the goldsmith Nicolò of Perugia.[18] He was to be paid every month and given a pair of boots. In exchange he promised to work a third of every night, and not to gamble on working days at all. On feast days he would not gamble for high stakes (*pecunias*) but only for small change (*denarios*). Although artists did form partnerships whose equality was guaranteed in careful legal agreements, the organization of teaching and working was in large part hierarchical. Frequently, fathers taught their sons. Sometimes brothers worked together. Where designers were not following in the paternal footsteps, their fathers' occupations were often those of other mechanical arts such as notaries and physicians.

Some sculptors belonged to religious orders, and payment went to their community. For example, there was the 'famous Master of stone and wood' Jacopo Talenti of the Dominican Order of Florence – as those choosing him as artistic arbitrator for the sculpture on the Porto a San Gallo in Florence in 1342 called him.[19] In Siena there was Fra Guido from the Carthusian monastery of Pontignano, who carved figures for the choir of the cathedral in 1390–95.[20]

TRAVELLING SCULPTORS

The geographical origin of sculptors working in Siena, Florence and Padua needs to be considered. Among the stone-carvers working on the façade of the Duomo in Florence,

Plate 98 Ugolino di Vieri and colleagues, detail of reliquary for the Holy Corporal (a priest of Bolsena gives evidence to the Pope), 1338, silver gilt with enamel, Duomo, Orvieto. Photo: Alinari.

there was probably a preponderance of indigenous workers. However, a sculptor from Germany or the Netherlands called Pietro di Giovanni Tedesco (sometimes called Bramantia – from Brabant in present-day Belgium) and Luca di Giovanni da Siena were extensively employed in the late fourteenth century (1386–1402). Among the bronze-casters the Pisans were important, exporting the mastery of Andrea Pisano to Florence for the baptistery doors. Cities had their specialities – as, for example, in the armour of Florence, a centre which was the most important producer in Italy until the end of the century. Siena was the major centre for goldsmithing. However, the Sienese imported the skills of the stone-carvers of Pisa for some of the work on the façade and the pulpit of their cathedral. Later the Sienese in the shape of Lorenzo Maitani were able to export their skills in stonework to Orvieto. Large-scale productions like the Duomos in Siena and Florence could attract many wood, stone and metal workers. But otherwise, workers in wood and stone would travel to where the work and the money was. And this would often apply to workers in precious metals, since a reliquary like that for the Holy Corporal at Orvieto needed to be tailored to its precious treasure on the spot (Plate 98). In Padua the woodworkers and stone-carvers all came from Venice or Milan. With the goldworkers most were from outside the city: they came from Verona, Venice, Genoa, Perugia, Trento, Cortona, Florence, Zara, France and

Germany.[21] We should, therefore, be cautious about what we mean when we talk about 'Paduan design'.

The way these sculptors travelled emphasizes that a wide repertoire of stylistic approaches was available to them as models. The art of the Roman Empire and Republic could be viewed as ruins, scattered across the peninsula in sculptures sometimes embedded in the fabric of medieval buildings, or in small gems or coins treasured in diocesan or monastic collections. The Romanesque styles – bold medieval versions of antique forms – were available in the older buildings of every city, while the newer Gothic styles filtered from northern Europe in the practice of artists from beyond the Alps and in small-scale imports like reliquaries or bookbindings.

Both Siena and Florence during the period were centres needing to buy in skills, but they were also capable of exporting sculptors. The best preserved example of imported skill in Siena is the marble pulpit carved for the Opera del Duomo in 1268, having been contracted in 1265 from Nicola Pisano and his Pisan assistants (Chapter 3, Plate 53).[22] The satisfaction felt by the Opera with this pulpit is indicated by its appointment between 1287 and 1296 of Nicola Pisano's son Giovanni, who had worked on the pulpit as an assistant, as *capomaestro* of the cathedral works.[23] (Also documented working with him are Ramo da Paganello, his brothers and nephews.) It has been inferred that Giovanni helped to design the statuary to decorate some or all of the lower section of the façade. The main components of this scheme comprise elaborately carved door jambs for the three portals, with especially lavish effects for the central entrance (Plate 99); six beasts set at the level of the lunettes over each doorway; and a series of free-standing figures placed on the cornices above them, and folding round the edges of the north and south flanks of the nave. The figures represent prophets and prophetesses who foretold the coming of the Virgin and Child (Plate 100). These sculptures have been ruinously weathered and relocated. Since the façade project seems to have been abandoned soon after 1310 and returned to only after 1355, when the busts of prophets now surrounding the large circular window were adapted to the new design, the original ordering of the statuary remains uncertain.

An impressive example of the export of Sienese skill is the reliquary for the Holy Corporal – the sacred napkin – at Orvieto by Ugolino di Vieri and his fellow goldsmiths.[24] In 1337 Ugolino was entrusted with making the reliquary to hold the sacred napkin which Pope Urban IV had transferred to Orvieto from Bolsena (Plate 98; see also Chapter 2, Plate 23). A year later the casing for the corporal was ready to be carried in procession for the Feast of Corpus Christi. The commission was placed by Archbishop Tramo Monaldeschi, the archpriest Angelo, papal chaplain Ligo and four of the canons of the cathedral. Costing 1274 florins, it required 400 pounds of silver. In the centre on one side there are two doors which open to reveal the relic, and enamelled scenes relate the story of the miracle at Bolsena, ending with Thomas Aquinas composing the office of the Feast of Corpus Domini. This napkin was soaked with wine which was believed to have turned to blood when the former was spilled by a priest at Bolsena celebrating the Eucharist. The corporal looks like a double-sided altarpiece; the front is signalled by the postures

Plate 99 Attributed to Giovanni Pisano, column from the central portal, 1287–96, marble, Duomo, Siena. Photo: Tim Benton.

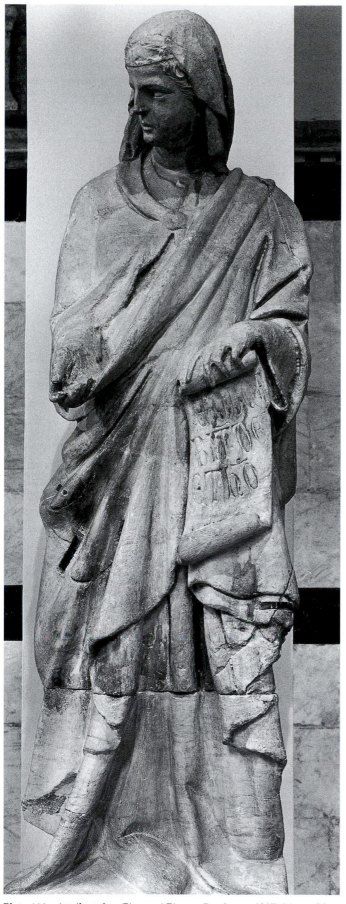

Plate 100 Attributed to Giovanni Pisano, *Prophetess*, 1287–96, marble, Museo dell'Opera del Duomo, Siena. Photo: Tim Benton.

of the figures of angels decorating the finials, and the cupboard holding the napkin below. It is on the front that the story of the miracle is told, from top left to bottom right, as a book reads. It is accompanied by scenes from the life of Christ emphasizing the Eucharist. Because this is a reliquary and the patrons evidently wished to lead the viewer up to contemplate the napkin, the reverse reads from bottom left up to top right, following Christ's Passion to his Resurrection and delivering the spectator to the apex and consideration of the miracle. The base is inscribed by the goldsmiths, and with the heraldry of the Pope and the Bishop of Orvieto, the patrons were also recorded.

If Pisa was the source of the best stone-carvers as far as the Sienese were concerned, it was also the source of skill in bronze casting in the view of the Florentine Arte di Calimala, who commissioned the bronze doors of the Baptistery in Florence from Andrea Pisano (who was born ten miles outside Pisa at Pontedera).[25] Initially they had considered hiring the Sienese Tino di Camaino in 1322. But in 1329 the Arte sent a representative to Pisa to draw the twelfth-century bronze doors of its cathedral, and then proceed to Venice to acquire a craftsman. In 1330 Andrea Pisano was documented as 'maestro delle porte'. Andrea was assisted by two goldsmiths (Lippo Dini and Pietro di Donato) in creating the moulds. A Venetian, Lionardo d'Avanzo, did indeed cast the doors between 1332 and 1333, and they were put into place in 1336. The doors are richly gilded and arranged in the pattern of the pages of a book, so that we read the life of the Baptist from top left to bottom right on each leaf (Plate 101; see also Chapter 1, Plate 14). The four lowest scenes on each leaf represent the virtues. This was an extremely lavish commission. Although less expensive than silver, bronze was still about ten times the price of marble. Bronze doors were possessed by only the most venerable buildings like the Pantheon in Rome, the Romanesque cathedral of Beneventum, and the church at San Zeno, Verona made in the eleventh century. But the comparison at the forefront of the minds of the Florentines was with the bronze doors of the Duomo at Pisa.

Where silver was sufficently ductile to be hammered into complex forms for a varied relief, bronze could only be cast and chased. Andrea Pisano and his team therefore cast the small scenes, each on a platform, separately from the quadrilobate fields to which they were later pinned. Where the silversmith could present a 'full stage', the bronze-casters had to communicate their mime using only the front stage. So it was with utmost economy in narration that the bronze doors gave the story of the Baptist's life. Props and settings are 'minimalist'. There is a dramatic austerity perhaps fitting to the last of the prophets. To take the end of the story: the Baptist's head is given to Salome, then by her to her mother, but the body is solemnly carried to its grave and buried (Plate 101).

Although the Florentines had imported Pisan and Venetian skills for large-scale bronze work in the 1330s, they were called upon by the Pistoians in the 1350s and 1360s to complete the silver altar of San Jacopo with eighteen reliefs relating the history of the Old Testament and the life of Saint James the Great (Plate 102). Between 1361 and 1371 two Florentines, Francesco Niccolai and Leonardo di ser Giovanni, fulfilled the requirements of the *opera* of San Jacopo at Pistoia

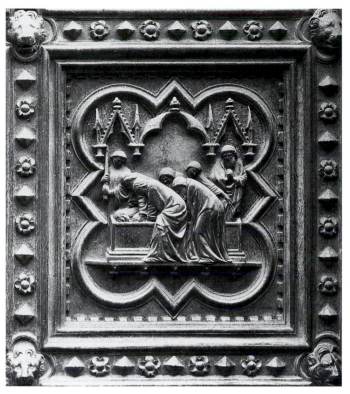

Plate 101 Andrea Pisano, *The Entombment of John the Baptist*, detail of doors, 1330, gilded bronze, Baptistery, Florence. Photo: Alinari.

near Florence.[26] Enormous quantities of metal were used costing vast sums, and the *opera* is documented as dwelling lovingly on the adornment of the silver reliefs with enamel and precious stones. Like the corporal reliquary for Orvieto, the commission was intended to be used by crowds of pilgrims, and the sculptors met these requirements with rich detail. Being an altar, reliefs were made to be looked at across or down. Leonardo's sequence is arranged on the familiar western page-like pattern (Plate 103). Along the top are three scenes: the calling of the apostles Peter, James and John; then Mary Salome, the mother of James and John, begging Christ to give them special treatment in heaven; and finally Christ pronouncing James a saint. In the centre we find the saint preaching, but he is taken by Herod's soldiers and brought before the tribunal for preaching Christianity. Along the base he baptizes Josias, is martyred, and his body goes by boat to Compostella. Leonardo carries the viewer along with astute compositional ploys. In the calling, Christ greets James but looks and points to John, and John gestures back to Peter. Mary Salome looks at Christ, but gestures to her two sons. The right-hand reliefs turn the viewer back: with Saint James kneeling towards Christ and facing away from the edge of the sculpted page, and below, the judge seated in his tribunal also turns us towards the centre of attention. There is variety to please the spectator and a moving story-line to satisfy the devout pilgrim.

I know of no examples of Paduan skill in three-dimensional designing being exported. A prominent example of Paduan patrons' reliance on external artistry is the hiring of the Venetian sculptor Andriolo de'Santi and his colleagues Francesco di Bonaventura and Alberto di Ziliberto in 1351 to create the tomb of the recently dead ruler of the city, Jacopo II

da Carrara.[27] The Carrara were able by this means to refer to a type of entombment which was associated with the elected rulers of Venice. The tomb was originally situated at Sant'Agostino, the dynastic burial place of these Paduan rulers, but on the destruction of this church, it was re-sited at the Eremitani (Chapter 8, Plate 164). Damaged also by bombardment in World War II, the original splendour of this imposing tomb can be recovered with some difficulty. The tomb chest is supported by columns, while a stone canopy sheltering it rests on brackets. Niches have been scooped out of the long side and the corners to hold statuary on the tomb chest, and the effigy of the erstwhile ruler is tipped sideways on his bier so as to be visible from far below. The effect of the ornament is extremely rich, with a virtuosity in carving being displayed to enhance the prestige of the dead man. Stone is twisted for the columns flanking each niche. It is scalloped for each vault of these niches. The cornice uses two rows of acanthus moulding and curves boldly over the niches to create beaked profiles at the corners. The base of the chest is carved as a laurel wreath, and it too breaks forward to register the presence of the niches. Green marble is used to panel the sides of the chest. Within this rich ornamentation, almost certainly painted and gilded originally, the niche figures narrate the story of the annunciation and birth of Christ. Two angels with bronze wings and candlesticks adorn the back corners. The Angel Gabriel and Mary stand in the two front corner niches. In the centre niche, in an appealing gesture, the

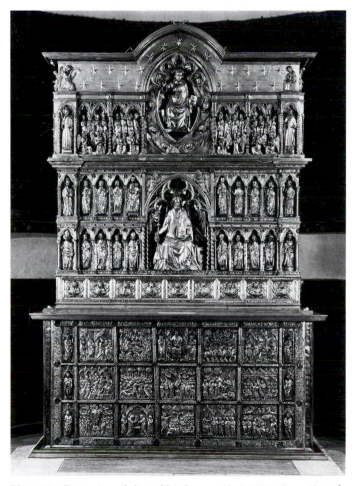

Plate 102 Front view of altar of San Jacopo, 1287–1456, silver gilt with enamel and jewels, San Jacopo, Pistoia. Photo: Scala.

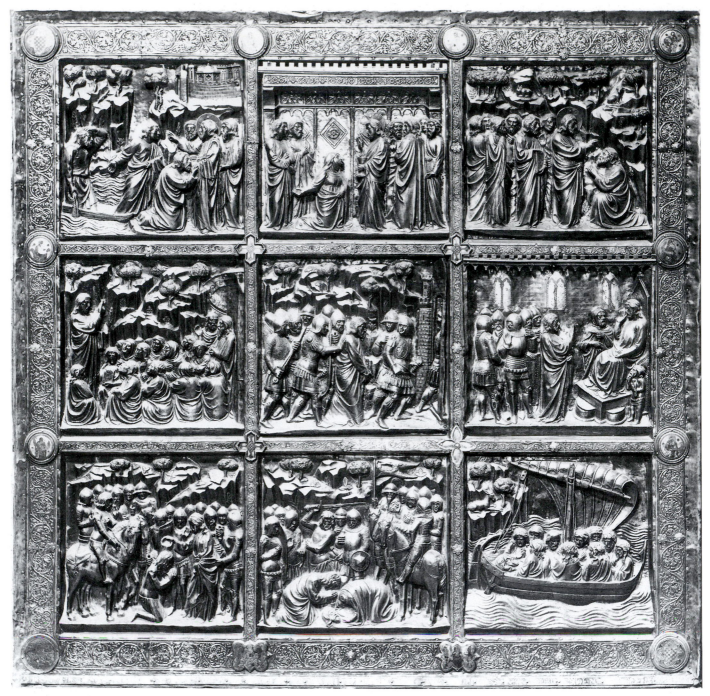

Plate 103 Leonardo di ser Giovanni, side view of altar of San Jacopo (the story of Saint James), 1361–71, silver gilt with enamel and jewels, San Jacopo, Pistoia. Photo: Alinari.

baby Christ pulls the mantle from his mother's face to reveal her to the viewer. Underlying the Venetian style of all this lavish decoration and the pious drama of Christian salvation, there are also allusions to the prestigious form of sarcophagus types for rulers from the late antique period.

DISMANTLED COMMISSIONS

It is important to pay some attention to commissions which were of significance to the three cities in the fourteenth century, but which have been virtually or entirely dismantled. In Siena, for example, an important enterprise in the late

fourteenth century was the creation of the wooden choir for the cathedral (Plates 104, 105).[28] The significance of the task is underlined by the way the *opera* in 1388 gathered together a group of fifteen judges, including painters, a glazier, wood-carvers, a stone-carver, a goldsmith and a silversmith to judge the designs.[29] With one accord, they chose that of the wood and stone sculptor and goldsmith Mariano d'Agnolo Romanelli, and by 1397 his design was executed by Barna di Turino, Giovanni di Francesco and Luca di Giovanni. Parts of these choir stalls survive, but they have been moved to either side of the main apse; they can be identified by their Gothic ornamentation with their trefoil arches. Busts of saints were

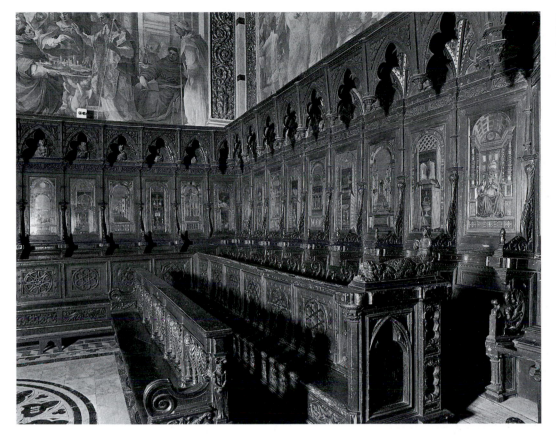

Plate 104 Mariano d'Agnolo Romanelli, choir stalls, 1388–97, wood, Duomo, Siena. Photo: Tim Benton.

carved and painted to place over the seats of the canons who daily sang the office. The seats were canopied, and the choir adorned with separate figures of saints and virtues carved in wood, some or all of them life-size, commissioned from Fra Guido di Giovanni of the Carthusian monastery at Pontignano. One of his statues for the choir survives – of the cathedral's patron saint, Sabinus, carved between 1393 and 1395 (Plate 106) and painted by Paolo di Giovanni Fei. As was proper to such a choir, the saintly personalities suggested by Mariano and Fra Guido were appealing but dignified.[30]

For Florentines, the development of the decoration of the façade of their cathedral was a significant enterprise. A start seems to have been made in 1296 when Arnolfo di Cambio was appointed as *capomaestro*. Following his years as assistant to Nicola Pisano, Arnolfo, who was born in the Florentine *contado* of Colle Val d'Elsa, worked extensively in Rome. He was documented as being in Florence in 1300.[31] The façade sculpture celebrated the patron saint of the cathedral: the Virgin Mary. Over the left-hand portal was the annunciation, nativity and the adoration of the shepherds and the kings. Over the right-hand portal was the bodily death of the Virgin, and Christ taking the soul to heaven. The central door displayed the Virgin and Child with the diocesan patrons, Saints Reparata and Zenobius, flanked by prophets (Plate 107). At some point there was a colossal statue of Pope Boniface VIII, an important patron of the fabric, who had sent his legate in 1296 to lay the foundation stone of the new cathedral. The location of these sculptures is indicated by a sixteenth-century drawing made before the dismantling of the façade. They display an impassive grandeur drawing on ancient Roman precedents, calculated to awe and impress the viewer (Plate 108).

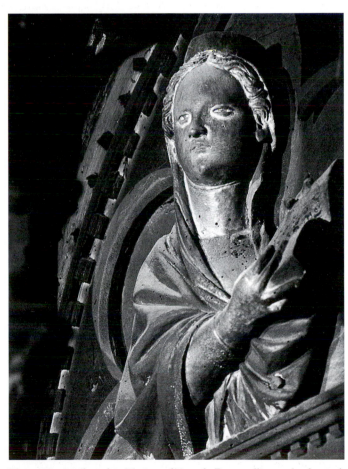

Plate 105 Attributed to Mariano d'Agnolo Romanelli, wooden bust of the Virgin from the seat back of one of the stalls, detail of choir stalls (Plate 104). Photo: Tim Benton.

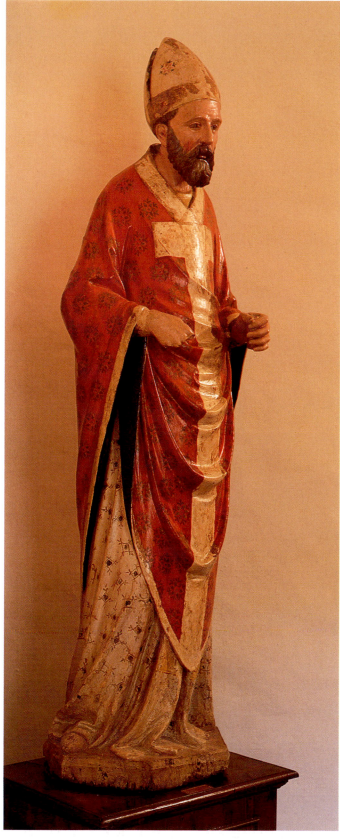

Plate 106 Fra Guido di Giovanni and Paolo di Giovanni Fei, *Saint Sabinus*, 1393–95, polychrome wood, 187 cm high, Museo dell'Opera del Duomo, Siena. Photo: Tim Benton.

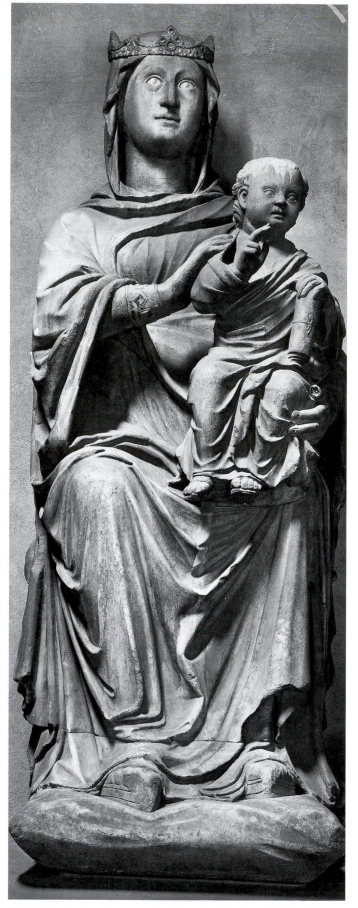

Plate 107 Attributed to Arnolfo di Cambio, *Virgin and Child*, 1296–1300, marble and glass, Museo dell'Opera del Duomo, Florence. Photo: Alinari.

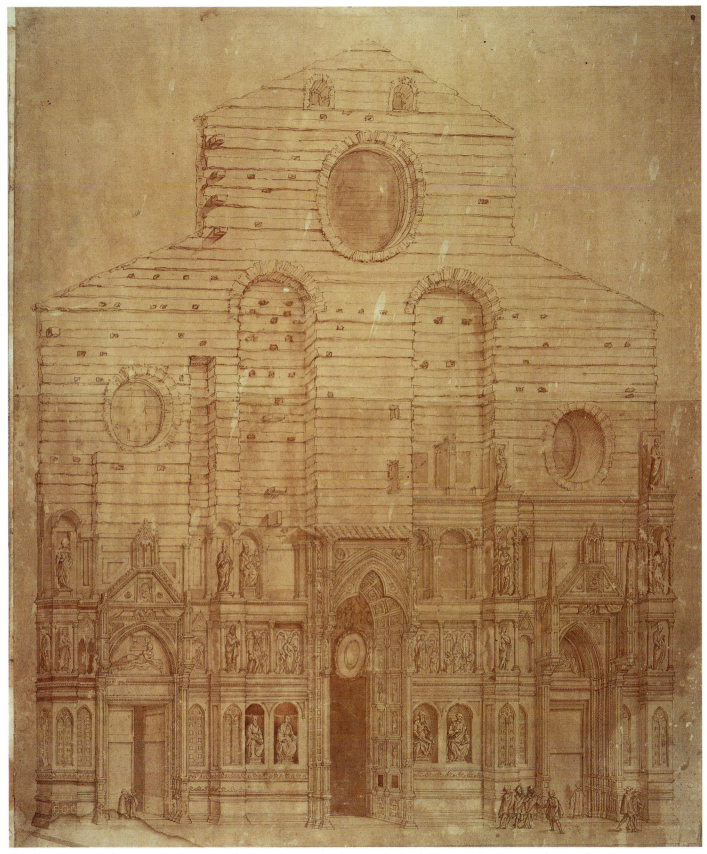

Plate 108 Bernardino Poccetti, drawing of façade of the Duomo, Florence, *c.*1587, Museo dell'Opera del Duomo, Florence. Photo: Scala.

Attention turned to the sculptural decoration of the campanile and its building when Giotto was *capomaestro* of the cathedral (1334–37) and then Andrea Pisano (1337–43). At this time the campanile was initiated and the 21 hexagonal reliefs, most of which show the mechanical arts, put in place.[32] Like the bronze baptistery doors, these lowermost reliefs were required to communicate to a vast general audience. Many display an exquisite sensitivity to the textures and appearances of plants, animals and household objects. In the invention of weaving, for example, the sculptors managed to suggest the complexities of the loom. The designers also announced an interest in the exemplars of ancient art, in this case most pointedly in the relief of 'sculpture', which shows the artist attentively carving a free-standing nude in the form of the Satyr of Praxiteles (Plate 97).

Despite the Black Death, the sculptors of the cathedral completed the building and adornment of the campanile; Francesco Talenti and Alberto Arnoldi are documented as having contributed to this programme between 1351 and 1359. During this time, a register of lozenge-shaped reliefs was carved, presenting the seven liberal arts, seven sacraments, seven virtues and seven planets.[33] Placed so much higher than the mechanical arts, these reliefs suppress detail, emphasizing instead the symbols and key poses which will cue recognition. For instance, Charity holds a huge heart and a cornucopia. But these figures are not mere repositaries of attributes, for Charity holds the cornucopia as tenderly as a baby, her large hand curved protectively round its bottom and her gaze attentively fixed upon it (Plate 109). The expertise in figural carving contributes to the expression of the idea of charity. On the next register, above the lozenges, the campanile contains four niches on each side. On the most prominent west and south flanks, these niches were filled with statues of Old Testament prophets and pagan sibyls.[34] Like the earlier sculptures for the adjacent façade of the cathedral, they suggest a stoic, unperturbable security, generalizing figural forms to make sense when seen from a great distance or at an acute angle (Plate 110).

The cathedral façade was not pursued with similar success, and although numerous statues of prophets and apostles are documented (and survive dispersed among various collections), attribution and location is highly problematic. However, the bodies of the statues of the four Doctors of the Church, sculpted by Niccolò di Piero Lamberti and Pietro di Giovanni Tedesco from 1396 onwards, may be identified and seen in their four canopied niches between and on either side of the portals in the drawing by Poccetti (Plates 108, 111). (Subsequently they had new heads attached to transform them into Roman poets.)[35]

Considerable work did take place on the façades of the flanks of the nave. On the north side the Porta dei Canonici was completed, comprising the lunette statuary created by Niccolò Lamberti and Lorenzo di Giovanni d'Ambrogio including the Virgin and Child between 1401 and 1402, and collaborative work to produce the general framing (Plate 112). This was registered in payments between 1397 and 1402 to Zanobi di Bartolo in 1377–78 for the Saint Michael at the apex, and to Lorenzo di Giovanni d'Ambrogio and his father Giovanni d'Ambrogio, as well as Pietro di Giovanni Tedesco and Urbano d'Andrea.[36] As on the columns of Siena Duomo,

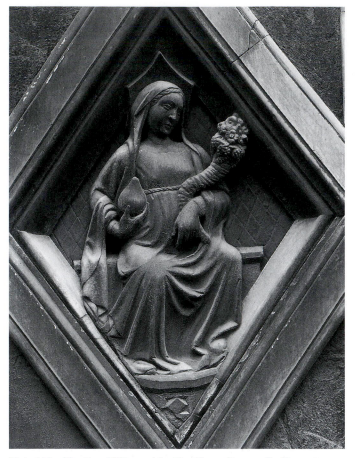

Plate 109 *Charity, c.*1350, marble, 87 x 63 cm, Campanile, Duomo, Florence (original sculpture now removed to Museo dell'Opera del Duomo, Florence). Photo: Alinari.

a sumptuous variety of foliage and figures has been carved for the pilasters on the frame (Plate 114). Instead of acanthus, the sculptor provides oak. And through this oak wood a hound chases a boar, while a snake slides beneath its paws. Lizards, birds, cows, a child with a basket all join in the fun. On the south side of the nave, considerable attention was also paid to the Porta della Mandorla (Plates 113, 115). Giovanni d'Ambrogio and Pietro di Giovanni Tedesco completed the jambs by 1395. Here the motif is the traditional acanthus, but with great emphasis on references in the small figures to ancient mythology. The labours of Hercules – symbol of Christian virtue for theologians – are taking place in the foliage, but the familiar detailing of birds, dogs, goats and playful babies is still present. During 1396 the lunette framing for this portal was produced by Giovanni d'Ambrogio, Niccolò di Pietro Lamberti, Jacopo di Pietro Guidi and Pietro di Giovanni Tedesco.[37] Here figures from classical mythology are presented again, but alternating with reliefs showing angels. During the fourteenth century the whole of the campanile, the flanks of the nave, and the base of the façade of Florence's Duomo were gradually completed.

In Padua there was no equivalent large-scale sculptural enterprise. Nevertheless, a visitor to the city in the late fourteenth century would have been very impressed by the elaborate tomb commissioned by Raimondino Lupi, Marquess of Soragna, in the Oratory of San Giorgio.[38] Carved by an unidentified sculptor, only the hulk of this tomb

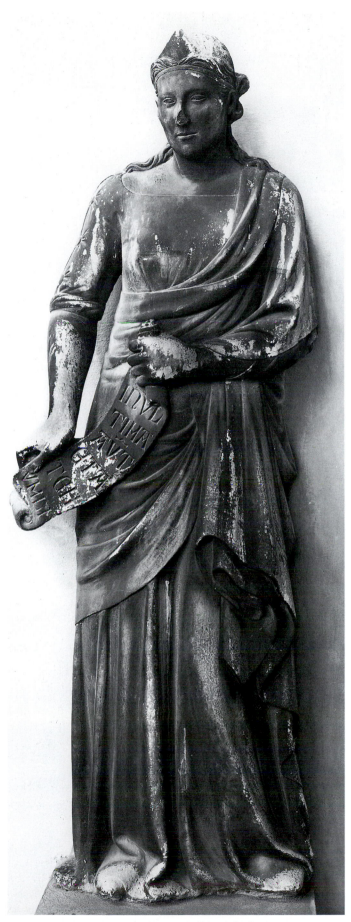

Plate 110 *Eritrean Sibyl, c.*1350, marble, 176 cm high, Museo dell'Opera del Duomo, Florence. Photo: Alinari.

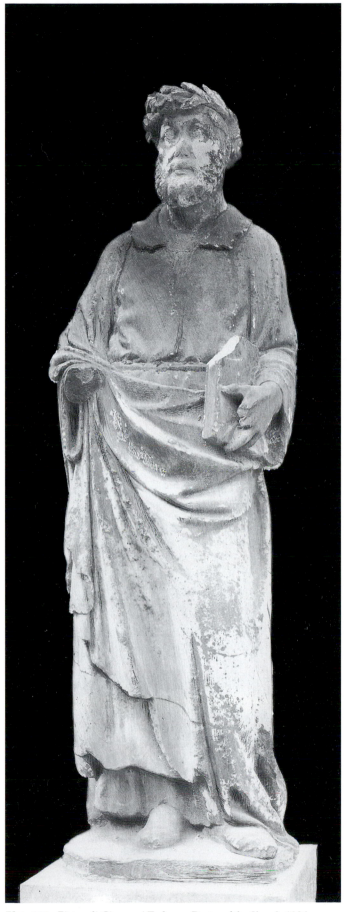

Plate 111 Pietro di Giovanni Tedesco, *Doctor of the Church*, 1396 onwards, marble, 238 cm high, Museo dell'Opera del Duomo, Florence. Photo: Alinari.

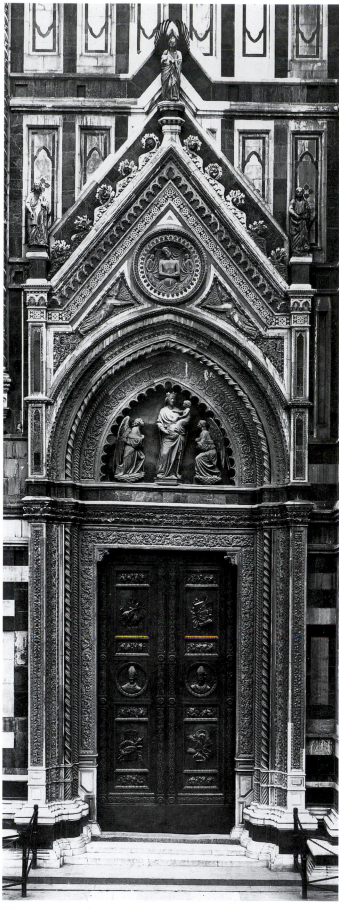

Plate 112 Porta dei Canonici, 1377–1402, marble, Duomo, Florence.
Photo: Alinari-Brogi.

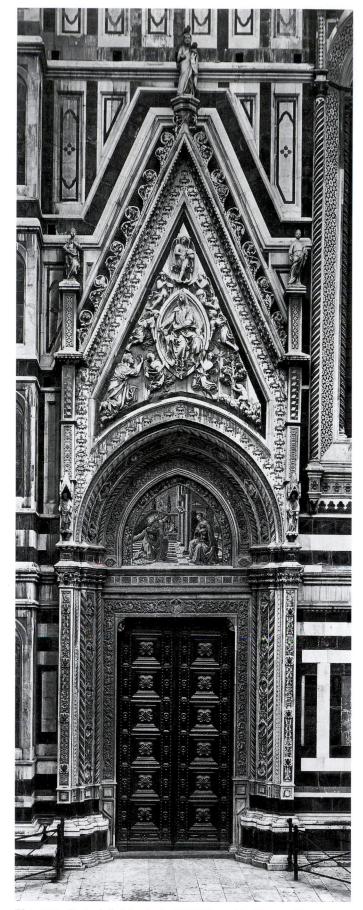

Plate 113 Porta della Mandorla, 1395–96, marble, Duomo, Florence.
Photo: Alinari-Brogi.

Plate 114 Jamb or reveal, detail of the Porta dei Canonici (Plate 112). Photo: Alinari-Brogi.

Plate 115 Jamb or reveal, detail of the Porta della Mandorla (Plate 113). Photo: Alinari-Brogi.

survives (Plate 116). According to late sixteenth-century descriptions, the tomb chest was free-standing and raised off the ground with four columns resting on a high podium, like the tombs of the greatest rulers in Verona or Naples or, indeed, like the splendid tombs for saints. The chest was sheltered by a large canopy comprising two bays on the long sides and one on the short side. This supported a tall pyramid. Around the pyramid were placed life-sized effigies of the dead man's relations (himself being situated so as to greet the visitor to the oratory at the entrance end and with his father and mother standing to face the altar).[39] The marquess, who died in 1379, eschewed the religious narrative and secular dress adopted for the tomb of Jacopo II da Carrara, ruler of Padua, with its references to the annunciation and birth of Christ. Instead the emphasis was military (all the men were in full armour) and heraldic. The

tomb was supported and topped with the heraldic wolves or *lupi* of the patron's battle standard. The whole was painted in black, gold, blue, red and silver.

CHURCH COMMISSIONS

It cannot be emphasized too strongly that our notion of fourteenth-century Italian sculpture is conditioned primarily by what has survived. The most powerful institutions capable of protecting some of their commissions from this period were strong ecclesiastical or monastic establishments. In Padua, for instance, the Benedictines of the church of Santa Giustina commissioned an impressive tomb for the body of Saint Luke, along with a chapel to contain it, during the abbacy of Gualpertino Mussati (1300–37) (Plate 117).[40] When

Plate 116 Tomb of the Marquesses of Soragna and the Marchioness Matilda, *c.*1379, marble, Oratory of San Giorgio, Padua. Photo: Tim Benton.

their new church was erected beside the structure of the old, the monks moved the *arca* to the new north transept. Critics have differed as to whether to attribute it to Tuscan or Venetian skills. But it has been suggested that Gualpertino Mussati, an absentee abbot and a member of the papal court, might have encouraged the hiring of artists from quite far afield. The original chapel was erected between 1301 and 1316, with an apse at one end, and the *arca* was placed on the long axis. This arrangement allowed visitors to process round the saint's human remains, and the designers made provision for this kind of scrutiny. The *arca* consists of a table of pink Verona marble carried by four columns of oriental granite. This supports a chest of green porphyry with alabaster reliefs: three on the long sides and one on either end. These reliefs represent the busts of angels carrying twisted candles, the bust of Saint Luke himself and his symbol, the bull. To encourage an all-round viewing, the centre of the chest is supported by a group of four angels placed as if back to back. Given the reverent charm of these angels, it seems likely that the tomb was originally set on a higher plinth. Here they would be at eye-level. Such an elevation would explain the boldness and size of the imagery on the reliefs, which have the colour, polish and slight translucency of wax.

Whereas in Padua the cathedral chapter is not recorded as initiating grand sculptural schemes, and monastic churches like Santa Giustina or Sant'Antonio commissioned only relatively minor works, in Siena and Florence the cathedrals were centres of patronage. At Siena the decision in 1339 to attempt to create a much larger cathedral by reorientating the nave – though abandoned in 1355 – sustained such sculpted enterprises as the surviving portal for the new cathedral, to have been on its liturgical south flank.[41] Dating from the mid century this shows an intriguing blend of classicizing and Gothic motifs which support a lunette representing Christ seated in judgement, flanked by adoring angels (Plates 118, 119). The portal aperture is narrow, with slender twisting pilasters and elaborate foliated ornament. The architrave and the entablature mouldings are classically correct but curve unclassically. The lunette has a pointed arch. The frontispiece above has the Lamb of God in a trefoil. In their present museum location the lunette group displays the well-calculated distortion in the figures (the deep undercutting of bold sweeps of stone drapery, the tall torso of Christ, the exaggerated poses of wonderment in the angels) which made sense to the viewer of the portal approaching at the very steep incline to the cathedral.

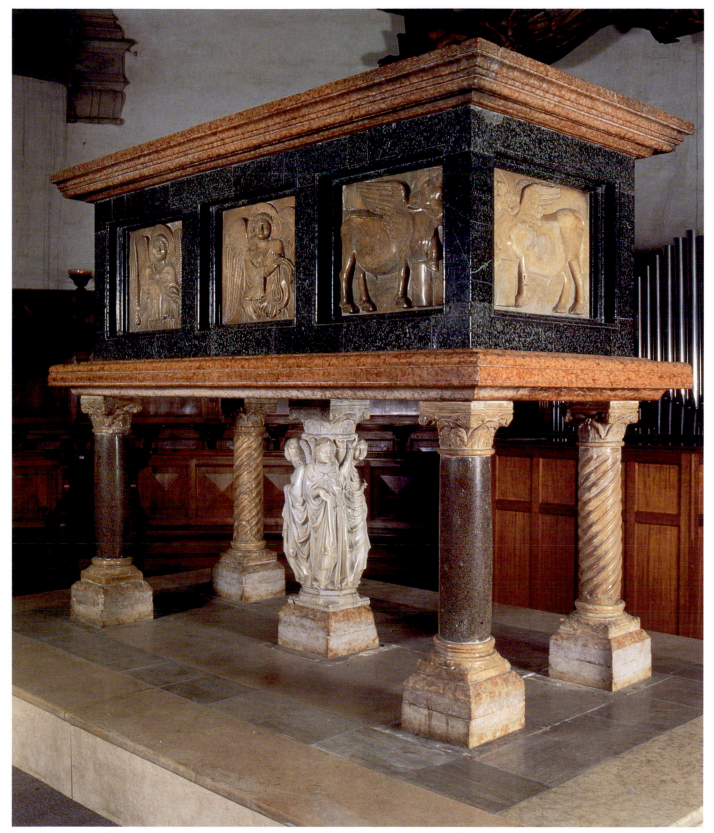

Plate 117 Reliquary tomb or *arca* of Saint Luke the Evangelist, *c.*1316, marble, oriental granites and alabaster, Santa Giustina, Padua. Photo: Alinari.

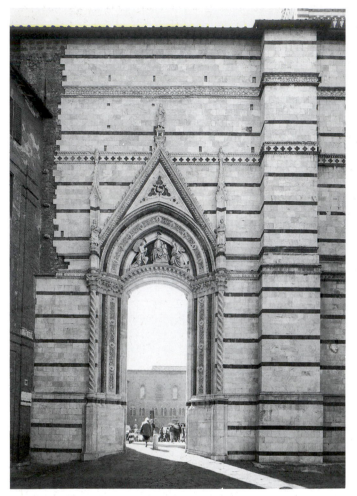

Plate 118 Attributed to Giovanni d'Agostino, portal for the new Duomo of Siena, 1340–55, marble (overdoor is a replica). Photo: Lensini.

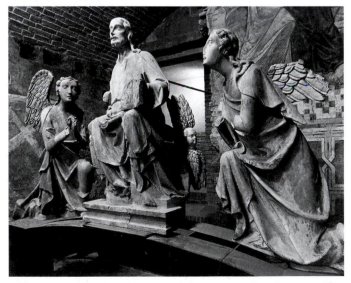

Plate 119 Attributed to Giovanni d'Agostino, *Christ in Judgement with Two Angels*, detail of portal (Plate 118) (original sculpture removed to crypt, Duomo, Siena). Photo: Tim Benton.

CONFRATERNITY AND GUILD COMMISSIONS

Confraternities were commissioners willing to bear the expense of large-scale sculpture and capable, on occasion, of protecting it. In the basilica of Sant'Antonio in Padua, for example, the Confraternity of Saint Anthony was able, through the generosity of one of its members, Domenico de'Lami, to commission an elaborate tabernacle sheltering a marble statue of the Virgin and Child, completed in 1396 by an artist of French origin, Rainaldino di Pietro da Francia (Plates 94, 120).[42] The confraternity was a group of devout lay people attached to the church, and led in their devotions by one of the friars. Perhaps in token of their piety or perhaps in response to the general plans of the friars, the tabernacle beautified and emphasized the importance of the part of the basilica from which it had stemmed: the tiny church of Mater Domini where Saint Anthony had prayed, which had been incorporated into the fabric of the Santo. This venerable role has ensured its security and good condition, although it is unclear whether the statue was originally painted. It was Rainaldino's task to create a focus for at least weekly, and probably daily, devotion for the confraternity, which would also be an attractive focus for prayer to others. With its nineteenth-century altar, the tabernacle presents the Virgin and Child in the most benevolent guise as persons of great strength and vigour. Behind, angels and the prophets Isaiah and Daniel foretell the gift of salvation to humanity. Above, on the tabernacle, space has been made for a God the Father, a Virgin and the Angel Gabriel on either corner to suggest the annunciation of the era of grace to come with Christ's birth, and at the rear we find Saints Mary Magdalen and John the Baptist. This ensemble seems a comfortable image: one which would have, and has, commanded the most continuous affection.

Although guilds would have had occasion to purchase many objects, those which survive are of a religious nature. Nothing at all seems to have come down to us from Padua, but in Florence we can look at the beginning of guild commissions for marble sculpture to adorn the exterior of Orsanmichele. And in the Sienese dependency of Montalcino, we can find a wooden tableau of the annunciation made for the chapel in San Francesco which the shoemakers' guild used for its feast day devotions: the Feast of Saint Nicholas. These statues were, then, commissioned for purposes quite comparable with those of the voluntary confraternities. The guild would have had its own, obligatory, feast day when – as we saw in the case of the goldsmiths of Siena – workers were expected to join in devotions at the confraternal chapel. The Chapel of the Annunciation at San Francesco in Montalcino had been adopted by the shoemakers' guild for this role. The statuary of patron saints which Florentine guilds were expected by the Commune (in its decree of 1339) to place on the exterior of Orsanmichele were designed to be visited by the confraternity of the guild on its feast day, and honoured as an outdoor shrine.[43]

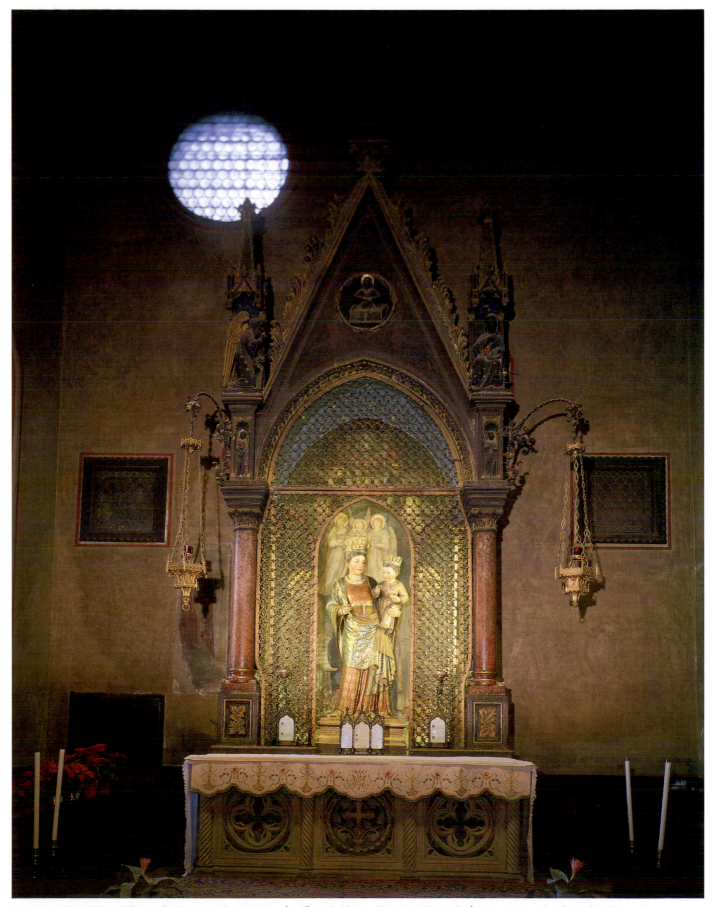

Plate 120 Rainaldino di Pietro da Francia, tabernacle for the Chapel of Mater Domini, 1396, polychrome pietra columbina (local stone), Sant'Antonio, Padua. Photo: Alessandro Romanin.

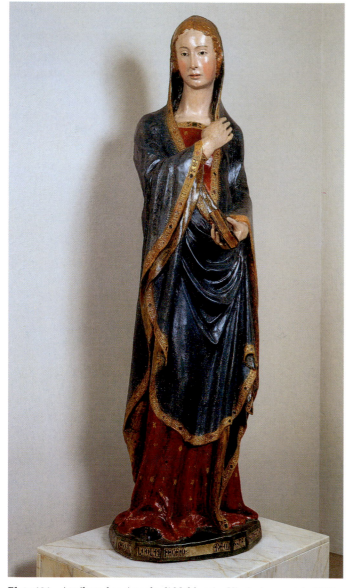

Plate 121 Attributed to Angelo di Nalduccio, *Virgin Annunciate*, 1369, polychrome wood, 181 cm high, Museo Diocesano, Montalcino. Photo: Lensini.

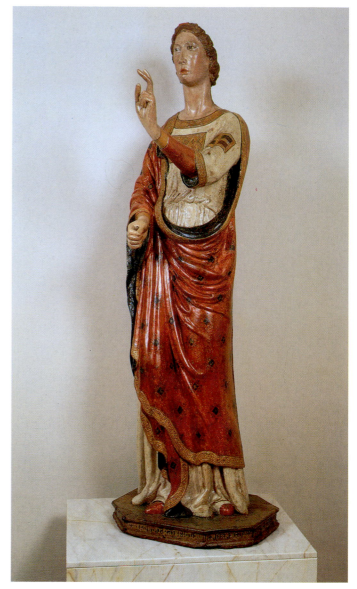

Plate 122 Attributed to Angelo di Nalduccio, *Angel Gabriel*, 1370, polychrome wood, 176 cm high, Museo Diocesano, Montalcino. Photo: Lensini.

The guild of the shoemakers at Montalcino had two greater than life-size statues of the Virgin Mary and the Angel Gabriel made in, respectively, 1369 and 1370 (Plates 121, 122). The artist who sculpted and painted the angel was called Agnolo and has been identified as Angelo di Nalduccio.[44] The Virgin was made slightly taller than the angel. The condition of these statues is good, although the metal wings of the angel have been removed and the flesh pigment of the Virgin has been repainted. As if to emphasize their personal credit while rectors of the guild (for the six-monthly term), 'Tofo Bartalini' and 'Agnolino' had their names included in the inscriptions placed on the bases of these statues.

> AD 1369 the guild of shoemakers had this figure made at the time of the rectorship of Agnolino.

> This angel the guild of the shoemakers had made. Angelo sculpted and painted it at the time when Tofo Bartalini was rector 1370.[45]

In 1383–88 Bartolo di Fredi made an altarpiece of *The Coronation of the Virgin* for this chapel. Presumably the two figures of the Virgin and Gabriel were placed on either side. Such life-size painted wooden sculptures have survived in quite large numbers in the region around Siena, possibly indicating, like the expertise in goldsmithing, a special interest in wood-carving there. Often commissioned to create dramatic tableaux of some sort (such as of the patron saints of the Siena Duomo choir), we get the impression that, while the sculptors would consider various ways in which they look well together in terms of answering shapes and expressive narrative relationships, there was a welcome flexibility for patrons in buying these relatively light, movable images. The guild could alter the spacing of the figures, add dramatic lighting, foliage or drapery, and turn, lower or raise them. As photographs demonstrate, each of these statues could be moved about without losing the force of the angel's annunciation to the surprised young woman who holds a

small book in her hand. These statues would be seen at very close range and need to bear close scrutiny (for example, the shaping convincingly suggests the distribution of weight supposedly sustained by the limbs 'beneath' the drapery). They are highly empathetic at close quarters. The light weight of these figures meant that they could be used in much more flexible, dramatic roles than stone pieces. Yet they also needed to provide striking, communicative poses at a distance and retain the dignity proper to holy persons: a quality rendered here, I think, in the elongation of limbs and refinement of delicate hand gestures.

The marble group of the seated Virgin and Child, commissioned by the Arte dei Medici e Speziali (to which the painters belonged) in Florence for Orsanmichele, required rather different qualities from the sculptor (Plate 123).[46] This guild was the second to comply with the government decree of 1339, and obtained a prime site for its exterior altarpiece. This was on the pier of the loggia of grain merchants right by the much honoured pictorial image of the Virgin inside, and visible to people using the main thoroughfare leading from the Piazza della Signoria to the cathedral. (The first guild to comply replaced its statue in the fifteenth century.) To draw attention to its statue, the guild provided an elaborate stone canopy, with rich polychrome stone inlay, to set off a group

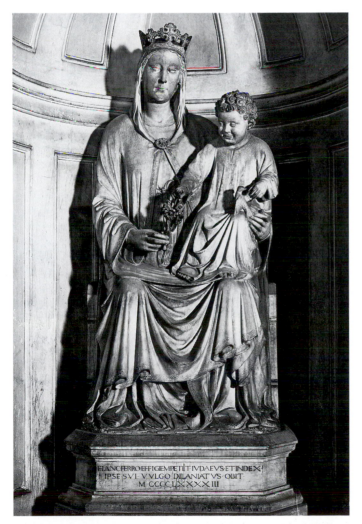

Plate 123 Attributed to Niccolò di Piero Lamberti, *Virgin and Child*, c.1399, marble, Orsanmichele, Florence. Photo: Alinari.

which appears not to have been pigmented. This frame is dated 1399. The statue focuses on the joyfulness of Mary giving birth in the expression of Christ, in his game with a bird, and in his delight in his mother's flowers. Only she, of all the later statues of their patron saints commissioned by guilds, had the dignity of being seated in majesty. Only her niche was graced with a canopy. But the pleasure of the group is balanced by the solemnity of her expression: the representation of a knowing wistfulness that belies the babbles of infancy, and promises the epic event which would earn her the coronation signified by her crown.

GOVERNMENTAL COMMISSIONS

Governments were significant sources of patronage, but unfortunately very few of their purchases survive. We can only read, for example, of the greater than life-size ensemble by Paolo and his father Giovanni designed to adorn the Porta di San Gallo at Florence in 1342, and displaying the coronation of the Virgin flanked by Saints Peter and Laurence to the left, and Saints John the Baptist and Reparata to the right.[47] Monumental sculptures such as these were powerful political images, as evidenced by the careful instructions of the civic officials concerning the attributes of each saint (Peter was to hold 'huge and beautiful keys') and the prominent position of three heraldic shields of the Commune on the pedestal supporting the coronation scene. We can only look at the simplest remains of the Sienese battle *carroccio* (the civic carriage which carried the battle standards in war) in the cathedral, where all that survive are the tall wooden poles resting against two of the piers of the crossing.

From the little that survives, it seems that governments usually did not think of their concerns as separate, secular matters. Such religiosity is present in the small wooden chest, bound in iron and painted with a scene of the annunciation and the arms of the Commune of Siena, which was paid for in 1373 'to store official acts, newly made' (Plate 124). The chest has three locks and iron handles (so it could be carried around by bearers), and the iron studs have been placed in floreate fashion.[48] The government paid three people for this multi-media work: Cristofano de Cosona, Vincenzo di Lutini and Agnolo di Piero. (Presumably the theme of the annunciation sprang quite readily to mind to protect the record of new civic enunciations.)

A much grander civic commission survives in Florence in the sculpted reliefs for the spandrels of the Loggia dei Lanzi representing the seven virtues.[49] In 1356 the Consiglio Generale had decreed that 'a beautiful and honorable' loggia should be built for its use.[50] In the event, the loggia was built between 1373 and 1374 with Francesco Talenti as *capomaestro* along with Benci di Cione, while the reliefs were made between 1383 and 1391 by Jacopo di Pietro Guidi, Giovanni d'Ambrogio and Giovanni di Francesco Fetti. The figures were subsequently painted, and they were placed on a painted ground plated with glass. It is not clear who carved the figure of Charity, but she was the major virtue ('the greatest of these is Charity'), singled out by being given a projecting canopy (Plate 125). Charity is characterized in terms of the Virgin and Child. Given that there were other ways of signifying Charity (with a burning heart, suckling

Plate 124 Cristofano de Cosona, Vincenzo di Lutini and Agnolo di Piero, wooden chest, 1373, iron bound and painted, Palazzo Pubblico, Siena. Photo: Lensini.

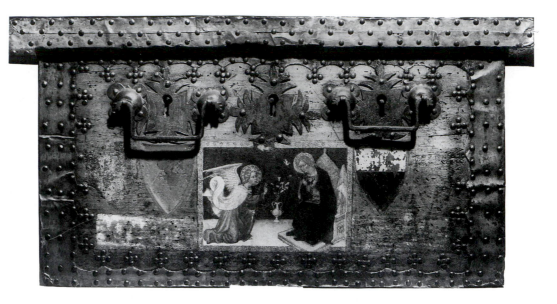

many children, with a cornucopia), the pointed comparison with the Madonna suggests the devotional allegiance of the Commune. She suckles one child and holds a burning heart in her hand. When the loggia was built, the shields of the Commune were placed along the façade beneath the cornice. It is this shape which the frames of the virtues echo with their lobed triangles. While the four cardinal virtues were placed on the long façade of the loggia, the three theological virtues were clustered on the short side, and Charity was placed over the arch where the government officials were most likely to enter ceremonially.

The governmental patronage of Padua is difficult to gauge, but two examples of political imagery by the Carrara family we can refer to are the medals of Francesco il Vecchio and his son Francesco il Novello (Plate 126).[51] These were struck, apparently in 1390, to celebrate the re-conquest of Padua against the might of the Visconti. There is nothing surprising about the reverses of these medals, since they show the battle *carroccio* of the Carrara family, used in many of the coins of the city and as heraldic shield of the seigneur of the city. The *carroccio* was placed on many of their commissions. However, the obverses show profile portraits of the two rulers. These are extraordinary in several ways. They are very close imitations of imperial Roman coins, so they indicate an especially antiquarian spirit in the Paduan court. Like the coinage of imperial Rome, these medals represent Francesco il Vecchio and Francesco il Novello in terms of profiles which suggest 'warts-and-all' portraits. The former is shown without indication of clothing; the latter wears the Roman patrician toga. This use of portraiture contrasts with the communal Florentine and Sienese aspirations. The value of rule by men through family succession, like the imperial succession of Rome, may be the political message of these two classicizing obverses. It is also significant that there is no trace of Christian imagery in these Paduan governmental statements.

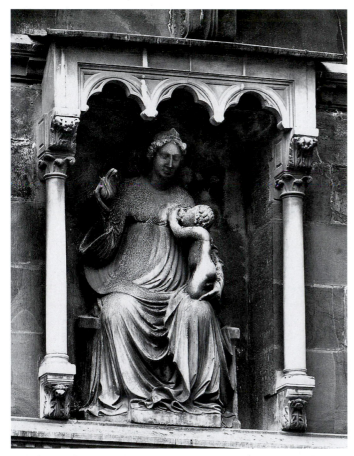

Plate 125 *Charity*, 1383–91, marble, Loggia dei Lanzi, Florence. Photo: Alinari.

Plate 126 Medal struck for Francesco il Vecchio da Carrara, *c.*1390, silvered bronze, 3.3 cm, British Museum, London. Reproduced by permission of the Trustees of the British Museum.

INDIVIDUAL COMMISSIONS

Individual commissioners existed, but what survives best is work ordered by individuals in connection with the institution within which they functioned. A member of a church hierarchy like a bishop or cardinal might order a tomb to be made, but it might well be read as an ecclesiastical government commission, representing a clerical version of the political imagery we have just considered. It would also be likely that the cardinal or bishop would request the tomb in his will, leaving institutional or family executors to realize the commemoration. Members of religious orders could be quite impressively entombed, but the commissions were placed by their order. Lay people, like the nobility or jurists, were capable of commissioning their own tombs (but we have seen that the tomb of Raimondino Lupi commemorated a host of his male relatives and his mother). As with the clerical tombs, the noble's or jurist's family would often design the tomb for its dead relative.

If we examine seals we find that, while some provided the name of the person whose documents and letters were to be validated, most emphasized the institution within which he or she lived. The nobleman used his family heraldry; the abbess relied on the convent's patron saint to stand for her (Chapter 11, Plate 232).[52] Only jurists draw attention in their seals to personal skills, showing their qualifications in separately tailored images of the lawman at his desk with his books.

Individuals also commissioned housings for relics. The most splendid of these were paid for by powerful clerics, like the absentee Archbishop of Padua, Hildebrand, who willed the Duomo at Padua a relic of the True Cross enclosed in a silver gilt and enamelled crucifix made sometime before 1339.[53] However, more humble patrons could purchase decorative containers of relics, like the priest of the same cathedral, Canon Orfeo, whose reliquary of Saints Anatolia and Emerenziana was recorded in the 1405 inventory.[54] Only some of these commissions would have been personally directed, however.

To complete this sampling of the sculpture of the period, I want to look at a Sienese tomb for a cardinal and a reliquary bust which a man had made for his distinguished relative in Florence. The tomb of Cardinal Riccardo Petroni in Siena is attributed to Tino di Camaino and his father about 1318 (Chapter 2, Plate 21).[55] Petroni was from an important local family, and Tino's was a local firm. The cardinal had died in 1313 in Genoa, so he did not personally direct his monument design, but he had asked in his will for a wall tomb in the cathedral. Having been moved three times, this tomb probably appears without some of the original elements: a painted setting, an image of God the Father presiding overall. Much plainer in the decorative detailing than the tomb of Jacopo II da Carrara in Padua, the tomb of this prince of the church is, however, more sumptuous in its five narrative reliefs on the tomb chest. These state his hopes of salvation in the resurrection and the encounters of the Magdalen and Thomas. On either side appear two reliefs: one shows the three Marys (Mary Magdalen, Mary the wife of Cleophas, and Mary the wife of James) arriving to find an empty tomb; on the other side is shown one of the first appearances of Christ after the Resurrection when he was recognized by Luke on the road to Emmaus disguised as a pilgrim. In the richness of the figures of prophets dividing these scenes like pilasters and the caryatid saints supporting his tomb, there is everything to impress and delight the spectator. The commissioners had been able to afford the dignity of a portrait effigy of the cardinal as if lying on his bier, and the charming motif of angels ready to draw the curtains from his resting place on the Day of Judgement. At the apex the most powerful intercessor, in the mother of Christ, is seated. The cardinal's executors emphasized the family importance of this monument by employing his heraldry both on the supports of the tomb chest and on the bier.

Paradoxically the more individually controlled of these two commissions – probably because executed during the patron's lifetime – is the reliquary bust of Beata Humiliana (1219–46) at Santa Croce in Florence, which Giovanni di Riccardo de'Cerchi had made in silver gilt (Plate 127).[56] On the breast of the bust, he placed the inscription: 'Saint Humiliana de'Cerchi. This work Giovanni son of Riccardo de'Cerchi had made.'[57] There is no date, but Giovanni made a will in 1394 endowing Santa Croce for the celebration of the feast of the saint on 19 May annually. Humiliana was a Franciscan tertiary of Santa Croce with a reputation for piety and self-sacrifice as wife and widow. In 1246 she was buried in the common grave in the cloister, but was exhumed in the first half of the fourteenth century when she was recognized as a local saint. The descendants of her paternal nephews contributed to her cult. (In 1361, for instance, Berto de'Cerchi left the community 20 gold florins for the relics of Saint Humiliana.) It seems likely that the bust was made towards the end of the century. Like the tomb, it declares family interests in the placing of the heraldic linked circles of the beatified and the donor on the relic. The appearance of life-likeness is avoided as if a realistic-looking portrait, which the patron could have commissioned, was inappropriate. The bust is highly polished. The gaze is slightly lowered. The features are formed with stern, sharp regularity. The effect is of a shining mask, to produce an impressive spectacle on the feast day at a distance on the high altar. For close reverence, there is a hinged plate to allow inspection of the skull. The drab poverty of the tertiary's veil is rendered in gilded silver as if to indicate one of the stories in her biography: that she would give away whatever clothes her husband gave her, or if it was a cloak, she would tear it in two pieces and keep only one piece for herself.

CONCLUSION

Generalizing about the style of sculpture bought by Paduans is problematic because of the paucity and condition of examples and because of the cosmopolitan body of artists. From the end of the period, for example, we have the graceful yet powerful French Gothic tabernacle for the Confraternity of Saint Anthony as well as the confidently classicizing images on Francesco il Vecchio's medal. From the beginning of the century, we have the impressive *arca* of Saint Luke which emphasizes how vaguely local styles can be characterized, in being attributed either to a sculptor from Venice or to a 'Tuscan'. Such imprecision does not breed confidence in seeking to differentiate very precisely between the stylistic traits of sculptors from the two Tuscan cities of Siena and

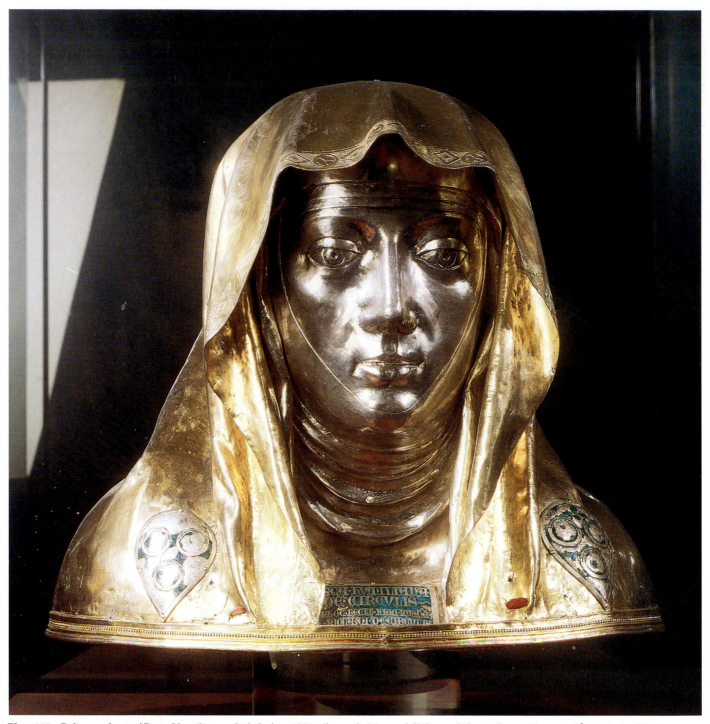

Plate 127 Reliquary bust of Beata Humiliana, a little before 1394, silver gilt, Museo dell'Opera di Santa Croce, Florence. Photo: Index / Tosi.

Florence. Both cities admired the powers of monumental sculptors from Pisa, for example. Both cities exported exquisite metal smithing. From Florence survive a sturdy group of marble carvings (mostly from exterior sites on the cathedral, the Loggia del Bigallo, at Orsanmichele) exploring the dramatically expressive lessons of Arnolfo di Cambio and Andrea Pisano during the latter part of the century. In Siena there seems to be marginally more interest in gothicizing styles emphasizing elegance and exquisiteness. However, there is still marked concern for dramatic versimilitude (which has been plausibly inferred to stem from the models of Giovanni Pisano, fellow pupil of Nicola Pisano with Arnolfo).

This is recorded not in stone or metal, but rather in the survival of a series of touching and dignified personalities carved and painted in wood.

Usually commissioned by or within the institutions of diocese or monastery, government, confraternity, guild or family, the very wide range of sculpture created in this period survives in a rather piecemeal fashion, dependent on the powers and longevity of the institutions which initiated them or on the reverence they acquired, either through religious belief, or the preciousness of their components, or both. Designers drew on the elegant forms of northern European styles, reaching them in the importation of small pieces like

ivories, and through travelling artists like Pietro di Giovanni Tedesco or the apprentice in Padua, Lamprecht, with his German parentage. Designers drew too on the robust formulae of Italian Romanesque motifs, as well as the classicizing compositions they could study in the ancient Roman reliefs built into Christian tombs and churches, or resting in coins, rings or cameos in treasuries. Figurative sculptors explored a variety of realistic styles which would achieve the objectives of Gregory the Great for religious images: to inflame the viewer with love of the pictured person and 'delight their minds'. But they also held a special place in their figurative repertoire for modes of representation which turned self-consciously away from illusion, towards an abstraction suitable for rendering certain kinds of sacred objects – most obviously, objects like the reliquary busts protecting the skull of Saint Humiliana.

Until the eighteenth century, historians and critics of fourteenth-century sculpture tended to praise and focus solely on the development of realistic and dramatically expressive techniques (see Chapter 11). However, since then, with the growing re-evaluation of Byzantine and Gothic styles, it has been possible to admire and discuss as well the more abstract and idealizing approaches we have seen to be operating in the sculpture of the three cities during this period.

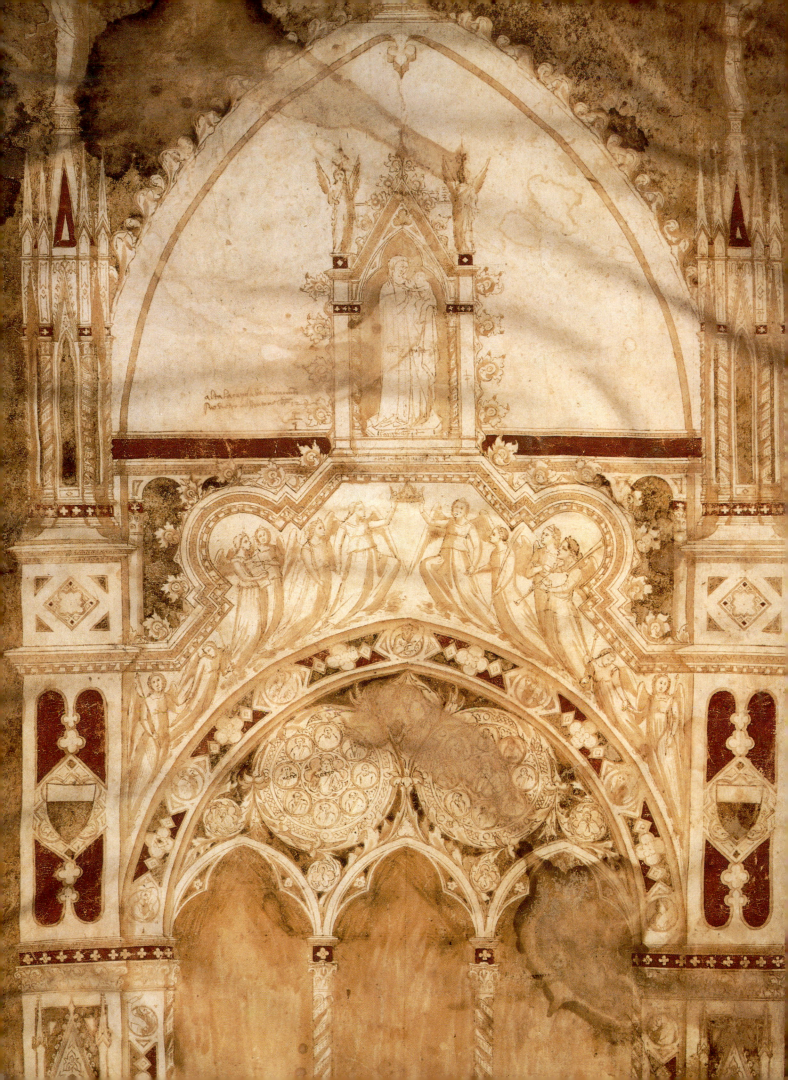

The building trades and design methods

How big a part did building and urban renewal play in the fourteenth-century Italian city economy? There are various reasons why it is very hard to answer this question with precision. One is that the surviving evidence makes it difficult to enter into the design process. We have no Italian architectural treatises that can be compared to Cennino Cennini's handbook for painters[1] or to the various manuscripts that have survived elsewhere in Europe, which give an insight into architectural theory. In addition, the buildings that still exist have been changed in various ways, by time and fashion. We must therefore assemble a rather diverse assortment of sources to try to assess the impact of building on Italian cities at this time. We know something about how the various building trades were organized professionally and where they obtained their materials. We can deduce something about the skills that were required by extrapolating the evidence from other cultures, to see if it fits the Italian context, and by looking at the buildings and the few drawings that have survived. This should help us to consider with a new eye the buildings of the period that remain and to place them into their social context.

THE COST OF BUILDING

Despite the plentiful documentation that exists about many of the important decisions on state spending, this evidence inevitably conceals the real cost (both human and material). For example, in Siena the Opera del Duomo received a constant stream of funds from the state from the early thirteenth century until the 1370s. It is difficult to quantify this investment, however, since the archives record only some of the payments. When, for example, in 1353, following the interruption caused by the Black Death of 1348, the Council of the Bell voted to renew direct funding, the sum of 200 gold florins twice yearly might have seemed small compared with the enormous sum of 2000 lire each semester (third of a year) paid for the swift construction of the Palazzo Pubblico in 1297.[2] The reality, however, was that the revenues of the Opera del Duomo included substantial undisclosed sums from other sources, including revenues from the lands of the bishop and canons, pious offerings of various kinds and legacies.[3] The very detailed study made of the comparable revenues of the Duomo at Orvieto in the same period is shown in the following table.[4]

What this table shows is that the number of pious offerings, legacies and sales (of candles and other goods, including bread for the poor) rocketed as a result of the dreadful scourge that killed between one-third and one-half

	1347	1348	1349	Total	%
Rent		349	570	919	0.3
Gifts		5483	4085	9568	3.2
Dowries	161	368	1815	2344	0.7
Offerings	2928	48,319	48,258	99,505	33.2
Wills	130	13,175	13,014	26,319	8.8
Sales	200	53,660	107,815	161,675	53.8
Total	3419	121,354	175,557	300,330	100

of the population of all the Italian cities in 1348. A similar phenomenon was documented in Florence, where serious progress on the construction of the body of the Duomo really began only after 1353, and where the revenues of Orsanmichele, with its tabernacle housing a thaumaturgic image of the Virgin Mary,[5] reached such heights that they temporarily overshadowed the revenues of the state. Building was an important item of public expenditure, but its demands were made perhaps even more insistently on the private purse. If this was dramatically true of the period after the Black Death, it was to a lesser extent true at other times, when the pious devotion of the populace could be stirred to give generously to major building projects. Special collections were made on the saints' days appropriate to the cathedrals all over the territories of the state; indulgences were offered by the bishop and the papal legate; special taxes were voted, including a *gabella* of four denari in the lira and two soldi per head.[6]

High-quality building work was dependent on certain criteria, the fulfilment of which could not be hurried. There were only a limited number of skilled *maestri* (masters) who, with their assistants, could be used and trusted to work well. For Siena Duomo, the approved number was ten; when it rose above this figure, there were complaints and the number was reduced.[7] These ten privileged *maestri* were paid in winter as in summer, despite the shorter days and interruption by the weather. Similarly, whilst brick and rubble walls could be built quite fast and the materials were locally produced, it took time and great quantities of money to obtain the worked marble for the external facing of a building. The Sienese accounts tell us a great deal about the cartage of stone and marble,[8] and about the quantities of metal utensils and lime used, but hardly anything about the precise quantity of human labour involved. A certain number of workmen were available to the Opera del Duomo (in Florence, as in Siena) and they were paid on a more or less regular basis. However, these workers were also available to carry out other work, which might include street paving, building or mending walls, or cutting underground aqueducts for the inner-city

Plate 128 (Facing page) Elevation drawing, presumed to be of the Cappella di Piazza, Siena, *c*.1350, Museo dell'Opera del Duomo, Siena. Colour washes indicate the use of expensive marble inlay, and the full-size statues would have been complemented by mosaic or painted decoration. Photo: Lensini.

fountains. Each of these projects took as much time and effort as work on the cathedrals. They were undertaken at various times and often account for interruptions in the construction of the cathedrals.

In each city the *operai* of the Opera del Duomo were empowered to solicit and receive donations and to administer these, as well as the receipts from the state, for the construction and repair of the cathedral. To these sums must be added an unknown amount from the very large revenues of the bishop and canons. The flexible allocation of the workforce and the various sources of income combine to make it unlikely that we will ever be able to quantify precisely the human and material cost of great works such as Siena and Florence Duomos or Sant'Antonio (the Santo) in Padua.

THE STRUCTURE OF MASONS' GUILDS AND TRADES

The building trades incorporated a number of different skills, many of which were clearly differentiated but which still allowed for some mobility between them. At one end of the production cycle were the quarrymen, in one of the biggest industries of the medieval period, who not only dug tunnels and hewed stone but also dressed and prepared the stone for transportation. Sometimes these men reached sufficient status and wealth to become real entrepreneurs, able to transport their own stone and supply expert carvers to carry out designs for details on a remote building site.

For example, the Florentine builder Benci di Cione built up a very successful career from his contracted work at the Bargello, Orsanmichele, the Duomo and the Loggia dei Lanzi in Florence. By 1348 he had amassed sufficient capital to be in a position to contract for a chapel for the nuns of Santa Maria del Fiore, Fiesole. Apparently, he could afford to supply all the material, cartage and labour and to complete the job in six months for a flat fee of 440 florins.[9] In 1355 we find him advising the Sienese state on the condition of its cathedral, but his high status as entrepreneur also carried heavy responsibilities. In 1361 the Silk Guild held him accountable for poor work on Orsanmichele and petitioned to have all his goods and properties appropriated.[10]

Many of the trades began to organize into *arti* in the thirteenth century. One of the first seems to have been the stoneworkers (*lapidici*) of Siena, who were incorporated into a guild at least as early as 1212.[11] The original statute of the stoneworkers' guild (the Magistri Lapidum or Magistri di Pietra) has not survived, but a document that appears to be a revision of it, dating from before 1270, was first published in the eighteenth century. The guild was democratically structured in imitation of the councils of the Commune, with three rectors, a treasurer and thirteen consuls distributed between the *terzi* (five from the Terzo di Città and four each from the Terzi di Camollia and San Martino). The officers served for six months and received a salary. Elections required the presence of 61 masters (distributed across the *terzi*). The purpose of an organization like this was to settle disputes between members, help out those in need and maintain a strong differentiation between the more skilled members and the manual labourers who often worked under them and to their orders. Interestingly enough, the names of

the signatories to the revision of the statute suggest that a majority came from provincial towns in the Sienese *contado*, often areas known for their quarries. The document also includes a clause prescribing the methods for incorporating foreigners, probably reflecting the large-scale immigration into Siena and the amount of building work in the rapidly expanding city. Many of the stoneworkers were men of substance, who bought and sold houses.

In Florence the various building trades were gathered together under the Ordinances of Justice of 1293 into the largest of the minor guilds, the Arte di Pietra e Legname, which included masons, quarrymen, kilnmen, bricklayers, carpenters, roofers and tilers, as well as many other specialist trades, such as foundation-layers and well-diggers. This grouping was part of a definite policy on the part of a new regime to divide and rule the different classes and groupings of workers in Florence and break down medieval traditions of exclusivity among the prestigious trades, such as the stoneworkers. If the example of one of the largest of the major guilds, the Arte della Lana, is anything to go by, this composite guild would have suffered tensions similar to those between the wealthy and prestigious wool merchants and manufacturers and their *sottoposti* or underlings (carders, spinners, weavers, dyers, etc.). The masons' guild tried to ensure that any painter or goldsmith working as architect on the cathedral became a member of the guild. Many of the masons were Lombards or Pisans, and a majority of the members of the guild lived outside the city, in the surrounding countryside, near the sources of their various raw materials. For example, many masons and quarrymen came from the villages around Fiesole and Settignano, within about 15 kilometres of Florence, where there were plentiful quarries for the *pietra serena* limestone that supplied much of the best building material. Many of the *muratori* or 'wallers' (masons and bricklayers) lived close to the clay-pits and brick kilns along the left bank of the River Arno.

Most of the clay-pits and kilns were located just outside the walls of the cities. Landowners would rent out a suitable site to one or more kilnmen, who would construct the relatively modest buildings needed to dry, fire and store the bricks and lime.[12] Although there is evidence of popular suspicion about the unseemly profits made by the makers and suppliers of bricks, it seems to have been a relatively lowly trade, open to wide competition. In Florence the brickmakers never established themselves with a separate guild, and in Siena, where they did, this guild (the Arte dei Fornaciai) was split by internal rivalries and never achieved important political status. In Siena, too, the carpenters had their own guild until 1355, when they were amalgamated under political pressure into a general building guild. In Padua, where stone was used less frequently in building operations, workers in brick (from manufacture to walling) played a prominent role in the masons' guild.

The very detailed records that have survived at Orvieto give us a privileged insight into the range of people employed on a cathedral building site.[13] Between 1347 and 1349 around 260 people were being paid for work on the site, including masons, sculptors, carpenters, glass-makers and blacksmiths. There were 66 women on the books, all in lowly positions of manual labour (removing stone and earth). Of the *muratori*,

only 29 were named masters, but they were assisted by a large number of manual labourers and unspecified workers. Most of the *scalpellini* (stone-carvers) worked on the site, but the *tagliapietre* (stone-hewers) all worked in the quarries and were paid by the day. There were six *segatori* (wood-cutters) under the control of a single carpenter and his son, who made the scaffolding and wooden centring for the vaults. In addition, 16 blacksmiths were kept busy making nails, chisels, tie rods and chains. Among all these 260 people, one was indicated as a German and one as a Fleming, most of the others seeming to have come from the locality. On this site, as on so many others, however, the prestigious leader of the whole operation, the *capomaestro*, was invariably a 'foreigner'. Lorenzo Maitani, the Sienese master, was in charge of operations from 1308 alongside another Sienese, Ramo di Paganello, who had worked on the façade of Siena Duomo in an uneasy relationship with Giovanni Pisano. Later Andrea Pisano, who had played an important role in extending the Campanile of Florence Duomo after the death of Giotto, came to play the key role at Orvieto. Certain masters reached a level of prestige where they could move from one city to another, attracting generous fees and special privileges. It is not always clear what their specific role was, and their value was probably precisely in their distance from the everyday work of the *muratori*, *scalpellini* and *lapidici* .

RECONSTRUCTING THE FOURTEENTH-CENTURY CITY: BUILDING MATERIALS

Nineteenth- and twentieth-century restorations have given a misleading impression about the original appearance of fourteenth-century buildings. For example, in Siena the stucco rendering that can be seen on many buildings in contemporary frescoes[14] has been stripped off to reveal the brick underneath.[15] This raises important and difficult questions about fourteenth-century building practice. In Siena the upper storeys of the Palazzo Pubblico, the Franciscan and Dominican monastic buildings and the extensions to the hospital of Santa Maria della Scala demonstrate the use of high-quality brickwork, and the existence of finely moulded brick details on these and some other elevations suggests that some façades were intended to be seen in this way (Plate 129). However, in other cases the rough bricklaying and hopelessly inadequate protection from the weather would suggest that the brickwork was originally intended to be rendered.

In Siena in the thirteenth century stone had been used more commonly than brick by the wealthy magnate families anxious to provide the best military protection for themselves and their *consorteria*. Many of their fortified houses accumulated wooden structures (balconies, lean-to roofs, etc.), which have since been demolished (Plate 130). During the building booms of the late thirteenth century and early fourteenth century brick came to be used, increasingly, for speed and economy. Paradoxically, an opposite tendency may be discernible in Florence, where many buildings constructed in brick were subsequently faced in stone during the Renaissance period, in emulation of prestigious buildings such as the Palazzo dei Priori (Palazzo Vecchio).[16] This process was initiated by a decree of 1385 requiring new house builders to build in stone at least up to a height of 4 braccia (2.33 metres), later increased for important buildings facing public squares. The presence of stone facing is in part evidence of an important fourteenth-century regard for civic

Plate 129 Detail of moulded brick, No. 11, Via dei Rossi, Siena. Photo: Tim Benton.

Plate 130 Detail of Palazzo Rinuccini, Siena. Photo: Tim Benton.

pride and a desire to give the impression of permanence, but in part the effect of later generations of Renaissance patrons. In Padua, where the nineteenth-century spirit of conservation made few inroads, apart from changes to a few prestigious monuments, we can see a mixture of rendered walls and stripped brickwork.

The façades of most of the houses lining the streets in Siena, Florence and Padua tell a lurid but enigmatic tale of losses and additions over the years. Holes or brackets mark places where lean-to roofs would have provided shelter for shops or work spaces in the street below, or where the very frequent wooden balconies, or cantilevered upper storeys, would have provided much-needed extra floor space above. Windows and doors have been opened in the base of towers, which before may have been either blind up to a safe height or left open as loggias. All the houses had to be defensible in times of civic disorder, and most families dedicated the ground floor to loggias, shops and store houses, which could be abandoned in times of crisis.

In Florence and Siena clay of sufficient quality for brickmaking was found in the immediate vicinity. In Florence there were some kilns within the fourteenth-century walls, although concerns about fire risk and the nuisance of the fumes restricted their number. In Siena, similarly, there were clay-pits and kilns in the grounds of the friary of Sant'Agostino and in Follonica, near the outskirts of the walled city.[17] A location within the walls allowed brickmakers to avoid paying the *gabelle*, since unbaked clay was exempt. The Commune was itself exempt from the *gabelle*, and it was common practice for the state to buy bricks cheaply outside the walls and supply them to worthy organizations, such as the Dominicans and Franciscans, to help them complete their churches. Although the staple building material in each city during the fourteenth century was brick, its use in Siena came to play a more important role.

In Siena, as the Council of Nine established increasing prosperity and order and under pressure of rapid expansion, brick became the main material used in building, even for the houses of the wealthy. A statute of 1309 ordained that all domestic architecture should be constructed of brick, whether as part of the general policy of stopping the magnate families building impregnable urban fortresses or from an aesthetic desire for coherence in street frontages.[18] The scale of brick production was further increased by the great new ring of walls begun in 1326 and by the government policy, enshrined in the Constitution of 1262 and confirmed in that of 1309–10, of supporting the religious institutions by giving them an annual allocation of bricks for construction purposes.[19] Another important use for brick was in the paving of the Campo (1333–34) and the principal streets. According to the *Statuto dei Viari* (street-paving statute) of 1290, the definition of a *strada*, as opposed to a *via*, was that the former was paved in brick. The Via Francigena was paved along its length,[20] as was the Strada Galgaria (now the Via di Città) and the street going down to the Porta d'Ovile, now known as the Via dei Rossi. The Council of Nine constantly intervened to widen streets and open up bottlenecks, using its compulsory purchase powers to buy properties in the way.

Plate 131 Detail of corner showing mezzanine window (left) and holes and brackets to support lean-to roof, Palazzo Quaratesi, Florence. Photo: Tim Benton.

The Sienese brickmakers seem to have been fairly inexpert, judging by the number of half-baked bricks visible in fourteenth-century walls. A petition from brickmakers of 1337 pleads for them not to be punished if the occasional under-baked brick occurred within a batch.[21] The widespread use of brick, closely controlled and in part subsidized by government, is a characteristic form of early investment, allowing for rapid results with materials close at hand and thus for the swift incorporation of a growing population.

Stone was also readily available in the three cities. Several quarries within the fourteenth-century walls in Florence (for example, in the area of the Boboli Gardens), including one leased out by the nuns of Santa Felicità, provided stone that was free of import tax. Many other quarries were located immediately outside the gates or along the banks of the Arno. Wallers would often quarry their own stone, under contract, paying charges per cart load to the owner of a quarry and paying for cartage and the *gabelle*. The most commonly used stone in Florence was *pietra forte*, an easily worked buff limestone, which can be seen in buildings all around the city. This material does not lend itself to fine cutting as does the grey *pietra serena* beloved of Renaissance architects in the fifteenth century. Its main use was as a surfacing material, cut in more or less regular rusticated blocks (Plate 131). The corners of buildings were typically detailed with very discreet colonnettes.

As in Siena, in Padua the use of stone was more usual in the twelfth and thirteenth centuries, when small blocks from the quarries in Montagnana or Costoza were brought in for fortifications and the lower courses of towers built by aristocratic families. A characteristic building technique, as in Siena, consisted of interleaving courses of stone with brick (Plate 132). As the demographic explosion placed pressure on prices and increased the urgency of building operations, however, stone came to be reserved for small decorative details.

BUILDING SKILLS: HAND AND BRAIN

Medieval masons had always been respected for their feats of structural daring, and sculptors and painters were becoming increasingly conscious of their status. A traditional feature of the French cathedral was an inlaid labyrinth in the floor of the nave, where pilgrims would progress to the centre on their knees. It was common to place there the names and even portraits of the main builders of the cathedral. For example, at Rheims a labyrinth showed portraits of the four architects responsible for carrying out the work from 1211 to 1290.[22] The new status achieved by architects emerges clearly from a sermon of 1261 by the French Dominican Nicholas de Biart, who railed against 'Masters of the masons, carrying a yardstick and with gloves on their hands, [who] say to others: "Cut it for me this way" and do not work; yet they receive higher pay, as do many present-day Bishops.'[23] The division of labour was clearly becoming an issue.

In Italy many of the most famous men placed in charge of the biggest building projects began as sculptors, painters or goldsmiths. Giovanni Pisano, who trained as a sculptor in his father's workshop, was allowed a burial near the façade of Siena Duomo, which he may have designed, and an inscription commemorating his involvement. However, when he was given Sienese citizenship and immunity from taxes in

Plate 132 Detail of twelfth- to thirteenth-century walls adjoining the Porta di Ponte Molino, Padua. Photo: Tim Benton.

1284–85, he was described simply as 'magister' (master), and there is no clue as to whether he was being honoured as sculptor or architect.[24] By 1290, by which time he was being referred to as 'capudmagister' (master builder), his great importance to the Commune is evidenced by an extraordinary series of decisions. The General Council of the Bell met specially to commute a threatened prison sentence for Giovanni into a fine of 800 lire, on the grounds that he was vital for building works. The Council later found a way to reimburse the exact sum of the fine so that eventually Giovanni was not even out of pocket. Even so, there is no hard documentary evidence that his contribution to the façade was as an architect rather than sculptor. Indeed, he was accused of gross mismanagement of the site in 1296–97, when numerous pieces of marble lay strewn about, with no obvious location on the façade. Even if this was a retrospective accusation after he had left the job, as some scholars claim, it sounds as if the priorities of the post had been sculptural rather than architectural.[25]

Similarly, the man called for in 1339 to take charge of the ambitious new project to double the size of Siena Duomo, who was in Naples at the time, was Lando di Pietro. Trained as a goldsmith, he became famous for designing the crown used in the coronation in Rome of Emperor Henry VII (1312).[26] In the 1330s he seems to have been most in demand as an expert in balancing bells, and when he died in August 1340 he was recorded as 'Aurifex' (goldsmith). Yet in January 1339 he was paid 41 lire, 13 soldi and 4 denari as five months' salary 'for making the great church', and in February 1339 we find him undertaking the highly complex and risky task of 'bringing water into the Fonte Gaia in the Campo'. In this enterprise he was associated with the masons Agostino di Giovanni and Giacomo di Vanni (both of them involved with the cathedral works) in receipt of the sizeable sum of 6000 gold florins.[27] In interpreting evidence of this kind it is difficult to know whether the famous goldsmith is being employed for his prestige and general wisdom, or whether he brought specific skills to bear, such as surveying, drawing or sculpting.

The profession of architect was less clearly defined than today. North of the Alps architectural design was generally carried out by experienced master builders who began their careers as stone-carvers or masons. In Italy the high prestige of the visual arts meant that a man like Giotto with little experience of building could be made responsible not only for the Duomo but also for the city walls of Florence. It is notable, however, that in the document celebrating his achievements (worthy of exemption from taxes) he is described as 'pittore' (painter) and 'magnus magister' (great master).[28] Arnolfo di Cambio, although primarily known as a sculptor in his early career, had more specifically been described, in 1300, as 'famosior magister et magis expertus in hedificationibus ecclesiarum' (renowned master and skilled expert in building churches).[29] An inscription that commemorates the founding of Florence Duomo in 1296 refers to 'istud ab Arnulfo templum fuit edficatum' (this temple was built by Arnolfo). The plaque that bears the inscription, on the south-west corner of the cathedral, was probably erected as late as 1368, indicating that the memory of the famous architect had persisted for over 60 years after his death.[30] In Padua the

reputation of Fra Giovanni degli Eremitani, who carried out a number of works for the city, was sufficient for the chronicler Giovanni da Nono to describe him as 'ceteris edificatoribus excellentior' (this excellent builder), and the engineer Leonardo Bocaleca was allowed to place on the Palazzo del Consiglio the inscription: 'Magister Leonardus Bocaleca fecit hoc opus' (Master Leonardo Bocaleca made this work).[31] Thus, there is documentary evidence of masters, whether sculptors, masons or engineers, being described as designers, or creators, of buildings.

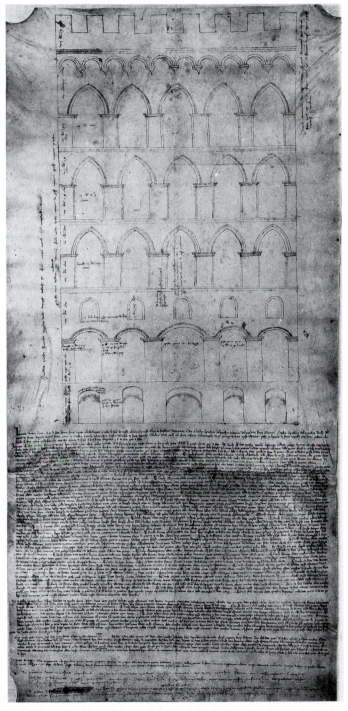

Plate 133 Elevation drawing for the Palazzo Sansedoni, Siena, 40.6 x 71 cm, reproduced from a Sansedoni Palace contract of 1340 in the collection of the Monte dei Paschi di Siena Bank. Photo: Lensini.

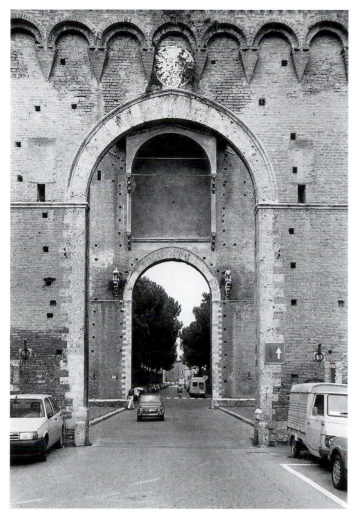

Plate 134 Porta Romana, Siena. Photo: Tim Benton.

One of the defining characteristics of architectural practice (especially from the Renaissance period onwards) is the use of measured drawings to fix the overall lines and much of the detail of a design. Did these men use drawings and is this a means of identifying them as architects? Frustratingly, although a number of measured plans and elevation drawings exist, in very few cases can a firm attribution be made to a man who might also be thought of as the designer of a building.[32] One drawing that does provide clear evidence of a mason being known to be an architect and builder is an elevation drawing attached to a contract concerning the Palazzo Sansedoni, on the Campo in Siena (Plate 133). The drawing is a freehand copy of the original architect's elevation drawing, not a simple diagram illustrating features discussed in the contract. The three masters contracted to build the Palazzo were Agostino di Giovanni, Agostino di Rosso and Cecco di Casino. The first of these was the father of Giovanni di Agostino, responsible for much of the work on the extension to the cathedral in Siena. Agostino di Giovanni had worked on the Porta Romana (Plate 134) and the tower of the Palazzo Pubblico, as well as the big commission with Lando di Pietro already mentioned to supply water to the Fonte Gaia. Agostino's son Giovanni di Agostino made himself surety to complete the work if his father defaulted.[33] The drawing specifies a building that follows the Ordinance of 1297, which stipulated that all palaces adjoining the Campo should use windows 'with columns' in emulation of the Palazzo Pubblico. The façade facing the Campo has been restored beyond recognition, as part of a unification with the adjoining properties. Parts of the 1340 façade can be seen facing the Banchi di Sotto, however (Plate 135). Although there are small differences in execution, and many subsequent changes which have to be erased in the mind's eye, the drawing has been followed fairly closely (Plate 136).

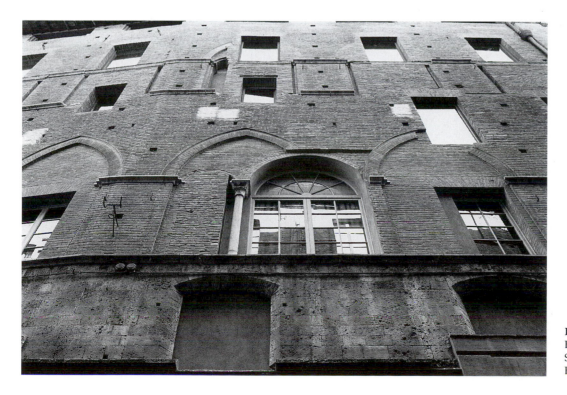

Plate 135 Façade facing the Banchi di Sotto, Palazzo Sansedoni, Siena. Photo: Tim Benton.

Plate 136 Comparison by Toker of the north façade of the Palazzo Sansedoni, Siena, as drawn and as built. Reproduced from 'Gothic architecture by remote control: an illustrated building contract of 1340', *Art Bulletin*, March 1985 by permission of Professor Franklin Toker.

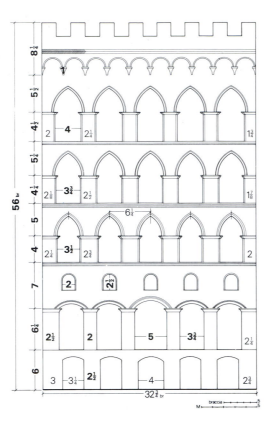

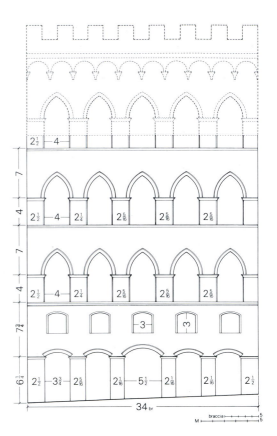

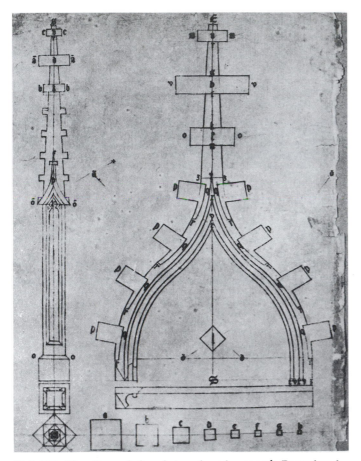

Plate 137 Elevation and plan of pinnacle and ogee arch. Reproduced from Hans Schmuttermayyer, *Fialenbüchlein, c.*1486, Germanisches Nationalmuseum, Nürnberg, Inc. 80 36045/k497.

It has also been argued that the dimensions of the façade were derived from the standard medieval masons' design method, known as *ad quadratum*. This procedure, used by masons for setting out architectural details and recorded in a number of texts proceeding from north of the Alps, depends on the relationship between the sides of a square and its diagonal.[34] Masons could quickly set out, for example, the base of a Gothic pinnacle by drawing eight interconnecting squares and taking from them all the required dimensions (Plate 137). From an initial square 'a', a smaller square is derived on the diagonal by joining the mid points of each side, and so on for squares 'b' to 'h' (illustrated at the foot of the pinnacle on the left). Extrapolating these squares into a row (illustrated at the foot of the ogee arch on the right) produces a scale of dimensions that can be used for every detail of the pinnacle and arch. Each successive square has an area half that of its predecessor, and every second square in the sequence has its sides half the height of the square before its predecessor.[35] The usefulness of these dimensions derives from the fact that they 'go together' well: adding a 'd' square measure to a 'b' square measure gives an approximation of an 'a' square measure. This is important when setting out decorative mouldings where three or four subdivisions have to add up to one or two larger divisions. Medieval craftsmen required techniques like this for setting out geometric drawings to any scale, using only a straight edge, right angle and compass. Similarly, when medieval masons needed to find the circumference of a circle, they did not use Archimedes' famous theorem[36] but traced out the circle (perhaps the base of a column) three times, drew a line bisecting the resulting three circles and added a seventh part

of one of them.[37] This is a practical way to work out how to divide up the surface of a circular form into precise segments. From these methods, which acquired an aura of mystery fiercely protected as the secret of the masons, draughtsmen provided themselves with rules that were not only arrived at geometrically (that is, independently of specific measurements), but also thought to be inherently harmonious. Indeed, the proportional relationship between the sides of a square and its diagonal, and the geometrical means of deriving it, were first explained by Plato and recorded by Vitruvius.

Another procedure was used for the construction of an elevation from a plan. In the case of a finial, this was simply a question of using multiples of the same dimensions; thus, the height of the finial is 16 times the width. Other more elaborate constructions were available, but the common theme was that plan and elevation, both in detail and in large scale, should be related by a shared set of dimensions or their multiples. From this deeply ingrained habit of methodical working springs the sense of proportion and balance that characterizes much medieval work. For similar reasons, dimensions in a ground plan and elevation would be set by the mason's yardstick, which might vary from town to town and site to site. In practice, architects and masons almost certainly worked out most of their large-scale designs at full scale on the ground.[38]

If the attribution of the drawing for the Palazzo Sansedoni is correct, Giovanni di Agostino and his father are showing in this modest drawing that they possess the secret of the masons and are using it to achieve a finely proportioned façade. By comparison with the northern masons and builders, however, the Italian tradition of craftsmanship placed a higher premium on visualization through drawing, and the fantasy and creative daring of the surviving architectural drawings match the sculptural inventiveness of the constructed buildings (Plate 128).

To expand on this argument and look for sophisticated proportional relationships in other drawings, and in buildings, is beyond the scope of this essay. Indeed, it would be unlikely to produce positive results. One thing that is palpably obvious about fourteenth-century building methods is that, whatever might be planned out on paper or in model form, the reality was subject to widespread variation. The geometry of Siena Duomo, for example, is wildly erratic. The hexagon of the crossing is blatantly asymmetrical, and every bay of the nave has different proportions. The piers of the choir, built out over the newly created baptistery, do not coincide exactly with the piers below. That the buildings of this period did not fall down was due not to the geometrical skill and surveying abilities of the architects, but to the subtle adjustments and pragmatic adaptation of the skilled craftsmen who built these great works.

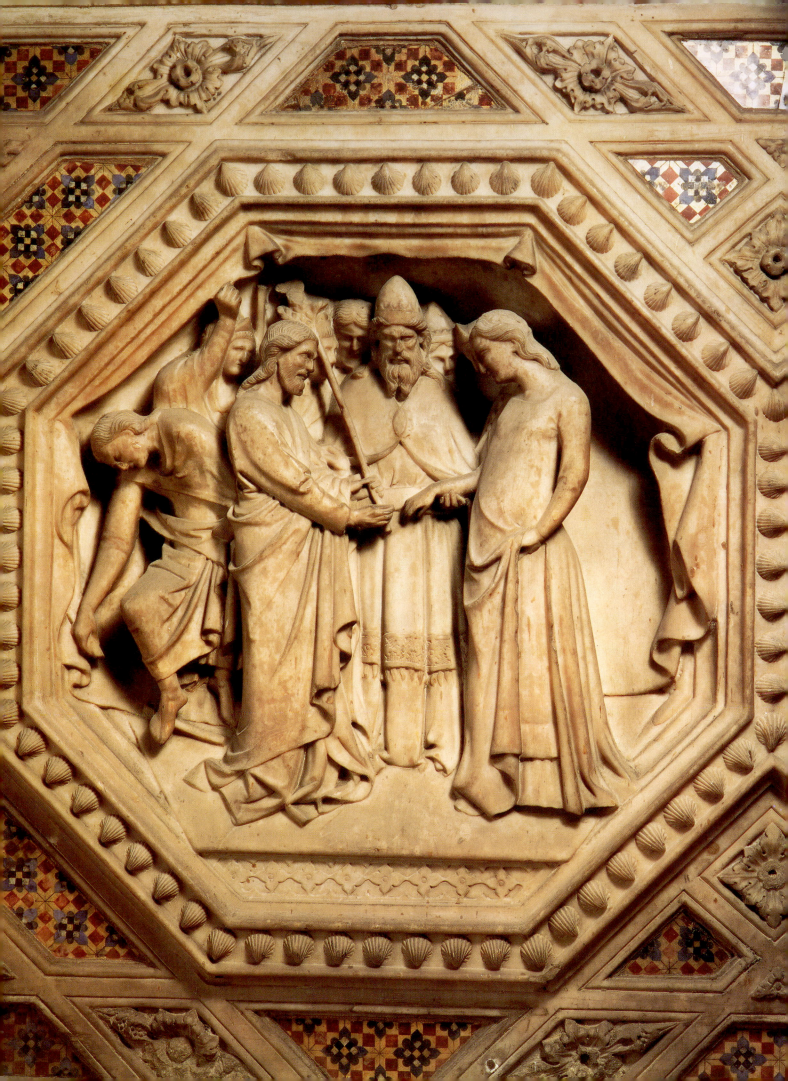

'The glorious deeds of the Commune': civic patronage of art

Within fourteenth-century Siena, Florence and Padua corporate organizations and associations – the Commune, the guilds, family allegiances (*consorterie*), religious orders, confraternities and universities – were the norm. Much of the art that we admire today in the three cities was initiated by these groups of individuals. Certain works of art present straightforward examples of such patronage: two of the most striking of these are Siena Duomo, under the patronage of the Commune and the cathedral canons, and Duccio's *Rucellai Madonna*, financed by the Florentine confraternity of the Laudesi of Santa Maria Novella (Chapter 3, Plate 55).[1] Other kinds of commission are less easy to attribute. Ambrogio Lorenzetti's *Saint Louis of Toulouse before Pope Boniface VIII* (Chapter 1, Plate 17) once featured as part of the painted decoration of the chapter-house of Siena's principal Franciscan friary and could, therefore, be presumed to be the result of a classic act of fourteenth-century corporate patronage. Yet it appears that a single family – the Petroni – may have played a significant part in the commissioning and financing of this project.[2] Indeed, familial patronage of art – expressed in such monuments as the private *palazzo* or the family chapel within one of the cities' churches – was as often as not designed to serve the needs of an extended network of family interests.[3] There is thus potential overlap between what constituted 'corporate' and 'individual' initiatives within the context of fourteenth-century art patronage.

Whilst corporate groups were often formed for reasons of self-interest and in direct competition with one another, many civic bodies, such as the Commune, the guilds and the confraternities, were, in theory, deeply committed to the corporate ideal. In other words, there was a belief that the political powers exercised in the name of the corporation ultimately resided in the community of its members. As John Najemy has succinctly summarized:

> the membership of the corporation, or a council representing the same, delegated those powers to elected heads, who served for limited terms and with the specific mandate to preside over the corporation, or to represent it, within the limits of its written constitution, according to the will of the majority, and for the common good of the community.[4]

Such political idealism, in turn, had an impact upon fourteenth-century art. First, it had a practical effect on the processes by which corporate patrons acquired their art. Responsibility for art patronage was generally given either to the leaders of the organization in question or to a specially appointed committee of members – the *opera*. In the contract for the *Rucellai Madonna*, the individuals named as Duccio's patrons were the two rectors of the confraternity and two elected members of the *opera* – the *operai*. Since these offices

were customarily of a short tenure, and since delegated representatives were expected to consult with the wider membership, this well-established practice opened the patronage of art to a much larger number of people than would have been the case had the purchase of art been confined to merely a few individuals. Secondly, and more crucially, since much of the art commissioned by corporate patrons was intended to celebrate their group identities and to validate their corporate activities and practices, the corporate ideal had an effect upon the content of the art produced under these corporations' auspices.

For example, Duccio was commissioned by the Laudesi of Santa Maria Novella to paint an altarpiece that would depict 'the blessed Virgin Mary and her omnipotent Son' in order to celebrate the holy patron of the confraternity and to assist its collective religious devotions within the Dominican church of Santa Maria Novella. By successfully executing a painting that, in terms of both its subject and its pictorial treatment, fulfilled the confraternity's expectations, Duccio supplied the Laudesi with a work of art that ably served 'the common good' of that particular Florentine association.[5]

The paintings within Siena's monumental town hall – the Palazzo Pubblico – constitute another record of fourteenth-century art patronage by a civic institution, namely the Sienese government. Documentary evidence for the processes by which art was obtained for this building survives only in a very dispersed form. Even when located within such sources as the deliberations of the Consiglio della Campana (the Council of the Bell or main legislative body of the Sienese communal government) or the city's account books, it is often disappointingly brief and uninformative. Indeed, it is the surviving art itself that provides the fullest and most impressive evidence for this particular sequence of communal patronage. By studying the varieties of imagery chosen for the interior of the Palazzo Pubblico, one may cautiously but plausibly attempt to reconstruct what the civic patrons required to be painted and what the significance of the imagery was for them, and hence also what kinds of artistic demand and challenge painters encountered in the execution of these public and highly prestigious commissions.

This essay will focus, first, upon the mural paintings of one of the principal council rooms in the Palazzo Pubblico – the Sala del Consiglio – in which the Consiglio della Campana met.[6] Secondly, the essay will compare this Sienese painted scheme with those for the town halls of Padua and Florence, considering what is reputed to have been commissioned for the Palazzo dei Priori in Florence and what survives of an early fourteenth-century painted scheme for the Salone of the Palazzo della Ragione in Padua. Thirdly, since next to nothing survives of the interior painted decoration of Florence's town

Plate 138 (Facing page) Orcagna, *The Marriage of the Virgin*, marble relief, detail of tabernacle (Plate 157). Photo: Scala.

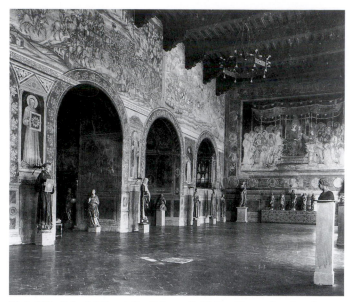

Plate 139 Sala del Consiglio, Palazzo Pubblico, Siena, showing the newly restored *Maestà*. Photo: Lensini.

hall, the essay will examine the nature of Florentine corporate, civic patronage in terms of a different kind of public monument, namely that of the city granary of Orsanmichele.

THE PAINTINGS OF THE SALA DEL CONSIGLIO, SIENA

Before the beginning of the fifteenth century when a chapel was installed in its north-east corner, the Sala del Consiglio constituted a more expansive space than it does today, with a row of south-facing windows on one side and an open arcade on the other (Plate 139). On the east wall is a large-scale mural, which depicts the familiar Sienese iconography of the *Maestà* (Plate 140). This impressive painting by Simone Martini[7] offers a sophisticated and urbane reinterpretation of Duccio's earlier treatment of the same subject for the high altarpiece of Siena Duomo (Chapter 3, Plates 43 and 57). The painting adapts the *Maestà* theme for a new location, within a room designed to house the collective deliberations of Siena's main legislative body.

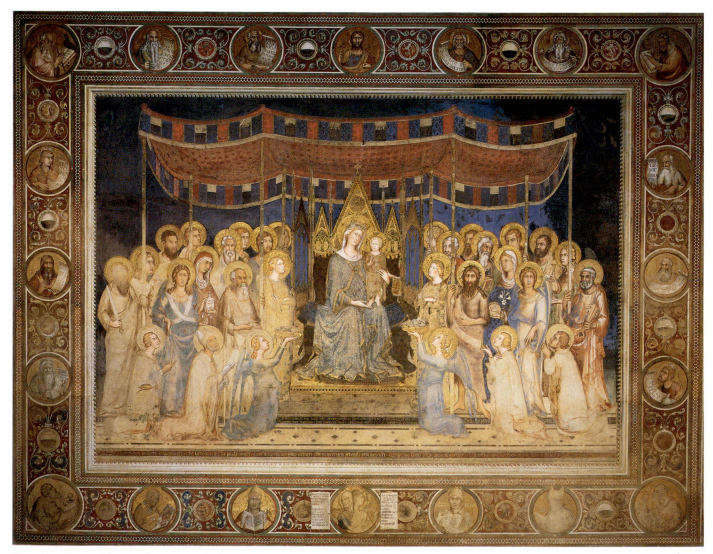

Plate 140 Simone Martini, *The Virgin and Child and Saints*, also known as the *Maestà*, 1315–16, fresco, 836 x 977 cm, east wall, Sala del Consiglio, Palazzo Pubblico, Siena. Photo: Lensini.

In place of the gold background and somewhat stylized treatment of the characters in Duccio's *Maestà,* the figures in Simone Martini's painting are represented in a far more illusionistic way, as if gathered in the open air under an expansive canopy. They thus appear to the viewer as relatively accessible, a pictorial consideration that increases in significance when one reviews further details of the painting. The Christ Child, portrayed as a young infant, is shown standing on his mother's lap, looking directly at his audience and in the act of blessing it. Around the Virgin's throne are ranked 30 saints and angels who, since they are more than life size, constitute an imposing presence. Kneeling at the Virgin's feet are two angels, each offering a bowl of flowers, and Siena's major patron saints – Ansanus, Sabinus, Crescentius and Victor. Thus, as in Duccio's high altarpiece, those saints who were deemed to be the city's most powerful spiritual advocates are represented in the immediate foreground of this monumental, civic image. Grouped behind them are other major representatives of sainthood or of the hierarchy of angels – Paul, the Archangel Michael, John the Evangelist, John the Baptist, the Archangel Gabriel, Peter, Mary Magdalen and Agnes, together with other female saints, angels and apostles.

The painting's elaborate figural scheme is further extended by 20 roundels within the wide, painted border. These depict God the Father, the four Evangelists, Old Testament prophets and the Doctors of the Church. At the centre of the lower border is a complex and intriguing representation of two laws or dispensations (Plate 141). The laws are portrayed as a two-headed figure, thus recalling representations of the classical god Janus. The composite nature of this figure is further elaborated upon by the painted text on her octagonal halo, which refers both to the old and new law and to the seven Christian virtues: prudence, justice, fortitude, temperance, faith, hope, charity. The old law is represented, appropriately enough, as an old woman seen in profile and facing an abbreviated text of the Ten Commandments, the summary of Mosaic Law as recorded in the Old Testament (Exodus 20:1–17). Conversely, the new law is represented as a *young* woman – again seen in profile – pointing towards a text that lists the seven sacraments: baptism, confirmation, the eucharist, penance, matrimony, ordination, extreme unction.

Whilst the painting obviously conveys primarily religious concepts, the civic role that it was also intended to perform is clearly alluded to by a number of heraldic devices, portrayed within both the painting itself and its border. Embedded in the wall below the wide border of the painting is a painted replica of the communal seal of Siena, with its distinctive imagery of the enthroned Virgin Mary and Christ Child flanked by two angels each holding a candle in a candlestick. When reconstructed, the inscription around this reproduction of the seal reads, in translation: 'May the Virgin preserve Siena the ancient whose loveliness may she seal.'[8] This painted civic emblem is accompanied by a painted replica of the seal of one of the city's principal officials – the Capitano del Popolo (Captain of the People). Within the painting and its border there are depictions of other Sienese civic emblems – the *balzana* (the shield of the Commune of Siena), the lion of the Popolo and the fleur-de-lis (which was adopted by the Guelph Party as a sign of its solidarity with Siena's political allies, the Angevin monarchy of Naples) (Plate 140).

The political message of the painting is further underlined by the texts incorporated within it. The scroll that the Christ Child carries bears the injunction: 'Love justice, you who judge the earth', a message that, although it is a biblical text,[9] would also have had clear political resonances for the painting's first audience, the Consiglio della Campana. On the step of the Virgin's throne is another, longer text, which adds further emphasis to this aspect of the painting's significance. In the text the Virgin first expresses her delight in righteous counsel and her contempt for selfishness, which leads citizens to despise her and deceive her land. Secondly, in reply to a now lost prayer once painted on the scrolls held by the four kneeling saints, she states that her acceptance of their prayers on behalf of the citizen body would not extend to those who oppress the weak and betray her land.[10] Thus, the Virgin Mary is emphatically portrayed as the heavenly patron and governor of Siena, an enduring and passionately held aspect of Siena's civic ideology. Indeed, as Helen Wieruszowski has remarked, the Virgin is depicted in the guise of a queen of the city, who will personally assist at meetings of the council and inspire the city authorities to wise decisions.[11] Furthermore, the wording of the text painted on the steps of the throne outlines in precise detail the decisively reciprocal nature of the archetypal patron–client relationship. The Virgin will undertake to protect Siena, but only if the citizen body, united as one, will honour her and the land that she rules.

It is also significant that, in the latter text, reference is to the Virgin Mary undertaking to protect her *terra* (land) and not merely her *città* (city). The distinction embodied in this choice of word was by no means arbitrary. As indicated in Chapter 2, the Italian Communes were assiduous in establishing territorial states that ensured for them a measure of economic and political autonomy.[12] Siena was no exception to this rule and pursued a determined and relentless policy of territorial acquisition throughout the thirteenth and fourteenth centuries. This process included not only the political and military subjugation of other Communes, such as the south Tuscan towns of Grosseto, Massa Marittima, Montalcino and Montepulciano, but also the acquisition of the fortresses and lands of powerful local noble families. These included, for example, the Aldobrandeschi, the Counts of

Plate 141 Simone Martini, *The Old and New Law,* detail of *The Virgin and Child and Saints* (Plate 140). Photo: Lensini.

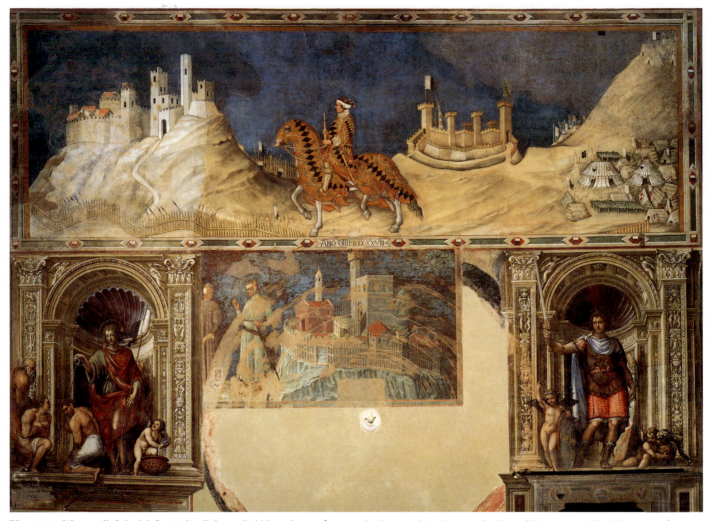

Plate 142 West wall, Sala del Consiglio, Palazzo Pubblico, Siena, showing *Guidoriccio da Fogliano at the Siege of Montemassi*, *The Submission of a Castle*, *Saint Ansanus* and *Saint Victor*. Photo: Lensini.

Santa Fiora, whose territories extended throughout southern Tuscany and whose power base lay in the mountains surrounding Santa Fiora. Furthermore, it is clear from a number of brief but revealing references in Sienese government records, and from surviving fragments of the original painted scheme of the Sala del Consiglio as a whole, that this policy of territorial acquisition was commemorated and celebrated upon the walls of the room.

Today all that survives from the fourteenth century of this particular aspect of the room's pictorial decoration is two paintings on the west wall directly opposite the *Maestà* (Plate 142) and another upon the upper arcade of the north-west section of the room (Plate 146). The largest and best preserved of the paintings on the west wall portrays Guidoriccio da Fogliano, a celebrated fourteenth-century soldier from central Italy employed by the Sienese as their Capitano della Guerra (Captain of War), who captured the Aldobrandeschi stronghold of Montemassi in 1328 (Plate 145). The second surviving – although much damaged – fourteenth-century painting on the west wall apparently depicts the capitulation of another well-defended hilltop castle (Plate 143). The large painting on the upper arcade of the north-west section of the room, meanwhile, portrays a victory won by the Sienese in 1363 (Plate 146). The official

records, however, refer to a more extensive series of commissions, commencing before 1314, for paintings to depict a sequence of conquered towns, including not only Montemassi but also Giuncarico, Sassoforte, Arcidosso and Castel del Piano.[13]

The recent history of the investigation of these particular paintings celebrating the territorial expansion of early fourteenth-century Siena provides an interesting case study of the nature of modern art-historical research and debate. In 1977 a number of questions were raised concerning the traditional dating and attribution of the principal painting on the west wall of the Sala del Consiglio, *Guidoriccio da Fogliano at the Siege of Montemassi* (Plate 145). In the detailed technical examination of the painting that followed, one of the previously lost paintings of the cycle celebrating fourteenth-century Siena's newly conquered possessions was rediscovered (Plates 142 and 143). This newly rediscovered painting depicts, on the right, a small hilltop community, dominated by an imposing castle at its summit and protected by two sets of palisades, and, on the left, two men whose dress suggests persons of some social standing. Since the layers of plaster on which it was painted lie beneath the painting of Guidoriccio, it appears that this painting was executed *before* the painting directly above it and then

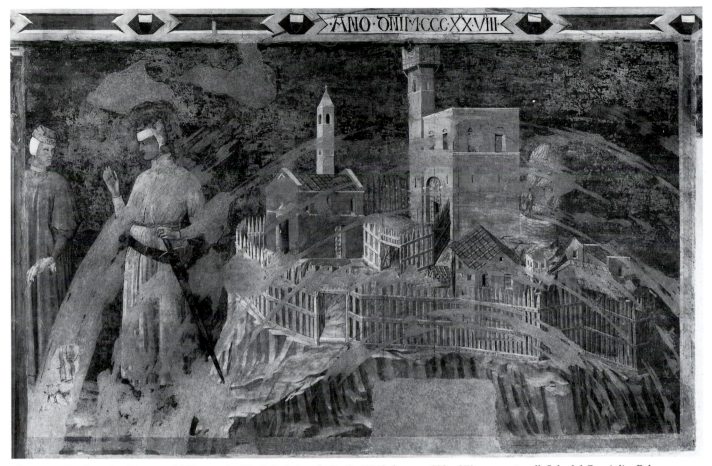

Plate 143 Attributed to Memmo di Filippuccio, *The Submission of a Castle*, 1314?, fresco, *c.*223 x 378 cm, west wall, Sala del Consiglio, Palazzo Pubblico, Siena. Photo: Lensini.

subsequently covered in 1345 by a circular map of the world – the *Mappamondo* – by Ambrogio Lorenzetti. Its left-hand side was destroyed in 1529 by a painting of Saint Ansanus by the sixteenth-century painter, Sodoma.

The attribution of the rediscovered painting remains hotly debated and includes within its range Duccio, Simone Martini, Ambrogio Lorenzetti, Pietro Lorenzetti and Simone Martini's father-in-law, Memmo di Filippuccio. Debate has centred, however, upon the case for Duccio, Simone Martini and Memmo di Filippuccio. What, in summary, is the case for the attribution of this painting to one or other of these painters? In view of its somewhat archaic treatment, particularly in respect of the discrepancy in scale between the figures and the town, it has been proposed that the scene represents the submission of the town of Giuncarico in 1314, the figures being identified as, on the left, a representative of the Sienese government and, on the right, a member of the town's community. Advocates of this identification tend to attribute the painting to Duccio who, in 1314, was by far the most prestigious and well-established painter in Siena.[14] Others have argued that the town in the painting represents Arcidosso, an identification based upon comparison between the buildings in the painting and the topography of Arcidosso and the representation of the town on Arcidosso's civic seal. Exponents of this view suggest that the figure with the sword might represent Guidoriccio, to whom the authorities of Arcidosso had submitted in 1331, the other figure being a

member of Arcidosso's community. The Sienese treasury made a payment in 1331 to 'Simone, painter' in order that he visit Arcidosso, Castel del Piano and Scansano. In the same year he was also paid for painting Arcidosso and Castel del Piano in Siena's town hall. It has, therefore, been proposed that the painting was executed by Simone Martini in 1331. Its somewhat old-fashioned treatment might be accounted for by the fact that he was contributing to a cycle of earlier paintings of conquered castles and tailored his style to match that of the paintings already decorating the walls of the Sala del Consiglio.[15] However, the topographical similarities between the simple groups of buildings represented in the painting and the well-fortified hill town of Arcidosso are not that striking. Moreover, in terms of the graphic but simplified forms of both the buildings and the rocky terrain, the painting is far more reminiscent of certain narrative scenes in Duccio's *Maestà* than of Simone Martini's rendition of buildings and hills as seen in, for example, *The Blessed Agostino Novello* (Chapter 1, Plate 2) or *The Knighting of Saint Martin* in the Montefiore Chapel in the Lower Church at Assisi (Chapter 2, Plate 29). In the light of the latter stylistic considerations, it seems more likely that the painting was executed in the second decade of the fourteenth century. However, the treatment of the figures is not typical of Duccio. It more closely resembles that of Memmo di Filippuccio, a Sienese painter who was active in Siena and San Gimignano during the first three decades of the fourteenth century (Plate 144).[16]

Plate 144 Memmo di Filippuccio, detail of *The Torments of Love*, *c.*1305–10, fresco, Camera del Podestà, Palazzo Comunale, San Gimignano. Photo: Lensini.

The striking mural above the rediscovered painting, *Guidoriccio da Fogliano at the Siege of Montemassi*, commemorates the overtly military dimension of Siena's campaign of territorial expansion (Plate 145). The painting constitutes an impressive and large-scale representation of a man on horseback, portrayed riding between two kinds of fourteenth-century fortification. A painted inscription on the lower frame of the painting gives a date of 1328,[17] the year that marked the capture, after a seven-month siege, of Montemassi. The citadel on the left has, therefore, been identified as Montemassi, an ascription that is supported by its resemblance to what remains of the Aldobrandeschi fortress, which still today dominates the hill town of Montemassi. The other fortification, considered in older sources to be the neighbouring town of Sassoforte, is now generally thought to be a representation of a fourteenth-century siege fortress – a *battifolle*. From the fourteenth century onwards, the striking figure on horseback has been identified as the victor of the Montemassi campaign, Guidoriccio da Fogliano, Siena's Capitano della Guerra from 1326 to 1333, and again in *c.*1351–52. This identification is confirmed by the depiction of the Fogliano family's heraldic device (black diamonds on a yellow ground covered with vine leaves) on the figure's costume and the caparison of his

horse. The painting has generally been attributed to Simone Martini and dated *c.*1328–30, based on a number of early historians' accounts of the painting and an archival record of a payment to one 'Simone' on 2 May 1330 for a painting of Montemassi and Sassoforte in the 'Palazzo del Comune'.[18]

As we have already noted, however, this painting has recently come under intense scrutiny following the questioning of its traditional attribution and dating. This questioning included the radical alternative proposal that the painting is, in fact, not by Simone Martini nor, indeed, fourteenth century at all. The case for such radical re-dating was based upon two kinds of historical evidence – iconographic and technical. In respect of the former, certain anachronisms were believed to have been identified within the painting, although subsequent scholarship had tended to reject these claims.[19] In respect of the latter, one modern restorer has claimed that, at one point in the right-hand corner of the wall, the present *intonaco* or layer of plaster on which the *Guidoriccio* is painted overlaps that of the adjacent *The Battle of the Val di Chiana*.[20] Since the latter painting has a secure date of 1363, the overlapping *intonaco* would seem to suggest that the *Guidoriccio* was executed after 1363. How is this suggestion to be evaluated? It is not known at present *how far* the layer of plaster on which the 1363 painting is executed

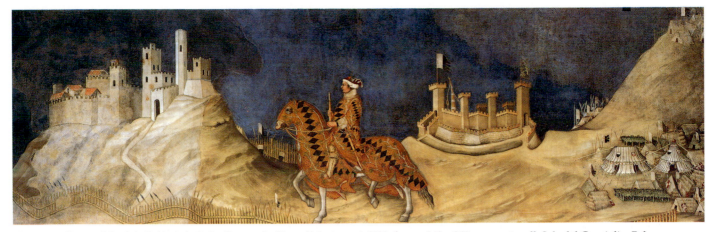

Plate 145 Simone Martini, *Guidoriccio da Fogliano at the Siege of Montemassi*, 1328, fresco, 340 x 968 cm, west wall, Sala del Consiglio, Palazzo Pubblico, Siena. Photo: Scala.

extends beneath the right-hand side of the *Guidoriccio*. It is known, however, that the corner of the room where the two walls meet has been subjected to extensive restoration and repainting. It is entirely plausible, therefore, that at some point in its long history – possibly even during the painting of *The Battle of the Val di Chiana* – the original *intonaco* of the *Guidoriccio* was damaged and then repaired and repainted, thus accounting for the apparent discrepancy in the relationship between the layers of plaster of the two paintings.

If the radical re-dating of the *Guidoriccio* is ruled out as unnecessary, what positive evidence is there for it being the work of Simone Martini? Close and detailed examination of the painting furnishes evidence of its painter having employed a number of distinctive techniques that occur in other more securely documented works by Simone Martini. The surface on which the armour of Guidoriccio has been painted is worked in relief with punched patterns, a technique also used on the *Maestà* on the opposite wall. Similarly, the vine leaves of Guidoriccio's armorial devices were originally covered in silver leaf. This is an unusually lavish piece of decoration for a fresco painting, but one deployed by Simone on other paintings.[21] It seems, therefore, that on technical grounds alone the traditional attribution of the painting to Simone Martini remains secure. The *precise* dating of the painting remains open to question, although it is almost certain to lie somewhere between 1328 (the date of the painted inscription on the lower frame) and 1330 (the date of the recorded payment to 'Simone' for a painting of Montemassi).

What is quite clear, however, is that the Sienese wished to include a painted celebration of their Capitano della Guerra Guidoriccio da Fogliano within the principal hall of their town hall, and to set his portrait against a backdrop that alluded to one of his most significant military victories. Yet, it has shrewdly been observed by Andrew Martindale, this painting should not be read primarily as a *personal* or *private* monument to Guidoriccio. On the contrary, the painting is properly understood only if located within the context of the entire room within which it is situated. The pictorial decoration of the room was not devoted to the celebration of the city's temporary military employees but to the glorification of Siena itself – a point confirmed by the large number of civic emblems depicted within both the *Guidoriccio*

and its border. Thus, the painting should be read in symbolic terms and in relation to the imposing *Maestà* opposite. Medieval seals frequently portray, on one side, a ruler enthroned and, on the reverse, the same ruler armed and on horseback. Within the context of the Sala del Consiglio, the enthroned ruler has been represented by the city's 'queen' and patron – the Virgin Mary – and the armed and mounted ruler by Siena's Capitano della Guerra, who thus embodies in his equestrian portrait the military achievements, duties and responsibilities of the Sienese republic.[22]

In 1345 the embellishment of the west wall was further complicated by the introduction of a huge map painted by Ambrogio Lorenzetti, which was mounted on a wooden circular disc so that it could be rotated. Its repeated rotation left grooves in the wall, which were revealed during the rediscovery of *The Submission of a Castle* below the *Guidoriccio* (Plate 143). Seventeenth- and eighteenth-century sources suggest that this *Mappamondo* might once have continued the iconographic theme of Siena and her military conquests by depicting Siena at its centre, with the city's main castles and countryside around it.[23] Since medieval cartographers traditionally placed Jerusalem at the centre of their maps, if these sources are accurate in their description of this fourteenth-century painting, it appears that the Sienese were making a further grandiose claim for their city by likening it to Jerusalem, a city associated in medieval thought with heaven itself.

The upper arcade of the north-west section of the room, immediately adjacent to the *Guidoriccio*, portrays a late fourteenth-century contribution to the pictorial scheme of the Sala del Consiglio, namely Lippo Vanni's *Battle of the Val di Chiana*. The painting commemorates a battle in 1363 in which the Sienese defeated a company of English mercenaries on the wide plain of the Val di Chiana.[24] This Sienese victory was generally attributed to the timely intervention of Saint Paul. Accordingly, the saint is represented on the left-hand side of this wide fresco, in front of Siena's gateway and in the company of the seven virtues. To the right (as shown in Plate 146), unfolds a panoramic battle scene executed in brown monochrome, which is only alleviated by the blue sky above. In order to locate the site of the battle, individual groups of buildings within the painting have been labelled

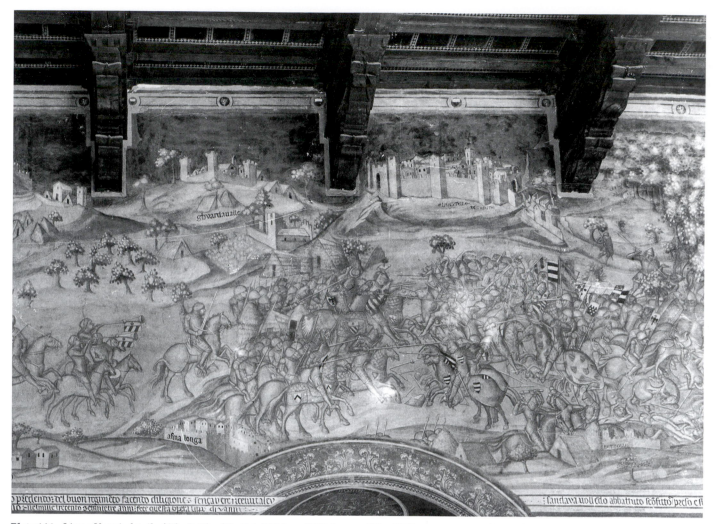

Plate 146 Lippo Vanni, detail of *The Battle of the Val di Chiana*, 1363, fresco, 400 x 1250 cm, upper arcade, north-west section, Sala del Consiglio, Palazzo Pubblico, Siena. Photo: Lensini.

with the names of the towns in whose vicinity the battle took place. Whilst the painted composition, with its multiple figural groups and buildings, is primarily descriptive and therefore a less striking pictorial statement than the *Guidoriccio*, it nevertheless represents an ambitious attempt on the part of the painter to render an expansive pictorial space and a wealth of narrative detail.

Some 30 years before the painting of *The Battle of the Val di Chiana* the Sienese government embarked on another ambitious scheme of painting for the room adjacent to the Sala del Consiglio. This room, then the Sala dei Nove but known today as the Sala della Pace, functioned as the meeting room for Siena's principal magistracy of the Nine. Ambrogio Lorenzetti's murals for this room present a very coherent sequence of paintings whose collective message was of the benefits of government by the Commune.[25] By contrast, the paintings within the Sala del Consiglio appear to have been conceived in a less coherent and more opportunistic manner, only retrospectively acquiring a unity of purpose.[26] Nevertheless, what survives is indicative of the potential that large-scale mural painting provided for Siena's governors. First, as represented by Simone Martini's *Maestà*, it could rehearse the cult of the city's patron saints as protectors of the city's political and spiritual welfare. The figure of Saint Paul

in Lippo Vanni's *Battle of the Val di Chiana* carries a similar message. Indeed, the presence of the *Maestà*, a painting characterized by an impressive panoply of holy figures and religious concepts, within a room specifically designated for practical governmental functions vividly demonstrates the indivisibility of the sacred from the secular within fourteenth-century Italian civic life. This point is reiterated by the city's official records of deliberations, in which the opening preamble frequently refers to God, Jesus, the Virgin and all the saints. Secondly, by putting on record (in such paintings as *The Submission of a Castle*, the *Guidoriccio* and *The Battle of the Val di Chiana*) events deemed by the current governing regime as, at the very least, significant in the history of Siena, painting could celebrate in a very immediate and public way the political and civic achievements of the Commune as a whole.

PAINTINGS IN THE TOWN HALLS OF FLORENCE AND PADUA

We have seen that, in the complex intermingling of religious and secular themes in the mural paintings of the Sala del Consiglio, Siena's governors achieved an expression of crucial

aspects of their civic ideology. To what extent was this expression of civic, political and ideological concerns a common feature of other fourteenth-century Italian city states? How far do the civic monuments of fourteenth-century Florence and Padua, in particular, suggest a similar set of concerns and interests?

Florence's counterpart to Siena's Palazzo Pubblico – the Palazzo dei Priori – has undergone such extensive alterations to its fabric during its history that all that survive today of its fourteenth-century painted decorations are fragments of a purely ornamental kind. It is, therefore, extremely difficult to establish what kinds of painting the Florentine Commune was committed to sponsoring. It appears from a payment to an artist in 1303 that within the Palazzo dei Priori there was once a large painting that commemorated a military victory secured by the current Ghibelline governing regime at the expense of a rebellious Guelph faction in opposition to it.[27] This suggests that, as in the Sala del Consiglio in Siena, the pictorial decoration of one room in the Palazzo dei Priori may have been devoted to recording events that were deemed by the prevailing political regime to be of particular significance in Florentine history. It also seems that, in another room, Giotto executed a painting of Florence's Angevin ally and (from 1324 to 1328) so-called protector Charles of Calabria, kneeling at the feet of the Madonna.[28] Thus, as in the case of Guidoriccio da Fogliano in Siena, a specific individual who was prominent in the city's political fortunes was commemorated within the fabric of the city's town hall.

The celebration of specific individuals whose deeds had enhanced or promoted the life of the Commune was not, however, the only kind of political commemoration favoured by the fourteenth-century Italian city state. Not only heroes but also villains of civic life might be portrayed in civic art, albeit for very different purposes (Plate 147). Thus, for example, another significant Florentine political figure, the French nobleman Walter of Brienne, who held the title of Duke of Athens, also featured within the decoration of communal buildings, but certainly not with the intention of celebrating him. In 1342 Walter of Brienne was appointed for a six-month term as Capitano del Popolo. He executed a *coup d'état* to become *signore* of the city, but was subsequently overthrown and expelled from the city in 1343. In 1344 an artist (probably Maso di Banco) was paid to portray the Duke of Athens, together with several of his close associates, on the façade of the tower of the Palazzo del Podestà (the present-day Bargello). The painting no longer survives but, from early descriptions, clearly belonged to a specific genre of political image, the *pittura infamata*, which was used to portray wrong-doers and hold them up to public exhibition and censure. Some two decades later the event of the Duke's expulsion from Florence was also depicted in a fresco by an unknown painter to embellish the interior of the city's debtors' prison, the Stinche.[29] The painting shows the discomfiture of the Duke, with the flag bearing his personal escutcheon, the sword of office and the scales of justice – symbols of personal, military and judicial power – lying broken on the ground beside him. Behind him looms an empty throne, another compelling pictorial symbol of his lost political power. He is pursued by an avenging angel and holds in his hand a hybrid creature, with a curled scorpion's tail and a human head,

which vividly symbolizes the Florentines' belief in the Duke's deceitful, fraudulent behaviour. The fact that it was on Saint Anne's feast day (26 July) that the Duke's overthrow and expulsion from the city were effected is recalled by the imposing presence of Saint Anne, gesturing in a protective fashion towards a well-observed representation of the fourteenth-century Palazzo dei Priori (including a fortified barbican that, ironically, was installed by the Duke himself). The saint's role as patron of the city is further emphasized by a group of kneeling knights, to whom she is distributing banners, upon which are the civic emblems of the Florentine lily and the red cross of the Popolo. Around the frame of this circular painting there was once a sequence of astrological signs, indicating clearly to those versed in astrological law the exact date on which the event took place. Thus, in a similar way to Lippo Vanni's later Sienese fresco of *The Battle of the Val di Chiana* (Plate 146), the painting had a dual purpose. On the one hand, it celebrated a momentous victory in Florence's history (made the more vivid by accurate portraiture of the city's principal town hall) and, on the other, commemorated and celebrated the saint to whom this victory was attributed.

As in the case of Florence, it is by no means straightforward to reconstruct the scheme of paintings within the principal town hall of Padua. The fabric of the Palazzo della Ragione was substantially extended during the early decades of the fourteenth century.[30] It was in this period that the first-floor Salone was extended to its present height, thus providing the additional wall surface for an ambitious programme of fresco painting. Like so many fourteenth-century pictorial schemes, the history of the paintings and their survival is complex. Padua's early fourteenth-century chronicler Giovanni da Nono refers to a scheme of paintings on an astrological theme in the Salone and attributes their extraordinarily skilled execution to Giotto. Most modern scholars concur with this, dating the frescoes to the period 1309–13.[31] The paintings were located at the top of the newly heightened walls, immediately below the roof. Some time later in the fourteenth century, possibly between 1370 and 1380, at the zenith of the Carrara ascendancy in Padua, the pictorial scheme of the Salone was extended by the addition of a series of allegorical figures and scenes executed on the lower walls of the Salone, possibly by the Florentine painter Giusto de'Menabuoi.[32] On 2 February 1420 a fire destroyed the roof of the Salone and gravely damaged much of the early fourteenth-century painted scheme on the upper walls of the room, which, therefore, had to be extensively repainted. The original frescoes attributed to Giotto are thus lost. However, although the fifteenth-century repainting of the schemes introduced certain kinds of imagery that specifically alluded to the current Venetian rule of Padua, it is generally agreed by scholars that the fifteenth-century paintings preserve the outline and content of the ambitious iconographical programme of the early fourteenth century. The invention of this programme is attributed to the famous early fourteenth-century Paduan scholar, philosopher and astrologer, Pietro d'Abano (d.1315).[33]

The original fourteenth-century paintings that remain occur principally on the lower walls and thus belong to the later fourteenth-century campaign. They present a series of enthroned figures, which depict the three theological virtues

Plate 147 Anonymous, *The Fall of Walter Brienne, Duke of Athens*, c.1360, fresco, Palazzo Vecchio, Florence, formerly on the interior of the Stinche, Florence. Photo: Alinari.

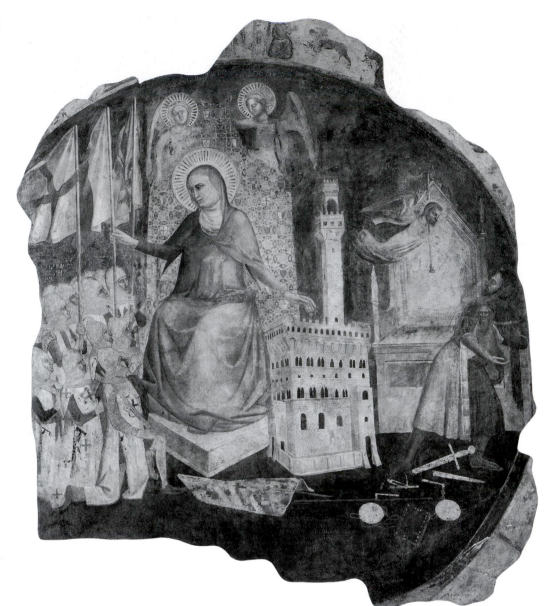

and the four cardinal virtues (Plate 148) and the city's major patron saints, including Saints Giustina and Prosdocimus. Between these representatives of sainthood and depictions of Christian virtue are other figural groups, whose subjects underline the legislative functions that once took place within the building. Thus, *The Commune Ruling* (*Il Comune in signoria*) features on the south wall and shows the Commune personified as an enthroned male figure surrounded by other men in the costume of fourteenth-century civic officials. A further scene of government administration occurs in a painting on the west wall, in which a group of male figures is shown apparently debating a legal case (Plate 149). The lower walls are further enlivened by, for example, a series of painted animals after whom the various judicial tribunals of the city magistracy were named.[34]

On the upper walls of the Salone is a three-tiered cycle of painting, which comprises an astonishing 333 compartments. This ambitious pictorial scheme is ordered around a sequence of three kinds of pictorial imagery, namely the twelve calendar months in the form of figures engaged in seasonal occupation associated with each month;

personifications of the seven planets; and the conventional symbols for the signs of the zodiac. Grouped around these three categories are subsidiary scenes, which symbolize either certain human occupations associated with the planets (the so-called 'Children of the Planets') or natural conditions attributable to zodiacal and planetary influence.[35] For example, a section on the upper north wall depicts the zodiacal sign of Sagittarius, a personification of Jupiter, the month of December as a man butchering a pig (still a characteristic winter occupation for Italian country-dwellers) and the zodiacal sign of Capricorn (Plate 150). Around the regal figure of Jupiter appear vignettes of human activity or animal behaviour, which are intended to illustrate Jupiter's role as protector of religious and secular rulers and the planet's beneficent influence of controlling instability through strength. Interspersed throughout the scheme are hugely complex and diverse paintings of each of the twelve apostles and of the Virgin being crowned as queen of heaven. Thus, whilst this painted scheme depicts an enormously rich array of secular imagery, it is nevertheless safely rooted within a secure, religious framework.

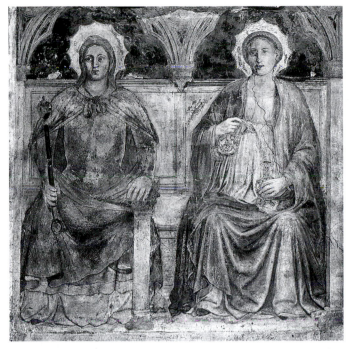

Plate 148 Attributed to Giusto de'Menabuoi, *The Cardinal Virtues of Fortitude and Temperance*, 1370s, fresco, west wall, Salone, Palazzo della Ragione, Padua. Reproduced by courtesy of Musei Civici Padova, Gabinetto Fotografico.

Plate 149 Anonymous, *The Dispensing of Justice*, 1370s, fresco, west wall, Salone, Palazzo della Ragione, Padua. Reproduced by courtesy of Musei Civici Padova, Gabinetto Fotografico.

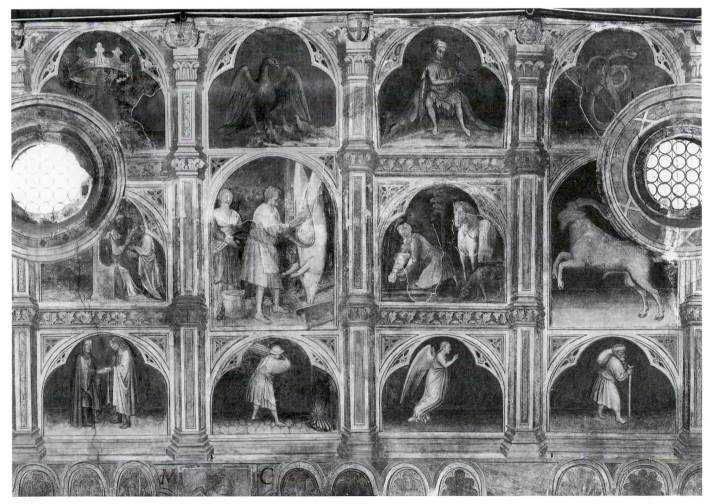

Plate 150 Section of the upper north wall, Salone, Palazzo della Ragione, Padua, showing, among other details, *Labour of the Month for December* and *Capricorn*, fifteenth-century repainting of an early fourteenth-century fresco attributed to Giotto. Photo: Barbara Piovan.

The later fourteenth-century programme of saints, virtues, personifications of the Commune and scenes of judicial processes on the lower walls of the Paduan Salone are all entirely conventional for this kind of setting. The astrological scheme on the upper walls is, however, far more versatile and original, encompassing a great deal of fourteenth-century belief in astrology and its effects on nature and human experience. This body of knowledge was in itself highly complex and mutable, combining as it did both Arabic and classical learning with medieval scholasticism.[36] Padua, like other Italian Communes, had astrologers in its employ, whose tasks included determining the most propitious days for beginning a war or engaging in battle.[37] Astrology was part of political policy making and it is thus conceivable that the painted scheme of the Salone was intended to have a political dimension. Moreover, the movement of the stars was deemed to be a manifestation of God's will, and virtuous behaviour a means by which people could avoid the possible evil effects of stellar portents. It was appropriate, therefore, that representations of the seven Christian virtues should appear in personified form upon the lower walls of the Salone (Plate 148).

The painted schemes within the principal civic buildings of Siena, Florence and Padua thus exhibit a number of common traits. Whilst the incidence of survival of specifically fourteenth-century works varies greatly, it appears that all three Communes were committed to financing large-scale pictorial schemes that expressed in visual form certain commonly held views as to the nature of government. Key iconographic themes tend to predominate. Each city's principal patron saints were frequently represented, often in a way that alluded to specific interventions that these saints were believed to have made on behalf of the city and its inhabitants. The concept of good government was conveyed either by the personification of the Commune as a venerable male figure – often in the company of the seven virtues – or by the depiction of specific scenes of judgement. Key historical events, such as battles or the submission of subject towns, were commemorated and occasionally a key historical figure was portrayed. Such a person usually represented symbolically an aspect of sound government. For example, the celebration of Sienese military might was shown in the person of Guidoriccio da Fogliano and the excoriation of a tyrannical 'protector' was demonstrated in the depiction of the downfall of Walter Brienne, Duke of Athens. Finally, government policy and notions of rule might be grounded within a much wider context, namely God's scheme for the whole of creation.

The demand for such varied and often quite secular imagery presented fourteenth-century artists, who had hitherto been accustomed to representing primarily religious imagery, with new challenges. Simone Martini, in the Sala del Consiglio, took considerable care to render in recognizable form a specific topographical site within the Sienese *territorio* (territory) and, in the case of Guidoriccio, to offer a sense of the character and appearance of a specific person (Plate 145). Indeed, it might well be argued that it was painters' increasingly assured abilities in the art of representation (be it of celebrated political figures or specific topographical locations) that alerted communal patrons to the powerful potential of new and secular imagery. Notwithstanding such innovative initiatives, which of their very nature encouraged careful empirical observation on the part of painters, there was the expectation that the new-found pictorial inventiveness would be kept strictly within a familiar framework of pictorial convention, which relied heavily on the use of symbolism and allegory.

ORSANMICHELE IN FLORENCE

In addition to the painted schemes of the town halls of fourteenth-century Siena, Florence and Padua, a further example of corporate civic patronage of art occurred in the construction and embellishment of the public market-places and storehouses. These facilities assisted in the maintenance and regulation of an adequate food supply, which was a central preoccupation of any Italian Commune. One of the most impressive and best-documented examples of this particular kind of civic endeavour occurs in the imposing three-storied building of Orsanmichele, which constituted Florence's public granary and grain market (Plate 151). In the present context, the example of Orsanmichele offers a further and significantly more complex example than those so far considered of the way in which civic institutions might act as patrons of art.

The focus of this building's interior embellishment lay in the construction of a monumental stone tabernacle designed to house a thaumaturgic image of the enthroned Virgin and Child (Plates 152 and 157). The history of the tabernacle furnishes an informative example of the complex interplay of factors that enabled a corporate body of patrons to initiate and bring to fruition the erection of a large-scale public monument. As in the case of the painted imagery of the cities' town halls, the choice of subject-matter and, indeed, its pictorial treatment, provide considerable insight into the collective concerns of this body of patrons in respect of the art that it commissioned. More intriguing still, it appears from both the history of the commission and the sculpted imagery that the tabernacle represents the outcome of initiatives by *two* separate sets of corporate patrons. These were, on the one hand, a Florentine confraternity and, on the other, the Florentine government.

In 1284 Florence's government erected a grain market on a site formerly occupied by an oratory dedicated to the Archangel Michael. This oratory was known as San Michele in Orto[38] or, more popularly, Orsanmichele. The thirteenth-century grain market comprised an open-sided loggia, supported on sturdy piers, on one of which was placed, some time between 1285 and 1292, an image of the Virgin and Child. In 1291 a Laudesi confraternity was founded – the Compagnia della Nostra Donna Sancta Maria e del Beato Messer Santo Michele in Orto. Its members were committed to taking care of both the image of the Virgin and Child and an altar dedicated to the Archangel Michael. Every evening when the grain market had completed its business, the members of the confraternity would gather before the image of the Virgin and Child in order to sing *laude*. The confraternity established its headquarters in a building facing the south-east corner of Orsanmichele and set up an official,

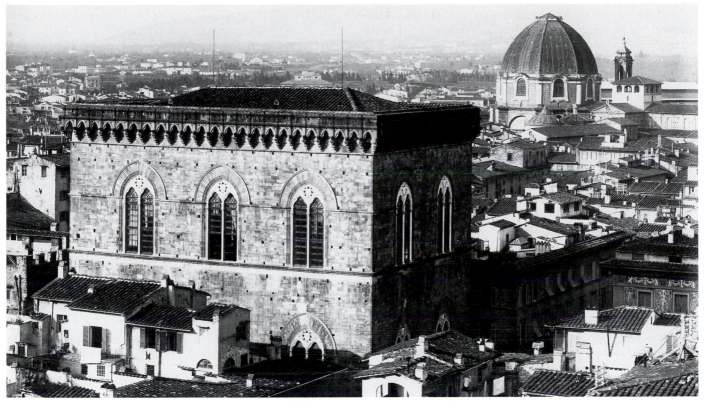

Plate 151 Exterior of Orsanmichele, Florence, rebuilt in 1337, exterior refashioned between 1380 and 1404. Photo: Alinari/Brogi.

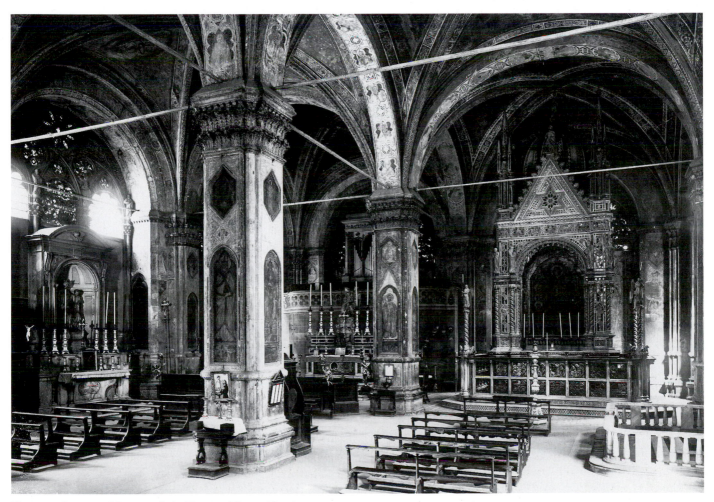

Plate 152 Interior of Orsanmichele, Florence. Photo: Alinari.

administrative organization headed by a committee, the Capitani of Orsanmichele, the membership of which rotated among members of the confraternity. The confraternity drew up rules for the devotional and charitable activities of its membership and kept extensive accounts of its financial transactions (Plate 153), among which appear records of purchases of art for Orsanmichele. As was the case for other fourteenth-century Florentine public buildings, such as the cathedral and baptistery, the Capitani tended to delegate responsibility for the administration of art patronage to *operai*, whose recommendations would, from time to time, be discussed and recorded within the confraternity's official records. However, the Capitani also consulted the Commune over such matters as the further embellishment of the building. One lucrative source of income for the confraternity was the image of the Virgin and Child. In 1292 the image apparently began to work miracles, an event that naturally attracted large numbers of pilgrims to the grain market. This brought to the confraternity large amounts of money in the form of votive offerings, which the confraternity in turn distributed to the poor as bread.[39] An illumination from a contemporary account of the grain business in Florence between 1320 and 1334 provides a valuable illustration of the confraternity's activities in this respect (Plate 154). It shows within the grain market a stone tabernacle housing the painting of the Virgin and Child. Inside the tabernacle – a forerunner to Orcagna's tabernacle – is an official of the confraternity ready to sell candles, receive offerings and distribute alms to the needy, three of whom – a blind man, a

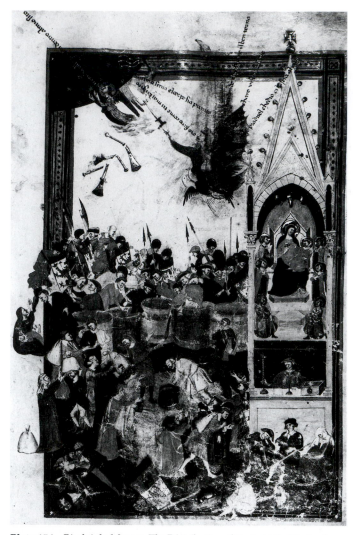

Plate 154 Biadaiolo Master, *The Distribution of Grain to the Needy at Orsanmichele, c.*1335–40, manuscript illumination, Biblioteca Medicea Laurenziana Ms. laur. Tempi 3, c. 79. Photo: Alberto Scardigli.

lame man and a pregnant woman – are portrayed in front of the tabernacle.

In 1304 a fire destroyed a large part of central Florence, including most of the grain market, and in the following year a replica of the destroyed Virgin and Child was painted. Modern scholars have plausibly identified this second image as being that on a panel depicting the Virgin and Child enthroned with angels that is now located in the Oratory of Santa Maria Maddalena at Pian di Mugnone in the Florentine *contado* (Plate 155).[40] This second image continued to be under the care of the confraternity (as the confraternity's statutes of 1333 make clear),[41] and amidst the busy mercantile activities of Orsanmichele it continued to be the focus for intense religious devotion.

In 1336 the second government of Florence decided to build 'a palace in which the veneration of the glorious Virgin Mary could be more fittingly carried out and the grain and wheat better protected, preserved and gathered'.[42] The construction of this new building was to be paid for by indirect taxes and the project was to be supervised by the silk guild – the Arte di Por Santa Maria. This furnishes another example of guild involvement with the construction and maintenance of a major Florentine civic monument. Two

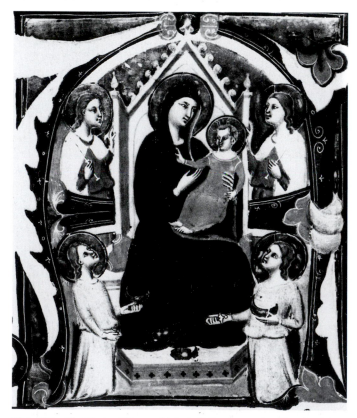

Plate 153 *The Virgin of Orsanmichele, c.*1340, manuscript illumination, *Libro dei lasciti alla Compagnia dei Capitani* (book of bequests to the confraternity of Orsanmichele), folio 1 recto, Archivio di Stato, Florence.

years after the initiation of the building project, twelve of the city's most affluent and politically influential guilds, together with the Guelph Party (another corporate body that was a powerful force in communal politics) were given permission by the government to decorate the exterior piers of the new building with images of their patron saints. The patron saints would thus be seen as guarding the venerated image of the Virgin and Child and the grain inside the building. Indeed, this particular feature of the building's programme, it has perceptively been observed by Nancy Rash Fabbri and Nina Rutenburg, provides a kind of visual analogue of Florence's republican government, since the leading members of Florence's government were drawn from the Guelph Party and the guilds, who were the patrons of this artistic scheme.[43]

Between 1337 and 1359 the three-storied building was duly erected, with an open arcade of cut stone at street level and two enclosed upper floors above, one of which stored grain to feed the population and the other of which probably housed the officials who were in charge of the storage and distribution of the grain. In 1347, well before the completion of the building, a new, third image of the Virgin and Child was commissioned by the confraternity from the painter Bernardo Daddi (Plate 156), the second painting being relegated to the confraternity's Audience Hall. Comparison of the second and third versions of this image reveals that the later painting incorporates details more typical of late

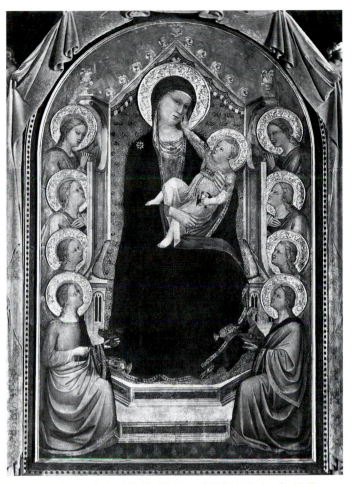

Plate 156 Bernardo Daddi, *The Virgin and Child with Angels*, 1347, tempera on panel, 250 x 180 cm, tabernacle, Orsanmichele, Florence. Photo: Alinari.

thirteenth century images of this type, most notably the architectural style of the Virgin's throne and the placing of the two angels in the foreground. It seems, therefore, that Bernardo Daddi was instructed by his confraternity patrons to fashion an image that had formal associations with the first and much-venerated miracle-working image of the Virgin and Child. Such self-conscious reference to the original image would have been particularly appropriate in the later 1340s, which proved a period of political and economic difficulties. The evocation of the original painting may well have been part of a deliberate attempt to restore something of the devotional ethos surrounding the thirteenth-century image, attract bequests into the confraternity and thus increase the financial support for the completion of the market building.[44]

Ironically, it was in fact a major disaster that caused a significant revival of religious fervour centred on the image of the Virgin and thus brought concomitant financial gains for the confraternity under whose care the image resided. In 1348, when the Black Death struck Florence with terrible ferocity, Bernardo Daddi's image became the devotional focus for numerous supplicants who, in gratitude for their survival and in the hope of securing continued divine protection, bestowed large sums of money upon the confraternity in the form of offerings and legacies. The fourteenth-century chronicler Matteo Villani suggests that these gifts amounted to as much as 350,000 florins, but he also notes abuses of funds by

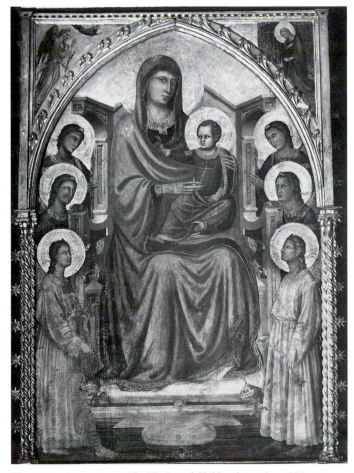

Plate 155 Anonymous, *The Virgin and Child and Angels*, c.1305, tempera on panel, 205 x 137 cm, Oratory of Santa Maria Maddalena, Pian di Mugnone. Photo: Alinari/Brogi.

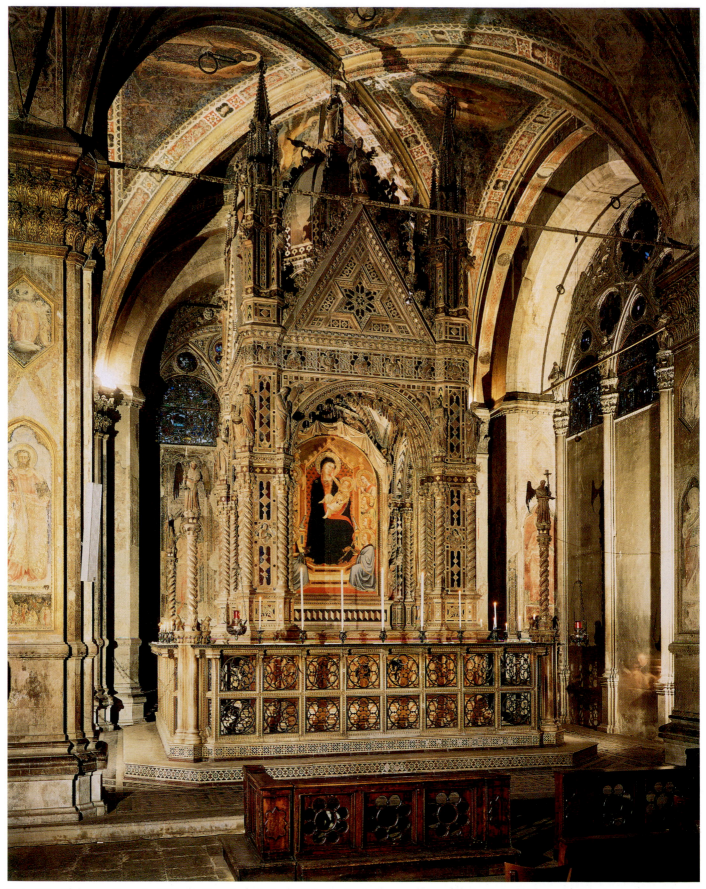

Plate 157 Orcagna, tabernacle, 1359, marble, coloured glass, gilding and polychromy, Orsanmichele, Florence. Photo: Scala.

confraternity members, which made it necessary for the government to intervene and control the confraternity's affairs by supervising the election of its officers. However, in the early 1350s government finances were in some disarray and the government needed to avail itself of the confraternity's considerable financial resources.[45] This greater control by the government may well have influenced the decision, reached *c*.1352, to commission an imposing architectonic tabernacle to protect the painting of the Virgin and Child. The project was completed in 1359 by the Florentine painter–sculptor Andrea di Cione, better known as Orcagna (Plate 157).[46]

The tabernacle, a striking edifice erected in the south-east corner of the grain market, was originally more visible and accessible than it is today. It could be approached on all four sides and was only enclosed by a bronze and marble railing in 1366. In terms of its scale and structure, it is reminiscent of a ciborium – an ecclesiastical monument specifically designed to act as an imposing setting for an altar within a church (Chapter 9, Plate 196). However, the tabernacle was intended to house, not an altar, but a miracle-working image. It seems likely, therefore, that Orcagna conceived of it as a monumental shrine to protect and display to the faithful a precious and holy object. The artist may well have been aware of a number of venerable precedents for such a shrine within the churches of Rome.[47] He deployed upon the tabernacle a sophisticated architectural vocabulary which, in terms of its component parts and decorative ornament, was closely comparable to work then being executed upon the cathedral, another civic project that was of crucial importance to the Florentine government. The visual impact of the monument is made the more striking by its materials – white marble, coloured mosaic inlay and gold. On completion, the tabernacle must have constituted an imposing religious presence within the busy commercial hubbub of the fourteenth-century grain market.

The tabernacle is rendered the more distinctive by its elaborate sculpted programme. The structure is crowned by five statues of warrior angels, with the Archangel Michael on the apex of the cupola and four other angels on the apices of the gables. The shields of the angels on the gables are inlaid with the words 'Ave Maria' (Hail Mary) or 'Gratia Plena' (Full of Grace), thus evoking the opening lines of the Archangel Gabriel's salutation to the Virgin Mary at the annunciation. The frieze on the entablature contains a series of half-length angels and Old Testament figures in quadrilobe frames. Below the entablature and grouped at the corners of the edifice are the twelve apostles, carrying books or scrolls inscribed with the texts from the Apostles' Creed. On the two outer faces of each of the corner piers are the busts of angels. Each is depicted either in the act of adoration or with a shield emblazoned with the Florentine civic emblem of a lily or carrying a cornucopia and a sheaf of corn (Plate 158). On three of the four faces of the base of the tabernacle are pairs of octagonal reliefs, each framing a central hexagonal relief. The octagonal reliefs represent narrative scenes from the life of the Virgin and the hexagonal reliefs represent the three theological virtues. On the fourth and east-facing side of the tabernacle the two Marian narrative reliefs frame a low wooden door by which those in charge of the tabernacle could enter it. The bases of the piers are further ornamented with

twelve hexagonal reliefs that depict virtues (the four cardinal virtues and eight others, such as humility and perseverance) and hexagonal reliefs that depict male saints or Old Testament prophets.

The sequence of eight octagonal reliefs devoted to the depiction of the life of the Virgin (Plate 138) begins on the north face of the tabernacle with *The Birth of the Virgin* and continues in an anti-clockwise direction around the tabernacle, finishing with *The Annunciation of the Death of the Virgin* at the base of the east face. The Marian narrative series culminates in *The Death and Assumption of the Virgin*, which takes the form of a large relief covering the entire extent of the east face of the tabernacle (Plate 159).

The construction of the tabernacle was not the only example of increasing civic involvement with Orsanmichele. From 1336 onwards, after its initial decision to build a city granary at Orsanmichele, the Commune steadily took on a more pronounced role in the patronage of Orsanmichele. In 1357, two years before the completion of Orcagna's tabernacle, as a response to a petition from the confraternity, the Commune decided to remove the grain market from Orsanmichele, although this was not accomplished until 1367. In 1358 Orsanmichele gained further civic prominence when the Commune decided to erect an altar dedicated to Saint Anne on its north-east corner. This altar became the focus for the annual civic celebrations to mark the expulsion of the Duke of Athens from Florence on Saint Anne's feast day 1343 and the consequent regaining of the city's liberty. In 1365, on the Feast of the Assumption, the Virgin of Orsanmichele was made the special protectress of the city of Florence. In 1366 the decision was taken to close the open arcades of the loggia, at once transforming the former grain market into a conventional ecclesiastical space and increasing the control of both the Commune and the guilds over this civic monument. Provision was made for services to be rotated among the city clergy and a sacristan was appointed. In the same year the tabernacle was enclosed by a balustrade, on the four corners of which were placed twisted columns topped by statues of angels holding candelabra. In the last decades of the fourteenth century the space between the elaborate tracery of the ten arches of the former arcade was filled in with stained glass (to form windows that depicted scenes from the early life of the Virgin and miracles performed by her) and the interior piers were painted with frescoes. Finally, in the early decades of the fifteenth century the projected series of statues of patron saints was commissioned by the city's principal guilds and the Guelph Party and installed on the exterior of the building.[48]

How might the stylistic and iconographic details of the sculpted tabernacle have been effected by the needs and requirements of the joint patrons of the project – the confraternity and the Commune? Initially, the architectonic structure of the tabernacle provided the confraternity with a site for its devotional and charitable activities within the grain market, an important consideration for a city-based confraternity that was not attached to a city church. Its material opulence reflected well on the confraternity and its status as a pious organization that had the honourable role of guarding and tending a sacred and revered image. Moreover, the restricted means of access to the tabernacle may have been

Plate 158 Orcagna, *Angel with Cornucopia and Sheaf of Corn*, marble relief, detail of tabernacle (Plate 157). Photo: Index/P. Tosi.

designed specifically to serve the exclusive rights of the confraternity members, who were thus permitted to gain greater proximity to the thaumaturgic image.[49] Clearly, the sculpted programme supported and endorsed the Marian cult initiated by the image itself. It provided an extraordinarily sumptuous setting for the painting, adding to the dignity and sanctity of the image. Furthermore, the sculpted frame around the painting displays ten angels, sculpted in low relief and shown either playing musical instruments or pulling back a curtain. This sculpted framework extended the figural content of the painting and simulated two of the confraternity's most important activities. The first of these was the performance of liturgical music. We know that by the end of the fourteenth century the tabernacle at Orsanmichele had become the location for elaborately staged performances of music, not only by the Laudesi but also by professional musicians paid for by the confraternity and the Commune.[50] The second

activity was the veiling of the painting and its exposure at certain times in the liturgical calender. It appears that as early as 1333, if not before, the confraternity undertook to cover the painting with veils of fine silk and expose it to view on Sundays, feast days and other days chosen by the Capitani. Once Orcagna's tabernacle was completed in 1359 this practice seems to have continued in a more sophisticated form, using moveable metal grills covered with leather hangings.[51]

By illustrating scenes that celebrate Mary's role in the Incarnation, the tabernacle's sculpted programme offered spiritual guidance not only to the confraternity's members but also to members of the general public, be they citizens, visitors or pilgrims. Indeed, even today, the tabernacle continues to attract considerable numbers of people, who visit the monument specifically to perform their personal devotions before it. The texts referring to the Apostles' Creed

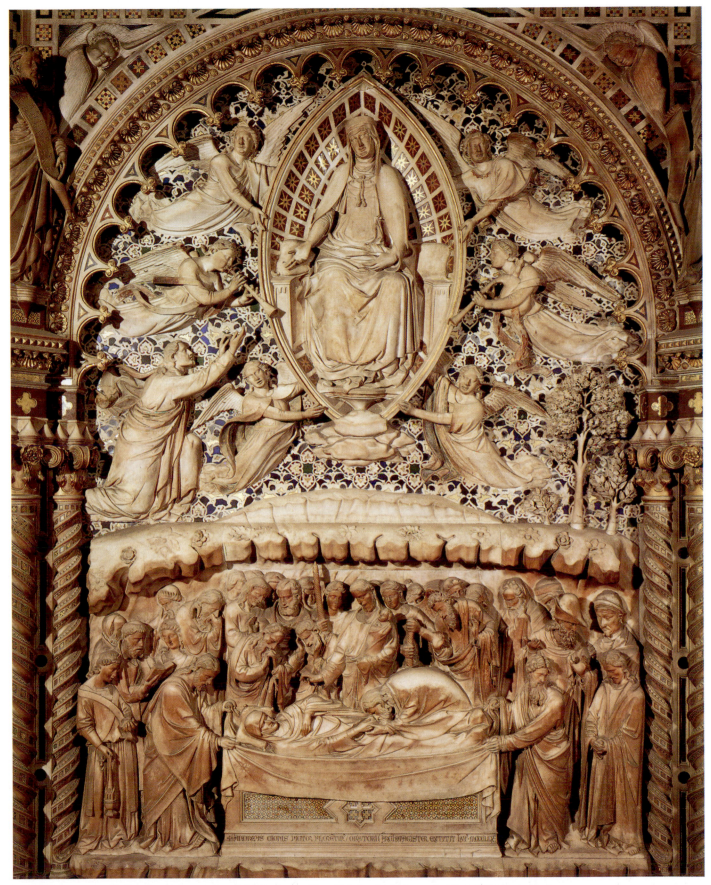

Plate 159 Orcagna, *The Death and Assumption of the Virgin,* marble relief, detail of tabernacle (Plate 157). Photo: Scala.

and the 'Ave Maria' further emphasize the role of the tabernacle in assisting not only the collective devotions of the confraternity but also those of the general public. Indeed, the recurrent decorative motif of scallop shells – a standard symbol of pilgrimage – suggests an explicit recognition of the spiritual needs of pilgrims. The presence of the Archangel Michael, God's principal agent at the last day of judgement, and the imposing scene of Mary's death and her assumption into heaven (Plate 159) would both have focused visitors' minds upon the Church's teachings concerning redemption and salvation. Finally, the very location of the tabernacle within the grain market and its patrons' pious act of distributing bread to the poor are acknowledged in the two reliefs of angels with cornucopia and sheaves of corn, ancient symbols of abundance and plenty (Plate 158).

What, then, of the Commune's interest in this civic project? Quite apart from its iconographic relevance for the confraternity, the tabernacle's imagery bears the hallmarks of a number of specifically communal concerns. The keystone directly above the tabernacle is ornamented with the communal emblem of a lily. Similarly, angels are shown with shields emblazoned with this civic emblem. The virtue Fortitude carries a shield ornamented with the cross of the Popolo. At the base of the twisted columns of the balustrade are grouped lions and lionesses, a civic symbol that was adopted by the city as early as 1250. In addition to this civic heraldry and the martial aspect of many of the angels represented on the tabernacle, the treatment of the subject of the assumption of the Virgin on the large-scale relief on the east face of the tabernacle may also be interpreted in terms specifically relevant to the Florentine Commune (Plate 159). The particular representation of Mary's relationship with Saint Thomas and her act of dropping her girdle to the saint at the point of her assumption into heaven is afforded considerable attention within the relief's figural composition. This apocryphal incident was of special local interest, particularly in the neighbouring city of Prato where the holy relic of the Virgin's girdle was preserved in the principal church of San Stefano. Prato was acquired by Florence in 1350 as part of the city's campaign of territorial expansion. Moreover, a year later, on the eve of the Feast of the Assumption, a Milanese force that was threatening Prato withdrew, thus averting a military crisis for Florence. It seems plausible, therefore, to associate the depiction of the assumption of the Virgin upon this civic monument with the city authority's wish to celebrate the Virgin's apparent intervention in the city's political fortunes.[52] In 1358 the Commune instituted both another altar at Orsanmichele in honour of Saint Anne and an official celebration of the cult of the Virgin of Orsanmichele. This would suggest that the former grain market had, by the late 1350s, become a site specifically marked for the commemoration of the city's triumph over tyranny and a reflection of its gratitude towards it saintly protectors. In the latter stages of its artistic embellishment, Orsanmichele thus appears to have developed well beyond its original confraternal and guild significance and to have taken on an impressive range of specifically civic iconography not dissimilar in content to the pictorial embellishment of the Sala del Consiglio in the Palazzo Pubblico of Siena.

CONCLUSION

In the late thirteenth century a Genoese city chronicler described his motives for writing in the following way:

> every Genoese by reading this may learn more about the excellent deeds of the Commune and his own predecessors; and that through their example and the acceptable rewards which they deservedly gained, he may be the more eagerly inspired to work for and maintain the honour and advantage of the Commune.[53]

From our extended analyses of the art and architecture of two kinds of civic monument – the pictorial decoration of the town halls of Siena, Florence and Padua and the history of the construction and embellishment of Florence's granary – it appears that the patrons and artists responsible were engaged in similar exemplary and inspirational enterprises. Each of these monuments acted as effective propaganda for the success of the corporate and communal model of political and social organization upon which the fourteenth-century city Communes were based, at the same time celebrating the corporate ideals to which the Communes were committed.

It must be acknowledged, however, that within such corporate enterprises certain kinds of élitism undoubtedly thrived. The rare survival of records of a minuted discussion that took place between the members of the Florentine confraternity, the Compagnia di Gesù Pellegrino, provides a vivid example of one such case. In 1347 five members of this confraternity voluntarily undertook to finance the construction and painting of an altarpiece for the confraternity's chapel in the Chiostro dei Morti in Santa Maria Novella. Four were officials of the confraternity with a record of holding office, but the fifth and most generous donor was a relatively new and apparently wealthy member. As reward for their financial support, the officials were allowed to choose the subject-matter of the altarpiece, each member choosing holy figures to be represented on the panels of a polyptych. Four of the patrons chose between them 'Our Lady with [her] Son' and Saints Simon and Thaddeus, the saints to whom the confraternity chapel was dedicated and thus a choice that could only have met with approval from the majority of members of the confraternity. However, the most generous donor, Filippo Nicholi, chose two saints: a patron saint of Florence, Saint Zenobius, and, most significant of all, his own name saint, Saint Philip.[54] Thus, by his generous subvention of this altarpiece, Filippo Nicholi was able to include a representation of his name saint, and thereby within the context of a corporate venture to 'buy' more prestige and obtain more religious merit than those less wealthy and powerful than himself, even though they were of longer standing in the confraternity.

This one incident reflects a much wider and more significant feature of fourteenth-century corporate patronage of art. The widely established practice of delegation within a confraternity, guild or even communal government could easily result in only a minority of the members of a group being able to exercise their influence over the commissioning of works of art. This minority, moreover, was apt to consist of the most powerful and the most wealthy members of the group concerned. This aspect of the corporate patronage of art mirrors an underlying tendency, which was ever present

within the fourteenth-century civic Commune, to view *de facto* political power as residing most properly in the hands of an experienced élite. This élite received its political mandate from the willing support of the wider community, which respected the political experience and acumen that it represented. It might be argued that this tendency reached its logical, if dynastic, conclusion within fourteenth-century Padua. The choice of subject-matter for their altarpiece by the five members of the Compagnia di Gesù Pellegrino necessitated striking a balance between, on the one hand, acknowledging the collective needs and concerns of the confraternity and, on the other hand, allowing an expression of personal preference. In this instance, the former, for the most part, apparently took precedence over the latter.

In the case of Siena and Florence, it is possible to discern a similar balance having to be struck in relation to the patronage of each city's principal civic monuments. The interests of the Commune consistently predominated, although occasionally particular individuals achieved a more than usual prominence as a result of their significance and influence in civic life. Padua provides a contrast, however,

notwithstanding the conventional civic iconography adopted for the paintings of the Salone of the Palazzo della Ragione in the 1370s. The surviving evidence concerning the patronage of Padua's major public monuments from the 1330s onwards presents clear evidence of a decisive shift away from the priority of corporate ideals and towards the celebration of a politically dominant dynastic regime. Indeed, the tendency towards 'dynastic' emphases (when compared with the decided balance in favour of communal concerns that prevailed in both Siena and Florence) emerges with great clarity. Fourteenth-century Siena and Florence each maintained a lively tradition of civic patronage of art, expressed through a variety of civic monuments collectively more dominant than those of any single family. In Padua the surviving evidence suggests that the balance was quite different. The significance of the major civic monument and its principal fourteenth-century embellishment – the painted programme of the Salone of the Palazzo della Ragione – lies precisely in its apparent singularity as a civic monument in a city otherwise dominated by the monuments of a powerful family: the Carrara dynasty.[55]

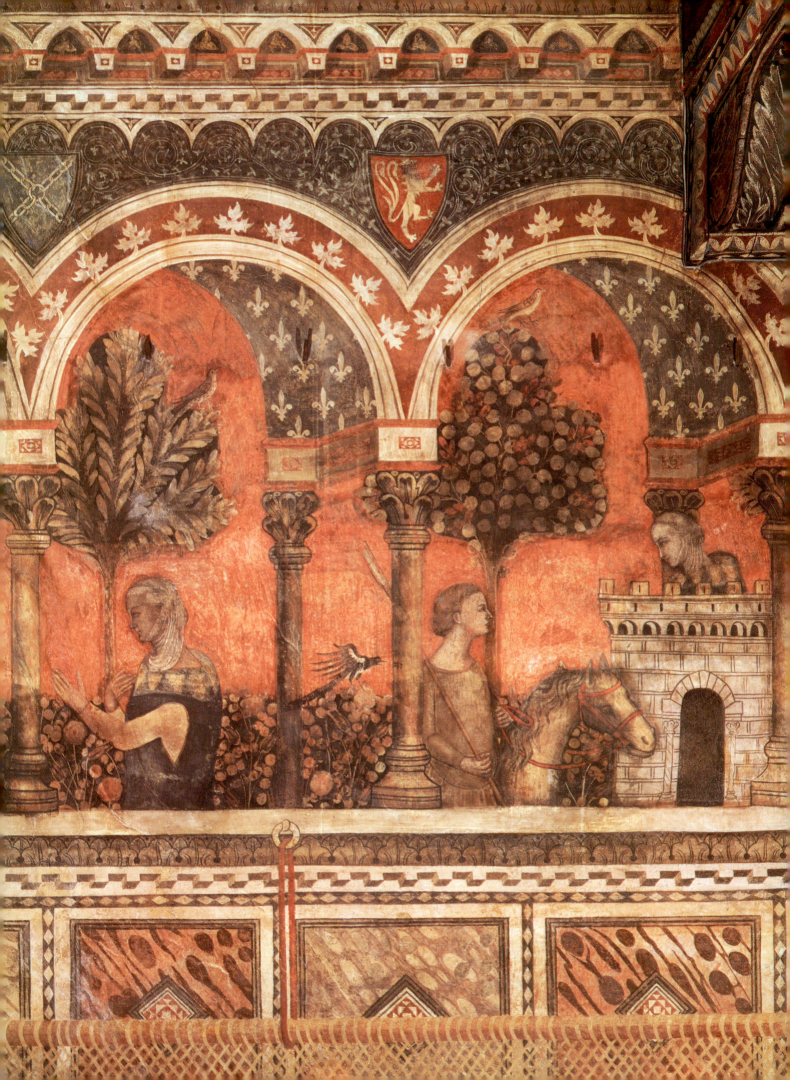

'Splendid models and examples from the past': Carrara patronage of art

As readers familiar with Francis Ford Coppola's film *The Godfather* will recall, the character of the Godfather himself is first encountered in the opening sequence in the act of receiving, during the festivities for his daughter's wedding, a sequence of petitioners asking for his help and protection. He, in turn, warns one of them – an undertaker – that one day he, the Godfather, may expect his favour to be returned by the supplicant. The sequence of reciprocity is clear – a powerful individual, representing a family interest, attracts those of humbler status. To them the powerful individual extends his personal and familial assistance, expecting in return their loyalty and the deployment of their skills in the interest of his own family. It is a scene that vividly encapsulates the way in which patronage traditionally functioned within Italian society.

Lest it be thought anachronistic to begin an essay on fourteenth-century Italian patronage by reference to a film about a twentieth-century Sicilian-American Mafia boss, it is instructive to consider the case of a schoolmaster, Giovanni Conversini, who offered his services successively to two of the most powerful patrons of fourteenth-century Padua – Francesco il Vecchio da Carrara and his son Francesco il Novello. In a treatise of 1385, in which he recounted his experiences in the Carrara household and analysed the nature of his relationship with Francesco il Vecchio, Conversini expressed a strong sense of duty and deference towards his patron.[1] Yet such sentiments were also combined with a shrewd and realistic assessment of what he himself had to offer to his patron and what he might gain in return from such a client–patron relationship. The mutually advantageous relationship that Conversini believed should ideally exist is tellingly summarized by the following passage in the treatise:

> It is material goods you lack, but he [the ruler] lacks your education; you are able to improve yourself by your own wits, and to improve him by telling of splendid models and examples from the past and by reading him things he will find most useful.[2]

Elsewhere in the treatise, Conversini lists some of the 'material goods' he acquired from the Carrara – rent of a house in Padua, an annual allotment of wine, other provisions, firewood and pork, a daily supply of food and drink, a generous monthly stipend of ten ducats and several one-off gifts of money and clothing.[3]

We do not know whether artists also featured as members of the Carrara household and were, therefore, similarly recipients of a salary for which, in return, they had to produce whatever artefacts were required of them. In a later treatise, written in 1399 when chancellor to Francesco il Novello, Conversini refers to the presence of painters within a ruler's entourage and significantly affords them a more lowly place in its hierarchy – grouping them with musicians and actors as of value only 'for the pleasure they give'.[4] It is likely, therefore, that painters (and other kinds of artist) did indeed feature as salaried retainers of the Carrara. What is certain, however, is that successive Carrara *signori* commissioned work from a variety of artists, thus promoting an image of themselves as politically powerful, lavish in their generosity, and knowledgeable in the breadth of their cultural interests. Indeed, on the basis of such commissions, one scholar has recently argued, 'In its period of domination in Padua from 1337 to 1405, the house of Carrara sustained a singular chapter in the history of patronage.'[5]

The principal focus of this essay, therefore, will be the patronage of art by the Carrara family. By investigating both surviving monuments and other evidence for Carrarese commissioning of art and artists, it will assess the potential effectiveness of fourteenth-century familial patronage. In so doing, it will also draw attention to the distinctive features of Carrara family patronage when compared to that characteristic of the prominent families of contemporary Florence and Siena. The position, power and influence of the Carrara family within Padua were far in excess of any single family in either Florence or Siena. Indeed, in the scale of their wealth – based on their ownership of fertile land in the Paduan *contado* and extensive property holdings within the city itself[6] – and their sheer political prominence within Paduan civic life, the Carrara family most closely resemble the similarly powerful Scaligeri dynasty in contemporary Verona or, indeed, the Visconti family of Milan.

In examining the nature and significance of Carrara patronage, the essay will explore the diverse ways in which the Carrara utilized art both to advertise their wealth and prominent political status within Padua and also self-consciously to validate their dynastic claims over Padua and its surrounding territory. In addition, it will identify crucial interactions between 'public and private' and 'religious and secular' in their artistic patronage, and will note a striking example – in Fina Buzzacarina, wife of Francesco il Vecchio – of a fourteenth-century woman utilizing her considerable personal financial resources to further her family's promotion of art for dynastic ends.

Plate 160 (Facing page) Detail of scenes from the *Châtelaine de Vergi* (Plate 184). Photo: Scala.

PUBLIC AND PRIVATE 'RITES OF PASSAGE' AND THEIR CELEBRATION IN ART

In the fourteenth-century chronicle of Galeazzo Gatari and his son Bartolommeo, it is striking how, as their account of life in Padua under the Carrara regime unfolds, the authors become more and more detailed in their descriptions of the public rituals of the ruling family. In particular, two kinds of familial event appear to have especially captured their attention and imagination, namely the marriages and funerals of the various Carrara *signori* and their closest relatives. In due course we shall consider their accounts of marriage ceremonies, but we begin with their careful attention to the funerary rituals of the Carrara dynasty.

Whilst every Carrara funeral recorded by the Gatari (from Jacopo I in 1324 to Francesco il Vecchio in 1393) appears to have been marked by lavishly staged funerary processions and burials, the description of the elaborate ceremonial that accompanied the funeral of Francesco il Vecchio is the most striking.[7] He died in humiliating circumstances, in exile at Monza under the jurisdiction of the *signore* of Milan, Gian Galeazzo Visconti. His son, Francesco il Novello, by then re-established as ruler of Padua, requested Gian Galeazzo that his father's body be brought back to Padua for solemn burial within the city. The body was transported to Padua by boat and, accompanied by representatives of Padua's citizens, was carried to the Carrara palace (the Reggia) and placed in its private chapel. Here the coffin was opened for Francesco il Novello to see and to pay his last respects to his father.

From the accounts given by both the Gatari and other contemporary commentators, it is clear that the funeral was a very solemn, moving and elaborate affair. The funerary procession followed a route through the Piazza delle Biade and the Piazza della Frutta (and thus through the political and commercial heart of the city) to the cathedral. It comprised over 100 horsemen representing the various offices of the seigneurial and civic government, together with Francesco il Novello himself, ambassadors of Florence, Venice and other Italian cities, members of the Carrara household and a multitude of 'poor people, all dressed in brown'. The coffin was further dignified by a cloth-of-gold covering and a canopy – both items being lined with ermine. Within the cathedral itself, the women of Padua greeted the arrival of the coffin with loud lamentation. Having accompanied the coffin to the cathedral, Francesco il Novello returned to his palace to hear a private funerary oration on the merits of his father. According to the humanist scholar, Pier Paolo Vergerio, another eyewitness to these events, the Carrara *signore* then returned to the cathedral for a further oration delivered by a Dominican friar, after which a solemn funerary mass was celebrated and Francesco il Vecchio's body was taken to the neighbouring baptistery, where his tomb monument was still being constructed.[8]

Although the frescoed decoration of the baptistery and its original fourteenth-century altarpiece bear ample witness to the declaration made in the last will and testament of Fina Buzzacarina that she and her husband should be buried within the baptistery and that it should function liturgically as their funerary chapel,[9] little now remains of either Fina's or Francesco il Vecchio's tomb monuments. The surviving stone canopy and frescoed decoration around the west doorway of the baptistery indicate that Fina's once took the much-favoured form for north Italian tomb monuments, namely a tomb chest or *arca* set high on a wall, supported on elaborately carved brackets and embellished by painted decoration incorporating portraits of the deceased. It is debatable exactly where Francesco il Vecchio's tomb was located within the baptistery and also why it was dismantled. But it appears from both a passing reference by Pier Paolo Vergerio and an entry in the Gatari chronicle for Easter day 1398, that the tomb was executed within five years of Francesco il Vecchio's death and that it took the form of an impressive free-standing *arca* of red Veronese marble supported on four columns.[10]

Three other fourteenth-century tombs of Carrara *signori* do, however, survive. Although two of them have been relocated and stripped of vital elements of their painted and sculpted embellishment, all three sculpted monuments nevertheless confirm both the importance that the Carrara attached to commemorating their dead and the potential that they saw in art for the endorsement and validation of their political status and dynastic power. The earliest of these three funerary monuments, that of Marsiglio da Carrara who died in 1338, is located within the abbey church of Carrara San Stefano, south of Padua (Plate 161). As its name suggests, Carrara was the ancestral home of the family and indeed a member of the family, Litolfo da Carrara, had in the eleventh century founded the church of San Stefano and its Benedictine monastery.[11] Given that much of the family's economic wealth and political effectiveness was derived from their extensive properties within the Paduan *contado*, it was both entirely traditional and indeed highly appropriate that Marsiglio (the first member of the Carrara family to attain true seigneurial status) was commemorated by a tomb monument in a *contado* church which had enjoyed a long history of patronage by the Carrara family.

The tomb, again, takes the popular Paduan form of an *arca* and is made the more eye-catching by its marble panelling and carved embellishment.[12] On the outer corners of the tomb chest appear two figures, carved in high relief, depicting the Annunciate Virgin and the Archangel Gabriel, while at the

Plate 161 Anonymous, tomb monument of Marsiglio da Carrara, after 1338, marble, stone and polychromy, San Stefano, Carrara San Stefano. Photo: Frick Art Reference Library, New York.

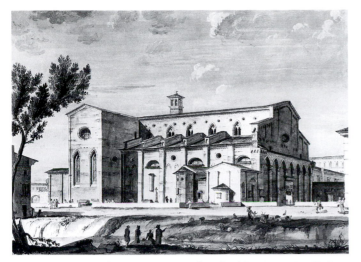

Plate 162 View of the now destroyed church of Sant'Agostino, Padua. Watercolour by M. Urbani conserved in Museo Civico, Padua, reproduced by courtesy of Musei Civici Padova, Gabinetto Fotografico.

centre of the chest itself is a carved relief showing Marsiglio in the conventional guise of a donor figure being presented to the enthroned Virgin and Child by a saint – probably Saint Anthony of Padua. The subject of this carved relief thus not only acts as an endorsement of the deceased's devotion towards Mary, her Son and two saints (one of whom was particularly revered in Padua), but also expresses the pious hope that, through the intercession of Mary and the saints, Marsiglio da Carrara might attain life-everlasting. This early Carrara tomb also begins a tradition of commemorating the physical appearance of the deceased, which was to continue throughout the century on the tombs of the Carrara, their close associates and followers within Padua.

As with Marsiglio, so also his immediate successors to the title of *signore*, Ubertino da Carrara (d.1345) and Jacopo II da Carrara (d.1350), were given elaborately staged funerals with all due honours worthy of their political and knightly status. These funerals took place within Sant'Agostino – Padua's principal Dominican church.[13] Situated on the west bank of the Bacchiglione, this basilican church was demolished by the Austrian government in 1819, but a sense of its imposing scale can still be derived from early pictorial representations of it (Plate 162).[14] Within its chancel (a site which, owing to its proximity to the high altar, held great prestige) elaborate wall tombs had been prepared for each of the Carrara *signori*. In the case of Jacopo's tomb we know from a surviving contract dated 26 February 1351 that the Venetian sculptor Andriolo de'Santi, together with two other named sculptors, were commissioned to execute this work.[15] According to the Gatari each tomb was ready to receive the body of the deceased at the time of his funeral, and since both tombs are similar in overall design (Plates 163, 164), it seems highly likely that Andriolo de'Santi and his associates were also responsible for Ubertino da Carrara's tomb. Fortunately, the two tombs did not suffer the fate of Sant'Agostino itself but were transferred (albeit with some damage) to the church of the Augustinian Hermits – the Eremitani.

While still belonging to the basic *arca* type of funerary monument, these two Carrara tombs already signal a striking departure from the much simpler design of that for Marsiglio

da Carrara (Plates 163, 164; cf. Plate 161). They both incorporate full-scale effigies of the deceased which provide a strong sense of the physical presence of the persons in whose memory the monuments were erected. More specifically, they allow for detailed portrayal not only of these persons' distinctive facial features but also of their clothing – a detail which, in a society ruled by strict regulations as to what people of different social status might or might not wear, must once have offered a clear statement concerning the social rank of the deceased.

Significantly the two Carrara *signori* are portrayed not in armour but in the long robes and distinctive head-dress of fourteenth-century merchants, lawyers and the like. They present, therefore, an image not of warrior-knights but of citizens capable of administering fair and equitable government to the population and community of Padua. A further sculpted detail once on Ubertino's tomb (visible in old photographs) adds additional credence to this interpretation (Plate 163). Originally placed at the effigy's feet was a sculpted model of the city of Padua which, in terms of its accurate topographical detail, found an echo in the later painted representation of the city by Giusto de'Menabuoi (Chapter 1, Plate 6). The inclusion of this model city effectively related Ubertino to Padua itself and, as one scholar has plausibly remarked, epitomized his role as city father reconsolidating Padua after its war with Verona.[16]

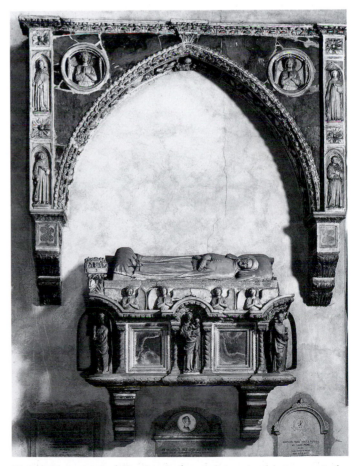

Plate 163 Andriolo de'Santi and other sculptors, tomb monument of Ubertino da Carrara, *c*.1350, marble, Istrian stone, polychromy and gilding (*The Virgin and Child*, 89.3 cm high), Eremitani, Padua, formerly chancel of Sant'Agostino, Padua. Photo: Alinari.

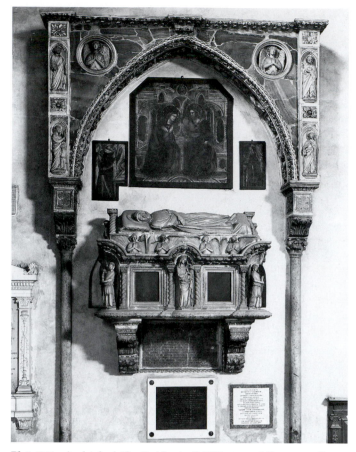

Plate 164 Andriolo de'Santi, Alberto di Ziliberto and Francesco di Bonaventura, tomb monument of Jacopo II da Carrara, 1351, marble, Istrian stone, polychromy and gilding (*The Virgin and Child*, 92 cm high), Eremitani, Padua, formerly chancel of Sant'Agostino, Padua. Photo: Alinari.

entry into heaven and her coronation as queen – a composite religious message which could only have had the most positive of associations for the Carrara (Plate 165).

As well as describing the funerals of the Carrara *signori* and other members of their family, Bartolommeo Gatari also provides a vivid description of the festivities that took place to mark the marriage in 1372 of Caterina, daughter of Francesco il Vecchio and Fina Buzzacarina, to Stefano, Count of Veglia.[18] According to his account, the marriage was celebrated by jousts, dancing and other public festivities, the departure of the newly married Caterina likewise being marked by lavish public ceremony. Although his account of Caterina's wedding festivities is confined to public events, we also know that the ceremonies for the marriages of both Lieta, daughter of Francesco il Vecchio, to Frederick, Count of Oettingen (1382), and Gigliola, daughter of Francesco il Novello, to Nicolò d'Este (1397), took place within a large *salone* known as the Sala Virorum Illustrium – the room of famous men – within the Carrara palace of the Reggia.[19]

These references to Carrara weddings and their celebration within the family palace remind us of a second and crucial venue for the private patronage of fourteenth-century art. Hitherto we have been considering evidence for Carrara familial patronage within the public sphere of the city's churches – sites which were relatively accessible to the world at large. Thus, by virtue of their very location, the Carrara funerary monuments made an impressive and very public statement of the worth and reputation of the family dynasty. There was also, however, another more private and exclusive location – the family's private residence, the *palazzo* or town house – where members of wealthy and influential families

It seems that these tombs not only included sculpted portraits of the Carrara in effigy form but also incorporated painted representations of them as pious supplicants before the Virgin Mary and her Son. Three fragments of a large mural painting – depicting Christ in the act of crowning the Virgin Mary and two male donor figures arrayed in ermine-lined robes, each with a vestige of a saintly patron behind him – are now displayed in the chancel of the Eremitani (Plates 165, 166). Convincingly attributed to the Paduan Guariento, it seems that they were once part of the tomb monument of Jacopo II da Carrara, appearing as a large-scale painting above the effigy of the deceased – an arrangement seen in old photographs of the tomb (Plate 164). In its original form in Sant'Agostino, this tomb monument must once have presented a compelling statement of Carrarese status and aspirations. Beneath the *arca* appeared a long inscription recording an epitaph composed by Petrarch in honour of his patron, Jacopo II da Carrara.[17] Above it was situated the tomb chest supporting an imposing sculpted image of the deceased which, in terms of its representation of a recumbent human form and its subdued monochrome colour, would have offered a strongly evoked image of death. And immediately above this would have been the richly coloured painting showing two male representatives of the Carrara family in a scene alluding in no uncertain terms to Mary's triumphal

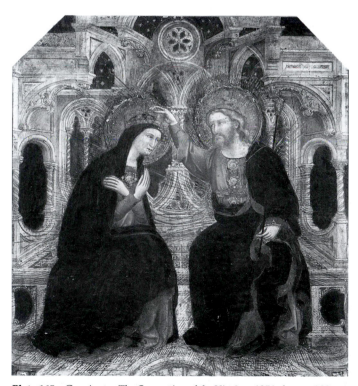

Plate 165 Guariento, *The Coronation of the Virgin*, c.1351, fresco, 200 x 180 cm, chancel, Eremitani, Padua, formerly part of tomb monument of Jacopo II da Carrara, Sant'Agostino, Padua. Reproduced by courtesy of Musei Civici Padova, Gabinetto Fotografico.

Plate 166 Guariento, Carrara votive figure, c.1351, fresco, 100 x 50 cm, chancel, Eremitani, Padua, formerly part of tomb monument of Jacopo II da Carrara, Sant'Agostino, Padua. Reproduced by courtesy of Musei Civici Padova, Gabinetto Fotografico.

could exercise their patronage of art. Moreover, it was within precisely this private domestic setting that women could make their mark as purchasers of art, acquiring such items as small-scale religious artefacts for their private devotions and exquisitely crafted textiles and jewellery for the furnishing of the *palazzo* and for their own apparel.

Clearly, when dealing with a family such as the Carrara who were rulers of the city state of Padua and whose palace and private household had taken on the scale and character of a princely court, such public/private and male/female dichotomies within their patronage of art cannot be pressed beyond a certain point. The principal patronage of art by Fina Buzzacarina, for example, was triumphantly conducted within the public venues of Padua's churches.[20] Similarly, the scale and magnificence of the Reggia and the programme of

painting executed for its rooms were likewise designed not only for the private enjoyment of the Carrara, but also to accommodate the public ceremonial life of the *signore* and impress visiting dignitaries as to the worth and valour of the Carrara dynasty. Nevertheless, the basic distinctions are worth keeping in view as a broad working hypothesis for distinguishing between the different kinds of intention and motivation that lay behind the patronage of art by private individuals in Padua as well as Florence and Siena.

THE REGGIA AND ITS PAINTED DECORATION

As noted in Chapter 1, the Reggia once occupied an extensive site within the centre of the oldest part of the city. Indeed, in terms of its sheer scale (encompassing, as it did, the administrative, judicial and military offices of the seigneurial regime, as well as the residential quarters of the family and their household) it must once have rivalled the principal civic centre of the Palazzo della Ragione and its market places lying to the immediate east of the Reggia. Only tantalizing glimpses remain of what this complex of buildings, porticoes and enclosed courtyard must once have constituted. The main surviving part of the Reggia is the imposing double loggia which fronts what was once a southern wing of the palace (Plate 168). Now housing the library and meeting rooms of an academic institution, this building still contains fragmentary remains of its fourteenth-century painted decoration. For example, in a ground floor room – probably the documented Anticamera dei Cimieri (Antechamber of the Crests) of 1343 – a painted frieze displays a sequence of heraldic motifs including the stylized red chariot (*carro*) of the Carrara family and the helmet surmounted by a Saracen's head which was a personal device first adopted by Ubertino da Carrara and continued by his successors (Plate 167).[21] This repeated pattern of heraldic motifs is further enlivened by geometric interlacing and a broad frieze executed in grisaille so as to simulate carved stone. The depiction of light falling across these heads is both subtle and highly illusionistic. Such

Plate 167 Anonymous, Carrara emblems, mid fourteenth century, fresco, in the former Anticamera dei Cimieri of the Reggia. Accademia Patavina, Padua. Photo: Alessandro Romanin.

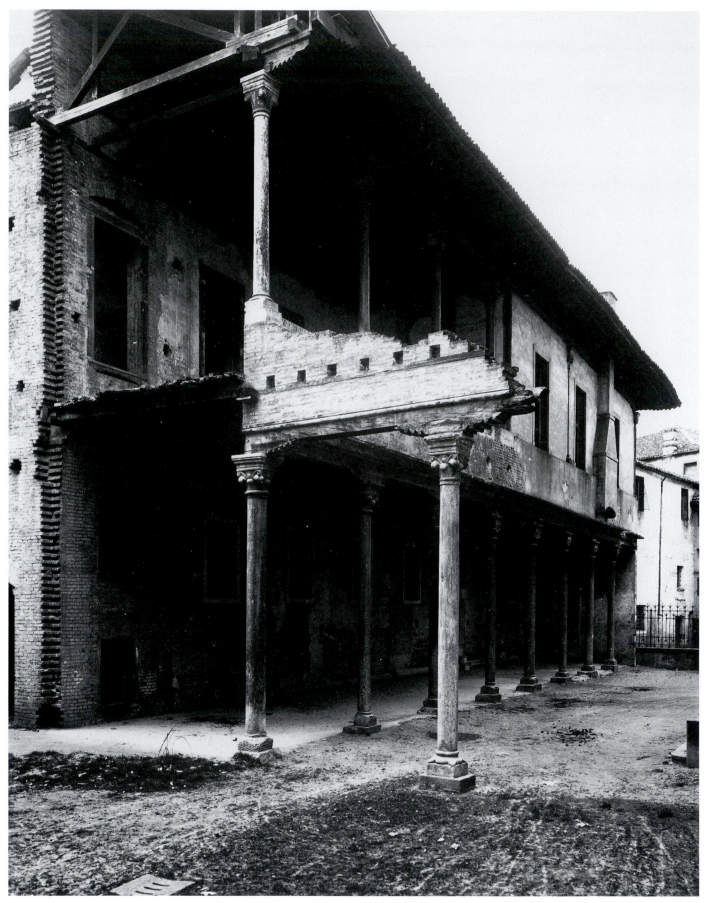

Plate 168 Portico of Accademia Patavina, Padua, formerly part of the southern wing of the Reggia. Photo: Alinari.

fragments provide an indication of the quantity and quality of painted decoration that once embellished the walls of the Reggia and other such privately owned fourteenth-century residences.[22]

THE CHAPEL OF THE REGGIA AND ITS PAINTINGS

As already noted, Bartolommeo Gatari's account of Francesco il Vecchio's funeral makes a reference to a chapel within the Reggia in which Francesco's body was first placed before its solemn journey to the cathedral for burial. It is likely that Gatari was referring here to a private chapel which was constructed – probably during Jacopo II's reign as *signore* (1345–50) – by closing up an external loggia situated on the west end of the present building.[23] Little remains today of the original architecture and painted decoration of this private family chapel. In the eighteenth century the east wall of the chapel was demolished, the windows on the west wall altered and the ceiling redesigned (Plate 169). Nevertheless, despite such grave losses, a series of murals attributed to Guariento still survive, thus providing a sense of what this frescoed scheme was originally like (Plate 170).[24] In addition, a series of painted panels, also attributed to Guariento and now housed in the Museo Civico and elsewhere but once located in the chapel, likewise provide another tantalizing indication of the painted decoration of this private oratory (Plates 171–173).

There was already an important precedent for an extensively painted chapel in Padua within a palace complex (Chapter 4, Plate 68). Nevertheless the design and conception of the two painted schemes were somewhat different. In the case of the Arena Chapel, Giotto located each narrative scene within a discreet painted frame. In the case of the Reggia Chapel, Guariento used the expanse of wall at his disposal to portray within one continuous setting a number of different narrative incidents from the Old Testament (Plate 170). As a consequence much of the clarity and impact of the individual Arena Chapel narrative scenes is lost. This might account for the presence in the upper borders of Guariento's scheme of extensive painted texts which describe what is being represented in the painting below. Despite such loss of narrative clarity, however, Guariento was able to offer a strong indication of various human actions being consequent upon others, thus fulfilling one of the basic demands of the narrative convention.

In one painting, for example, Guariento has depicted three narrative incidents described in the Book of Genesis: the apparition of three angels to announce to Abraham that he and Sarah would have a son in their old age (Genesis 18:1–16), the destruction of the city of Sodom with only Lot, his wife and daughters saved from its destruction (Genesis 19:1–29), and Abraham's attempted sacrifice of his son Isaac (Genesis 22:1–14). Thus, on the extreme left Abraham is shown kneeling before three angels whose graceful poses and hand gestures are indicative of their role as God's emissaries to Abraham. A tall rock behind them accentuates their presence and discreetly separates them from the next narrative scene of the destruction of Sodom and its inhabitants, a dramatic event encapsulated by the detailed representation of a generic fourteenth-century Italian city with a pile of corpses before its gateway. To the right appears a highly unusual portrayal of Lot's wife turned to a pillar of salt in consequence of her act of disobedience in looking back at

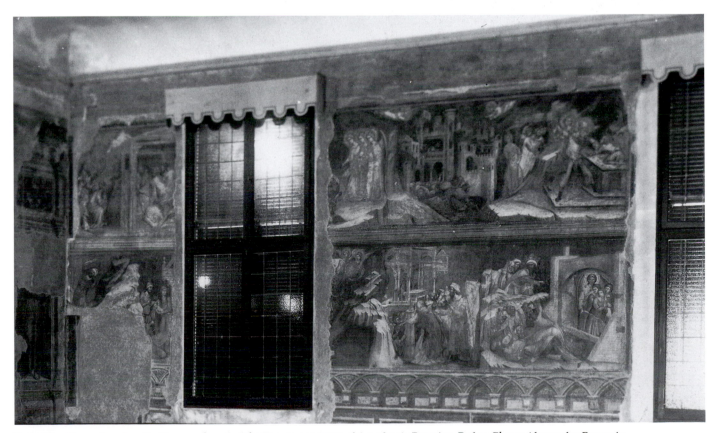

Plate 169 View of west wall of former chapel of the Reggia, now part of Accademia Patavina, Padua. Photo: Alessandro Romanin.

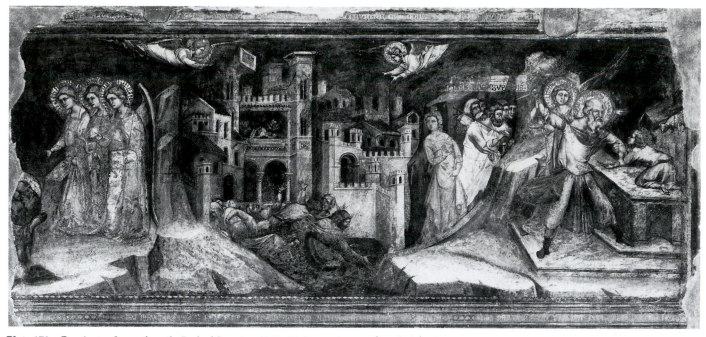

Plate 170 Guariento, *Scenes from the Book of Genesis*, c.1347–50, fresco, former chapel of the Reggia, now part of Accademia Patavina, Padua. Photo: Barbara Piovan.

the city (Genesis 19:26). Her elegant curving pose and the direction of her glance provide a clear indication of her previous act which has caused her misfortune. Rather than represent the somewhat dull image of a 'pillar of salt' demanded by the biblical text, Guariento has chosen to paint her in monochrome as if turned into an elegant Gothic statue. Meanwhile, her companions are represented as resolutely moving forward towards the next narrative scene, in which an angel dramatically prevents Abraham from killing his own son upon a stone altar. As in the case of Abraham's meeting with the angels, a rocky outcrop has been used to throw this act of highly emotive human drama into greater relief.

The subject-matter of the surviving series of panels which formed a further element of the pictorial decoration of the Carrara chapel consisted of a series of single figures or figural groups representing the Virgin and Child (Plate 171), the gospel writer Saint Matthew, and a number of varied representations of angels (Plates 172, 173). The treatment of the latter subject appears to correspond to the nine divisions of the angelic host as defined by early Christian theologians – seraphim, cherubim, thrones, dominions, virtues, powers, principalities, archangels and angels. It is clear from the surviving panels and reports of other lost examples that this series of painted figures must once have been of an imposing number. Moreover, it appears from the dimensions and formats of the surviving panels that they once formed an integrated ensemble. Unfortunately there remains no known description of the chapel to explain exactly their original arrangement and position. It has been suggested that they once formed a huge panelled ensemble which would have functioned as a kind of altarpiece. It seems much more likely, however, that they were arranged as a panelled frieze around the four walls of the chapel, above the mural paintings and just below the roof.[25] Such an arrangement would account for the asymmetrical shape of certain of the panels, which would thus fit into the corners of the room. Moreover, within

fourteenth-century Padua, the Salone of the Palazzo della Ragione presented an impressive precedent for such an elaborate painted scheme located at the juncture between the walls of a room and its wooden ceiling (Chapter 7, Plate 150). *The Virgin and Child*, meanwhile, probably functioned as a centrepiece within the ceiling proper with circular panels of the four evangelists located over each of the four corners of the chapel.

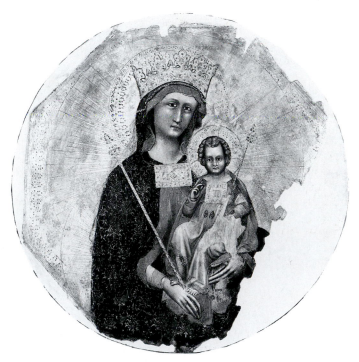

Plate 171 Guariento, *The Virgin and Child*, c.1347–50, tempera on panel, Museo Civico, Padua, formerly chapel of the Reggia. Reproduced by courtesy of Musei Civici Padova, Gabinetto Fotografico.

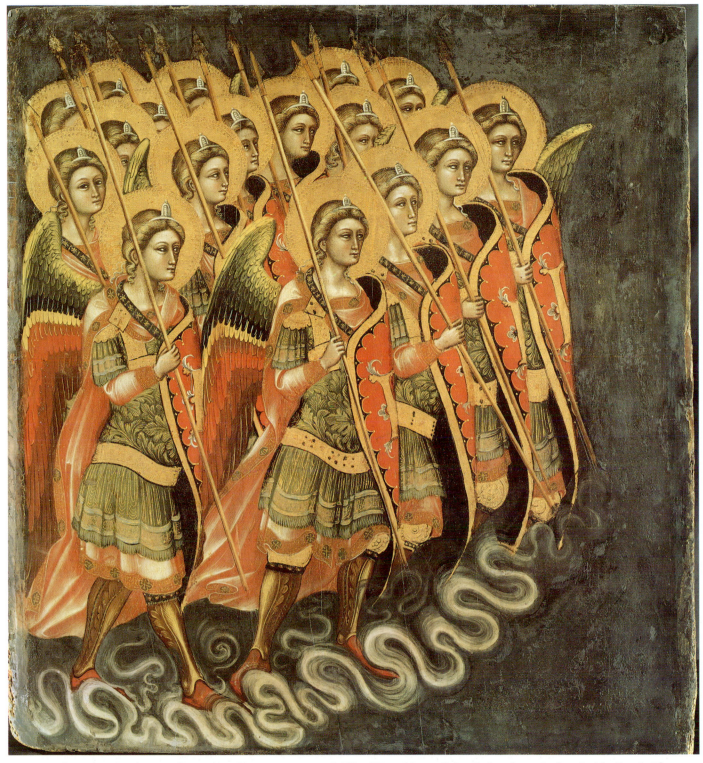

Plate 172 Guariento, *Angel Principalities*, *c*.1347–50, tempera on panel, 119 x 107 cm, Museo Civico, Padua, formerly chapel of the Reggia. Photo: Scala.

Taken as a whole, the *Angels* provide an imposing sequence of paintings, each angel or group of angels being silhouetted against a dark blue ground, which has now darkened almost to black. The effect of such a colour scheme can be gauged from one of two of the larger panels, where the background acts as a foil to the vibrant red and gold of the armour and haloes of the angelic host (Plate 172). Within

these paintings, there is also a degree of formality which is absent from the chapel's narrative mural paintings. These panel paintings are almost icon-like – an effect due in part to their subject-matter, since within Christian art angels were traditionally represented in robes derived from either Byzantine court costume or, in the case of the warrior principalities, Byzantine armour. Nevertheless, such an effect

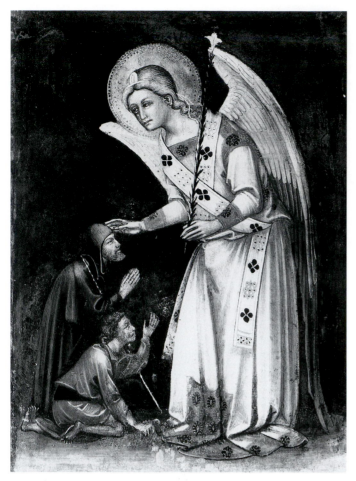

Plate 173 Guariento, *Angel Virtue Ministering to Two Supplicants,* *c.*1347–50, tempera on panel, 80 x 57 cm, Museo Civico, Padua, formerly chapel of the Reggia. Reproduced by courtesy of Musei Civici Padova, Gabinetto Fotografico.

is also conveyed by the paintings' very carefully calculated compositions. Thus on a large panel depicting the thrones, the angels have been grouped into a highly organized and carefully balanced semicircle. Similarly, the strongly stated diagonals of the lances and balances of the scales held by the archangels are counterpoised by the subtle curves of the archangels' drapery and the contours of their bodies. Notwithstanding such attention to matters of formal composition and design, there are also highly inventive and humane touches present within these paintings, such as the little souls held by the angels in their cloth-covered hands, the devils cavorting around at the end of chains held by the powers, and the pathos implicit in one of the angel virtues bending down to administer to the needs of a small-scale pilgrim and his companion (Plate 173).

In the absence of any known documentation regarding the terms of the commission awarded to Guariento by his Carrara patrons,[26] it is difficult to speculate on their intentions for their private chapel scheme and on what, if anything, these paintings tell us about their artistic tastes and preferences. It is possible, however, to reconstruct a sense of how elaborate the chapel interior must once have been, both in terms of its complex mural paintings and its panelled sequence of brightly gilded and coloured figures. We can gauge that Guariento tended to adopt a somewhat arbitrary attitude as

regards the proportions of his figures and representations of coherent pictorial space. Nevertheless, he also had a pronounced interest in the convention of continuous pictorial narrative, in the marrying of painted texts with painted images, and in the exploration of artistic challenges such as representing human bodies divested of their garments (Plate 170), and occasionally a pronounced delight in representing fashionable contemporary dress. Similarly, the painted panels provide evidence of Guariento adopting, on the one hand, an almost Byzantine-like formality of figural representation and, on the other, the use of lively and well-observed naturalistic detail (Plate 173). It may be, also, that these particular kinds of pictorial skills were most valued by the Carrara, thus causing them to employ this Paduan painter to paint the walls and ceiling decoration of their private chapel.

THE SALA VIRORUM ILLUSTRIUM AND ITS PAINTED PROGRAMME

When describing the Reggia, fourteenth, fifteenth and sixteenth-century sources also refer to further rooms whose very name, designated function or painted embellishment was deemed worthy of comment.[27] One group of rooms was known by either their classical name or their schemes of narrative paintings of various classical subjects. In the Sala Thebana (Theban Room) were paintings of the mythical military expedition against Thebes as recounted in the Latin epic poem, the *Thebaid,* by the first-century poet Statius. There were also paintings in the Camera Camilli (Room of Camillus) illustrating the life and deeds of the great fourth-century B.C. Roman statesman and general, and paintings in the Camera Herculis celebrating the classical hero and demi-god Hercules. Two other rooms – the Camera Neronis and the Stanza di Lucrezia (Room of Lucretia) – were named, respectively, after the first-century Roman Emperor Nero and the virtuous Roman heroine Lucretia, presumably because some aspect of their decoration alluded to these two notables. In the Stanza delle Navi (Room of Ships) it is likely that the room's decoration had as its painted subject the fourth-century siege of ancient Padua – Patavium – by the Spartans. In a second group of rooms, meanwhile, later events in Paduan history were also apparently commemorated. Thus the Stanza delle Brentelle (Brenta Room) probably contained paintings of the 1314 military campaign between Padua and Verona, whilst in the Stanza Nuova degli Viri Illustri (New Room of Famous Men) contemporary notables and more particularly the Carrara themselves and their military exploits were recorded in pictorial form. In the Sala Inferiore delle Bestie (Lower Room of the Wild Animals) there were probably either painted scenes of the courtly pastime of hunting or, like the Anticamera dei Cimieri, painted heraldic decoration (Plate 167). On an outside balcony which functioned as an entrance to the palace, there appears to have been a further series of life-size painted portraits of the Carrara *signori* executed in grisaille.[28]

Although nothing of these painted rooms survives today, a review of their subjects provides some insight into the motivation of the Carrara in choosing to have their palace embellished in this manner. For example, they clearly looked

to classical antiquity as a major source of subject-matter, and chose from this rich historical and literary tradition either key *figures* who were deemed to embody certain kinds of human and moral virtue, or *events* which celebrated varieties of human valour and achievement. It is also significant that in two rooms at least – the Sala Thebana and the Stanza delle Navi – notable military events in ancient history were commemorated, and that in two others – the Stanza delle Brentelle and the Sala Nuova degli Viri Illustri – contemporary victories in Padua's recent history and more specifically those of the Carrara were depicted. The moral is clear: the military policies and objectives of the Carrara were effectively legitimated and glorified by a series of rooms whose names and painted embellishment put on record, and implicitly drew parallels between, the exploits of the Carrara dynasty and those of the ancient world. One is reminded forcibly of Giovanni Conversini's remark, cited at the beginning of this essay, that a scholar's usefulness to a princely ruler is that, by virtue of his education, he could improve the prince 'by telling of splendid models and examples from the past'. The painters employed upon these schemes within the Reggia undoubtedly served a similar artistic function for their Carrara patrons.

In the mid fifteenth century, Michele Savonarola provided a vivid eyewitness account of two of the grandest of these rooms. After describing an ascent by a dignified ceremonial staircase to an upper loggia of marble columns and magnificent windows, he writes:

> Situated there are two very large rooms which are elaborately decorated with pictures. The first of these rooms is called the Theban Room (Sala Thebarum), the other one,

which is larger and more glorious than the first, is named the Room of the Generals (Sala Imperatorum). In this room are depicted the Roman generals [*Romani imperatores*], in wonderful figures and with their triumphs, painted with gold and the best colours. The representation of these men was the work of the famous painters Ottaviano and Altichiero. This is indeed an imperial palace and worthy of an emperor.[29]

Leaving aside for the present the question of which fourteenth-century painters were in fact responsible for these paintings, let us consider what may still be reconstructed of the appearance of one of these two fourteenth-century schemes within the Carrara Reggia. The room described by Savonarola as the 'Sala Imperatorum' is now part of Padua University. It is now known – from its sequence of greater than life-size sixteenth-century paintings of famous rulers, statesmen and generals of antiquity – as the Sala dei Giganti (Room of the Giants) (Plate 174). In the fourteenth century, however, the room was known as the Sala Virorum Illustrium (Room of the Famous Men). Despite its changed appearance, by virtue of its very scale it is still possible to gain a strong sense of what an impressive room it once must have been within the heart of the fourteenth-century Reggia. Moreover, from the descriptions of the two Carrara marriages that took place within it, we can also appreciate how it once functioned as an imposing ceremonial hall. Its original painted decoration was undoubtedly calculated to persuade visiting dignitaries and foreign potentates of the worth and magnificence of the Carrara dynasty.

One fourteenth-century mural – albeit in much repainted state – survives on the short west wall of this room (Plate 175). It represents a full-length portrait of the famous

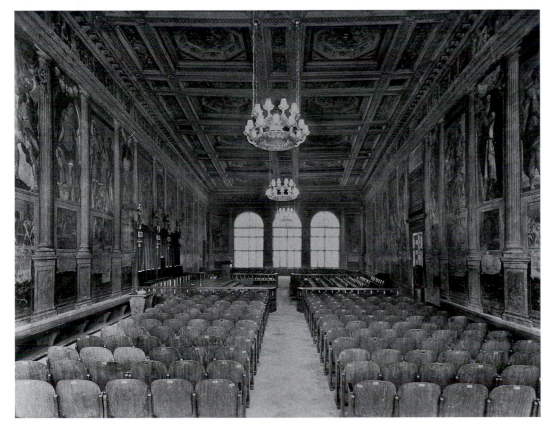

Plate 174 View of Sala dei Giganti, 37 m long, 17.5 m wide, 9 m high, formerly Sala Virorum Illustrium of the Reggia. Photo: Danesin.

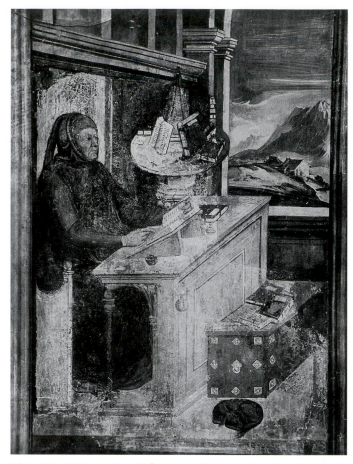

Plate 175 Attributed to Altichiero and Ottaviano Prandino, *Petrarch in his Study*, *c*.1374–79, extensively repainted fresco, west wall, Sala dei Giganti, formerly Sala Virorum Illustrium of the Reggia. Photo: Danesin.

regime appears to have occurred in 1349 when he was awarded a cathedral canonry by Jacopo II da Carrara. It was, however, under Francesco il Vecchio that he appears to have enjoyed the benefits of a more long-lasting and fruitful period of patronage by the Carrara family. In 1367 he took up permanent residence in Padua, and lived the last six years of his life a short distance from the city in the Euganean Hills at Arqua, where Francesco il Vecchio had given him land. As a testimony to the close friendship between the two men and the sense of gratitude that Petrarch clearly felt towards his Carrara patron, it is significant that on his death Petrarch bequeathed to Francesco il Vecchio a painting of the Virgin and Child executed by Giotto.[31]

The relationship between Petrarch's literary interests and the paintings of the Sala dei Giganti provides a particularly telling example of the interaction possible between client and patron. After a visit to Rome in 1336, Petrarch had resolved to write a historical work in the form of a collection of biographies of celebrated Romans from Romulus to Titus. During the late 1330s and early 1340s he actively pursued this project but thereafter other interests distracted him. At the

fourteenth-century humanist Francesco Petrarch (1304–74), whose scholarship is alluded to by showing him seated at a desk, surrounded by the materials of his profession – wooden reading stands, plentiful books, inkstand and pens. As the painting survives only in a repainted state, it is fortunate, therefore, that in the last decade of the nineteenth century another, closely comparable portrait of Petrarch was identified as a frontispiece to an early fifteenth-century manuscript copy of an Italian translation of Petrarch's own work, *De Viris Illustribus* (Plate 176). Since this manuscript once belonged to the Papafava family, a minor branch of the Carrara dynasty, it has plausibly been argued that this manuscript portrait is a faithful copy of the original fourteenth-century painting for the Carrara Reggia. Moreover, the descriptive detail and confident handling of pictorial space of the manuscript portrait offer a tantalizing indication of what might have been the very high quality of the original mural painting.[30]

The presence of this portrait of Petrarch within the Sala Virorum Illustrium – together with another portrait of a close friend and professional associate of his, the Paduan lawyer and scholar Lombardo della Seta (also located on the west wall but now completely repainted) – alerts us to the role that Petrarch might once have played in devising the subject-matter for this room's fourteenth-century painted scheme. Petrarch's first significant contact with Padua and the Carrara

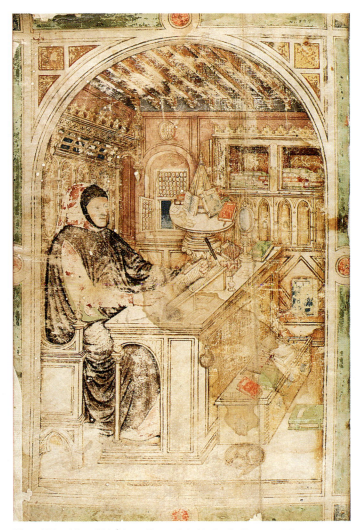

Plate 176 After Altichiero, *Petrarch in his Study*, Donato Albanzani's Italian translation of Petrarch's *De Viris Illustribus*, *c*.1400. Hessische Landes und Hochschul Bibliothek, Darmstadt, Handschriftenabteilung Codex 101, folio 1 verso.

request of Francesco il Vecchio, however, from 1367 he again addressed himself to this work, composing a final version of 24 biographies of primarily Roman statesmen and generals and dedicating it to his Paduan patron. In 1379, five years after Petrarch's death, his literary executor, Lombardo della Seta, completed his own continuation of the work, adding twelve new biographies and again dedicating it to Francesco il Vecchio.[32] In the prologue of this extended version of *De Viris Illustribus*, Lombardo della Seta addresses his patron thus:

> As an ardent lover of the virtues, you have extended hospitality to these famous men [*viri illustres*], not only in your heart and mind but also very magnificently in the most beautiful part of your palace. According to the custom of the ancients you have honoured them with gold and purple, and with images and inscriptions you have set them up for admiration ... To the inward conception of your keen mind you have given outward expression in the form of most excellent pictures, so that you always keep in sight these men whom you are eager to love because of the greatness of their deeds.[33]

This dedication thus demonstrates that by 1379 Francesco il Vecchio had commissioned for 'the most beautiful part of [his] palace' paintings and inscriptions closely associated with Petrarch's collection of biographies of the famous men of antiquity. It also vividly evokes the exemplary role that these paintings were intended to perform. Moreover, by combining the evidence supplied by the repainted *sixteenth*-century scheme within the Sala dei Giganti, eyewitness accounts of the original *fourteenth*-century scheme and the pictorial decoration of a number of contemporary or near contemporary manuscript copies of various editions of Petrarch's *De Viris Illustribus* (Plates 177, 178), it is possible to offer a plausible reconstruction of the visual appearance of the scheme of paintings originally initiated by Francesco il Vecchio. Painted images, probably in full colour, of 36 men – among them Romulus, Hannibal, Julius Caesar and Vespasian, all of whom feature in Lombardo della Seta's version of Petrarch's *De Viris Illustribus* – would have been ranged along the long north and south walls of the room, eighteen to each side. As in the case of the later sixteenth-

Plate 177 Anonymous, *The Death of Lucretia and Brutus' Expulsion of Tarquinius*, Donato Albanzani's Italian translation of Petrarch's *De Viris Illustribus*, c.1400. Hessische Landes und Hochschul Bibliothek, Darmstadt, Handschriftenabteilung Codex 101, folio 8 recto.

Plate 178 Anonymous, *The Building of the Walls of Rome and the Quarrel between Romulus and Remus*, Donato Albanzani's Italian translation of Petrarch's *De Viris Illustribus*, c.1400. Hessische Landes und Hochschul Bibliothek, Darmstadt, Handschriftenabteilung Codex 101, folio 4 verso.

century paintings, below each heroic figure would almost certainly have been a scene of an event from his life, probably executed in grisaille. Below this narrative scene again would have been a painted text identifying the figure above (Plate 174).[34] That the fourteenth-century scheme was indeed organized thus is suggested by Lombardo della Seta's reference to 'images and inscriptions' and Savonarola's later reference to 'figures and their triumphs'.

A broad indication of the narrative form which these painted 'triumphs' might once have taken is supplied by the illustrations in grisaille that appear at the foot of 24 of the pages of the early fifteenth-century manuscript copy of Petrarch's *De Viris Illustribus* (Plates 177, 178).[35] Certain of these narrative scenes appear to identify and describe details which feature particularly prominently in *De Viris Illustribus*. Thus, for example, in his account of the suicide of Lucretia and Brutus' expulsion of Tarquinius from Rome, Petrarch emphasized the vigorous, active nature of Brutus' act as contrasted to the essentially passive, if sorrowful, reaction of the other witnesses. He also specifically praised Brutus as the founder of liberty. In the manuscript depiction of this event, Lucretia appears on the left, facing a sedate group of male bystanders (Plate 177). On the right, the confrontation between Brutus and Tarquinius is portrayed as a highly charged and energetic act. Moreover, Brutus has been made the more clearly identifiable by his sash with the word 'LIBERTAS' upon it.[36]

If this group of manuscript illuminations approximate the original 'triumphs' within the Sala Virorum Illustrium, they provide a significant insight into the attitudes of the painters, their patron and the latter's scholarly advisers towards the notion of history. It is striking, for example, that in the scene of Lucretia's suicide, the Roman heroine and her companions are portrayed in fashionable contemporary garb. Similarly, those scenes which purport to represent ancient battles have likewise been recast into representations of fourteenth-century chivalric practice. It appears, therefore, that it is the exemplary nature of the classical subject-matter rather than classical style *per se* which is of importance to painters and patron alike. At the same time, however, there are instances of the manuscript artist (presumably in imitation of the mural paintings in the Sala Virorum Illustrium) attempting topographical accuracy and the representation of specific antique buildings within Rome itself. Thus in the scene of the building of the walls of Rome and the quarrel between Romulus and Remus, the manuscript painter has represented a number of Rome's most famous ancient monuments – the Colisseum, Castel Sant'Angelo, Janus Quadrifons and the Vatican Obelisk (Plate 178). Taken in its entirety, therefore, the fourteenth-century painted scheme within the Sala Virorum Illustrium in the Carrara Reggia must once have represented not only an extraordinarily ambitious painted programme but also one which, within its own terms, was extremely erudite in its range of classical, historical, literary and topographical references.

On the basis of Lombardo della Seta's tribute to Francesco il Vecchio in his version of *De Viris Illustribus*, it is reasonable to assume that Francesco was responsible for commissioning this ambitious scheme of paintings. The precise dating of the commission remains a matter of debate, although there is a

general agreement that the project was executed somewhere between 1367 and 1379.[37] Much of the argument concerning dating inevitably turns on which of the painters active in Padua during this period were most likely to have been responsible for the project in the Sala Virorum Illustrium. Fourteenth-century sources remain silent on this point, and the fifteenth and sixteenth-century sources provide conflicting evidence, offering the names of Guariento, Jacopo Avanzo, Altichiero and Ottaviano da Brescia.[38] All in all, however, Savonarola's attribution of the paintings to Ottaviano da Brescia and Altichiero appears the most plausible. Savonarola's account is clearly that of an eyewitness, whereas the other later sources tend to rely on the conflicting opinions of others. We know that Guariento was dead by 1370, which effectively means that he could only have participated in the painted scheme at an early stage of its execution. Altichiero had previously executed a major fresco cycle based on Josephus' account of Vespasian and Titus' campaign against the Jews for the Sala Grande in Cangrande della Scala's palace in Verona, of which only a series of profile heads of Roman emperors survive (Plate 179).[39] Further there is the documented relationship between Altichiero and Lombardo della Seta. In the 1377–79 commission for the painting of the Lupi Chapel in the Santo by Altichiero, Lombardo della Seta acted as the notary and agent for the chapel's patron, Bonifacio Lupi.[40] In addition, the manuscript portrait of Petrarch (Plate 176) has been attributed to the painter,

Plate 179 Attributed to Altichiero, Roman head, *c*.1364, fresco, originally from an arch of the loggia of Cangrande della Scala's Sala Grande, Castelvecchio, Verona, now relocated in Museo degli Affreschi. Comune di Verona, Musei e Gallerie d'Arte. Photo: Umberto Tomba.

together with a number of other illuminations from the 1379 and 1380 editions of *De Viris Illustribus*.[41] Although less than certain, when taken cumulatively such evidence strongly supports an attribution of this painted scheme to the Veronese painter Altichiero, with the lesser known Brescian painter Ottaviano Prandino (doc.1370–1420) also perhaps taking part in its execution.[42]

THE CARRARA AND THEIR STYLE OF ART PATRONAGE

This analysis of a number of key monuments commissioned by the Carrara *signori* and close members of their family allows us to identify some of the salient characteristics of their style of art patronage. Beginning with the art produced at their behest within the highly public arena of the city's churches, a careful balance appears to have been struck between conventional religious imagery and imagery which was more secular in orientation. Thus our reconstruction of the original appearance of the tomb of Jacopo II da Carrara suggests that this monument once combined sculptures of the Virgin, the Christ Child and angels and a painting of the Virgin being crowned by her Son with sculpted and painted portraits of Jacopo II. Such, moreover, was the powerful

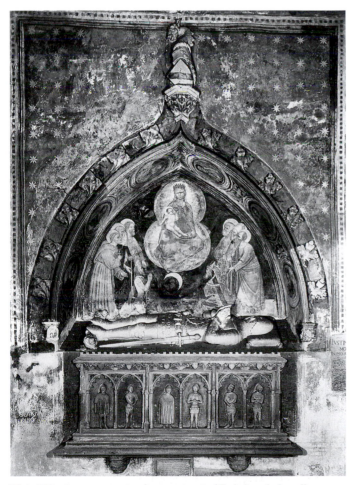

Plate 180 Anonymous, tomb monument of Federigo da Lavellongo with frescoed *Madonna of Humility with Saints and Federigo Lavellongo*, c.1373, passageway between the Santo and the Chiostro del Capitolo, Padua. Reproduced by courtesy of Musei Civici Padova, Gabinetto Fotografico.

impact of this impressive Carrara tomb that it appears other Paduan patrons and artists utilized it as a model for their own tomb monuments. For example, the tomb of Federigo da Lavellongo, Brescian Podestà to Francesco il Vecchio, provides evidence of a similar concern to commemorate the physical appearance and social status of the deceased and to use the resources of both sculpture and painting in order to achieve this end (Plate 180).[43] It is also notable that the richly narrative biblical scenes in the frescoes of the baptistery similarly include a number of portraits of the Carrara family and their closest and most illustrious associates. Perhaps the most striking example occurs in the scene depicting Christ healing the sick where, among the ranks of onlookers witnessing this miraculous event, there appear a number of figures who have convincingly been identified as Fina Buzzacarina, her sister Anna Buzzacarina (abbess of San Benedetto), Francesco il Vecchio and Petrarch (Plate 181).[44]

It is important not to overstate the significance of such combinations of contemporary portraiture and conventional religious imagery. The inclusion of such portraits was, after all, consistent with the religious practices of the day whereby a person was urged to visualize sacred events described in either biblical or hagiographical accounts as occurring within her or his own environment. The presence of such painted portraits could be interpreted as a sign of the whole-hearted commitment of the Carrara to the religious cults celebrated in these painted scenes. This qualification notwithstanding, however, the tradition of depicting patrons within the context of conventional religious narratives occurs with particular clarity and prominence within the art of fourteenth-century seigneurially governed Padua. Thus, in addition to the Carrara themselves, the practice also occurs in a number of other late fourteenth-century Paduan funerary chapels founded by their close associates. For example, the chapels of Bonifacio Lupi and of Naimerio and Manfredo dei Conti in the Santo and of Raimondino Lupi in the nearby Oratory of San Giorgio all include large-scale votive portraits of the patrons and members of their families (Chapter 1, Plate 16). In addition, in all three chapels narrative paintings ostensibly depicting scenes from the lives of various saints include portraits of the commissioners, their Carrara patrons – be it Francesco il Vecchio, Francesco il Novello or Fina Buzzacarina – and leading members of the Carrara court such as Petrarch and his close associate Lombardo della Seta.[45] It seems, therefore, that within the extended ambience of the Carrara regime there was a sustained interest in the cult of the individual – an interest notably expressed by the frequent insertion of contemporary portraits within religious art.

The strikingly high incidence of portraits of Petrarch within fourteenth-century Paduan painting is also worthy of comment since it highlights another crucial aspect of Carrarese patronage. As Conversini's treatises on the life of the courtier serve to highlight, a ruler's reputation as an enlightened and cultured man was substantially increased if he was known to have supported men of letters. Indeed it was the support of such men of letters, rather than of artists, which was most likely to enhance a ruler's reputation. The support extended to Petrarch first by Jacopo II and then by his son Francesco il Vecchio, and the latter's involvement and encouragement of Petrarch's project of writing *De Viris*

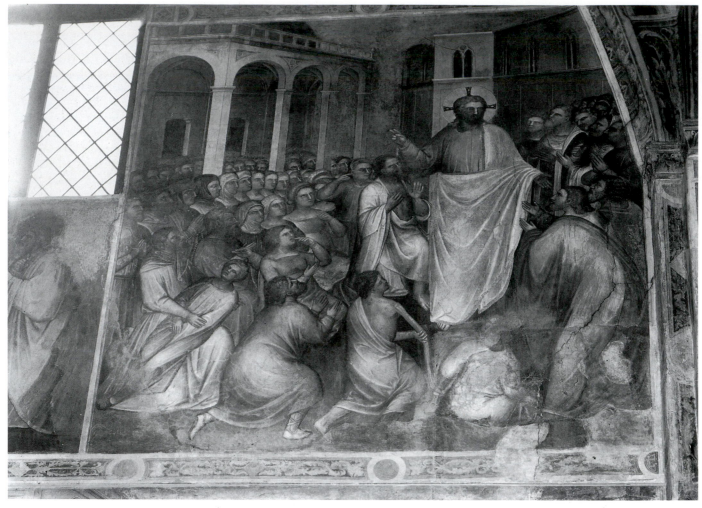

Plate 181 · Giusto de'Menabuoi, *The Healing by Christ*, 1370s, fresco, south wall of the Baptistery, Padua. Photo: Alessandro Romanin.

Illustribus, are symptomatic of such a commitment on the part of the Carrara family. Nor was Petrarch the only recipient of such enlightened support. All the Carrara *signori* took care to offer their support to the already famous University of Padua and also acted as patrons to a number of scholars, including notably Pier Paolo Vergerio.[46] Vergerio is best known for his enlightened views concerning the education of the young, which he put into practice at the Gonzaga court of Mantua in the early fifteenth century. While still in Padua, however, he repaid his Carrara patrons by producing several works in the 1390s, one of which, entitled *Liber de Principibus Carrariensibus et Gestis Eorum* (*The Book of the Carrara Princes and their Deeds*), details the lives and achievements of six of the Carrara *signori*. While largely dependent on earlier chronicles and thus a highly derivative piece,[47] this work (like the painted portraits of the Reggia) served to bolster an image of the Carrara dynasty as effective and enlightened rulers (Plate 182).

Turning to the Reggia and what we can reconstruct of its painted decoration, it is striking how committed the Carrara apparently were to the cult of antiquity – self-consciously

Plate 182 · Anonymous, *Jacopo II da Carrara*, manuscript illumination in *Liber de Principibus Carrariensibus*, 1390s, Museo Civico, Padua, MS BP 158. Reproduced by courtesy of Musei Civici Padova, Gabinetto Fotografico.

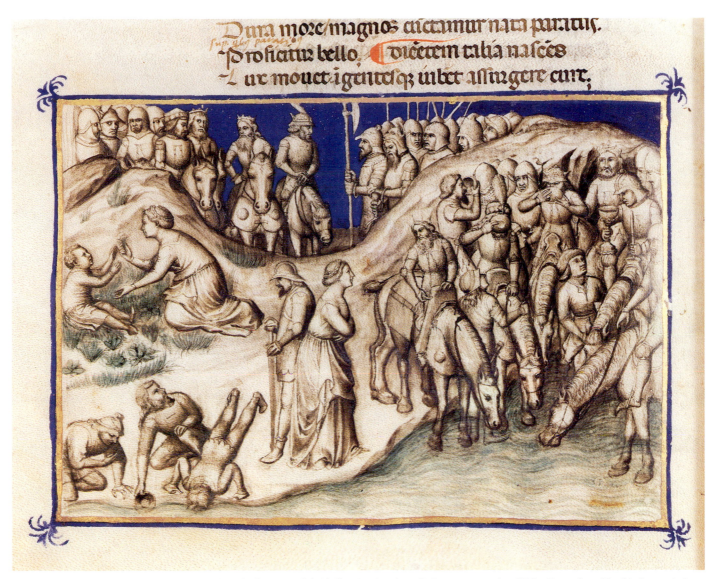

Plate 183 Anonymous, *Scene from the Fourth Book of Statius' Thebaid*, illumination from Paduan manuscript, 1370s. Reproduced by kind permission of the Trustees of the Chester Beatty Library, Dublin.

utilizing it in order to draw parallels between the achievements of the ancient world and those of their own city and family. Moreover, their commitment to antique models manifested itself not only in terms of subject-matter but occasionally in the very manner in which these classical themes were represented. On the evidence of the manuscript images which in all probability approximate the original appearance of the paintings of the Sala Virorum Illustrium, such pictorial representations of classical themes were for the most part couched in a contemporary idiom. Nevertheless, as a number of scholars have observed, in at least three respects fourteenth-century Paduan art showed a marked dependence on antique art. First, as we have already noted in another context, there was a sustained interest in the use of portraiture, a genre much favoured in ancient art and literature. Secondly, there was a preference for the use of grisaille. Thus it appears that the lost portraits of the Carrara on the exterior of the Reggia were once executed in green monochrome. The illuminations within the manuscripts closely associated with the painted decoration of the Sala Virorum Illustrium were similarly executed in monochrome, as were the nine full-page portrait illustrations of the Carrara *signori* within Pier Paolo Vergerio's *Liber de Principibus* (Plate 182).[48] In addition, scenes from the *Thebaid* in a fourteenth-century Paduan manuscript (which may record the lost frescoes in the Sala Thebana of the Reggia) were also executed in monochrome (Plate 183).[49] It is true that fourteenth-century artists working in Padua had the precedent of Giotto's virtues and vices in the Arena Chapel. Nevertheless, this marked preference for a single colour (exploiting the full range of tones that this one colour could afford) may well have been intended to emulate antique sculpture. Thirdly and finally, it is significant that both the manuscript drawings in the *Thebaid* and Guariento's Old Testament scenes in the one-time chapel of the Reggia employ the continuous narrative form (Plates 170, 183) – a technique much favoured by the artists of antiquity as attested by a number of antique sculpted reliefs.[50]

CODA: SIENESE AND FLORENTINE STYLES OF ART
PATRONAGE

Compared with the Carrara in Padua, no single family within fourteenth-century Siena or Florence could compete in terms of the scale and extent of their art patronage. Nevertheless, familial patronage was also an important agency for the production of art within these two other cities. In the churches of both Siena and Florence, tomb monuments and privately owned funerary chapels occurred. For example, in terms of its impressive scale and sophisticated sculpted repertoire, the tomb monument of Cardinal Petroni erected in the Duomo of Siena is comparable to the two tombs of the Carrara *signori* that once stood in the chancel of Sant'Agostino in Padua (Chapter 2, Plate 21; cf. Plates 163, 164). Similarly, if one considers the painted imagery of the tomb in the Bardi di Vernio Chapel in Santa Croce, it is clear that fourteenth-century Florentine individuals were, like the Carrara, not adverse to commemorating themselves in a highly personalized way (Chapter 1, Plate 19; cf. Plate 166). Turning to the privately owned chapels within the churches of Siena and Florence, unfortunately little remains of Siena's fourteenth-century chapels and altars. Nevertheless, it is clear from documents, visual records and the remains of murals that, like those of Florence and Padua, Siena's churches were once lined by family altars and chapels, each of which provided a focus for painted and sculpted decoration. Florence, by contrast, offers a much higher rate of survival of fourteenth-century familial monuments within the city's churches – the chapels in Santa Croce providing the most striking example.

There is, then, ample evidence that in both Siena and Florence leading families employed artists to embellish the cities' churches with artistic monuments and schemes. It is possible, however, to discern a significant difference between Sienese and Florentine familial patronage and that of the Carrara and their associates in Padua. In the case of the Paduan monuments there is apparently a much more sustained and self-conscious assertion of familial identity, inclusion of secular themes and contemporary details. The most obvious manifestation of this tendency was the introduction into sculpted and painted monuments and narrative painted scenes of portraits of members of the family, their close friends and professional associates.

Comparison of the private residences of leading Florentine and Sienese families with the Carrara is similarly revealing. As with the Reggia in Padua, so also in Florence and Siena, it is extremely difficult to reconstruct what the interiors of such buildings once looked like. However, in the Florentine Palazzo Davizzi (now Davanzati), a number of frescoed rooms provide a valuable indication of the kinds of subject-matter chosen for the embellishment of at least one such private residence. One room, for example, displays a late fourteenth-century scheme which, like the surviving fragments of decoration in the rooms of the Reggia, simulates fictive textiles hanging on the walls, heraldic emblems and an illusionistic architectural arcade (Plates 1, 184; cf. Plate 167). This arcade provides the setting for a painted narrative which depicts the story of the *Châtelaine de Vergi*, 'The Lady of Vergi', a chivalric French tale of the trials of fidelity and chastity. Since the pattern of the painted textiles includes the emblems of the Alberti and Davizzi families, it has been suggested that the painted decoration of this particular room was intended to celebrate the marriage of Catelana degli Alberti and Francesco di Tommaso Davizzi in 1395 – a proposal which increases in plausibility in view of the prominence of the themes of fidelity and chastity.[51] The use of familial heraldry and painted imagery pertinent to the personal history of the Davizzi family thus, at one level at least, resembles the practices of the Carrara in Padua. The sheer scale of the decorative schemes involved is, however, completely different.

Indeed if one recalls the extent of the interior embellishment of the Reggia – complete with painted chapel and sequence of ceremonial and private rooms containing painted schemes of ancient and contemporary history – it is clear that no privately owned family residence in either Florence or Siena could compete in terms of the scope and ambition of the Paduan palace. In order to find anything analogous to the Reggia, one has to look to other seigneurial, or indeed royal, palaces in Italy. We know, for example, that around 1332 Giotto painted the Sala dei Uomini Famosi in the palace of Robert of Anjou in Naples. This scheme, now lost, comprised nine heroes of the Old Testament and of antiquity and possibly also their wives.[52] Similarly, we know that Giotto executed a painting of *Vanagloria (An Allegory of Earthly Glory)* for the palace of Azzo Visconti, *signore* of Milan.[53] And as already noted above, Cangrande della Scala's palace in Verona was embellished with scenes of Roman history and antique portraiture by Altichiero (Plate 179).

In the context of Siena or Florence, however, the closest analogies to such ambitious painted schemes do not occur within private family residences but in such civic buildings as the Palazzo Pubblico in Siena and the Palazzo dei Priori and the Palazzo del Podestà in Florence. These buildings once included chapels which, like that of the Reggia, contained extensive painted schemes within them. Similarly, the council rooms and offices were also embellished with series of paintings whose subject-matter was specifically designed to commemorate either the ideal of civic government or notable events in the histories of the two cities. Moreover, in the 1380s a minor hall in the Palazzo dei Priori in Florence was painted with a series of 22 famous men whose collective achievements were further celebrated by epigrams devised by the humanist chancellor, Coluccio Satutati.[54] Similarly, at the very beginning of the fifteenth century an antechamber to the Sala del Concistoro in the Palazzo Pubblico, Siena, was painted by the Sienese artist Taddeo di Bartolo with a series of representations of famous men of antiquity (Plate 185). Since the painter probably himself worked in Padua in the 1390s, he may have consciously emulated the scheme of the Sala Virorum Illustrium of the Carrara Reggia.[55]

Given the political power of the Carrara within fourteenth-century Padua, it is perhaps not surprising that the painted schemes for their own residence should prove comparable to those of the major communal buildings of Siena and Florence. Notwithstanding such comparison, however, the mural paintings of the Reggia must in a number of other ways have presented a strikingly different aspect from communal schemes. First, some of these painted schemes directly

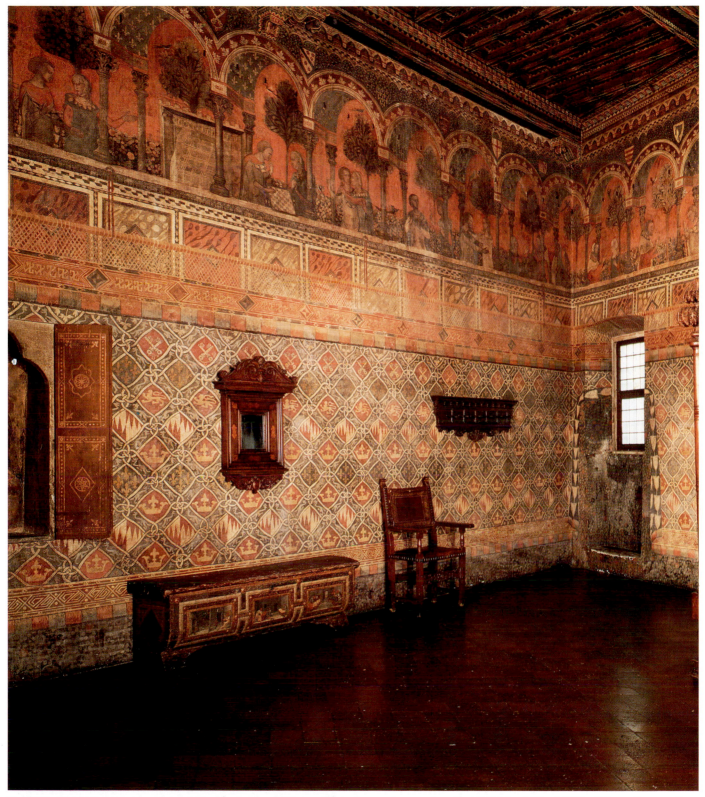

Plate 184 View of upper room decorated with murals of fictive wall hangings and scenes from the *Châtelaine de Vergi*, 1390s, Palazzo Davanzati, Florence, formerly Palazzo Davizzi and now Museo della Casa Fiorentina Antica. Photo: Scala.

commemorated the identities and achievements of the Carrara themselves. While specific and individual portraiture occasionally occurred within the major communal buildings of Siena and Florence – most notably that of Siena's one-time Capitano della Guerra, Guidoriccio da Fogliano, in the Sala del Consiglio of the Palazzo Pubblico (Chapter 7, Plate 142) –

such images portrayed their subjects specifically as representatives of the government and its collective concerns and ambitions. It is also unlikely that the now lost Reggia paintings made any direct reference to the community and citizenry of Padua, except perhaps in the guise of willing agents of the Carrara. Their original message must thus have

Plate 185 Taddeo di Bartolo, details of *The Famous Men of Antiquity*, 1413–14, fresco, 230 x 745 cm (including outer borders), antechamber to the former Sala del Concistoro, Palazzo Pubblico, Siena. Photo: Lensini.

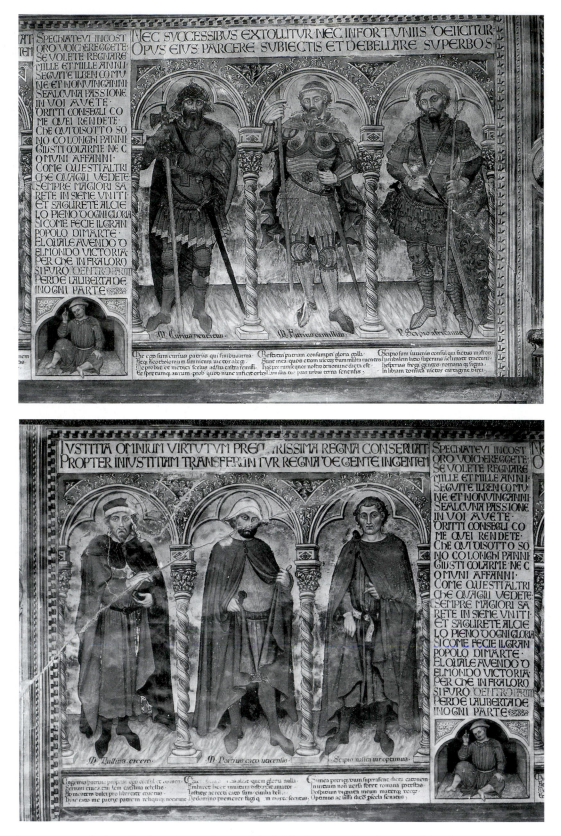

been very different from that conveyed by Ambrogio Lorenzetti's representation within the Sala dei Nove of a sedate procession of citizens carrying the rope of concord towards the personification of the wise and judicious Commune. Secondly, while some of the painted schemes of both the Paduan Reggia and the communal palaces of Siena and Florence revived subjects derived from classical antiquity,

the political ideology underpinning this choice of subject-matter was significantly different. In the case of the Reggia schemes, it is likely that flattering analogies were being made between the deeds of the great figures of antiquity and those of the *signore* and his family. In the Sienese and Florentine communal schemes, it is more likely that such historical figures acted as a timely reminder to the governors of Siena

and Florence of their collective duties and obligations towards preserving the ideal of republican government within their two cities.

How, then, may we sum up the essential similarities and differences between the private patronage of Padua, Siena and Florence? As a fragment of a fresco in San Domenico in Siena demonstrates, artistic monuments in public venues might also include highly personalized imagery. Plausibly attributed to Pietro Lorenzetti, this fragment depicts an intimate votive scene of Saint John the Baptist presenting a figure of a kneeling knight to the Virgin and Child (Plate 186).[56] Nothing is known of the commission of this fresco, but it is likely by its very subject to have belonged to a personal monument of some sort – be it part of a funerary monument or a privately owned family altar or chapel. The portrayal of the knight suggests that here we have the representation of a specific person who wished his identify and status as a knight to be remembered for posterity. In some respects, therefore, this image is comparable to chivalric images commissioned by knights of the Carrara circle in Padua (Plate 180). Comparable but not identical: for although the impulse towards personalized commemoration was also present in both Florence and Siena, the social and political circumstances which so facilitated its growth and expression in Padua were not. In Siena and Florence the celebration through art of both individuals and the families from which they came remained firmly subservient to the interests of the Commune. In Padua, however, as we have seen, the power and influence of the Carrara family was such that – during the period of their dominance – civic and familial art and patronage were effectively merged.

Plate 186 Pietro Lorenzetti, *The Virgin and Child with Saint John the Baptist and Votive Figure,* 1320s, detached fresco, San Domenico, Siena. Photo: Lensini.

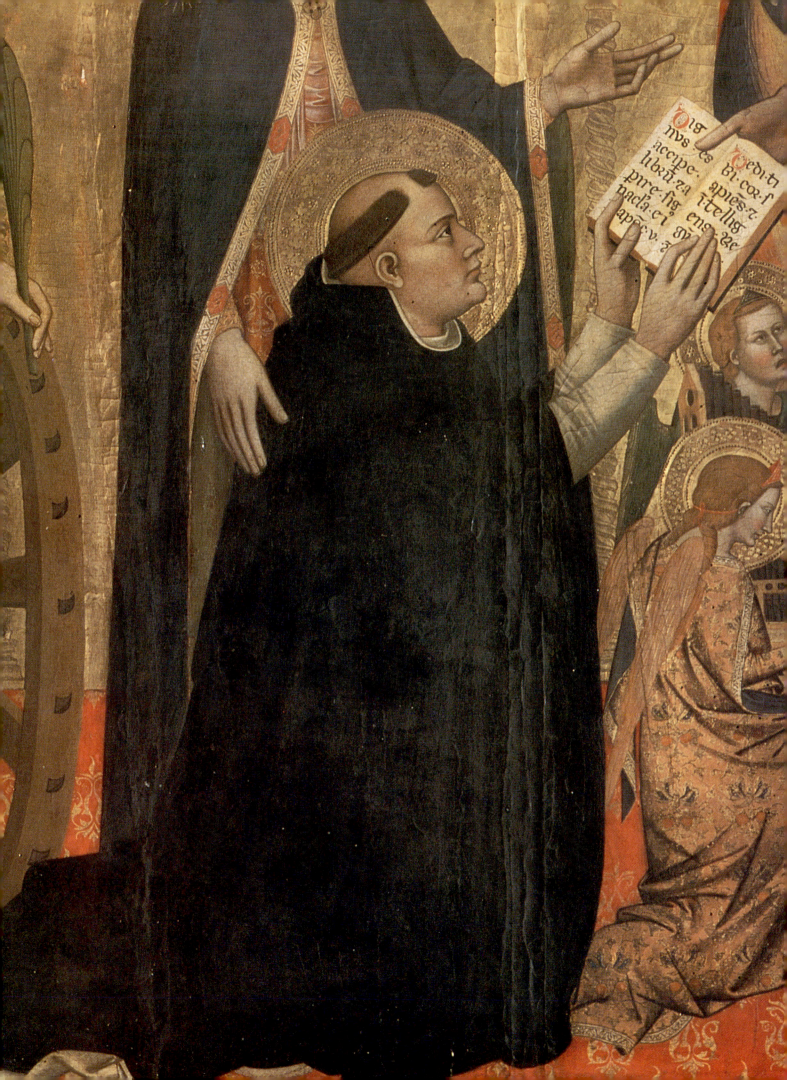

Change and continuity: art and religion after the Black Death

In his highly esteemed *Painting in Florence and Siena after the Black Death* (1951), Millard Meiss set out a bold and influential thesis. He claimed that the appearance of Tuscan art changed dramatically after 1348, the year of the Black Death, and linked that change decisively to a transformation in the religious and cultural sensibilities of the post-plague era. Meiss began his study of fourteenth-century Tuscan painting with an arresting iconographic and stylistic discussion of Orcagna's *Christ in Glory with Saints* – better known as the Strozzi altarpiece (Plate 188). Still situated over the altar of the Strozzi Chapel in Santa Maria Novella, this impressive mid fourteenth-century painting had – in Meiss's view – no precedent within early fourteenth-century Italian painting. The only previous examples that he could find for the portrayal of Christ as a full-length, centrally placed figure were all thirteenth century. For Meiss, therefore, 'Orcagna's design is reminiscent … of an older religious outlook and an older artistic convention.'[1]

Turning specifically to the treatment of Christ in this painting, he continued:

> Orcagna's Christ, like those of the early Dugento, is a transcendent figure, superior to specific acts and functions. Frontal, elevated, and almost motionless, he looks directly outward with glowing but unfocused eyes. Looming before a yellow radiance intensified by the dark blue of his mantle, he is a visionary but massive figure, seated but without visible means of support. These paradoxes are continued in the definition of his position in space. He seems both near and

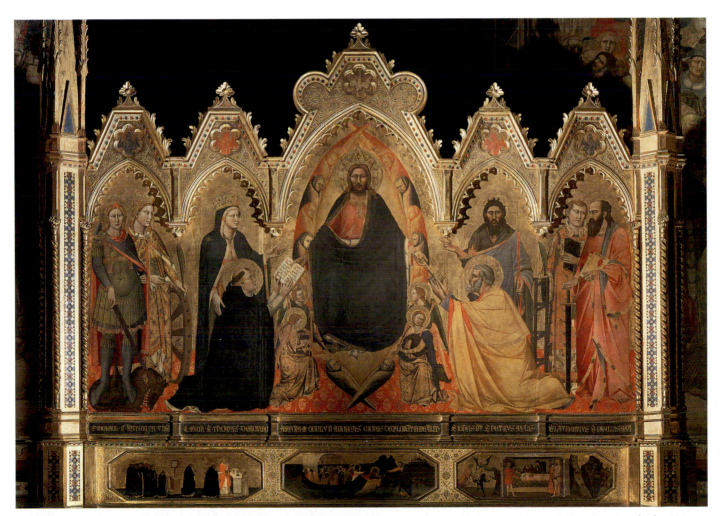

Plate 188 Orcagna, *Christ in Glory with Saints*, 'the Strozzi altarpiece', 1354–57, tempera on panel, 296 cm wide, central panel 160 cm high, side panel 128 cm high, Strozzi Chapel, Santa Maria Novella, Florence. Photo: Scala.

Plate 187 (Facing page) Orcagna, *Saint Thomas Aquinas*, detail of the Strozzi altarpiece (Plate 188). Photo: Scala.

far: near because his form is large, insistent, and linked with Thomas and Peter, more distant because the four kneeling angels, set away from the lower frame and much smaller in scale than the adjacent figures, press backward the mandorla that surrounds him. It is apparent that the qualities of Christ's form and of his exclusive space are partly incommensurate with those of the rest of the composition.[2]

For Meiss, then, this representation of Christ was both iconic and deliberately archaic. There was, moreover, a paradox in the way that the painter defined pictorial space – a perceptive observation when Christ's position in space is compared with that of the paired saints on the outer edges of the painting who – in terms of their poses – offer a greater sense of recession and depth.

Meiss also argued that Orcagna's iconic representation of Christ extended to his treatment of the outer figures on the altarpiece. The Baptist was 'a dour double of Christ … encased in a mantle that binds and limits his gesture'; the Virgin's tightly wound head-dress gave her 'an ascetic and monastic look'. In more general terms the figures had 'a sort of dense substantiality, a mass that is confined, repressed, and even denied by outlines that obstruct the implied turning of the planes'. Such impressions were further assisted, according to Meiss, by Orcagna's treatment of colour and pattern, whilst the tension in Orcagna's portrayal of space in the main register of the altarpiece applied equally to the three narrative scenes of the predella.[3]

For Meiss, therefore, the Strozzi altarpiece represented the example *par excellence* of a stylistic revolution that occurred within Florentine painting after the Black Death.[4] In his view, the post-plague generation of Florentine painters rejected, at least in part, many of the accomplishments and qualities of Giotto's artistic legacy which had dominated Florentine painting in the first half of the century. That legacy Meiss defined in terms of 'linear perspective … equilibrium … between form and space … supple figures moving freely in a measured, easily traversible, receptive world … an exalted and profoundly moral humanity'.[5] In addition, quite apart from such stylistic considerations, Meiss considered the Christocentric subject of the Strozzi altarpiece to be representative of a wider trend within post-plague Florentine painting. Throughout the rest of his book Meiss explored this artistic trend, characterizing it as a pronounced interest in iconographic themes which signified, on the one hand, a preoccupation with the supernatural and, on the other, an exaltation of God, the Church and the priesthood. Such art also conveyed to Meiss an impression of profound pessimism, renunciation of life, asceticism, penance, guilt and religious rapture.

Moreover, it was not only within mid fourteenth-century Florentine painting that Meiss discerned such a reaction. He also perceived an analogous development within the art of Siena where a later generation of – in his view – less gifted painters consciously rejected the achievements of Duccio, Simone Martini, and Pietro and Ambrogio Lorenzetti. One of his most striking examples of this particular aspect of Sienese painting was the comparison made between Ambrogio Lorenzetti's *Purification of the Virgin*[6] and Bartolo di Fredi's later treatment of the same subject (Plates 189, 190). Meiss's description of Bartolo's painting echoed his earlier analysis of

Orcagna's Strozzi altarpiece:

> [Bartolo] transformed Ambrogio's design … Ambrogio's deep space is curtailed, his system of perspective distorted. The inlaid floor that defined the recession and the position of the figures in space has been eliminated. The figures have been drawn into one or two shallow planes and knit tightly together by their more salient outlines and drapery folds … Whereas in Ambrogio's concentrated design the figures are united in contemplation of Anna's prophecy, Bartolo has created three separate competitive centers – around the child, the priest, and the prophetess Anna. Even within these centers, the figures are withdrawn from one another … at the same time he increased the importance of the altar, introducing a ceremony of inscription around it and *elevating the High Priest* to a position of dominance in the entire scene.[7]

Although Meiss's model of stylistic change had been anticipated in the work of other scholars of fourteenth-century Tuscan painting, his originality lay in his proposed identification of its causes.[8] Combining art-historical and broader cultural studies, Meiss examined the history of mid fourteenth-century Florence and Siena. He found evidence of bankruptcies, famine, war and, ultimately, the Black Death – a veritable sequence of economic and natural disasters which,

Plate 189 Ambrogio Lorenzetti, *The Purification of the Virgin*, 1342, tempera on panel, 257 x 168 cm, Uffizi, Florence, formerly altar of Saint Crescentius, Duomo, Siena. Photo: Alinari.

in his view, exercised a profound effect upon the minds of those who experienced them. It was this fundamental shift – and in particular its religious consequences – which, he maintained, explained the marked stylistic change he detected within the painting of Florence and Siena.

Meiss's book was enormously influential. Since its publication in 1951 it has provoked a wide range of reactions from historians and art historians alike. Two issues, however, have dominated the debate. First, could one substantiate Meiss's proposed stylistic shift between Tuscan painting produced before and after the Black Death? Secondly, if it could be substantiated, could such stylistic developments plausibly be related causally to specific historical events and circumstances? Much of the debate is highly detailed and complex. A number of significant modifications and qualifications of Meiss's original thesis have, however, emerged clearly.[9] Thus, for example, historians have questioned the accuracy of Meiss's portrayal of the Black Death in 1348 as the decisive moment of mid fourteenth-century crisis. Studies of Florence, Siena and Pistoia have shown that, though highly disruptive, the Black Death was followed by a period of political and economic recovery

Plate 190 Bartolo di Fredi, *The Purification of the Virgin, c.*1390–1409, tempera on panel, 180 x 125 cm, Louvre, Paris, probably originally for an altar in Sant'Agostino, San Gimignano. Photo: Réunion des Musées Nationaux Documentation Photographique.

during which social activities such as the dispensation of charity and the strengthening of familial ties were actually enhanced.[10] It has also been noted that the Black Death was not the only outbreak of plague to occur within the fourteenth century.[11] Throughout the last four decades of the century, Tuscany was periodically visited by outbreaks of pestilence (1362–63, 1373–74, 1375, 1383–84, 1389, 1390 and 1399–1400). Thus, the Florentine chronicler Matteo Villani could describe the plague of 1362–63 as 'the accustomed mortality'.[12] Moreover, the evidence of both Tuscan and Umbrian testamentary bequests suggests that, in terms of attitudes to death and post-mortem commemoration in art, it may well have been these later outbreaks of plague which affected religious behaviour more strikingly than the Black Death itself.[13]

Art historians, meanwhile, have re-examined the individual works of art upon which Meiss focused, and have argued that his analysis often insufficiently acknowledged the particular historical circumstances under which they were produced. Thus, for example, it has been argued that the Christocentric imagery of the Strozzi altarpiece (Plate 188) is particularly appropriate both to its Dominican setting and to its function as an altarpiece for the Strozzi family funerary chapel. Scholars have also argued that the formal characteristics of the painting are much more subtle and innovative than suggested by Meiss – a point to which we shall return.[14] Meiss's decisive watershed of 1348 has also been challenged. Certain key monuments that he dated to the post-plague period (such as *The Triumph of Death* in the Camposanto, Pisa) have now been convincingly dated to before the Black Death.[15] Indeed, Meiss's basic chronological scheme has itself been subjected to thoroughgoing revision. It has been suggested that the painting of fourteenth-century Florence embodies four stylistic phases, not just two – the first of which (beginning at the end of the 1320s and ending in the 1360s) effectively crosses the great divide of the Black Death.[16]

Finally, there also remains the question of the impact of the plague upon art produced elsewhere in fourteenth-century Italy. Thus, it is significant that in Padua, for example, there was apparently no stylistic disjunction in the religious art produced before and after the Black Death – despite the fact that the city suffered severely in 1348 and was subject to several later visitations of the plague.[17]

Subsequent historical research has thus suggested a number of limitations in Meiss's bold thesis concerning fourteenth-century Tuscan art. But what of his further proposal concerning the interrelationship between the religious art of the period and contemporary religious attitudes, mentalities and sensibilities? For Meiss, so close were the two phenomena that any change occurring in one would certainly be mirrored in the other. The remainder of this essay addresses this particular aspect of Meiss's argument.

RELIGION AND ART

From its early history onwards, the western Church had always been aware of the potential of imagery as a highly effective means by which the teachings of the Church could be communicated and made memorable. As early as the sixth

century Pope Gregory the Great had furnished the classic endorsement of this position – images were, he said, the bible of the illiterate. Christian churches were thus characteristically embellished with imagery in the form of sculpted portals, stained-glass windows, mosaics, frescoes, painted panels and metalwork. The churches of fourteenth-century Siena, Florence and Padua were certainly no exception. Moreover, this practice received further official approval from a decree issued in 1310 by a major council of the Church, which instructed that on or behind every church altar there should be an image (*imago*) in the form of a scriptural text, a sculpture or a painting. Such an image, in turn, should reflect the saints in whose honour the altar had been erected.[18]

Since such imagery characteristically portrayed *figures*, be they of God the Father, Christ, Mary or the saints, religious art was susceptible to the charge of encouraging idolatry – and thus specifically breaking the Second (or by some late medieval reckoning, the First) Commandment (Exodus 20:4–5). The standard rebuttal of this charge was elegantly framed by the great thirteenth-century Dominican scholar Saint Thomas Aquinas:

> There is a twofold movement of the mind toward an image: one toward the image as a thing itself, another toward the image insofar as it is a representation of something else … Thus, therefore, we must say that no reverence is shown to Christ's image as a thing, for instance, carved or painted wood … It follows therefore that reverence should be shown to it insofar only as it is an image.[19]

In practice, however, especially in lay devotion, this distinction between reverence towards an image and the worship of the person represented was not easily sustained. Thus, within late medieval Christianity it was, in fact, widely believed that the divine power attributed to the holy person portrayed could also reside in the image itself, which might accordingly work miracles or possess sensory attributes.[20] One particularly striking example of such belief occurred in the cult which surrounded a late thirteenth or early fourteenth-century panel painting of the Virgin and Child located in the parish church of Impruneta, six miles outside Florence (Plate 191). From the mid fourteenth century onwards, it was believed that this painting – popularly attributed to the hand of Saint Luke himself – was capable of performing miracles on behalf of Florence and its inhabitants. It did not, however, manifest its power within the parish church where it was kept. It did so only when it was brought in procession to Florence itself and made the object of civic and popular devotional ritual. The image was invoked in this manner primarily to alleviate adverse weather conditions, but also occasionally to combat the effects of the plague or to celebrate or ratify a particular course of political action.[21]

Two features of the cult of the Madonna of Impruneta emerge with great clarity from contemporary accounts of these supplicatory events. First, the painting – an inanimate material object – was treated like a revered person, bedecked in vestments and afforded ritual respect. There was thus a blurring between the honour accorded to the holy persons represented within the painting and the painting itself. We have compelling evidence of other examples of fourteenth-century painted and sculpted images being honoured in this way. Thus, in 1348 a woman from the Pisan *contado* offered

'to the image of Our Lady who is in the Duomo of the city of Pisa' a roll of cotton cloth, a gold ring and 60 silver buttons. Similarly, in 1362 a widow from Pontedera living in Pisa likewise offered 'her best underwear and a cloak to Our Lady' in the same church.[22] Secondly, the spiritual power attributed to a painting, or any other sacred object such as the consecrated communion wafer or a relic of a saint, was sustained and its reputation nurtured by suitable demonstrations of religious devotion. Such devotion might take the form of making the object the focus of prayer, carrying it in procession, or singing *laude* before it. Giovanni Villani's early fourteenth-century account of the spontaneous religious cult which arose at Orsanmichele around the painting of the Virgin and Child offers an example of how effectively such a reciprocal relationship might work:

> In that year [1292], on the 3rd of July, there began to be manifested great and obvious miracles in the city of Florence by a figure [*figura*] of the Virgin Mary painted on a pilaster of the loggia of Orto San Michele, where the grain is sold … out of custom and devotion, a number of laity sang laude before this figure, and the fame of these miracles, for the merits of Our Lady, so increased that people came from all over Tuscany in pilgrimage.[23]

This particular aspect of image veneration was undoubtedly itself fuelled by two broader aspects of late medieval religious

Plate 191 *Madonna of Impruneta*, late thirteenth to early fourteenth-century panel painting, heavily repainted in subsequent centuries, Santa Maria Impruneta, Impruneta. Photo: Alinari.

life. First, it corresponded to the increasingly assertive role that the laity took within religion. No longer content merely to leave the salvation of their souls to the clergy who undertook religious rites on their behalf, they now wanted to take a more active and participatory role. Moreover, the particular kind of religious belief espoused by the laity was primarily neither liturgical nor contemplative but, rather, centred on personal devotion.[24] In other words, the laity tended to practise their religion 'by saying their prayers, going on pilgrimage, fasting, participating in processions, joining in the activities of confraternities, wearing hairshirts, giving alms, attending sermons, and performing other pious acts'.[25] In this respect, the influence of the mendicant orders on religious practice was paramount. Thus, both the Franciscans and the Dominicans as well as the Servites and the Humiliati actively encouraged such demonstrations of piety among the laity. For example, in a sermon preached in November 1305, the celebrated Dominican preacher Fra Giordano da Pisa exhorted Florentines to:

> Make use of confession, make use of communion, make use of the church, make use of Masses, keep good company, make use of prayers, make use of the sermons … and especially read good little books, and other such things.[26]

Such exhortations were the common fare of the enormously influential preaching of the mendicant orders which, particularly during Lent, drew large audiences in all major Italian cities including Siena, Florence and Padua.

The second aspect of late medieval religious life reflected in the veneration of images was the role of saints as intercessors. As indicated by Giovanni Villani's description of the cult of the Virgin of Orsanmichele, there was a strong sense of reciprocity between, on the one hand, the spiritual power of the image itself and, on the other, the religious commitment and fervour of the image's devotees. Such reciprocity arose from the very fact of belief in the intercession of saints. Thus, a person would pray to a saint to intercede with God on her or his behalf. In exchange, the petitioner would promise to perform certain pious acts. As we have seen in Chapter 8, patronage and clientage were important features of fourteenth-century Italian civic society. In a similar way, a saint might well be seen as an archetypal patron receiving from devotees – or 'clients' – petitions for favours to be granted. If the saint responded to such a petition, the devotee would then feel obliged to perform a service in return – in the form of one or other kind of religious devotion. What is striking about such an arrangement, however, is that it constitutes an interplay of relationships and obligations which were formally similar to the world of personal and commercial transactions most fourteenth-century Sienese, Florentines and Paduans habitually negotiated.[27]

How, then, did these broader aspects of fourteenth-century religious life affect art? In the first instance, devotionalism was both assisted by and often focused upon material objects such as relics and works of art. One of the most striking examples of this phenomenon was the active use of religious art by fourteenth-century lay confraternities. Such confraternities were broadly of two kinds – the Laudesi companies and the flagellants or Disciplinati. The Laudesi exhibited many characteristic aspects of late medieval devotionalism. Thus, on the main feast days of the liturgical calendar and the feast day of the confraternity's patron saint, these companies participated in carefully staged religious ceremonies in which the confraternity members carrying lighted candles walked in procession through the particular local church with which they were associated. Similarly, they held such a procession on one Sunday of every month. In addition, quite apart from such regular manifestations of religious observance and ceremony, the confraternities also performed funeral rituals and attended commemorative masses on behalf of their deceased members. Finally, they gathered daily to practise religious devotions which involved praying together, reciting or singing *laude*, hearing a sermon, making their confession and receiving absolution.[28] Whereas the Laudesi were defined by their commitment to the communal singing of *laude*, the Disciplinati were characterized primarily by their practice of penitential flagellation. Like the Laudesi, however, the Disciplinati also made a point of staging public processions as an act of corporate piety.

Crucially for our present purposes, such devotional activities were enhanced by a variety of cult objects and religious artefacts. When staging processions either in the city streets or churches, confraternities characteristically carried *stendardi* – banners often painted with either the insignia of the confraternity or the particular saint to whom it was devoted. Thus, in a fourteenth-century miniature of a flagellant confraternity in procession, the leading figure is shown carrying a *stendardo* depicting the Flagellation of Christ (Plate 192). Similarly, most Sienese, Florentine and Paduan confraternities also commissioned other kinds of art as an aid and focus for their collective devotions. Since most confraternities were attached to one or other of their cities' churches, their religious devotions often centred on altars under their patronage. Such altars were frequently adorned with painted or sculpted images.

The most celebrated example of such a confraternity image to survive is Duccio's *Rucellai Madonna* (Chapter 3, Plate 55), which once belonged to the Laudesi Compagnia di Santa Maria Vergine, later known as the Compagnia di San Pietro Martire.[29] The records of other Florentine confraternities similarly reveal that they too owned devotional images. Thus, during the fourteenth century the Confraternity of Saint Zenobius, based within Florence Duomo, owned at least six paintings, three of which depicted the Virgin.[30] Siena and Padua also had numerous confraternities active in the patronage of art. In 1396 the Confraternity of Saint Anthony of Padua, which met in the Santo, commissioned a sculpture of the Virgin. This survives today over the altar of the Chapel of Mater Domini.[31] Four years later in Siena, Taddeo di Bartolo painted a triptych of *The Virgin and Child with Saints* for the Compagnia di Santa Caterina della notte, which met in the hospital of Santa Maria della Scala.[32] Quite apart from such paintings and sculptures, confraternity records reveal that they also commissioned a variety of other artefacts such as crucifixes, candle-holders, chests and benches, religious textiles and finely decorated books of music – of which the surviving laudario of the Florentine Compagnia di Santo Spirito, based in the Augustinian church of that name, is a particularly fine example (Plate 193).[33]

How, then, might such works of art have assisted the pursuit of a confraternity's collective religious devotions? To take again the *Rucellai Madonna*, the painting's very subject expresses in visual form the holy person in whose honour the confraternity was founded (Chapter 3, Plate 55). In other words, the painting would have acted as a powerful reinforcement of the very Marian devotion to which the Laudesi – as one of the principal guardians of the cult of the Virgin in Florence – were particularly dedicated. Indeed, this representation of Mary presented a concrete visual equivalent of the same celebratory imagery utilized in the sung devotions of the *laude* themselves.[34] Meanwhile, the subsidiary figures of saints depicted in the frame represented further spiritual advocates whose very position *between* the spectator and the painted representation of the Virgin and her Son underlined their intercessionary role. This, in turn, paralleled the devotional practice of the Laudesi. Just as the surviving statutes of the confraternities characteristically open with an invocation of saints – ranging from the major saints to the very local and particular saints towards whom the confraternity felt a special reverence – so the painted frame of this huge panel provided a representation in miniature of the chain of relationships which the Laudesi cultivated between themselves and the community of heaven.

Quite apart from the painting's subject-matter so effectively complementing the religious devotions of the confraternity, it was also undoubtedly the case that Duccio's artistic skills contributed to the religious efficacy of the image. It can legitimately be argued that the original material splendour of the painting, with its extensive use of gold leaf and rich pigments combined with its intrinsic aesthetic qualities, was once perceived as enhancing the painting's spiritual power and potential.[35] Indeed, it was generally acknowledged that artists – and particularly painters – could, by their skills in representation, provide religious imagery of a highly effective and emotive kind. Painters, it has been observed, were professional visualizers of holy stories who could rely on their public being 'practised in spiritual exercises that demanded a high level of visualization'.[36] This point is amply supported by contemporary religious texts such as the popular late thirteenth-century Italian *Meditations on the Life of Christ*. In this text, the author – a Franciscan friar from Tuscany – discusses the event of the Nativity and directly addresses the reader in the following way:

> You too, who lingered so long, kneel and adore your Lord God, and then His mother, and reverently greet the saintly old Joseph. Kiss the beautiful little feet of the infant Jesus who lies in the manger and beg His mother to offer to let you hold Him a while. Pick Him up and hold Him in your arms. Gaze on His face with devotion and reverently kiss Him and delight in Him.[37]

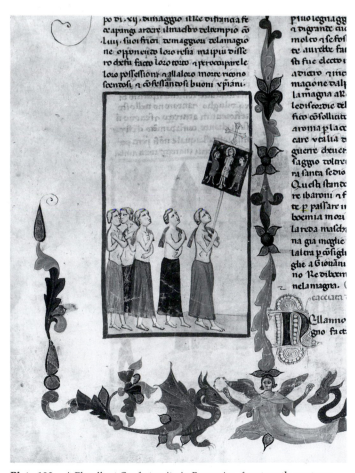

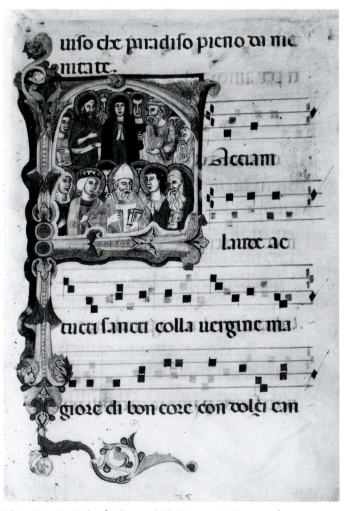

Plate 192 *A Flagellant Confraternity in Procession*, fourteenth-century copy of Giovanni Villani's *Cronica*, Biblioteca Apostolica Vaticana, Vatican City, Cod. L.V., III. 296, folio 197 verso.

Plate 193 *Lauda* for the Feast of All Saints, early fourteenth-century laudario of the Compagnia di Santo Spirito, Florence, Biblioteca Nazionale, Banco Rari, 18, folio 133 recto.

The concrete sensuous imagery to which the author of the *Meditations* resorts in this passage finds a ready counterpart in the increasingly naturalistic portrayals of the Christ Child in fourteenth-century Italian art (Plate 194). Indeed, another fourteenth-century Tuscan Franciscan, describing the process of religious meditation, drew an explicit parallel between an unfolding sequence of devotional experiences and the successive stages in the completion of a painting:

> The first time the mind begins to think of Christ … Christ appears in the mind and the imagination as if written. The second [time] He seems to be outlined. In the third, He seems to be outlined and shaded. In the fourth, He seems painted and individuated. In the fifth, He seems individuated and modelled.[38]

We have described a number of aspects of fourteenth-century religious life which affected the religious art of the period. These factors were, however, *constant*: in every decade of the century, examples may be found of art which fulfilled the kinds of devotional requirements outlined above. By contrast, what evidence is there of a marked *change* in both the form and content of religious art during the fourteenth century? And can any such changes be linked convincingly to shifts in religious attitudes caused by the traumatic effects of the Black Death and subsequent outbreaks of the plague? The remaining sections of this essay will explore these questions by reference to three examples of religious art produced in the latter half of the century.

THE STROZZI ALTARPIECE

We may begin, appropriately, with the Strozzi altarpiece – in Meiss's view a prime example of the changes in religious art prompted by the Black Death (Plate 188). What were the precise historical conditions under which this altarpiece was produced? The altarpiece for the Strozzi family chapel in the Dominican church of Santa Maria Novella was completed in 1357 by the painter-sculptor Andrea di Cione, better known as Orcagna. The altarpiece, therefore, was designed as the focal point of a family funerary chapel in which were buried members of one of Florence's leading families. It was not, however, the only painted embellishment in the chapel. At the same time as the altarpiece was executed, the walls were painted with murals of *Christ in Judgement*, *Paradise* and *Hell*. The vault and inner surface of the entrance arch, meanwhile, were embellished with four images of Saint Thomas Aquinas, accompanied by two virtues and the four Doctors of the Church: Jerome, Augustine, Gregory and Ambrose. The three principal murals were probably painted by Orcagna's brother, Nardo di Cione, and those on the vault and entrance arch by Giovanni del Biondo, a Florentine painter who, at the time of this commission, may well have been working as a fully trained member of the Cione family workshop.

The context of a familial funerary chapel undoubtedly affected the choice of subject for the altarpiece itself. Thus, it has plausibly been argued that the inclusion of the Archangel Michael provides a link between the altarpiece and the themes of divine judgement and salvation encapsulated in the chapel's mural paintings.[39] Such religious themes were highly appropriate for a funerary chapel. Similarly, the inclusion in

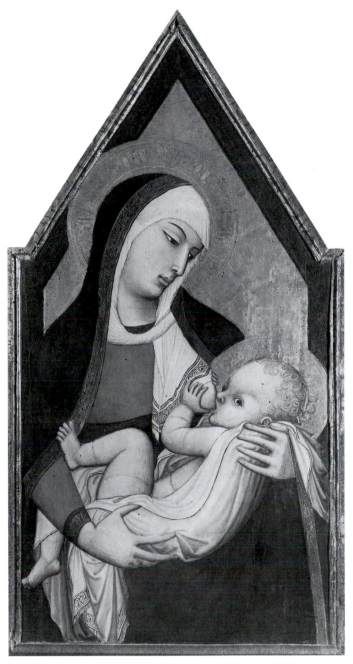

Plate 194 Ambrogio Lorenzetti, *Madonna del Latte*, mid 1320s, tempera on panel, 90 x 48 cm, Palazzo Arcivescovile, Siena. Photo: Lensini.

the predella of the relatively unusual subject of *Saint Lawrence Saving the Soul of Henry II of Germany* – a saintly intervention prompted by the king's gift of a chalice to the church – may well reflect the desire of the commissioner of the altarpiece to allude to his own act of beneficence.[40]

As well as registering its function within a family funerary chapel, the subject-matter of the altarpiece was designed to complement its Dominican setting. Thomas Aquinas (the order's greatest teacher and theologian) is accorded a prominent role, kneeling in the foreground to the left of Christ and receiving a book from him (Plate 187). The saint's status is further emphasized by his close association with the Virgin – the titular saint of the church of Santa Maria Novella. The first scene of the predella is directly related to his cult – that of

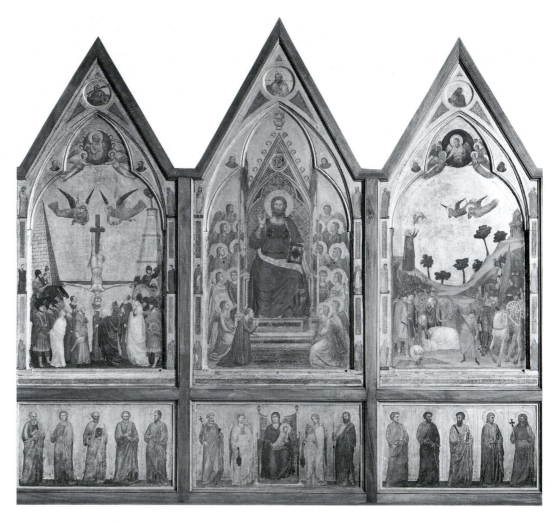

Plate 195 Associate of Giotto, *Christ Enthroned with Cardinal Giacomo Stefaneschi and the Martyrdoms of Saints Peter and Paul*, late 1320s–early 1330s, tempera on panel, 220 x 245 cm, Museo Vaticano, Vatican City, front face of double-sided altarpiece formerly over the high altar of Saint Peter's, Rome. Photo: Monumenti Musei e Gallerie Pontificie Archivio Fotografico.

Saint Thomas Aquinas Moved to Spiritual Ecstasy during the Elevation of the Host at Mass. The prominence of Thomas Aquinas within the altarpiece is all the more significant because of his relatively recent canonization in 1323. Although Dominican communities had already commissioned representations of Aquinas, his striking position within the Strozzi altarpiece is nevertheless worthy of note. His presence may be accounted for by the fact that, by the 1350s, the chapel itself was probably already dedicated to Saint Thomas Aquinas and that the commissioner of the altarpiece was named Tomaso di Rossello Strozzi. The saint was therefore probably included not only as the titular saint of the chapel, but also as Tomaso Strozzi's name saint.[41]

As Meiss himself noted, the subject of the Strozzi altarpiece is also rendered distinctive by the intensity of its focus upon Christ. Indeed, for Meiss, this emphasis upon Christ was indicative of a self-conscious return to the concerns of thirteenth-century religious art. In point of fact, however, there was an important early fourteenth-century Giottesque precedent for such Christocentric imagery on the front face of the double-sided high altarpiece for Saint Peter's in Rome – a work which, if not by Giotto himself, was certainly the product of one of his close associates (Plate 195).[42] Orcagna himself, or members of the Dominican Order then resident in Florence who had previously been in Rome, may have been aware of this iconographic precedent. It is also possible, moreover, that the Dominicans of Santa Maria Novella would

have regarded it as additionally prestigious to secure an altarpiece which emulated the high altar of Saint Peter's.

Despite the common focus on Christ in both altarpieces, the actual representation of Christ is significantly different, however. The earlier altarpiece depicts Christ seated upon a throne with the donor – Cardinal Stefaneschi – kneeling as a supplicant before him. On the Strozzi altarpiece, meanwhile, Christ is shown, through the device of the mandorla, as a heavenly apparition (Plate 188). In addition, he is portrayed giving a set of keys to Saint Peter and an open book to Saint Thomas Aquinas. The subject of Christ giving Peter the keys of the Church is derived from the gospel account of Christ awarding Peter authority in the Church and, indeed, the 'keys to the kingdom of heaven' (Matthew 16:18–19). This biblical passage had tremendous significance for the medieval popes – believed to be the successors of Peter himself – since it offered an unequivocal validation of the papacy's claim to a unique spiritual role. Artists accordingly evolved a powerful pictorial iconography to express such papal ideology, portraying Christ in a mandorla (symbolizing his divinity) and in the act of handing to Peter the keys of the Church. As exemplified by the thirteenth-century high altar ciborium in Sant'Ambrogio, Milan, this iconography was further elaborated to include Saint Paul (another saint whose cult was closely associated with Rome and the papacy) receiving a scroll or book as a symbol of divine approbation of the doctrinal teaching of the Church (Plate 196). Within the

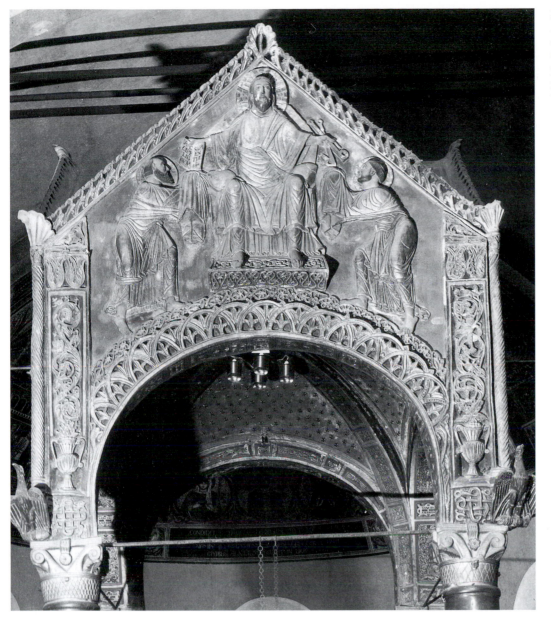

Plate 196 *Christ Presenting the Keys to Saint Peter and the Book to Saint Paul*, early thirteenth-century sculpted relief, high altar ciborium, Sant'Ambrogio, Milan. Photograph courtesy of Basilica di Sant'Ambrogio.

Strozzi altarpiece, however, this orthodox, pro-papal iconography was decisively reworked in order that Saint Thomas Aquinas be represented – by the gift of the book from Christ – as the recipient of divine knowledge and the guardian of Church doctrine. Paul, meanwhile, was relegated to a subsidiary position within the figural composition (Plates 188, 197).

Although both the Dominicans of Santa Maria Novella and Orcagna himself were undoubtedly aware of earlier precedents for this prestigious subject, it seems unlikely that they were motivated merely by a wish to imitate and adopt earlier pictorial conventions in order to express a distinctively conservative spiritual outlook. A more likely account is that they wished to have this subject and its associations with papal authority reworked in a form that reflected well upon the Dominican Order.[43] In other words, one of Orcagna's achievements was that he furnished the Dominicans of Santa Maria Novella with a powerful pictorial iconography which made a bold claim for the status and importance of one of their more recently canonized saints. It remains a matter of

debate whether such a reworking was a result of Dominican support for the papacy or, rather, a Dominican claim of comparable status as guardians of the temporal and spiritual authority of the Church.[44]

Meiss's analysis of the Strozzi altarpiece, however, was not confined merely to its allegedly conservative subject-matter and iconography. Meiss also addressed the very style in which the painting was executed. To recapitulate briefly: in his view Orcagna's treatment of the principal figures on the altarpiece was characterized by, in the case of Christ, the figure's frontality (Plate 188) and, in the case of the other figures, a tension between, on the one hand, an illusion of solidity and, on the other, strongly stated outline (Plate 197). Furthermore, all these figures were located within a spatial context giving an impression of flatness, not depth.

In some respects Meiss's observations of the painting are perceptive. The gold background does indeed discourage a sense of spatial depth. Similarly, the pattern of the carpet on the ground is not foreshortened in any way. The illusion of the three-dimensional forms of the figures – conveyed by

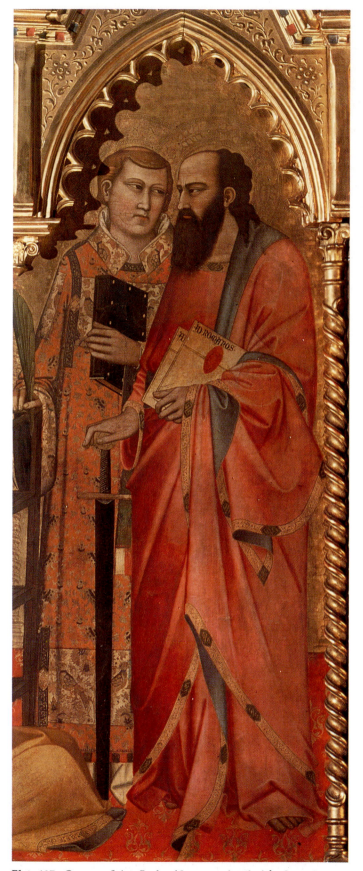

Plate 197 Orcagna, *Saints Paul and Lawrence*, detail of the Strozzi altarpiece (Plate 188). Photo: Scala.

strongly differentiated modelling – is counterbalanced by their emphatic contours and the distribution of bright, unsaturated colours throughout their draperies, regardless of any one figure's position within the implied spatial setting.

The Strozzi altarpiece, in point of fact, encapsulates an ongoing tension within fourteenth-century religious art. Artists sought to convey a sense of mystery and awe whilst, at the same time, encouraging empathy and close involvement with the holy men and women represented. Orcagna's treatment of Christ encourages the former impression. Christ appears as a divine vision removed from this world in terms of space and time. The frontality and the abstract device of the mandorla cutting the frame contribute to this effect. By contrast, the treatment of the drapery, with its deep folds suggestive of the volume of the figure beneath, and the insistent modelling of such details as Christ's head offer a sense of this holy figure being a palpable and 'real' presence. Similar considerations inform the treatment of the subsidiary saints. In this respect, Orcagna – as the painter – appears to have worked in relief rather like a sculptor releasing the volume of his figures from the surface of the stone.[45]

Such tensions are also implied by the different viewpoints presented in the central predella scene and its counterparts. In the central scene of *The Navicella* the viewpoint above the scene affords a highly privileged sight of the events portrayed (Plate 198). However, the other two scenes, seen as if from a low vantage point, are more akin to our normal experience of viewing (Plate 188).[46]

Furthermore, any adequate analysis of Orcagna's treatment of pictorial space must acknowledge the presence of architectural details tooled onto the surface of the gold leaf of the panel. When viewed in conjunction with the handsome architectonic frame,[47] these contribute decisively to the illusion of space intended by the painter. Between the main groupings of the holy figures – and corresponding to the springing points of the five cusped arches of the frame – appear five spiral columns (each with an ornamental capital and moulded base). Each has been delicately incised onto the surface of the gold leaf. Close examination of the outermost right-hand edge of the main panel of the altarpiece reveals that the profile of the incised column and its capital faithfully follows the design of the inner column of the frame (Plate 197). It has been observed that, despite the close association of the capitals of the tooled columns with the four gilded wooden corbels of the upper frame, the former should not be seen as supporting the latter. Rather, the incised columns should be read as a continuous arcade of cusped arches (delicately incised around the profile of the arches of the upper frame) running the entire width of the painting and as if behind the holy figures. The corbels of the frame, meanwhile, were intended to be read as the terminal points on a series of free-hanging canopies or baldachins similar to those constructed over contemporary tomb sculptures (Plate 199).[48] The treatment of pictorial space conceived within this imposing architectonic framework would thus have been both subtle and highly sophisticated. Moreover, the strong similarities between the design of the altarpiece and that of an altar baldachin – an architectural monument specifically designed as an imposing ceremonial setting for liturgical ritual and the housing of prized relics – would have

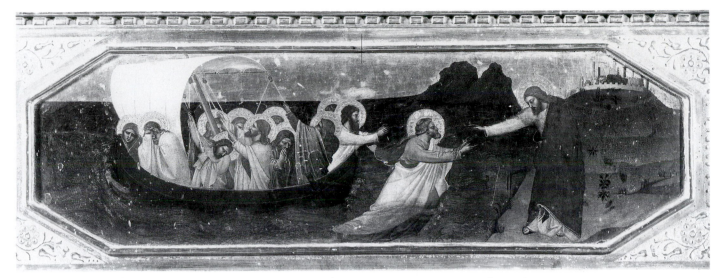

Plate 198 Orcagna, *The Navicella*, central predella panel, detail of the Strozzi altarpiece (Plate 188). Photo: Alinari-Brogi.

decisively enhanced and emphasized the impact and significance of the Strozzi altarpiece as a religious work of art.

In short, our analysis of this striking example of religious art produced within a decade after the Black Death reveals elements of both continuity and change. In terms of its design and execution, it represents a highly sophisticated work of art which arguably vies with any work of comparable scale produced in the half century before the occurrence of the Black Death. At the same time, however, it also provides evidence of a painter deploying techniques favoured by artists of his own post-plague generation and different from those deployed by Giotto and his close contemporaries. Some of the

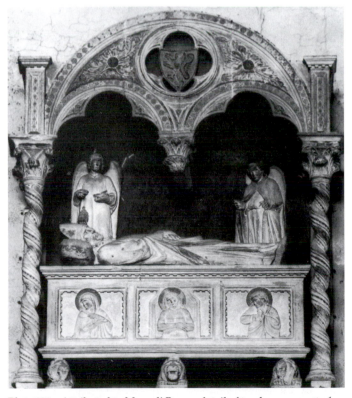

Plate 199 Attributed to Maso di Banco, detail of tomb monument of Tedice Aliotti, 1336–40, Santa Maria Novella, Florence. Photograph reproduced by permission of the Conway Library, Courtauld Institute.

techniques and modes of representation favoured by Orcagna appear to be intimately linked with his experience of working on architectonic and sculptural monuments such as the Orsanmichele tabernacle (Chapter 7, Plate 157). It is this, rather than some traumatic reaction to the impact of the Black Death, which may most plausibly explain Orcagna's stylistic treatment of his theme. In terms of its iconography, meanwhile, the Strozzi altarpiece is indeed indicative of a painter and his patrons resorting to an ancient and revered religious iconography. Yet even here there is evidence of Orcagna imaginatively re-interpreting an established iconography in order to serve the particular and contemporary requirements of both the Strozzi family and the Dominican Order in the years of the painting's execution.

TWO PLAGUE IMAGES

In his analysis of post-plague art, Meiss remarked not only upon the phenomenon of painters reverting to time-honoured themes, but also upon their introduction of new religious subject-matter whose iconography directly related to the plague itself and its devastating effect upon humanity. Two examples of later fourteenth-century painting, commissioned respectively for the Duomos of Padua and Florence, exhibit iconographies which allude very directly to the plague, and may thus be used to test this aspect of Meiss's thesis.

In 1367 the Venetian Nicoletto Semitecolo signed and dated a series of painted panels which, in all probability, formed a reliquary cupboard that stood upon the altar of Saints Sebastian and Fabianus in Padua Duomo.[49] In the fourteenth century Saint Sebastian and his companion Fabianus were standardly invoked as protectors against the plague. Sebastian, it was thought, was a particularly suitable saint for this purpose because of the manner of his persecution and his survival from it. A third-century commander of the special bodyguard of the Roman emperors, he was condemned for his Christian faith and shot repeatedly with arrows, the wounds he thus received acting as a powerful symbol of the effects of the plague.[50] It seems likely, therefore, that this commission for a painted reliquary had some connection with Padua's second outbreak of plague in 1362.

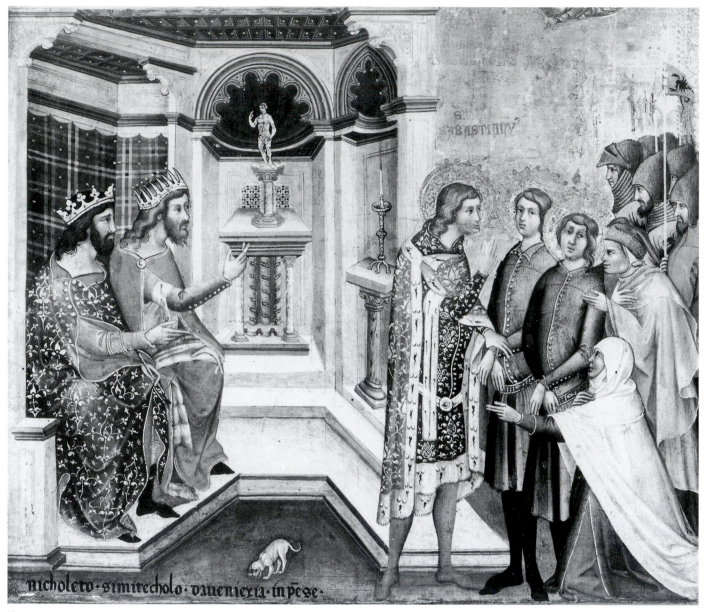

Plate 200 Nicoletto Semitecolo, *Saint Sebastian before the Emperors Diocletian and Maximian*, 1367, tempera on panel, 65 x 72 cm, Sacristy of the Canons, Duomo, Padua. Photo: Barbara Piovan.

Modern reconstruction of this panelled cupboard suggests that, when closed, it would once have comprised three pairs of paintings displayed one above the other (Plate 201).[51] At the top would have appeared two iconic representations of the Trinity and of the Virgin and Child (with the Virgin portrayed seated on the ground and suckling the Child, thus corresponding to a particular type of popular image known as the Madonna of Humility). The middle and lower tier contained four narrative scenes from the legend of Saint Sebastian. The first of the four narrative paintings represents Sebastian, dressed in the elegant garb of a fourteenth-century courtier, urging two fellow Romans, Mark and Marcellinus, not to renounce their faith (Plate 200). In the foreground Zoe, the wife of the saint's jailor, is shown kneeling before Sebastian and stretching out her arm in order to testify to her miraculous cure by the saint. Her recently converted husband Nicostratus stands behind her at the head of a group of soldiers. To the left of this group are two enthroned figures

who probably represent the twin Emperors Diocletian and Maximian. The inclusion in the background of a niche containing an altar upon which stands a nude pagan idol on a column alludes to a later moment in the hagiography of Saint Sebastian when he is ordered to worship pagan idols on pain of death. The fact that the saint is shown with his back to the two rulers also hints at Sebastian's refusal to comply with this order.

The other three panels show, variously, the tortures to which Sebastian was subjected before finally being killed and the circumstances of his burial. The right-hand central scene depicts the well-known iconography of Sebastian tied naked to a stake and pierced by over a dozen arrows (Plate 202). The two lower scenes depict, first, Sebastian being clubbed to death and his body thrown into a Roman sewer and, secondly, the saint's burial near the tombs of Saints Peter and Paul.

Meanwhile, on the back of the panel of *Sebastian before*

Plate 201 Reconstruction of the reliquary cupboard over the altar of Saints Sebastian and Fabianus when closed, Duomo, Padua. Reproduced by courtesy of Musei Civici Padova, Gabinetto Fotografico and Barbara Piovan.

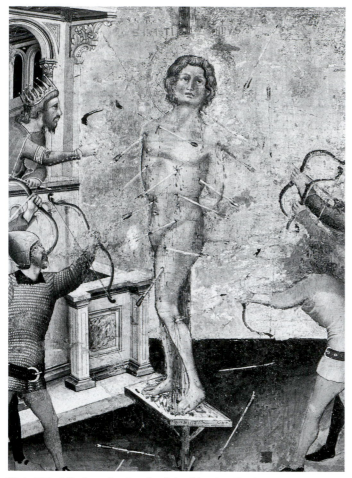

Plate 202 Nicoletto Semitecolo, *Saint Sebastian Shot by Arrows*, 1367, tempera on panel, 64 x 69 cm, Duomo, Padua. Reproduced by courtesy of Musei Civici Padova, Gabinetto Fotografico.

1361, in honour of a relic of Saint Sebastian which he brought back from Rome and presented to the cathedral.[53] This altarpiece no longer survives intact. A second altarpiece in honour of Saint Sebastian survives, however, in a more complete form. Painted by the Florentine Giovanni del Biondo and dated (on style grounds) to the 1370s, it combines elements from two distinct but traditional altarpiece types, namely the triptych and that of a central iconic image of a saint surrounded by scenes from his or her legend (Plates 205, 206; cf. Chapter 1, Plate 2). Here, however, the customary central iconic image is replaced by a narrative scene of Sebastian being shot by arrows (Plate 205). The treatment of this narrative scene is, nevertheless, carefully organized to make the arrow-ridden body of the saint strikingly visible, as befitted the centrepiece of a painting destined for an altar dedicated to Saint Sebastian and perhaps also containing a relic of this early Christian martyr.

The narrative sequence begins in the middle panel of the left-hand wing with a depiction of Saint Sebastian preaching, possibly with Zoe and Nicostratus among his audience (Plate 206). It then continues in the main central panel with its large-scale depiction of the saint being shot with arrows (Plate 205). The third scene, which occurs in the middle of the right-hand wing, portrays Sebastian's death by clubbing (Plate 206). The fourth scene, in the lower part of the right-hand wing, shows both the apparition of the saint to the Roman matron Lucina (when he informs her of the location of

Diocletian and Maximian, there appears a representation of the saint himself portrayed as a three-quarter-length figure (Plate 203). On the back of *Sebastian Shot by Arrows*, there was once a representation of the early Christian martyr Saint Daniel holding a model of Padua.[52] On both of these paintings there are also the remains of a substantially effaced representation of a third, female saint who has plausibly been identified as another of Padua's patron saints, Justina. It has been argued that the two central panels of the reliquary cupboard would originally have been hinged at their bases, so that on feast days they could be opened downwards to display the relics of the martyrs (Sebastian, Daniel and Justina) within the reliquary (Plate 204). On such occasions the highly descriptive narrative scenes of Sebastian's legend would no longer have been on view. Rather, the relics would have been displayed within the context of a sequence of primarily figural, iconic images of the Trinity, the Madonna of Humility and the saints whose relics were revealed.

At approximately the same time as the 1367 commission for the painted reliquary cupboard in Padua Duomo, Sebastian was adopted as the titular saint of several altars in the newly rebuilt Duomo of Florence. The new altars were duly embellished with altarpieces. The first of these, which probably once represented an enthroned Virgin and Child with Saint Sebastian to their right, was commissioned by Filippo dell'Antella, Bishop of Florence from around 1353 to

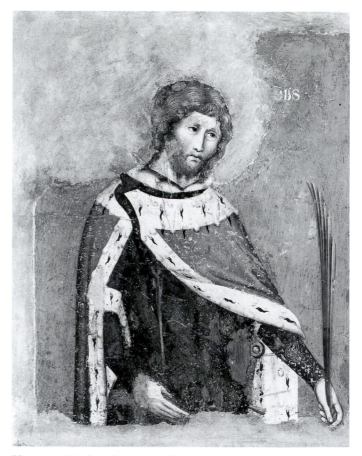

Plate 203 Nicoletto Semitecolo, *Saint Sebastian*, reverse of *Saint Sebastian before the Emperors Diocletian and Maximian* (Plate 200). Reproduced by courtesy of Musei Civici Padova, Gabinetto Fotografico.

Plate 204 Reconstruction of the reliquary cupboard over the altar of Saints Sebastian and Fabianus when open, Duomo, Padua. Reproduced by courtesy of Musei Civici Padova, Gabinetto Fotografico.

Plate 205 Giovanni del Biondo, *Saint Sebastian Shot by Arrows*, 1370s, tempera on panel, 224 x 89 cm, Museo dell'Opera del Duomo, Florence, centrepiece of a triptych formerly in the Duomo. Photo: Alinari-Brogi.

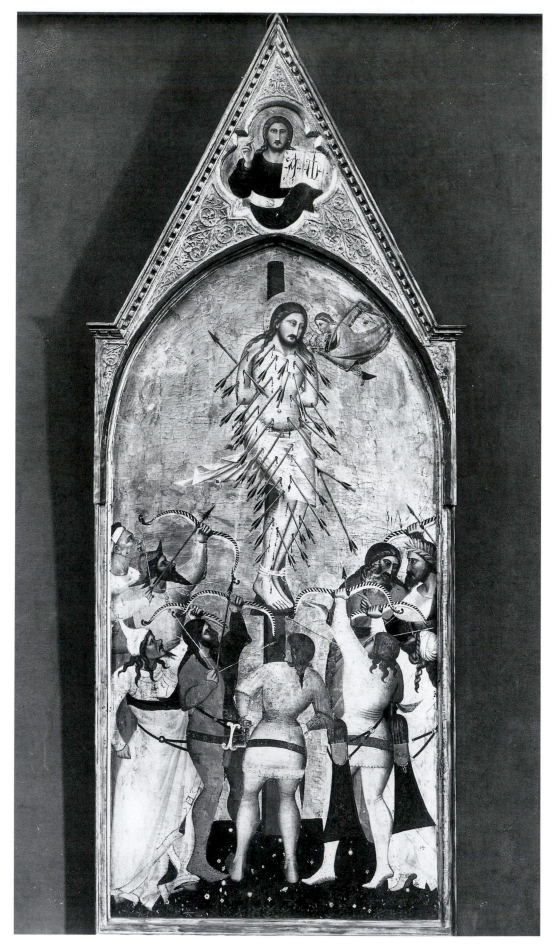

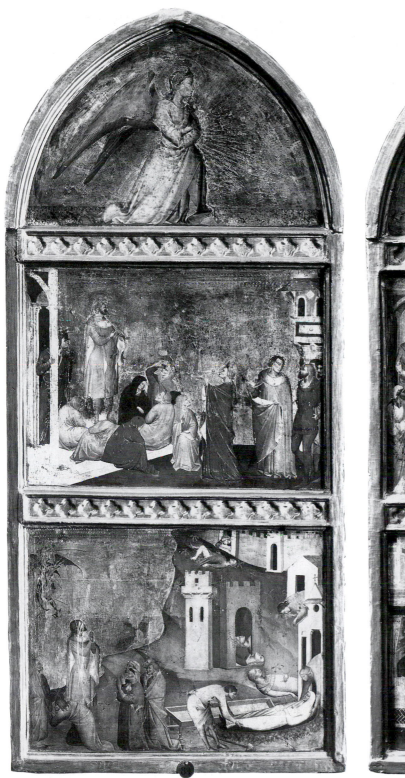

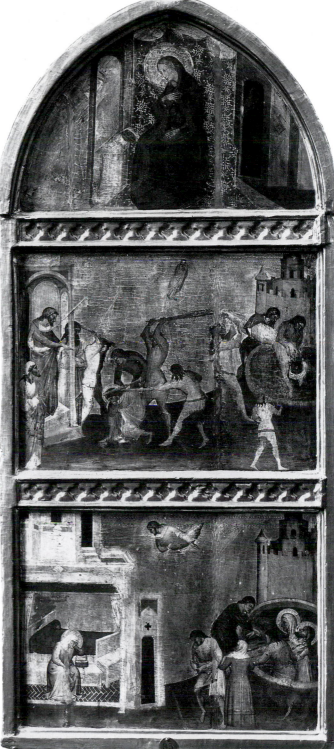

Plate 206 Giovanni del Biondo, *Scenes from the Life of Saint Sebastian*, 1370s, tempera on panel, each wing 149 x 67 cm, Museo dell'Opera del Duomo, Florence, wings of a triptych formerly in the Duomo. Photo: Alinari-Brogi.

his body) and her retrieval of his body from a Roman sewer. The final narrative scene occurs in the lower part of the left-hand wing, and shows the inhabitants of a town petitioning the saint to intercede with God to relieve the town from the plague. This painted scene offers a particularly graphic portrayal of the devastating effects of the plague upon a contemporary town. The town is represented on the right, deserted except for those who are either dead or dying. In the

foreground two grave-diggers lift a corpse onto a bier (Plate 207). Given the specificity of the detail of this image of the plague, it is probably correct that this altarpiece commission was closely related to the outbreak of plague in Florence in 1376.[54]

For Meiss the portrayal of Sebastian on the central panel of Giovanni del Biondo's altarpiece is another compelling piece of evidence for the spiritual crisis undergone by fourteenth-

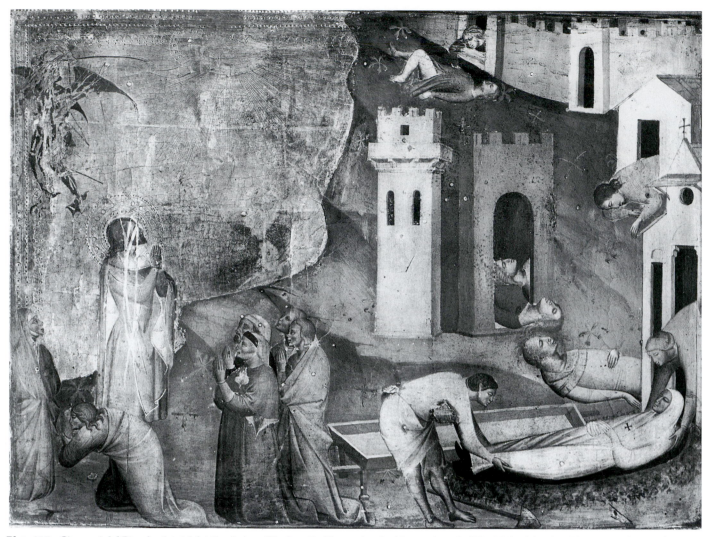

Plate 207 Giovanni del Biondo, *Saint Sebastian Saves a City from the Plague*, detail of *Scenes from the Life of Saint Sebastian* (Plate 206). Photo: Alinari-Brogi.

century Tuscan society in the post-plague era. He comments that Sebastian 'is a relentlessly tortured figure, blood dripping from more than thirty wounds'.[55] Yet Giovanni del Biondo's representation of the saint pierced by numerous arrows corresponds well with the description given in Jacobus de Voragine's much earlier, pre-plague text, *The Golden Legend*, where the tortured saint is described as resembling a hedgehog.[56] Moreover, as has plausibly been suggested, the emergence of such 'plague' imagery suggests not merely the reaction of a fearful, paralysed populace, but also a positive attempt to engage with a frightening situation and turn it to good effect.[57] Fourteenth-century society, already well accustomed to petitioning saints to intercede on its behalf in times of crisis, naturally resorted to such intercessionary practice when faced with the truly horrifying catastrophe of the pandemic of 1348 and its subsequent occurrences. Clearly, religious art functioned as a powerful vehicle for effecting such processes of negotiation between an allegedly angry deity and a fearful and horror-stricken population. Indeed, the inclusion of an angel putting a demon to flight in the scene of Saint Sebastian saving a city from the plague is symptomatic of a certain confidence that such invocations would be effective (Plate 207).

A comparison between these two composite portrayals of Saint Sebastian – produced within approximately ten years of one another – is both revealing and informative. Both represent the result of commissions for the embellishment of the cathedrals of their respective cities, and thus enjoyed highly prestigious locations within the ecclesiastical life of Padua and Florence. Both commemorate and celebrate the cult of the plague saint, Sebastian, and both may have been associated with thaumaturgic relics of that saint. And yet they are strikingly different in terms of both their style and their iconography. Nicoletto Semitecolo's paintings provide evidence of an artist working within a highly descriptive miniature style and apparently possessing a pronounced interest in courtly accoutrements and classicizing detail – be it by a faithful representation of an antique statue (Plate 200) or the attempt to situate his Saint Sebastian scenes within Rome itself. While the descriptive miniature style may be accounted for by his Venetian training, the courtly and classicizing references may well have been influenced by the distinctive ambience of Carrarese Padua and the pronounced interest in classical themes and artefacts cultivated among Padua's social élite.[58] Giovanni del Biondo, by contrast, shows no interest in courtly or classicizing detail (Plates 205, 206). He was, how-

ever, clearly familiar with the quite different kinds of format characteristically used by Tuscan painters in the production of altarpieces – an art form which enjoyed particular popularity and prominence within fourteenth-century Tuscany. He also worked in a significantly more monumental manner than his north Italian counterpart. It seems, therefore, that in order to account for the distinctive stylistic and iconographic features of these two paintings, it is not sufficient merely to resort to their association with the plague and its effects upon contemporary Italian society. For a satisfactory explanation of their varying and distinctive features, one must also appeal to a number of other, more stubbornly local factors, such as the particular painter's training and professional experience and the pictorial and intellectual traditions of the cultural milieu in which he painted.

CONTINUITY AND CHANGE

The Strozzi altarpiece and the two Sebastian paintings are representative of a variety of changes that do appear to have occurred within the production of religious art during the fourteenth century, many of which may plausibly be linked to the social, economic and religious upheaval of the Black Death and later outbreaks of the plague. A significant number of artists must have died as a result – including at least two of the leading practitioners of the era.[59] Such losses appear to have disrupted the established pattern of workshop practice and the transmission of artistic skills from the masters of one generation to their pupils and successors of the next. Patterns of commissioning were also apparently affected. Major projects such as the Duomos of Siena and Florence faltered, changed direction or encountered difficulties in sustaining the required financial support.[60] Individual artists were forced to work further afield. The study of the work of the Sienese painter Bartolo di Fredi, for example, reveals that many of his most important commissions were for altarpieces for provincial towns – such as Montalcino, San Gimignano and Torrita di Siena – and also that many of Bartolo's paintings were, in fact, derived from early fourteenth-century altarpieces painted for churches within Siena itself. Thus, Bartolo's *Purification of the Virgin* (Plate 190) was probably painted for Sant'Agostino in San Gimignano,[61] but derived its prestige as a religious painting precisely because it supplied a version of Ambrogio Lorenzetti's earlier altarpiece on this theme, which then stood over the altar of Saint Crescentius in the south transept of Siena Duomo (Plate 189).

Similarly, it appears from various kinds of evidence that producers of religious art in the second half of the fourteenth century were operating within very different circumstances to those of their pre-plague counterparts. For example, extensive examination of the tooling patterns habitually used by producers of panel paintings suggests that in the second half of the century, in place of their own large, well-established workshops, individual painters were increasingly obliged to resort to a variety of collaborative arrangements in order to fulfil their commissions – a development indeed suggestive of a diminished workforce adapting its practices to changed circumstances.[62]

It was not only painters who were affected by the impact of the plague, however: patrons also made new demands in response to its social and religious consequences. For example, examination of a large number of last wills and testaments made by fourteenth-century Tuscans has revealed a significant development in the commissioning of religious art. In the pre-plague era testators characteristically instructed their executors to commission religious art in their memory, but did not, on the whole, leave explicit instructions concerning what was to be represented in that art. In the immediate aftermath of the Black Death, this practice did not substantially change. However, after the second major outbreak of plague in 1362–63, such testamentary instructions became much more detailed and prescriptive. Testators became anxious that certain specified saints should be included within commemorative art, with the result that the artists employed on such commissions were required to accommodate significantly more representations of particular saints than had previously been the case.

The reasons for this are undoubtedly complex. However, it seems that the cumulative effects upon the population of Tuscany of successive outbreaks of plague were such as to cause an increasingly acute awareness of personal mortality. As a result, testators were markedly more anxious to have their own specially chosen spiritual advocates representing them within the art they commissioned. In addition, it also embodied an increasing awareness of the potential of art to register such *personal* religious convictions and record them for posterity.[63] The representation of these saints – many of them chosen for purely personal reasons and therefore often relatively obscure in terms of their identities – posed a new and demanding challenge for contemporary religious artists. Confronted with an increasing number of such commissions and themselves – as we have seen – diminished in number by the plague, artists accordingly tended to rely upon tried and tested figural types. At the same time, however, they sought to introduce variety by such expedients as reworking the established attributes of well-known saints in order to provide an iconography for lesser known saints and their cults.

Where, then, does this leave Millard Meiss's influential thesis concerning the relationship between religion, painting and the Black Death in fourteenth-century Florence and Siena? On the one hand, it is clear from our analysis of the Strozzi altarpiece and the two Saint Sebastian paintings that, unqualified by local circumstance and custom, Meiss's thesis is too bold, positing a radical break where in reality there were both change and continuity. On the other hand, Meiss's thesis embodies, at the very least, one abiding virtue. Whatever its shortcomings when examined against the evidence of local and particular cases, the thesis as a whole insists upon the vital importance of the relationship between artistic practice and concrete experience. Just how the Black Death affected the religious and social ethos of fourteenth-century Italian cities and their populations and how, in turn, such effects were expressed in artistic terms may still remain open to debate and in need of further research. That Meiss identified a compelling and enduring problem of interpretation can hardly be in doubt.

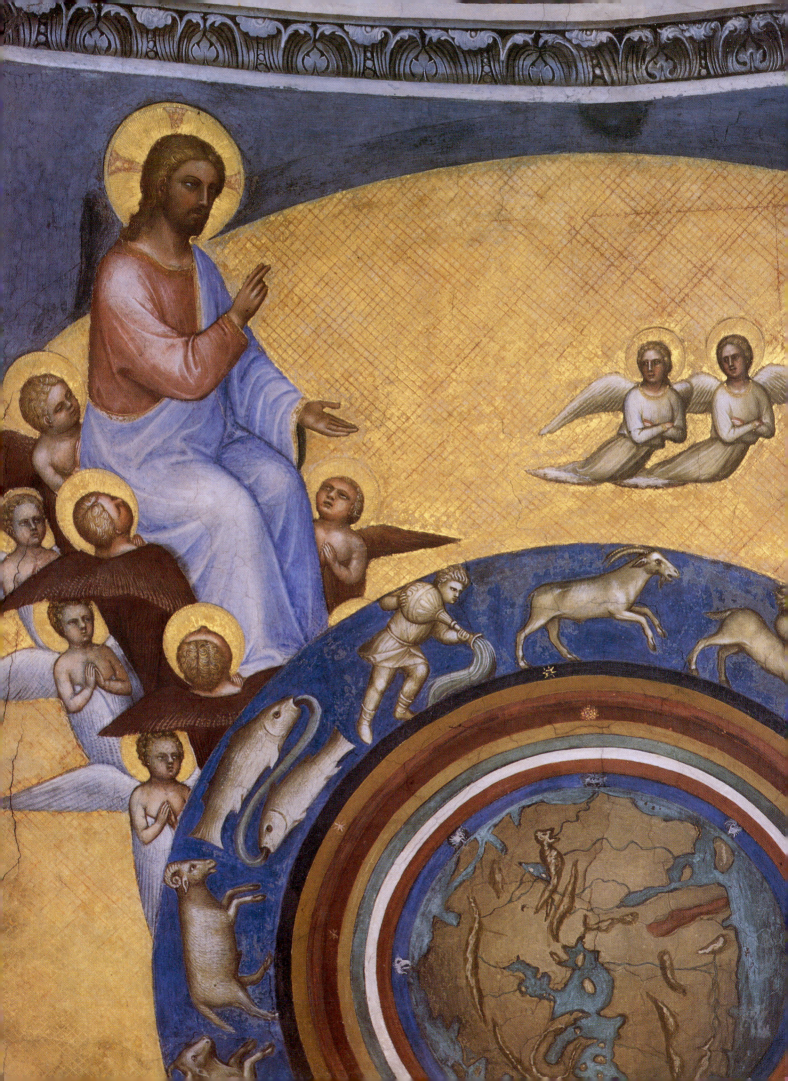

Astrology, antiquity and empiricism: art and learning

In an early chapter in his monograph on the fourteenth-century Sienese painter Simone Martini, Andrew Martindale considers the broader theme of how medieval artists and their patrons were influenced by the intellectual conditions of their society.[1] While judiciously arguing against a straightforward correlation, Martindale identifies a number of broad categories within medieval thought which, in his view, had a demonstrable impact upon late medieval European art, namely: secularity, a concern with material things, definition and the use of the senses. In respect of the last three categories, Martindale specifies a number of areas of particular concern to artists, including the observation of foliage, flowers, birds and human faces and the portrayal of space. Although Martindale draws his examples from medieval European art in general, there are particular instances of fourteenth-century Sienese, Florentine and Paduan art that may also be cited in support of his claim. For example, the carved detail on the portals of Siena's Baptistery – which was undoubtedly the work of local Sienese stone-carvers – incorporates closely observed flora and fauna, which suggests that close visual scrutiny enabled fine distinctions to be made between various species of plant and animal. A similar concern for horticultural accuracy is evident in a series of studies in a late fourteenth-century Paduan herbal (Plate 209).[2]

As regards observation of human faces, the issue is complicated by the fact that we have no means of verifying whether portrayals of named individuals of this period were accurate representations of what they looked like. In fourteenth-century Italy, however, there appears to have been a steady demand for funerary monuments that incorporated effigies, and it is tempting to interpret the detailed portrayal of distinctive facial features as evidence of a desire to commemorate the deceased as accurately and as 'true to life' as possible. As Martindale again shrewdly observes, sculptors appear to have sought to convey a sense of the specific character of the deceased, moving away from a generalized representation of princeliness to a particular representation of the individual concerned.[3] Moreover, in the case of Padua, enough examples of paintings and manuscript illustrations of specific members of the Carrara family and their circle survive to suggest that the images depicted are, indeed, accurate representations of specific historical persons.[4]

Martindale also identifies the evocation and manipulation of space in late medieval European art as evidence of artists exploiting their visual senses. In his view, the artists' deployment of perspective enabled them, first, to create a credible and striking visual context for their figures, and, secondly, to construct architectural forms in two dimensions.[5] Again fourteenth-century painting and sculpture produced in Siena, Florence and Padua provide compelling evidence of

Plate 209 Anonymous, *Study of a French Bean*, detail from a Paduan herbal, before 1403. British Museum, London Egerton 2020, 56 verso, reproduced by permission of the Trustees.

artists of the period utilizing their visual perceptions to this end.

As well as such concern with distinctively *empirical* enquiry, Sienese, Florentine and Paduan artists were influenced by at least two other broad intellectual trends. Medieval learning was significantly indebted to the intellectual and cultural legacy of antiquity. Although this knowledge was deemed 'pagan' and therefore viewed with some ambiguity by medieval Christianity, certain branches of learning – including, specifically, astrology and astronomy – had changed little since antiquity. In their astrological and astronomical treatises, medieval scholars accordingly adopted the convention of Greek and Roman writers, naming each of the known planets after one of the major gods in the ancient

Plate 208 (Facing page) Giusto de'Menabuoi, detail of *The Creation of the World* (Plate 224). Photo: Barbara Piovan.

pantheon. These were *Luna* (the moon goddess Diana), Mercury, Venus, *Sol* (the sun god Apollo), Mars, Jupiter and Saturn. Furthermore, medieval scholarship adopted the ancient belief, dating from Babylonian and Egyptian civilizations, that these heavenly bodies influenced the course of events on earth. After the fall of the Roman Empire much of this astrological lore was preserved by Arab scholars and was effectively lost to European culture until the establishment of military, mercantile and missionary contacts with Muslim communities, particularly those of Sicily and Spain.[6]

In addition to the astrological inheritance of classical civilization, antiquity contributed to the late medieval interest in the secular. The rich literary heritage of antiquity, with its frequent emphasis upon the personal valour and achievements of individuals, both historical and mythical, offered fourteenth-century patrons the opportunity to portray their own experiences in a similar light. Moreover, the issue of portraiture or characterization was also related to admiration for and emulation of classical texts and artefacts. Representative examples of antique art – mostly Roman – survived within Italy in the form of remains of buildings, sculpted funerary monuments and small-scale artefacts such as coins and medals. The prominence of figural representation in such art offered fourteenth-century artists a precedent for the kind of particularization and characterization that they themselves sought. Moreover, thirteenth- and fourteenth-century painters maintained a link – albeit several steps removed – with the traditions of classical painting. Both early Christian mosaics and frescoes and contemporary Byzantine panel painting and manuscript illumination retained vestiges of the system of highlighting and modelling adopted by painters of late antiquity. By study of such 'echoes' of late antique painting, thirteenth- and fourteenth-century painters encountered a precedent for the convincing portrayal of three-dimensional objects upon a two-dimensional surface.[7]

Medieval knowledge was, then, a complex amalgam of both Christianity and the cultural inheritance of antiquity. This essay will examine the three broad and distinctive areas of intellectual inquiry identified above – empiricism, astrology and antiquity – each of which was cultivated to a greater or lesser degree within Siena, Florence and Padua, and all of which made an impact upon the art produced within the three cities.

THE INTELLECTUAL BACKGROUND

Of the three cities, Padua had the greatest claim to being a centre of learning. The origins of its famous university appear to date from 1222, when, according to a contemporary chronicler, Rolandino, a group of professors and students from the University of Bologna migrated to Padua and founded a *studium generale*[8] there. In its early stages, Padua University was largely staffed by visiting teachers from Bologna, but it soon grew in size and importance, becoming one of the most important universities in Europe and attracting large numbers of both Italian and foreign students. These scholars were divided into four associations or 'nations' – French (including students from Britain), Italian,

German and Provençal (including students from Spain). The *studium* comprised three student universities and two doctoral colleges. Two student universities of law and a college of law were the dominant faculties, enjoying a number of civic privileges during the period of communal rule. The extent of the university's success in teaching law can be gauged from the numerous tombs of thirteenth- and fourteenth-century lawyers still to be seen in Padua's churches (Plate 210).[9] The student university of arts and the college of arts – which included not only the teaching of the subjects of the trivium (grammar, rhetoric, logic) and the quadrivium (arithmetic, geometry, astronomy, music) but also the natural sciences, metaphysics and medicine – also gradually increased in importance, making the university renowned for its teaching of medicine. Indeed, since the study of medicine frequently involved relating parts of the human body and various kinds of human temperament to the planets and the stars, this well-developed interest in medicine provided a major stimulus for the practical application of astrology at the university.

During the fourteenth century, under the rule of the Carrara, the university continued to be a protected and privileged civic institution. Thus, as one modern historian of the university has remarked:

> the Carrara … proved to be notable patrons of the schools, not only confirming and extending scholarly privileges granted by the communal government, but also actively seeking to recruit students from other *studia* and to improve academic standards. The *studium generale* of Padua was, after all, one of the principal ornaments of the city.[10]

As well as the university, Padua boasted another kind of learning, often described as an early prototype of the civic humanism for which Florence was later celebrated.[11] This civic humanism was broadly characterized by a marked interest in the literature of antiquity, the rediscovery of 'lost' Latin texts, the study of their literary form and the imitation of their style and content. Although the university, through its teaching of grammar and rhetoric, exerted an influence on this brand of civic humanism, it was mainly pursued by members of the governing and administrative classes of the Commune. Thus, there was a well-established tradition of members of the communal government in Padua writing on current affairs. As early as the 1220s Rolandino wrote a history of Padua entitled the *Rolandina*, which represented an amalgamation of the style of a chronicle with that of a rhetorical treatise, based on precepts taught in medieval *studia*. Subsequently, Lovato dei Lovati (d.1309), a Paduan notary and judge who was knighted in 1291, wrote poetry that attempted to emulate what he had found in ninth-century manuscripts preserved in Verona and Pomposa. In 1315 Albertino Mussato (d.1329) was honoured by the university in recognition of his achievements as a poet and historian. Among his most notable works were the *Historia Augusta*, a prose history modelled on that of Padua's famous classical historian Livy, and the *Ecerinide*, a verse tragedy modelled on that of the classical rhetorician Seneca. Finally, Marsiglio of Padua (d.1340), who also came from the legal, administrative background of these early civic humanists and had studied in Paris, was the author of the *Defensor Pacis*, a political treatise on the precepts of good government, which was based on his

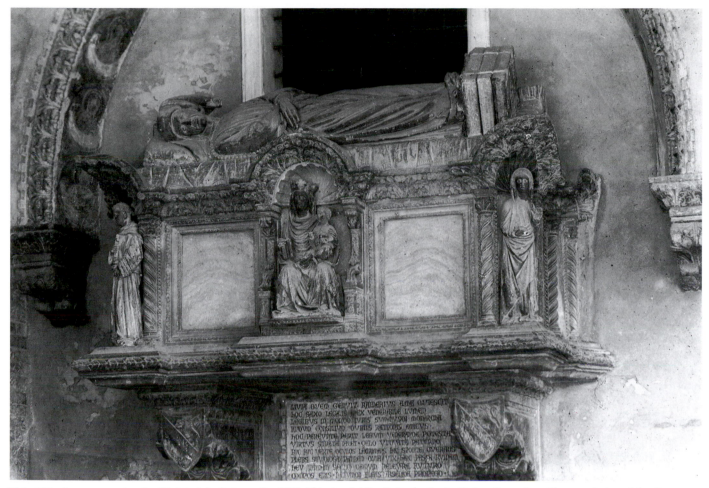

Plate 210 Anonymous, tomb of Rainieri degli Arsendi, *c.*1358, Chiostro del Capitolo, the Santo, Padua. Reproduced by permission of the Conway Librarian, Courtauld Institute of Art.

experience of Paduan political ideas and institutions under the Commune.

During the fourteenth century this precocious tradition in humanist studies continued, both within the city and at nearby Arquà, principally through the presence of Petrarch (1307–74). The work of this Florentine scholar was remarkably classical in its orientation, Petrarch having immersed himself in the literature of antiquity. He also actively publicized and promoted humanist studies. As discussed in Chapter 8, his work made a demonstrable impact on at least one major mural scheme within the Reggia – that of the Sala Virorum Illustrium. Similarly, a large number of other scholars, including the lawyer Lombardo della Seta and the schoolmasters Giovanni Conversini and Pier Paolo Vergerio, also cultivated humanist studies within Padua. Such humanist scholars added further intellectual lustre to Paduan society by serving on Carrara embassies and composing rhetorical defences of the style of rule practised by the Carrara regime.

A somewhat different situation pertained within both Siena and Florence. In neither city could the history of the university compare with that of the University of Padua. The early histories of both *studia* were complicated and were dogged by constant setbacks.[12] The origins of the university in Siena date from the 1240s, but the *studium* was only formally opened in 1275. It was not, however, until 1357, after the fall of the Nine, that the Holy Roman Emperor Charles IV granted

the institution its official foundation. By 1360 the newly founded institution was in financial difficulties, with students being allowed to leave for other universities. Between 1369 and 1385 the university was virtually at a standstill. In 1386 the *studium* was refounded, and yet by 1390 the payment of teachers had stopped and by 1402 the institution was again closed. A similarly modest record of achievement marked the foundation and early development of Florence's *studium generale*. In the words of Gene Brucker, this was a 'rare phenomenon of Florence's failure'.[13] In 1321 the city made attempts to recruit breakaway teachers from the University of Bologna, an initiative that did not succeed. It was not until 1349 that the university was granted a papal bull of foundation. Thereafter it continued in a rather desultory fashion, attracting from time to time some fairly eminent teachers.

Whilst neither city had a thriving university, both Siena and Florence had religious houses with schools or *studia* attached to them. In Siena the Augustinian priory of Sant'Agostino was the location of an important and influential *studium generale*, whilst in Florence the Franciscan convent of Santa Croce, the Dominican priory of Santa Maria Novella and the Augustinian priory of Santo Spirito were all sites of *studia*. A measure of their influence may be gauged by Dante's comment in his *Convivio* that, for 30 months, he attended the *studia* in order to listen to philosophical debate.[14]

Such institutions, although potentially intellectually prestigious in their own right, nevertheless fell short of being fully fledged universities, their curricula being characteristically narrower and more exclusively theological in content. Thus, Padua had a Franciscan *studium* at the Santo as well as its more famous university.

In addition to their *studia*, Siena and Florence both enjoyed thriving traditions of more popular writing. Florence, in particular, could boast of Dante (1265–1321) and Boccaccio (1313–75).[15] Both wrote works in Latin for an educated minority of jurists, theologians, school-teachers and the like. More significantly, they also wrote in the vernacular, thus addressing an even wider audience. For example, in *The Divine Comedy* Dante took the Tuscan dialect and fashioned it into a literary language, in so doing presenting for a popular audience an exposition of the Christian faith, based upon his extensive knowledge of late medieval theology and philosophy, yet reworked into an immediate and very human account (Plate 211). Boccaccio, likewise, in his *Decameron*, wrote an immensely popular collection of stories, whose characters were both highly entertaining and very life-like in terms of their reported behaviour and attitudes.

Petrarch, although Florentine by birth, spent little time in Florence. Nevertheless, he had many admirers and correspondents in the city, the two most eminent being Boccaccio and Coluccio Salutati (1331–1406).[16] The latter wrote an eloquent eulogy after Petrarch's death in 1374 and was elected chancellor of Florence, a post that he used to promote humanistic studies. He arranged for the appointment of the Greek scholar Manuel Chrysolaras to a professorship in the university in 1397 and encouraged younger local scholars, such as Leonardo Bruni and Poggio Bracciolini, to pursue their studies and careers as professional humanists.

Although Siena could not boast writers of the stature of either Dante or Boccaccio, it too had a thriving tradition, expressed in the works of such lesser writers as the poet Niccolò di Mino Cicerchia.[17] Similarly, in the Florentine chronicles of Giovanni and Matteo Villani or comic stories of Francesco Sacchetti, and in numerous anonymous religious and secular poems of both cities, there survives ample evidence of a flourishing popular literary tradition alongside the revival of classical studies cultivated by the Sienese and Florentine intellectual élites.

In what ways might these differing intellectual backgrounds have affected the style and content of the art produced within fourteenth-century Siena, Florence and Padua? In order to pursue this question, we may profitably examine three artistic schemes, one from each city, all of which were avowedly 'learned' in intellectual content and iconographical detail.

Plate 211 Anonymous, *Dante, Virgil and Cato Ulicensis, Guardian of Purgatory*, detail from a fourteenth-century manuscript of *The Divine Comedy*, Biblioteca Nazionale, Florence. Photo: Scala.

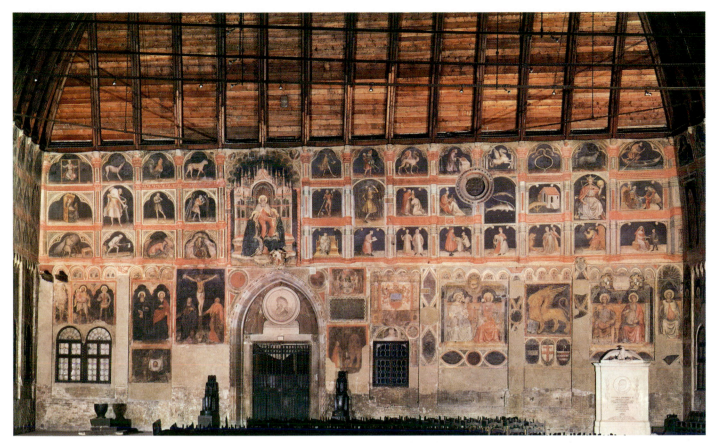

Plate 212 General view, Salone, Palazzo della Ragione, Padua, showing (below, to the right, attributed to Guariento) the virtues and (above) a fifteenth-century repainting of an early fourteenth-century scheme attributed to Giotto incorporating, among other details, the planets, saints, the signs of the zodiac and the labours of the months. Photo: Scala.

THREE PROGRAMMES OF LEARNING

The Paduan Salone

Analysis of the earliest of the three examples in question – the extensive cycle of paintings situated on the upper walls of the Salone in the Palazzo della Ragione in Padua – is complicated by the fact that the scheme was substantially repainted in the early fifteenth century following a disastrous fire in 1420, which completely destroyed the huge wooden roof over this immense public hall (Plate 212).[18] Modern scholars are reasonably confident, however, that the fifteenth-century repaintings follow the original scheme. The design of this complex programme of painted imagery has traditionally been attributed to an eminent local scholar, Pietro d'Abano (1250–1315), who studied at the University of Paris, visited Constantinople, apparently learnt Greek, and taught philosophy, medicine and astronomy at the University of Padua. Significantly for our present purposes, astrology and astronomy were central elements in Pietro's thought.[19] The execution of the early fourteenth-century painted scheme has been credited to Giotto, who was working in Padua for the wealthy merchant Enrico Scrovegni at this time.

The 333 compartments in the Salone scheme contain within them an immense variety of painted imagery, complete explication of which has defeated even the most ingenious of modern iconographers and scholars.[20] It is reasonably secure, however, that this extraordinary scheme is devised around an astrological and calendrical system according to which each section of the painted imagery is focused upon representations of the months. The months, however, are portrayed according to the dictates of a particular iconographical convention in medieval art (known as the labours of the months), whereby each month is personified as an individual or group engaged in an appropriate seasonal occupation. For example, December is shown as a man disembowelling a pig, while a woman assists him by collecting the resulting blood in a bowl (Chapter 7, Plate 150). Accompanying these striking images of the labours of the months are large-scale paintings of the signs of the zodiac, depicted in a form recognizable to the modern viewer.

On a similarly large scale to the labours of the months and the signs of the zodiac appear the planets, represented as the seven major pagan deities: *Luna*, Mercury, Venus, *Sol*, Mars, Jupiter and Saturn. Following a long and complex iconographical tradition, these figures appear in various kinds of costume, which denote the social types and human characteristics that each of the deities was supposed to embody. Accordingly, Jupiter is represented as a ruler or a king, whereas Mercury is represented as a scholar. Additionally, a number of the planetary deities appear twice, thus alluding to astrological lore whereby it was believed that at certain times of the year the planets appear in a significant conjunction with a zodiacal sign, and that this, in turn, changes their character or nature. For example, in the area of the wall where April and Taurus appear, Venus is to be seen in her guise of the celestial Venus, who embodied the qualities

Plate 213 *Venus*, detail of painted scheme, Salone, Palazzo della Ragione, Padua. Reproduced by courtesy of Musei Civici Padova, Gabinetto Fotografico.

of chaste, legitimate love; significantly, she is represented as the Virgin and Child (Plate 213). Meanwhile, on the section of wall where September and Libra appear, Venus again features, but now as the mundane Venus, personifying carnal love. Appropriately for the underlying ideology, Venus is here represented as a classical naked figure holding a mirror, a well-known symbol of vanity.[21]

The iconography of the scheme is further complicated by other painted compartments whose subjects are sometimes quite obscure. Broadly, however, it appears that symbols of the four elements – air, earth, fire and water – have been woven into the scheme, together with representations of various human occupations (such as practising medicine, selling fish and working in wood) and certain human qualities (such as strength, instability and anger). This subject-matter again derives from a rich literary and pictorial tradition, whereby it was believed that a person born under a particular sign of the zodiac possessed a particular temperament determined by one of the four elements, and was likely to follow an occupation appropriate to the sign. The latter belief, codified by medieval scholars into a system known as the Children of the Planets,[22] suggests, for example, that the Children of Mercury were likely to be involved in the pursuit of scholarly, mercantile and artistic activities. Appropriately, therefore, on the section of the wall where Mercury is represented as scholar using an astrolobe, there also appear other small painted scenes of a painter working upon a panel, a teacher teaching a pupil and a merchant at his counter.

Finally, whilst the painted scheme acts as an indication of the rich and complex body of astrological belief evolved from classical astrology and astronomy, it is also emphatically

Christian in its intent. Thus, the most striking images within the mass of painted detail are the full-length representations of the twelve apostles, together with an impressively large image of the coronation of the Virgin. On the lower walls of the Salone appear representations of other saints, notably the patron saints of Padua, together with the three theological virtues and the four cardinal virtues.

In view of the substantial fifteenth-century repainting, it is impossible to state categorically how far the Salone scheme in its present state represents the fruit of perceptive visual observation and empirical enquiry on the part of its original fourteenth-century painters. In its present form, it is replete with lively genre detail, which may or may not have been present in the earlier scheme. What can legitimately be deduced from this ambitious scheme of pictorial imagery, however, is that it appears to have been designed to represent a comprehensive world-view of God's creation in all its manifold aspects. In terms of its comprehensiveness, therefore, it presents a pictorial equivalent of the encyclopaedic scholastic works of such thirteenth-century scholars as the French Dominican Vincent of Beauvais (*c*.1190–1264) and the Florentine layman Brunetto Latini (*c*.1212–94), authors whose work consisted of extensive and systematic presentations that embraced the whole of human knowledge, viewed in the light of orthodox Christian doctrine. The Paduan scheme also includes, however, a remarkably prominent and explicit astrological dimension. It is at least plausible to suggest, therefore, that the scholarly ambience of the university and, in particular, its reputation for the study of astrology was influential in the devising of this complex cosmological programme for the walls of Padua's principal civic building.

The Sienese Sala dei Nove

Whatever doubts surround the original appearance of the Paduan Salone scheme, the painted programme of the Sala dei Nove in Siena is certainly fourteenth century in its conception and execution (Plate 214).[23] Painted by Ambrogio Lorenzetti between 1337 and 1340, the room was the meeting-room of the Nine, Siena's chief magistracy from 1287 to 1355. The painted scheme in the Sala dei Nove is confined to three large paintings, one on each of the three walls of the room, the fourth wall being taken up by a window. The subject-matter of the three paintings is complex and open to widely differing detailed interpretations. There is, however, a general consensus that, as a whole, the painted scheme was intended as an exemplification of good and bad government. Thus, on the north wall appears a painted scheme of seated figures who personify the qualities of good government – the Sienese Commune itself and such concepts as justice, magnanimity and peace. On the west wall, meanwhile, appear figures who represent the negative counterparts to this ideal of good government – tyranny, fraud, division and so forth. These figures are thus similar to the enthroned virtues on the lower walls of the Salone. What is remarkably different in the Sienese scheme is that the abstract personifications are accompanied by less abstract and much more realistic pictorial imagery. Upon the east wall there is a painting of a walled city and surrounding countryside, both of which are

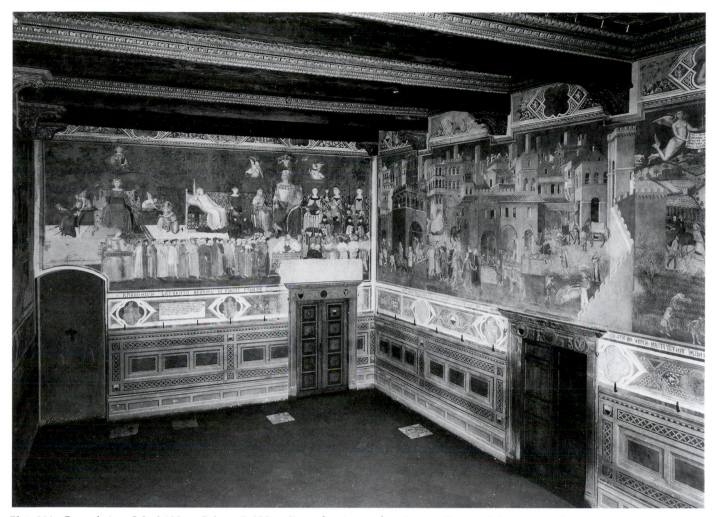

Plate 214 General view, Sala dei Nove, Palazzo Pubblico, Siena, showing north and east walls (overall dimensions of room, 14.04 x 7.70 metres). Photo: Lensini.

filled with people engaged in various kinds of activity. The symbolic significance of this scene is indicated by the personification of security, who is represented as hovering over the crenellated wall of the city and holding a painted text that describes the beneficial results of good government (Plate 215). As a direct counterpart to this painted scene, a second city and surrounding countryside, in this case representing places of violence and destruction and thus the consequence of bad government, appears on the opposite west wall.

By his use of personification and, indeed, contrasting figural and topographical types – peace versus war, security versus fear, a peaceful city versus a war-torn city – Ambrogio Lorenzetti, like Giotto in the Paduan Salone, adopted and developed familiar themes of late medieval scholarship, as expressed in such encyclopaedic works as Vincent of Beauvais's *Speculum Maius* and Brunetto Latini's *Li livres dou tresor*. The didactic intent of the painted scheme's adoption of polarized personifications of good and evil is clearly indicated by the extensive painted texts both within the paintings themselves and within the painted borders.[24] Moreover, Ambrogio Lorenzetti utilized a further dimension of medieval scholarship already identified in the Salone scheme. Within the upper border of the three paintings appears a sequence of medallions portraying images of the seven planets, five of

which are accompanied by appropriate zodiacal signs.[25] Intervening between this sequence of planets are personifications of the four calendrical seasons – spring, summer, autumn and winter. Each of these four seasons is represented as a person whose costume and attributes allude to the time of year. In the case of winter, for example, we see, in profile, a man dressed warmly against the cold and holding a snowball in his hand. The time of the year is further graphically conveyed by the presence of snowflakes (Plate 216).

In the medallions in the lower borders of the paintings on the north and east walls appears a third category of personification, that of the liberal arts. Although many of the images are now so damaged as to be largely unrecognizable, the medallions show female personifications of particular branches of intellectual inquiry, in a form described by such scholars as the fifth-century grammarian Martianus Cappella and the sixth-century encyclopaedist Isidore of Seville. For example, grammar is represented as a woman teaching a child to read, whilst geometry is portrayed as a person holding a compass. Finally, on the west wall below the painting of *The Bad Government and City*, there were originally representations of ancient rulers who, because of their tyrannical acts, acted as historical exemplars of the kind of government portrayed in the painting above them.

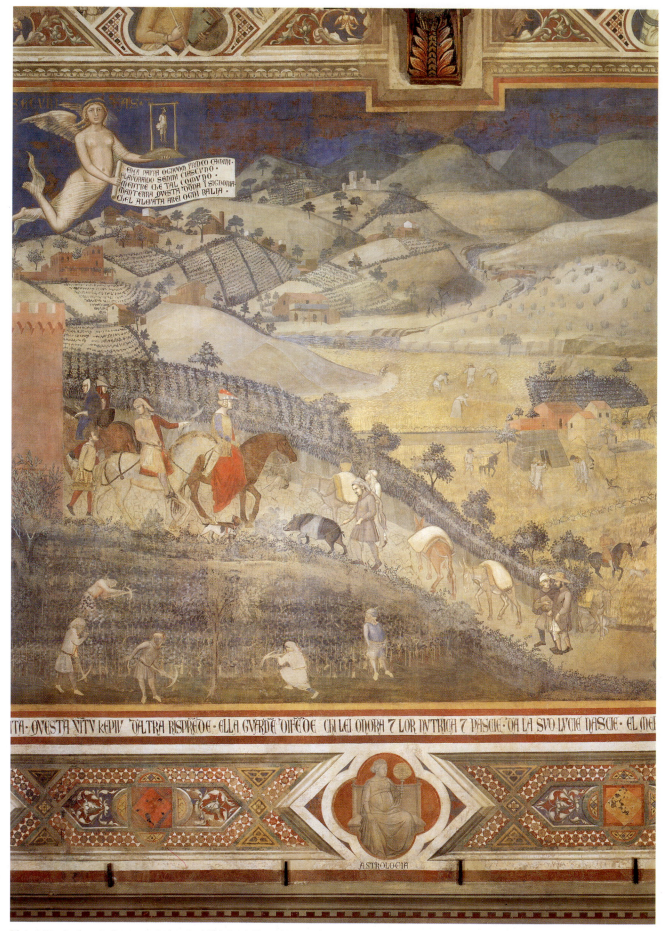

Plate 215 Ambrogio Lorenzetti, detail of *The Good City*, 1337–40, fresco, east wall, Sala dei Nove, Palazzo Pubblico, Siena. Photo: Lensini.

It has also plausibly been suggested that within the painting of *The Good City* the activities depicted both inside and outside the city walls are representative of both the labours of the months and the mechanical arts.[26] The fishing, tending of vines, riding, ploughing, harvesting, threshing and hunting are all appropriate to the labours of the months of spring and summer, themselves personified in the border above the painting in question (Plate 215). Similarly, the kinds of activity taking place within the city can be associated with the mechanical arts. Thus, for example, the figure at the loom is representative of the art of *Lanificium* (weaving), and the builders on their scaffolding are representative of *Armatura* (construction) (Plate 217).

It is also clear from the paintings in the Sala dei Nove that Ambrogio Lorenzetti was aware of classical art and its use of life-like forms and details. Thus, he portrayed the figure of Peace in *The Good Government* with a garland of olive leaves and an olive branch, objects that feature prominently on classical representations of this allegorical figure (Plate 218). Moreover, the treatment of the figure's white robe with its multiple folds and its accentuation of the female form beneath is reminiscent of similarly garbed figures on Roman sculpted reliefs.[27] Meanwhile, Security, a female figure divested of all but the most transparent drapery, is suggestive of a classical winged Victory (Plate 215).

Plate 216 Ambrogio Lorenzetti, *Winter*, detail of upper border of west wall, Sala dei Nove, Palazzo Pubblico, Siena. Photo: Lensini.

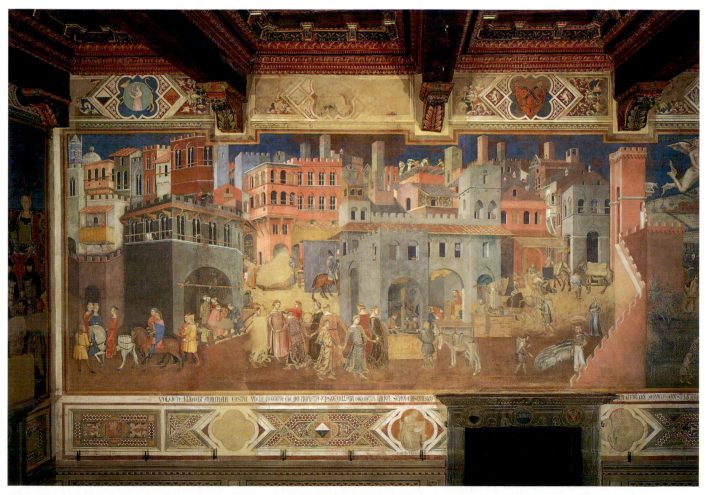

Plate 217 Ambrogio Lorenzetti, detail of *The Good City*, 1337–40, fresco, east wall, Sala dei Nove, Palazzo Pubblico, Siena. Photo: Lensini.

Plate 218 Ambrogio Lorenzetti, *Peace, Fortitude, Prudence and Citizens*, detail of *The Good Government*, 1337–40, fresco, north wall, Sala dei Nove, Palazzo Pubblico, Siena. Photo: Lensini.

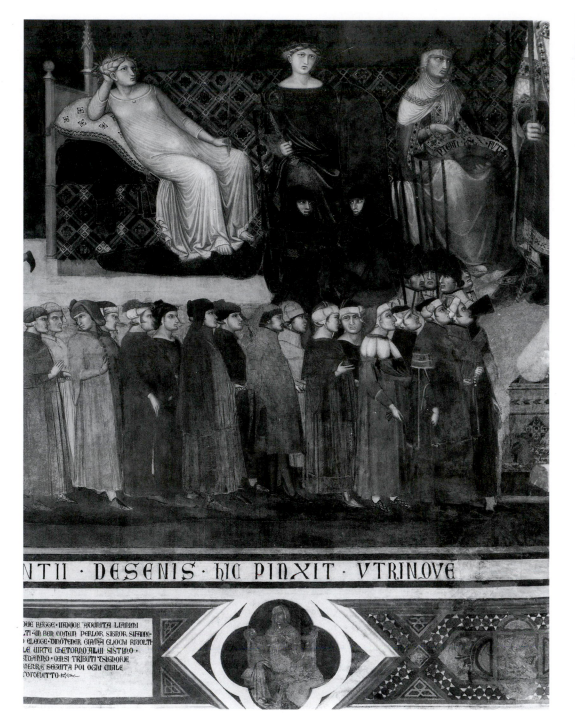

It has also been suggested that Ambrogio Lorenzetti may have been inspired by the work of the Roman writer Pliny the Elder who, in his *Natural History*, offered particularly detailed descriptions of the work of classical artists. When describing the Roman painter Studius, Pliny remarks on how the artist was able to paint:

> villas, harbours, landscape gardens, sacred groves, woods, hills, fishponds, straits, streams and shores, any scene in short that took the fancy. In these he introduced figures of people on foot, or in boats, and on land of people coming up to the country-houses either on donkeys or in carriages, besides figures of fishers and fowlers, or of hunters or even of vintagers.[28]

Much of the detail of the countryside in *The Good City* is consistent with this particular passage in Pliny. It is also significant in this respect: that when describing the achievement of the Greek painter Polygnotes, Pliny praises the artist's ability to paint women with transparent drapery.[29] Might Ambrogio Lorenzetti have read Pliny, therefore? There is no concrete evidence that he did, but the apparent correspondences between Pliny's text and the painting of *The Good City* are at least suggestive of the possibility. Moreover, there is a well-established tradition that Ambrogio Lorenzetti had a reputation for learning. Quite apart from the fact that he is recorded as participating and speaking wisely in a Sienese government debate, later writers, such as the fifteenth-century

Florentine sculptor Lorenzo Ghiberti and the sixteenth-century painter and writer Giorgio Vasari, refer to Ambrogio Lorenzetti's reputation as a person of intellect.[30]

What is equally striking about these paintings, however, is the apparent realism whereby the painter transcends the constraints imposed by the highly allegorical subject-matter of the programme as a whole. To take but one detail within *The Good Government*, the procession of male figures in contemporary dress is sufficiently life-like to suggest a portrayal of actual contemporaries of the painter (Plate 218). Similarly, the medallion portraying winter provides a compelling evocation of snowfall (Plate 216). Indeed, on the testimony of Ghiberti, it appears that Ambrogio Lorenzetti was extremely innovative in his depiction of climatic conditions. When describing the now-destroyed cycle of paintings by Ambrogio Lorenzetti on the walls of the cloister of San Francesco in Siena, Ghiberti describes how:

> [In the scene which occurs after] the decapitation of the friars there arises a storm with much hail, flashes of lightning, thunder, and earthquakes … The hailstones are so thick on the shields that they seem actually to bounce on the shields with the extraordinary winds. The trees are seen bending even to the ground as if they were breaking, and each person seems to be fleeing.[31]

The paintings of the Sala dei Nove thus combine insights and influences derived from empirical, astrological and classical emphases which, as we have seen, informed much of late medieval thought. Whilst clearly principally political in intent, as appropriate to their location and setting, the paintings also rely upon the essentially complex body of knowledge encompassed within late medieval scholasticism. The planets and zodiacal signs, together with personifications of the liberal arts and allusions to the labours of the months and the mechanical arts, are subtly integrated within a painted scheme apparently dedicated to a realistic portrayal of fourteenth-century civic life based upon empirical observation.

The Florentine Campanile

At approximately the same date as Ambrogio Lorenzetti was working on the fresco scheme for the Sala dei Nove in Siena, the Florentine Commune embarked upon a similarly ambitious civic project, which, in terms of its imagery, also alluded to the encyclopaedic knowledge of late medieval learning. This scheme – executed in sculpture – took the form of a series of hexagonal and lozenge-shaped reliefs located on all four sides of the Campanile of Florence Duomo (Plate 219). The authorship of this sculpted programme, and indeed the identities of the artists who designed and executed the individual reliefs, remains a matter of intense debate among modern scholars. What is of interest for our present purposes, however, is that, in its early stages of construction and embellishment, the campanile came under the responsibility of Giotto, who was appointed *capomaestro* of the Opera del Duomo from 1334 until 1337 (the year of his death). Since parts of the sculpted programme are distinctively encyclopaedic and astrological in subject-matter and since Giotto is traditionally associated with the painted scheme in the Palazzo della Ragione in Padua, it seems likely that this

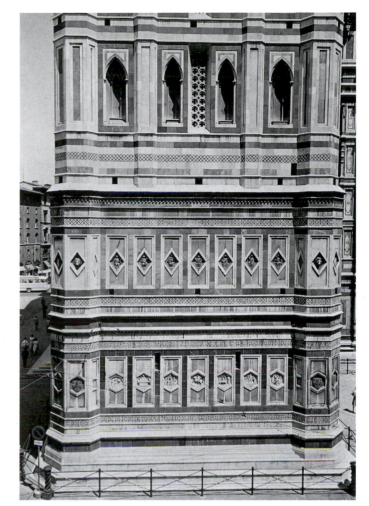

Plate 219 South face, Campanile, Florence. Photo: Scala.

celebrated painter played a part in devising at least some of the subject-matter of the sculpted reliefs for the campanile.[32]

Compared with the Paduan scheme, the Florentine Campanile is simpler and more orderly in terms of both content and visual impact. It comprises a lower tier of 21 hexagonal reliefs and an upper tier of 28 reliefs (27 of which are lozenge shaped and one of which takes the form of a small triangle).[33] The hexagonal reliefs begin with three scenes from the Book of Genesis: the creation of Adam, the creation of Eve and Adam and Eve's first labours. These biblical scenes are followed by a sequence of reliefs whose subjects are designed to celebrate the invention of various occupations. The sequence begins with so-called biblical inventors. For example, the portrayal of Noah's drunkenness, described in Genesis, is intended to allude to Noah's status as the first cultivator of vines (Plate 220). Following the biblical inventors are other mythical inventors, such as Phoroneus, who was believed to have invented law, and Daedalus, the patron of artists. Further reliefs celebrate heroes of antiquity such as Hercules. Interleaved between these figures are representations of the seven mechanical arts. Significantly – given Florence's contemporary reputation as a city where painting, sculpture and architecture thrived – the seven mechanical arts are accompanied by representations of the practical skills of painting, sculpture and architecture (Chapter 5, Plate 97).

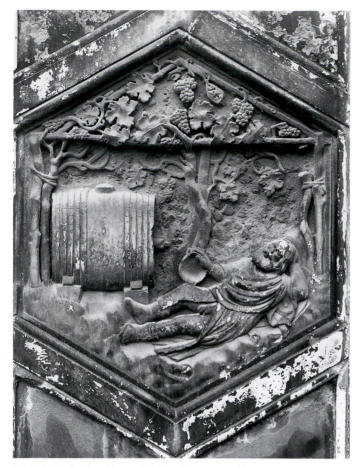

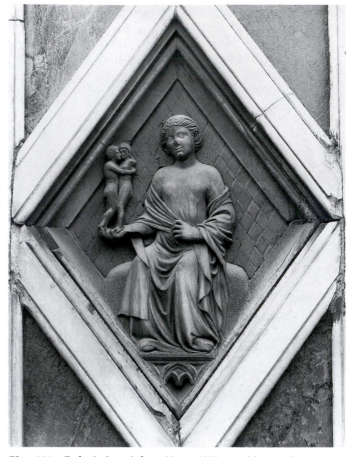

Plate 220 Andrea Pisano, *Noah*, c.1334–37, marble relief, 83 x 69 cm, west face, Campanile, Florence (original sculpture now removed to the Museo dell'Opera del Duomo, Florence). Photo: Alinari.

Plate 221 Cathedral workshop, *Venus*, 1350s, marble and glazed terracotta relief, 87 x 63.5 cm, west face, Campanile, Florence (original sculpture now removed to the Museo dell'Opera del Duomo, Florence). Photo: Alinari.

In the upper tier appear four further sequences of reliefs. These present personifications of the seven planets, the seven virtues, the seven liberal arts and the seven sacraments. As in the case of both the Salone in Padua and the Sala dei Nove in Siena, the seven planets are represented as the seven major deities of the classical pantheon. These figures appear in costumes that identify them readily with contemporary social types. Thus, Jupiter appears in the guise of a cleric and Mars as a knight on horseback. Venus appears with the uncovered head and robe customarily adopted by young unmarried women in fourteenth-century Italy. She is also depicted holding a naked man and woman embracing – a clear acknowledgement of her status as the goddess of human love expressed in explicitly sexual form (Plate 221).

The Florentine Campanile scheme, therefore, exhibits a broad similarity with the Paduan and Sienese schemes. It too relies on the device of personification in order to allude to varieties of human endeavour (such as the mechanical and liberal arts) or human qualities (such as the virtues). Like the Paduan and Sienese schemes, it has an astrological dimension by virtue of the inclusion of the seven pagan deities, thus referring indirectly to the well-established belief in the influence of the planets upon human destiny. As in the case of the Paduan scheme, astrological themes were subordinate to overarching Christian themes. The sculpted narratives begin with three scenes from the creation of the world as recounted in the Book of Genesis. The message of the scheme, moreover,

appears to have been adopted from the beliefs of such scholars as Vincent of Beauvais, who argued that three evils were brought upon humanity by Adam and Eve, namely: sin, ignorance and mortality. As an antidote, God provided three corresponding remedies: virtue, wisdom and practical necessity. These divine gifts are represented on the campanile by, respectively, the seven virtues, the seven liberal arts and the seven mechanical arts. Accordingly, all human invention and endeavour is deemed to be governed by Christian precepts. Indeed, the sequential ordering of the sculpted scheme ends with the seven sacraments, thus implying that it is only through the practice of these Christian rites that true salvation may be attained.[34]

As in the case of the Sala dei Nove murals, the influence of antiquity is highly apparent in the campanile reliefs.[35] As well as the inclusion of representations of specific classical heroes – such as Hercules and Daedalus – it is possible that other figures in the hexagonal reliefs also represent prominent figures of antiquity. Whilst the woman at her loom in the relief of *Lanificium* ostensibly celebrates Florence's textile industry, the standing woman beside her may well represent the goddess Minerva, who was credited with introducing the art of weaving to humanity. Similarly, it may be that, in the depictions of the practices of painting and sculpture on the campanile, the painter shown may be the famous Greek painter Apelles, and the sculptor, the equally celebrated Greek sculptor Phidias (Chapter 5, Plate 97).

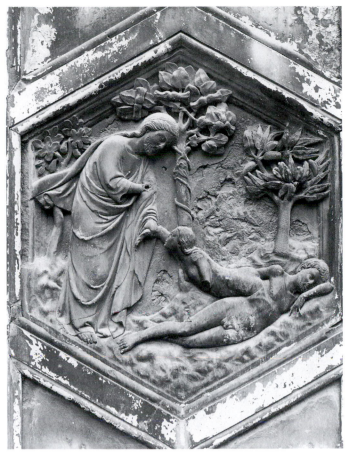

Plate 222 Andrea Pisano, *The Creation of Eve*, c.1334–37, marble relief, 83 x 69 cm, west face, Campanile, Florence (original sculpture now removed to the Museo dell'Opera del Duomo, Florence). Photo: Alinari.

The campanile reliefs are, moreover, frequently imitative of classical art. As with Ambrogio Lorenzetti's figure of Peace, the so-called Minerva figure on the campanile is similar to classical sculpture in its treatment of the draped female form. Similarly, in *The Creation of Eve*, the figure of Eve presents a remarkably assured treatment of the unclothed female form (Plate 222). Such confident treatment of the female body is suggestive of attentive study of similar representations on classical sculpted reliefs. During the fourteenth century one such relief was on display in Siena Duomo (Plate 223) and,

although this particular relief, with its lively depiction of nereids riding on the back of sea creatures, may not have been Andrea Pisano's direct model for his figure of Eve, it remains plausible that he turned to classical models of this type.[36] A letter from the fourteenth-century Paduan scholar Giovanni Dondi provides good circumstantial evidence for the general availability of such sculptural remains and for contemporary sculptors' interest in studying them:

> I myself used to know a marble sculptor ... famous among those whom Italy then had, particularly in working figures. More than once I heard him discuss the statues and sculptures he had seen in Rome with such admiration and veneration that in his discourse he seemed to be all beyond himself, so full of wonder was the subject ... he talked a great deal about the excellence of these figures and praised their makers and acclaimed their talent beyond all measure. He used to conclude – I quote his own words – that if such sculptures had only the spark of life, they would be better than nature.[37]

As this quotation suggests, one of the principal reasons for sculptors (and also painters) studying Roman antiquities was that these provided them with the means to attain greater life-likeness in their work. What level of empirical observation, therefore, is discernible on the campanile reliefs? The sculptors of the campanile, unlike painters such as Ambrogio Lorenzetti, were deprived of the full resources of colour and tone in order to achieve their objectives. Nevertheless, the reliefs provide vivacious depictions of human physicality and expression. Among the many examples, the indolent, languid pose of Noah in his inebriated state is particularly striking (Plate 220). In addition, the sculptors have also overcome the constraints inherent in relief carving whereby only a limited spatial setting can be described. In *The Creation of Eve*, for example, by utilizing fine gradations in the carving of the relief, Andrea Pisano achieved a convincing illusion of the two major protagonists, situated within an outdoor spatial setting which, in turn, recedes into depth (Plate 222). The exploitation of such techniques may plausibly be attributed to a combination of perceptive study of classical precedents and a contemporary desire to evoke a credible and naturalistic environment in which to situate sculpted figures.

Analysis of the paintings in the Paduan Salone and the Sienese Sala dei Nove, and of the sculpted reliefs of the

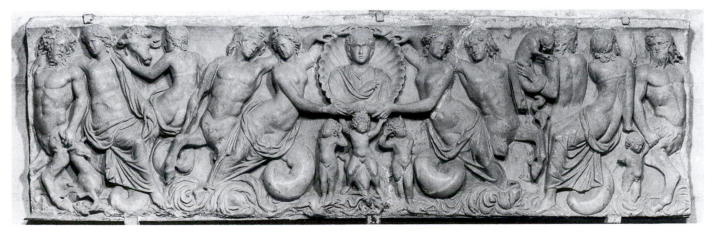

Plate 223 *Nereids and Sea Centaurs*, early third century, Roman sarcophagus front, Museo dell'Opera del Duomo, Siena. Photo: Lensini.

Florentine Campanile, provides compelling evidence that the three broad categories of empiricism, astrology and antiquity informed both the content and form of these three major artistic schemes. However, each in turn displays a different balance and emphasis between the three categories. Thus, in the Paduan painted scheme it appears that empirical and astrological themes predominate, whilst antiquity features only in a disguised form as part of the legacy of planetary deities and zodiacal signs. By contrast, in the Sienese painted scheme, empiricism appears to be the most influential factor in the final resolution of the paintings. Yet, as we have seen, astrological and classical themes inform the paintings' content, and examples from classical art also appear to have facilitated the portrayal of both key figures and descriptive details. Finally, whilst the Florentine Campanile reliefs acknowledge the debt of medieval learning to astrology, cosmology and scholasticism in general, their lively subject-matter and mode of representation suggest pronounced skills in empirical observation and an indebtedness to the art of antiquity.

ART AND LEARNING

As the three artistic schemes examined in the preceding section of this essay demonstrate, empiricism, astrology and antiquity each exerted an influence upon major works of art produced in fourteenth-century Siena, Florence and Padua. Turning from specific schemes to survey the influence of such intellectual concerns upon the general pattern of the art produced in each of the three cities during the fourteenth century, Padua apparently exhibits a certain distinctiveness. Fourteenth-century Paduan art, as a whole, provides evidence suggestive of a particularly rich and ongoing interrelationship between empirical, astrological and classical concerns. The influence on art is most strikingly evident in relation to astrology. Following the incorporation of astrological motifs in the Salone scheme, Paduan interest in astrology and astronomy was subsequently reflected in a series of further monuments. In 1344 Jacopo Dondi (1290–1359) installed an astronomical clock in the principal tower of the Reggia. Now replaced by an exact fifteenth-century copy, it measured not only the hours but also the days, months and phases of the moon. Jacopo's son Giovanni Dondi (1318–89) lectured at the university on medicine, astrology, philosophy and logic and built himself a planetarium in Padua for the study of the sun, the moon and the planets.[38]

Two decades later the seven planets again featured prominently, within a conventional cycle of religious paintings for the chancel of the Eremitani – the church of the Augustinian Hermits in Padua. Executed in the 1360s by the Paduan painter Guariento, the frescoes commemorated the lives of Saints James the Less, Philip and Augustine.[39] The curved surface of the apse once housed an impressive painting of Christ, the Virgin and saints in paradise. Despite its orthodox Christian subject-matter, the chancel's painted programme also incorporated representations of *Luna*, Mercury, Venus, *Sol*, Mars, Jupiter and Saturn, each accompanied by a male and a female representative of the seven ages: infancy, childhood, puberty, youth, maturity, old

age, senility. Like the representations of the planets in the Salone, the deities were portrayed in broadly contemporary dress. Mars, for example, appears as a mounted knight. This sense of contemporaneity is further increased by the observant depiction of the accompanying figures: in the case of *Luna*, a young boy is shown vivaciously riding a hobby-horse and a young girl clutching a doll in the fold of her dress (Plate 225). Significantly, this sequence of planetary deities was painted in grisaille and would thus have provided a striking contrast to the colourful paintings originally situated above it. Moreover, this choice of colour was by no means arbitrary. Like their influential precedents in the nearby Arena Chapel, Guariento's dado figures were probably painted in this restricted and subdued range of colours precisely in order to signify that, whilst the planets were influential in the lives of men and women, they were yet subordinate to the Christian values triumphantly exemplified by the lives of the saints portrayed above them.

The continuing Paduan interest in matters of astrology and cosmology was further demonstrated in the late 1370s when Giusto de'Menabuoi painted a representation of the creation of the world (Plate 224). Located in the drum of the Baptistery in Padua, the painting was the first in a series of frescoes depicting scenes from the Old Testament.[40] In order to portray this scene from Genesis, God the Son is shown in the act of blessing the world,[41] which is represented not as a sphere but as a flat disc, surrounded by a band of blue. Next appear seven concentric bands of different colours ending with an eighth black band. Surrounding the entire image is a further broad circle of blue upon which appear the zodiacal signs, delicately executed in shades of white and grey. This painted image corresponds to an understanding of the universe derived from such classical authorities as Aristotle and Ptolemy. Such sources had described the universe as a series of concentric spheres rotating around the earth. Seven of the spheres were hollow shells, each holding one of the seven planets. Beyond the seven spheres was an eighth sphere – the firmament – in which the belt of the zodiac and other constellations was fixed. By the date of Giusto de Menabuoi's painting, this system of heavenly spheres had become more elaborate. At its most highly developed it could encompass as many as fifteen components: air, earth, fire, water (the four elements), the seven planets, the firmament, the crystalline sphere, the prime mover and the empyreum.[42] However, in common with other contemporary and later examples of this subject, it seems more probable that the painting in the baptistery depicts only the following. First, it shows the four elements: the 'earth' surrounded by the 'water' of the seas; 'air' as a blue band delicately embellished with heads depicting the winds; and 'fire' as a band of red. Following these are seven further bands, beginning with a white band and ending with a black band. Each, in all likelihood, represents one of the planetary spheres. Significantly, the deep purplish red band corresponding to that of the planetary sphere of *Sol* is embellished with a miniature gold sun. Likewise, the golden band of Jupiter shows a golden star on it. These two details correspond closely to a later fifteenth-century Sienese *Creation*.[43] The four elements and seven planets are finally encircled by the 'firmament' and its constellations. Beyond these appears God

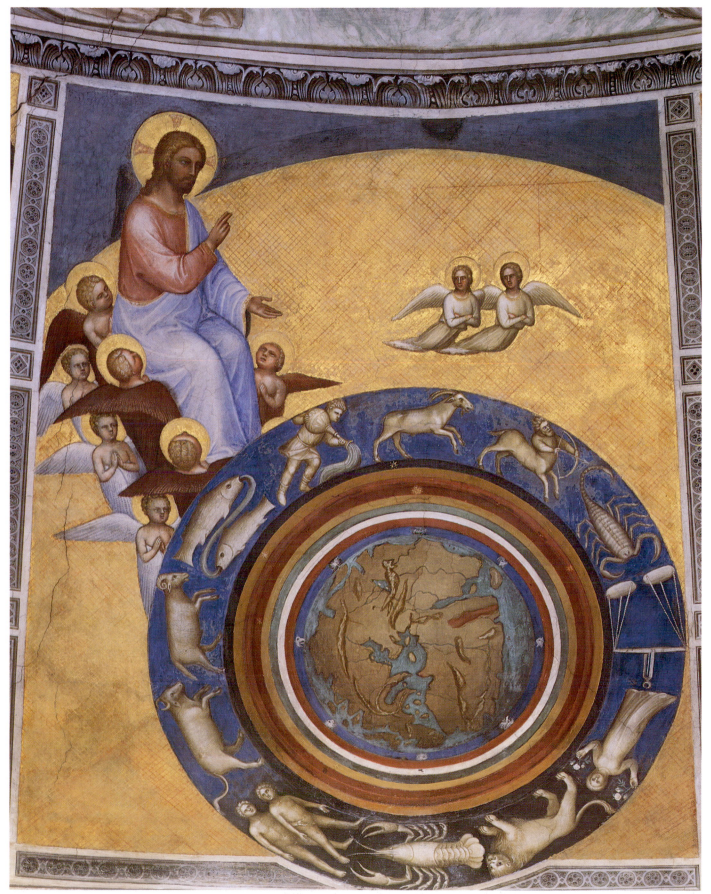

Plate 224 Giusto de'Menabuoi, *The Creation of the World*, late 1370s, fresco, drum, Baptistery, Padua. Photo: Barbara Piovan.

Plate 225 Guariento, *The Planet Luna with Two Children*, 1360s, fresco, dado zone, chancel of the Eremitani, Padua. Reproduced by courtesy of Musei Civici Padova, Gabinetto Fotografico.

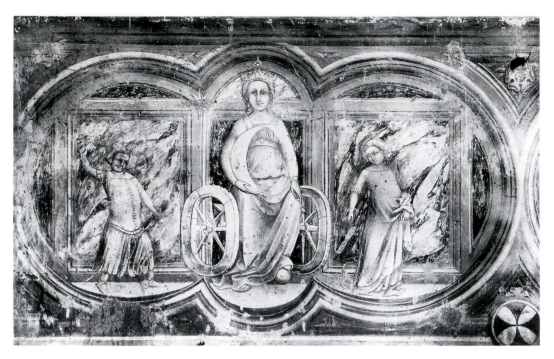

the Son, against a golden radiance surrounded by cherubim – a common device for paintings of this subject. Although Giusto de'Menabuoi has therefore adopted pictorial conventions that were fairly standard for this biblical subject, his representation is remarkably self-assured in its use of astrological and cosmological detail. If the Paduan painting is compared with a slightly earlier painting of the same subject by the Sienese painter Bartolo di Fredi, it is clear that in the Sienese version the representation of the world is much more generalized, whilst the system of the spheres is both simpler and less descriptive in form (Plate 226).

In addition to a marked interest in astrology, fourteenth-century Paduan art also exhibited a consistent, highly developed enthusiasm for the literature and art of antiquity. The Carrara, in particular, were adept at exploiting antiquity as a means of promoting their political and cultural reputation. Quite apart from offering their patronage to such scholars as Petrarch, Giovanni Dondi and Pier Paolo Vergerio – all of whom were deeply committed to the study of classical texts – it appears that the Carrara encouraged artists in their employment not only to represent classical subjects but also, on occasion, to show such subject-matter in self-consciously classical form. For example, the decoration of the principal city residence of the Carrara – the Reggia – included several ambitiously conceived programmes of painting that depicted subjects drawn from classical texts or portrayed fourteenth-century interpretations of the achievements of heroes and heroines of antiquity.[44] Whilst the majority of these painted schemes are now lost, an impression of their original appearance may be derived from a number of illuminated manuscripts produced within Padua during the latter years of Carrara rule in the city (Chapter 8, Plates 176 and 182).

Turning to the question of the role of empirical observation in fourteenth-century Paduan art, it is clear that Giotto's frescoes in the Arena Chapel provide a compelling early instance of such interest. To take but one example, the portly

figure in the act of drinking in *The Feast at Cana* is so vividly characterized as to suggest that Giotto might well have had a particular person in mind. If correct, this hypothesis lends support to the view that late medieval artists were attempting to move away from generalized and idealized representations of people and towards the portrayal of particular individuals (Plate 227).[45] Similarly, the wine jars in the foreground of the painting give an illusion of rotond, three-dimensional objects. Furthermore, the painted architecture gives a strong visual sense of an enclosed room, spacious enough comfortably to house an L-shaped trestle table with figures seated around it. An impression of projection and recession is further enhanced by the treatment of the intricately decorated canopy above the seated figures and the wooden bench on which the wine jars are grouped.[46]

Later fourteenth-century painting in Padua provides examples of other painters similarly utilizing their perceptive observation of people, objects and narrative situations. It may even be the case that the Arena Chapel frescoes were a constant source of stimulus for painters working in Padua to achieve such ends. A letter written in 1396 by Pier Paolo Vergerio suggests that Giotto was, indeed, a model for later painters in this respect:

> Though Seneca considers one should not follow a single model but form a style out of various models, I do not think this is so; rather, one should have a single writer – and him the best – whom one imitates before all others, because the more one follows an inferior model and departs from the best, the worse one becomes. So one should do what the painters of our own age do, who though they may look with attention at famous paintings by other artists, yet follow the example of Giotto alone.[47]

It should be acknowledged, however, that later painters also brought their own individual skills and experiences to bear upon the task of portraying life-like characters and situations. For example, *The Martyrdom of Saint George*, painted by Altichiero between 1379 and 1384 for the Oratory of San

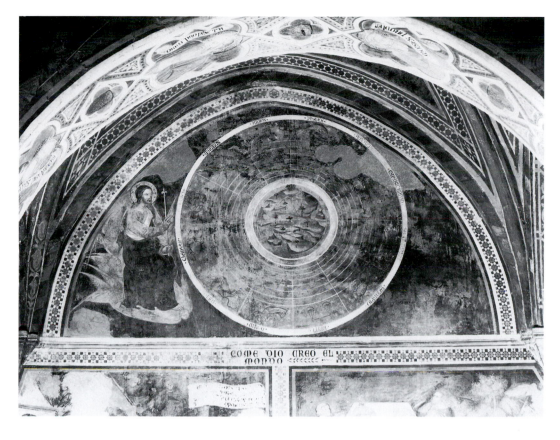

Plate 226 Bartolo di Fredi, *The Creation of the World*, 1367, fresco, south aisle, Collegiata, San Gimignano. Photo: Lensini.

Giorgio,[48] incorporates a complex figural composition set within a highly competent representation of a sophisticated architectural building (Plate 228). The tripartite building portrayed not only provides a striking backdrop for the scene of the saint's torture upon a wheel but also offers glimpses of two vaulted upper rooms where subsidiary events from the legend of the saint are depicted. Meanwhile, the figures within the painting constitute an ambitiously conceived crowd scene reminiscent of other works by the artist, including most notably the panoramic *Crucifixion* from the Chapel of Bonifacio Lupi in the adjacent church of the Santo. The subject of Saint George also offers Altichiero a chance to portray a semi-naked body, convincingly rendered to show the outlines of the saint's rib-cage as he lifts his hands in prayer above his head. Among the onlookers on either side, a variety of physiognomies are included, encompassing different ages, genders and ethnic types. In the case of the figure on the extreme left, dressed in black, the distinctive haircut and individualized features suggest a portrait of a specific individual.[49]

A number of late fourteenth-century Paduan works of art, particularly those by or associated with Altichiero, include fairly ambitious representations of pictorial space. For example, another mural in the Oratory of San Giorgio, *The Funeral of Saint Lucy*, depicts a complex building seen in perspective (Plate 229). Another example occurs in a drawing that has plausibly been attributed to an artist working within Altichiero's circle in late fourteenth-century Padua (Plate 230).[50] The drawing, which offers a remarkably detailed and accurate representation of the Santo, renders the perspective of the building from an angular viewpoint, whereby every detail of the building is seen as if at an angle.

Whilst the draughtsman has thus been able to describe the complex apsidal chapel system of this Paduan church very accurately, he undoubtedly attained such an objective by means of empirical observation rather than by using the single vanishing point system, which was the achievement of the fifteenth century. Such concern with the way that objects are perceived in space – and indeed the crucial role of light in this respect – finds a broad parallel in the well-developed interest in optics at Padua University, of which Biagio Pelacani's influential treatise on perspective, entitled *Questiones Perspectivae*, is a striking example.[51] It should, however, be acknowledged that the kind of perspective studied at the university did not obviously provide or naturally lead towards a technique of pictorial perspective. At the most it would appear that within late fourteenth-century Padua there was a well-developed concern on the part of both university scholars and artists with how things appear to the eye. The manner in which such concern was expressed was, however, strikingly different.

CONCLUSION

In the light of the evidence surveyed in this essay, it is at least plausible to suggest that Padua's *studium generale* and the work and scholarly interests of its professors and students exercised a decisive influence upon the kind of art produced in Padua throughout the fourteenth century. An interest in matters of astrology and astronomy and the question of perspective is evident in a number of major Paduan works of art in this period. In addition, the early interest in the study of the humanities among Padua's governing and administrative

Plate 227 Giotto, *The Feast at Cana*, 1304–13, fresco, north wall, Arena Chapel, Padua. Reproduced by courtesy of Musei Civici Padova, Gabinetto Fotografico.

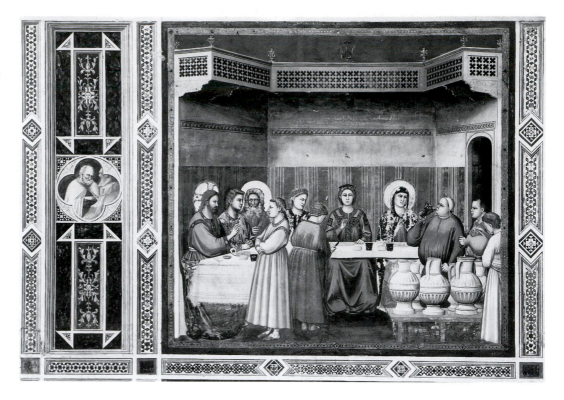

Plate 228 Altichiero, *The Martyrdom of Saint George*, 1380s, fresco, east wall, Oratory of San Giorgio, Padua. Reproduced by courtesy of Musei Civici Padova, Gabinetto Fotografico.

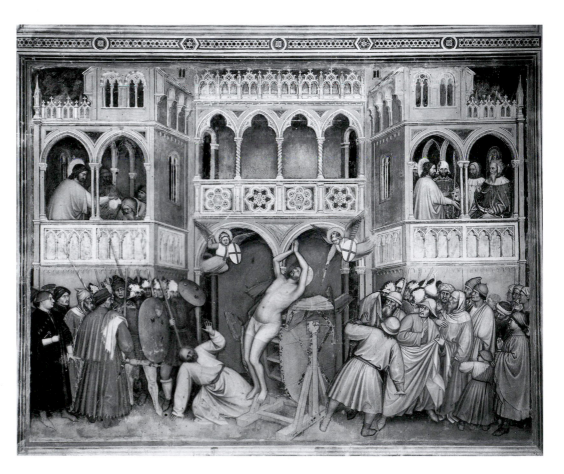

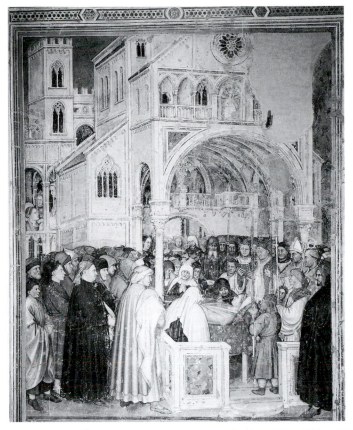

Plate 229 Altichiero and assistants, *The Funeral of Saint Lucy*, 1380s, fresco, west wall, Oratory of San Giorgio, Padua. Reproduced by courtesy of Musei Civici Padova, Gabinetto Fotografico.

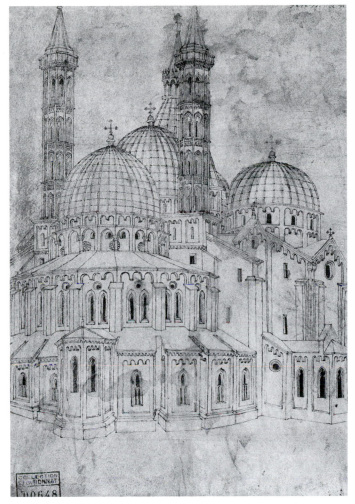

Plate 230 Anonymous, drawing of the Santo, late fourteenth-century, pen and ink, 26.1 x 18.4 cm, Musée Bonnat, Bayonne.

officials – an interest further stimulated by the presence of Petrarch in the city – may also have effected the prevalence of secular, and often classical, themes in the art patronized by the Carrara and their close associates.

In respect of the collective influence of empiricism, astrology and antiquity, fourteenth-century Sienese and Florentine art apparently exhibits a significantly different pattern. The paintings of the Sala dei Nove in Siena and the Florentine Campanile sculptures provide compelling evidence of the impact of empirical observation and interest in the portrayal of astrological and classical themes and motifs. Even in these schemes, however, the intense interest in astrological and astronomical matters apparently characteristic of Paduan art is not repeated. In both the Sala dei Nove and the campanile schemes it is empirical and classical concerns that predominate.

In the second half of the fourteenth century, moreover, an even more marked divergence between Paduan art, on the one hand, and Florentine art, on the other, appears to emerge. Although the Sienese and Florentine concern with empirical observation remains constant, the interest in both astrological and classical themes apparently diminishes. Neither vanishes completely. For example, portrayals of illustrious men from antiquity figure in Taddeo di Bartolo's early fifteenth-century

scheme for the Palazzo Pubblico in Siena (Chapter 8, Plate 185), and astrological symbols feature in the border of *The Fall of Walter of Brienne, Duke of Athens* (Chapter 7, Plate 147) for the interior of the debtors' prison in Florence. However, these appear to have been exceptions rather than examples of a common or widespread continuity of interest in such matters within later Sienese and Florentine art. Thus, the intensity of interest, relative prominence and insistent recurrence of these preoccupations in Paduan art is notably absent in that of the other two cities.

It is possible that this apparent distinction may be the result of factors other than the influence of the respective intellectual milieux of the three cities. It may be that opportunities for commissions that reflected such interests did not arise in either Siena or Florence in the second half of the fourteenth century. Similarly, it may be that works from these decades that once incorporated such concerns have not survived – a perennial problem in the evaluation and interpretation of trends in fourteenth-century art. However, it may also be the case that this distinction between the art of Siena, Florence and Padua registers a genuine difference in the intellectual preoccupations of the three cities, and emphasizes the uniquely influential legacy of Paduan scholarship and humanism.

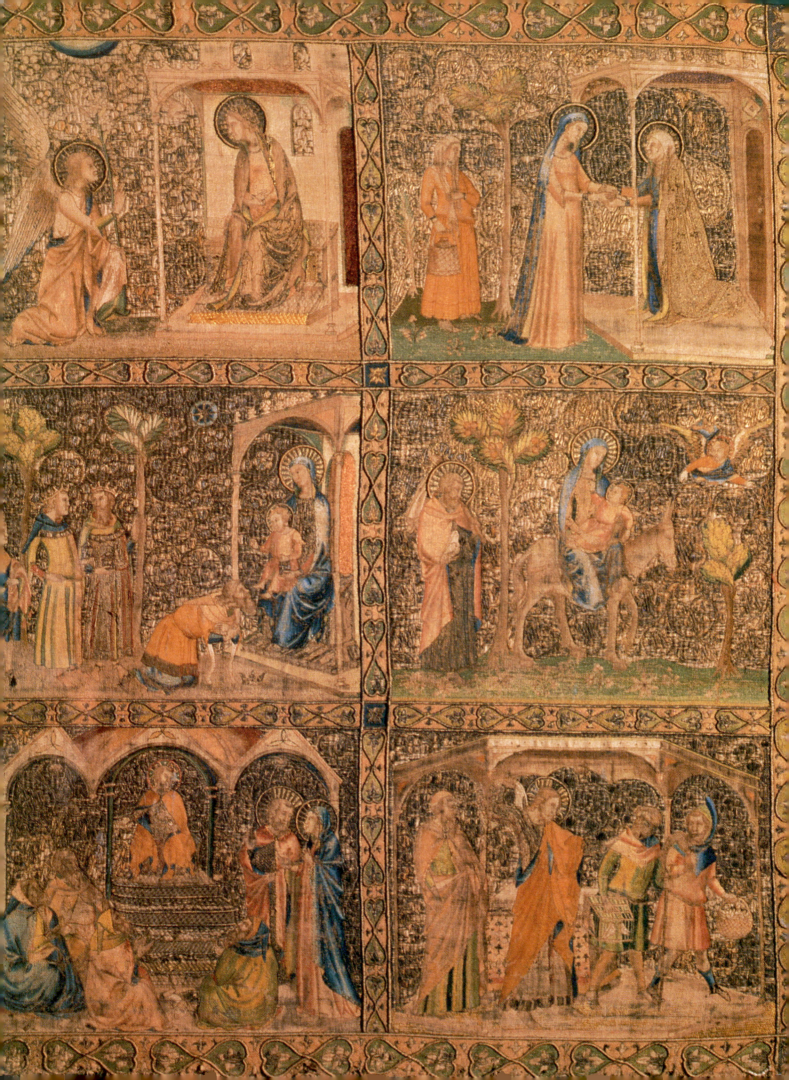

CHAPTER **11**

The Trecento: new ideas, new evidence

The way viewers see fourteenth-century Italian art and architecture is conditioned by their cultural and personal attitudes, and by the state in which art is presented to them. These conditions of viewing have been moulded in large part by generations of historians and critics. For example, NASA's decision to call the Mars space probe 'Giotto' relates to one of the earliest historical appraisals of this artist: in the second half of the fourteenth century, Filippo Villani described Giotto as setting out to record and observe reality for the first time since antiquity. For me and presumably many others, such a choice singles out works attributed to Giotto as likely to be packed with observation of the universe. Historians have also made important decisions about the material conditions in which objects are seen. The coin, medal or embroidered cloth has been placed in the museum along with other minor or decorative arts, while the altarpiece or monumental sculpture is in the gallery and has come to be regarded – through the acceptance by historians of the theories of the academies of art – as belonging to the category of fine art. In such circumstances the viewer may be discouraged from paying attention to a small item like the gold seal of the Sienese convent of Santa Chiara, although arguably it would have been regarded at the time as worthy craftsmanship (Plate 232).[1] And, outside museums, historians have often determined the condition in which fourteenth-century art is seen. Thus, the tomb of Bishop Orso in Florence Duomo, inscribed as by Tino di Camaino, was taken down in 1850 but reconstituted in part in 1905, and there has been considerable debate as to the survival and original positioning of other components belonging to this monument (Plate 233).[2] Historians have shaped the way viewers understand works of art, what they count as works of art at all, and the physical conditions under which they see them. Consequently, the importance of considering their work lies not only in explaining the formation of the interpretations available to us now, but also in assessing the value of our own efforts to tell the story of fourteenth-century art.

Studying the writing of historians of art – historiography – can be seen in a variety of ways. At one extreme, it may show that historians have developed better and better descriptions and explanations of what happened in the past. At the other, it may show that each group of historians at any time constructs a story about the past which suits its interests. Or, taking a middle view, it may be thought to show that historians offer partly wishful thinking and partly an accurate description of what happened and why.

The progressive model will treat historiography as a charting of the progress of art history, showing how secure data have been accumulated, methods of enquiry tried and tested, and false approaches discarded. The analogy might be

Plate 232 Anonymous Sienese goldsmith, seal of the convent of Santa Chiara, Siena, fourteenth century, gilded bronze, 5.3 x 3.1 cm, Museo Nazionale del Bargello, Florence. Photo: Scala.

with the development of a craft – the craft of history. Historians may well then see themselves as pushing forward frontiers of knowledge, and consider the range of interpretative options open to them as superior to those in the past. Their ultimate aim is to know all there is to know about an epoch.

But historiography could be regarded less in a developmental way and more in terms of tracing the changing roles that statements about past art have played in different societies, and the variety of interests which the writing of the history of art has served. Any historiography provides some understanding of what has happened to works of art over time and how we have arrived at our particular cultural standpoints. However, less progressive models tend

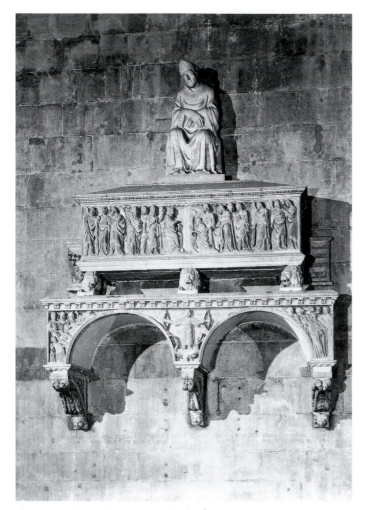

Plate 233 Tino di Camaino, tomb of Bishop Antonio Orso, reconstructed *in situ*, 1321–23, marble, height of seated bishop 132 cm, Duomo, Florence. Photo: Scala.

to counsel modesty. If we treat historiography as the account of the series of myths that each generation of historians has woven entirely to serve its own interests, we may regard our own efforts also in an evanescent light, as telling stories that convey our own fears, delights and needs.

Otherwise, we could take some kind of half-way position, arguing that historians must speak from cultural and social perspectives (only some of which they are conscious of having) in order to deduce plausible interpretations and collect data, without claiming that they obtain the whole truth. From this point of view, the way historians have accumulated secure documentary evidence – for instance, of the attribution and dating of works – could represent the achievement of a body of truths, but one which is so incomplete, so easily misrepresented and so unlikely to be adequate for answering all the questions of future historians that it cannot be considered to be the final truth.

From this position, we might consider those who have treated art history as the history of artists – dwelling on the careers of specific individuals – as offering interpretations of art which serve societies supporting the values of self-help and *laissez-faire.* At the same time, such an approach arguably can make sense of some aspects of fourteenth-century Italian art. Equally, we might trace the connections between accounts

of the material techniques and media used to create art, and the requirements of museums and restoration laboratories. In an interview given in 1992, the head of the restoration department of the Uffizi Gallery, Alfio del Serra, convincingly announced that the normally hidden back of a panel was more informative and beautiful than the front.[3] His statement made clear the surprising priorities of those working as historians in the area of restoration. Del Serra's point of view has parallels with the approach of feminist historians in considering the previously hidden aspects of women as commissioners or audiences of art and as users of buildings and urban space. There are, then, multiple stories to tell with interests to benefit and, at the same time, new data to find and good working hypotheses to present. Indeed, it has been argued that the more interpretations there are from different points of view, the more likely we are to collect reliable data and good working hypotheses.[4]

An example of such a hypothesis might be the attribution of the *Rucellai Madonna* to Duccio. It is now generally accepted that the Sienese artist Duccio painted the *Rucellai Madonna* in the Florentine church of Santa Maria Novella (see also Chapter 3). However, this is an extremely recent attribution, and following the influential assertion of the Florentine historian Giorgio Vasari, for three centuries it was accepted that the Florentine Cimabue had made this altarpiece. Only in 1782 did the champion of Sienese artists, Guglielmo della Valle, suggest that Cimabue had not been the author of the panel, attributing it instead to a Sienese master, Mino da Torrita.[5] In a polemical spirit, della Valle argued on stylistic grounds to assert Sienese claims to having played an important part in the initiation of the renaissance of painting, as against Florentine claims of primacy. Encouraged by della Valle's proposal, in 1790 Vincenzio Fineschi pointed to information in the archives of Santa Maria Novella recording a contract in 1285 between the rectors of the Compagnia di Santa Maria and Duccio to paint a large panel of the Madonna as probable evidence of the authorship of the *Rucellai Madonna.*[6]

However, Duccio's authorship was not widely accepted until well into the twentieth century. In the mid nineteenth century Jacob Burckhardt, in his authoritative *Cicerone,* described the *Rucellai Madonna* as 'an apparition from on high' exemplifying Cimabue's all-powerful influence on his contemporaries.[7] In 1903 Sir Joseph Crowe and Giovanni Cavalcaselle could still report that the attribution was being questioned – by Roger Fry – though they themselves supported Fineschi's suggestion and considered the *Rucellai Madonna* to be by Duccio.[8] And if we consult Bernard Berenson's magisterial text published in 1932, we find that he preferred to attribute the *Rucellai Madonna* to the 'Master of the Rucellai Madonna', whom he described as working in a manner midway between that of Cimabue and Duccio.[9]

It was possible for historians to disagree about the attribution because the evidence linking Duccio to the panel was only circumstantial. First, there was the contract of 1285 between the rector of the confraternity and Duccio. Secondly, it could be shown that the confraternity had the patronage of a chapel in Santa Maria Novella. Thirdly, the first evidence concerning the painting known as the *Rucellai Madonna* came from Vasari 265 years after its probable execution, stating that

it was hanging on the wall *outside* the chapel patronized by the confraternity. Though it is a good circumstantial case, the time lapse makes the connection between the contract and the panel somewhat tenuous. The issue was, and is, crucial to estimations of the role of Sienese and Florentine painters, as well as views of the careers of Duccio and Cimabue. At different times and for different historians, the *Rucellai Madonna* has stood for the quintessentially Florentine initiation of the rebirth of painting, or the Sienese renovation of pictorial art, or an admixture of Sienese and Florentine approaches.

What is to be learned from this? Shall we say that we have progressed to the truth that Duccio painted the *Rucellai Madonna* after centuries of misapprehension? Shall we say that histories are powerful interest-serving myths, and the *Rucellai Madonna* belonged to Florence for as long as the shadow of Vasari fell across viewers and historians – that it could begin to belong to the Sienese Duccio as the cultural partisanship of Italian cities began to fade slightly after the unification of Italy in 1875? Or shall we say that it seems a plausible working hypothesis at present to attribute the panel to Duccio, but given the ambiguities of the documentary evidence and the way it seemed so obvious for centuries that the panel was by Cimabue, the future may see yet other shifts in attribution using as yet unimaginable scientific and technical approaches?

The historiography of art provides many other case studies showing how historians from different epochs have interpreted artistic work in varying ways. For example, the murals of the Spanish Chapel at Santa Maria Novella in Florence were from the 1560s attributed to the Sienese Simone Martini and to the Florentine Taddeo Gaddi (Plate 234).[10] During the eighteenth century the scholarly champion of Sienese art, della Valle, put forward the murals as representing the Sienese style as opposed to the Florentine. By the early twentieth century it was considered that the murals were so close in style to ones in the Camposanto, Pisa documented as by 'Andrea da Firenze' in 1377 that Vasari's sixteenth-century attribution could no longer stand. Yet in their discussion published in 1903, Crowe and Cavalcaselle still responded to the long tradition of Sienese attribution, writing that the scheme seemed to represent the 'spirit of the Sienese school'.[11] Only in 1916 were documents published showing that payment was made to Andrea Bonaiuti of Florence in 1365 for his painting of the Spanish Chapel, which he probably started the following year.[12] In this case a truth – not a good working hypothesis – about the authorship of the murals is now known, because the archival information can be linked to a mural scheme that (unlike the *Rucellai Madonna*) is an integral part of the vault and wall structure of the chapel.

However, to new generations of historians who know from other documented works and the size of the enterprise that the murals must have been made by a team, much remains unknown: for instance, the names of the artists who worked with Andrea Bonaiuti and the adviser(s) who helped invent the iconographical scheme. For these historians, interested in comprehending the process of collaboration, shorthand statements that the murals are 'by Andrea Bonaiuti' cannot be claimed to be truthful. From this viewpoint, the facts about

the authorship of the chapel are incomplete and easily misrepresented. Furthermore, other groups of historians will in all likelihood be interested in different sorts of enquiry, such as the nature of fourteenth-century audiences of the mural or the ways in which things and people have been represented. Since the 1960s there has been growing interest in considering the ways in which certain sections of society were excluded from making or controlling art, and a growing concern for the interests served by the exclusive nature of representation. How did images normalize certain notions of power in society and the Church? What purpose did art serve? For example, in the scene of *The Pentecost* in the Spanish Chapel, it seems of interest to note the way the inventors and executors of the programme decided to show people from all over the world – a Turk with a turban, an African with dark skin, and a Chinese with a pigtail (Plate 234). Andrea showed these people as inferior and still shut out from the superior truth belonging to Christians. He portrayed them as singular and masculine, too, as if a stereotypical image was sufficient to stand for a mass of different individuals. To different groups of historians, the truth about the name of the artist who led the group executing the mural programme will have different value, being of precious significance for a biographer of artists though of peripheral importance for a student of iconography.

THE EARLIEST HISTORIES: LATE FOURTEENTH TO EARLY SIXTEENTH CENTURIES

The most powerful accounts of artistic events during the fourteenth century as a whole were initially created and maintained in Florence, beginning with the earliest historical statements written in the late fourteenth century and culminating in the *Lives of the Artists* produced in the mid sixteenth century by Giorgio Vasari. Florence defeated Pisa (1509) and Siena (1555), and Florentine historians absorbed and demoted the stories of the artists of their subject cities as they told of Florentine prowess and invention. Similarly, Padua was conquered by Venice (1405), and while local historians of Padua did continue to some extent to praise their artists, the dominant voice was that of Venice. In this situation Duccio and Guariento were marginalized, while Cimabue and Giotto were given priority.

The earliest text to take an overview of artistic events seems to have been that by the Florentine Filippo Villani. Around 1380 he composed a series of 35 biographies of notable poets, statesmen, doctors, jurists, orators, astrologers and musicians from his city – and included one painter, Giotto. Relying on the example of ancient writers who had counted their artists among illustrious men, Villani decided that he could

> record my worthy Florentine painters who awoke an art which was wandering off the path and was practically extinct, among which the first was Giovanni called Cimabue, who with skill and talent began to call back ancient painting to that likeness to nature from which painters had wandered and strayed. Indeed, before this, Greek and Latin painting for many centuries had erred as the figures painted in the past on wall and panel openly show. After him, Giotto was not only equal to the ancient painters in most illustrious fame, but their superior in skill and talent. He restored painting to

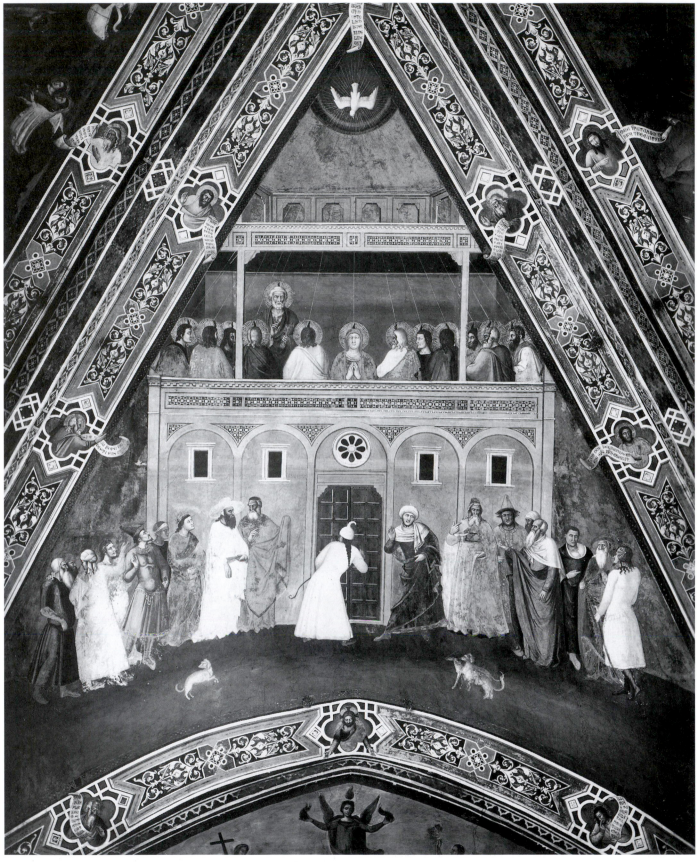

Plate 234 Andrea Bonaiuti, *The Pentecost*, 1366–68, fresco, Spanish Chapel, Santa Maria Novella, Florence. Photo: Alinari.

its ancient dignity and its greatest reknown, as appears in many paintings, especially in the church of Saint Peter's in Rome, where there is a marvellous work in mosaic represented with greatest skill. He also painted himself as a public spectacle in his city with the help of a mirror, and his contemporary the poet Dante Alighieri on the wall of the chapel of the Palazzo del Podestà.[13]

Villani went on to explain how from this 'pure and most abundant spring flowed the clearest streams to create a renovated painting'. The streams were metaphors for the disciples of Giotto, among whom he singled out Tommaso di Stefano, 'who painted most delicately with marvellous beauty', Stefano, who was an 'ape of nature', and Taddeo Gaddi. This account concentrated on painting, assessing it in terms of delicacy, beauty, likeness to nature, and the renovation of its ancient prowess. Cimabue and Giotto are singled out as agents for change, the former recalling painting to the true path, and the latter as a reviving spring of clear water.

Born about 1370 near Florence, the Florentine-trained Cennino Cennini moved to Padua in 1398. It was probably there that he wrote his craftsman's handbook *Il libro dell'arte*, which contains a glimpse of his notion of art history when he offers a genealogy of his right to be authoritative on technical matters:

> I was trained in this profession for twelve years by my master, Agnolo di Taddeo of Florence; he learned this profession from Taddeo, his father; and his father was christened under Giotto, and was his follower of four-and-twenty-years; and that Giotto changed the profession of painting back from Greek to Latin, and brought it up to date; and he had more finished craftsmanship than anyone has had since.[14]

By Greek, Cennini meant what we call Byzantine.

The Florentine sculptor Lorenzo Ghiberti made a short statement about fourteenth-century Florentine art as preface to his own biography written about 1450, emphasizing like Cennini that Giotto had stepped decisively away from Byzantine Greek practices. This account was preceded in his *Commentari* by a first section devoted to the lives of the ancient Greek and Roman artists. Like Cennini, Ghiberti saw himself and the artists of the fourteenth century as 'moderns', for he began his second section by explaining that, after the Emperor Constantine (early fourth century A.D.), the statuary and painting of the ancients, which were of such nobility and perfection, were destroyed along with the knowledge of drawing and theory that created such noble arts. The Greek (meaning Byzantine) artists feebly began to paint, but it was not until one of their number, Cimabue, recognized the brilliant personal talent of Giotto when he was still a boy and took him as a disciple that the new art of painting was introduced:

> He [Giotto] abandoned the crudeness of the Greeks and rose to be the most excellent in Etruria. Wonderful works were executed especially in the city of Florence and in many other places. Many of his disciples were as gifted as the ancient Greeks. Giotto saw in art what others had not attained. He brought the natural art and refinement with it, not departing from the proportions. He was extremely skillful in all the arts and was an inventor and discoverer of many methods which had been buried for about six hundred years.[15]

So for Ghiberti Giotto unearthed the techniques suppressed after late antiquity. Most significantly, Ghiberti then mentioned a group of painters as followers of Giotto from not only Florence but Siena as well: Ambrogio Lorenzetti, Simone Martini and Duccio (who he said held to the Greek manner). He also noted that Sienese painters were in demand in Florence. Ghiberti had worked extensively in Siena himself on the Baptistery font, so he knew the city well. Ghiberti then mentioned the names of some sculptors (Giovanni and his father Nicola along with Andrea Pisano), adding a few works he thought they had made, but without comment on their artistic role.[16]

Some fifteenth-century Florentines were more inclined to see fourteenth-century artists as preliminaries to the great achievements belonging to their own time. For instance, in 1473 Alamanno Rinuccini wrote in the preface to his translation of the life of Apollonius by Philostratus of the way in which

> the arts of sculpture and painting, graced in earlier times by the talents of Cimabue, Giotto and Taddeo Gaddi, have been carried to such greatness and excellence by painters who flourished in our own age, that they may well deserve to be mentioned beside the ancients.[17]

Like Ghiberti, Christophoro Landino's preface to his commentary on Dante's *Divine Comedy*, written in Florence in 1480, treated fourteenth-century painters as his predecessors after he had dealt with the ancient painters:

> Giovanni the Florentine, called Cimabue, was the first who retrieved the natural lineaments and the true proportions which the Greeks call symmetry, and the figures which in earlier paintings were dead he made living with varied gestures. But Giotto was so perfect and absolute that long afterwards others tired themselves out trying to do better.[18]

Landino then provided the names of some Florentine followers of Giotto.

The Florentine Leonardo da Vinci saw fourteenth-century events rather differently. He recorded his ideas in a statement written in the 1490s as part of an unpublished treatise on art probably written at the court of Milan. He made the story of Giotto's turning back to nature into an exemplar for the fifteenth-century artist. In his view the decline of ancient art had occurred when artists did nothing but copy one another, and art had been rescued from this situation only by Giotto. However, artists had then copied him and the standard had again declined, though Masaccio in the fifteenth century had shown the way to turn back to nature.[19]

However, with Leonbattista Alberti (1435) and Antonio Averlino il Filarete (c.1460) in their treatises on art, we find that Florentines could take a completely negative view of fourteenth-century practitioners. Alberti highlighted solely the innovations of his contemporaries; Filarete stated that only in his time had Filippo Brunelleschi revived the good antique way of building, while previously architects had erroneously adopted German and French methods imported from across the Alps – which he called the *maniera tedesca* (German style).[20]

The first century of the history of Trecento art, therefore, shows contrasting approaches. Ghiberti saw fourteenth-century products as having a continuous relation to his own

...M PERQVEM PICTVRA EXTINCTA·
...M RECTA MANVS TAM FVIT ET FA...
...DEERAT NOSTRAE QVOD DEFVI...
...VIT NVLLI PINGERE NEC MELIVS

Plate 235 Benedetto da Maiano, tomb portrait of Giotto, 1490, marble, Duomo, Florence. Photo: Scala.

time, uniquely recognized Sienese painters, and had a word for sculptors with their Pisan-derived names. Filarete and Alberti did not consider fourteenth-century artists in general as contributing to the Renaissance of the fifteenth century at all (although Alberti did describe Giotto's *Navicella* as a model narrative). Leonardo suggested that Giotto's innovation in painting was followed by decline among his copyists not arrested until the appearance of Masaccio. All but Ghiberti focused solely on Florentines. And it is worth drawing attention to the earliest portrait of a painter to be commissioned in order to commemorate his role in modern art. This is the portrait bust of Giotto probably ordered by the Medici family, and placed in 1490 in the Duomo of Florence on the aisle wall nearest Giotto's campanile. The bust was sculpted by Benedetto da Maiano (Plate 235). The epitaph written by Angelo Poliziano repeated the century-old Florentine myth of Giotto as artist life-giver: 'Lo, I am he by whom dead Painting was restored to life, to whose right hand all was possible, by whom art became one with nature. No-one ever painted more or better.'[21] And where art becomes one with nature, the artist is a little god.

The writers of Siena, in contrast, were silent on the prowess of their artists, while those of Padua were muted. In his praise of people who had lived and worked in Padua, composed around 1460, Michele Savonarola (a Paduan scholar at the Ferrarese court) recorded that 'the fame of Guariento and Giusto was still most outstanding given their marvellous and glorious paintings'. He also noted that many took the opportunity on Ascension Day – when the Sala Maggiore in the Doge's Palace in Venice was open to all – to see Guariento's murals. He dwelt on 'the great artifice in figural compositions' provided in the decoration of the Baptistery in Padua by Giusto. Michele then praised the works of Giotto in the Arena Chapel, Jacopo d'Avanzo of Bologna in the Lupi Chapel in Sant'Antonio, Altichiero of Verona in the Oratory of San Giorgio, and Stefano of Ferrara in the altar chapel of Sant'Antonio.[22] According to the reports of the Venetian antiquarian Marcantonio Michiel written in the 1530s of the works of art to be seen in Padua, the fifteenth-century painter Girolamo Campagnuola and the sixteenth-century sculptor Andrea Riccio had made art-historical records too, but these have not survived.[23] The absence of Paduan or Sienese interpretations of their own histories at this time created something of a cultural power vacuum.

THE GEOGRAPHY OF ART HISTORY

Florentine prominence in art was given great impact through being incorporated into the general history of artists by Vasari, also a Florentine, in 1550 and revised in 1568. The title shows what universalizing claims he was making: *The Lives of the Most Eminent Painters, Sculptors and Architects …* (now generally known by a condensed title, *Lives of the Artists*). And because his book was the first independent text devoted to art history to be written in the west since antiquity, his views had great prestige. Vasari stated in the first preface to the *Lives* that, after the disastrous decline he thought had occurred following the fall of the Roman Empire in Italy, some progress had been made in architecture from the ninth to the eleventh centuries in the Tuscan cities of Lucca and Pisa and at Saint Mark's in Venice. However, he still began his account of the rebirth of art with the life of Cimabue, who, he said, had originated the new way of drawing and painting. He then went on to present Giotto as the real hero of the infancy of art: 'for he had opened the door of truth to those who have subsequently brought the art of painting to the greatness and perfection it can claim in our century'. Vasari announced that the arts, 'like human bodies, are born, grow up, become old, and die'.[24] And he divided the history of modern art into three periods corresponding to childhood, youth and adulthood. The art of Cimabue and onwards during the fourteenth century comprised the babyhood of the rebirth in this system, while much of the fifteenth century saw its youth. The art of the generation of Leonardo, Michelangelo, Raphael and Titian lasting up to his own time represented the triumphant maturity of the standards and achievements of ancient Greek and Roman art – for which he coined the term *rinascita* or renaissance.

While he offered a sequence of biographies, each with an engraved portrait, Vasari announced that he would actually be dealing with artists according to schools and styles rather than chronologically. Like Filarete, he felt that the Gothic style of northern Europe was an intrusion and, like Cennini, he saw Giotto as improving on the Byzantine style or *maniera greca*. Although he followed Ghiberti in mentioning some Sienese painters and Pisan sculptors, he gave them much less space

than Florentines. Padua received similar treatment. Vasari's book was linked with the foundation in 1563 of the first academy of art in Florence, the Accademia del Disegno. It stood for a new programme of education outside the craft guilds and workshops, for the professional status of the artist, and for the idea that sculpture, painting and architecture were intellectual, imaginative activities employing the theory of design. It also put a high premium on individual creativity. Vasari's history, then, offered a very narrow definition of the arts in comparison with that which had operated in the fourteenth century. For the next two centuries and more, Vasari's interpretation – which valued fourteenth-century art for the ways in which it could be shown to pave the way for the conquest of realistic techniques and classicizing styles in the High Renaissance of the late fifteenth and early sixteenth centuries (and was therefore highly teleological) – dominated art history.

Although Vasari's main lines of argument were largely followed, nevertheless a favourite topic was the rebuttal of his proposition that the Renaissance had begun in Florence. Historians of different cities scoured their churches for early inscribed paintings and their archives for evidence of local activity to prove him wrong. For example, in *Le meraviglie dell'arte* (1648) the Venetian Carlo Ridolfi claimed that about 1300 Venetian painters had begun to improve on previous techniques without the help of the Florentines, and he described the Paduan Guariento's *Paradise* in the Doge's Palace with admiration.[25] The Sienese scholars Giulio Mancini (1621) and Isidoro Azzolino Ugurgieri (1649) pointed to known Sienese predecessors of Cimabue, praised the Byzantine modes of painting, and spoke for the first time of a 'Sienese school'.[26] Such claims brought lengthy replies as, for example, in the history by Filippo Baldinucci (1681) published in Florence, whose title – 'Information concerning the professors of design from Cimabue onwards by which is demonstrated how and through whom the fine arts of painting, sculpture and architecture, lost in the crudeness of the Greek and Gothic manners, were in these centuries brought back safely to their ancient perfection' – explains his earnest intentions.[27]

This topic has been sustained, and presumably will continue to be so, as long as Italian identities belong to their different cities. Local historians continued to use their archives to create different, richer stories of their art. In the case of Guariento, for instance, the important local historian was Giovanni Verci, who wrote a history of painting in Bassano del Grappa published in 1775; he saw Guariento as the complex product of Byzantine techniques, contact with Bolognese painters, the influence of Giotto's work in Padua, and his own interests and powers.[28] By the early nineteenth century Giovanni Moschini (1826) could write a history of Paduan painting which stated:

> the fourteenth century was the century in which one may say the art of painting made such advances in Padua that, in this respect, it was permitted in this epoch to enter into the field to prove itself along with all the other Italian cities.[29]

While he admitted the role of the Florentines Giotto and Giusto de'Menabuoi, as well as Avanzo of Bologna and Altichiero of Verona, he also described the career of Guariento of Padua. Historians like della Valle (1782–83) and

Gaetano Milanesi (1854–56) meanwhile piled up documentary evidence to testify to the immense vitality of Sienese artistic life. Arguing that the renovation of painting was due to the artist Jacopo Torriti (in his view Sienese), della Valle saw Sienese painting as being to Florentine as poetry is to science and imagination is to thought.[30] But he also considered other aspects of art such as sculpture and the systems of commissioning and training – for instance, he carefully researched the career of the sculptor Gano da Siena, and collected information on the running of the guilds and the modes of artistic patronage. Milanesi amassed enough documentary evidence to allot one of his three volumes of sources for Sienese art to the fourteenth century, and proceeded to deliver the *coup de grâce* with his critical edition of Vasari's *Lives* (1878–81).[31] It is, however, instructive to note the way Milanesi's overarching Tuscan allegiance against the Italian south swung into action as he dismissed the suggestion of Carl von Rümohr (1837) that Pisan sculptors owed their new ideas to the father of Nicola Pisano – documented as Pietro of Apulia. Milanesi devoted a long footnote to arguing that this Apulia was a village near Lucca or Arezzo and certainly not the southern province of Puglia.[32] The importance of identity in determining response to reasonable argument is suggested by the way that, in contrast, Crowe and Cavalcaselle – publishing in Britain in 1903 – could view with equanimity the idea of the Tuscan sculptural renaissance beginning in southern Italy.[33] For the schools of sculpture flourishing around Brindisi and Naples in the thirteenth century were producing designs of a monumental classicism which could plausibly be regarded as helping, through the journey of Pietro of Apulia, to found the art of the Pisans.

GOTHIC AND BYZANTINE ADMIRED: A WIDENING CONTEXT FOR INTERPRETING THE FOURTEENTH CENTURY

During the seventeenth and much of the eighteenth centuries, contemporary artists dismissed fourteenth-century art, with guidebooks to Italy ignoring Siena completely and failing to mention anything from this period as worth seeing in Padua.[1] The writing of history was driven by local pride, by devout antiquarianism, and to record what Vasari termed the 'First Period' of art – the fourteenth century – which had culminated in the Renaissance of Leonardo, Michelangelo, Raphael and Titian. However, during the eighteenth and nineteenth centuries, some artists turned to those of the fourteenth century as exemplars, as the Gothic and Byzantine styles of the Middle Ages came to be admired for such qualities as 'heartfelt spiritual depth', 'elevated concepts', 'purity' and 'infinite original beauties' – to quote Count Leopoldo Cicognara (1813) and von Rümohr (1837).[35] In contrast, Cicognara saw the 'science of Florence' as restricting the imagination. He preferred a lack of interest in realistic techniques because he thought it represented freedom from the mere surface delights of 'the harlot appearance'.[36] A historian like Giovanni Lami writing in 1757 could support the value of Byzantine art against the disparaging remarks of the Vasarian tradition, and praise works made in the eleventh century 'which are quite admirable whether one regards their design, their life-likeness, or their nobility of colouring'.[37]

According to Cicognara, painting never died so it did not need Cimabue and Giotto to revive it. With such values in mind, von Rümohr feared that the discoveries of Giotto ushered in decadence, since artists were increasingly tempted to employ realistic techniques to serve their capricious fancies rather than religious beliefs. As far as building was concerned, in 1781 Francesco Milizia could describe Gothic architecture as 'more virile than the modern mime of the classic Greek and Roman magnificence'. Milizia delighted in this 'extraordinary type of architecture, scattered with irregularity, strewn with transgressions against art and monstrous offences against nature'.[38] Nevertheless, in a deeper way he thought that it did relate to nature, being 'all original, that is dug out from nature, but from a nature studied in all its grandeur, in all its combined living beauty and majesty'.[39]

At the same time, della Valle was writing of Giotto's murals in the Arena Chapel that 'they have the same irregularity and the same beauties that are scattered throughout the *Divine Comedy* of Dante'.[40] In such contexts fourteenth-century art could be valued insofar as it belonged to the end of the medieval period rather than the beginning of the Renaissance. And even when an author clung somewhat to seeing the period as the threshold to the Renaissance, it was possible to praise the effects for more than their promise. In his *Sketches of the History of Christian Art* (1847), Lord Lindsay admired fourteenth-century artists in these terms:

> There is in truth, a holy purity, an innocent naïveté, a child-like grace and simplicity, a freshness, a fearlessness, an utter freedom from affectation, a yearning after all things truthful, lovely and of good report, in the productions of this early time.[41]

The value systems for describing fourteenth-century images and buildings solely according to whether they were more or less realistic or classicizing were disturbed, and the teleological views of Vasari were called into question. The interest in Gothic and Byzantine styles – and medieval art in general – developed along with the critique of a one-dimensional aesthetic like that of Vasari concerning the Renaissance, and Johann Winckelmann's (1764) approach towards classical Greek art. Bishop Richard Hurd (1762) could argue that both Greek poetry and Gothic writing are interesting and have their own separate criteria of goodness, while Friedrich Riedel (1767) insisted that taste changes from people to people, century to century, and person to person.[42] Wilhelm Wackenroder (1797) asked: 'Why do you not condemn the Indian who speaks Indian and not another language, and still wish to condemn the Middle Ages because its temples are not those of Greece?'[43]

As historians began to investigate the craft conditions in which art had been made in the medieval period, they also attempted to assess how meaningful the academic divide between fine and applied arts could be when studying an epoch before such distinctions had been drawn. They began to take pleasure in the products of anonymous groups of artists without seeking out the rare geniuses dear to Vasari. Most influentially, John Ruskin and William Morris expressed the view that medieval craft methods allowed freedom for the individual artist because they were indulgent to the imperfections of each person. Ruskin connected this

accommodation of idiosyncrasy with the development and power of Christian concepts of the importance of the individual soul. This artistic valuing of the individual was, he thought, absent in the more secular classical and Renaissance cultures. Ruskin thought that artistic freedom was suppressed in classical and Renaissance art to achieve an arid idealization, order, rationality and perfection. He praised the nature of Gothic in *The Stones of Venice* (1853), asking the viewer to

> go forth again to gaze upon the old cathedral front, where you have smiled so often at the fantastic ignorance of the old sculptors: examine once more those ugly goblins, and formless monsters, and stern statues, anatomiless and rigid; but do not mock at them, for they are signs of the life and liberty of every workman who struck the stone.[44]

When Ruskin visited the Arena Chapel in Padua a year after he published *The Stones of Venice*, he enjoyed describing Giotto as 'merely a travelling decorator of walls', 'a serene labourer' of 'healthy simplicity', whose murals had the effect on spectators of making them morally better.[45] Ruskin interpreted the Arena Chapel as displaying a 'symbolical art which addresses the imagination':

> It is especially to be noticed that these works of Giotto, in common with all others of the period, are independent of all the inferior sources of pictorial interest. They never show the slightest attempt at imitative realization: they are simple suggestions of ideas, claiming no regard except for the inherent value of the thoughts.[46]

It is from this phase of interpretations of the fourteenth century that 'Trecento' derives. The term was coined in English in the first half of the nineteenth century and is short for 'mille trecento', meaning one thousand three hundred. It stemmed from the artists and writers of the late eighteenth and early nineteenth centuries who were called 'trecentisti' for emulating the literature and art of fourteenth-century Italy.[47] (Such admiration did not go unquestioned. It is not hard to imagine the pleasure it gave Stendhal in his account of Italian art, published in 1817, to claim that the best art was created by decadent and luxurious societies, offering the example of the High Renaissance.[48])

The views of the 'trecentisti' did not necessarily replace the values of the academies, and the way the two bodies of ideas were often held together is nicely illustrated in the 1893 catalogue of the National Gallery in London. Sir Edward Cook, quoting Ruskin at every opportunity, explained that the viewer is to value the paintings of the fourteenth century both as the forerunners of the brilliant achievements of the High Renaissance and because, being free of concern as to imitative skills and knowledge of 'alien emanations from classic culture', the painters were the better able to express profound ideas and feelings.[49]

However, the development of research on and evaluation of Gothic and Byzantine art widened the repertoire of interpretations of fourteenth-century Italian art considerably. In these circumstances it could be treated, following the periodization of Vasari, as the early part of the Renaissance in Berenson's *Florentine Painters of the Renaissance* (1896). It could also be treated along with the fifteenth century as the time of the 'Primitives'. (This term, like 'Trecento', derived from an enthusiasm for archaic art; it was first used in the early

nineteenth century to describe the pupils of the French painter Jacques David, who emulated the style of the archaic period of ancient Greek vase painters. By the late nineteenth century the term was used to describe the art of Italy and the Netherlands before the Renaissance of the sixteenth century.[50] Alternatively, the fourteenth century in Italy could be called 'Italian Gothic', as in Burckhardt's *Cicerone* (1855).

From belonging to Florentines and later to the antiquarians and scholars of particular Italian cities who wished to criticize Vasari and his followers and to trumpet their prowess, the study of fourteenth-century Italian art came, through the rehabilitation of medieval art, to belong to the multifarious and lively debate about the Renaissance and the Middle Ages in general. In this debate it continues to stand in a sensitive and pivotal position as a result of reappraisals of Gothic and Byzantine art, and subsequent shifts and expansion in these fields of research.

'ART AND HISTORY ARE INSEPARABLE'

Something of the many-sidedness of the debate is displayed in the way historians have sometimes stressed the discontinuities between medieval and Renaissance societies, and at other times the continuities. For example, in the mid nineteenth century one could read either Ruskin or Burckhardt. Each saw Renaissance and medieval art as contrasting – but for opposing reasons. Ruskin extolled what he saw as the individual freedoms created by the spiritual values of Christianity in the Middle Ages, and contrasted the democracy of Gothic style to the tyrannies of Renaissance and classical culture. Burckhardt thought that the Renaissance developed the value of the individual artist, encouraged by the examples of personal fame in classical culture:

> In the Middle Ages both sides of human consciousness – that which was turned within and that which was turned without – lay as though dreaming or half awake within a common veil. The veil was woven of faith, illusion and childish prepossession, through which the world and history were seen clad in strange hues. Man was conscious of himself only as a member of a race, people, party, family or corporation – only through some general category. It is in Italy that this veil dissolved first; there arose an objective treatment and consideration of the State and of all the things of this world, and at the same time the subjective side asserted itself with corresponding emphasis. Man became a spiritual individual and recognized himself as such.[51]

Where Ruskin saw medieval individuality, Burckhardt read corporate lack of personal identity.

Equally, historians who would agree on linking medieval and Renaissance art have had very different grounds for their vision. For instance, both Henry Thode (1885) and Jean Seznec (1940) stressed the development of the Renaissance out of the Middle Ages, but for Thode the continuity was of Christian spirituality, while for Seznec it was the survival of the representation of classical deities. For Thode the individualism of the art of Giotto and his followers expressed the personalized religious mysticism and devotion which had been encouraged by the teachings of Saint Francis from the thirteenth century onwards. Nicola Pisano, Cimabue, Giotto and Giovanni Pisano 'were the first to express the new

emotional religious message of Franciscan poets and preachers in works of art.'[52] For Seznec a sense of continuity in European culture had been noted by historians like Charles Haskins (1927), who argued that there had been several renaissances during the Middle Ages – the most powerful being that of the twelfth century:

> As the Middle Ages and the Renaissance come to be better known, the traditional antithesis between them grows less marked. The medieval period appears 'less dark and static', and the Renaissance 'less bright and less sudden'. Above all, it is now recognized that pagan antiquity, far from experiencing a 'rebirth' in fifteenth-century Italy, had remained alive within the culture and art of the Middle Ages. Even the gods were not *restored* to life, for they had never disappeared from the memory or the imagination of man.[53]

A great variety of definitions and evaluations of the place of fourteenth-century Italian art have been created. At the same time, the forms in which the history of art have been written, the social and cultural positions from which they have been composed, and the issues that have been considered pertinent have shifted. Early accounts appeared in the format of guidebooks to Italian cities, in treatises on art, in prefaces to autobiographies, as part of the 'Lives of Famous Men' of a community. Only from the text of Vasari onwards were some histories of art written as a separate genre. In the eighteenth century, for example, the highly influential pieces of art history by della Valle appeared as a series of letters addressed to academies or individuals. The earliest art histories were composed by artists themselves like Ghiberti or scholars who have come to be called humanists: a term which denotes persons skilled in Latin and Greek, the *litterae humaniores*. In the seventeenth and eighteenth centuries art history was often written by clerics (the priest della Valle, for example) in a spirit of devout antiquarianism. In the eighteenth and nineteenth centuries art history began to be produced by those working for galleries like Luigi Lanzi (*Storia pittorica della Italia*, 1795–96), Antiquary of the Galleria Granducale of Florence, and university teachers like Franz Kugler, Professor of Art History at Berlin, who taught Burckhardt. From the standpoint of the academies Hippolyte Taine, who was Professor of Aesthetics and the History of Art at the École des Beaux Arts in Paris, composed a travel-book (*Voyage en Italie*, 1866) as well as publishing his lectures (*Philosophy of Art in Italy*, first translated 1876). Gallery and university could join forces with, for instance, the editions of Kugler's *Handbook of Painting: The Italian Schools*, first published in 1842, though edited by Sir Charles Eastlake and published in English in 1874. Eastlake was then Director of the National Gallery in London. The kinds of texts which have commanded an audience and the kinds of people who have produced them have been diverse.

Like pieces of art, pieces of art history are commissioned, are paid for, have specific audiences and are created by groups of individuals with identifiable powers as well as limitations. Like works of art, they belong to certain forms or genres of art history: the biography of the artist's career or the treatment of an entire period which groups artists according to different regional schools. These are the genres with which interpretations of fourteenth-century art and architecture began, and they continue to be used. However, during the

nineteenth and twentieth centuries the genres of art history have expanded. This period has seen the closest scrutiny of texts concerning art, using techniques developed by literary historians to make inferences from the internal evidence of the account – as in Milanesi's 1878–81 edition of Vasari's *Lives*, where he criticized the biography of Cimabue as largely fictional. Artefacts, too, have been subjected to the closest scrutiny, with an emphasis on obtaining the greatest possible information from examining the appearance and structure of the things themselves. Expertise has been built up through stylistic deductions of connoisseurship, employing archaeological approaches for buildings, and using laboratory analysis to infer dating, authorship and techniques. Broadly speaking, these technical approaches are linked with the conservation of objects in museums and galleries and the restoration of buildings by civic and ecclesiastical authorities.

Accompanying the detailed scrutiny of artefacts has come an interest in examining art and architecture in terms of the culture of which they were an integral part. How does a knowledge of the politics, economy, society, religious beliefs, science and arts explain what happened in art and architecture or guide our interpretation of artefacts? What sort of work did they do in the society which created them? How did art counsel humans to behave, and how did the structures of buildings and cities divide and unite people? The importance of the material and intellectual culture of a society for art and architecture is evident in the analyses of Ruskin and Burckhardt. By the late nineteenth century, writing a popular history of Renaissance art, Lucy Baxter (publishing under the pseudonym of Leader Scott) could confidently state that 'art and history are inseparable'.[54] In general, these approaches are linked with the development of art history as a subject to be studied at university or in the academy and, perhaps, with the making of histories suitable for a widening audience. Eugène Müntz, for instance, in his *Histoire de l'art pendant la Renaissance* (1889–95) considered the following topics: patronage, artistic traditions especially in relation to antiquity, religious and secular functions, artists' workshops and guilds, subject-matter, styles and techniques, and finally individual artists. In this century art historians have continued to debate the way these aspects interweave in the creation of artefacts and buildings, and in some cases have devoted detailed separate studies to some of these headings.

In the late nineteenth and the early twentieth centuries further shifts in taste took place in favour of abstraction in art, demoting the admiration for representational skills or allusive architectural designing, whether referring to medieval or classical styles. For viewers sharing the approach of Maurice Denis in the 1890s ('A painting is essentially a flat surface covered with colours arranged in a given order'), fourteenth-century compositions could be seen primarily as abstract designs – their flatness and attention to colour and pattern seen as of high value. Expression through abstract composition could now be seen in the Primitives when Denis stated that 'the photograph of a primitive is enough to remind us what our soul is and that its gestures are sublime'.[55] A concern for the expressiveness of abstract forms is sustained in Michael Ayrton's biography of Giovanni Pisano (1969) with an introduction by Henry Moore. For Moore, what was interesting was the way Giovanni used three-dimensional

forms poised in space to express ideas: Giovanni 'used the body to express his deep philosophical understanding of human nature'.[56]

Among the many important interests motivating historians during the nineteenth and twentieth centuries have been the Catholic revival – with its concern for the spirituality of the fourteenth century – the rise of nationalism – with its concepts of racial and linguistic groupings to explain different artistic styles – and the development of socialism with its ideas of the importance of understanding the economic and social structures that produce art. The viewpoints of the religious enthusiasm expressed in Catholic revival are evident in *De l'art Chrétien* by François Rio (1836–55). In the period of Cimabue, Rio wrote, 'there was the most intense concentration of ascetic spirituality which inevitably found its counterpart in an aesthetic spirituality'.[57] Giotto was the founder of a new tradition – an 'inspired legislator … [having] more sympathy with the people than Cimabue'. Giotto 'penetrated more deeply than he [Cimabue] did into the mysteries of Christian symbolism'.[58] Rio, however, preferred Duccio to Giotto, praising the *Maestà* in Siena Duomo as

> a happy mixture of grace and majesty, uniting with the maintenance of the traditional type something quite superior to the semi-byzantine designs of the thirteenth century, and to the prosaic Madonnas that the naturalist Giotto was beginning to provide for the Florentine bourgeoisie.[59]

With his preference for the spiritual, Rio defended the role of Siena, and he treated Florence and Siena as 'two sisters'. In Padua Rio enthused not only at the effects of the Arena Chapel, but also at the brilliant draughtsmanship and perspectival handling of the murals by Altichiero and Jacopo Avanzo in the Oratory of San Giorgio and the Lupi Chapel: 'the most beautiful work of painting that the fourteenth century had seen in the whole of northern Italy'.[60]

Another important concern has been nationalism, sometimes related to theories about race. The patriotic motive had a powerful effect on the work of historians north of the Alps who sought to draw attention to the achievements of France, Germany or Britain during the medieval period. They either proposed an equivalence of importance between the styles of art and architecture north and south of the Alps or promoted Gothic values, seeing the Renaissance as inferior and a symptom of decline. For instance, in *The Gothic Image* (1910) Émile Mâle described the Renaissance styles as imported and élitist works which were foisted onto French people. He saw the Gothic architecture created on French soil as superior:

> Symbol of faith, the cathedral was also symbol of love. All men laboured there. The peasants offered their all, the work of their strong arms. They pulled carts, and carried stones on their shoulders with all the good will of the giant-saint Christopher. The burgess gave his silver, the baron his land, and the artist his genius. The vitality which radiates from these immortal works is the outcome of the collaboration of all the living forces of France for more than two hundred years.[61]

Ideas of national characteristics became commonplace. In his *Voyage en Italie* Taine described the façade of Siena Duomo as

'Italian Gothic': less grandiose, less impassioned, less frail-looking as well as less violent than the Gothic of the north because of the 'joyfulness innate to the genius of the Italians' and the 'precocious existence of a lay culture'.[62] Historians tended to draw on concepts of racial characteristics as forms of explanation. Thus, Ruskin described Cimabue:

> Then, in Cimabue you have his own Etruscan ancient and peaceful blood – the Lombardic temper mingling in its restlessness; and, finally the traditional education in religious legend given him by his Greek masters.[63]

A concern for class has been advanced by considering the power relationships between patrons and artists, as well as the ways in which images and buildings could be seen to further the interests of various social groups or express their attitudes to the world – whether through stylistic traits or through the representation of people and things. Such approaches have tended to be linked with socialist theories. For example, Frederick Antal considered the relationship between art and class in a study entitled *Florentine Painting and its Social Background: The Bourgeois Republic before Cosimo de'Medici's Advent to Power: The Fourteenth and Fifteenth Centuries* (1947). In it he sought to 'associate each style with the conception of life corresponding to it', and in this correlation 'the subject-matter is of no less importance than its formal elements'. Antal set out to study the psychology of different social classes to 'account for what we see'.[64] He thought that the style of Giotto – with what he described as its spatial clarity, severe rationalist conception and compactness in composition – matched and expressed the needs and views of a confident upper middle class in the Florence of his time. To explain what he saw (like Leonardo or Berenson) as a decline later in the fourteenth century when painters just copied Giotto, he stated that:

> In general Giotto's towering personality as an artist had a paralysing influence on his successors; his severe, systematised, formal style could not become universal. For there was in fact no longer that ideological self-assurance which in Giotto's time the victorious upper middle-class still possessed.[65]

With the development of the sociology discipline and the use of class theories in such areas as market research, the concept of linking taste or cultural capital[66] to social position has wide and varied usage.

THE NEW ART HISTORY

These six centuries of histories of the Trecento provide a rich diversity of readings for the art of the period. Their differences suggest that values are contingent to persons and groups and are highly temporal. Not only does the viewing subject keep altering, but the objects of study and available data about them also shift. For example, at present we count the history of town planning and fortifications as belonging to fourteenth-century art, but previously only churches and palaces would have been included. The most self-consciously plain descriptions by past historians seem stylized to a later reader. What remain, in my view, are some data, some good working hypotheses, and a mass of theories from which we may want to select any concepts we feel to be viable.

Since the 1960s a variety of viewers looking from different and marginalized perspectives have developed critiques of what has been seen as a male, middle-class, Eurocentric monopoly. According to these viewpoints, the writing of art history is situated in institutions and represents the interests (largely and most effectively in ways of which the writers are unaware) of those who hold the power to pronounce on knowledge. The emphasis on studying the development of artists' careers is read as sustaining beliefs in individual autonomy and personal agency in history, closely linked with the primacy of masculine genius. Emphasis on the invention of pictorial and sculptural images that match surface reality can be seen as stressing western supremacy. Adherence to the narrow definitions of the fine arts bequeathed to western culture by the first academicians of the sixteenth century can be seen as sustaining notions of high art which fit uneasily onto the art of the fourteenth century. These notions define as superior the specific conditions under which art has been made for a few centuries in western Europe, so that other kinds of art made by people across the world are pushed down into second place.

From the viewpoint of these critiques, different models of art history may be proposed which offer some honourable viewing positions for women and non-Europeans, and which do not marginalize collaborative, anonymous craft and art work. Such models define art in wider rather than narrower senses, and point to the differing and fluid definitions of what counted as art in the past and counts as art now. While the consideration of the career of the master of a workshop is important, so too is the study of the audiences artists addressed, the users of buildings, and the role of commissioners and scholarly advisers in the creation of art and architecture. These models pay attention to the work that art did in society in presenting ideals and strictures to viewers through images, in decorating some objects rather than others, in ordering society through urban planning, and in structuring ordinary life and ceremony with edifices. These approaches can be broadly clustered under the heading of 'the new art history', a phrase first used publicly at a conference in London in 1982 and discussed by Alan Rees and Frances Borzello in *The New Art History* (1986):

> When an article analyses the images of women in paintings rather than the qualities of the brushwork, or when a gallery lecturer ignores the sheen of the Virgin Mary's robe for the Church's use of religious art in the Counter-Reformation, the new art history is casting its shadow.[67]

From the viewpoint of these critiques, the list that Müntz made in the late nineteenth century of the issues he felt useful to deal with in explaining art and architecture of this period still looks relevant, although there have been some additions. The requirements, attitudes and education of commissioners of different sorts remain key factors to consider. However, it could be important to consider what female commissioners were allowed to contract, and to identify the way men's patronage represented ideas of the masculine – rather than being read as an expression of general, neutral, human taste. If it is relevant to consider the class position of a buyer or group of buyers, it also seems important to consider their gender. And if the commissioner is important, so too is the audience – the viewers and users whom both artists and

patrons address. Thinking about the kind of audience that was anticipated can alert us to features of the design, and help to define the power of an image or building in representing new or old ideas. It seems appropriate, for instance, to notice that the image on the seal of the convent of Santa Chiara in Siena was sent by a community of women on documents written to mostly male recipients (Plate 232). It represents a role for women which was accorded dignity in this society: the enclosed pious nun. It seems helpful to think about what classes of people – secular and religious – could view and use the pieces of art we examine. It is interesting to note that Michele Savonarola explained that anyone could go to see Guariento's mural of *Paradise* in the Doge's Palace on Ascension Day – though otherwise this was an image which spoke only to a governmental élite. It might also be

Plate 237 Duccio, detail of cloth of honour behind Virgin and Child, *Rucellai Madonna*, 1285, Uffizi, Florence. Photo: Scala.

Plate 236 After Praxiteles, *Satyr*, Roman imperial marble after bronze original of 370 A.D., 160 cm, Staatliche Kunstsammlungen, Dresden.

Plate 238 Anonymous, Persian silk fabric, 1262, Islamic collection, Staatliche Museen zu Berlin Preussischer Kulturbesitz, Museum für Islamische Kunst. Photo: Reinhard Saczewski.

productive to add to Müntz's list the headings of function and genre, building on the studies of items with a common function such as Burckhardt's studies of altarpieces and portraits and Gardner's analysis of tombs.[68] We can see artists and patrons designing within traditional expectations for certain purposes with rules which are most apparent when such forms are studied in groups.

For Müntz, the phrase 'artistic tradition' mainly denoted the study of antique precedents available to artists. And much research has been done on the debts of fourteenth-century Italian artists to ancient sculpture – summed up by the way the representation of 'Sculpture' on the Campanile of Florence Duomo was shown modelling a naked, free-standing figure closely resembling the ancient Satyr of Praxiteles (Plate 236; cf. Chapter 5, Plate 97). However, a wider interpretation has included searches for Gothic, Romanesque and Byzantine precedents on which the artist might also have drawn. For instance, Birgitte Klesse's research on the employment of silk textile motifs in pictorial designs during the fourteenth century has shown that the cloth of honour in the *Rucellai Madonna* refers to Persian designs (Plates 237, 238).[69] Her evidence highlights the way an emphasis on antique and European sources of inspiration has skewed descriptions of fourteenth-century painting. Her research displays artists' and patrons' interest in using the ornament of Chinese, Islamic and Spanish cloth to create symbols of richness and honour in their paintings. And she was able to characterize Sienese and Venetian painting as specifically keen on Chinese and Persian designs, where Florentines were more dependent on designs produced in Lucca and their own city.

In connection with Müntz's heading of religious and secular functions and beliefs, we might add a consideration of any systems of belief which were held by those controlling the institutions of learning, by artists and their commissioners and audiences – including their attitudes to youth and age, the family, sexual difference, and the wider world beyond the Italian peninsula. It may be important to keep in mind what was not thought suitable subject-matter to represent, or what objects were not thought worthy of elaborate architectural sheltering. And with the religious life in mind, we might consider why so much attention has been paid to those works which could be seen as evidence of figurative and narrative skills in the service of meditations on the life of Christ and the saints, and very little attention paid to the quite numerous fourteenth-century reliquaries, which are well documented and well preserved in ecclesiastical treasuries. These reliquaries emphasize practices bordering on the magical and superstitious facets of religious belief, tend not to explore expressive naturalistic techniques, fit badly with academic definitions of sculpture, and in general have failed to suit interpretations of the fourteenth century as the childhood of the Renaissance or a period of religious truth and purity. For these reasons it seems worth including such a piece as the relic of the column of the Flagellation from Sant'Antonio, Padua in accounts of the art of the period (Plates 239, 240). As so often with reliquaries, this work set the artist a unique problem in securing the strangely shaped piece of stone and expressing its religious significance. For security, the rock was banded in decorative plates of silver gilt and hinged to open for close inspection. To explain its meaning, the relic was raised on a twisted column, and a small sculpture of Christ being beaten at this column was placed on the summit.[70]

Müntz's concern for analyzing the way that artists were organized, learned their trades and ran their workshops is still shared by historians, as is his interest in styles and techniques. However, with an eye to getting beyond definitions of high art, it would be interesting to study the business organization, methods and materials of craftsmen other than the goldsmiths and stone-carvers who have received most attention. What of the conditions in which the painted leather reliquary bust of Saint Fina was made in the early fourteenth century (Plate 241)?[71] Knowledge of saddling and cobbling skills would perhaps have played an important part in the creation of this bust to enclose the cranium of the teenage saint for the Collegiata at San Gimignano. It has been dated about 1310 on stylistic grounds. Although most surviving reliquary busts are of precious metals, the use of leather could have been regarded as appropriate because of its malleability, and the way sculptors could draw on their day-to-day experience of making leather armour for horses and men shaped to fit the body.[72] We are also beginning to think more about the techniques and effects possible using the portable and flexible medium of wood.[73] But scant attention seems to be paid to the styles and techniques of embroiderers of works such as the altar frontal inscribed by Jacopo Cambi and dated 1336, which as a minor art is in the collection of the silver museum in the Pitti Palace in Florence (Plate 242). The altar frontal is about a metre high and over four metres wide, and celebrates the coronation of the Virgin. The embroidered frieze running the length of the frontal represents eleven scenes from the life of the Virgin. The representation is made in coloured and painted silk and gold and silver thread, imparting through the use of cloth and sewing an effect which is something between sculpture and painting, since couched and raised work is employed to raise architectural detail, ornaments and foliage.[74] Müntz's heading devoted to the individual artist remains very much to the forefront in historians' work, but continues to need to be balanced by care in describing the collaborative habits through which pupils were taught and any artefact completed. This could be a type of research which is angled towards masters of wood-carving, goldsmiths, silversmiths and embroiderers rather than being confined to stone-carvers and painters.

Finally, much work has been done on Müntz's topic of 'subject-matter', now generally termed iconography, with spectacular results. There are still plenty of areas which the iconographer could beneficially scrutinize in order to explore the work done by images. The area of the representation of different classes with reference to religious roles and gender may be of great interest. For example, it is instructive to find from Klesse's research that Orcagna signified the regal status of Saint Catherine of Alexandria in his polyptych for the Strozzi Chapel by representing her as robed in modern silk damask woven in Italy. Presumably viewers would have recognized the local textile allusion (Plates 243, 244). Another fruitful area of research would be the consideration of the way people who did not believe in Christianity were represented at this time. A man with black skin is shown as one of those who mock Christ in the Arena Chapel – what can this tell us about how imagery represented definitions of

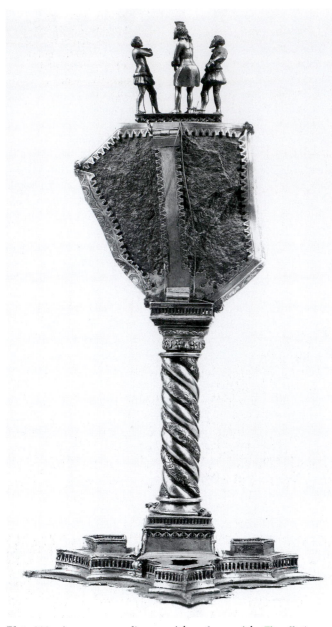

Plate 240 Anonymous, detail of reliquary of the column of the Flagellation (Plate 239) showing right-hand side. Note hinges top and bottom. Photo: Index/Lufin.

Plate 239 Anonymous, reliquary of the column of the Flagellation, back view, fourteenth century, porphyry and silver gilt, 40 cm high, Sant'Antonio, Padua. Photo: Index/Lufin.

Christian identities (Plate 245)?[75] On the one hand, the non-Christian could be seen as distanced from the opportunities of salvation. On the other hand, a splendid Persian hanging could be chosen to honour the Virgin in the *Rucellai Madonna*. How did these meanings interrelate? New ideas highlight new data. For example, were we to be more interested in what people outside Italy knew of the art of fourteenth-century Siena, Florence and Padua, we might focus our attention on manuscript illuminations, reliquaries and textiles like the altar curtain representing the life of Christ commissioned by the Spanish Bishop Raimondo de Area and made for his cathedral at Manresa in Catalonia, Spain by the *ricamatore* (male embroiderer) of Florence, Geri di Lapo, between 1322 and 1357 (Plates 231, 246).[76]

The critique presented by varieties of 'the new art history' has certain parallels with the critiques of the verities of Vasari and Winckelmann offered by historians who admired Gothic and Byzantine art in the eighteenth and nineteenth centuries. Indeed, the present arguments for a plural aesthetic sound very much like the calls by Hurd, Riedel and Wackenroder to abandon the one-dimensional standard of the classical period and the High Renaissance. It will be interesting to see how these debates develop.

In the face of the historiographical evidence of contradiction and contest over time, it seems difficult to maintain that historians can build up a cumulatively clearer picture of the realities of the fourteenth century, to the point of some future perfect description and explanation of what happened. And with the evidence of the gathering of some reliable data, however patchy, it also seems difficult to maintain that art historians deal entirely with the dreams of their own times. To my mind, historiography shows how powerfully personal and cultural interests shape the repertoire of interpretations presented by a writer. But to say this does not require giving up the desire to provide arguments that are plausible, reasonable and fair to the evidence. And rather than being regarded as a negative element, the interests of the interpreter may be viewed as skills to acknowledge and work with, rather than defects to try impossibly to expunge.

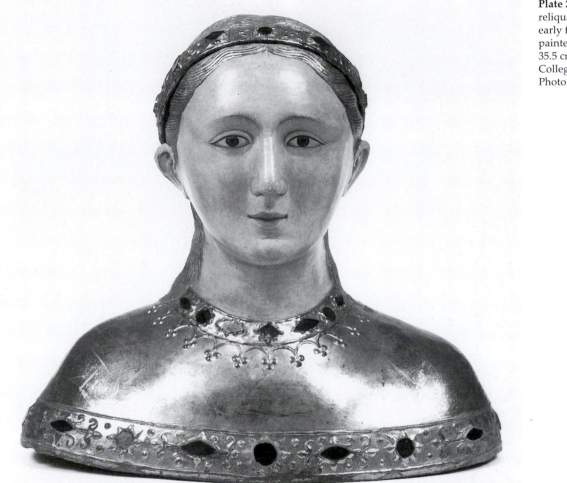

Plate 241 Anonymous, reliquary bust of Saint Fina, early fourteenth century, painted leather with gilding, 35.5 cm high, church of the Collegiata, San Gimignano. Photo: Lensini.

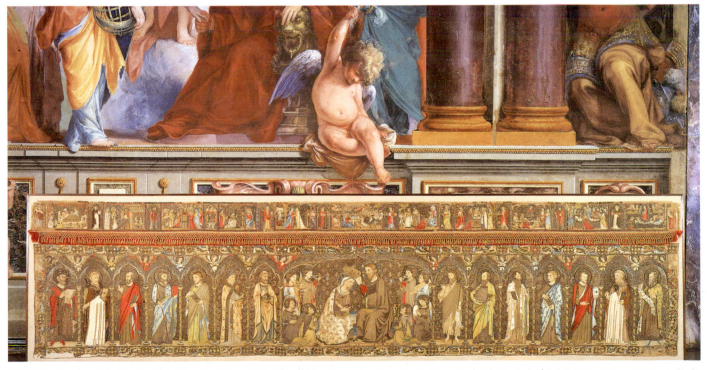

Plate 242 Jacopo Cambi, altar frontal with frieze, 1336, linen with coloured and painted silk and gold and silver thread, 105 x 425 cm, Museo degli Argenti, Palazzo Pitti, Florence. (The frieze on top shows the life of the Virgin from birth to assumption. The altar frontal below shows the coronation of the Virgin with saints.) Photo: Scala.

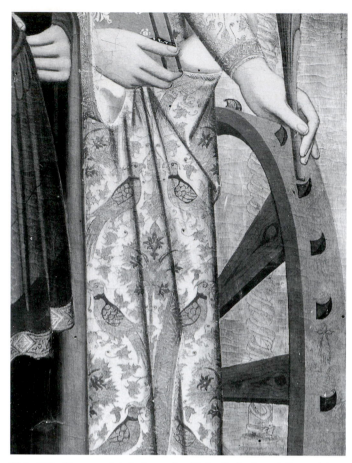

Plate 243 Orcagna, detail of mantle of Saint Catherine of Alexandria, *Christ in Glory with Saints*, 'the Strozzi altarpiece', 1354–57, tempera on panel, Strozzi Chapel, Florence. Photo: Alinari/Brogi.

Plate 244 Anonymous, Italian silk brocade, fourteenth century, Staatliche Museen zu Berlin, Kunstgewerbemuseum, Inv. K6105. Photo: Hilda Deecke.

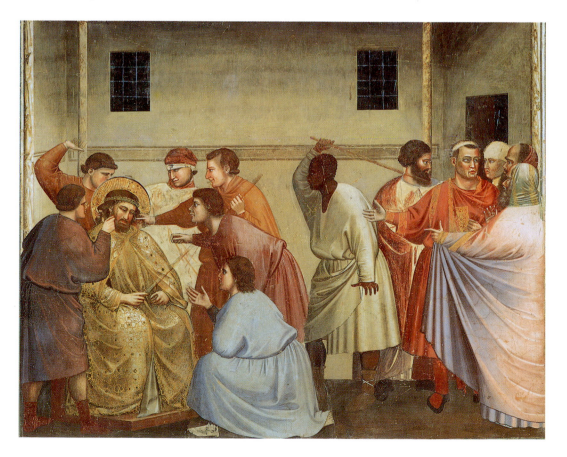

Plate 245 Giotto, detail of *The Mocking of Christ*, 1304–13, fresco, Arena Chapel, Padua. Photo: Scala.

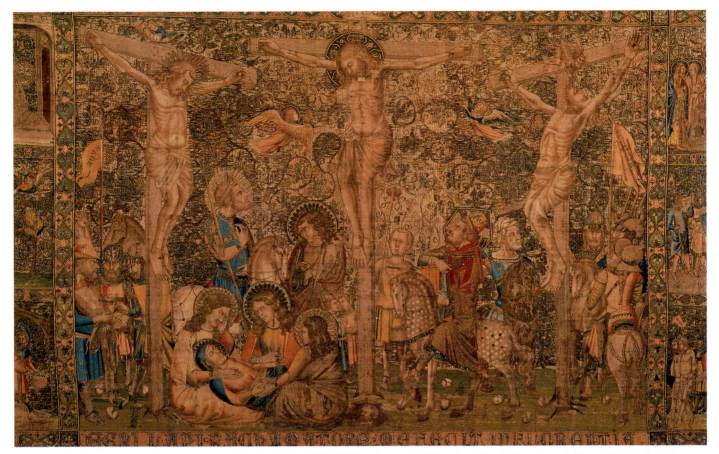

Plate 246 Geri di Lapo, detail of altar curtain, *The Crucifixion*, 1322–57, linen base with silk and gold and silver thread, 90 cm high, Cathedral, Manresa, Catalonia. Photo: Arxiu Mas, Barcelona.

Notes

INTRODUCTION

1 The term 'city state' is intended to signify that a city such as Florence also had political jurisdiction over a wider area of territory which incorporated other towns within it. 'Commune' (*comune* in Italian) was a contemporary term used of city states like Florence which were governed by the citizens themselves. Government office was limited to male citizens who enjoyed a degree of financial affluence and social standing. Nevertheless, this served to distinguish Florentine communal government from that of other cities ruled by a single individual or family.

2 For a more detailed discussion of the complex relations between Gian Galeazzo Visconti and Florence from the 1380s onwards, see Bueno de Mesquita, *Giangaleazzo Visconti*, pp.84–136. See also Baron, *The Crisis of the Early Italian Renaissance*, ch.2, 'A Florentine war for independence', pp.12–46. For Siena's surrender to Visconti rule, see Bueno de Mesquita, *Giangaleazzo Visconti*, pp.247–9 and Hook, *Siena*, p.160.

3 For further details of this episode in Padua's history, see Bueno de Mesquita, *Giangaleazzo Visconti*, pp.69–83, 122–3; Simioni, *Storia di Padova*, pp.536–68.

4 For further references to Giotto's status within western art, see Chapter 4.

5 See White's perceptive comments on this historiographic tradition in *Duccio*, ch.1, 'The vicissitudes of fame', pp.9–16. See also Chapters 3 and 11.

6 See Chapter 4 and Harrison, 'The Arena Chapel' [Chapter 4 in the companion volume to this one].

7 See Chapters 2 and 10. See also the essays on fourteenth-century painting in Padua by Francesca d'Arcais in *La pittura in Italia. Il Duecento e il Trecento*, I, pp.150–71, and by Anna Maria Spiazzi in *La pittura nel Veneto. Il Trecento*, I, pp.88–177, where it is generally acknowledged that Giotto's Arena Chapel murals had a seminal influence upon later fourteenth-century painting in Padua.

8 See the list of Podestà given in Pecori, *Storia di S. Gimignano*, pp.742–51. It should be noted that even before San Gimignano's submission to Florence, a number of Florentines also served in this capacity. For accounts of the principal surviving fourteenth-century paintings by Sienese painters in the Palazzo del Popolo and the present-day Collegiata of San Gimignano, see Carli, *La pittura senese*, pp.81, 120–1, 125–33, 237–8.

9 For an account of the origins of the convent of Santa Maria Maddalena in San Gimignano and its subsequent impact upon two major works of art by Taddeo di Bartolo, see Norman, 'The case of the *beata* Simona'.

10 See Harpring, *The Sienese Trecento Painter Bartoli di Fredi*, pp.38–63, 108–22, 149–50, 155, 156; Solberg, 'Taddeo di Bartolo', pp.236–8, 784–852.

11 Relevant extracts from these documents are published in Sartori, 'La cappella di S. Giacomo', doc.IX, pp.316, 320. For further biographical detail on Bonifacio Lupi and Caterina dei Francesi, see Bourdua, 'Aspects of Franciscan Patronage', pp.25–6.

12 For a detailed discussion on the question of Giotto's contribution to the Saint Francis cycle in the Upper Church, see Chapter 4.

13 For further discussion of the extent to which Renaissance patronage is indebted to Italy's classical and feudal past, see Weissman, 'Taking patronage seriously'.

14 As shrewdly observed by Wilson, *Music and Merchants*, pp.10, 15.

15 This topic is explored in further detail in King, 'Women as patrons' [Chapter 11 in the companion volume to this one].

16 See the relevant extracts from documents published in Sartori, 'Nota su Altichiero', doc.X, pp.311–14, esp. p.314; doc.XII, p.317; and doc.XIII, p.319, nos13–21. The chapel and its sculptures and paintings are discussed in detail in Norman, 'Two funerary chapels' [Chapter 8 in the companion volume to this one].

17 For further discussion of this cycle of paintings, see Chapters 1 and 10.

18 The Reggia and its painted decoration are discussed in further detail in Chapter 8.

19 See also Chapter 3 and Norman, 'A noble panel: the *Maestà*' [Chapter 3 in the companion volume to this one].

CHAPTER 1

1 The designation *beato* refers to Agostino Novello's religious status as a person beatified after his death. He was thus entitled to public veneration. For a detailed discussion of the painting, see Seidel, 'Conversatio Angelorum in Silvis', esp. pp.77–117. See also the catalogue entry in Torriti, *La Pinacoteca Nazionale di Siena*, p.51.

2 Dante, *Purgatorio* V, l.134, *Divine Comedy*, 2, pp.74–5.

3 Latini, *Il tesoretto*, cited in Martines, *Power and Imagination*, p.95.

4 Giovanni da Nono, 'Visio Egidii Regis Patavie'. For discussion of this text, see Hyde, 'Medieval descriptions of cities'.

5 Frequent reference will be made in this volume to the best-known chronicles of this type. These are those compiled between *c.*1333 and 1348 by the Florentine Giovanni Villani and continued by his brother Matteo until his death in 1363; the chronicle of *c.*1318–1407, compiled by the Paduan Galeazzo Gatari and his son Bartolommeo and revised and extended by another son, Andrea; and the chronicle of the Sienese Agnolo di Tura which, although compiled at different times and from different sources, provides well-informed eye-witness accounts of key historical events in fourteenth-century Siena.

6 Hyde, *Society and Politics in Medieval Italy*; Waley, *The Italian City-Republics*; Martines, *Power and Imagination*, chs1–8.

7 It is a notoriously difficult exercise to establish accurate figures for the population of medieval cities. For a table detailing the differing estimates of the thirteenth- and fourteenth-century populations of Florence, see Goldthwaite, *The Building of Renaissance Florence*, p.33. For an estimate of Siena's mid thirteenth-century population, see Hook, *Siena*, p.17. For Padua's population growth in the thirteenth century, see Hyde, *Padua in the Age of Dante*, pp.32–7.

8 The mendicant orders derived their name from the practice of working or begging (*mendicare*) for a living. Members were originally forbidden to own property either individually or in common. This commitment was a difficult one to maintain, and by the fourteenth century it had been relaxed. The orders' exemption from local episcopal control and their extensive faculties for preaching and hearing confession made their ministry particularly effective in the towns.

9 Bowsky, *A Medieval Italian Commune*, pp.11–19, provides useful summaries of the principal features of Siena's urban topography. For a more detailed treatment, see Bortolotti, *Siena*, pp.1–56 and accompanying bibliography, and Benton, 'The three cities compared: urbanism' [Chapter 1 in the companion volume to this one].

10 Siena lacked a river and had therefore to rely on a complex network of underground wells (*bottini*) and fountains in order to supply the city with water, a factor that imposed a limit on her output of textiles.

11 These are known today as the Palazzo Vecchio and the Bargello, respectively. For a detailed examination of these public monuments, see Cunningham, 'The design of town halls' [Chapter 2 in the companion volume to this one].

12 This was built by the Davizzi family in the mid fourteenth century, but is known today as the Palazzo Davanzati after the family who acquired it two centuries later. Brucker, *Renaissance Florence*, pp.1–50, and Goldthwaite, *The Building of Renaissance Florence*, pp.1–26, provide useful summaries of Florence's urban topography and its development. For a more detailed treatment, see Fanelli, *Firenze* and accompanying bibliography, and Benton, 'The three cities compared: urbanism' [Chapter 1 in the companion volume to this one].

13 For a more detailed discussion of this palace and its painted decoration, see Chapter 8.

14 Hyde, *Padua in the Age of Dante*, pp.29–37, provides an introduction to the principal features of fourteenth-century Padua's urban topography and its demographic growth. For a more detailed treatment, see Puppi and Universo, *Padova*, pp.1–84 and accompanying bibliography, and Benton, 'The three cities compared: urbanism' [Chapter 1 in the companion volume to this one].

15 According to the city constitution of 1309–10, the Nine had to be 'de'mercanti de la città di Siena o vero de la meza gente' (of the merchants of Siena or truly of

the middling sort of people), cited by Waley, *Siena and the Sienese*, p.48. For the families who were represented on the Council of the Nine, see Bowsky, *A Medieval Italian Commune*, p.73.

16 Beyond the limited political world that this outline describes there existed a complex social and political situation, which Samuel Cohn has succinctly described as the outcome of a historical process where 'struggles between merchants and the old aristocratic families yielded to the blending of these classes with the gradual dominance of the latter' (*Death and Property in Siena*, p.5). This blending of social and political interests did not, however, prevent the endemic factionalism, often erupting in major civil disturbances, that dogged fourteenth-century political and civic life.

17 Hook, *Siena*, pp.31–52; Bowsky, *A Medieval Italian Commune*, pp.260–98, esp. pp.293–8. See also Chapter 7.

18 Florence had as many as 72 guilds, but at the turn of the fourteenth century only 21 of these had access to government office. For a detailed analytical account of Florence's fourteenth-century guild government, see Najemy, *Corporatism and Consensus*.

19 Agnolo di Tura, in *Cronache senesi*, p.555: 'El padre abandonava el figliuolo, la moglie el marito, e l'uno fratello l'altro … E io Agnolo di Tura, detto il Grasso, sotterai 5 miei figliuiolo co'le mie mani.' (Father abandoned child, wife abandoned husband and brothers one another … And I, Agnolo di Tura, known as Agnolo the Fat, buried five of my children with my own hands.) For a comprehensive analysis of the advent and effects of the Black Death in Siena, see Bowsky, 'The impact of the Black Death'.

20 Boccaccio, *The Decameron*, ed. Speight, 'Introduzione', pp.4–22. It should be noted, however, that Boccaccio's description of the plague belongs to a well-developed literary genre of Christian apologia. See Marshall, '"Waiting on the will of the Lord"', pp.27–8.

21 See the comparative table of figures for Florence's pre- and post-plague population given in Goldthwaite, *The Building of Renaissance Florence*, p.33; for the difficulties of estimating Siena's pre- and post-plague population, see Bowsky, 'The impact of the Black Death', pp.5–18.

22 See Cohn's study of testamentary bequests in Siena and its surrounding territories, *Death and Property in Siena*, chs1–5.

23 For a summary of Florence's post-plague economic recovery, see Brucker, *Florence*, pp.55–6, and for a more detailed account, see Brucker, *Florentine Politics and Society*. For varying views on the extent of Siena's post-plague economic recovery, see Douglas, *A History of Siena*, pp.153–63, and Hicks, 'Sources of wealth in renaissance Siena'.

24 Wainwright, 'Conflict and popular government in fourteenth-century Siena'; Rutigliano, *Lorenzetti's Golden Mean*.

25 Giovanni Villani, *Cronica*, ed. Gherardi-Dragomanni/Moutier, bk12, ch.23, vol.IV, p.51: 'innanzi … signoreggiava il popolo grasso … ora siamo al reggimento deglia artefici e del popolo minuto'.

26 Brucker, *The Civic World of Early Renaissance Florence*, pp.269–70.

27 Meiss, *Painting in Florence and Siena after the Black Death*, pp.59–73. For a summary of critical views *vis-à-vis* Meiss's thesis, see Chapter 9, where the issue of a qualitative decline in art is also addressed.

28 See below, note 32.

29 For a succinct and illuminating analysis of this sculpted programme, see White, *Art and Architecture in Italy*, pp.114–22 and Chapter 5.

30 See Chapter 3 and Plate 57.

31 Only Simone Martini and Lippo Memmi's *Annunciation* (Plate 12) retains the framing saints.

32 For a useful summary of the complex building history of Siena's Duomo and Baptistery, see White, *Art and Architecture in Italy*, pp.45–7, 234–40.

33 Lusini, *Il duomo di Siena*, I, p.206; Milanesi, *Documenti per la storia dell'arte senese*, II, p.36.

34 Van Os, *Sienese Altarpieces*, I, p.51.

35 In a statute of 1299, cited in Brucker, *Renaissance Florence*, p.32.

36 For a useful summary of the complex building history of Florence's Duomo, see White, *Art and Architecture in Italy*, pp.52, 495–502.

37 Giovanni del Biondo's painted panel of the enthroned bishop and patron of Florence, *Saint Zenobius*, provides an example of the kind of fourteenth-century religious image commissioned for Florence's Duomo (illustrated and discussed in Offner *et al.*, *Corpus*, 4, V, pp.91–6, pl.xxii). Undoubtedly the lack of painted decoration in the Duomo was a reflection of the unfinished state of the building.

38 White, *Art and Architecture in Italy*, pp.107–11; Weinberger, 'The first façade of the Cathedral of Florence'.

39 For the architecture of the campanile and its sculpted reliefs, see Trachtenberg, *The Campanile of Florence Cathedral*. For Andrea Pisano's baptistery doors, see White, *Art and Architecture in Italy*, pp.471–80, and for a detailed photographic survey, see Finn, *The Florence Baptistery Doors*, pp.26–92.

40 From 1265 onwards the Commune allocated an annual grant of 4000 lire to help with the construction of the Santo. See Bourdua, 'Aspects of Franciscan Patronage', pp.15, 17.

41 See Chapter 2.

42 For the Buzzacarini, see Kohl, 'Giusto de'Menabuoi', pp.14–22.

43 Simioni, *Storia di Padova*, pp.353–745; Vasoin, *La signoria dei Carraresi*, pp.45–83; Kohl, 'Government and society in renaissance Padua', pp.205–14.

44 Gottfried, *The Black Death*, pp.117–18.

45 One surviving fourteenth-century work of art, at present located in the canons' sacristy and possibly once decorating a reliquary cupboard, is Nicoletto Semitecolo's eight panels dated 1367. For illustration and discussion of this work of art, see Chapter 9.

46 Transcribed in Kohl, 'Giusto de'Menabuoi', pp.24–5.

47 See Bettini, *Le pitture di Giusto de'Menabuoi*; Plant, 'Patronage in the circle of the Carrara family', pp.189–91; and Chapter 8.

48 See Lorenzoni, *L'edificio del Santo*, with full documentation for the history of this building.

49 In his *Compilatio cronologica*, Riccobaldo Ferrarese states that there were works by Giotto in the Franciscan churches in Assisi, Rimini and Padua: 'qualis in arte fuerit [Giotto] testantur opera facta per eum in ecclesia minorum Assisii Arimini Padue'. D'Arcais, 'La presenza di Giotto al Santo', argues that Giotto's work in the Santo possibly survives in the form of two painted busts of female saints on the entrance arch to a chapel once under the patronage of the Scrovegni family. In her view, what survives of the chapter-house frescoes represents evidence of work by a close collaborator of Giotto. See also Bourdua, 'Aspects of Franciscan Patronage', p.20.

50 Modern criticism generally dates the paintings to the 1370s. The dedicatory plaque, however, records a date of 1382. See Bettini, *Giusto de'Menabuoi*, pp.99–101, 136–7, and, more recently, Puppi, *La cappella del Beato Luca*; Semenzato, *La cappella del Beato Luca*; Bourdua, 'Aspects of Franciscan Patronage', pp.38–42.

51 For detailed discussion of this privately endowed chapel and its sculpted and painted iconography, see Plant, 'Portraits and politics in late Trecento Padua' and Norman, 'Two funerary chapels' [Chapter 8 in the companion volume to this one].

52 The original document is transcribed in Milanesi, *Documenti per la storia dell'arte senese*, I, pp.160–1.

53 Hook, *Siena*, p.41.

54 Seidel, 'Wiedergefundene Fragmente eines Hauptwerks von Ambrogio Lorenzetti'; 'Gli affreschi di Ambrogio Lorenzetti nel Chiostro di San Francesco'.

55 Ladis, *Taddeo Gaddi*, pp.171–3.

56 These familial monuments would once have extended to the two-storey vaulted *tramezzo*, an architectural structure half a bay deep and, with its superstructure, 15 metres tall, which originally closed the public part of the nave from the friars' choir, which occupied the last two bays of the nave. See Hall, 'The *Tramezzo* in Santa Croce'.

57 Ladis, *Taddeo Gaddi*, p.137, is of the view that the female donor figure on the panelling of Christ's tomb is probably an ingenious restoration and that, if she featured at all, she would have been represented just above the now-lost lid of the tomb.

58 Plant, 'Portraits and politics in late Trecento Padua'; 'Patronage in the circle of the Carrara family', pp.180–1, 185–6, 188–9, 195–8.

CHAPTER 2

1 'In arte Lane instructi sufficientius' and '[non] acti ad laborerium terre', cited in Piccinni, 'I "villani incittadinati"', p.207.

2 'Ugolino Lorenzetti' combines the names of two Sienese painters, Ugolino di Nerio and Pietro Lorenzetti, whose work this unknown painter's is deemed to resemble most. Recent art-historical opinion has assigned his work to the Sienese painter Bartolommeo Bulgarini, doc.1337–78.

3 Simone married Giovanna, sister of Lippo Memmi, in 1324. See Martindale, *Simone Martini*, pp.6–7.

4 Skaug, 'Notes on the chronology of Ambrogio Lorenzetti'.

5 Freuler, 'L'altare Cacciati'; Freuler, 'Bartolo di Fredis Altar für die Annunziata-Kapelle'; van Os, 'Tradition and innovation', pp.57–66.

6 Hueck, 'Le matricole', p.114.

7 For an analysis of the membership lists of the Sienese painters' guild (dated 1356, 1389 and 1428), see Fehm, 'Notes on the … Sienese Painters' Guild'.

8 It should be noticed, however, that in 1347 Bernardo Daddi (and in 1352 Taddeo Gaddi) served in the Arte dei Medici e Speziali as guild consuls. See Ciasca, *L'Arte dei Medici e Speziali*, pp.717–18.

9 Ciasca, *L'Arte dei Medici e Speziali*, pp.87–90.

10 Becker, 'Notes on the *Monte* holdings', pp.376–7.

11 As verified by an archival document, dated 16 August 1304, transcribed in White, *Duccio*, pp.191–2.

12 Borghesi and Banchi, *Nuovi documenti*, pp.10–11.

13 Bacci, *Fonti e commenti*, pp.145–7; Martindale, *Simone Martini*, pp.6–7.

14 Wainwright, 'Andrea Vanni and Bartolo di Fredi', pp.174–5.

15 As verified by an archival document of 1295, transcribed in White, *Duccio*, p.190.

16 Bacci, *Fonti e commenti*, pp.160–1; Martindale, *Simone Martini*, p.217.

17 Rowley, *Ambrogio Lorenzetti*, I, p.132. See also Wainwright, 'Andrea Vanni and Bartolo di Fredi', p.199.

18 Freuler, 'L'altare Cacciati' and 'Bartolo di Fredis Altar für die Annunziata-Kapelle'.

19 In 1382 and 1391 the name of the painter Jacopo di Cione appears on the voting list for those guild members eligible to be elected to the Priorate, the city's principal governing executive body. Similarly, the painter Agnolo Gaddi appears in two lists dated respectively 1381 and 1391. It appears, therefore, that in Florence during the second half of the century, one or two artists were actively involved in political life but not as members of the inner policy-making élite. See Wainwright, 'Andrea Vanni and Bartolo di Fredi', pp.113–14.

20 The nature and extent of Jacopo's work in Padua is very controversial. A number of sixteenth-century sources attribute certain paintings in the chapels of Bonifacio Lupi (in the Santo) and Raimondino Lupi (in the nearby Oratory of San Giorgio) to him. If they are correct he would have been active in Padua during the 1370s and 80s. For a rejection of Jacopo's intervention in these two Paduan chapels, see Simon, 'Altichiero versus Avanzo'.

21 Among the documentary references listed by Sartori, *Documenti per la storia dell'arte a Padova*, pp.383–444, are a number of fourteenth-century specialists in painting, manuscript illumination and goldsmithing.

22 D'Arcais, *Guariento*, p.51, n.7.

23 Cited in Bettini, *Giusto de'Menabuoi*, p.18.

24 Sartori, *Documenti per la storia dell'arte a Padova*, p.117. This reference to a painter's widow dealing with a matter of family business alerts us to the role of women within the organization of family-based workshop practice. Apart from providing an economic infrastructure for their male relatives by their domestic role, female members of the family might well contribute to the busy and highly diversified output of the fourteenth-century workshop. Women also practised art in other venues, notably within convent scriptoria producing illuminated manuscripts of a very high quality. For example, Sister Giovanna Petroni, an Augustinian nun at the Sienese convent of Santa Marta, executed eight large and beautifully illuminated (but no longer extant) choir books for the Augustinian rural hermitage of Lecceto. See Hackett, 'The medieval archives of Lecceto', p.32, n.62. For a number of more general remarks on the role of women as producers of medieval art, see Kessler, 'On the state of medieval art history', p.180.

25 Cited in Bettini, *Giusto de'Menabuoi*, p.15.

26 See Chapters 1 and 7.

27 See Norman, 'Two funerary chapels' [Chapter 8 in the companion volume to this one].

28 'Magistro Justo Pictore q. Joh. de Menaboibus de Florentia habitatore Padue in contrada Scalumnae cive civitatis Padue cum privilegio M. et potentis D.D. Francisci de Carraria.' (To the Master Painter, Giusto, son of Giovanni Menabuoi, of Florence, resident of Padua, in the *contrada* of Scalumna, the citizenship of the city of Padua by permission of the magnificent and powerful lord Francesco of Carrara.) Cited in Bettini, *Giusto de'Menabuoi*, p.17.

29 Pope-Hennessy, *Italian Gothic Sculpture*, 2nd edn, p.184; Gardner, *The Tomb and the Tiara*, pp.112–14; see also Chapter 6.

30 Within the records of the Opera, Taddeo Gaddi is named seven times between 1355 and 1366. Meanwhile, in 1366 Orcagna is cited four times and Andrea Bonaiuti three. See Ladis, *Taddeo Gaddi*, docs81–90.

31 During the same period of residence in that city, he also appears to have executed a tomb monument for a member of the della Torre family in Santa Croce. All three monuments survive in a fragmentary state and are now divided between the cathedral, the Museo dell'Opera del Duomo and Santa Croce. See Pope-Hennessy, *Italian Gothic Sculpture*, 2nd edn, pp.183–5; White, *Art and Architecture in Italy*, pp.441–2.

32 White, 'The reliefs on the façade'.

33 In 1264 a German priest's faith in the doctrine of transubstantiation was restored when, while celebrating Mass in Bolsena, he observed that the host had begun to bleed, covering the linen cloth or corporal with 20 drops of what was believed to be the blood of Christ. Because of the very nature of this miracle, the

Holy Corporal became a revered relic and a powerful eucharistic symbol within late medieval Christendom. Harding, 'The Miracle of Bolsena', p.83.

34 Harding, 'The Miracle of Bolsena'; Carli, *Il Reliquiario del Corporale*.

35 D'Arcais, 'Pittura del Duecento e Trecento a Padova', pp.156, 164–8; For Tebaldo Cortelliero and Enrico Spisser, see Kohl, 'Giusto de'Menabuoi', pp.13–14.

36 In particular, the research undertaken by a team of scholars working on a corpus of Sienese churches, under the auspices of the Kunsthistorische Institut, Florence, is yielding good results.

37 Cannon, 'Simone Martini, the Dominicans'.

38 Cannon, 'Simone Martini, the Dominicans', p.92.

39 These are conveniently listed in Cannon, 'Simone Martini, the Dominicans', p.90, n.169. For a comprehensive reconstruction of the Santa Croce high altarpiece, see Bomford *et al.*, *Art in the Making*, pp.98–123.

40 The following account is indebted to Lavin, *The Place of Narrative*, pp.28–39, 53–63. See also White, *Art and Architecture in Italy*, pp.178–90, 199–224, 361–6, 374–9, 402–5.

41 Van Os, 'St. Francis of Assisi as a second Christ'.

42 Lavin, *The Place of Narrative*, p.36.

43 Certain scenes within the Francis cycle were executed by another painter dubbed the Saint Cecilia Master (after a panel in the Uffizi depicting this female saint). For further discussion of the authorship of this mural scheme, see Chapter 4.

44 See Brink, 'Sts Martin and Francis'; Hoch, 'St. Martin of Tours'.

45 Martindale, *Simone Martini*, pp.19–23; 174–81; Lavin, *The Place of Narrative*, pp.55–9.

46 Lavin, *The Place of Narrative*, pp.99–113.

47 For an account of Padua's thirteenth-century territorial expansion and the variety of ways in which Padua exerted its control over such towns as Vicenza, Treviso and Monselice, see Hyde, *Padua in the Age of Dante*, pp.220–51. For a brief but illuminating account of Siena's territorial expansion, see Bowsky, *A Medieval Italian Commune*, pp.1–11. For an account of Florence's territorial expansion as charted by either the foundation or the expansion of subject towns, see Friedman, *Florentine New Towns*, pp.39–49.

48 Friedman, *Florentine New Towns*.

49 Van Os, *Sienese Altarpieces*, I, pp.34–7.

50 For an attribution of this architectural and sculptural work to the Pisan Giovanni Pisano, see Pope-Hennessy, *Italian Gothic Sculpture*, 2nd edn, p.175; cf. Carli, *L'arte a Massa Marittima*, p.22, and White, *Art and Architecture in Italy*, p.54, who argue that the evidence provided by a damaged inscription in the church argues for an attribution to an unknown Pisan sculptor.

51 The painting has been variously attributed to Duccio himself, his workshop and the youthful Simone Martini. For the essential bibliography, see Torriti, *Mostra di opere d'arte restaurate*, p.25.

52 While it is generally assumed that the altarpiece was commissioned for Sant'Agostino in Massa Marittima, Gardner von Teuffel, 'Review of H.W. van Os, *Sienese Altarpieces*', p.39, has made the perceptive observation that the altarpiece was probably commissioned for San Pietro in Orto, which was the Augustinian Hermits' first church in Massa Marittima.

53 Van Os, *Sienese Altarpieces*, pp.58–9.

54 Illustrated in King, 'Women as patrons' [Chapter 11 in the companion volume to this one]. See also Spiazzi, 'Padova', p.112.

55 D'Arcais, *Guariento*, p.75. See also p.51 for a transcription of an entry from a document of 3 October 1352, where Guariento is named as a witness to the archpriest's appointment of two procurators. For discussion of Guariento's work for the Carrara, see Chapter 8.

56 For a succinct analysis of these complex political allegiances, see Waley, *The Italian City-Republics*, pp.145–56.

57 Holmes, *Florence, Rome and the Origins of the Renaissance*, pp.190–4; Hyde, *Padua in the Age of Dante*, pp.255–9.

58 For the two commissions awarded to the Pisan sculptor Giovanni Pisano by Henry VII, see Pope-Hennessy, *Italian Gothic Sculpture*, 2nd edn, pp.179–80; Seidel, 'Das Grabmal der Kaiserin Margarethe'.

59 White, *Art and Architecture in Italy*, pp.439–41.

60 White, *Art and Architecture in Italy*, p.332; Cole, *Giotto*, p.11.

61 Martindale, *Simone Martini*, pp.45–54, 181–4.

62 De Castris, *Arte di corte nella Napoli angioina*, esp. pp.155–65.

63 According to Brucker, *Florence*, p.250: 'his nineteen month stay in the city had cost the city a good three hundred thousand florins'. For a detailed account of the political relations between Florence and the Angevin regime in Naples in the early decades of the fourteenth century, see Holmes, *Florence, Rome and the Origins of the Renaissance*, pp.163–203.

64 Bowsky, *A Medieval Italian Commune*, pp.176–8.

65 For a discussion of the documentary evidence for Simone's presence in Naples, see Martindale, *Simone Martini*, pp.6, 216, who thinks it likely that Simone went to Naples to execute the Saint Louis altarpiece. For the altarpiece itself, see pp.18, 192–4.

66 De Castris, *Arte di corte nella Napoli angioina*, pp.313–20.

67 For these two Angevin tombs, see Pope-Hennessy, *Italian Gothic Sculpture*, 2nd edn, pp.185–6; Gardner, 'A princess among prelates'.

68 Wainwright, 'Andrea Vanni and Bartolo di Fredi', pp.119–20, 136–7.

69 It is also significant that Bonifacio Lupi is documented as having contacts with Sienese residents of Padua. Such contacts were undoubtedly facilitated by the fact that his second wife, Caterina dei Francesi, came from Staggia, a town lying a short distance north of Siena.

70 For a more detailed discussion of this representation of the Hungarian king, see Plant, 'Portraits and politics'.

CHAPTER 3

1 Mancini, *Considerazioni sulla pittura*, pp.166–7.

2 White, *Duccio*, pp.11–13.

3 English translation in Baxandall, *Giotto and the Orators*, pp.70–1.

4 White, *Duccio*, p.9.

5 Weigelt, *Duccio di Buoninsegna*, pp.123–58; Stubblebine, *Duccio di Buoninsegna and his School*, pp.21–7; White, *Duccio*, pp.12, 33; Santi, '*De pulcerima pictura* … la *Madonna Rucellai*', pp.11–12.

6 It is generally agreed that Duccio's only surviving works are panel painting and not fresco. Longhi, 'Giudizio sul Duecento', followed by Volpe, 'La formazione di Giotto', however, suggest that the young Duccio assisted in the painting of the late thirteenth-century New Testament series in the nave of the Upper Church of San Francesco, Assisi, a view not generally shared by other Duccio scholars (see Deuchler, *Duccio*, p.21). More recently, Bologna, 'The crowning disc … Duccio's relationship to Cimabue', has raised again the question of Duccio's presence at Assisi, arguing that, as a pupil and close collaborator of Cimabue, the Sienese painter did contribute to the late thirteenth-century mural programme of the Upper Church. The newly discovered mural, *The Submission of a Castle* (Chapter 7, Plate 143), in the Sala del Consiglio of the Palazzo Pubblico, Siena, has been attributed by some scholars to Duccio. For further discussion of this attribution, see Chapter 7.

7 Pope-Hennessy, 'A misfit master', p.47.

8 For transcription and English translation of extracts from 39 documents that refer to Duccio and his family, see White, *Duccio*, pp. 184–200.

9 Anonymous, in *Cronache senesi*, p.90.

10 Stubblebine, *Duccio di Buoninsegna and his School*, p.3.

11 White, *Duccio*, doc.24.

12 Borgia *et al.*, *Le Biccherne*, esp. cat. nos28, 36, 38.

13 White, *Duccio*, doc.17.

14 White, *Duccio*, doc.5. The designation of Laudesi (which applied to a number of Florentine confraternities) derived from the practice of singing songs of devotion, *laude*. For further discussion of the Laudesi, see Chapter 9.

15 The *Rucellai Madonna* is so called because by 1681 it was located in the Rucellai Chapel (the chapel of Saint Catherine of Alexandria, which was under the patronage of the Rucellai family) at the end of the right or eastern transept of Santa Maria Novella (Plate 56, C). It was removed to the Uffizi in 1948. For further discussion of the painting's possible location within the church, see below, pp.59–61.

16 Van Os, *Sienese Altarpieces*, I, pp.35–7.

17 White, *Duccio*, doc.25.

18 In 1301 Cimabue also received payment for an altarpiece with a predella for the hospital of Santa Chiara in Pisa (cited in White, *Duccio*, p.34). On the basis of a number of early fourteenth-century *Maestàs* produced by various painters working within Duccio's orbit, Stubblebine, 'Duccio's *Maestà*'; *Duccio di Buoninsegna and his School*, pp.8–9, offers a hypothetical reconstruction of Duccio's lost *Maestà*. He also proposes a series of narrative scenes of the Passion for the predella; cf. Brandi, *Il restauro della Maestà di Duccio*, pp.83, 141, and Deuchler, *Duccio*, p.30, who suggest respectively either the Articles of the Creed or a series of half-length figures as the subject of the predella.

19 In this essay, the *Maestà* will be treated within the wider context of Duccio's practice as a painter. Readers who wish to learn more of the details, both of the commission and of the original appearance of this altarpiece, should consult the extended case study on the *Maestà* in Norman, 'Duccio's *Maestà*' [Chapter 3 in the companion volume to this one].

20 White, *Duccio*, doc.28; Pope-Hennessy, 'A misfit master', p.45; Norman, 'Duccio's *Maestà*' [Chapter 3 in the companion volume to this one].

21 White, *Duccio*, doc.30.

22 White, *Duccio*, doc.32, see also pp.96–7; van Os, *Sienese Altarpieces*, I, p.39.

23 Stubblebine, *Duccio di Buoninsegna and his School*, pp.30–1; White, *Duccio*, pp.62–3; Deuchler, *Duccio*, p.46; Davies, *The Early Italian Schools*, pp.20, 22, n.4.

24 See above, note 6. The dating proposed by modern scholars for the Perugia *Virgin and Child* is very varied, but it is generally agreed that the painting dates to the first five years of the fourteenth century.

25 Stubblebine, *Duccio di Buoninsegna and his School*, p.4, doc.32, pp.199–200; see also White, *Art and Architecture in Italy*, p.175, pl.99.

26 Stubblebine, *Duccio di Buoninsegna and his School*, p.6; Deuchler, *Duccio*, p.58.

27 Stubblebine, *Duccio di Buoninsegna and his School*, pp.4, 198, nn.27–8; Deuchler, *Duccio*, p.24.

28 This painting is not signed by Duccio nor is there any contemporary documentation of it. However, the consensus among modern scholars is that it is by Duccio and that the date of its execution was probably in the mid 1290s. It was thus painted slightly later than the documented *Rucellai Madonna* of 1285 and the small-scale *Crevole Madonna* (Museo dell'Opera del Duomo, Siena), which is generally considered an early work by Duccio of the 1280s. For a perceptive analysis of the latter painting, see White, *Duccio*, pp.23–4.

29 Stubblebine, *Duccio di Buoninsegna and his School*, p.19; White, *Duccio*, p.54.

30 Deuchler, *Duccio*, p.24, pl.27.

31 Deuchler, *Duccio*, p.42, 46.

32 Stubblebine, *Duccio di Buoninsegna and his School*, pp.6, 20; see also White, *Duccio*, p.57; Belting, 'The "Byzantine Madonnas"', pp.10, 19.

33 White, *Duccio*, p.125, pls93–4.

34 White, *Duccio*, pp.55–8; Deuchler, *Duccio*, p.175; Belting, 'The "Byzantine Madonnas"'.

35 Cimabue's *Santa Trinita Madonna* (executed probably in the 1280s) for the high altar of the Vallombrosan church of Santa Trinita, Florence and Giotto's *Ognissanti Madonna* (Chapter 4, Plate 72) (executed probably *c*.1310–15) for the high altar of the Humiliati church of Ognissanti, Florence. Recent scholarship has, however, questioned whether these paintings were, in fact, high altarpieces. See Hueck, 'Le opere di Giotto', pp.37–50. Both paintings at present (1994) hang together with the *Rucellai Madonna* in the same room of the Uffizi, Florence.

36 Orlandi, 'La Madonna di Duccio', p.207.

37 In 1316 the Laudesi made two payments for furnishings for this chapel (see Wilson, *Music and Merchants*, p.203, n.70). In 1336 the patronage of the chapel was conceded by the Dominicans to the Bardi di Vernio family (see Hueck, 'La tavola di Duccio', p.41). It may therefore be the case that the Dominican friars of Santa Maria Novella allowed the confraternity only to use the chapel and that its members did not, in fact, have patronal rights over the chapel.

38 Stubblebine, 'Cimabue and Duccio in Santa Maria Novella'.

39 Hueck, 'La tavola di Duccio', pp.40–3; see also Cämmerer, 'La cornice della *Madonna Rucellai*', p.54 and fig.4 for a discussion of the back of the *Rucellai Madonna*.

40 Stubblebine, *Duccio di Buoninsegna and his School*, p.22; see also White, *Duccio*, pp.36–7.

41 Hueck, 'La tavola di Duccio', pp.37–8; see also Santi, '*De pulcerima pictura* … la *Madonna Rucellai*', pp.13–17.

42 White, *Duccio*, pp.37, 39; Deuchler, *Duccio*, p.32. In this context, it is useful to note that it has been further suggested (Santi, '*De pulcerima pictura* … la *Madonna Rucellai*', pp.13–14; Hueck, 'La tavola di Duccio', p.38) that the iconography of the painting specifically alludes to the doctrine of the Virgin's assumption into heaven.

43 The following analysis relies on the technical report given by del Serra, 'Il restauro', in *La Maestà di Duccio restaurata*, pp.57–63, the account of fourteenth-century panel painting techniques given in Bomford *et al.*, *Art in the Making*, pp.11–31, and the interviews conducted with White and del Serra in 1992 for *The Rucellai Madonna*, a BBC/Open University television programme on the *Rucellai Madonna*.

44 Del Serra, 'Il restauro', p.57; Bomford *et al.*, *Art in the Making*, pp.81, 86, 93–4.

45 Bomford *et al.*, *Art in the Making*, pp.30–43.

46 White, *Duccio*, p.45.

47 For further discussion of this point, see Norman, 'Duccio's *Maestà*' [Chapter 3 in the companion volume to this one].

48 White, *Duccio*, pp.133–4.

49 Bomford *et al.*, *Art in the Making*, pp.26, 130–3.

50 Stubblebine, 'Duccio and his collaborators'.

51 Bomford *et al.*, *Art in the Making*, pp.83–9; Norman, 'Duccio's *Maestà*' [Chapter 3 in the companion volume to this one].

52 The best documentary source that attests to such habits of collaboration within the fourteenth-century painter's workshop is Cennino Cennini's treatise, *Il libro dell'arte* (*The Craftsman's Handbook*), which was written *c*.1390 by a Florentine painter who was a pupil of Agnolo Gaddi, son of the painter Taddeo Gaddi. See also the useful summaries on workshop practice offered by White, *Duccio*, pp.104–7, and Bomford *et al.*, *Art in the Making*, pp.2–4.

53 White, *Duccio*, pp.58–60; Carli, *La pittura senese*, p.44; Davies, *The Early Italian Schools*, cat. no.566, pp.14–16; cf. Stubblebine, *Duccio di Buoninsegna and his School*, pp.63–4; 'The Boston Ducciesque Tabernacle'; Deuchler, *Duccio*, pp.25, 46, 188, 216.

54 White, 'Measurement, design and carpentry in Duccio's *Maestà*'; see also Norman, 'Duccio's *Maestà*' [Chapter 3 in the companion volume to this one].

55 Bomford *et al.*, *Art in the Making*, p.90.

56 Bomford *et al.*, *Art in the Making*, pp.93–4, figs57–9, see also pp.81, 86, fig.47.

57 The remaining inscription reads 'SCA AU … '. For a discussion of the historical evidence, see Davies, *The Early Italian Schools*, pp.14–15.

58 Cannon, 'Dominican Patronage', pp.270, 315, n.240.

59 For the likelihood of 'Polyptych 28' once being over the high altar of San Domenico in Siena, see Cannon, 'Simone Martini', pp.79–80.

60 Stubblebine, 'Duccio's *Maestà*', has argued that these paintings may be indebted to the lost Palazzo Pubblico altarpiece. The principal paintings concerned are: *The Virgin and Child Enthroned with Angels* in Santi Salvatore e Cirino at Badia a Isola; *The Virgin and Child Enthroned with Angels and Votive Dominican* in the Galleria Comunale, Città di Castello; and Segna di Bonaventura's *Virgin and Child Enthroned with Angels, Saints and Donors* in the Collegiata di San Giuliano, Castiglion Fiorentino.

61 These works include *The Virgin and Child Enthroned with Angels*, Kunstmuseum, Bern; *The Virgin and Child Enthroned with Angels*, National Gallery, London; and a triptych of *The Crucifixion*, British Royal Collection. For a summary of the debated attributions of the first of these two paintings, see Maginnis, 'The literature on Sienese Trecento painting', p.279. More recently Joanna Cannon and Viola Pemberton-Pigott, 'The Triptych Attributed to Duccio', have argued for the personal involvement of Duccio in the execution of the triptych of *The Crucifixion* in the British Royal Collection.

62 White, *Duccio*, pp.64–79; van Os, *Sienese Altarpieces*, I, pp.64–5, 74; Bomford *et al.*, *Art in the Making*, pp.98–123, esp. pp.112–23.

63 White, *Duccio*, p.10.

CHAPTER 4

1 Davies, *The Earlier Italian Schools*, p.230.

2 Dante, *Purgatorio* XI, ll.94–6, *Divine Comedy* 2, p.146: 'Credette Cimabue nella pintura/tener lo campo, e ora ha Giotto il grido,/sì che la fama di colui è scura.' (In painting, Cimabue was believed to hold the field, but now the cry is for Giotto, so that the reputation of the former is obscured.)

3 Boccaccio, *The Decameron*, ed. Rigg, Sixth Day, Fifth Story, p.73.

4 Cennini, *The Craftsman's Handbook*, I.1, p.2.

5 Vasari, *Lives of the Artists*, p.15.

6 An interesting discussion of the significance of the concepts of achievement and progress that are central to Florentine culture is to be found in Gombrich, 'The Renaissance conception of artistic progress'.

7 Meier-Graefe, *Modern Art*, p.21.

8 Bell, *Art*, p.147.

9 Rivera, 'The revolutionary spirit in modern art', p.407.

10 This focus is given explicit form in Harrison, 'The Arena Chapel' [Chapter 4 in the companion volume to this one].

11 Cited in Baxandall, *Giotto and the Orators*, p.51.

12 Cited in Baxandall, *Giotto and the Orators*, p.60.

13 For a review of testimonials to Giotto's wit, see Ladis, 'The legend of Giotto's wit'.

14 White, *Art and Architecture in Italy*, p.309.

15 The text of a royal order of 1330 is given in Martindale, *The Rise of the Artist*, p. 37:

> Freely do we associate in the community of our *familia* those approved by the uprightness of their ways and commended by their distinctive excellence, sensible therefore that master Giotto of Florence, painter, *familiaris* and our faithful servant, is sustained by prudent deeds and exercised in fruitful services, we willingly receive him as our *familiaris* and retain him in our household, that he may possess and enjoy those honours and privileges which other *familiares* possess, after taking the accustomed oath.

To guard against overestimation of the status of a *familiaris*, Martindale observes that some years earlier the royal barber had been accorded the same honour. He also makes the point that the title was more likely to have been used to secure the company of those considered entertaining companions than to ensure services easily enough obtained without conferring it (pp.38–9).

16 White, *Art and Architecture in Italy*, pp.340–1.

17 White, *Art and Architecture in Italy*, p.341.

18 The phrase is Michael Baxandall's, from his study of *Painting and Experience in Fifteenth Century Italy*, in which this transfer is nicely described (see particularly pp.14–27).

19 The contract for Duccio's *Maestà* is a notable example.

20 See, for example, the contracts with Piero della Francesca and Luca Signorelli quoted in Baxandall, *Painting and Experience in Fifteenth Century Italy*, pp.20, 23.

21 See, for example, Davies's catalogue entry on the small Giottesque panel of *The Pentecost* in the National Gallery, London. After listing other panels supposed to be from the same series, he turns to the question of whether or not the work in question should be ascribed to Giotto's own hand:

> The compiler feels that the problems of attribution to Giotto himself are almost hopelessly confused, even for the frescoes; that the status of panel pictures of large size, which might be expected to conform a good deal to the frescoes, is even more dubious; and that it is impossible to obtain any sure evidence of what Giotto's style for small figures may have been.
> (Davies, *The Earlier Italian Schools*, p.231)

Following technical examination, more recent opinion at the National Gallery has identified *The Pentecost* and its companion panels as belonging originally to a single altarpiece from Giotto's workshop; see Bomford *et al.*, *Art in the Making*, pp.64ff.

22 The evidence for this dating is considered in Harrison, 'The Arena Chapel' [Chapter 4 in the companion volume to this one].

23 The date is implied in a Florentine chronicle, the *Ottimo commento*, probably written by an author contemporary with Giotto (see White, *Art and Architecture in Italy*, p.345). The much later Vasari gives a date of 1276.

24 In addition to the authors referred to in the following paragraphs, see for example: Meiss, *Giotto and Assisi*; Tintori and Meiss, *The Painting of the 'Life of St Francis'*; Smart, *The Assisi Problem*; Stubblebine, *Assisi and the Rise of Vernacular Art*.

25 White, *Art and Architecture in Italy*, p.207.

26 Bellosi, *Giotto*.

27 Bellosi, *Giotto*, p.16.

28 White, *Art and Architecture in Italy*, pp.344–8.

29 See White, *Art and Architecture in Italy*, p.326, on fold forms in Giotto's drapery in relation to characteristics in the work of Nicola and Giovanni Pisano.

30 Hills, *The Light of Early Italian Painting*, pp.2–3.

31
> The dialectic of word and image seems to be a constant in the fabric of signs that a culture weaves around itself. What varies is the precise nature of the weave, the relation of warp and woof. The history of culture is in part the story of a protracted struggle for dominance between pictorial and linguistic signs, each claiming for itself certain proprietory rights on a 'nature' to which only it has access.
> (Mitchell, *Iconology*, p.43)

32 In the potentially messy business of fresco painting it clearly makes sense to work from the ceiling and upper wall down to the floor, although allowance has to be made for the fact that at San Francesco the nave walls are divided by their columniation into separate bays, which would no doubt have been separately scaffolded.

33 Hills, *The Light of Early Italian Painting*, p.12.

34 *Legenda Major*, 1266; see Saint Bonaventura, *Doctoris Seraphici*.

35 The various issues involved are thoroughly reviewed in a chapter on 'The Assisi problem' in White, *Art and Architecture in Italy*. The later dating is advocated by Stubblebine in *Assisi and the Rise of Vernacular Art*. On the basis of stylistic and iconographic analyses, he argues controversially that the work of the Isaac Master should be dated in the 1320s and the work of the Master of the Saint Francis cycle in the 1330s.

36 Bellosi, *Giotto*, p.14.

37 It is true that we are availed of an alternative explanation if we assume a comparable but now lost Roman scheme. However, it seems perverse to rely on the assumed qualities of a hypothetical and non-extant scheme when it is still possible to experience the qualities of a surviving one.

38 Riccobaldo Ferrarese, *Compilatio cronologica*.

39 White, *Art and Architecture in Italy*, p.309.

40 See, for example, Gardner, 'The Louvre Stigmatization'.

41 Whilst another difference, that Saint Francis appears clean-shaven in the Florentine fresco, is significant, it is not significant in a way bearing on the identification of a Giottesque style. Saint Francis is known to have been bearded, as he is shown in the earlier fresco. By the time the later version was painted, beards had become decidedly unfashionable. To have shown Saint Francis bearded would then have been to represent him as disturbingly uncouth – as he no doubt was from the point of view of the Florentine banker or the papacy.

CHAPTER 5

1 Chasing – the final stages in casting metal sculpture involving carving, chiselling and polishing.
2 Churchill, 'Giovanni Bartolo of Siena', pp.120–5.
3 Passerini, *Curiosità storico-artistiche fiorentini*, pp.91–8, includes the full contract.
4 Milanesi, *Documenti per la storia dell'arte senese*, I; Sartori, *Documenti per la storia dell'arte a Padova*, IV; Poggi, *Il duomo di Firenze*, I–II.
5 Brunetto Latini, *Livre de trésor*, c.1260. French text quoted in Evans, 'Allegorical women and practical men', p.322: 'Li mestier ke l'en oeuvre tousjors des mains et des piés ce sont sueurs, drapiers, cordewaniers, et ces autres mestiers ki sont besoignable a la vie des homes, et son apièles mechanique.'
6 King, 'Representations of Artists and of Art', pp.12–13.
7 Baxandall, *Giotto and the Orators*, pp.55–6.
8 Dominici and Gregory the Great quoted in Ringbom, *From Icon to Narrative*, pp.11, 32–3.
9 These reliefs are fully discussed by Wylie-Egbert, *The Medieval Artist at Work*, who identified the quotation from Praxiteles; they are also discussed further in Chapter 10 and Norman, 'The art of knowledge' [Chapter 10 in the companion volume to this one].
10 Vasari, *Le opere di Giorgio Vasari*, I, pp.673–4.
11 Milanesi, *Documenti per la storia dell'arte senese*, I, p.103.
12 Milanesi, *Documenti per la storia dell'arte senese*, I, pp.102–4, 132–4.
13 *Scultura dipinta*, pp.56–60, 80–2.
14 Pope-Hennessy, *Italian Gothic Sculpture*, 3rd edn, p.188.
15 Milanesi, *Documenti per la storia dell'arte senese*, pp.57–96.
16 Roberti, 'Le corporazioni padovane', pp.111–53, 207–20.
17 Sartori, *Documenti per la storia dell'arte a Padova*, IV, p.245.
18 Sartori, *Documenti per la storia dell'arte a Padova*, IV, p.355.
19 Milanesi, *Nuovi documenti per la storia dell'arte toscana*, p.39.
20 *Scultura dipinta*, p.101.
21 Sartori, *Documenti per la storia dell'arte a Padova*, IV, pp.445–529 (all fourteenth-century documents relating to stone-carvers), pp.245–380 (goldworkers), pp.3–242 (sculptors).
22 Pope-Hennessy, *Italian Gothic Sculpture*, 3rd edn, p.116.
23 Pope-Hennessy, *Italian Gothic Sculpture*, 3rd edn, pp.176–7.
24 Gauthier, *Émaux du moyen-âge occidentale*, pp.217–23.
25 Pope-Hennessy, *Italian Gothic Sculpture*, 3rd edn, pp.190–1.
26 Gai, *L'altare argenteo di San Iacopo*, pp.114–15; the present left-hand antependium (originally on the right side) is inscribed and dated 1371.
27 Wolters, *La scultura veneziana gotica*, I, pp.168–69, cat. no.41.
28 *Scultura dipinta*, pp.80–2.
29 Milanesi, *Documenti per la storia dell'arte senese*, I, pp.354–6.
30 *Scultura dipinta*, p.102.
31 Pope-Hennessy, *Italian Gothic Sculpture*, 3rd edn, pp.182–3.
32 Becherucci and Brunetti, *Il Museo dell'Opera del Duomo a Firenze*, I, pp.232–7.
33 Becherucci and Brunetti, *Il Museo dell'Opera del Duomo a Firenze*, I, pp.237–40. See also Chapter 10.
34 Becherucci and Brunetti, *Il Museo dell'Opera del Duomo a Firenze*, I, pp.240–4.
35 Becherucci and Brunetti, *Il Museo dell'Opera del Duomo a Firenze*, I, pp.254–5.
36 Poggi, *Il duomo di Firenze*, I, pp.LXV–VIII.
37 Poggi, *Il duomo di Firenze*, I, p.LXX.
38 Sartori, 'Nota sul Altichiero', pp.291–326. See also Norman, 'Two funerary chapels' [Chapter 8 in the companion volume to this one].
39 Gonzati, *La basilica di Sant'Antonio di Padova*, II, pp.V–VI, and Polidoro, *Le religiose memorie di Sant'Antonio*, p.37.
40 Tonzig, *La basilica di Santa Giustina*, p.97.
41 Garzelli, *Sculture toscane nel Dugento e nel Trecento*, p.194, attributes it to Giovanni d'Agostino. Lunette 175 cm high.
42 Wolters, *La scultura veneziana gotica*, pp.209–10. The group was later called the *Madonna della Mora* because of its dark colour.

43 Though each Florentine guild had its own chapel at various churches apart from Orsanmichele.
44 *Scultura dipinta*, pp.73–4.
45 *Scultura dipinta*, pp.73–4. '[ANNO DOMINI] MC[CC] LXVIIII L'ARTE DE C[A]LCOLARI FECERO [...] FARE QUESTA FIGURA AL TE[M]PO D'AGNOL[I]NO RETOR[E].'
'QUESTO ANGNIOLO FECE FARE L'ARTE DE CALCOLARI ANGIELUS SCULPSIT ET PINSIT AL TENPO DI TOFO BARTALINI RECTORE MCCC LXX.'
46 Pope-Hennessy, *Italian Gothic Sculpture*, 3rd edn, p.208, attributes it to Niccolò di Piero Lamberti.
47 Milanesi, *Nuovi documenti per la storia dell'arte toscana*, p.39.
48 *L'Art gothique siennois*, p.258.
49 Pope-Hennessy, *Italian Gothic Sculpture*, 3rd edn, pp.197–8.
50 Frey, *Die Loggia dei Lanzi*, p.213.
51 Hill, *Medals of the Renaissance*, pp.19–20. See Chapter 8 for a detailed discussion of Carrara patronage.
52 Rizzoli, *I sigilli nel Museo Botticin*, and Coine, *Il sigillo a Siena nel Medioevo*.
53 Moschetti, 'Il tesoro della cattedrale di Padova', pp.79–109, esp. p.94.
54 Moschetti, 'Il tesoro della cattedrale di Padova', p.104.
55 Pope-Hennessy, *Italian Gothic Sculpture*, 3rd edn, p.184, and Kreytenberg, *Tino di Camaino*, pp.22–3.
56 Bollandus and Henschenius, *Acta sanctorum*, pp.384–418, esp. pp.414–17.
57 'S. HUMILIANA DE CIRCULIS HOC FIERI FECIT, JOANNES RICCARDI DE CIRCULIS.'

CHAPTER 6

1 Cennini, *The Craftsman's Handbook*.
2 These figures might be compared with really major expenses, such as the 13,000 gold florins used to buy off the bandit army of Fra Moriale in 1354 (see Bowsky, *A Medieval Italian Commune*, p.306). For comparison, in Florence at the start of building work on the Duomo, a public vote of 2400 lire in March–April 1297 was followed in October by another vote of 8000 lire, to be paid over two years. By 1364 revenue came in from a dozen taxes, producing a regular annual income of 1066 gold florins and 8324 lire (Guasti, *Santa Maria del Fiore*, p.lxxxi).
3 These included the sale of indulgences, a tax levied directly by the *operaio* on the populace, and contributions to buy wax for candles, which could then be sold. See Middeldorf-Kosegarten, *Sienesische Bildhauer*, pp.18–20.
4 Riccetti, 'Il cantiere edile negli anni della Peste Nera', p.143.
5 See Chapter 7.
6 For example, in the case of the Duomo in Florence, 4800 lire was raised in two years (1295–96) by direct subsidy of the Commune. Another measure called on those who had defrauded the Commune to commute their fines as donations to the cathedral works. In addition, Pope Boniface VIII contributed 3000 gold florins (see Guasti, *Santa Maria del Fiore*, pp.xxxiv, 6 and 8).
7 Ten was the figure in the Constitution of 1262; see Lusini, *Il duomo di Siena*, I, p.16. In 1247 there seem to have been only six *maestri* and in 1249 eight, with ten appearing for the first time in 1252 (see Middeldorf-Kosegarten, *Sienesische Bildhauer*, p.17). In 1310 it was decided to reduce the number of *maestri* to ten (from an unknown figure) but by 1318 it had risen to 24.
8 Much of the cost was defrayed to the provinces, who were expected to pay for the extraction and transportation of the marble and mend roads and repair bridges damaged by the heavy carts. The cost fell too on individual citizens, who were called on to supply their own beasts of burden, twice a year, to carry stone and marble for the cathedral (Constitution of 1262, cited in Middeldorf-Kosegarten, *Sienesische Bildhauer*, p.16).
9 See Goldthwaite, *The Building of Renaissance Florence*, p.136.
10 See Goldthwaite, *The Building of Renaissance Florence*, p.143.
11 The document of incorporation is cited and interpreted in Middeldorf-Kosegarten, *Sienesische Bildhauer*, pp.13–15. A later, fully authenticated document exists: the statute of the stone masons of Strasbourg (see Recht, *Les batisseurs des cathedrales gothiques*, pp.103–9).
12 Most Tuscan kilns made as much revenue from burning stone for lime as from baking bricks. Goldthwaite, *The Building of Renaissance Florence*, pp.171–242, summarizes the history of stone and brick manufacture in and around Florence.
13 Riccetti, 'Il cantiere edile negli anni della Peste Nera', pp.170ff.
14 For example, the frescoes by Ambrogio Lorenzetti in the Palazzo Pubblico in Siena. See Norman, 'The paintings of the Sal dei Nove in the Palazzo Pubblico, Siena' [Chapter 7 in the companion volume to this one].
15 Balestracci, 'Introduzione', pp.8ff.

16 Goldthwaite, *The Building of Renaissance Florence*, p.171.

17 Balestracci and Piccinni, *Siena nel Trecento*, p.65.

18 Balestracci and Piccinni, *Siena nel Trecento*, p.63.

19 Balestracci and Piccinni, *Siena nel Trecento*, p.73. The Constitution of 1262 lists beneficiaries in receipt of a total of 370,000 bricks per annum.

20 In Siena today, the line of the Via Francigena is traced in the Via Montanini, Banchi di Sopra, Banchi di Sotto and the Via del Porrione.

21 Balestracci and Piccinni, *Siena nel Trecento*, p.69.

22 Gimpel, *The Medieval Machine*, p.118. Duccio signed the *Maestà* in Siena (see Chapter 3) and Giovanni Pisano signed the pulpit in Pistoia, asserting his superiority over his father Nicola.

23 Cited in Toker, 'Gothic architecture by remote control', p.70.

24 Carli, *Il duomo di Siena*, p.47.

25 Middeldorf-Kosegarten, *Sienesische Bildhauer*, p.17.

26 Holy Roman Emperors were traditionally crowned in Paris or Milan with the 'Iron Crown of the Lombards', but we can assume that Lando di Pietro's creation would have been largely of gold and gems.

27 Pietramellara, *Il duomo di Siena*, p.60.

28 Guasti, *Santa Maria del Fiore*, p.43.

29 Guasti, *Santa Maria del Fiore*, p.20.

30 Guasti, *Santa Maria del Fiore*, pp.10, 211. A document of April 1368 records the commissioning of an inscription, and this date is confirmed by the style of the lettering.

31 Cited in Prosdocimi, 'Note su Fra Giovanni degli Eremitani', pp.18, 29.

32 Two such drawings are discussed in Benton, 'The design of Siena and Florence Duomos' [Chapter 6 in the companion volume to this one].

33 Toker, 'Gothic architecture by remote control', attributes the drawing to Giovanni di Agostino on plausible grounds.

34 1:√2, that is, the diagonal of a square is equal to the square root of twice the length squared of one of its sides.

35 Starting with a square of side 16, the sequences are 16, 11.31, 8, 5.66, 4, etc., down to 1.414 for the sides and 256, 128, 96, 48, 24, etc., down to 2 for the areas, but the numbers are less significant than the simple means of drawing them out.

36 See Russell, *History of Western Philosophy*, p.220.

37 Mathes Roriczer, *Geometria deutsch*, *c*.1486, quoted in Shelby, *Gothic Design Techniques*, p.64, demonstrates this method, which is accurate to two places of decimals. The value derived is 3.14286, compared with pi, which is 3.14159.

38 Examples exist of full-size geometric constructions scratched onto walls or floor surfaces, see Schöller, 'Le dessin d'architecture à l'époque gothique'.

CHAPTER 7

1 See Chapters 1 and 3.

2 See Chapter 1.

3 The private *palazzo* provided accommodation for several branches of one family and the family chapel commemorated past and present members of the extended family.

4 Najemy, 'Guild republicanism in Trecento Florence', p.56.

5 For further elaboration of this point, see Chapter 9.

6 This room is also known popularly as the Sala del Mappamondo after a lost rotating map of the world by Ambrogio Lorenzetti, which was placed in the room in 1345. By 1343 the Sala del Consiglio no longer functioned as the meeting room of the Consiglio della Campana. See Southard, 'The Frescoes in Siena's Palazzo Pubblico', I, p.213 and Cunningham, 'The design of town halls' [Chapter 2 in the companion volume to this one].

7 A fragmentary painted text below the lower frame of the painting indicates a date of 1315–16, and an inscription below it refers to one 'Simone'. Simone Martini received payments from the magistracy of the Biccherna in October and December 1315. He received a further payment for repair of the painting on 30 December 1321. For details of the payments, see Southard, 'The Frescoes in Siena's Palazzo Pubblico', I, pp.216–17, and for transcription of the two texts giving the date and name of the painter, see Martindale, *Simone Martini*, cat. no.35, pp.207–8. At the time of going to press (1994), the painting was undergoing an extensive campaign of restoration.

8 'SALVET VIRGO SENAM VETEREM QUAM SIGNAT AMENAM.' Translation from White, *Duccio*, p.95.

9 The opening verse of the Book of Wisdom: 'DILIGITE IUSTITIAM QUI IUDICATIS TERRAM.'

10 The angelic flowers, the rose and lily
 With which the heavenly fields are decked

Do not delight me more than righteous counsel.
But some I see who for their own estate
Despise me and deceive my land
And are most praised when they speak worst.
Whoever stands condemned by this my speech take heed.

The reply of the Virgin to the words of the saints:

My beloved bear it in mind
When your just devotees make supplication
I will make them content as you desire,
But if the powerful do harm to the weak
Weighing them down with shame or hurt
Your prayers are not for these
Nor for whoever deceives my land.
(Translation from White, *Duccio*, p.96)

11 Wieruszowski, 'Art and the Commune', p.19.

12 See Chapter 2.

13 For the archival evidence for these lost paintings of conquered castles, see Mallory and Moran, '*Guido Riccio da Fogliano*', p.10, nn.3–5.

14 For example, Bellosi, '*Castrum pingatur in palatio*'; Torriti, *Tutta Siena*, p.44.

15 Mallory and Moran, 'New evidence concerning *Guidoriccio*', pp.251–6; Martindale, 'The problem of *Guidoriccio*', pp.265, 270–1.

16 Carli, *La pittura senese del Trecento*, p.260, n.64; Polzer, 'The technical evidence … of Simone Martini's "*Guidoriccio*"', p.145; Polzer, 'Simone Martini's *Guidoriccio* fresco', pp.18–21.

17 The painted inscription, although partially repainted, is substantially original. See Polzer, 'Simone Martini's *Guidoriccio da Fogliano*', pp.108, 140, figs9–10 (pp.116–17).

18 For the archival record of the payment of 1330, see Mallory and Moran, '*Guido Riccio da Fogliano*', p.10, n.3. In *Cronache senesi*, p.496, Agnolo di Tura refers to paintings of Montemassi and Sassoforte executed in April 1330 by Simone di Lorenzo di Siena for an upstairs room in 'the great palace'. Sigismondo Tizio (*c*.1527) refers to a painting of Guidoriccio and Montemassi in the Sala del Mappamondo. Giugurta Tommasi (late sixteenth century, published 1625–26) refers to a painting of Guidoriccio and Montemassi in that room and to Simone Martini as its painter. See Martindale, 'The problem of *Guidoriccio*', pp.260–1, for transcriptions of the relevant passages. Giovanni Pecci, 'Raccolta universale di tutte l'iscrizioni', fol.191r., also claims to have seen Simone Martini's signature below the frame of the painting.

19 It is not possible within the confines of this essay to describe every detail of this scholarly controversy. Readers interested in the debate should read Moran, '*Novità su Simone?*'; Mallory and Moran, '*Guido Riccio da Fogliano*'; Martindale, 'The problem of *Guidoriccio*'; Polzer, 'Simone Martini's *Guidoriccio* fresco'.

20 The text of this claim, made by Giuseppe Gavazzi in an unpublished restoration report of 1981, is published in Polzer, 'Simone Martini's *Guidoriccio* fresco', p.25. There is also another unpublished restoration report of the painting compiled by Leonetto Tintori in 1979.

21 Polzer, 'The technical evidence … of Simone Martini's "*Guidoriccio*"', p.144; 'Simone Martini's *Guidoriccio da Fogliano*', pp.117–19; 'Simone Martini's *Guidoriccio* fresco', pp.23–4.

22 Martindale, 'The problem of *Guidoriccio*', pp.267–8; *Simone Martini*, pp.40–1.

23 For a summary of these references to the lost painting, see Southard, 'The Frescoes in Siena's Palazzo Pubblico', I, pp.237–8.

24 Borghini *et al.*, *Il Palazzo Pubblico di Siena*, pp.224–6.

25 For discussion of the Sala dei Nove and its highly politicized pictorial programme, see Chapter 10 and Norman, 'The paintings of the Sala dei Nove in the Palazzo Pubblico, Siena' [Chapter 7 in the companion volume to this one].

26 Indeed, during the fifteenth and sixteenth centuries the pictorial programme of the Sala del Consiglio was extended by the execution of another battle scene on the upper arcade of the north-east section of the room and representations around the walls of other of the city's patron saints.

27 Cited in Wieruszowski, 'Art and the Commune', p.22. It appears that the Palazzo del Podestà also contained a painting of at least one military victory – the 1289 Florentine victory at Campaldino against the Ghibellines – and also a sequence of subject towns. See Wieruszowski, 'Art and the Commune', p.21; Seidel, '*Castrum pingatur in palatio*', p.33.

28 Wieruszowski, 'Art in the Commune', p.20, n.3. In the 1380s one of the minor rooms (*aula minor*) was painted with a series of 22 famous men for which the humanist Chancellor of Florence, Coluccio Salutati, composed epigrams. See Hankey, 'Salutati's epigrams for the Palazzo Vecchio'. For further discussion of this later addition to the interior of the Palazzo dei Priori, see Chapter 8.

29 Edgerton, *Pictures and Punishment*, pp.41, 83–4. For a discussion of other examples of Trecento *pitture infamate*, see Edgerton, *Pictures and Punishment*, pp.59–90.

30 See Chapter 1. For a more detailed account of these extensions, see Cunningham, 'The design of town halls' [Chapter 2 in the companion volume to this one].

31 Giovanni da Nono, 'Visio Egidii Regis Patavie', p.20. For Giotto's part in this scheme, see Hartlaub, 'Giotto's Zweite Hauptwerk in Padua'; Grossato, 'La decorazione pittorica del Salone', pp.47–69; Smart, *The Assisi Problem*, p.64.

32 Bettini, *Giusto de'Menabuoi*, pp.118–20.

33 Grossato, 'La decorazione pittorica del Salone', p.53; for Pietro d'Abano's role, see also Hartlaub, 'Giotto's Zweite Hauptwerk in Padua', pp.22–3, 27, n.22.

34 Grossato, 'La decorazione pittorica del Salone', p.49.

35 Although it is old, the most comprehensive study of this complex scheme is Barzon, *I cieli e la loro influenza negli affreschi del Salone*.

36 See Chapter 10. The fundamental study of astrology and its impact on medieval and Renaissance art is Seznec, *The Survival of the Pagan Gods*.

37 Reiss, *Political Ideals in Medieval Italian Art*, p.73.

38 The title is a reference to the gardens (*orti* in Italian) that lay in the close vicinity of the oratory.

39 On the confraternity, see Passerini, *Storia degli stabilimenti di beneficenza*, pp.404–39; La Sorsa, *La Compagnia d'Or San Michele*, pp.16–32; and Zervas, *Orsanmichele*.

40 Cohn, 'La seconda immagine della Loggia di Orsanmichele'; Cole, 'On an early Florentine fresco'.

41 See below, p.150.

42 Cited in Fabbri and Rutenburg, 'The tabernacle of Orsanmichele', p.388.

43 Fabbri and Rutenburg, 'The tabernacle of Orsanmichele', p.404.

44 Fabbri and Rutenburg, 'The tabernacle of Orsanmichele', pp.388–90.

45 Matteo Villani, *Cronica*, ed. Gherardi-Dragomanni/Moutier, pp.15–16; Cassidy, 'The financing of the tabernacle of Orsanmichele', p.3.

46 The inscription on the back of the tabernacle reads: 'ANDREAS CIONIS PICTOR FLORENTIN[US] ORATORII ARCHIMAGISTER EXTITIT HUI[US] MCCCLIX.' (Andrea di Cione, Florentine painter, was master-in-charge of this oratory 1359.)

47 Cassidy, 'Orcagna's tabernacle in Florence', pp.198–204.

48 Fabbri and Rutenburg, 'The tabernacle of Orsanmichele', pp.404–5. For the commissioning of the stained-glass windows, see Zervas, 'Lorenzo Monaco, Lorenzo Ghiberti, and Orsanmichele'.

49 Fabbri and Rutenburg, 'The tabernacle of Orsanmichele', p.391.

50 For the performance of music at Orsanmichele, see Wilson, *Music and Merchants*, pp.78–88.

51 See Wilson, *Music and Merchants*, p.193, which quotes in translation the confraternity's statutes of 1333; Cassidy, 'Orcagna's tabernacle in Florence', pp.186–9.

52 Cassidy, 'The *Assumption of the Virgin* on the tabernacle of Orsanmichele'.

53 Cited in Waley, *The Italian City-Republics*, p.107.

54 Published in Arthur, 'Cult objects and artistic patronage', p.357. For a discussion of the commission, with slightly different emphases, see Arthur, 'Cult objects and artistic patronage', pp.345–7.

55 For further amplification of this point, see Chapter 8.

CHAPTER 8

1 *De Primo Eius Introitu ad Aulam*, 13 September 1385 (*Of His Earliest Introduction to Court*), in Conversini, *Two Court Treatises*, p.29.

2 Conversini, *Two Court Treatises*, p.29.

3 Conversini, *Two Court Treatises*, p.33.

4 *De Dilectione Regnantium*, 5 September 1399 (*On the Proper Love due to Princes*), in Conversini, *Two Court Treatises*, p.167.

5 Plant, 'Patronage in the circle of the Carrara family', p.177.

6 Kohl, 'Carrara, Francesco da', p.652.

7 Gatari, *Cronaca*, pp.440–4, see also pp.12–13, 22–3, 24–5, 27, 29, 158–9.

8 Vergerio, *De Dignissimo Funebri*, cols.189–98, esp. col.193.

9 Transcribed in Kohl, 'Giusto de'Menabuoi e il mecenatismo artistico', pp.24–6, doc.8.

10 Gatari, *Cronaca*, p.444, n.1; Vergerio, *De Dignissimo Funebri*, col.193; Saalman, 'Carrara burials', pp.376, 380–1.

11 Vasoin, *La signoria dei Carraresi*, p.180.

12 Wolters, *La scultura veneziana gotica*, cat. no.30, pp.162–3, figs95–8.

13 Gatari, *Cronaca*, pp.24–5, 29.

14 This church appears to have been designated as the burial place of a number of Padua's most illustrious fourteenth-century citizens. The mathematician and scholar Pietro d'Abano was buried within it, and Petrarch expressed a wish to be buried there. Toffanin, *Cento chiese padovane*, pp.25–8.

15 Published in Wolters, *La scultura veneziana gotica*, cat. no.41, p.169.

16 Plant, 'Patronage in the circle of the Carrara family', p.178. The sculpted model of Padua is now in the possession of the Eremitani, but its original placement on the tomb is clearly visible in old photographs of the tomb. See Wolters, *La scultura veneziana gotica*, pl.137.

17 Gatari, *Cronaca*, p.29, n.6.

18 Gatari, *Cronaca*, pp.59–60. All the Carrara *signori* had been assiduous in securing advantageous marriage alliances for themselves and their sons and daughters. Thus, Jacopo I's second wife had been the daughter of the Venetian doge Pietro Gradenigo, and he had married his daughter Taddea to Mastino della Scala, Cangrande's nephew and future *signore* of Verona. Marsiglio's first wife had been Bartolommea Scrovegni, the niece of Giotto's wealthy and socially influential Paduan patron Enrico Scrovegni. Marsiglio's second wife was Beatrice, the daughter of Guido da Correggio, the *signore* of the north Italian town of that name. Such examples provide an indication of the general pattern of the Carrara's policy for securing dynastic weddings – choosing brides from leading families of other Italian city republics or local *signori*. Alternatively, they might contract a marriage alliance with a powerful Paduan family such as the Scrovegni or the Buzzacarini.

19 Puppi and Toffanin, *Guida di Padova*, p.87.

20 Kohl, 'Giusto de'Menabuoi', pp.18–20; King, 'Women as patrons' [Chapter 11 in the companion volume to this one].

21 Gasparotto, 'La Reggia dei Da Carrara', p.112, 'Gli ultimi affreschi', p.238; Richards, 'Altichiero and Humanist Patronage', pp.156–7.

22 The surviving painted decoration of rooms in the Carrara fortress at Monselice in the Padovano shows a similar taste for heraldic embellishment. See Vasoin, *La signoria dei Carraresi*, figs26, 27.

23 Gasparotto, 'La Reggia dei Da Carrara', p.93.

24 D'Arcais, 'Gli affreschi del Guariento'.

25 D'Arcais, *Guariento*, p.67.

26 D'Arcais, *Guariento*, p.70, dates the painting of the chapel to the 1360s during the rule of Francesco il Vecchio. Plant, 'Patronage in the circle of the Carrara family', p.182, favours an earlier date between 1347 and 1350 during the rule of Jacopo II.

27 *The Anonimo*, pp.37–8; Gasparotto, 'La Reggia dei Da Carrara', pp.82, 95–7, 101–9, 114–15, 'Gli ultimi affreschi … nella Reggia', pp.250–5; Plant, 'Patronage in the circle of the Carrara family', pp.182–4, 196; Richards, 'Altichiero and Humanist Patronage', pp.156–9.

28 *The Anonimo*, p.38: 'The balcony at the back, where the Signori of Padua are portrayed life-size in green colour.'

29 Savonarola, *Libellus de Magnificis Ornamentis Regie*, p.49; the translation is taken (with minor revisions) from Mommsen, 'Petrarch and the … Sala Virorum Illustrium', p.101.

30 Richards, 'Altichiero and Humanist Patronage', pp.115–18. The identification was first made by von Schlosser, 'Ein Veronesisches Bilderbuch'.

31 Mommsen, 'Petrarch and the … Sala Virorum Illustrium', p.97. The nature of their relationship is further summed up by a statement in a letter of *c*.1371–72 written by Petrarch to his brother Gherardo, where Petrarch states: 'the lord … a very wise man, loves and honours me, not as a master but as a son does'. For a summary of the letter's full contents, see Wilkins, *Life of Petrarch*, pp.211–12.

32 Mommsen, 'Petrarch and the … Sala Virorum Illustrium', pp.95–8; Richards, 'Altichiero and Humanist Patronage', pp.93–5.

33 Paris, Biblioteque Nationale, MS, lat., 6069 F, fol.144r. The translation is taken from Mommsen, 'Petrarch and the … Sala Virorum Illustrium', p.96.

34 Mommsen, 'Petrarch and the … Sala Virorum Illustrium', pp.103–13, esp. pp.108–9.

35 Hessische Landesbibliothek, Darmstadt, cod.101, fol.1v. This manuscript presently contains as its frontispiece the portrait of Petrarch (Plate 176), although this may have been added in at a later date. See Richards, 'Altichiero and Humanist Patronage', pp.120–2. Additionally, at the head of the first folio of this manuscript is an image of a woman in a chariot surrounded by horsemen, which has been identified as a representation of the Petrarchan theme of the *Triumph of Fame*. Since this allegorical subject (with minor variations) also features in two fourteenth-century Paduan manuscript copies of *De Viris Illustribus*, Mommsen, 'Petrarch and the … Sala Virorom Illustrium', p.107, following von Schlosser, has suggested that this image once featured on the short east wall of the Sala Virorum Illustrium opposite the portraits of Petrarch and Lombardo della Seta. Gilbert, 'The fresco by Giotto in Milan', and Richards, 'Altichiero and Humanist Patronage', pp.132–49, for differing reasons doubt that it was in the room. Given

that there is not enough wall surface available to depict such a painting and that none of the early descriptions of the room refer to such a subject, it seems unlikely that in this instance the imagery of the manuscript corresponds to a painting within the Sala Virorum Illustrium.

36 Mommsen, 'Petrarch and the ... Sala Virorum Illustrium', pp.108–9.

37 Mommsen, 'Petrarch and the ... Sala Virorum Illustrium', pp.98–102; Wilkins, *Petrarch's Later Years*, pp.300–1; Simon, 'Altichiero versus Avanzo', pp.266–71; Richards, 'Altichiero and Humanist Patronage', pp.95, 101–2.

38 *The Anonimo*, p.38; cf. Savanorola, *Libellus de Magnificis Ornamentis Regie*, p.49.

39 Varanini, *Gli Scaligeri*, pp.318–20; Richards, 'Altichiero and Humanist Patronage', pp.13–93.

40 See the contract published in Sartori, 'Nota su Altichiero', pp.311–14; see also Norman, 'Two funerary chapels' [Chapter 8 in the companion volume to this one].

41 Mellini, *Altichiero e Jacopo Avanzi*, pp.36–7; Simon, 'Altichiero versus Avanzo', pp.268–9; Richards, 'Altichiero and Humanist Patronage', pp.116–18, 122, 124, 149–52.

42 For what little is known of Ottaviano Prandino as a painter, see Thieme and Becker, *Allgemeines Lexikon*, XXVII, p.346. Richards, 'Altichiero and Humanist Patronage', p.196, n.29, makes the perceptive observation that the Brescian painter's presence in Padua might be related to the fact that from 1370 to 1373 the Podestà of Padua was Federigo da Lavellongo di Brescia (Plate 180).

43 Wolters, *La sculptura veneziana gotica*, pp.203–4.

44 Kohl, 'Giusto de'Menabuoi', p.19; Bellinati, 'Iconografia e teologia', pp.58–9.

45 Plant, 'Portraits and politics in late Trecento Padua', 'Patronage in the circle of the Carrara family', pp.180–1; see also Chapter 1 and Norman, 'Two funerary chapels' [Chapter 8 in the companion volume to this one].

46 Siraisi, *Arts and Sciences at Padua*, p.29; Billanovich, 'Carrara, Ubertino da', p.702; Kohl, 'Carrara, Francesco da', p.654; Plant, 'Patronage in the circle of the Carrara family', p.197.

47 Robey, 'P.P. Vergerio the Elder', p.22.

48 Medin, 'I ritratti autentici'.

49 Gasparotto, 'La Reggia dei Da Carrara', pp.95–6 and n.75; Plant, 'Patronage in the circle of the Carrara family', pp.184–5; cf. Richards, 'Altichiero and Humanist Patronage', p.198, n.69.

50 Plant, 'Patronage in the circle of the Carrara family', pp.184–5.

51 Borsook, *The Mural Painters of Tuscany*, pp.141–2.

52 Mommsen, 'Petrarch and the ... Sala Virorum Illustrium', p.113.

53 Gilbert, 'The fresco by Giotto in Milan'.

54 Rubinstein, 'Classical themes in the decoration of the Palazzo Vecchio', pp.29–32; Donato, 'Hercules and David in the early decoration of the Palazzo Vecchio', p.86.

55 Southard, 'The Frescoes in Siena's Palazzo Pubblico', I, pp.358–71; Solberg, 'Taddeo di Bartolo', pp.121–2, 223–33, 883–960.

56 Volpe, *Pietro Lorenzetti*, pp.194–5.

CHAPTER 9

1 Meiss, *Painting in Florence and Siena after the Black Death*, p.10.

2 Meiss, *Painting in Florence and Siena after the Black Death*, pp.10–11.

3 Meiss, *Painting in Florence and Siena after the Black Death*, pp.11–12.

4 While Meiss, in general, confined the scope of his argument to fourteenth-century Florentine painting, he also cited Orcagna's sculpted tabernacle of Orsanmichele (Chapter 7, Plate 157) as another example of a reactionary stylistic trend within fourteenth-century Florentine art. For a convincing refutation of Meiss's argument in respect of the Orsanmichele tabernacle, see Fabbri and Rutenburg, 'The tabernacle of Orsanmichele'.

5 Meiss, *Painting in Florence and Siena after the Black Death*, p.6.

6 Known more commonly as *The Presentation in the Temple*. In the gospel account these two episodes are synonymous with one another, but in late medieval Catholicism the event was celebrated in the liturgical calendar as the Marian Feast of the Purification. Ambrogio's painting originally formed a centrepiece to a triptych for an altar in Siena Duomo, and was one of a series of early fourteenth-century Marian altarpieces designed to celebrate the cult of the Virgin. The painting's subject was, therefore, intended primarily to honour Mary and thus should be referred to as *The Purification*.

7 Meiss, *Painting in Florence and Siena after the Black Death*, pp.19–20; emphasis added.

8 Van Os, *Sienese Altarpieces*, II, pp.24–5; Paoletti, 'The Strozzi altarpiece', p.279.

9 Readers interested in this historiographical debate should consult van Os, *Sienese Altarpieces*, II, pp.24–33; Cohn, *The Cult of Remembrance*, pp.271–80.

10 Brucker, 'Florence and the Black Death'; Bowsky, 'The impact of the Black Death'; Herlihy, 'Population, plague and social change'.

11 Marshall, '"Waiting on the Will of the Lord"', pp.28–9; Cohn, *The Cult of Remembrance*, p.5.

12 Matteo Villani, *Cronica*, X, ch.46, ed. Gherardi-Dragomanni/Moutier, II, p.345: 'la pestilenza dell'anguinaia usata'.

13 As argued by Cohn in *Death and Property in Siena* and *The Cult of Remembrance*.

14 See, for example, Giles, 'The Strozzi Chapel'; Paoletti, 'The Strozzi altarpiece'; Kreytenberg, 'Image and frame'.

15 As argued by Polzer, 'Aristotle, Mohammed and Nicholas V in hell', esp. pp.467–8, and 'Aspects of the fourteenth-century iconography of death and the plague'. Meiss, 'Notable disturbances', stands by his post-Black Death dating of the Camposanto frescoes.

16 As argued by Boskovits in *Pittura fiorentina*.

17 See Chapter 1.

18 Cited in von Simpson, 'Über die Bedeutung von Masaccios Trinitäts-fresko', p.122, n.9.

19 Thomas Aquinas, *The 'Summa Theologica'*, 3a, 25.3. Trans. in Lee, 'Images', p.372. My attention was first drawn to this Thomist passage by Wilson, *Music and Merchants*, p.185.

20 Trexler, 'Florentine religious experience', pp.18–19.

21 The painting survives today in Santa Maria Impruneta set within an elaborately decorated chapel niche. Subjected to numerous repaintings within its long history, little, if anything, survives of its original paint surface. For a graphic evocation of how these crisis processions were staged, see Trexler, 'Florentine religious experience', pp.12–13, and *Public Life in Renaissance Florence*, pp.63–6.

22 Cited in Cohn, *The Cult of Remembrance*, p.231.

23 Giovanni Villani, *Cronica*, VII, ch.154, ed. Gherardi-Dragomanni/Moutier, I, p.479; trans. in Wilson, *Music and Merchants*, pp.41–2.

24 Kieckhefer, 'Major currents in late medieval devotion', pp.75–7.

25 Kieckhefer, 'Major currents in late medieval devotion, p.81.

26 Cited and trans. in Wilson, *Music and Merchants*, p.19.

27 Marshall, '"Waiting on the Will of the Lord"', pp.57–9; Wilson, *Music and Merchants*, pp.7, 9–10, 15–16, 24–6.

28 For a comprehensive account of the ceremonial life and religious practices of the Florentine Laudesi, see Wilson, *Music and Merchants*, pp.45–73. For a general survey of confraternities, see Henderson, 'Piety and Charity in Late Medieval Florence'.

29 For the debate over whether the *Rucellai Madonna* was or was not an altarpiece, see Chapter 3.

30 Wilson, *Music and Merchants*, p.187.

31 See Bourdua, 'Aspects of Franciscan Patronage', pp.18–19; see also Chapter 5, Plates 94, 120.

32 Carli, *La pittura senese*, p.248.

33 Wilson, *Music and Merchants*, pp.63–4, 103–4, 133, 183–211; see also the cult objects listed in the inventory of the Compagnia di Gesù Pellegrino in Arthur, 'Cult objects and artistic patronage', pp.353–6.

34 As, for example, the sentiment expressed in one fourteenth-century Florentine *laude* (trans. in Wilson, *Music and Merchants*, p.23):

> Hail most saintly Lady,/most powerful queen./The celestial virtue/with supernatural grace/descended most benignly in you,/virgin of virgins./Our redemption/was incarnated/without corruption/in you, sweetest Lady.

35 Wilson, *Music and Merchants*, p.187. See also Chapter 3.

36 Baxandall, *Painting and Experience in Fifteenth Century Italy*, p.45.

37 Giovanni de Caulibus, *Meditations on the Life of Christ*, p.38.

38 Ugo Panziera da Prato, trans. in Assunto, 'Images and iconoclasm', p.819. My attention was first drawn to this passage in Wilson, *Music and Merchants*, p.188.

39 Offner *et al.*, *Corpus*, 4, I, p.30; Giles, 'The Strozzi Chapel', pp.83–4; cf. Kreytenberg, 'Image and frame', p.638, who considers that Michael stands for the saint who destroys evil as defined by the teaching of the Church and Aquinas himself. The two interpretations are, of course, not mutually exclusive. The emphasis on salvation within the altarpiece's imagery probably also accounts for the presence of Saint John the Baptist, who embodies baptism. He may also have been included as one of Florence's leading patron saints. The presence of Saint Catherine of Alexandria may be accounted for by the Dominican respect for the saint's intellectual gifts. See Offner *et al.*, *Corpus*, 4, I, p.30. For the unlikelihood of her representing the name saint of Tomaso Strozzi's wife, Caterina di

Buonaccorso Palacioni, see Giles, 'The Strozzi Chapel', p.56. Saints Peter, Paul and Lawrence (as a deacon and treasurer of Pope Sixtus II) were probably intended to represent the official Church of Rome. For further discussion of this latter point, see above, pp.184–5. Saint Peter may have also commemorated the name saint of Tomaso's uncle, the Dominican theologian Pietro di Ubertino Strozzi, who attained the status of Prior of Santa Maria Novella. See Offner *et al.*, *Corpus*, 4, I, p.30.

40 Giles, 'The Strozzi Chapel', pp.57–8, 83.

41 Giles, 'The Strozzi Chapel', pp.41–58. Because of the portrait-like qualities of Aquinas's face, it has been suggested by Gronau, *Andrea Orcagna*, p.13, that this figure is a portrait of Tomaso di Rossello Strozzi.

42 Giles, 'The Strozzi Chapel', pp.68–71.

43 Giles, 'The Strozzi Chapel', pp.73–9; Paoletti, 'The Strozzi altarpiece', pp.285–92; Kreytenberg, 'Image and frame', p.637.

44 Giles, 'The Strozzi Chapel', pp.79–80; cf. Paoletti, 'The Strozzi altarpiece', pp.291–4, 300.

45 Offner *et al.*, *Corpus*, 4, I, p.viii; Giles, 'The Strozzi Chapel', p.145.

46 Kreytenberg, 'Image and frame', p.636.

47 The present frame is completely modern. It is generally agreed, however, that it represents in most essentials an exact imitation of the original frame. See Offner *et al.*, *Corpus*, 4, I, p.31, pl.1, pp.28–9; Gardner von Teuffel, 'Studies of the Tuscan Altarpieces', pp.11–13.

48 Kreytenberg, 'Image and frame', pp.634–5. See also the perceptive analysis in Gardner von Teuffel, 'Studies of the Tuscan Altarpieces', pp.11–17.

49 The existence of an altar dedicated to Saints Sebastian and Fabianus can be documented from 1370; in 1533 it is described as having a *palla lignea*, which Grossato, *Da Giotto al Mantegna*, cat. no.36, has taken to refer to a reliquary cupboard.

50 Marshall, '"Waiting on the Will of the Lord"', pp.64–7.

51 Grossato, *Da Giotto al Mantegna*, cat. nos36–44, provides the most convincing reconstruction upon which the following account is based.

52 This painting survives today in the form of an independent panel painting. At some time in its history it must have been separated from the *Sebastian Shot by Arrows* and at the same time slightly trimmed down on all sides. See Grossato, *Da Giotto al Mantagna*, cat. nos37, 41.

53 Offner *et al.*, *Corpus*, 4, I, p.130, illus. in *Corpus*, 3, V, plsXXXII, XXXIII.

54 Offner *et al.*, *Corpus*, 4, IV, pp.130–1.

55 Meiss, *Painting in Florence and Siena after the Black Death*, pp.77–8.

56 Jacobus de Voragine, *The Golden Legend*, p.109.

57 Marshall, '"Waiting on the Will of the Lord"', p.2 and throughout.

58 See Chapters 8 and 10.

59 On 9 June 1348 the Sienese painter Ambrogio Lorenzetti, foreseeing the possibility that he, his wife and three daughters would all shortly die, drew up his will bequeathing his property to the Confraternity of the Virgin Mary. It appears that his brother Pietro Lorenzetti also died in the Black Death. See Frugoni, *Pietro and Ambrogio Lorenzetti*, pp.4, 36.

60 See Chapter 1.

61 For a résumé of the historical evidence for this location, see Kanter, 'A Massacre of Innocents', pp.21–4; Harpring, *The Sienese Trecento Painter Bartolo di Fredi*, pp.116–22, cat. no.29, p.156.

62 Skaug, 'The "St. Anthony Abbot"' and 'Punch marks'. For a number of more general observations on using punch marks as a means by which to establish painters' personal and workshop associations, see Frinta, 'An investigation of the punched decoration'.

63 Cohn, *The Cult of Remembrance*, esp. pp.244–80.

CHAPTER 10

1 Martindale, *Simone Martini*, ch.3, 'Simone Martini, the European setting', pp.9–13.

2 Bettini, 'Le miniature del "Libro Agregà de Serapoim"', pp.55–60. For a well-informed account of fourteenth-century manuscripts from Bologna and Lombardy and the evidence they provide of direct visual observation, see White, *Art and Architecture in Italy*, pp.579–90.

3 Martindale, *Simone Martini*, p.11. For further discussion of representations of the human body by fourteenth-century sculptors, see King, 'Effigies: human and divine' [Chapter 5 in the companion volume to this one].

4 See Chapter 7; Plant, 'Patronage in the circle of the Carrara family', esp. pp.178–81, 188–9, 195–6; and Norman, 'Two funerary chapels' [Chapter 8 in the companion volume to this one].

5 Martindale, *Simone Martini*, p.12.

6 Saxl, 'The revival of late antique astrology'; Seznec, *The Survival of the Pagan Gods*, pp.162–3, 179–82.

7 For a detailed account of this process, see Hills, *The Light of Early Italian Painting*, esp. chs1–2.

8 *Studium generale* was the general designation for what we would call a university. It signified a place where students from all backgrounds were received. It could therefore apply both to a teaching institution established in a city and to one in a religious house within that city.

9 For the tomb of Rainieri degli Arsendi, see Lorenzoni, *Le sculture del Santo di Padova*, pp.14–15.

10 Siraisi, *Arts and Sciences at Padua*, p.29. See also pp.15–31 for a well-informed account of the origins and growth of the *studium*.

11 The following account of early Paduan humanism is indebted to Hyde, *Padua in the Age of Dante*, ch.10, pp.283–310.

12 For the early histories of the *studia* of Siena and Florence, see Rashdall, *The Universities of Europe*, II, pp.31–5, 47–51, and Denley, 'Academic rivalry and interchange', pp.194–6.

13 Brucker, 'Florence and its university', p.221.

14 The relevant passage is given in Holmes, *Florence, Rome and the Origins of the Renaissance*, p.121.

15 The literature on these two authors is immense. A comprehensive survey of Dante scholarship is contained in the *Enciclopedia dantesca*. For a stimulating essay on Dante, his work and its historical context, see Holmes, *Florence, Rome and the Origins of the Renaissance*, ch.10, pp.233–63. For Boccaccio, see Branca, *Boccaccio*, esp. part II, ch.3, 'The mercantile epic', pp.276–307.

16 See Wilkins, *Life of Petrarch*, pp.220–1 and throughout, for Petrarch's relations with Boccaccio. For Salutati, see Ullmann, *The Humanism of Coluccio Salutati*, esp. pp.40–3, 121–6.

17 Hook, *Siena*, p.123.

18 For further discussion of the Salone programme from the perspective of its civic location within a town hall, see Chapter 7.

19 Thorndike, *A History of Magic*, II, pp.874–947, esp. pp.890–902; Hyde, *Padua in the Age of Dante*, pp.303–4; Siraisi, *Arts and Sciences at Padua*, pp.81–9.

20 The most comprehensive interpretation of this complex scheme is still Barzon, *I cieli e la loro influenza negli affreschi del Salone*, pp.280–6, 474–5. See also Saxl, 'Un ciclo astrologico', pp.280–6, 474–5.

21 For an investigation of the complex, dual role of Venus in fourteenth-century mythography, particularly in respect of Boccaccio's *Genealogie Deorum Gentilium Libri*, see Schreiber, 'Venus in the medieval mythographic tradition'.

22 Saxl, 'I figli dei pianeti', pp.274–9, 473–4.

23 For a detailed discussion of the commission and the essential bibliography, see Norman, 'The paintings of the Sala dei Nove in the Palazzo Pubblico, Siena' [Chapter 7 in the companion volume to this one].

24 For transcription and translation of these painted texts, see Stefanini, Appendix I in Starn and Partridge, *Arts of Power*.

25 For a more detailed discussion of the significance of the inclusion of the planets in the Sala dei Nove programme, see Greenstein, 'The vision of peace', pp.498–506.

26 Feldges-Henning, 'The pictorial programme of the Sala della Pace', pp.150–6.

27 White, *Art and Architecture in Italy*, p.391, remarks of Peace that the painted figure is 'the most deeply felt and thoroughgoing re-evocation of Antique, close-folded, sculptural forms in pre-Renaissance painting'.

28 Pliny the Elder, *The Elder Pliny's Chapters on the History of Art*, p.147. (The *Natural History* comprises 37 books and the digression on art occurs in Books 33–7 on minerals and metallurgy.) See also Edwards, 'Ambrogio Lorenzetti and classical painting', pp.146–55.

29 Pliny the Elder, *The Elder Pliny's Chapters on the History of Art*, p.103, noted in Edwards, 'Ambrogio Lorenzetti and classical painting', p.148.

30 Ghiberti, *I commentari*, ed. Morisani, pp.37–8, esp. p.38; Vasari, *Le vite*, ed. Bettarini, pp.181–2; Starn and Partridge, 'The republican regime of the Sala dei Nove', pp.4–5.

31 Ghiberti, *I commentari*, ed. Morisani, pp.37–8; trans. with emendments from Rowley, *Ambrogio Lorenzetti*, I, p.133.

32 For further discussion of the commission for the campanile, see Chapter 5 and Norman, 'The art of knowledge' [Chapter 10 in the companion volume to this one].

33 Five hexagonal reliefs were added by Luca della Robbia in the fifteenth century. The triangle replaces a lozenge-shaped relief where the positioning coincides with a window.

34 This interpretation of the campanile programme relies on that of von Schlosser as set out in his highly influential article, 'Giusto's Fresken in Padua', pp.53–76. See also Becherucci, in Becherucci and Brunetti, *Il Museo dell'Opera del Duomo a Firenze*, I, pp.233–4.

35 See Chapter 5.

36 For the history of this relief, see Bober and Rubinstein, *Renaissance Artists and Antique Sculpture*, cat. no.104, pp.134–5. For this and other parallels between antique sculpture and the campanile hexagonal reliefs, see Moskowitz, 'Trecento classicism and the campanile hexagons', pp.49–65, esp. p.58.

37 Translation (with an emendment) taken from Krautheimer, *Lorenzo Ghiberti*, p.296.

38 Siraisi, *Arts and Sciences at Padua*, pp.92–3; Plant, 'Patronage in the circle of the Carrara family', pp.192–3.

39 D'Arcais, *Guariento*, pp.29–35, 61–3. As noted in Chapter 2, this fresco cycle was extensively damaged by a bomb blast sustained during World War II.

40 For a thorough discussion of the murals as a whole, see the essays in Spiazzi, *Giusto de'Menabuoi nel Battistero di Padova*.

41 The cruciform pattern on the halo identifies the figure as God the Son. Furthermore, if this image is turned in order that it follows the conventions of modern map making, in which the north (rather than the east) appears at the top, it is possible to see that the painting provides a recognizable representation of the coastline of Europe, and of Italy in particular. Africa and Asia remain much more generalized in their outlines and the Americas and Australia are notably absent. For further discussion of the geographical accuracy of the painting, see Spiazzi, 'Un documento storico-geografico'.

42 As graphically shown in Hartmann Schedel's *Liber Chronicarum*, in the 'seventh day of creation', a woodcut that conveniently labels the spheres from *terra* (earth) to *primum mobile* (the prime mover). Illustrated in Heninger, *The Cosmographical Glass*, fig.10g.

43 Giovanni di Paolo's *Creation and Expulsion of Adam and Eve from Paradise* in the Robert Lehman Collection, the Metropolitan Museum of Art, New York. For a detailed discussion of this painting and its cosmological detail, see the catalogue entry by Carl Strehlke in Christiansen *et al.*, *Painting in Renaissance Siena*, pp.193–200.

44 See Chapter 8.

45 Ladis, 'The legend of Giotto's wit', p.585, also comments on the humorous character of the wine steward in *The Feast of Cana*.

46 For further analysis of the sophistication of Giotto's treatment of space in this painting, see White, *The Birth and Rebirth of Pictorial Space*, pp.372–3. In general terms the paintings of the Arena Chapel offer ample evidence of a painter exploiting to very good effect his perceptive observation of people, objects and narrative situations. However, it is likely that Giotto also utilized certain motifs from antique art within this painted scheme. Thus, for example, it has plausibly been suggested by Anne Markam Telpaz, 'Some antique motifs in trecento art', pp.372–3, that the pose and drapery of the sorrowful Joachim in *Joachim's Return to the Sheepfold* might well have been derived from the bearded, heavily draped Bacchus figure depicted (albeit in reverse) on a neo-Attic crater then located before the Porta San Ranieri of Pisa Duomo. The crater is now on display in the Camposanto, Pisa. See Bober and Rubinstein, *Renaissance Artists and Antique Sculpture*, cat. no.91.

47 Translated in Baxandall, *Giotto and the Orators*, pp.43–4.

48 For the patrons of the oratory and their commission to Altichiero, see Bourdua, 'Aspects of Franciscan Patronage', pp.25, 27–9, 31–2.

49 As in the case of the Arena Chapel frescoes, it is likely that certain of the painter's pictorial solutions were facilitated by his study of antique art. For example, it has plausibly been suggested by Richards, 'Altichiero and Humanist Patronage', p.177, that the frieze-like 'processional logic' of the figural composition in *The Torture of Saint Lucy by Bulls* may be indebted to sculpted scenes of sacrificial processions such as the one portrayed on a Julio-Claudian relief now in the Louvre. For the relief itself, see Bober and Rubinstein, *Renaissance Artists and Antique Sculpture*, cat. no.190.

50 Mellini, *Altichiero e Jacopo Avanzi*, pp.73–7.

51 Plant, 'Patronage in the circle of the Carrara family', pp.192–3.

CHAPTER 11

1 *Sigilli nel Museo Nazionale del Bargello*, p.284.

2 Pope-Hennessy, *Italian Gothic Sculpture*, 3rd edn, pp.184–5, 276–7.

3 Tim Benton interview with Alfio del Serra for a BBC/Open University television programme on Duccio, *The Rucellai Madonna*.

4 Haraway, 'Situated knowledges', pp.575–600.

5 Della Valle, *Lettere Senesi*, I, p.288.

6 Fineschi, *Memorie istoriche*, pp. 99, 118, 321.

7 Burckhardt, *Cicerone*, p.505.

8 Crowe and Cavalcaselle, *A History of Painting in Italy*, III, pp.7–8.

9 Berenson, *Italian Pictures of the Renaissance*, pp.176–7, 149–50, 349.

10 Offner *et al.*, *Corpus*, 4, VI, pp.71–8.

11 Crowe and Cavalcaselle, *A History of Painting in Italy*, II, p.145.

12 Taurisano cited in Offner *et al.*, *Corpus*, 4, VI, p.76.

13 Villani, *Croniche*, ed. Racheli, I, p.450.

14 Cennini cited in Holt, *A Documentary History of Art*, I, p.138.

15 Ghiberti, *I commentari*, cited in and trans. Holt, *A Documentary History of Art*, I, pp.153–4.

16 Ghiberti, *I commentari*, ed. Morisani, pp.33–9.

17 Cited in Gombrich, 'The Renaissance conception of progress', pp.1–2.

18 Landino, *Comento di Christophoro Landino Fiorentino*, fol.5v.

19 Leonardo da Vinci, *The Notebooks of Leonardo da Vinci*, II, p.258.

20 Alberti and Filarete cited in Holt, *A Documentary History of Art*, I, pp.205–6, 247, 253–4.

21 Cited in Cartwright, *The Painters of Florence*, pp.45–6.

22 Savonarola, *Libellus de Magnificis Ornamentis Regie Civitatis Padue*, p.44.

23 Cited in Savonarola, *Libellus de Magnificis Ornamentis Regie Civitatis Padue*, p.45.

24 Vasari, *Lives of the Artists*, p.6.

25 Ridolfi, *Le meraviglie dell'arte*, I, pp.32–3.

26 Mancini cited in Previtali, *La fortuna dei primitivi*, pp.47–9; Ugurgieri cited in Previtali, *La fortuna dei primitivi*, pp.47–51.

27 Baldinucci, *Notizie dei professori del disegno da Cimabue in qua per le quale si dimostra come, e per chi le belle arti di pittura, scultura e architettura lasciata la rozzezza delle maniere greca e gotica si siano in questi secoli ridotte all'antica loro perfezione*. For Baldinucci on Guariento, see I, p.287.

28 Verci, *Notizie intorno*, cited in Previtali, *La fortuna dei primitivi*, pp.98–9.

29 Moschini, *Della origine e delle vicende della pittura in Padova*, p. 3.

30 Della Valle, *Lettere Senesi*, II, p.276.

31 Milanesi, *Documenti per la storia dell'arte senese*; Vasari, *Le vite*, ed. Milanesi.

32 Vasari, *Le vite*, ed. Milanesi, I, pp.322–3.

33 Crowe and Cavalcaselle, *A History of Painting in Italy*, I, p.109.

34 Barri, *The Painters' Voyage of Italy*, pp.108–10 on Padua; Siena is omitted altogether.

35 Cicognara cited in Previtali, *La fortuna dei primitivi*, pp.192–4; von Rümohr, *Italienische Forschungen*, pp.273–4.

36 Cicognara cited in Previtali, *La fortuna dei primitivi*, pp.192–4.

37 Lami cited in Previtali, *La fortuna dei primitivi*, p.90.

38 Milizia cited in Previtali, *La fortuna dei primitivi*, pp.105–7.

39 Milizia cited in Previtali, *La fortuna dei primitivi*, p.107.

40 Della Valle, *Lettere Senesi*, I, p.4.

41 Lindsay, *Sketches of the History of Christian Art*, II, p.162.

42 Cited in Venturi, *History of Art Criticism*, p.172 (Winckelmann), pp.166–7 (Hurd) and p.192 (Riedel).

43 Wackenroder cited in Venturi, *History of Art Criticism*, p.172.

44 Ruskin, *The Stones of Venice*, pp.193–4.

45 Ruskin, *Giotto and his Works in Padua*, pp.332–3.

46 Ruskin, *Giotto and his Works in Padua*, pp.40–1.

47 Murray, *A New English Dictionary*, X, part I, p.311.

48 Cited in Wakefield, *Stendhal and the Arts*, pp.33–5.

49 Cook, *A Popular Handbook to the National Gallery*, pp.3–7.

50 Murray, *A New English Dictionary*, VII, pp.1365–6.

51 Burckhardt, *The Civilization of the Renaissance in Italy*, p.121.

52 Thode, *Franz von Assisi*, p.425.

53 Seznec, *The Survival of the Pagan Gods*, p.3, quoting Haskins.

54 Scott, *The Renaissance of Art in Italy*, p.xi.

55 Denis cited in Curtis, *Search for Innocence*, p.64.

56 Moore, introduction to Ayrton, *Giovanni Pisano*, p.10.

57 Rio, *De l'art Chrétien*, I, p.237.

58 Rio, *De l'art Chrétien*, I, p.238.

59 Rio, *De l'art Chrétien*, I, pp.96–7.

60 Rio, *De l'art Chrétien*, IV, p.20.

61 Mâle, *The Gothic Image*, p.398.

62 Taine, *Voyage en Italie*, II, p.64.

63 Ruskin, *The Schools of Art in Florence*, p.203.

64 Antal, *Florentine Painting and its Social Background*, pp.4–8.

65 Antal, *Florentine Painting and its Social Background*, p.172.

66 Bourdieu, *Distinction*, pp.13–14, 53–4, 114–15, explores the connection between the kinds of art people are prepared to view or buy and their education level, financial assets and class position. He suggests that 'cultural capital' is a useful concept to explain the way 'taste' is formed by a person's education, wealth and class, and those of his or her family.

67 Rees and Borzello, *The New Art History*, p.2.

68 Burckhardt, *Beiträge zur Kunstgeschichte von Italien*, considered the altarpiece, the collector and the Italian portrait. Gardner, *The Tomb and the Tiara*.

69 Klesse, *Seidenstoffe in der italienischen Malerei des 14 Jahrhunderts*, pp.26–7, 52–3, 487.

70 *Inventario degli oggetti d'arte d'Italia*, pp.20–1.

71 *Scultura dipinta*, p.23–5

72 *Scultura dipinta*, pp 23–5.

73 *Scultura dipinta*, passim.

74 Salmi, 'Il Paliotto di Manresa e l'opus florentinus', p.383.

75 Devisse and Mollat, *The Image of the Black in Western Art*, pp.67, 85.

76 Salmi, 'Il Paliotto di Manresa e l'opus florentinus', p.383.

Bibliography

PRIMARY SOURCES

ALIGHIERI, DANTE, *The Divine Comedy*, Italian text with trans. and commentary by J.D. Sinclair, 2nd edn, Oxford and New York, 1961, 3 vols.

ANONYMOUS, in *Cronache senesi*, ed. A. Lisini and F. Iacometti, in *Rerum Italicarum Scriptores*, n.s., XV, 6, 1, Città di Castello, 1931–39.

ANTAL, FREDERICK, *Florentine Painting and its Social Background*, London, 1947.

AYRTON, MICHAEL, *Giovanni Pisano: Sculptor*, London, 1969.

BACCI, PELEO, *Fonti e commenti per la storia dell'arte senese*, Siena, 1944.

BALDINUCCI, FILIPPO, *Notizie dei professori del disegno da Cimabue in qua per le quale si dimostra come, e per chi le belle arti di pittura, scultura e architecttura, lasciata la rozzezza delle maniere greca e gotica si siano in questi secoli ridotte all'antica loro perfezione*, Florence, 1681, 7 vols.

BARRI, GIACOMO, *The Painters' Voyage of Italy*, trans. W.L., London, 1679.

BERENSON, BERNARD, *Italian Pictures of the Renaissance*, Oxford, 1932.

BOCCACCIO, GIOVANNI, *The Decameron: A Selection*, trans. J.M. Rigg, 2nd edn, London and New York, 1968, 2 vols.

BOCCACCIO, GIOVANNI, *The Decameron: A Selection*, Italian text with commentary by K. Speight, Manchester, 1983.

BOLLANDUS, J. and HENSCHENIUS, G., *Acta sanctorum*, XVII, 17–19 May, ed. J. Carnandet, Paris, 1866.

BONAVENTURA, SAINT, *Doctoris Seraphici S. Bonaventurae S.R.E. Episcopi Cardinalis Omnia Opera*, Florence, 1882–1902.

BORGHESI, SCIPIONE and BANCHI, LUCIANO (eds), *Nuovi documenti per la storia dell'arte senese*, Siena, 1898.

BURCKHARDT, JACOB, *Beiträge zur Kunstgeschichte von Italien*, Berlin and Stuttgart, 1911.

BURCKHARDT, JACOB, *Cicerone*, Basel, 1855.

BURCKHARDT, JACOB, *The Civilization of the Renaissance in Italy*, first published 1860, trans. S.G.C. Middlemore, New York, 1960.

CARTWRIGHT, JULIA, *The Painters of Florence*, London, 1901.

CAULIBUS, GIOVANNI DE (attrib.), *Meditations on the Life of Christ: An Illustrated Manuscript of the Fourteenth Century*, trans. I. Ragusa, ed. I. Ragusa and R.B. Green, Princeton, 1961.

CENNINI, CENNINO D'ANDREA, *The Craftsman's Handbook: The Italian 'Il libro dell'arte'*, trans. D.V. Thompson, Jr, 2nd edn, New York and London, 1954.

CONVERSINI DA RAVENNA, GIOVANNI, *Two Court Treatises*, ed. and trans. B.G. Kohl and J. Day, Munich, 1987.

COOK, EDWARD, *A Popular Handbook to the National Gallery*, London, 1893.

CROWE, JOSEPH and CAVALCASELLE, GIOVANNI, *A History of Painting in Italy: Umbria, Florence and Siena from the Second to the Sixteenth Centuries*, revised edn, London, 1903–14, 6 vols.

DA NONO, GIOVANNI, *Liber de Generacione Aliquorum Civium Urbis Padue*, see P. Rajna, 'Le origini delle famiglie padovane e gli eroi romanzi cavalereschi', *Romania*, IV, 1875.

DA NONO, GIOVANNI, 'Visio Egidii Regis Patavie', ed. G. Fabris, *Bollettino del Museo Civico di Padova*, n.s., 10–11 (27–28), 1934–39, pp.1–30.

DELLA VALLE, GUGLIELMO, *Lettere Senesi*, Siena, 1782–86, 3 vols.

DI TURA, AGNOLO, in *Cronache senesi*, ed. A. Lisini and F. Iacometti, in *Rerum Italicarum Scriptores*, n.s., XV, 6, 1, Città di Castello, 1931–39, 2 vols.

FEHM, JR SHERWOOD A., 'Notes on the statutes of the Sienese Painters' Guild', *Art Bulletin*, 54, 1972, pp.198–200.

FERRARESE, RICCOBALDO, *Compilatio cronologica* (c.1312–18), Rome, 1474, fol.101v., in P. Murray, 'Notes on some early Giotto sources', *Journal of the Warburg and Courtauld Institutes*, 16, 1953, p.60, n.1.

FINESCHI, VINCENZIO, *Memorie istoriche di … convento di S.Maria Novella*, Florence, 1790.

GARDNER, JULIAN, *The Tomb and the Tiara: Curial Tomb Sculpture in Rome and Avignon in the Later Middle Ages*, Oxford, 1992.

GATARI, GALEAZZO, BARTOLOMMEO and ANDREA, *Cronaca carrarese*, ed. A. Medin and G. Tolomei, in *Rerum Italicarum Scriptores*, n.s., XVII, 1, Città di Castello, 1909–31.

GHIBERTI, LORENZO, *I commentari*, ed. O. Morisani, Naples, 1947.

HOLT, ELIZABETH GILMORE, *A Documentary History of Art*, I–II, New York, 1957.

HUECK, IRENE, 'Le matricole dei pittori fiorentini prima e dopo 1320', *Bollettino d'arte*, 57, 1972, pp.114–21.

LANDINO, CHRISTOPHORO, *Comento di Christophoro Landino Fiorentino, sopra la Comedia di Danthe*, Florence, 1481.

LEONARDO DA VINCI, *The Notebooks of Leonardo da Vinci*, ed. and trans. E. MacCurdy, London, 1954, 2 vols .

LINDSAY, ALEXANDER, *Sketches of the History of Christian Art*, London, 1847, 2 vols.

MÂLE, ÉMILE, *The Gothic Image*, trans. D. Nussey, London, 1913 (first published 1910).

MANCINI, GIULIO, *Considerazioni sulla pittura* (1621), ed. A. Marucchi and L. Salerno, Rome, 1956.

MILANESI, GAETANO, *Documenti per la storia dell'arte senese*, Siena, 1854–56, 3 vols.

MILANESI, GAETANO, *Nuovi documenti per la storia dell'arte toscana dal XII al XV secolo*, Florence, 1901.

MOSCHINI, GIOVANNI, *Della origine e delle vicende della pittura in Padova*, Padua, 1826.

MURRAY, JAMES A.H., *A New English Dictionary on Historical Principles*, Oxford, 1888–1928, 10 vols.

PECCI, GIOVANNI, 'Raccolta universale di tutte l'iscrizioni, arme e altri monumenti … fino a questo presente anno, 1730', Archivio di Stato, Siena, MS D5 G.

PLINY, THE ELDER, *The Elder Pliny's Chapters on the History of Art*, trans. and ed. K. Jex-Blake and E. Sellers, 1896, reprinted Chicago, 1968.

POGGI, GAETANO, *Il duomo di Firenze*, I–II, ed. Margaret Haines, Florence, 1988 (originally published Berlin, 1909).

PORTENARI, ANGELO, *Della felicità di Padova*, Padua, 1623.

REES, ALAN and BORZELLO, FRANCES (eds), *The New Art History*, London, 1986.

RIDOLFI, CARLO, *Le meraviglie dell'arte*, ed. D. von Hadeln, Berlin, 1914–24, 2 vols.

RIO, FRANÇOIS, *De l'art Chrétien*, 2nd edn, Paris, 1871, 4 vols.

RÜMOHR, CARL VON, *Italienische Forschungen*, ed. J. von Schlosser, Frankfurt am Main, 1920 (first published 1837).

RUSKIN, JOHN, *Giotto and his Works in Padua*, first published 1854, in *The Complete Works of John Ruskin: The Library Edition*, XXIV, ed. E.T. Cook and A. Wedderburn, London, 1903–12, 39 vols.

RUSKIN, JOHN, *The Schools of Art in Florence*, lecture series first published 1874, in *The Complete Works of John Ruskin: The Library Edition*, XXIII, ed. E.T. Cook and A. Wedderburn, London, 1903–12, 39 vols.

RUSKIN, JOHN, *The Stones of Venice*, first pubished 1853, in *The Complete Works of John Ruskin: The Library Edition*, X, ed. E.T. Cook and A. Wedderburn, London, 1903–12, 39 vols.

SARTORI, ANTONIO, *Documenti per la storia dell'arte a Padova*, in *Fonti e studi per la storia del santo a Padova: Fonti 3*, IV, ed. C. Fillarini, Vicenza, 1976.

SAVONAROLA, MICHELE, *Libellus de Magnificis Ornamentis Regie Civitatis Padue*, ed. A. Segarizzi, in *Rerum Italicarum Scriptores*, XXIV, 15, Città di Castello, 1902.

SCHEDEL, H., *Liber Chronicarum*, Nuremberg, 1493.

SCOTT, LEADER, *The Renaissance of Art in Italy*, London, 1883.

SEZNEC, JEAN, *The Survival of the Pagan Gods: The Mythological Tradition and its Place in Renaissance Humanism and Art*, trans. B.F. Sessions, New York, 1953 (first published 1940).

TAINE, HIPPOLYTE, *Voyage en Italie*, Paris, 1866, 2 vols.

The Anonimo: Notes on Pictures and Works of Art Made by an Anonymous Writer in the Sixteenth Century, trans. P. Mussi and ed. G.C. Williamson, London, 1903.

THODE, HENRY, *Franz von Assisi und die Anfänge der Kunst der Renaissance in Italien*, Berlin, 1885.

THOMAS AQUINAS, SAINT *The 'Summa Theologica' of Saint Thomas Aquinas*, trans. the Fathers of the English Dominican province, 2nd edn, London, 1920–32, 22 vols.

VASARI, GIORGIO, *Le opere di Giorgio Vasari con nuove annotazione e commentari*, ed. G. Milanesi, I–IX, Florence, 1906 (reprinted Florence, 1973).

VASARI, GIORGIO, *Le vite de' più eccellenti pittori, scultori ed orchitettori*, ed. G. Milanesi, Florence, 1878–81, 7 vols.

VASARI, GIORGIO, *Le vite de'più eccellenti pittori, scultori e architettori nelle redazioni del 1550 e 1568*, Volume II, *Testo*, ed. R. Bettarini, commentary P. Barocchi, II, 'Testo', Florence, 1966.

VASARI, GIORGIO, *Lives of the Artists*, abridged version, ed. and trans. J. Conaway Bondanella and P. Bondanella, Oxford, 1991.

VERCI, GIOVANNI, *Notizie intorno alla vita e alla opere de pittori, scultori … di Bassano*, Venice, 1775.

VERGERIO, PIER PAOLO, *De Dignissimo Funebri Apparatu in Exequiis Clarissimi Omnium Principis Francisci Senioris de Carraria*, ed. L. A. Muratori, in *Rerum Italicarum Scriptores*, XVI, Milan, 1730.

VILLANI, FILIPPO, *Croniche di Giovanni, Matteo e Filippo Villani*, ed. A. Racheli, Trieste, 1857–58, 2 vols.

VILLANI, GIOVANNI, *Cronica di Giovanni Villani a miglior lezione ridotta*, ed. F. Gherardi-Dragomanni and I. Moutier, 1845, 4 vols.

VILLANI, MATTEO, *Cronica di Matteo Villani a miglior lezione ridotta*, ed. F. Gherardi-Dragomanni and I. Moutier, Florence, 1846, 2 vols.

VORAGINE, JACOBUS DE, *The Golden Legend*, ed. and trans. G. Ryan and H. Ripperger, New York, 1948.

SECONDARY SOURCES

ARTHUR, K.G., 'Cult objects and artistic patronage of the fourteenth-century flagellant confraternity of Gesù Pellegrino', in *Christianity and the Renaissance: Image and Religious Imagination in the Quattrocento*, ed. J. Henderson and T. Verdon, Syracuse, New York, 1990, pp.336–60.

ASSUNTO, R., 'Images and iconoclasm', in *New Catholic Encyclopaedia*, VII, New York, 1963, p.819.

BALESTRACCI, D., 'Introduzione', in *Fornaci e mattoni a Siena*, Siena, 1991.

BALESTRACCI, D. and PICCINNI, G., *Siena nel Trecento. Assetto urbano e strutture edilizie*, Florence, 1977.

BARASCH, M., *Giotto and the Language of Gesture*, Cambridge, 1987.

BARON, H., *The Crisis of the Early Italian Renaissance*, revised edn, Princeton, 1966.

BARZON, A., *I cieli e la loro influenza negli affreschi del Salone in Padova*, Padua, 1924.

BAXANDALL, M., *Giotto and the Orators: Humanist Observers of Painting in Italy and the Discovery of Pictorial Composition, 1350–1450*, Oxford, 1971.

BAXANDALL, M., *Painting and Experience in Fifteenth Century Italy*, Oxford, 1972.

BAXANDALL, M., *Patterns of Intention: On the Historical Explanation of Pictures*, New Haven and London, 1985.

BECHERUCCI, L. and BRUNETTI, G., *Il Museo dell'Opera del Duomo a Firenze*, I–II, Milan, 1969.

BECKER, M.B., 'Notes on the *Monte* holdings of Florentine trecento painters', *Art Bulletin*, 46, 1964, pp.376–7.

BELL, C., *Art*, 2nd edn, London, 1928.

BELLINATI, C., 'Iconografia e teologia negli affreschi del Battistero', in *Giusto de'Menabuoi nel Battistero di Padova*, ed. A.M. Spiazzi, Trieste, 1989.

BELLINATI, C. et al., *Il duomo di Padova e il suo battistero*, Padua, 1977.

BELLOSI, L., 'Castrum pingatur in palatio, 2. Duccio e Simone Martini pittori di castelli senesi a l'esemplo come erano', *Prospettiva*, 28, 1982, pp.41–65.

BELLOSI, L., *Giotto – Complete Works*, Florence, 1981.

BELTING, H., 'The "Byzantine" Madonnas: new facts about their Italian origin and some observations on Duccio', *Studies in the History of Art*, 12, 1982, pp.7–22.

BENTON, T., 'The design of Siena and Florence Duomos', in *Siena, Florence and Padua: Art, Society and Religion 1280–1400*, II, ed. D. Norman, New Haven and London, 1995.

BENTON, T., 'The three cities compared: urbanism', in *Siena, Florence and Padua: Art, Society and Religion 1280–1400*, II, ed. D. Norman, New Haven and London, 1995.

BETTINI, S., *Giusto de'Menabuoi e l'arte del Trecento*, Padua, 1944.

BETTINI, S., 'Le miniature del "Libro Agregà de Serapiom" nella cultura artistica del tardo Trecento', in *Da Giotto al Mantegna*, ed. L. Grossato, Milan, 1974, pp.55–60.

BETTINI, S., *Le pitture di Giusto de'Menabuoi nel Battistero del Duomo di Padova*, Venice, 1960.

BETTINI, S. and PUPPI, L., *La chiesa degli Eremitani*, Vicenza, 1970.

BILLANOVICH, M.C.G., 'Carrara, Francesco da, il Novello', 'Carrara, Giacomo da', 'Carrara, Marsilio da', 'Carrara, Ubertino da', in *Dizionario biografico degli Italiani*, XX, Rome, 1977, pp.656–62, 671–3, 688–91, 700–2.

BOBER, P.P. and RUBINSTEIN, R.O., *Renaissance Artists and Antique Sculpture: A Handbook of Sources*, with contributions from S. Woodford, Oxford, 1986.

BOLOGNA, F., 'The crowning disc of a Trecento Crucifixion and other points relevant to Duccio's relationship to Cimabue', *Burlington Magazine*, 125, 1983, pp.330–40.

BOMFORD, D., DUNKERTON, J., GORDON, D., ROY, A., with contributions from KIRBY, J., *Art in the Making: Italian Painting Before 1400*, London, 1989.

BORGHINI, G., BRANDI, C. and CORDARO, M., *Il Palazzo Pubblico di Siena, vicende costruttive e decorazione*, Siena, 1983.

BORGIA, L., CARLI, E., CEPPARI, M.A., MORANDI, U., SINIBALDI, P. and ZARRILLI, C., *Le Biccherne: tavole dipinte delle magistrature senesi (secoli xiii–xviii)*, Rome, 1984.

BORSOOK, E., *The Mural Painters of Tuscany from Cimabue to Andrea del Sarto*, 2nd edn, Oxford, 1980.

BORTOLOTTI, L., *Siena (Le città nella storia d'Italia)*, series ed. C. de Seta, 2nd edn, Rome and Bari, 1983.

BOSKOVITS, M., *Pittura fiorentina alla vigilia del Rinascimento, 1370–1400*, Florence, 1975.

BOURDIEU, P., *Distinction: A Social Critique of the Judgement of Taste*, first published 1979, trans. R. Nice, London, 1984.

BOURDUA, L., 'Aspects of Franciscan Patronage of the Arts in the Veneto during the Later Middle Ages', PhD thesis, University of Warwick, 1991.

BOWSKY, W.M., *A Medieval Italian Commune: Siena under the Nine, 1287–1355*, Berkeley, Los Angeles and London, 1981.

BOWSKY, W.M., 'The impact of the Black Death upon Sienese government and society', *Speculum*, 39, 1964, pp.1–34.

BRANCA, V., *Boccaccio: The Man and his Works*, ed. D.J. McAuliffe and trans. R. Monges, New York, 1976.

BRANDI, C., *Il restauro della Maestà di Duccio*, Rome, 1959.

BRINK, J., 'Sts Martin and Francis: sources and meaning in Simone Martini's Montefiore Chapel', in *Renaissance Studies in Honor of Craig Hugh Smyth*, II, ed. A. Morrogh et al., Florence, 1985, pp.79–92.

BRUCKER, G.A., *Florence: 1138–1737*, London, 1984.

BRUCKER, G.A., 'Florence and its university, 1348–1434', in *Action and Conviction in Early Modern Europe: Essays in Memory of E.H. Harbison*, ed. T.K. Rabb and J.E. Seigel, Princeton, 1969, pp.220–36.

BRUCKER, G.A., 'Florence and the Black Death', in *Boccaccio: Secoli di vita*, ed. M. Cottino-Jones and E.F. Tuttle, Los Angeles, 1977.

BRUCKER, G.A., *Florentine Politics and Society, 1343–1378*, Princeton, 1963.

BRUCKER, G.A., *Renaissance Florence*, New York, 1969.

BRUCKER, G.A., *The Civic World of Early Renaissance Florence*, Princeton, 1977.

BUENO DE MESQUITA, D.M., *Giangaleazzo Visconti, Duke of Milan (1351–1402)*, Cambridge, 1941.

CÄMMERER, M., 'La cornice della *Madonna Rucellai*', in *La Maestà di Duccio restaurata*, ed. A. Petrioli Tofani et al., Florence, 1990, pp.47–55.

CANNON, J., 'Dominican Patronage of the Arts in Central Italy: The *Provincia Romana*', PhD thesis, Courtauld Institute of Art, University of London, 1980.

CANNON, J., 'Simone Martini, the Dominicans and the early Sienese polyptych', *Journal of the Warburg and Courtauld Institutes*, 45, 1982, pp.69–92.

CANNON, J. and PEMBERTON-PIGOTT, V., 'The Triptych Attributed to Duccio in the Royal Collection', paper given at a conference on 'Conservation and Attribution' at the Courtauld Institute of Art, University of London, February 1990.

CARLI, E., *Il duomo di Siena*, Genoa, 1979.

CARLI, E., *Il reliquiario del Corporale ad Orvieto*, Milan, 1964.

CARLI, E., *L'arte a Massa Marittima*, Siena, 1976.

CARLI, E., *La pittura senese del Trecento*, Milan, 1981.

CASSIDY, B., 'Orcagna's tabernacle in Florence: design and function', *Zeitschrift für Kunstgeschichte*, 55, 1992, pp.180–211.

CASSIDY, B., 'The *Assumption of the Virgin* on the tabernacle of Orsanmichele', *Journal of the Warburg and Courtauld Institutes*, 51, 1988, pp.174–80.

CASSIDY, B., 'The financing of the tabernacle of Orsanmichele', *Source Notes in the History of Art*, 8, 1988, pp.1–6.

CHRISTIANSEN, K., KANTER, L.B. and STREHLKE, C.B., *Painting in Renaissance Siena 1420–1500*, New York, 1988.

CHURCHILL, S.J.A., 'Giovanni Bartolo of Siena, goldsmith and enameller, 1364–85', *Burlington Magazine*, 10, 1907.

CIASCA, R., *L'Arte dei Medici e Speziali nella storia e nel commercio fiorentino dal secolo XII al XV*, Florence, 1927, republished 1977, 2 vols.

COHN, JR, S.K., *Death and Property in Siena, 1205–1800: Strategies for the Afterlife*, Baltimore and London, 1988.

COHN, JR, S.K., *The Cult of Remembrance and the Black Death: Six Renaissance Cities in Central Italy*, Baltimore and London, 1992.

COHN, W., 'La seconda immagine della Loggia di Orsanmichele', *Bollettino d'arte*, 42, 1957, pp.335–8.

COINE, E., *Il sigillo a Siena nel Medioevo*, Siena, 1990.

COLE, B., *Giotto and Florentine Painting, 1280–1375*, New York, 1976.

COLE, B., 'On an early Florentine fresco', *Gazette des beaux-arts*, 80, 1972, pp.91–6.

CUNNINGHAM, C., 'For the honour and beauty of the city: the design of town halls', in *Siena, Florence and Padua: Art, Society and Religion 1280–1400*, II, ed. D. Norman, New Haven and London, 1995.

CURTIS, M. (ed.), *Search for Innocence: Primitive and Primitivistic Art of the Nineteenth Century*, Baltimore, 1975.

D'ARCAIS, F., 'Gli affreschi del Guariento dell'Accademia di Padova', *Arte veneta*, 16, 1962, pp.7–18.

D'ARCAIS, F., *Guariento*, Venice, 1965.

D'ARCAIS, F., 'La presenza di Giotto al Santo', in *Le pitture del Santo di Padova*, ed. C. Semenzato, Vicenza, 1984, pp.3–13.

D'ARCAIS, F., 'Pittura del Duecento e Trecento a Padova e nel territorio', in *La pittura in Italia. Il Duecento e il Trecento*, I, ed. E. Castelnuovo, 2nd edn, Milan, 1986, pp.150–71.

DAVIES, M., *The Earlier Italian Schools*, London, 1961.

DAVIES, M., *The Early Italian Schools Before 1400*, rev. D. Gordon, London, 1988.

DE CASTRIS, P.L., *Arte di corte nella Napoli angioina*, Florence, 1986.

DENLEY, P., 'Academic rivalry and interchange: the Universities of Siena and Florence', in *Florence and Italy: Renaissance Studies in Honor of Nicolai Rubinstein*, ed. P. Denley and C. Elam, London, 1988, pp.193–208.

DEUCHLER, F., *Duccio*, Milan, 1984.

DEVISSE, J. and MOLLAT, M., *The Image of the Black in Western Art*, trans. W.G. Ryan, Fribourg, 1979.

DONATO, M.M., 'Hercules and David in the early decoration of the Palazzo Vecchio: manuscript evidence', *Journal of the Warburg and Courtauld Institutes*, 54, 1991, pp.83–98.

DOUGLAS, L., *A History of Siena*, London and New York, 1902.

EDGERTON, JR, S.Y., *Pictures and Punishment: Art and Criminal Prosecution during the Florentine Renaissance*, Ithaca and London, 1985.

EDWARDS, M.D., 'Ambrogio Lorenzetti and classical painting', *Florilegium*, 2, 1980, pp.146–60.

Enciclopedia dantesca, Rome, 1970–78, 6 vols.

EVANS, J., 'Allegorical women and practical men: the iconography of the *Artes* reconsidered', in *Medieval Women*, ed. D. Baker, Oxford, 1978.

FABBRI, N.R. and RUTENBURG, N., 'The tabernacle of Orsanmichele in context', *Art Bulletin*, 63, 1981, pp.385–405.

FALASCHI, E., 'Giotto: the literary legend', *Italian Studies*, 27, 1972, pp.1–27.

FANELLI, G., *Firenze* (*Le città nella storia d'Italia*), series ed. C. de Seta, 2nd edn, Rome and Bari, 1981.

FELDGES-HENNING, U., 'The pictorial programme of the Sala della Pace', *Journal of the Warburg and Courtauld Institutes*, 35, 1972, pp.145–62.

FINN, D. *et al.*, *The Florence Baptistery Doors*, London, 1980.

FREULER, G., 'Bartolo di Fredis Altar für die Annunziata–Kapelle in S. Francesco in Montalcino', *Pantheon*, 43, 1985, pp.21–39.

FREULER, G., 'L'altare Cacciati di Bartolo di Fredi nella chiesa di San Francesco a Montalcino', *Arte Cristiana*, 73, 1985, pp.149–66.

FREY, C., *Die Loggia dei Lanzi*, Berlin, 1885.

FRIEDMAN, D., *Florentine New Towns: Urban Design in the Late Middle Ages*, Cambridge, Mass. and London, 1988.

FRINTA, M.S., 'An investigation of the punched decoration of medieval Italian and non-Italian panel paintings', *Art Bulletin*, 47, 1965, pp.261–65.

FRUGONI, C., *Pietro and Ambrogio Lorenzetti*, trans. L. Pelletti, Florence, 1988.

FRY, ROGER, 'Giotto', *Monthly Review*, London, 1901, reprinted in R. Fry, *Vision and Design*, London, 1920, pp.131–77.

GAI, L., *L'altare argenteo di San Iacopo nel duomo di Pistoia*, Turin, 1984.

GARDNER, J., 'A princess among prelates: a Neapolitan fourteenth-century tomb and some northern relations', *Römisches Jahrbuch für Kunstgeschichte*, 23–4, 1988, pp.29–60.

GARDNER, J., 'The Louvre Stigmatization and the problem of the narrative altarpiece', *Zeitschrift für Kunstgeschichte*, 45, 1982, pp.217–47.

GARDNER, J., *The Tomb and the Tiara: Curial Tomb Sculpture in Rome and Avignon in the Later Middle Ages*, Oxford, 1992.

GARDNER VON TEUFFEL, C., 'Review of H.W. van Os, *Sienese Altarpieces, Volume I*', *Burlington Magazine*, 127, 1985, p.391.

GARDNER VON TEUFFEL, C., 'Studies of the Tuscan Altarpieces in the Fourteenth and Early Fifteenth Centuries', PhD thesis, University of London, 1975.

GARZELLI, A., *Sculture toscane nel Dugento e nel Trecento*, Florence, 1969.

GASPAROTTO, C., 'Gli ultimi affreschi venuti in luce nella Reggia dei Da Carrara', *Atti e memorie dell'Accademia Patavina di Scienze, Lettere ed Arti*, 81, 1968–69, pp.237–61.

GASPAROTTO, C., 'La Reggia dei Da Carrara', *Atti e memorie dell'Accademia Patavina di Scienze, Lettere ed Arti*, 79, 1966–67, pp.71–116.

GAUTHIER, M., *Émaux du moyen-âge occidentale*, Fribourg, 1972.

GILBERT, C., 'The fresco by Giotto in Milan', *Arte Lombarda*, 47–8, 1977, pp.31–72.

GILES, K.A., 'The Strozzi Chapel in Santa Maria Novella: Florentine Painting and Patronage, 1340–1355', PhD thesis, New York University, 1977, facsimile Ann Arbor, 1980.

GIMPEL, J., *The Medieval Machine*, London, 1992.

GIOSEFFI, D., *Giotto architetto*, Milan, 1963.

Giotto e il suo tempo (Acts of the international congress for the celebration of the seven hundredth anniversary of Giotto's birth, 1967), Rome, 1971.

GLI UFFIZI, *Studi e ricerche*, 8. *La 'Madonna d'Ognissanti' di Giotto restaurata*, ed. A. Petrioli Tofani *et al.*, Florence, 1992.

GOLDTHWAITE, R.A., *The Building of Renaissance Florence: An Economic and Social History*, Baltimore and London, 1980.

GOMBRICH, E., 'The Renaissance conception of artistic progress and its consequences' (1952), in E. Gombrich, *Norm and Form: Studies in the Art of the Renaissance 1*, London and New York, 1966, pp.1–10.

GONZATI, B., *La basilica di Sant'Antonio di Padova*, Padua, 1852–53, 2 vols.

GOTTFRIED, R.S., *The Black Death: Natural and Human Disaster in Medieval Europe*, London, 1983.

GREENSTEIN, J.M., 'The vision of peace: meaning and representation in Ambrogio Lorenzetti's *Sala della Pace* cityscapes', *Art History*, 11, 1988, pp.492–510.

GRONAU, H.D., *Andrea Orcagna und Nardo di Cione*, Berlin, 1937.

GROSSATO, L., *Dipinti della cattedrale di Padova*, Padua, 1971, pp.16–45, cat. nos3–10.

GROSSATO, L., 'La decorazione pittorica del Salone', in *Il Palazzo della Ragione di Padova*, ed. G. Mor, Venice, 1963, pp.47–67.

GROSSATO, L. (ed.), *Da Giotto al Mantegna*, Milan, 1974.

GUASTI, C., *Santa Maria del Fiore*, Florence, 1887.

HACKETT, M., 'The medieval archives of Lecceto', *Analecta Augustiniana*, 40, 1977, pp.14–45.

HALL, M.B., 'The *Tramezzo* in Santa Croce, Florence, reconstructed', *Art Bulletin*, 56, 1974, pp.325–41.

HANKEY, T., 'Salutati's epigrams for the Palazzo Vecchio at Florence', *Journal of the Warburg and Courtauld Institutes*, 22, 1959, pp.363–65.

HARAWAY, D., 'Situated knowledges: the science question in feminism and the privilege of partial perspective', *Feminist Studies*, 14, 1988, pp.575–99.

HARDING, C., 'The Miracle of Bolsena and the Relic of the Corporal at Orvieto Cathedral', in *Essays in Honour of John White*, ed. D. Davies and H. Weston, London, 1990, pp.82–8.

HARPRING, P., *The Sienese Trecento Painter Bartolo di Fredi*, London and Toronto, 1993.

HARRISON, C., 'The Arena Chapel: patronage and authorship', in *Siena, Florence and Padua: Art, Society and Religion 1280–1400*, II, ed. D. Norman, New Haven and London, 1995.

HARTLAUB, G.F., 'Giotto's Zweite Hauptwerk in Padua', *Zeitschrift für Kunstwissenschaft*, 21, 1950, pp.19–34.

HENDERSON, J., 'Piety and Charity in Late Medieval Florence: Religious Confraternities from the Middle of the Thirteenth to the Late Fifteenth Century', PhD thesis, University of London, 1983.

HENINGER, JR, S.K., *The Cosmological Glass: Renaissance Diagrams of the Universe*, San Marino, California, 1977.

HERLITHY, D., 'Population, plague and social change in rural Pistoia', *Economic History Review*, 2nd series, 18, 1965, pp.225–44.

HICKS, D.L., 'Sources of wealth in renaissance Siena: businessmen and landowners', *Bollettino senese di storia patria*, 93, 1986, pp.9–42.

HILL, G.F., *Medals of the Renaissance*, rev. J.G. Pollard, London, 1978.

HILLS, P., *The Light of Early Italian Painting*, New Haven and London, 1987.

HOCH, A.S., 'St. Martin of Tours: his transformation into a chivalric hero and Franciscan ideal', *Zeitschrift für Kunstgeschichte*, 50, 1987, pp.471–82.

HOLMES, G., *Florence, Rome and the Origins of the Renaissance*, Oxford, 1986.

HOOK, J., *Siena: A City and its History*, London, 1979.

HUECK, I., 'La tavola di Duccio e la Compagnia delle Laudi di Santa Maria Novella', in *La Maestà di Duccio restaurata*, ed. A. Petrioli Tofani *et al.*, Florence, 1990, pp.33–46.

HUECK, I., 'Le opere di Giotto per la chiesa di Ognissanti', in *La 'Madonna d'Ognissanti' di Giotto restaurata*, ed. A. Petrioli Tofani *et al.*, Florence, 1992, pp.37–50.

HYDE, J.K., 'Medieval descriptions of cities', *Bulletin of the John Rylands Library*, 48, 1966, pp.308–40.

HYDE, J.K., *Padua in the Age of Dante*, Manchester and New York, 1966.

HYDE, J.K., *Society and Politics in Medieval Italy: The Evolution of the Civil Life, 1000–1350*, London, 1973.

Inventario degli oggetti d'arte d'Italia, Volume VII, *Provincia di Padova: comune di Padova*, Rome, 1936.

KANTER, L.B., '*A Massacre of Innocents* in the Walters Art Gallery', *Journal of the Walters Art Gallery*, 41, 1983, pp.17–28.

KENT, F. W. and SIMONS, P. (eds), *Patronage, Art and Society in Renaissance Italy*, Oxford, 1987.

KESSLER, H.L., 'On the state of medieval art history', *Art Bulletin*, 70, 1988, pp.166–87.

KIECKHEFER, R., 'Major currents in late medieval devotion', in *Christian Spirituality II: High Middle Ages and Reformation*, ed. J. Raitt, New York, 1987, pp.75–108.

KING, C., 'Effigies: human and divine', in *Siena, Florence and Padua: Art, Society and Religion 1280–1400*, II, ed. D. Norman, New Haven and London, 1995.

KING, C., 'Representations of Artists and of Art in Western Europe *c.*1300–1570', PhD thesis, University of East Anglia, 1991.

KING, C., 'Women as patrons: nuns, widows and rulers', in *Siena, Florence and Padua: Art, Society and Religion 1280–1400*, II, ed. D. Norman, New Haven and London, 1995.

KLESSE, B., *Seidenstoffe in der italienischen Malerei des 14 Jahrhunderts*, Bern, 1967.

KOHL, B.G., 'Carrara, Francesco da, il Vecchio', in *Dizionario biografico degli Italiani*, XX, Rome, 1977, pp.649–56.

KOHL, B.G., 'Giusto de'Menabuoi e il mecenatismo artistico in Padova', in *Giusto de'Menabuoi nel Battistero di Padova*, ed. A.M. Spiazzi, Trieste, 1989.

KOHL, B.G., 'Government and society in renaissance Padua', *Journal of Medieval and Renaissance Studies*, 2, 1972, pp.205–21.

KRAUTHEIMER, R., *Lorenzo Ghiberti*, Princeton, 1956.

KREYTENBERG, G., 'Image and frame: remarks on Orcagna's Pala Strozzi', *Burlington Magazine*, 134, 1992, pp.634–9.

KREYTENBERG, G., *Tino di Camaino*, Florence, 1986.

KRISTEVA, J., 'Giotto's joy', in *Calligram: Essays in New Art History from France*, ed. N. Bryson, Cambridge, 1988, pp.27–52.

LADIS, A., *Taddeo Gaddi: Critical Re-appraisal and Catalogue Raisonné*, Columbia and London, 1982.

LADIS, A., 'The legend of Giotto's wit and the Arena Chapel', *Art Bulletin*, 68, 1986, pp.580–96.

L'Art gothique siennois: enluminure, peinture, orfèvrerie, sculpture, Florence, 1983.

LA SORSA, S., *La Compagnia d'Or San Michele*, Trani, 1902.

LAVIN, M.A., *The Place of Narrative: Mural Decoration in Italian Churches, 431–1600*, Chicago and London, 1990.

LEE, A.D., 'Images, veneration of', in *Encyclopaedia of World Art*, VII, New York, 1967, p.372.

LONGHI, R., 'Giudizio sul Duecento', *Proporzioni*, 2, 1948, pp.5–54.

LORENZONI, G. (ed.), *L'edificio del Santo di Padova*, Vicenza, 1981.

LORENZONI, G. (ed.), *Le sculture del Santo di Padova*, Vicenza, 1984.

LUCCO, M., 'Pittura del Duecento e del Trecento nelle province venete', in *La pittura in Italia. Il Duecento e il Trecento*, I, ed. E. Castelnuovo, 2nd edn, Milan, 1986, pp.113–49.

LUSINI, V., *Il duomo di Siena*, Siena, 1911, 2 vols.

MAGINNIS, H.B.J., 'Pietro Lorenzetti: a chronology', *Art Bulletin*, 66, 1984, pp.183–211.

MAGINNIS, H.B.J. 'The literature on Sienese Trecento painting 1945–1975', *Zeitschrift für Kunstgeschichte*, 40, 1977, pp.276–309.

MAGINNIS, H.B.J., 'The Passion Cycle in the Lower Church of San Francesco, Assisi: the technical evidence', *Zeitschrift für Kunstgeschichte*, 39, 1976, pp.193–208.

MALAVOLTI, O., *Dell'historia di Siena*, Venice, 1599.

MALLORY, M. and MORAN, G., 'Guido Riccio da Fogliano: a challenge to the famous fresco long ascribed to Simone Martini and the discovery of a new one in the Palazzo Pubblico in Siena', Studies in Iconography, 7–8, 1981–82, pp.1–13.

MALLORY, M. and MORAN, G., 'New evidence concerning Guidoriccio', Burlington Magazine, 128, 1986, pp.250–9.

MARKAM TELPAZ, A., 'Some antique motifs in trecento art', Art Bulletin, 46, 1964, pp.372–6.

MARSHALL, L.J., '"Waiting on the Will of the Lord": The Imagery of the Plague', PhD thesis, University of Pennsylvania, 1989.

MARTINDALE, A., Simone Martini, Oxford, 1988.

MARTINDALE, A., 'The problem of Guidoriccio', Burlington Magazine, 128, 1986, pp.259–73.

MARTINDALE, A., The Rise of the Artist in the Middle Ages and Early Renaissance, London, 1972.

MARTINES, L., Power and Imagination: City States in Renaissance Italy, London, 1979.

MEDIN, A., 'I ritratti autentici di Francesco il Vecchio e di Francesco il Novello da Carrara ultimi principi di Padova', Bollettino del Museo Civico di Padova, 11, 1908, pp.104–14.

MEIER-GRAEFE, J., Modern Art, London, 1908.

MEISS, M., Giotto and Assisi, New York, 1960.

MEISS, M., 'Notable disturbances in the classification of Tuscan Trecento painting', Burlington Magazine, 113, 1971, pp.178–87.

MEISS, M., Painting in Florence and Siena after the Black Death, Princeton, 1951.

MELLINI, G., Altichiero e Jacopo Avanzi, Milan, 1965.

MIDDELDORF-KOSEGARTEN, A., Sienesische Bildhauer am Duomo Vecchio, Munich, 1984.

MITCHELL, W.J.T., Iconology, Chicago, 1986.

MOMMSEN, T.E., 'Petrarch and the decoration of the Sala Virorum Illustrium in Padua', Art Bulletin, 34, 1952, pp.95–116.

MORAN, G., 'Novità su Simone? An investigation regarding the equestrian portrait of Guidoriccio da Fogliano in the Siena Palazzo Pubblico', Paragone, 28, 1977, pp.81–8.

MOSCHETTI, A., 'Il tesoro della cattedrale di Padova', Dedalo, 6, 1925.

MOSKOWITZ, A., 'Trecento classicism and the campanile hexagons', Gesta, 22, 1, 1983, pp.49–65.

Mostra di opere d'arte restaurate nelle province di Siena e Grosseto, Genoa, 1979.

MURRAY, P., 'Notes on some early Giotto sources', Journal of the Warburg and Courtauld Institutes, 16, 1953, pp.58–80.

NAJEMY, J.M., Corporatism and Consensus in Florentine Electoral Politics, 1280–1400, Chapel Hill, 1982.

NAJEMY, J.M., 'Guild republicanism in Trecento Florence: the successes and ultimate failure of corporate politics', American Historical Review, 84, 1979, pp.53–71.

NORMAN, D., '"A noble panel": Duccio's Maestà', in Siena, Florence and Padua: Art, Society and Religion 1280–1400, II, ed. D. Norman, New Haven and London, 1995.

NORMAN, D., 'The art of knowledge: two artistic schemes in Florence', in Siena, Florence and Padua: Art, Society and Religion 1280–1400, II, ed. D. Norman, New Haven and London, 1995.

NORMAN, D., 'The case of the beata Simona: iconography, historiography and misogyny in three paintings by Taddeo di Bartolo', Art History (forthcoming).

NORMAN, D., '"Love justice, you who judge the earth": the paintings of the Sala dei Nove in the Palazzo Pubblico, Siena', in Siena, Florence and Padua: Art, Society and Religion 1280–1400, II, ed. D. Norman, New Haven and London, 1995.

NORMAN, D., 'Those who pay, those who pray and those who paint: two funerary chapels', in Siena, Florence and Padua: Art, Society and Religion 1280–1400, II, ed. D. Norman, New Haven and London, 1995.

OFFNER, R., 'Giotto, non-Giotto', Burlington Magazine, 74, 1939, pp.259–68 and 75, pp.96–113, reprinted in Giotto: The Arena Chapel Frescoes, ed. J.H. Stubblebine, New York, 1969, pp.135–55.

OFFNER, R. et al., A Critical and Historical Corpus of Florentine Painting, New York and Berlin, 1930–60.

OFFNER, R. et al., A Critical and Historical Corpus of Florentine Painting, Section 3, Volume V, New York, 1947.

OFFNER, R. et al., A Critical and Historical Corpus of Florentine Painting, Section 4, Volume I, Andrea di Cione, New York, 1962.

OFFNER, R. et al., A Critical and Historical Corpus of Florentine Painting, Section 4, Volume IV, Giovanni del Biondo (Part 1), New York, 1967.

OFFNER, R. et al., A Critical and Historical Corpus of Florentine Painting, Section 4, Volume V, Giovanni del Biondo (Part 2), New York, 1969.

OFFNER, R. et al., A Critical and Historical Corpus of Florentine Painting, Section 4, Volume VI, Andrea Bonaiuti, New York, 1979.

ORLANDI, S., 'La Madonna di Duccio di Buoninsegna e il suo culto in S. Maria Novella', Memorie Domenicane, 12, 1956, pp.205–17.

OS, H.W. VAN, Sienese Altarpieces, 1215–1460: Form, Content, Function, Groningen, 1984–90, 2 vols.

OS, H.W. VAN, 'St. Francis of Assisi as a second Christ in early Italian paintings', Simiolus, 7, 1974, pp.115–32.

OS, H.W. VAN, 'The Black Death and Sienese painting', Art History, 4, 1981, pp.237–49.

OS, H. VAN, 'Tradition and innovation in some altarpieces by Bartolo di Fredi', Art Bulletin, 67, 1985, pp.50–66.

PANOFSKY, E., Renaissance and Renascences in Western Art, 2nd edn, London, 1970.

PAOLETTI, J., 'The Strozzi altarpiece reconsidered', Memorie Domenicane, n.s., 20, 1989, p.279–300.

PASSERINI, L., Curiosità storico-artistiche fiorentini, La Loggietta del Bigallo, Florence, 1866.

PASSERINI, L., Storia degli stabilimenti di beneficenza e distruzione elementare gratuita della città di Firenze, Florence, 1853.

PECORI, L., Storia di S. Gimignano, Florence, 1853, republished Rome, 1975.

PETRIOLI TOFANI, A. et al. (eds), La Maestà di Duccio restaurata, Florence, 1990.

PICCINNI, G., 'I "villani incittadinati" nella Siena del XIV secolo', Bollettino senese di storia patria, 82–3, 1975–76, pp.158–219.

PIETRAMELLARA, C., Il duomo di Siena, Florence, 1980.

PLANT, M., 'Patronage in the circle of the Carrara family: Padua, 1337–1405', in Patronage, Art and Society in Renaissance Italy, ed. F.W. Kent and P. Simons, Oxford, 1987, pp.177–99.

PLANT, M., 'Portraits and politics in late Trecento Padua: Altichiero's frescoes in the S. Felice Chapel, S. Antonio', Art Bulletin, 63, 1981, pp.406–25.

POESCHKE, J., Die Kirche San Francesco in Assisi und ihre Wandmalereien, Munich, 1985.

POLIDORO, V., Le religiose memorie di Sant'Antonio, Venice, 1590.

POLZER, J., 'Aristotle, Mohammed and Nicholas V in hell', Art Bulletin, 46, 1964, pp.457–69.

POLZER, J., 'Aspects of the fourteenth-century iconography of death and the plague', in The Black Death: The Impact of the Fourteenth-Century Plague, ed. D. Williman, New York, 1982, pp.108–30.

POLZER, J., 'Simone Martini's Guidoriccio da Fogliano: a new appraisal in the light of a recent technical examination', Jahrbuch der Berliner Museen, 1983, pp.103–41.

POLZER, J., 'Simone Martini's Guidoriccio fresco: the polemic concerning its origin reviewed, and the fresco considered as serving the military triumph of a Tuscan Commune', Canadian Art Review, 14, 1987, pp.16–69.

POLZER, J., 'The technical evidence and the origin and meaning of Simone Martini's "Guidoriccio" fresco in Siena', Canadian Art Review, 12, 1985, pp.143–8.

POPE-HENNESSY, J., 'A misfit master', New York Review of Books, 20 November 1980, pp.45–7.

POPE-HENNESSY, J., Italian Gothic Sculpture: An Introduction to Italian Sculpture, reprint of 2nd edn, New York, 1985; 3rd edn, London, 1986.

PREVITALI, G., La fortuna dei primitivi: dal Vasari al neoclassici, Turin, 1964.

PROKOPP, M., Italian Trecento Influence on Murals in East Central Europe, Particularly Hungary, trans. A. Simon, Budapest, 1983.

PROSDOCIMI, A., 'Note su Fra Giovanni degli Eremitani', Bollettino del Museo Civico di Padova, 52, 1, 1963, pp.15–61.

PUPPI, L., La cappella del Beato Luca e Giusto de'Menabuoi nella Basilica di Sant'Antonio, Padua, 1987.

PUPPI, L. and TOFFANIN, G., Guida di Padova: arte e storia tra vie e piazze, 2nd edn, Trieste, 1991.

PUPPI, L. and UNIVERSO, M., Padova (Le città nella storia d'Italia), series ed. C. de Seta, 2nd edn, Laterza, Rome and Bari, 1989.

RASHDALL, H., The Universities of Europe in the Middle Ages, ed. F.M. Powicke and A.B. Emden, Oxford, 1936, 3 vols.

RECHT, R., Les bâtisseurs des cathédrales gothiques, Strasbourg, 1989.

REISS, J.B., Political Ideals in Medieval Italian Art: The Frescoes in the Palazzo dei Priori, Perugia (1297), Ann Arbor, 1981.

RICCETTI, L., 'Il cantiere edile negli anni della Peste Nera', in Il duomo di Orvieto, ed. L. Riccetti, Rome and Bari, 1988, pp.139–215.

RICHARDS, J.C., 'Altichiero and Humanist Patronage at the Courts of Verona and Padua, 1360–1390', PhD thesis, University of Glasgow, 1988.

RINGBOM, S., From Icon to Narrative, Åbo, 1965.

RIVERA, D., 'The revolutionary spirit in modern art' (1932), reprinted in Art in Theory: An Anthology of Changing Ideas 1900–1990, ed. C. Harrison and P. Wood, Oxford, 1992, pp.404–7.

RIZZOLI, L., I sigilli nel Museo Botticin, Padua, 1903.

ROBERTI, M., 'Le corporazioni padovane', Memorie del Reale Istituto Veneto di Scienze, Lettere, ed Arti, 26, 8, 1902.

ROBEY, D., 'P.P. Vergerio the Elder: republicanism and civic values in the work of an early humanist', Past and Present, 58, 1973, pp.3–37.

ROWLEY, G., Ambrogio Lorenzetti, Princeton, 1958, 2 vols.

RUBINSTEIN, M., 'Classical themes in the decoration of the Palazzo Vecchio in Florence', Journal of the Warburg and Courtauld Institutes, 50, 1987, pp.29–43.

RUSSELL, B., History of Western Philosophy, 2nd edn, London, 1979.

RUTIGLIANO, A., Lorenzetti's Golden Mean: The Riformatori of Siena, 1368–1385, New York, 1991.

SAALMAN, H., 'Carrara burials in the Baptistery of Padua', Art Bulletin, 69, 1987, pp.376–94.

SALMI, M., 'Il Paliotto di Manresa e l'opus florentinus', Bollettino d'arte, 24, 1930–31.

SANTI, B., 'De pulcerima pictura … ad honorem beate et gloriose Virginis Marie: vicende critiche e una proposta di lettura per la Madonna Rucellai', in La Maestà di Duccio restaurata, ed. A. Petrioli Tofani et al., Florence, 1990, pp.11–19.

SARTORI, A., 'La Cappella di S. Giacomo al Santo di Padova', Il Santo, 6, 1966, pp.267–359.

SARTORI, A., 'Nota su Altichiero', Il Santo, 3, 1963, pp.291–326.

SAXL, F., 'I figli dei pianeti', in La fede negli astri. Dall'antichità al Rinascimento, ed. S. Settis, Turin, 1985, pp.274–9, 473–4.

SAXL, F., 'The revival of late antique astrology', in *A Heritage of Images: A Selection of Lectures by Fritz Saxl*, 2nd edn, Harmondsworth, 1970, pp.27–41.

SAXL, F., 'Un ciclo astrologico del tardo Medioevo: il Salone della Ragione a Padova', in *La fede negli astri. Dall'antichità al Rinascimento*, ed. S. Settis, Turin, 1985, pp.280–6, 474–5.

SCHLOSSER, J. VON, 'Ein Veronesisches Bilderbuch und die höfische Kunst des XIV Jahrhunderts', *Jahrbuch der kunsthistorischen Sammlungen des Allerhöchsten Kaiserhauses*, 16, 1895, pp.144–230.

SCHLOSSER, J. VON, 'Giusto's Fresken in Padua und die Vorläufer des Stanza della Segnatura', *Jahrbuch der kunsthistorischen Sammlungen des Allerhöchsten Kaiserhauses*, 17, 1896, pp.13–100.

SCHNEIDER, L. (ed.), *Giotto in Perspective*, Englewood Cliffs, New Jersey, 1974.

SCHÖLLER, W., 'Le dessin d'architecture à l'époque gothique', in *Les batisseurs des cathedrales gothiques*, ed. R. Recht, Strasbourg, 1989, pp.227–35.

SCHREIBER, E.G., 'Venus in the medieval mythographic tradition', *Journal of English and Germanic Philology*, 74, 1975, pp.519–35.

Scultura dipinta, maestri di legname e pittori a Siena 1250–1450, Florence, 1987.

SEIDEL, M., '*Castrum pingatur in palatio*, 1. Ricerche storiche e iconografiche sui castelli dipinti nel Palazzo Pubblico di Siena', *Prospettiva*, 28, 1982, pp.17–41.

SEIDEL, M., 'Conversatio Angelorum in Silvis: Eremiten-Bilder von Simone Martini und Pietro Lorenzetti', *Städel-Jahrbuch*, 10, 1985, pp.77–142.

SEIDEL, M., 'Das Grabmal der Kaiserin Margarethe von Giovanni Pisano', in *Skulptur und Grabmal des Spätmittelalters in Italien*, ed. J. Garms and A.M. Romanini, Vienna, 1990.

SEIDEL, M., 'Gli affreschi di Ambrogio Lorenzetti nel Chiostro di San Francesco a Siena: ricostruzione e datazione', *Prospettiva*, 18, 1979, pp.10–20.

SEIDEL, M., 'Wiedergefundene Fragmente eines Hauptwerks von Ambrogio Lorenzetti', *Pantheon*, 36, 1978, pp.119–27.

SEMENZATO, C., *La cappella del Beato Luca e Giusto de'Menabuoi nella Basilica di Sant'Antonio*, Padua, 1988.

SERRA, A. DEL, 'Il restauro', in *La Maestà di Duccio restaurata*, ed. A. Petrioli Tofani *et al.*, Florence, 1990, pp.57–80.

SHELBY, L.R., *Gothic Design Techniques*, Carbondale and Edwardsville, 1977.

Sigilli nel Museo Nazionale del Bargello, ed. A. Muzzi, B. Tomasello and A. Tori, I, Florence, 1988–90, 3 vols.

SIMIONI, A., *Storia di Padova, dalle origini alla fine del secolo XVIII*, Padua, 1968.

SIMON, R., 'Altichiero versus Avanzo', *Papers of the British School at Rome*, 45, n.s. 32, 1977, pp.252–71.

SIMPSON, O. VON, 'Über die Bedeutung von Masaccios Trinitäts-fresko in S. Maria Novella', *Jahrbuch der Berliner Museen*, 8, 1966, pp.119–59.

SIRAISI, N.G., *Arts and Sciences at Padua: The Studium of Padua before 1350*, Toronto, 1973.

SKAUG, E., 'Notes on the chronology of Ambrogio Lorenzetti and a new painting from his shop', *Mitteilungen des Kunsthistorischen Institutes in Florenz*, 20, 1976, pp.301–32.

SKAUG, E., 'Punch marks – what are they worth? Problems of Tuscan workshop interrelationships in the mid fourteenth-century: the Ovile Master and Giovanni da Milano', in *Proceedings of the 24th International Congress of the History of Art/CIHA*, Volume 3, *La pittura nel XIV e XV secolo: il contributo dell'analisi tecnica alla storia dell'arte*, Bologna, 1988, pp.253–82.

SKAUG, E., 'The "St. Anthony Abbot" ascribed to Nardo di Cione at the Villa I Tatti, Florence', *Burlington Magazine*, 117, 1975, pp.540–3.

SMART, A., *The Assisi Problem and the Art of Giotto*, Oxford, 1971.

SOLBERG, G.E., 'Taddeo di Bartolo: His Life and Work', PhD thesis, New York University, 1991.

SOUTHARD, E.C., 'The Frescoes in Siena's Palazzo Pubblico, 1289–1539: Studies in Imagery and Relations to Other Communal Palaces in Tuscany', PhD thesis, Indiana University, 1978, facsimile, Ann Arbor, 1980, 2 vols.

SPIAZZI, A.M., 'Padova', in *La pittura nel Veneto. Il Trecento*, I, ed. M. Lucco, Milan, 1992, pp.88–177.

SPIAZZI, A.M., 'Un documento storico-geografico in Padova nel Trecento: il Planisfero di Giusto', *Verona illustrata*, 1, 1988, pp.7–18.

SPIAZZI, A.M. (ed.), *Giusto de'Menabuoi nel Battistero di Padova*, Trieste, 1989.

STARN, R. and PARTRIDGE, L., 'The republican regime of the Sala dei Nove in Siena, 1338–1340', in *Arts of Power: Three Halls of State in Italy, 1300–1600*, Berkeley, Los Angeles and Oxford, 1992, pp.11–59.

STEFANINI, R., Appendix 1 in R. Starn and L. Partridge, *Art of Power: Three Halls of State in Italy, 1300–1600*, Berkeley, Los Angeles and Oxford, 1992, pp.261–6.

STUBBLEBINE, J.H., *Assisi and the Rise of Vernacular Art*, New York and London, 1985.

STUBBLEBINE, J.H., 'Cimabue and Duccio in Santa Maria Novella', *Pantheon*, 21, 1973, pp.15–21.

STUBBLEBINE, J.H, 'Duccio and his collaborators on the cathedral *Maestà*', *Art Bulletin*, 55, 1973, pp.185–204.

STUBBLEBINE, J.H., *Duccio di Buoninsegna and his School*, Princeton, 1979.

STUBBLEBINE, J.H, 'Duccio's *Maestà* of 1302 for the Chapel of the Nove', *Art Quarterly*, 35, 1972, pp.239–68.

STUBBLEBINE, J.H, 'The Boston Ducciesque Tabernacle: a collaboration', in *Collaboration in Italian Renaissance Art*, ed. W.S. Sheard and J.T. Paoletti, New Haven and London, 1978, pp.1–20.

STUBBLEBINE, J.H. (ed.), *Giotto: The Arena Chapel Frescoes*, New York, 1969.

THIEME, U. and BECKER, F. (eds), *Allgemeines Lexikon der bildenden Künstler*, Leipzig, 1907–47, 36 vols, XXVII, 1933.

THORNDIKE, L., *A History of Magic and Experimental Sciences*, London, 1923–58, 8 vols.

TINTORI, L. and BORSOOK, E., *Giotto: The Peruzzi Chapel*, New York, 1965.

TINTORI, L. and MEISS, M., *The Painting of the 'Life of St Francis' in Assisi with Notes on the Arena Chapel*, New York, 1962.

TOFFANIN, G., *Cento chiese padovane scomparse*, Padua, 1988.

TOKER, F., 'Gothic architecture by remote control: an illustrated building contract of 1340', *Art Bulletin*, 67, 1985, pp.67–95.

TONZIG, M., *La basilica di Santa Giustina*, Padua, 1970.

TORRITI, P., *La Pinacoteca Nazionale di Siena: i dipinti*, 3rd edn, Genoa, 1990.

TORRITI, P., *Tutta Siena, contrada per contrada*, Florence, 1988.

TRACHTENBERG, M., *The Campanile of Florence Cathedral: Giotto's Tower*, New York, 1971.

TREXLER, R., 'Florentine religious experience: the sacred image', *Studies in the Renaissance*, 19, 1972, pp.7–41.

TREXLER, R., *Public Life in Renaissance Florence*, New York, 1980.

ULLMANN, B., *The Humanism of Coluccio Salutati*, Padua, 1963.

VARANINI, G.M. (ed.), *Gli Scaligeri: 1277–1387*, Verona, 1988.

VASOIN, G., *La signoria dei Carraresi nella Padova del'300*, Padua, 1988.

VENTURI, L., *History of Art Criticism*, trans. C. Marriott, New York, 1964.

VOLPE, C., 'La formazione di Giotto nella cultura di Assisi', in *Giotto e i Giotteschi in Assisi*, Assisi, 1969, pp.15–59.

VOLPE, C., *Pietro Lorenzetti*, ed. M. Lucco, Milan, 1989.

WAINWRIGHT, V., 'Andrea Vanni and Bartolo di Fredi: Sienese Painters in their Social Context', PhD thesis, University of London, 1978.

WAINWRIGHT, V., 'Conflict and popular government in fourteenth-century Siena: Il Monte dei Dodici, 1355–1368', in *Atti del III Convegno di studi sulla storia dei ceti dirigenti in Toscana*, Florence, 1980, pp.57–80.

WAKEFIELD, D. (ed.), *Stendhal and the Arts*, London, 1973.

WALEY, D.P., *Siena and the Sienese in the Thirteenth Century*, Cambridge, 1991.

WALEY, D.P., *The Italian City-Republics*, 3rd edn, London and New York, 1988.

WEIGELT, C.H., *Duccio di Buoninsegna*, Leipzig, 1911.

WEINBERGER, M., 'The first façade of the Cathedral of Florence', *Journal of the Warburg and Courtauld Institutes*, 4, 1940–41, pp.67–79.

WEISSMAN, R., 'Taking patronage seriously: Mediterranean values and Renaissance society', in *Patronage, Art and Society in Renaissance Italy*, ed. F.W. Kent and P. Simons, Oxford, 1987, pp.25–45.

WHITE, J., *Art and Architecture in Italy 1250–1400* (The Pelican History of Art), 3rd edn, New Haven and London, 1993.

WHITE, J., *Duccio: Tuscan Art and the Medieval Workshop*, London, 1979.

WHITE, J., 'Measurement, design and carpentry in Duccio's *Maestà*', I, II, *Art Bulletin*, 55, 1973, pp.334–66, 547–69.

WHITE, J., *The Birth and Rebirth of Pictorial Space*, 2nd edn, London, 1972.

WHITE, J., 'The reliefs on the façade of the Duomo at Orvieto Cathedral', *Journal of the Warburg and Courtauld Institutes*, 22, 1959, pp.254–302.

WIERUSZOWSKI, H., 'Art and the Commune in the time of Dante', *Speculum*, 19, 1944, pp.14–33.

WILKINS, D., 'Early Florentine frescoes in Santa Maria Novella', *Art Quarterly*, n.s., 1, 3, 1978, pp.141–74.

WILKINS, E.H., *Life of Petrarch*, Chicago, 1961.

WILKINS, E.H., *Petrarch's Later Years*, Cambridge, Mass., 1959.

WILSON, B., *Music and Merchants: The Laudesi Companies of Republican Florence*, Oxford, 1992.

WOLTERS, W., *La scultura veneziana gotica 1300–1460*, Venice, 1976, 2 vols.

WYLIE-EGBERT, V., *The Medieval Artist at Work*, Princeton, 1967.

ZERVAS, D.F., 'Lorenzo Monaco, Lorenzo Ghiberti, and Orsanmichele: Parts I and II', *Burlington Magazine*, 133, 1991, pp.748–60, 812–19.

ZERVAS, D.F., *Orsanmichele*, Modena, 1993, 2 vols.

Index

Works of art are listed under names of artists. Where attributions are not known, works are listed under locations. If it is felt that confusion might arise, further information is given in parentheses. Names that contain reference to parentage or place of origin or principal activity are listed under Christian names. Other names are listed under family names. Page numbers in bold type are those on which illustrations appear. The abbreviations anon., attrib., assoc. and m. mean anonymous, attributed to, associate of, and married to, respectively.